Masters of Light

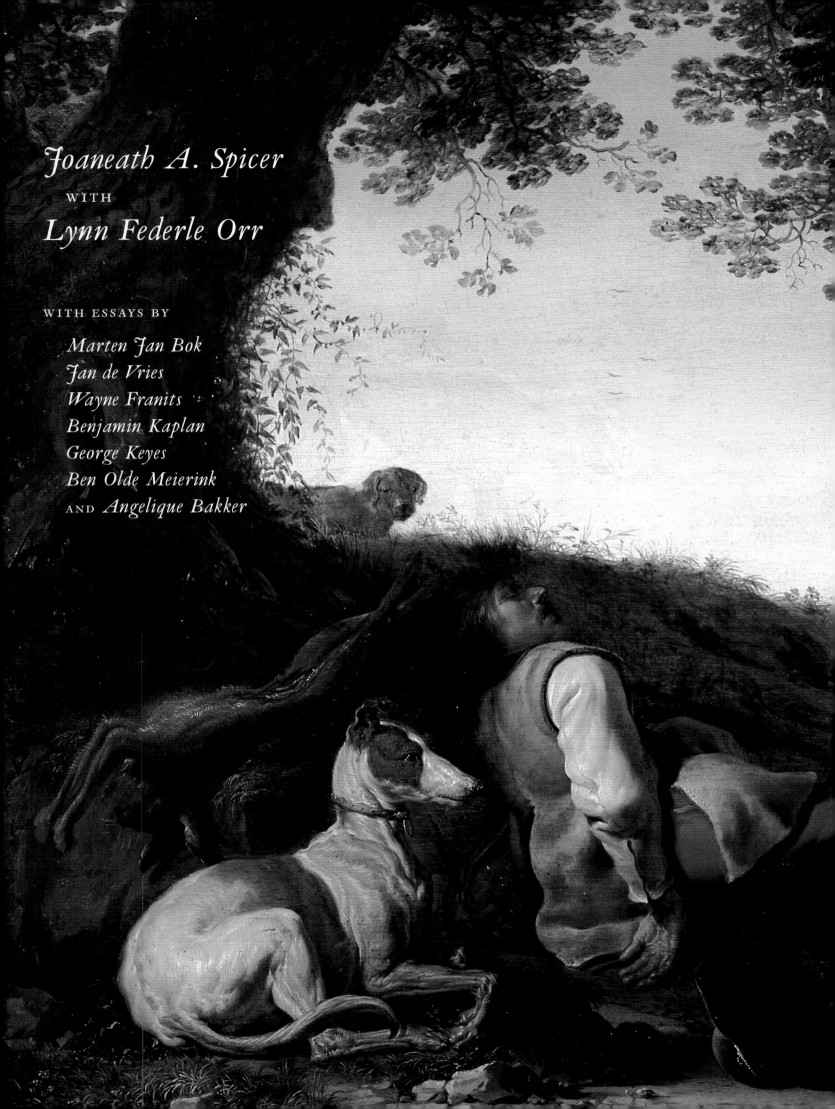

Joaneath A. Spicer

WITH

Lynn Federle Orr

WITH ESSAYS BY

Marten Jan Bok
Jan de Vries
Wayne Franits
Benjamin Kaplan
George Keyes
Ben Olde Meierink
AND Angelique Bakker

Masters of Light

PAINTERS IN UTRECHT DURING THE GOLDEN AGE

The Walters Art Gallery, Baltimore
Fine Arts Museums of San Francisco

DISTRIBUTED BY
Yale University Press, New Haven and London

This book has been published in conjunction with the exhibition
Masters of Light: Dutch Painters in Utrecht during the Golden Age

FINE ARTS MUSEUMS OF SAN FRANCISCO
California Palace of the Legion of Honor
13 September–30 November 1997

THE WALTERS ART GALLERY, BALTIMORE
11 January–5 April 1998

THE NATIONAL GALLERY, LONDON
6 May–2 August 1998

Masters of Light: Dutch Painters in Utrecht during the Golden Age
has been organized by the Walters Art Gallery, Baltimore; the
Fine Arts Museums of San Francisco; and the National Gallery,
London. We are grateful to the National Endowment for the
Humanities and the National Endowment for the Arts, U.S.
federal agencies, whose major grants have made this exhibition
and this catalogue possible. The exhibition is supported by
an indemnity from the Federal Council on the Arts and the
Humanities. Additional funding for the exhibition in San
Francisco has been generously provided by the Fine Arts
Museums Auxiliary. The Baltimore presentation is made possible
by the generous support of the Women's Committee of the
Walters Art Gallery and AEGON, USA, Inc. The exhibition
is sponsored in London by SBC Warburg, a division of Swiss
Bank Corporation.

First published in the United States of America in softcover in
1997 by the Walters Art Gallery, Baltimore, and the Fine Arts
Museums of San Francisco. First published in hardcover in 1997
by Yale University Press.

Library of Congress Catalog Card Number 97-061810

ISBN 0-88401-093-7 (softcover)
ISBN 0-300-07-3399 (hardcover)

A catalogue record for this book is available from the
British Library.

Printed and bound in Belgium.

FRONT COVER: Gerard van Honthorst, *Denial of Saint Peter*,
ca. 1620–25, The Minneapolis Institute of Arts, cat. 12 (detail).
TITLE PAGES: Cornelis Saftleven and Herman Saftleven the
Younger, *Sleeping Hunter in a Landscape*, 164[?], Boston, Abrams
Collection, cat. 73 (detail).
PAGES 130–31: Hendrick ter Brugghen, *Musical Group* (also
known as *The Concert*), ca. 1626–27, London, Trustees of the
National Gallery, cat. 40 (detail).
PAGE 161: Hendrick ter Brugghen, *Saint Sebastian Attended by
Irene*, 1625, Oberlin, Ohio, Allen Memorial Art Museum, Oberlin
College, cat. 10 (detail).
PAGE 199: Hendrick ter Brugghen, *Melancholia*, ca. 1627–28,
Toronto, Art Gallery of Ontario, on loan from a private collec-
tion, cat. 22 (detail).
PAGE 246: Dirck van Baburen, *The Procuress*, 1622, Boston,
Museum of Fine Arts, cat. 38 (detail).
PAGE 268: Nicolaus Knüpfer, *Bordello*, ca. 1650, Amsterdam,
Rijksmuseum, cat. 45 (detail).
PAGE 285: Joachim Wtewael, *Judgment of Paris*, 1615, London,
Trustees of the National Gallery, cat. 50 (detail).
PAGE 342: Jan Both, *Peasants with Mules and Oxen on a Track near
a River*, 1642–43, London, Trustees of the National Gallery,
cat. 70 (detail).

Masters of Light: Dutch Painters in Utrecht during the Golden Age
is produced by the Publications Department of the Fine Arts
Museums of San Francisco with the Walters Art Gallery, Balti-
more. Book design and composition by Susan E. Kelly, Marquand
Books, Inc., Seattle. Copyediting by Fronia W. Simpson and
Frances Bowles. Proofreading by Sharon Vonasch and Jessica Eber.
Type composed in Monotype Van Dijck. Printed and bound by
Snoeck Ducaju & Zoon, Ghent.

Contents

Directors' Foreword

Masters of Light: Dutch Painters in Utrecht during the Golden Age is the first exhibition in both America and Britain to highlight the unique achievements of the Utrecht school. This landmark exhibition includes some of the most beautiful, luminous, and deeply moving masterpieces created in a century known for its outstanding art. Utrecht painting epitomizes the best elements of European baroque art, combining Italian theatricality and innovative lighting effects with Dutch sensitivity to nature. Together the works in this exhibition reveal this unexpected aspect of Dutch painting: a warm, light-filled art that celebrates the senses in a manner uncommon in other artistic centers of the Dutch Republic.

A project conceived independently by Joaneath Spicer, James A. Murnaghan Curator of Renaissance and Baroque Art at the Walters Art Gallery, Baltimore, and George Keyes, Curator of European Paintings at The Detroit Institute of Arts, then at Minneapolis, who has contributed an essay to our publication, this exhibition began to take shape formally at the Walters Art Gallery in 1993. Having laid out the premise and parameters of the exhibition, Dr. Spicer was awarded a planning grant from the National Endowment for the Arts, a federal agency, to support early research and travel. In 1994 Dr. Lynn Federle Orr, Curator of European Paintings and Associate Department Head for European Art at the Fine Arts Museums of San Francisco, joined the project. Since that time Dr. Spicer and Dr. Orr have worked together to refine the scope and specific content of the exhibition and this accompanying catalogue. The two institutions agreed to co-organize the exhibition, sharing the many curatorial and administrative tasks required to bring such an ambitious international exhibition to fruition. In 1996, at the encouragement of Chief Curator Dr. Christopher Brown, The National Gallery in London became the third member of the organizational team.

This stunning exhibition has been a cooperative effort of our three institutions. We would like to acknowledge and express our gratitude to the professional staff for their successful efforts. Among the many who worked on this project, at the Fine Arts Museums particular thanks are due to Therese Chen Huggins, Director of Registration; Kathe Hodgson, Co-ordinator of Exhibitions; Ann Heath Karlstrom, Director of Publications; Karen Kevorkian, Managing Editor; and Lynn Angelo, Research Assistant. At the Walters Art Gallery special thanks go to Marianna Shreve Simpson, Chief Curator; Joy Hyerman, Director of Development; Beth Howell, Grants Manager; Eric Gordon, Conservator; and Martha Lucy and Quint Gregory, Curatorial Assistants. In

London we extend our particular thanks to Michael Wilson, Head of Exhibitions and Display.

Many American and European scholars, all specialists in seventeenth-century studies, have contributed their expertise to this publication. The latest scholarship on the social and cultural conditions in Utrecht that gave rise to the school's distinctive achievement in the arts is incorporated here.

As recognition of the importance of the exhibition and this scholarly catalogue, further assistance has come from the National Endowment for the Arts and the National Endowment for the Humanities, agencies of the federal government. Additional funding for the exhibition in San Francisco has been provided by the Fine Arts Museums Auxiliary. The Baltimore presentation is made possible in part through the support of the Women's Committee of the Walters Art Gallery and AEGON, USA, Inc. Meanwhile, in London the exhibition has been generously sponsored by SBC Warburg. Only through generosity of this kind can museums continue to present exhibitions of such high quality to their audiences. Indemnification for the exhibition has been provided by the governments of both the United States and Great Britain. The Netherland-America Foundation has provided an additional gift toward the publication of the catalogue. With sincere gratitude and appreciation we thank these granting agencies that promote cultural life in our two countries.

We also wish to acknowledge the lenders to the exhibition. Over forty prestigious museums and private collections are represented here by the generous loan of striking examples by Utrecht's foremost painters. Particular gratitude is due to our Dutch colleagues at the Centraal Museum, Utrecht; the Rijksmuseum, Amsterdam; and The Royal Picture Gallery, Mauritshuis, The Hague, for their extraordinary generosity in support of this exhibition. The full imaginative range and superb craftsmanship of the artists active in Utrecht during the Dutch Golden Age are illustrated here with paintings lent from these many collections. To each lender we extend our deepest appreciation.

HARRY S. PARKER III
Fine Arts Museums of San Francisco

GARY VIKAN
The Walters Art Gallery
Baltimore

NEIL MACGREGOR
The National Gallery
London

Preface

The critical evaluation of painting in the province of Utrecht, specifically in the city of Utrecht, is a twentieth-century phenomenon, even though painting there was held in high regard by contemporary writers during the Dutch Golden Age. Receding thereafter into the shadow of the art produced in the province of Holland—especially in Amsterdam, Haarlem, Leiden, and Delft—Utrecht painting benefited from a resurgence of interest manifested in the perceptive overview by C. H. de Jonge in the 1933 catalogue of Utrecht's Centraal Museum. De Jonge emphasized the international character of painting in Utrecht, in contrast to the "real national style [that] was achieved in Haarlem in the early seventeenth century." Since the 1950s, monographs on major artists, beginning with Benedict Nicolson's on Ter Brugghen (1958) and J. Richard Judson's on Honthorst (1959), and exhibitions, principally that on Ter Brugghen and Dutch Caravaggesque painters by Albert Blankert and Leonard Slatkes and others (1986), have been complemented by significant studies on the Dutch Italianate landscape by Blankert (1965) and on pastoral themes in Utrecht, including the influence of aristocratic tastes, by Alison Kettering (1983). Her study was critical to the 1993 exhibition on Dutch pastoral art by Peter van den Brink and Jos de Meyere and to the present publication. For the complexities surrounding Catholic art in Utrecht, Paul Dirkse (1989, 1991), Marcel Roethlisberger with Marten Jan Bok (1993), Xander van Eck (1993–94), Gero Seelig (1995), and Walter Melion (1997) have begun to fill the gaps in our knowledge. Bok's study on the artistic environment in Utrecht (1994) provided further important background.

In the last decades the study of painting in Utrecht has been influenced by attempts to characterize in general the art and culture of the Dutch Republic. These endeavors have often focused on "Holland," with the implication that it is the Dutch Republic that is being discussed when it may be simply the province of Holland. The result has been to perpetuate the marginalization of painting in Utrecht. In this publication, "Holland" is used only to refer to the province.

Since the idea behind the present exhibition began to take shape, two surveys have appeared that often have been consulted: the concise overview of Utrecht painting from 1600 to 1700 by Paul Huys Janssen (1990) and an exhibition in Spain of work by artists born or active in Utrecht sponsored by the Centraal Museum (De Meyere and Luna 1992). In October 1997 a general history of the province of Utrecht was published, edited by C. Dekker, which also addresses the province's rich artistic legacy. The present exhibition represented an idea whose time had come.

Our goal was to focus attention on the character and quality of painting in the city of Utrecht during the decades of greatest achievement, 1600 to 1650. We have emphasized works that conveyed the themes and patterns of patronage and also those of the finest masters. Thus we include more paintings by Ter Brugghen at the expense of, for example, works by Ambrosius Bosschaert the Younger or Herman van Vollenhoven. The paintings here are thought to have been made in Utrecht. We did not include artists working in a related style in other towns, such as Paulus Bor in Amersfoort, or those born in Utrecht who were not active there, such as Melchior de Hondecoeter. While it would have been desirable to map the reverberations of Utrecht painting in the art of Rembrandt, Georges de La Tour, Johannes Vermeer, Aelbert Cuyp, and so on, such an endeavor was beyond the parameters of the project.

Many colleagues made major contributions to this enterprise. We would like to express our particular gratitude and appreciation to Christopher Brown of the National Gallery for his participation in the preparation of this exhibition. We also extend our thanks to Michael Wilson, assisted by Jo Kent. Our discussions with them in London were critical in shaping the object list. Discussions with George Keyes at the onset were pivotal in evaluating the project. Marten Jan Bok has been unfailing in his assistance and support while, in Baltimore, Quint Gregory was indispensable. The generous grants to the Walters in the early stages of this project by the National Endowment for the Humanities and the National Endowment for the Arts were vital for the development of the exhibition and the catalogue, with additional funding for the catalogue graciously provided by The Netherland-America Foundation. We are grateful for the support of the exhibition by an indemnity from the Federal Council on the Arts and the Humanities. These grants were made possible by the dedication of Beth Howell and Martha Lucy. We are delighted to acknowledge further support for the exhibition in San Francisco from the Fine Arts Museums Auxiliary and in Baltimore from the Women's Committee of the Walters Art Gallery and AEGON, USA, Inc.

For their encouragement, assistance in obtaining works of art, and good counsel in general we would like to thank Michael Abromaitis, Milena Bartlova, Egbert Haverkamp-Begemann, Robert Bergman, Peter Blume, Alan Chong, Jean-Pierre Cuzin, Susan Dackerman, Paul Dirkse, Eric Domela Nieuwenhuis, Henry Dufour, Frits Duparc, Brian Dursum, Sjarel Ex, Everett Fahy, Richard Feigen, Ivan Gaskell, Burkhardt Göres, Richard Green, Bob Habolt, Johnny van Haeften, Alphons Hammer, Liesbeth Helmus, Nicole Holland, Ambassaore Adriaan Jacobovitz de Szeged, Paul Huys Janssen, Chiyo Ishikawa, Bob Jones, Jr., Michiel Jonker, Alison Kettering, Jack Kilgore, Wouter Kloek, Olaf Koetser, Olga Kotkova, Susan Donahue Kuretsky, J. Richard Judson, Walter Liedtke, Frank Ligtvoet, Bruce Livie, Anne W. Lowenthal, Susan Lucke, Jochen Luckhardt, Evan Maurer, Walter Melion, Peter Mitchell, Mireille Mosler, Alfred Moir, Otto Naumann, Charles Roelofs, Allen Rosenbaum, E. Peters Saenen, Charles Saunarez Smith, George Shackelford, Hannah Seifertová, Eric Sluijter, Bernhard Schnackenburg, Anthony Speelman, Leonard Slatkes, Marianna Shreve Simpson, Marion Stewart, Charles Stuckey, Pieter Gatacre de Stuers, Peter Sutton, Carol Tognieri, Clifford and Barbara Truesdell, Rafael Valls, Jan de Vries, George

Wachter, John Walsh, Roger Ward, Arthur K. Wheelock, Jr., Marjorie E. Wieseman, John Wilson, Marc Wilson, and Elizabeth Wyckoff.

We also express our deep appreciation to all those who worked with us on the editing and production of this catalogue. The demanding process of bringing the manuscript to print was ably directed in San Francisco by Ann Heath Karlstrom and Karen Kevorkian. The catalogue was edited by Fronia W. Simpson, to whom we extend our special thanks for her extraordinary and unfaltering support during the editorial phase. Frances Bowles edited half of the catalogue entries, and we thank her for her dogged precision. The manuscript was expertly proofread by Sharon Vonasch and Jessica Eber. We had the pleasure of working with four very proficient translators, whose careful and skilled work we would like to acknowledge: Rachel Esner (for Michael Rohe and Barbara Gaehtgens), Michael Hoyle (Liesbeth Helmus), Leopoldine Prosperetti (Eric Domela Nieuwenhuis and Ben Olde Meierink and Angelique Bakker), and Diane Webb (Marten Jan Bok). Ed Marquand and Susan E. Kelly guided the design process of this book, resulting in its distinctive character.

Our many colleagues at both the Walters and the Fine Arts Museums deserve our appreciation for their professional guidance of the exhibition to fruition. Special recognition is due to Kathe Hodgson in San Francisco, who coordinated all details of the exhibition, and Therese Chen, also in San Francisco, who, with the assistance of Anne Breckenridge in Baltimore and Rosalie Cass in London, oversaw the complex registration requirements. Once gathered together, the objects in the exhibition were monitored by the Walters's conservator Eric Gordon.

To those specifically mentioned here and to the many others who helped us in the lengthy process from initial idea to exhibition and catalogue, we express our deepest appreciation.

JOANEATH A. SPICER
The James A. Murnaghan Curator of Renaissance
and Baroque Art, The Walters Art Gallery, Baltimore

LYNN FEDERLE ORR
Curator of European Paintings,
Fine Arts Museums of San Francisco

Lenders to the Exhibition

ALLENTOWN ART MUSEUM, Allentown, Pennsylvania

RIJKSMUSEUM, Amsterdam

STICHTING COLLECTIE P. EN N. DE BOER, Amsterdam

THE WALTERS ART GALLERY, Baltimore

ÖFFENTLICHE KUNSTSAMMLUNG BASEL

STIFTUNG PREUßISCHE SCHLÖSSER UND GÄRTEN BERLIN-BRANDENBURG

ABRAMS COLLECTION, Boston

MUSEUM OF FINE ARTS, Boston

HERZOG ANTON ULRICH-MUSEUM, Braunschweig

FITZWILLIAM MUSEUM, University of Cambridge

FOGG ART MUSEUM, Harvard University Art Museums, Cambridge

CINCINNATI ART MUSEUM

THE CLEVELAND MUSEUM OF ART

STATENS MUSEUM FOR KUNST, Copenhagen

THE LOWE ART MUSEUM, University of Miami

THE DETROIT INSTITUTE OF ARTS

OPENBAAR CENTRUM VOOR MAAT-SCHAPPELIJK WELZIJN VAN DIEST

BOB JONES UNIVERSITY MUSEUM AND GALLERY, Greenville, South Carolina

MAURITSHUIS, The Hague

COLLECTION HANNEMA-DE STUERS FOUNDATION, Heino-Wijhe, The Netherlands

THE NELSON-ATKINS MUSEUM OF ART, Kansas City, Missouri

STAATLICHE MUSEEN KASSEL, GEMÄLDEGALERIE ALTE MEISTER

THE NATIONAL GALLERY, London

NATIONAL PORTRAIT GALLERY, London

LOS ANGELES COUNTY MUSEUM OF ART, MR. AND MRS. EDWARD CARTER COLLECTION

COLLECTION OF DRS. ISABEL AND ALFRED BADER, Milwaukee

THE MINNEAPOLIS INSTITUTE OF ARTS

MR. AND MRS. M. HORNSTEIN, Montreal

ARNOLDI-LIVIE, Munich

RICHARD L. FEIGEN, New York

THE METROPOLITAN MUSEUM OF ART, New York

ALLEN MEMORIAL ART MUSEUM, Oberlin College

MUSÉE DU LOUVRE, Paris

NATIONAL GALLERY, Prague

THE ART MUSEUM, Princeton University

CENTRAAL MUSEUM, Utrecht

MUSEUM HET CATHARIJNECONVENT, Utrecht

STERLING AND FRANCINE CLARK ART INSTITUTE, Williamstown, Massachusetts

YORK CITY ART GALLERY

PRIVATE COLLECTIONS

An Introduction to Painting in Utrecht, 1600–1650

JOANEATH A. SPICER

When the great Flemish painter and diplomat Peter Paul Rubens traveled to the Dutch Republic in 1627, he went first to Utrecht.[1] Though Utrecht was the chief city in the province of the same name, it was small, had little of the industry and, being far inland, none of the maritime trade that allowed cities in the province of Holland, such as Amsterdam, to prosper in the seventeenth century. What would have prompted Rubens's visit? Given that a state of war existed between the Spanish-controlled Southern Netherlands and the seven Northern Netherlandish provinces, which had declared their independence, his larger purpose was probably diplomatic and secret. Utrecht's industry may have been stagnant beyond a local focus on luxury goods, but for a painter it was a vital place. It was the most important center for painting in the Republic, though the population was less than 30,000, versus the 120,000 people living in Amsterdam, the cosmopolitan metropolis of the new country.

Rubens probably visited Utrecht because its art represented qualities he understood and admired. Like Rubens—but unlike the majority of their counterparts in other Dutch cities—most of the leading artists of Utrecht had worked in Rome or in other countries, resulting in a shared international outlook. A critical aspect of this shared outlook was that in Utrecht, as in Antwerp and Rome, Catholics and the aristocracy played formative roles, whereas the reigning ethos in the Dutch Republic as a whole was essentially Protestant and middle class.

Political Circumstances in Utrecht in 1627

Although the seven northern provinces of the Netherlands had declared their independence from Spain in 1581, they had yet to establish their sovereignty in law.[2] The war with Spain dragged on, resuming after a twelve-year truce in 1621, and was only brought to an end in 1648. Holland was the largest, richest, and most powerful province in the Republic, and the court of the stadholder was in Holland at The Hague. (The stadholder was the governor elected by the States General, the central legislature made up of nobles and representatives of the provincial States.) Balancing the rights of the provinces as exercised individually and by the States General against the need for central authority was one of the challenges faced by the stadholder, since 1626 Prince Frederik Hendrik of Orange-Nassau.

Politics in the Republic were intertwined with the conflicts between confessional groups, principally branches of Calvinism, the official church. At the time of Rubens's

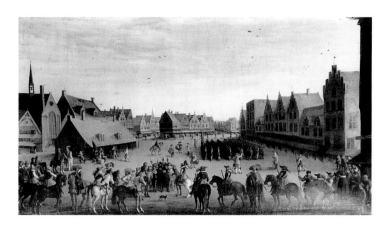

Fig. 1 Joost Droochsloot, *Prince Maurits Disbanding the Utrecht Militia (Mercenaries) in 1618*, 1625. Oil on canvas, 93 × 158 cm (36⅝ × 62¼ in.). Rijksmuseum, Amsterdam, A-606.

visit, the Contra-Remonstrants, or strictest Calvinists, controlled the socially prestigious and powerful city council. This was a result of the political coup instigated in 1618 by Prince Frederik Hendrik's predecessor, his half-brother Maurits, to gain power at the expense of the provinces by supporting the States General. Maurits sided with the Contra-Remonstrants, who were more ready to take up hostilities again than were the Remonstrants (more tolerant Calvinists) and other parties. In a dramatic gesture Maurits went to Utrecht and disbanded the mercenaries in the pay of the States of Utrecht to eliminate a military group on which he could not depend (fig. 1). This was also the year of the Synod of Dordrecht, an international Calvinist gathering, in which the Contra-Remonstrants triumphed, declaring Remonstrants to be heretics. In Utrecht, the Contra-Remonstrants were seen as the best protection against the perceived threat of Catholicism, still the private faith of one-third of the population.

Though curtailed after 1618, the power of the nobility in the province of Utrecht remained greater than in Holland and extended throughout public and private life. For a noble, holding a public appointment was not simply a question of power but of self-definition. To maintain noble status, it was necessary not only to demonstrate noble lineage but also to live nobly. This meant shunning any livelihood other than managing one's country estate or serving in the highest levels of government or the military. Once a university was established in the city in 1636, members of the English aristocracy and gentry preferred Utrecht to Leiden with its famous university, since they felt that "the air and company there [in Utrecht] were better."[3]

Character of Painting in Utrecht
We do not know what paintings Rubens would have seen in Utrecht. However, his guide while in the Republic, the young German Joachim von Sandrart (at the time a pupil in the academy kept by Gerard van Honthorst) later wrote that Rubens visited various leading artists: Abraham Bloemaert, Gerard van Honthorst, and Cornelis van Poelenburch are named.[4] Whether or not Rubens actually saw Bloemaert's *Adoration of the Magi* (cat. 16), Honthorst's *Musical Group by Candlelight* (cat. 35), or Poelenburch's *Landscape with the Flight into Egypt* (cat. 68), it was works like these or Hendrick ter Brugghen's *Saint Sebastian Attended by Irene* (cat. 10) that he had come to see. In 1627 painting in Utrecht can be described as the crossroads of the baroque. Ter Brugghen's *Saint Sebastian* is imbued with the energy of the Counter-Reformation expressed through the brilliant light effects, compositional drama, and intensity of contemporary Italian painting, especially that of Michelangelo da Caravaggio, whose paintings in Rome had been important as well for Rubens's own earlier development. In the work of the Utrecht Caravaggisti, the followers of Caravaggio, these qualities are mixed with the subtle sensitivity to natural detail of their native tradition to give these works their special appeal to the senses.

The individual subjects painted in Utrecht were not unique to the city, but the particular range of subjects chosen (or excluded) resulted in a distinctive profile. Under the impact of the

Counter-Reformation, the prevalence of subjects reflecting Catholic beliefs, such as the lives of the saints, is striking. Depictions of contemporary life focus on pleasures of the senses, idealizations of the rowdy life to be seen in inns and brothels, presented as natural human follies. Middle-class citizens and Dutch peasants are encountered less often than are Arcadian shepherds and shepherdesses, for whom the pursuit of love is everything. The mythological Golden Age, before mankind was reduced to working, and banquets of the Olympian gods were popular subjects. The pastoral portrait—the romantic, make-believe representation of sitters as shepherds and shepherdesses —is Utrecht's contribution to Dutch portraiture. Landscapists delighted in the imaginary, the idyllic, and the foreign, rather than the Dutch countryside. The range of still-life subjects was limited. Imaginary bouquets of brilliant flowers that bloom at different seasons was the favorite subject.

As these subjects suggest, there was a strong tendency among painters in Utrecht, regardless of their artistic background, to place the highest value on imagery created in the imagination (which is made plausible by borrowing from experience) as opposed to imagery that takes the reality of daily existence as a point of departure (which is then refined by the imagination). Both the older painters trained in the aesthetics of Haarlem, as conveyed in Karel van Mander's "Foundation of the Noble Art of Painting" published in 1604, and the following generation of painters, influenced by foreign travel, especially contemporary painting in Rome, paid homage in their art to the primacy of the imagination. Nevertheless, the two generations differed in how and to what extent they drew on experience to give shape to the workings of their imagination. For Van Mander,[5] art is elevating not only through the noble ideals it conveys but also through the noble manner in which those ideals are expressed. The artist must call on his higher faculties, his *geest*

(imagination), and not be content with imitating what he sees, with simply working *naer het leven* (from life). However, the persuasiveness of art calls for its being at least not inconsistent with experience. The eye is delighted not only by grace and harmony but by variety and abundance, as by a "meadow full of flowers in which the eyes, like bees, delight in all kinds of artful flowers."[6] On the other hand, the persuasiveness of the imagery by the Caravaggisti is based on a more direct mobilization of the senses, usually distilled, focused, and intense.

A Chronological Overview of Painting in Utrecht
A brief overview organized around critical dates between 1600 and 1650 provides a complement to the thematic organization of this study.

1600
There were three fine painters in Utrecht in 1600, Abraham Bloemaert, Joachim Wtewael, and Paulus Moreelse. The first two concentrated on history painting, expressed through the extravagant vocabulary of mannerism. The influence of artists in Haarlem was decisive, especially Hendrick Goltzius's engravings, Cornelis Cornelisz. van Haarlem's paintings, and Karel van Mander's writings. Goltzius's engraving *The Wedding of Cupid and Psyche* after a drawing by Bartholomeus Spranger, court painter to the Holy Roman Emperor Rudolf II (cat. 49, fig. 1), was the single most important source. A favored topic for Bloemaert and Wtewael was the Loves of the Gods, often on an intimate scale (cats. 46, 47). Wtewael painted a few inspired portraits (see fig. 8), and Moreelse would make it his specialty. In the next years landscape as a separate genre is inaugurated by the mannerist fantasies of Gillis de Hondecoeter (see fig. 18) from Antwerp.

1611
In 1611 the painters and sculptors separated from the saddlers and formed their own guild, fostering a sense of artistic community. A committed

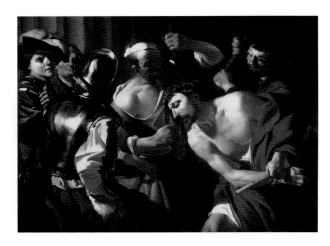

Fig. 2 Dirck van Baburen, *Mocking of Christ*, ca. 1622. Oil on canvas, 127 × 168 cm (50 × 66⅛ in.). Nelson-Atkins Museum, Kansas City, Missouri, 84-25.

Catholic, Bloemaert gave his best energies to religious works (cat. 3) and dominated the artistic scene through his teaching. Many of his students will become Utrecht's major artists: Hendrick ter Brugghen, Gerard van Honthorst, Jan van Bijlert, Cornelis van Poelenburch, Jan Both, and Nicolaus Knüpfer. Wtewael, busy with his flax business, concentrated on sensuous boudoir pieces on the leisures and loves of the gods (cats. 47–50). In 1611–12 the printmakers Crispijn van de Passe and Hendrick Goudt settled in the city. No Utrecht painter influenced by Caravaggio had yet returned from a trip to Italy.

1618–1627

The political upheavals of 1617–19 affected some artists personally. Moreelse, a Contra-Remonstrant, was invited to join the city council; perhaps in consequence, the demand for his portraits among the aristocracy and patriciate increased (cat. 29). However, Bloemaert, being Catholic, was replaced by Moreelse as dean of the Painters' Guild. This decade was the most creative in the city's history, in particular the years 1622 to 1627.

Critical to this development was the influx of artists. With the arrival of Ambrosius Bosschaert and Balthasar van der Ast in late 1615 and

Roelandt Saverij in 1618, flower painting enjoyed a short but sensational season. Returning from Italy were Honthorst (1620), Baburen (1621), and Van Bijlert (1625), all influenced by the naturalism and dramatic lighting of Caravaggio, as was Ter Brugghen, who had returned in 1614. While the imprint of Caravaggio is found in sensuous low-life scenes, its most profound effect was on religious art, as seen in Baburen's *Mocking of Christ* (fig. 2; cat. 7) and Honthorst's *Denial of Saint Peter* (cat. 12). The latter's academy carried on the tradition of Bloemaert, attracting students even from abroad, like Joachim von Sandrart. Poelenburch's return from Italy in 1625 ushered in the era of the Italianate landscape (cat. 68), which ultimately had as much impact on Dutch art as the Caravaggesque movement.

A second factor in painting's flowering was the patronage of Elizabeth, queen of Bohemia, and of Prince Frederik Hendrik, who established his court in The Hague in 1625. Frederik Hendrik wanted to create a court that could offer comparison to those in France and England, with all that that implies for the patronage of artists. This stance was fostered by his marriage in 1625 to Amalia van Solms, who had been a lady-in-waiting to Elizabeth Stuart, queen of Bohemia. Elizabeth and her husband, Frederick, had established their court in exile at The Hague after their disastrous, brief rule in Prague ended in 1620 with their expulsion. As a daughter of James I of England, Elizabeth was accustomed to an elaborate court life, which she sought to replicate. The taste of the court for the idyllic is reflected in the paintings that the States of Utrecht gave Amalia van Solms in 1627—a *Shepherd* (see fig. 13) and *Shepherdess* by Moreelse, a *Garden of Eden* by Saverij (see fig. 23), and Poelenburch's *Wedding Banquet of the Gods* (see fig. 11). Honthorst's work for the court was executed in a classicizing style, a move away from Caravaggesque light and shadow. Rubens's visit to the city in 1627 came at the peak of the artistic community's capabilities.

1635

Prince Frederik Hendrik's commission in 1635 for a series of paintings illustrating Giovanni Battista Guarini's play *The Faithful Shepherd* for his hunting palace at Honselaarsdijk confirmed the status of the pastoral. The work of the Utrecht painters who carried out the monumental works—Bloemaert, Poelenburch, Diderick van der Lisse, Hendrick Bloemaert, and Herman Saftleven—capped the development of the genre in Utrecht. Honthorst was active in court circles (cat. 26), especially as a portraitist (cat. 27). A refined Arcadian vision continued to evolve in the hands of Poelenburch (cat. 69) and artists in his circle, such as Carel de Hooch (cat. 54, fig. 2) and Van der Lisse (cat. 55). Caravaggism was supplanted by a tendency toward classicism and by a taste for small-figured compositions influenced by developments in Amsterdam and Haarlem, such as the work of Jacob Duck (cat. 34).

1643

The first extensive Dutch manual on painting and drawing for artists, *Van 't Licht der teken en schilderkonst* (The light of the art of drawing and painting), was published by Crispijn van de Passe the younger in 1643 in Amsterdam,[7] but it was dedicated to the city council of Utrecht and took its method and examples from the Utrecht artistic firmament. Low-life and religious subjects by the Caravaggisti were reinterpreted by Jan van Bronchorst, in whose work the mischievous sensuosity of his predecessors gave way to a harder sensuality, the latter also the focus of works by Duck and Knüpfer (cat. 56). Poelenburch continued painting languorous Arcadian landscapes (cat. 54), but in 1642 Jan Both returned from Italy, bringing a new approach based on the Arcadian vision fused with close observation of natural detail, including effects of light (cat. 70). Even established artists such as Herman Saftleven fell under Both's spell. In 1644 the city permitted the painters to establish a college or guild apart from sculptors.

1650

The serene Italianate landscapes by Van der Lisse, Poelenburch, and Both (cats. 71, 72) were joined by the lively, ruin-filled visions of the Roman Campagna by Jan Baptist Weenix (cat. 74). Saftleven turned Both's insights to imaginary views of the Rhine river and also to views of Utrecht. The growing market for portraits among the nobility and rising middle classes was filled by, among others, Van Bijlert, Hendrick Bloemaert, and the newly arrived Cornelis Janson van Ceulen, who introduced the elegance of Anthony van Dyck's English court portraiture. Genre, biblical, and mythological scenes attracted few adherents, an exception being Knüpfer (cat. 45). The one new development was in still-life painting, where a taste for realism was expressed in praise of the ordinary, in fish still lifes, set off against the celebration of the flamboyant and the aristocratic, in Weenix's life-size hunting trophy pieces (cat. 78), the latter capturing the mood of the following decades.

The themes favored by Utrecht painters, Body and Spirit: The Impact of the Counter-Reformation; The Wisely Led Life; Pleasures and Duties: Contemporary Life; Noble Ideals: Arcadian and Mythological Imagery; Fantasies of Arcadia and Eden: Landscapes of the Imagination; and Artifice and Reality: The "Still" Life, reveal the distinctive profile of painting in Utrecht and the patronage and taste that produced it. This profile will be contrasted with what has been thought of as typically Dutch, that is, art created in Amsterdam, Haarlem, Leiden, The Hague, Delft, and Rotterdam—but not in Utrecht.

Body and Spirit: The Impact of the Counter-Reformation

Religious subjects, many intended for a Catholic audience, constituted a major aspect of artistic production in Utrecht, more so than in any other place in the Republic including Haarlem, where

there was also a significant Catholic community. Though a few paintings executed in Utrecht depict themes chiefly of interest to Protestants, such as Moreelse's *Allegory of Protestant Faith* (cat. 19, fig. 1), and numerous representations of biblical themes could serve the needs of Protestants and Catholics alike, for example Bloemaert's *Four Evangelists* (cat. 3), many paintings respond to specifically Catholic concerns. Whether the artist was Catholic—as Bloemaert, Honthorst, or Poelenburch were—or Protestant, as were Ter Brugghen, Van Bijlert, Wtewael, or Moreelse—or professed no faith at all was less important than the audience for which paintings were made, about which we have few specifics. The religious environment in Utrecht, the Catholic community there, and the hidden Catholic churches are discussed in the essay by Benjamin Kaplan; here we will focus on the art.

The subject matter of Catholic art in Utrecht during these decades falls within the lines of Catholic art in Europe as a whole. In the face of Protestant rejection of central mysteries of the Catholic faith, the Church celebrated with intensified vigor the beliefs and traditions that were most fervently attacked. These centered on the redemptive promise of Christ's Passion as embodied in the sacrament of communion; the unique role of the Virgin Mary as intercessor with God through Christ on behalf of humanity; and the importance of the saints, whose example provide inspirational but realistic models of piety, sacrifice, and good works through which the devout hope to merit salvation. By contrast to the paintings of Rubens or the masters of the Roman baroque, there is a concentration on subjects conducive to individual devotion (frequently involving personal testing). On the other hand, there are few documented altarpieces, and Bloemaert's altarpieces were commissioned for churches elsewhere. There are almost no paintings celebrating the triumph of Christ or the Virgin, often equated with the Church itself. Perhaps because Catholic laymen

were not encouraged to read the Bible for themselves (as Protestants did), the choice of biblical stories could differ, as did the interpretations of the working of divine will and grace in the stories favored.[8]

In addition, painting with nominally Catholic subjects were appreciated, even commissioned, for reasons beyond their Catholic origins. Patron saints may have been officially suppressed, but they still had currency in people's hearts. Paintings of Saint Martin, Utrecht's former patron saint, a model of Christian charity, as that by Droochsloot (cat. 31), are listed in the inventories of Protestants, and in 1621 the Smiths' Guild commissioned a painting of Saint Eloy, their patron saint, for their hall (see cat. 52). There was also an increasing tendency to obtain and value paintings primarily as works of art.

The Catholic reform movement, or Counter-Reformation, extending from the early sixteenth century into the seventeenth, was shaped in many ways by its reaction to the Protestants who left the Church.[9] The general council called to address these schisms, meeting in sessions from 1545 to 1563 in Trent, aimed to purge abuses and reaffirm traditional doctrines under attack by the Protestants. The decrees of the Council of Trent included one on the regulation of art,[10] but it is vague and remembered for its indications of what should be condemned—inappropriately seductive or confused imagery that was not open to ordinary understanding. Thereafter Catholic writers sought to articulate clearly the universal role of art, especially painting, as a powerful incitement to belief through the reinforcement of positive behavior, whether in Utrecht, Rome, Antwerp, Madrid, or colonial America.[11] This role was expressed most simply by the Spanish painter Francesco Pacheco: "Holy images . . . show to our eyes and hearts the heroic and magnanimous acts of patience, of justice, chastity, meekness, charity and contempt for worldly things in such a way that they instantly cause us to seek

virtue and to shun vice, and thus put us on the roads that lead to blessedness."[12]

Given the effects of the iconoclasm of the 1560s and the continuing oppression reflected in the loss of Catholic churches, it is striking that there is such a body of Catholic art in Utrecht at all. The most important exponents of the proselytizing zeal of the Counter-Reformation that took seriously the role of art as a vehicle for persuasion were the Jesuits,[13] who established a station at Utrecht in 1613 with the mission to consolidate the faith of the Northern Netherlands. The Jesuit order founded in the sixteenth century by Ignatius of Loyola had among its primary goals spreading Catholic doctrine and combating heresy; in consequence, teaching, developing meditational practices or "spiritual exercises," publishing aids to devotions and tracts attacking heresies, and commissioning art were all important.

Antwerp, a major center of Jesuit activity, was the source for many books on Catholic subjects available in Utrecht, such as publications dedicated to the practice of meditation, specifically the role of visualization as an aid to prayer.[14] Visualization, with roots in medieval meditations,[15] had its contemporary foundation in Ignatius's own *Spiritual Exercises* (published in 1549 for the training of priests). This series of graduated exercises made use of the imagination and all the senses to arrive at an understanding of self and to experience as vividly as possible the events in the lives of Christ and the Virgin. Similar meditational practices involving an imaginative immersion in the actions and emotions of sacred events were developed for the layperson, such as those by Jerome Nadal. The significance of the link between visualization, painting, and prayer for the Jesuits is very clear in *Meditations affecteuses sur la vie de la Tressainte Vierge Mère de Dieu* (Loving meditations on the life of Holy Virgin Mother of God; Antwerp, 1632) by the Jesuit Estienne Binet.[16] These meditations revolve around moments in the Virgin's life with Christ, which the

reader is to visualize. They typically begin with, "You see how . . ." Then at various points the writer stops to address the painter who through his art can convey the emotional intensity of the moment in physical terms to which the worshiper can relate. In the visualization of the Crucifixion, Binet writes, "Painter, make us see the pierced heart of the Holy Virgin, pierced as much by the nails and by the thorns and by suffering as is the body of her precious son."[17] This passage conveys succinctly the role of empathy in devotion, the role of the Virgin as mediator in this experience, and the facilitating role of the painter who can create a surrogate visualization, providing what we might call a template for the worshiper's own imagination.

The Passion of Christ, culminating in his sacrifice on the cross, is not only central to the Christian faith and to the promise of redemption but was a traditional subject for personal meditations, which, since the Middle Ages, had encouraged a personal identity with Christ's suffering.[18] Within the Passion, the episode most favored by Utrecht painters was the mocking and torment that Christ underwent after his arrest—when he was bound, beaten and reviled, a crown of thorns jammed on his head and a reed thrust into his hand as a scepter to mock him as King of the Jews. In the *Meditations on the Passion of Christ*, published in Latin and Dutch in 1587 by the Antwerp Jesuit Franciscus Costerus, the meditator is urged to experience Christ's suffering and especially his humiliation. Only by such empathy can he or she appreciate that this suffering and sacrifice make human salvation possible and only through such understanding can the meditator be strengthened so as to deal with suffering and humiliation in his or her own life. In the meditation on the Crowning and Mocking of Christ, the meditator should think about the ways that the Savior was mocked: how his tormentors pulled off the cloth stuck to his open wounds, the indignity of their stripping him, and the filth and spittle with which he was

assaulted. Then one meditates on specific objects, such as the reed in Christ's hand. The passage closes: "Doe thou pray our Lord to make thee partaker of all these thinges."[19]

The powerful interpretations of this episode by Dirck van Baburen (fig. 2; cat. 7) and Hendrick ter Brugghen (cat. 6) take on added meaning in the context of these contemporary meditational techniques. Both artists visualize the subject in intensely emotional ways intended to engage the imagination of the viewer and let the viewer "partake." Baburen experimented first with a more spacious setting (fig. 2) but in rethinking the composition (cat. 7) seems to have eliminated the air itself. In visualizing the event, he drew on earlier paintings of the subject by another Caravaggio follower, Bartolomeo Manfredi (cat. 7, fig. 2), but Baburen's interpretation is even more intensely physical because of his success in engaging the senses of the viewer, especially touch. The viewer, having pushed his way, as it were, to an empty space at the front of the surly crowd and jostled by the sweaty guards pressing around Christ, is left to gaze in wonder at the dignity with which his Savior faced such humiliation. Ter Brugghen's interpretation lacks the body heat of Baburen's confrontation; evil is more coolly represented. Ter Brugghen here pays subtle homage to early Netherlandish traditions by adapting Lucas van Leyden's graphic renderings of the Crowning with Thorns (cat. 6, figs. 1, 2) with their grizzled, insinuating tormentors—represented as deformed embodiments of evil—bearing down on Christ. This homage is at the heart of his most puzzling work, *Crucifixion with the Virgin and Saint John* (cat. 8), ethereal in its archaizing imitation of a gold-ground altarpiece, yet intensely present and physical in the tormented body of Christ.[20]

The doctrine of Christ's physical presence in the bread of communion was, as a subject for art, associated with public devotion in connection with the celebration of the Eucharist, or Holy Communion. The strategy for conveying this more intellectual message can be quite different, and in paintings by Van Bijlert and Bloemaert the viewer is simply a witness, not a "partaker." The Catholic doctrine of transsubstantiation—that the bread and wine of communion, at the moment they are consecrated by a priest, are converted into the actual Body and Blood of Christ with only the superficial appearance of the bread and wine remaining—rejected by Protestants, was reaffirmed by the Council of Trent. Vigorous defense of this doctrine meant a greater emphasis on Holy Communion.[21] In Van Bijlert's altarpiece *Holy Trinity with Saint Willibrord and Saint Boniface* (see Kaplan, fig. 5, in this catalogue),[22] God the Father holds up the dead body of Christ, just as the priest holds up the consecrated bread or wafer during Communion. Both the clear presentation and the inclusion of familiar Utrecht saints, Willibrord and Boniface, support the instructional function of this altarpiece. It was commissioned for the Brotherhood of God's Mercy under the Protection of Saints Willibrord and Boniface, which was founded in 1603 by the apostolic vicar Sasbout Vosmeer, to strengthen and spread knowledge of Catholic doctrines.[23] In Bloemaert's *Four Fathers of the Church Discussing the Nature of the Eucharist* (fig. 3),[24] composed as both an engraving and an altarpiece,[25] Saints Augustine, Jerome, Gregory, and Ambrose, who lived at different times in the early centuries of the Church, are shown discussing the real presence of Christ in the eucharistic bread seen on the altar.[26] The effectiveness of the image depends on the viewer's being predisposed to accept the authority of the Church and thus was appropriate for a securely Catholic audience.

The Virgin Mary as Immaculate Mother of God and Queen of Heaven was a central figure in traditional Catholic devotional art, in which her role as loving intercessor with Christ and God the Father was paramount.[27] Her veneration was particularly encouraged by the Jesuits. In the *Loving Meditations* noted above, Binet calls on the pious reader to acknowledge the Virgin as "the advocate

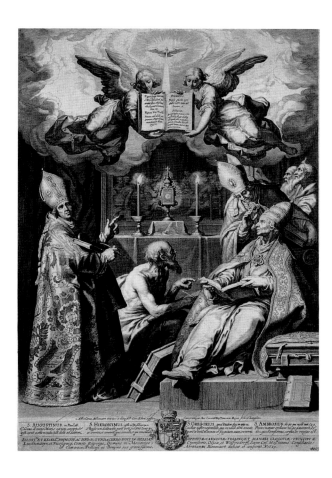

Fig. 3 Cornelis Bloemaert, after Abraham Bloemaert, *Four Fathers of the Church Discussing the Nature of the Eucharist*, 1629. Engraving, 478 × 357 mm (18⅞ × 14 in.). Rijksprentenkabinet, Amsterdam.

in heaven of mankind, [who] pleads so powerfully the case of her servants that she saves them."[28] While her intercessory role was depicted by showing her as mankind's advocate with Christ before God, as in an altarpiece painted by Bloemaert for the church of Saint John in 's-Hertogenbosch,[29] it was more commonly invoked in intimate images of the Virgin and Child (cat. 17). This sweet image of maternal care (which extends to the worshiper) is a traditional type of small painting meant as an aid to private devotion by encouraging the worshiper's prayer to the Virgin, appealing for her advocacy. This becomes explicit in the artist's *Virgin and Child in a Garland of Roses*, with its association with the rosary, each of the fifteen blooms representing prayers to Mary.[30] The timeless, universal quality of such images and the devotion

associated with them is brought home by reference to a traditional prayer that enjoyed renewed popularity in the early seventeenth century: "Hail, Holy Queen, Mother of Mercy, our life, our sweetness and our hope. . . . Turn then, most gracious advocate, thine eyes of mercy toward us, and . . . show us the blessed fruit of thy womb, Jesus."[31] Her singular privilege and grace as Christ's Mother (and therefore mankind's most effective advocate) are conveyed as well by Bloemaert's immense *Adoration of the Magi* (Musée de Peinture et de Sculpture, Grenoble) for the main altar of the Jesuits' new church in Brussels,[32] where it was surrounded by Rubens's paintings of Saint Ignatius and Francis Xavier. In Bloemaert's smaller, related *Adoration of the Magi* (cat. 16), the very splendor of the three kings and their gestures of homage throw into relief the poise and simplicity of the Virgin. Metaphors of light traditionally associated with the Virgin—Binet's reference to her as the "daughter of light" contrasted with the "shadows of the world"[33]—that evoke the dwelling of the Holy Spirit in her and the miraculous conception of Christ, are given a fuller sense in Ter Brugghen's luminous *Annunciation* altarpiece (cat. 15), in which Caravaggesque light and shade are fully exploited for their interpretive as well as aesthetic potential.

The aggressive image of the Virgin as the Church triumphing over heresy, characteristic of Counter-Reformation Rome,[34] does not play a role in Utrecht; it would be inflammatory. A more subtle commentary on heresy is found in Bloemaert's *Parable of the Wheat and the Tares* (cat. 18).

The saints were at the heart of Catholic personal devotion as inspirational but realistic models of sacrifice, piety, and good works, the bases for their merits as advocates for mankind. Protestant rejection of the cult of the saints resulted in a Catholic reassertion of the value of devotion to them and their images.[35] This was complemented by a renewed examination of their lives. Typical of this interest was the Jesuit publication for a wider

Catholic audience, *Generale legende der Heylighen met het leven Iesu Christi ende Marie* (Stories of the saints with the life of Jesus Christ and Mary; Antwerp, 1619) by Petrus Ribadineira and Heribert Rosweyde, the latter from Utrecht.

The most compelling image of Christian suffering and readiness to imitate the Savior's sacrifice is the martyrdom of Saint Sebastian, protector against the plague and patron of archers, as interpreted by Honthorst (cat. 9) and Ter Brugghen (cat. 10). The immediacy and direct appeal to the senses of Honthorst's *Saint Sebastian* and Ter Brugghen's *Saint Sebastian Attended by Irene* gain added meaning by considering the stunning parallels they offer to Jesuit meditational use of visualization as an aid in prayer. In Honthorst's painting there is little indication of setting, and the imagination of the devout is engaged in relating to the body of the suffering martyr. The artist has rejected the intricate surfaces and warm, glancing light effects that he had developed in Italy and continued to use in contemporaneous paintings, such as those in *Musical Group by Candlelight* (cat. 35) and the warm, sensuous flesh in *A Soldier and a Girl* (cat. 36), in favor of a stark wash of light sharply outlining the slumped body. In Ter Brugghen's *Saint Sebastian* the spiritual and the aesthetic are balanced, unified by soft light. The saint's body, collapsing to the ground, folds in on itself, subsumed into a diagonal swirl of fabric and limbs that transcends individual detail. One's eye is drawn, not to the wounds, but to the bony knee jutting out incongruously from the rich damask and to the arm with its flesh twisted and gray from loss of blood, set off against the youthful, unblemished blush of Irene's attentive face and the warming light of the coming dawn. In contrast, Wtewael's *Saint Sebastian* of 1600 (cat. 2) is an aesthetic tour de force in which the artist revels in his virtuoso ability to create the impression of sinuous movement, prompting comparison with the artist's *Andromeda* (cat. 51) of a decade later. If the painting was intended as a religious image of a

suffering martyr, the sexuality of the saint is jarring; this, then, is the "inappropriate seductiveness" that the Council of Trent had condemned. Anne Lowenthal's suggestion that the painting may have been commissioned for a guild, in keeping with the saint's role as patron of archers, must be seriously considered.

The largest and most varied group of images of the saints represents them as models of piety, frequently showing them in moments of great uncertainty or in the midst of revelation expressed through the vehicle of light.[36] Their ability to overcome their failings is a powerful inducement to try to follow their example, as is the persuasiveness of their revelations. Saint Peter wavering in his faith in the *Denial of Saint Peter* by Honthorst (cat. 12) and Peter Wtewael (cat. 13) is balanced by his role in his deliverance from prison, interpreted, for example, by Ter Brugghen (cat. 11). His deliverance, the moment when he puts himself in the hands of God's angel, is expressed through sudden, nearly blinding light. This painterly device owes much to Honthorst. As a metaphor of spiritual illumination it reflects the characterization of faith as conveyed in contemporary Jesuit meditational literature. For example, among the emblems assembled by the Jesuit theologian Guilielmus Hessius in *Emblemata sacra de fide, spe, charitate* (Sacred emblems of faith, hope, and charity; Antwerp, 1636),[37] under *Faith* is included as emblem 4, "The light shines in the darkness [and the darkness had not overcome it] (John I)," illustrated by a simple but striking woodcut of a light ray piercing a dark wall. The woodcut for book 2, *Hope*, emblem 4, represents a dark room into which light floods through a window, marking a swath of light on the wall, illustrating "We rejoice in our hope of sharing the glory of God (Romans 5)." Here as elsewhere it is a matter of art's being in tune with contemporary meditational practices rather than cause and effect. This view of Peter and the clandestine church he embodies in the Republic calls attention to the apparent absence of

paintings of Peter receiving the keys to heaven and earth from Christ, an assertion of papal authority well known from contemporary Italian art[38] but too inflammatory to be depicted in the Republic.

Ter Brugghen's *Doubting Thomas* (cat. 5) and representations of the Denial of Saint Peter by Honthorst (cat. 12) and Peter Wtewael (cat. 13) focus on the frailties of conviction that saints—even Peter, the rock on which Christ built his Church—may suffer. Ter Brugghen, following the image by Caravaggio that inspired him (see Orr, fig. 7, in this catalogue), takes advantage of the viewer's double reaction to Thomas's inserting his fingers into Christ's wound. The instinctual revulsion at the sight of such an act is accompanied by the viewer's understanding of Thomas's need to touch Christ to believe in him. As Thomas is persuaded to believe through touch, so can the "partaker" be, in his meditations.

In *Calling of Saint Matthew* by Ter Brugghen (cat. 4) and renderings by Van Bijlert and other Dutch Caravaggisti, Matthew is shown at the moment when he must decide between serving the state and answering Christ's call. His rejection of the materialism around him and his turning to Christ would be understood by Catholics as an ideal example of the exercise of free will. While the light flooding the room is certainly suggestive of Matthew's dawning spiritual illumination and consistent with contemporary imagery such as that by Hessius mentioned above, this and other versions of the subject by Dutch Caravaggisti are so securely in the debt of Caravaggio's *Calling of Saint Matthew* in S. Luigi dei Francesi in Rome (see Orr, fig. 1, in this catalogue) that further discussion of them is better left to that context.[39]

The revelations expressed in these paintings by the Caravaggisti are ones that the viewer can imagine experiencing. The impact of this is clearer by comparing these pictures with the representation of spiritual revelation couched in the traditional form of a vision, such as Bloemaert's *Vision of Saint Ignatius*, lost but recorded in an engraving

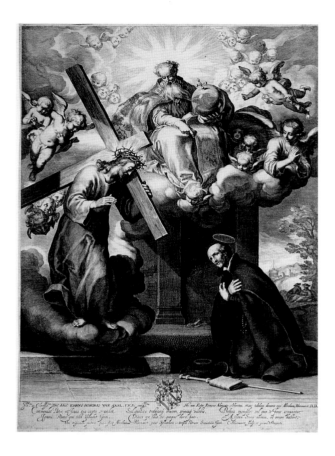

Fig. 4 Cornelis Bloemaert, *The Vision of Saint Ignatius*, 1622–25. Engraving after Abraham Bloemaert, 442 × 340 mm (17⅜ × 13⅜ in.). Rijksprentenkabinet, Amsterdam.

(fig. 4), painted in 1622 for the altar of the Jesuit church in 's-Hertogenbosch in response to the canonization of the saint in that year.[40] The vision that Saint Ignatius had in 1537 when working to secure papal approval for a new reform order was the subject of many contemporary depictions of the saint. He is represented as experiencing this vision of God and Christ as a sign of his destiny, but it is not a vision that the worshiper is expected to share, only to acknowledge.

The saint as a model of the active life of Christian charity, doing good works such as clothing the poor, which the Council of Trent affirmed to be a necessary adjunct to faith, is exemplified by images of Saint Martin dividing his cloak with a beggar, such as that by Joost Droochsloot (cat. 31). Saints as examples of the contemplative life are hard to find in Utrecht painting, probably

because of their association with the suppressed monasteries and convents, though Bloemaert produced them in print series, as those for Jesuit publications in Antwerp.[41] His *Saint Jerome in His Study* (cat. 14), illuminated by a shielded candle, a device borrowed from Honthorst, is represented as a scholar, the translator of the Bible, for which he was honored by Protestants and Catholics alike.

Old Testament subjects could convey the seriousness prized by writers such as Van Mander without being devotional; indeed, some artists seem to have drawn on it much as they would on Ovid's *Metamorphoses.* The popularity with Wtewael and Bloemaert of the Old Testament as a source about 1600 appears to have been chiefly due to the wonderful possibilities that certain kinds of stories, especially those involving either crowds of agitated people or overt sexuality, offered artists for the depiction of complicated figural compositions or sensuous young women.[42] People fleeing the Flood was one of the most popular subjects of the period, rivaling the Wedding of the Gods in its intricacies; the love of complexity is also beautifully exemplified by Bloemaert's *Moses Striking the Rock* (cat. 1), while Wtewael's *Lot and His Daughters* (cat. 2, fig. 1) offers a story of sex with willing young women that would delight many artists and patrons. The Old Testament continued to be a source for painters,[43] but interest in it as a vehicle for aesthetic complexities waned as the predominance of those sensibilities declined.

The Wisely Led Life
Fostering the wisely led life is the purpose of a wide range of paintings that call on virtues drawn from the morality of Christian life (both Protestant and Catholic), from antiquity, and from contemporary society. These compositions often center on a single figure seen close-up, either a personification of the virtue or a model exemplifying it. Paintings in Utrecht with a moral intent normally show actions to be imitated, not those to be rejected. There are many paintings of self-

indulgent behavior, but few in which such behavior is specifically chastised.

Many of the allegories of the temptations and triumphs of the Christian life are centered on a beautiful young woman and may draw on the traditional imagery of the penitent Mary Magdalene who turned to Christ after a life of prostitution. Examples are Ter Brugghen's ethereal *Melancholia* (cat. 22), in which the figure contemplates a human skull by candlelight, or Jan van Bijlert's allegory of the Catholic faith (cat. 19), in which a young woman forcefully pushes away symbols of worldly pleasures and turns toward a crucifix. In both, despite the absence of attributes normally used to identify the Magdalene in art, for example the ointment jar that refers to her role in preparing Christ's body for burial, both images draw their power from association with the Magdalene's exercise of will, underlining the capacity of the individual to choose for good (or evil).

The allegorical representation of a beautiful young woman entrapped by things of this world— thus a model of implicitly condemned behavior— is often encountered as a subject in Holland, as in *Lady World* by Jan Miense Molenaer (cat. 20, fig. 1), though less often in Utrecht, perhaps because of its Protestant associations, which may explain Moreelse's engagement with the subject, as in his fine *Allegory of Vanity* (cat. 21). Jacob Duck's *Lady World* (cat. 20) is enmeshed in transient pleasures, but Duck's interpretation is unusual in that his young woman, lounging amid luxury, turns her tearful gaze up into the light, a conventional expression of the desire for spiritual guidance and therefore for change.

The paired representations of the ancient philosophers Heraclitus, who weeps and throws up his hands over the frailty of human nature, and Democritus, who laughs and mocks them, as in the well-known pendants by Ter Brugghen (cats. 23, 24; cats. 23, 24, fig. 1), were very popular in Utrecht.[44] A key to this popularity may be found in two contemporary books on the philosophers,

L'Heralite chrestien, c'est a dire Les Regrets et les larmes du Pecheur Penitent (Heraclitus christianized, the regrets and tears of a penitent sinner; Limousin, 1611) and *Democrite chrestien, c'est a dire Le Mesprits, et mocquerie des vanites du Monde* (Democritus christianized, the disdain and mockery of the vanities of the world; Limousin, 1618) by Pierre de Besse, preacher to the king of France.[45] The first book, written in Heraclitus's voice, avows that his "life is nothing but repentance." In regretting his past vanities he drowns his sins in a torrent of tears.[46] The springtime of pleasure is turned into an unbearable winter of miseries.[47] "Man is born and dies a slave." The introductory sonnet to the volume on Democritus promises that after the winter of repentance come the joys of spring, so Democritus, whose "gentleness reveals the truth," comes after Heraclitus, "changing our sorrows into joys." In "To the Reader" De Besse discourages negative thinking: "To give oneself to tears is to demonstrate a cowardliness of heart and to distrust one's courage. But to laugh, and to mock one's afflictions is to govern one's emotions, it is to confront the vanities of the world, it is to show virtue, and to make it clear that one is a man." Being able to laugh at foibles is entwined with the exercise of free will. The triumph of Democritus was assumed to be self-evident. De Besse was not setting up a contrast between Catholic and Protestant but saying that the self-castigation often accompanying overzealous reform is itself a vanity. We do not know if these books were well known in Utrecht, but they reflect a contemporary mentality that draws on a perception of human nature that is consistent with the imagery projected in painting in Utrecht. The popularity of these philosophers and the rarity of images like Lady World reflect the benign, amused attitude toward human foibles that comes through in genre painting in Utrecht.

Examples of noble behavior from antiquity were also favored. Though the popularity of the story of Cimon and Pero (Roman Charity), as in the painting by Baburen (cat. 25), may have had less to do with the demonstration of Charity than with the opportunity for titillation, Honthorst's *Artemisia* (cat. 26) offered a rigorous example of female honor and loyalty. The painting series of the Twelve Caesars, apparently commissioned by the stadholder and which included *Emperor Titus* by Baburen (cat. 28), provided the ultimate ancestor portraits for a ruler who sought support in history. The guise of a Roman general for the subtle posthumous portrait of *Frederick V, King of Bohemia, as a Roman Emperor* (cat. 27), commissioned by his loving widow, Elizabeth, responds to this same impulse.

Portraits of men and women in everyday roles provide some of the most effective models of the wisely led life. They may explicitly evoke the faith of those portrayed, some by proclaiming the sitter's Protestant faith, for example by the inclusion of an open Bible, a reference to Protestant encouragement to read the Bible for oneself, as Wtewael's 1626 *Portrait of Johan Pater* (Centraal Museum, Utrecht).[48] Others are openly Catholic, more often by midcentury when strictures on Catholicism had eased. A striking type was the commemorative portrait of a dead ecclesiastic, such as the fine *Portrait of an Unknown Priest* (see Kaplan, fig. 4, in this catalogue) by Dirck van Voorst, a pupil of Bloemaert.[49]

The tradition of group portraits of leading citizens in civic, charitable, or military roles, well known through the memorable expressions given to this notion of civic virtue by Rembrandt, Hals, and others, did not exist in Utrecht.[50] Moreelse was commissioned to paint a militia company piece, but it was for a company in Amsterdam.[51] Nevertheless, the few group portraits of Utrechters that come closest to this type are intended to provide positive models. In *The Seven Acts of Mercy* as performed by the governors of the Saints Lawrence and Barbara Hospice (cat. 31, fig. 1) by Joost Droochsloot,[52] the governors, all from the nobility or the patriciate, are depicted

immersed in caring for the poor, performing the seven kinds of charity or good works; the emphasis is not on the governors but on their acts as models for others to imitate. Charity toward those deserving assistance was important to Protestants and Catholics alike; imagery encouraging charity had a long history in the Catholic Church and, just as the hospice retained its association with Saints Lawrence and Barbara, the image of charity it projected retained the stamp of Catholic attitudes about "good works" long after Catholic devotional works were no longer tolerated in public spaces. Possibly the only group portrait in which those portrayed presented themselves as models for imitation is an ideal assembly of painters. On the well-known title page designed by Crispijn van de Passe the Younger for his 1643 manual for young painters (see Bok, fig. 4, in this catalogue), Minerva, goddess of wisdom and patron of the arts, is surrounded by Utrecht artists who can probably be identified as (from the left): Abraham Bloemaert, Gerard van Honthorst, Cornelis van Poelenburch (?), Jan van Bijlert (obscured), Jan van Bronchorst, Roelandt Saverij, Joachim Wtewael, and Paulus Moreelse.[53]

Pleasures and Duties: Contemporary Life
Contemporary life prompted some of the most compelling pictures by Utrecht painters, for example *Musical Group* (cat. 40) by Hendrick ter Brugghen.[54] It is the pleasures and temptations of life—extracted from time and place and savored in the imagination—that attracted these artists, especially the physical pleasures and companions available to a man with money to spend. The indulgent acceptance of human weaknesses reflected that found in paintings of the world of prostitution and gambling in Rome by Caravaggio and his followers, which influenced Ter Brugghen and the other Caravaggisti in their formative years. It is also reflected in the popularity of representations of the philosophers Heraclitus and Democritus in Utrecht as discussed above (cats. 23, 24).

Corresponding to the infrequency in Utrecht art of people depicted working, either in the home or at a trade, is the notable frequency of depictions of all manner of people, from prostitutes to noblemen to gods at their ease. There is even a print series on Leisure (*Otia*; fig. 5; cat. 73, fig. 3)[55] by Cornelis Bloemaert after the designs of his father. A translation of the Latin inscription on the title plate reads in part: "Leisure gives pleasure and prepares you for great efforts. It strengthens weary limbs . . . , but idle laziness weakens the body with lethargy and numbs the spirit, and prevents you from being virtuous." *Otium* can be translated as "leisure," "rest," or "ease," which can be turned to good or bad effect depending on one's morals. Bloemaert's theme follows a traditional contrast between virtue and vice, yet his emphasis on the virtues of leisure, expressed through the medium of the herder, peasant woman, or soldier, while unprecedented is consistent with images produced in Utrecht, in which many are idle and an amazing number are asleep.[56] The naked couple asleep in Bloemaert's *Parable of the Wheat and the Tares* (cat. 18), who should be keeping the devil from sowing weeds in the field, are clearly lazy and to be condemned. More often idleness and its consequences—especially the idleness of soldiers and the ambience of the brothel—are mocked. This is seen in the fascination with sleep as conducive to sexual reverie, as that of the dozing soldier being awakened in Jacob Duck's *Soldiers Arming Themselves* (cat. 34). Sleep can be a beneficial respite, as in Bloemaert's engraving of a hunter who has taken his catch (cat. 73, fig. 3) or in the similar painting by Cornelis and Herman Saftleven (cat. 73). Of course leisure or spiritual quietude can lead to contemplation, as in Ter Brugghen's *Melancholia* (cat. 22).

THE PLEASURES OF INNS AND BROTHELS
The most intriguing images drawn from contemporary life in Utrecht are of inns and brothels, especially as treated by Utrecht painters who

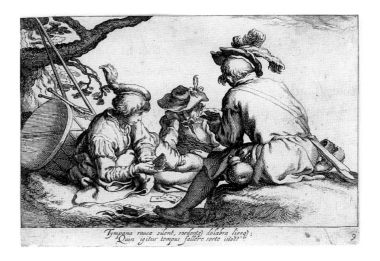

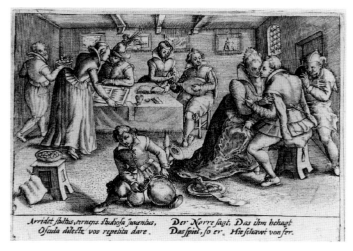

Fig. 5 Cornelis Bloemaert, after Abraham Bloemaert, *Soldiers Gambling*, from series on *Otia* (Leisure), 1620–25. Engraving, 97–101 × 149–153 mm (3⅞–4 × 5⅞–6 in.). Rijksprentenkabinet, Amsterdam.

Fig. 6 Crispijn van de Passe the Elder, *Students in a Brothel*, from *Academia sive speculum vitae scholasticae* (Utrecht, 1612). Engraving. Holl. 233ad. New York Public Library, Spencer Collection.

had come under the spell of paintings of Roman lowlife by Caravaggio and Manfredi.[57] *Students in a Brothel* (fig. 6), a plate in the little picture book on student life *Academia sive speculum vitae scholasticae* (Academia; or, a mirror of student life), engraved by Crispijn van de Passe and issued in 1612,[58] is a fitting point of departure for thinking about the subsequent popularity of this theme in painting. For a young man of means, as most students were, relaxing in a brothel, playing tennis, visiting a portrait painter, making music, going to lectures, even visiting the library, are among the activities of student life. The couples in this low-ceilinged room play backgammon, sing a duet to the music of a lute, and fondle each other, all under the eyes of two attendants who supply the prostitutes and their youthful customers with food and drink, and, at the right, of a laughing fool who, according to the inscription, enjoys watching the "game." "Wine and Venus," we are told in the accompanying verses, are corrupting influences on student life and offset the influence of Minerva, goddess of wisdom, and the Muses. The fool laughing at human weakness, like the mockery of Democritus,

provides a key to the relative tolerance and indulgence toward the life of the senses so sensuously reflected in painting in Utrecht,[59] ranging from Ter Brugghen's subtle *Musical Group* (cat. 40) to the more blatant message of Baburen's *Procuress* (cat. 38) or Honthorst's *Soldier and a Girl* (cat. 36).

In general, scenes in inns and brothels coalesce around the three activities depicted in Van de Passe's engraving. Jacob Duck's small-figured *Merry Company in a Bordello* (cat. 20, fig. 2), influenced by painting in Haarlem, is full of anecdotal detail inviting our gaze. The paintings by the Caravaggisti and those influenced by them, on the other hand, are invariably close-up views of men and women at their revels, the coarseness of the moment and tawdriness or the squalor of setting often veiled by soft nocturnal shadows. The visual prototypes are clearly paintings such as Caravaggio's *Cardsharps* (see Orr, fig. 3, in this catalogue) and *"Concert of Youths"* (cat. 40, fig. 1) and Manfredi's *Fortune-teller* (see Orr, fig. 8, in this catalogue) but illuminated and warmed by candlelight.

Men and women or, more often, just young dandies or coarse soldiers gambling on games of chance such as backgammon are frequently accompanied by the drinking that makes these encounters volatile. Baburen's *Backgammon Players* (see Franits, fig. 3, in this catalogue) with its angry soldier was used by Van de Passe to exemplify the choleric temperament in his engraved *Four*

Temperaments. According to the inscription, a man of this inclination can be despicable, "drinking, gambling, and beating his wife."[60] A more benign view of human nature underlies Bloemaert's *Soldiers Gambling* (fig. 5) from his series Leisure, its inscription reading in part: "The muffled drums fall silent . . . very well, then, you are allowed to while away the time with a game of chance."

The young man in the second couple in *Students in a Brothel* plays a lute, closely associated with scenes of idleness and dalliance, as in Honthorst's *Musical Group by Candlelight* (cat. 35), Baburen's *Procuress* (cat. 38), and Ter Brugghen's *Musical Group* (cat. 40).[61] The many paintings of single musicians, such as Ter Brugghen's (cat. 42) and Baburen's (cat. 42, fig. 1), also include idlers and prostitutes playing the violin,[62] a base instrument thought to be unsuited for people of culture; the flute, played by such young men as Bloemaert's (cat. 37, fig. 1), often with sexual connotations;[63] and even the lowly mouth harp, as in Baburen's *Young Man Playing a Jew's Harp* (cat. 37), associated with vagabonds.

The third couple in *Students in a Brothel* fondles each other. While many things can take place in inns frequented by soldiers and vagrants, brothels are about sex, which the viewer shares vicariously, as in Honthorst's *Soldier and a Girl* (cat. 36). That artists spent time in brothels for professional reasons is suggested by the studies of prostitutes in bed that were engraved as models of the female figure for Crispijn van de Passe's manual *In the Light of Drawing and Painting* of 1643 (cat. 44, fig. 2). Here these are attributed to Jan van Bronchorst, whose study head of a blowsy, sensuous young woman (cat. 44), surely a prostitute, and paintings of brothels, such as *Bordello with Young Man Playing a Theorbo-Lute* of 1644 (cat. 44, fig. 1), have the same voluptuous figure types.

The sexuality of these paintings is fairly direct, and the nature of this appeal is reflected in the greater allure of Bronchorst's *Study of a Young Woman* than the completely unclothed *Model.* The young woman's shirt pulled off her shoulder to reveal something that was hidden makes the viewer more aware of her naked flesh than if the figure is clothed *all'antica* with one shoulder naturally bare, as in Van de Passe's portrait of Virgil (see fig. 12). So many Utrecht painters played with the appeal of the uncovered shoulder that it can be seen as emblematic of the warm sensuousness of Utrecht painting as distinguished from the harder sensuality of the sexually charged paintings of Caravaggio and Manfredi, as in the former's *"Concert of Youths"* (cat. 40, fig. 1). It appears in an amazing range of situations—Wtewael's *Shepherdess* and *Shepherd* (cats. 62, 63), Baburen's *Young Man Playing a Jew's Harp* (cat. 37), or Hendrick Bloemaert's *Boy with a Cat* (see cat. 39, fig. 2 for Cornelis's engraving after the painting). The bare shoulder in Ter Brugghen's *Musical Group* (cat. 40) draws the eye like a magnet. In responding, the viewer is effectively drawn into the painting in much the same way that the appeal to the sense of sight is a surrogate for the other senses in the devotional paintings by the Caravaggisti, such as Ter Brugghen's *Doubting Thomas* (cat. 5).

By midcentury the pursuit of pleasure as a subject in art had lost its urgency; the impetus that Caravaggio and his circle had provided was not renewed. In addition, with the ascendancy of Gijsbertus Voetius, a leader of the stringent branch of Calvinism, installed as rector of the new University of Utrecht in 1636, the relative tolerance toward the luxuries for which the city had been known was a thing of the past. Paul Huys Janssen may be correct in proposing that Voetius's attacks on luxury had an indirect but real impact on the production of painting in general and in particular on paintings of pleasures vicariously enjoyed.[64] Perhaps Nicolaus Knüpfer's most striking composition of these years, painted with the collaboration of Jan Both and Jan Baptist Weenix and purchased from the artist by Willem Vincent, baron van Wyttenhorst, is *The Pursuit of*

Pleasure (Il Contento) (fig. 7), of 1651,[65] derived
from a painting by Adam Elsheimer. Taken from
the picaresque novel *Guzman de Alfarache* by Mateo
Aleman of 1599, the story tells of Jupiter's anger
at the self-indulgence of the people on earth. To
their chagrin, Jupiter asks Mercury to abduct the
goddess "Pleasure."[66]

THE REALITIES AND DUTIES OF THE EVERYDAY WORLD

The most characteristic representations of the
realities and duties of everyday life in Utrecht
painting center on the poor as the objects of char-
ity and on the prosperous as the subjects of por-
traiture. Pictures of people working or going
about their lives are rare. Wtewael's *Kitchen Maid*
(cat. 30) turns out to be about Christ in the House
of Mary and Martha.[67] Hendrick Bloemaert's *Poul-
try Cook* of 1634 (cat. 30, fig. 3),[68] which looks back
to Wtewael's painting, is exceptional only in the
rarity of its representation of someone at a task,
as is Jacob Duck's *Street Scene with a Knife Grinder
and an Elegant Couple* (cat. 34, fig. 1).

The poor may be represented, as they com-
monly are in Holland, as carousing louts who merit
ridicule; such figures are found in works by Joost
Droochsloot. However, it is more likely to be the
"deserving poor"—crippled, pregnant, or old (not
able-bodied), and from the local community—
who are deemed deserving of charity, as those
in Droochsloot's *Saint Martin Dividing His Cloak*
(cat. 31) to whom the saint turns his attention,
distinguished from the brawlers whom he ignores.
In Jan van Bijlert's extraordinary group portrait
Inhabitants of St. Job's Hospice (cat. 32), the
indigents cared for in the hospice, certainly
deserving poor, reach out to the viewer and ask
for alms, encouraging acts of charity in the viewer.
Though individuals were no longer normally
allowed to give alms, this is apparently another
instance of traditional Catholic images of charity
retaining a public validity.[69]

The most consistent representations of

Fig. 7 Nicolaus Knüpfer, Jan Both, Jan Baptist Weenix, *The Pursuit
of Pleasure (Il Contento)*, 1651. Oil on copper, 44 × 55.6 cm (17⅜ ×
21⅞ in.). Staatliches Museum Schwerin, Kunstsammlungen
Schlösser und Gärten, 2143.

everyday reality in Utrecht are portrait likenesses,
or *conterfeytselen*, of the prosperous patriciate, of
which fine examples are Joachim Wtewael's *Self-
Portrait at His Easel* (fig. 8)[70] with a portrait of the
artist's wife as its companion, and Paulus
Moreelse's *Portrait of a Member of the Strick Family*
(cat. 29). *Conterfeyten* means "to imitate" and is not
too far off from "to counterfeit" in English. It is
often coupled with *naer het leven* (from life) and
could be used to describe the act of representing
anything that is actually in front of the artist.
Portraiture, tied to the needs and discipline of
working *naer het leven* and less to the challenges and
license of composing *uit den geest* (from the imagi-
nation), had not been highly ranked by Karl van
Mander,[71] who nevertheless recognized it as a wor-
thy subject. The careful realism of the execution
and the inscription on Wtewael's self-portrait,
"Non gloria sed memoria" (Not for fame but
for remembrance), tie this painting to a funda-
mental goal of portraiture,[72] commemoration
of appearance.[73]

This characterization of the representation
of everyday life in Utrecht concludes with a con-
sideration of the subjects that are missing, those
involving industry, discipline, and middle-class

Fig. 8 Joachim Wtewael, *Self-Portrait at His Easel*, 1601. Oil on panel, 98 × 74 cm (38⅝ × 29⅛ in.). Centraal Musuem, Utrecht, 2264.

life. A dominant theme of the representation of everyday life in Holland was the well-ordered, middle-class household, a metaphor for the moral fate of the new Republic.[74] Articulated by the influential, moralizing text *Houwelijk* (Marriage), published by the Calvinist writer Jacob Cats in 1625,[75] it centers on the woman as homemaker who, besides being chaste and pious, is industrious, disciplined, preoccupied with cleanliness, and who teaches these virtues to her children. Simon Schama has justly characterized these images as Calvinist, aggressively middle class, and antiaristocratic, calling attention to an illustration in a popular emblem book by Roemer Visscher in which a hand holding a scrub brush issuing from a cloud is accompanied by the motto "Afkomst 'seyst niet" (Pedigree counts for nothing).[76] Similar images are found in Cats's *Christelijke self-strijt* (Christian self-control).[77] A characteristic image of feminine harmony and discipline is a young

woman playing a spinet or clavichord, perhaps with a servant with a broom seen through a door, as in Gabriel Metsu's *Woman at a Spinet* (Museum Boymans-van Beuningen, Rotterdam),[78] in which a biblical phrase inscribed on the spinet's lid requests divine aid in self-control: "O Lord in thee have I trusted, let me never be confounded."[79] But in Utrecht painting women do not play keyboard instruments; neither do they sweep, scrub, or teach their children. Indeed, there are almost no children,[80] in contrast to the scenes of everyday life in Holland with mother's little helpers or mischief makers. Children commonly appear only in portraiture, as in *Portrait of the De Kempenaer Family* (see fig. 16) by Jan Baptist Weenix.

Noble Ideals: Arcadian and Mythological Imagery
Noble ideals as embodied in the Arcadian and mythological themes as first developed in Greek and Latin literature played a significant role in Utrecht painting. The impetus was centered on The Hague in the court circles of the stadholder and the king and queen of Bohemia. Nevertheless, interest was more widespread, ranging from an unprecedented *Prometheus Chained to a Rock* (cat. 52, fig. 2) requested by officers of the powerful, prosperous metalsmiths' guild as an emblem of their guild, to landscapes with Arcadian themes by Poelenburch enjoyed by Willem Vincent, baron van Wyttenhorst. The principal theme is the sovereignty of love and beauty, a noble ideal fostered by a leisured lifestyle, which permits such higher pursuits. Within this larger theme, artists treated the loves of the gods and the pursuit of love among the shepherds and shepherdesses of Arcadia. This last is the frame for Utrecht's contribution to Dutch portraiture, the pastoral portrait.

Leisure is a prerequisite for the pursuit of love, and in Arcadia and on Mount Olympus it is the norm. *Otia*, or ease, and the abundance on which it is based are fundamental to Ovid's characterization in the *Metamorphoses* of the harmony and eternal spring of the Golden Age, evoked so

Fig. 9 Joachim Wtewael, *The Golden Age*, 1605. Oil on copper, 22.5 × 30.2 cm (8⅞ × 11⅞ in.). The Metropolitan Museum of Art, New York, Purchase, The Edward Joseph Gallagher III Memorial Collection, Edward J. Gallagher Jr. Bequest; Lila Acheson Wallace Gift; special funds; and Gift of George Blumenthal, Bequest of Lillian S. Timken, the Collection of Giovanni P. Morosini, presented by his daughter Giulia, Gift of Mr. and Mrs. Nathaniel Spear Jr., and Gift of Mrs. William M. Haupt, from the collection of Mrs. James B. Haggin, special funds, gifts, and bequests, by exchange, 1993 (1993.333).

Fig. 10 Abraham Bloemaert, *Marriage of Cupid and Psyche*, ca. 1590. Oil on panel, 61.6 cm (24¼ in.). The Royal Collection, Her Majesty Queen Elizabeth II, 949.

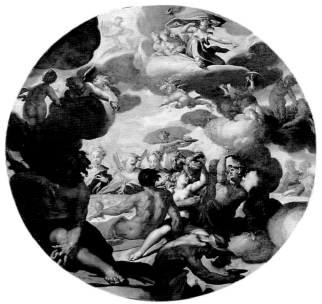

beautifully by Wtewael in 1605 (fig. 9), before the descent through the Ages of Silver, Bronze, and Iron, when conflict and work became part of human life. The innumerable representations of wedding banquets of the gods, such as those by Bloemaert (fig. 10; cat. 46), Wteweal (cat. 49), or Poelenburch (cat. 53), and the range of bucolic recreations, such as *Shepherd Playing Pan's Pipes* by Johannes Moreelse (cat. 65), celebrate these nobler pursuits. While carnal love is on the minds of many, the love that is triumphant is that of spiritual love coupled with the love of beauty.

The loves of the gods, favored in secular art for the social elite since the Renaissance, provide many of the most popular subjects in the decades around 1600.[81] The most characteristic, the Banquet of the Gods, usually in honor of the wedding of Cupid and Psyche or of Peleus and Thetis, responds to one of two prototypes.[82] The first is the fresco *The Wedding Banquet of Cupid and Psyche* painted by Raphael and assistants in 1516–18 on the ceiling of the Loggia of Psyche in the Palazzo Farnesina, then on the outskirts of Rome. Here the banquet is understood as an expression of cultured life of ease on a country estate, far from city noise and the working world. It is associated with the Golden Age characterized by *otium* in Ovid's description at the beginning of the *Metamorphoses*.[83] Underlying the notion of Raphael's banquet is that outside the urban setting, where most conflicts and corruptions have their origins, there is the possibility of a more carefree and

purer and therefore better and more noble life, as expressed through the myths of the Olympian gods. While Raphael's masterful conception stands behind all later ones, Poelenburch seems to be the Dutch artist most directly influenced by it.[84]

In 1587 Hendrick Goltzius made an immense engraving of *Wedding of Cupid and Psyche* after a drawing by Bartholomeus Spranger, painter to the Holy Roman Emperor in Prague (cat. 49, fig. 1),[85] that had a riveting effect on artists in both Haarlem and Utrecht. In many ways his composition encapsulates the aesthetic goals of an era. This complex work offered a virtual blueprint to artists, authorizing splendid displays of artistic virtuosity in compositional invention and intricate

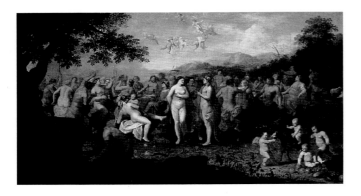

Fig. 11 Cornelis van Poelenburch, *Wedding Banquet of the Gods*, 1626–27. Oil on panel, 38 × 74 cm (15 × 29⅛ in.). Anhaltinische Gemäldegalerie, Schloß Georgium, Dessau, 801.

interweaving of the most beautiful human bodies. Wtewael comes the closest to Spranger in his *Wedding of Peleus and Thetis* of 1602 (cat. 49, fig. 2), but "international Sprangerism" underlies as well his later renderings of the subject, including that of 1612 (cat. 49). The elegant reconfiguring of these banquets by Utrecht silversmiths, as in a circular plaque by Adam van Vianen[86] or a silver footed dish by Ernst Jansz. van Vianen,[87] confirms the subject's aesthetic appeal. Bloemaert's earliest known essay of the *Marriage of Cupid and Psyche* (fig. 10), about 1590, with its swirling clouds and limbs, complements the circular format in creating an exciting vortex spiraling back to the poised, calm lovers in the sunlit rear. Later compositions take the wedding of Peleus and Thetis as their subject (cat. 46 [ca. 1595]; cat. 46, fig. 1 [1638]).

Poelenburch painted his first banquets of the gods during his Italian sojourn. In these and later versions such as the wonderfully airy *Feast of the Gods* set above a serene Italian landscape (cat. 53), the convoluted, licentious bacchanals of his predecessors are replaced by a relaxed dignity and solid bodies that look to Raphael and the classicism of the Carracci in Rome. This is evident in one of the first versions he painted after returning to Utrecht (fig. 11), one of the paintings given by the States of Utrecht to Amalia van Solms in 1627. The narrative, if there is one, is more likely to concern Cupid or his mother, Venus, as in *Cupid Presenting*

Psyche to Venus at a Banquet of the Gods (cat. 53, fig. 1). Though the banquet will be painted by other Utrecht artists, these sensitive interpretations from the 1630s by Poelenburch are the last original responses.[88] There are apparently no Banquets of the Gods painted in a Caravaggesque style. The appeal of the subject parallels that of the animal kingdoms by Roelandt Saverij, as the *Garden of Eden* (see fig. 23), celebrating variety and ingenuity that feasts the eyes.

In a few of the Weddings of Peleus and Thetis, Eris, goddess of envy and discord, who was not invited to the banquet, throws an apple "for the fairest" on the banquet table. When Venus, Juno, and Minerva all claimed it, Jupiter, chagrined, asked the shepherd Paris to judge among them. Being of healthy instincts (and noble birth, as it will afterward appear), he chooses Venus, goddess of love and beauty, as vividly depicted in Wtewael's *Judgment of Paris* (cat. 50) and in a more subdued fashion in a landscape by Jan Both and Cornelis van Poelenburch (cat. 72). Venus's bribe of the most beautiful woman in the world as wife results in Paris's abduction of Helen, wife of King Menelaus of Greece, and Menelaus's efforts to get her back, which led to the Trojan War. These consequences mean that the episode of the Judgment of Paris and indeed the larger subject of the Wedding of Peleus and Thetis could be interpreted in different ways. In art the Judgment of Paris is usually treated as the satisfying male fantasy of having three beautiful, slightly uneasy, naked women stand before a seated male judge, waiting deferentially for his assessment of their relative attractions. In contemporary Dutch literature the story could be interpreted as a cautionary tale emphasizing the violence that followed, as it was by Karel van Mander, ever the moralizer.[89] However, the romantic reading of Paris's choice for love and beauty over power and wisdom found in the poems of Joost van Vondel or Pieter Cornelisz. Hooft is far more consistent with the aesthetic character of these paintings.

Stories involving the voluptuousness of Venus and the chastity of Diana found their most devoted adherent in Wtewael, though many artists turned attention to them. Wtewael's *Mars and Venus Discovered by Vulcan* (cat. 47; cat. 47, fig. 1), with the lovers entangled on the bed and revealed for all to mock, is elaborated in a tight, linear style that exploits Wtewael's genius for interweaving intricate detail. By contrast, a soft sensuousness pervades the intimate *Mars, Venus, and Cupid* joined in languid embrace (cat. 48). The story of Diana and Actaeon, one of the more memorable metamorphoses recounted by Ovid, received a witty if indirect treatment in Knüpfer's *Diana and Her Nymphs at the Bath* (cat. 56). The story hinges on the fact that death awaits any mortal who sees Diana, the virgin goddess, naked. The fact that Actaeon, out hunting with his dogs, happened unintentionally upon her and her nymphs bathing did not soften his fate; he was changed into a stag to be killed by his own dogs. Knüpfer's Diana teases the viewer with the forbidden sexuality of her nearly naked body, while above the fountain, garlanded with flowers, is Actaeon's (stag) head mounted as a trophy with his quiver.[90]

THE ARCADIAN SHEPHERD

The sovereignty of love in the life of the carefree herder who lives in an idyllic world is one of the most joyful themes in Dutch art.[91] Utrecht painters were critical for its development, and the application of the theme to portraiture appears to be their invention. The setting for this idyll is usually in the long ago and far away and may be identified as the wilds of Arcadia in ancient Greece, but it is generally not to be confused with the world of rough Dutch peasants caring for lifestock. The subjects were favored by the social and economic elite, intellectuals, and the newly prosperous.[92] After the mid-1630s the locus of pastoral painting moved to Amsterdam, where much of the Republic's literary life was concentrated, as was much of its new money.

The classical ideal of the contented shepherd is associated first of all with the Latin poetry of Virgil, author of the *Eclogues* (or *Bucolics*, literally, "Shepherd's songs") and the *Georgics*, celebrating the simple life of a farmer.[93] The currency of these poems is reflected in the translations published of both books by Van Mander himself in 1597[94] and in Crispijn van de Passe's publication of captioned plates of Virgil's *Ecologues* and *Georgics* in his *Compendium of the Works of Virgil* (eleven plates; Utrecht, 1612).[95] The most influential contemporary literary sources were Italian and Dutch plays and Dutch poetry. Plays with pastoral themes provide the most explicit narrative sources, though popular poetry and songs created a broad market for pastoral imagery. Two plays deserve special attention. *Il Pastor fido* (The faithful shepherd; 1589) by Giovanni Battista Guarini brought Arcadia and the hero Mirtillo, the faithful shepherd, and his beloved Amaryllis to courts throughout Europe. *Granida en Daifilo* by Pieter Cornelisz. Hooft, influenced by Guarini's play, was first performed in 1605 and published in 1615. Set in Persia, Hooft's play is the story of the shepherd Daifilo who wins the heart and hand of the Princess Granida, thereby achieving a noble destiny as ruler of Persia. Both plays feature a conflict between lust and love, and in both a noble nature is prerequisite to the triumph of love. Poems were published with titles such as "Pastorael," by Daniel Heinsius (1616), which describes the "mournful singing of the lonely shepherd [Coridon] whose lover has forsaken him,"[96] or "Harders-clachte" (Herder's lament; 1618) by the versatile Jacob Cats. By 1608 songbooks aimed at the young of the social elite often contained songs about shepherds or shepherdesses that had a lighthearted, amorous quality. These "top-forty" publications of popular music culture were inexpensive and were discarded when fashions changed.

Bust-length representations of shepherd-poets and lovers and the shepherdesses who inspire them are the earliest extant pastoral paintings from

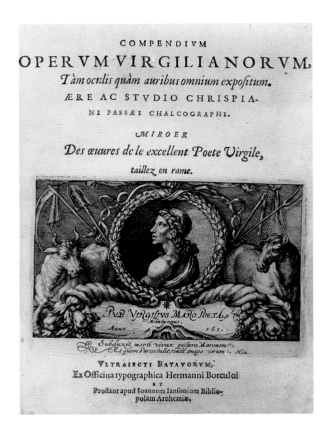

Fig. 12 Crispijn van de Passe the Elder, title page from *Compendium operum Virgilianorum* (Utrecht, 1612). Engraving, 84 × 128 mm (3¼ × 5 in.). Holl. 231ad. New York Public Library, Spencer Collection.

Utrecht. The idealized portrait of Virgil (fig. 12) dressed *all'antica* and wearing the laurel wreath of the poet on the title page of Van de Passe's *Compendium* equates the author of the *Eclogues* with the shepherd poets of whom he writes. The earliest identified painting is a *Shepherdess* by Moreelse of 1617 (cat. 64, fig. 1), from which evolved the type of sensual shepherdess (cat. 64) for which the artist is known. These were frequently paired with an amorous shepherd, as in the case of Moreelse's *Shepherd* (fig. 13) and *Shepherdess* (lost) given to Amalia van Solms in 1627 by the States of Utrecht,[97] and Wtewael's lusty pair dated 1623 (cats. 62, 63).

Shepherds play the leading roles in literature, whether by Virgil, Heinsius, or Hooft, and their shepherdesses tend to echo the male's virtues and vices. There are essentially two shepherd types, representing carnal versus spiritual love. The first

type is represented by Coridon, a simple shepherd appearing first in Virgil's *Eclogues*.[98] His name becomes almost a generic label for this type of shepherd in seventeenth-century Dutch poems and sometimes also in prints. The second type can be represented by Daifilo, the noble shepherd and male protagonist of *Granida and Daifilo*. The importance of class is clear. Though many paintings intended for diversion are inspired by Coridon, pastoral portraits are normally based on the role of Daifilo.

Virgil's shepherd Coridon makes his appearance in Dutch literature in 1608 in the first songbook with pastoral songs, the anonymous *Bloem-hof van de nederlantsche ieught* (Flower garden of the Netherlandish youth).[99] This is the birth of the herder in love in Dutch literature; indeed, Coridon learns to play his pipe from Venus's son, Cupid. In the illustration to the 1608 publication he is playing the earthy bagpipe with its unsophisticated sounds and sexual connotations. He is lusty, careless about decorum, plays the flute, pipe, or bagpipes, may be a poet, and is endowed with natural wisdom. Because he is more a type than a character in a narrative, he can play many roles; Van Bijlert's crude shepherd holding up a cut fig as a reference to female genitalia is labeled *Coridon* (fig. 14) in Van de Passe's engraving. A more debonair Coridon plays his pipe in Van de Passe's own *Mirror of the Most Beautiful Courtesans* (cats. 62, 63, fig. 1).[100] This is the more subtle Coridon as a shepherd-poet, whose sensitivity is especially depicted in paintings by Johannes Moreelse evoking artistic inspiration, such as *A Shepherd Playing Pan's Pipes* (cat. 65), contrasted with the more lusty, grinning, bagpipe-playing *Shepherd* (cat. 63) by Joachim Wtewael. Mercury takes this role of the simple shepherd lounging with legs spread to trick Argus in *Mercury Piping Argus to Sleep* (cat. 72, fig. 1).[101]

Coridon's shepherdess is named Sylvia in Van de Passe's *Mirror of the Most Beautiful Courtesans* (cats. 62, 63, fig. 1),[102] a rather disingenuous

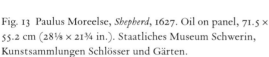

Fig. 13 Paulus Moreelse, *Shepherd*, 1627. Oil on panel, 71.5 × 55.2 cm (28⅛ × 21¾ in.). Staatliches Museum Schwerin, Kunstsammlungen Schlösser und Gärten.

Fig. 14 Crispijn van de Passe the Younger, after a lost painting by Jan van Bijlert, *Coridon*, in *Van 't Licht der teken en schilderkonst* (Amsterdam, 1643). Engraving, 215 × 148 mm (8½ × 5⅞ in.). Rijksprentenkabinet, Amsterdam.

publication of the idealized portraits of celebrated courtesans or prostitutes of the day dressed as shepherdesses. Often wearing the straw hat suggestive of a simple life spent outdoors or bedecked with summer flowers, the erotic object of Coridon's attentions typically plays on her youthful, blooming voluptuousness as does Moreelse's *Shepherdess* (cat. 64). These shepherdesses may express their availability through exposed breasts, which they may stroke. One shepherdess by Moreelse goes so far as to slide one finger into her cleavage while she gazes boldly at the viewer.[103] The voluptuous shepherdess underlies the role of Pomona, on whom Jupiter set his eye,[104] and personifications of Spring.[105]

Both Daifilo, in Hooft's *Granida and Daifilo*, and Mirtillo, in *Il Pastor fido*, are revealed as noble during the course of the plays in which they take the romantic lead (cat. 57; cat. 57, fig. 1; cat. 59). Daifilo's grace and wisdom make him a suitable match for the Princess Granida. Mirtillo's elevated birth was obscured to thwart an evil prophecy, but its eventual revelation confirms the virtues he had already demonstrated in expressing his faithful love for the noble maiden Amaryllis by being prepared to die for her. The noble shepherd is ardent but chaste; he does not chase or grab his beloved. The noble shepherd puts his hand over his heart in a gesture of sincere faith, not on his beloved's breast. He may play the flute or a pipe (though never provocatively),[106] not the bagpipes.

At his initial encounter with Granida, Daifilo falls to one knee and gallantly offers her a drink of water from a shell. This simple attribute and gesture are ideal for portraiture, and so it is Daifilo, and not Mirtillo, with no distinguishing attributes, who provides the male role in marriage portraits. Counterparts to the noble herder, prince

of the wilderness, include Moses,[107] David, and Paris (Wtewael's *Judgment of Paris*, cat. 50).

The noble shepherd's beloved conducts herself chastely as befits her noble status, which is never in doubt. This role most often finds expression in marriage portraiture. Individual portraits do not assume these personas, though a noblewoman might be portrayed as the chaste huntress Diana.[108]

THE FAITHFUL SHEPHERD AND THE PRINCE OF ORANGE

On his marriage to Amalia van Solms and taking the title of prince of Orange-Nassau in 1525 and being elected stadholder the following year, Prince Frederik Hendrik began creating a more splendid court.[109] His secretary, Constantijn Huygens, a poet as well as a diplomat and connoisseur of art, contributed significantly to this endeavor,[110] as did, more indirectly, the tastes of Elizabeth, queen of Bohemia, living in exile with her husband in The Hague. As a youth, Frederik Hendrik had been sent to live at the court of his godfather Henri IV of France at Fontainebleau outside Paris, and one of his first commissions as stadholder was to Bloemaert for paintings in imitation of ones he had seen at Fontainebleau representing episodes from the romance *Theagenes and Chariclea*, a fourth-century legend of renewed popularity,[111] at least one of which was installed as a mantelpiece at his palace Nooreinde in The Hague. Honthorst's *Granida and Daifilo* (cat. 57) dated 1625, also installed there, is the first painting of a pastoral theme associated with the prince and princess of Orange and may have been a wedding present. Honthorst's *Diana and Her Nymphs* (formerly Schloß Grunewald, Berlin) dates from 1626 and is possibly a portrait of the princess of Orange, while his *Allegory of Spring* dated 1627 (Seattle Art Museum),[112] very like the joyous celebration of pastoral love exhibited here (cat. 58), found a place over another mantel.

Among Frederik Hendrik's many commis-

sions, the most important for us is that of 1635 for the series of four monumental paintings illustrating scenes from Guarini's play *Il Pastor fido* for his hunting palace at Honselaarsdijk, where they were installed in Amalia's private quarters. The four paintings combine tantalizing pratfalls of romance, serious misadventure, and the story's happy resolution:[113] *Amaryllis Crowning Mirtillo* by Cornelis van Poelenburch (cat. 59, fig. 1),[114] *Blindman's Bluff* by Diderick van der Lisse,[115] *The Wounding of Dorinda* (fig. 15) by Hendrick Bloemaert and Herman Saftleven,[116] and *Amaryllis and Mirtillo* (cat. 59) by Abraham Bloemaert. Perhaps in connection with his work on this commission, Hendrick Bloemaert made his own rhymed translation of Guarini's play, which he would publish in 1650 and dedicate to Willem Vincent, baron van Wyttenhorst.[117]

The Faithful Shepherd was probably attractive to Frederik Hendrik as a theme because it was popular at the other courts he sought to imitate and because it permitted specific hunting motifs as well as pastoral allusions, which suited the purposes of Honselaarsdijk as a hunting lodge and escape from the court. One must wonder, however, if it was not also an homage to his noble shepherdess from "her shepherd," as he is referred to in the poem of a few years later that accompanies her portrait as a shepherdess (fig. 17).[118] This series caps the development of pastoral themes in Utrecht.[119] After Amalia van Solms was widowed, she commissioned a major decorative program of monumental allegorical paintings at Huis den Bosch in memory of her husband, who had died in 1647. Her advisor Huygens would look beyond Utrecht for artists to execute the major commissions.[120]

PORTRAITURE AND THE IDEALS OF COUNTRY LIFE

The most characteristic forms of portraiture of the social elite in Utrecht conveyed the ideals of country life, that part of the political and social

landscape where the nobility held sway and which was closely tied to their sense of identity. Living nobly meant projecting an image of country living (whether you lived there or not) in an ambience of ease, and the representation of that life in portraiture was part of that endeavor.[121] Within this larger category there seem to have been two basic types with somewhat different assumptions. In pastoral portraiture, the sitters, often a couple, masquerade as romantic, carefree, make-believe shepherds and shepherdesses. This type appears to have originated in the court environment of The Hague and involves both the illusion of escape from court and the reaffirmation of its noblest values. No setting is necessary. The other type celebrates contemporary country life, with elegantly attired family members shown at their leisure in a country setting, often including allusions to pastoral themes through fanciful motifs of clothing, or to the hunt, one of the prerogatives of the nobility or of those with large estates.

The values of the country life of the nobility, combining leisure for reflection with hunting, the land with its associations of domain, and the legacy that children represent, are subtly interwoven in Jan van Bijlert's portrait of Johan Strick's family (see Olde Meierink and Bakker, fig. 10, in this catalogue).[122] The wife is elegantly dressed in fashions that take their cue from court,[123] while the father and small sons, one of whom has just brought down a young deer with his arrow, are attired in a more pastoral mode. The earliest example may be Cornelis van Poelenburch's 1628 *Portrait of the Children of the King and Queen of Bohemia in a Landscape* (cat. 60, fig. 1).[124] The girls are fashionably dressed in the styles and pale colors of the court, while the hunting trophies in the foreground allude to the prerogatives of their class. These children are not role-playing but playing their natural roles.[125] This lifestyle was given literary expression in the popular genre of the country house poem, with its praise of the refreshment of country living—that is, on one's estate—

Fig. 15 Hendrick Bloemaert and Herman Saftleven, *The Wounding of Dorinda*, 1635. Oil on canvas, 114 × 140 cm (44⅞ × 55⅛ in.). Gemäldegalerie, Staatliche Museen zu Berlin-Preußischer Kulturbesitz, 958.

as a gentleman farmer with the leisure to cultivate flowers and go hunting.[126] The best-known is "Hofwyck" (literally, "Retirement from the court"; 1651) by Constantijn Huygens. That same year he published *Otia, of ledige uren* (Otia, or leisure hours), a collection of poems that was the product of his leisure.[127] A variation on such country-life portraiture that could appeal to the urban patriciate with social aspirations is reflected in Jan Baptist Weenix's handsome *Portrait of the De Kempenaer Family* (fig. 16).[128] Dressed in the fine but sober attire of the prosperous upper-middle class, the widow and children of the wealthy Utrecht merchant Jacobus de Kempenaer relax before a backdrop of an Italianate villa with its implications of a country estate.

Pastoral portraiture,[129] in which men and women masquerade as carefree shepherds and shepherdesses, was first developed in Utrecht. The earliest identified pastoral portrait in Utrecht is the idealized one of Virgil as a laurel-crowned shepherd-poet on the title plate of Van de Passe's 1612 *Compendium* (see fig. 12). As portraits, the roles of shepherd and shepherdess imply the innate

ORANIA P.O.

F 6

Fig. 16 Jan Baptist Weenix, *Portrait of the De Kempenaer Family*, 1653–54. Oil on canvas, 93.3 × 121.3 cm (36¾ × 47¾ in.). Private collection, U.S.A.

Fig. 17 Crispijn van de Passe the Younger, *Portrait of the Shepherdess "Orania P.O.,"* from *Les vrais pourtraits de quelques unes des plus grandes dames de la Chrestienté, desguisée en bergères* (Amsterdam, 1640) (detail). Engraving, 110 × 70 mm (4⅜ × 2¾ in.). Holl. 187. New York Public Library, Spencer Collection.

nobility reflected in Hooft's Daifilo.[130] Dirck van Baburen's 1623 *Granida and Daifilo* (cat. 57, fig. 1), in which the kneeling Daifilo was identified already in a contemporary document as the young noble-man Peter van Hardenbroeck, is the earliest painted pastoral portrait of a known person.

Several artists played a part in the creation of the pastoral portrait,[131] but the earliest docu-mented pair in this romantic guise are by Poelen-burch and Honthorst, both associated with the court circle in The Hague. Poelenburch's portraits *Jan Pellicorne as a Shepherd* and *Susanna van Collen as a Shepherdess* (cats. 60, 61), exquisite oval miniatures, are datable to 1626 in connection with their mar-riage in February 1626. Her casually draped, multi-colored silk scarf and his tousled hair are meant to convey freedom from everyday decorum; how-ever, his neat mustache lets us know that this is temporary. Portraits of Charles I and Henrietta

Maria as shepherd and shepherdess (now lost) were painted by Honthorst shortly after his arrival in London in the summer of 1628;[132] Elizabeth's delight at receiving copies of these from her brother Charles is shown in a letter of 1628.[133] Other pastoral portraits of the family and mem-bers of the queen's circle, such as *Catharina Elisabeth von Hanau as a Shepherdess* (cat. 60, fig. 2), were produced in Honthorst's shop.[134] In addition, an early pastoral portrait of Amalia, perhaps a marriage portrait from 1625, is hidden in plain sight: the engraved portrait of the princess as a shepherdess (fig. 17) included in Van de Passe's *Les vrais pourtraits de quelques unes des plus grandes dames de la Chrestienté, desguisées en bergères* (True portraits of some of the greatest ladies of Christendom dis-guised as shepherdesses; Amsterdam, 1640).[135] It shows her young but already married (she holds a branch of an orange tree, a reference to the House of Orange). In the painting from which it would have been taken, possibly by Honthorst or Poelen-burch, she turned to her right, toward her "shep-herd" to whom the accompanying verses allude.

Van de Passe's *True Portraits* tells us much about the wider appeal of pastoral portraits. The first section is devoted to queens and princesses, including the queen of Bohemia, the princess of

Orange, Amalia van Solms, and Catharina Elisabeth of Hanau in a thinly veiled adaptation of Honthorst's portrait; the second section, to ladies of the nobility; and the third, to "Wives and Daughters of Honorable Merchants." It is to the last that the book is really directed; Van de Passe tells his reader that wearing pastoral attire is part of being "made a Lady." He emphasizes that these fashions are not quickly "dated."[136] Then in the verse accompanying the portrait based on Honthorst's *Portrait of Catherina Elisabeth von Hanau*, he claims, "It would take an Apelles to paint this beauty, who is so chaste that she has no parallel." A clothing style that makes the wearer both sexy and virtuous and will not go out of style would be irresistible.

Fantasies of Arcadia and Eden: Landscapes of the Imagination

The preference for imagined vistas instead of the Dutch countryside and urban settings so beloved by artists in other parts of the Republic is the most striking characteristic of landscape painting in Utrecht in the first half of the seventeenth century.[137] Though many travelers gained their first impressions of Utrecht from arriving in the city by barge transport on the river Vecht,[138] the canal or river view, so popular in Haarlem, struck no chord in Utrecht. The same is so for images that might capture the real-life pleasures of rural walks, that revel in the local.[139] Of course people in Utrecht went on walks in the countryside; Abraham Bloemaert did,[140] but the drawings he made there are not views meant to bring to mind a locale but are individual motifs such as a dilapidated cottage destined for insertion in a biblical scene as "color." For Bloemaert, as for Wtewael and Moreelse, the local landscape per se was not a subject worthy of attention. The stunning portraits of Utrecht churches by the architectural painter Pieter Saenredam demonstrate the sublime to which imitative description could reach; however, their connection to Utrecht is misleading.

They were painted in Haarlem, using drawings the artist made on visits to Utrecht.[141]

Utrecht landscapists gloried in mountainous or hilly terrain with waterfalls, grottos, forests, or giant boulders—evoking the heroic and exciting, and exotically foreign. The site alluded to may be Italy, ancient Arcadia, Eden, the coasts of England or Spain, Bohemia, or a fantasy. Architectural painting is represented by Nicolaes de Gyselaer's fantastical interiors of Catholic churches as settings for services or biblical stories.[142] The few urban views are often sites of events, for example, *Prince Maurits Disbanding the Utrecht Militia (Mercenaries) in 1618* (fig. 1) by Joost Droochsloot.[143] It will be the 1640s before this trend changes, and then at first in the more experimental medium of etching.

The preference for the heroic and foreign or for the Arcadian vision may be due first of all to the tendency of Utrecht artists to travel abroad in search of fortune as well as inspiration and second to the fact that artists who had traveled abroad or who were foreigners tended to gravitate to Utrecht. In addition, many Utrecht landscapists working abroad, and later at home, enjoyed an impressive level of patronage by royalty and the highest nobility, a support that had an impact on the status of the specialty. Contemporaneous references to Roelandt Saverij consistently note that he had been a court painter to the Holy Roman Emperor. In Italy Cornelis van Poelenburch had worked for Duke Cosimo de' Medici, Jan Both worked on a commission for the king of Spain (to which Claude Lorrain also contributed), and Jan Baptist Weenix was in the service of Cardinal Camillo Pamphili. Poelenburch and Alexander Keirinx were invited to London to work for Charles I, and Dirck Stoop would become court painter to Infanta Catharina Braganza of Portugal. Adam Willarts, who had lived in London, produced paintings for Elizabeth, queen of Bohemia, and, with other Utrecht artists, produced designs for the king of Denmark.

Fig. 18 Gillis de Hondecoeter, *Musicians in a Landscape*, 1602. Oil on canvas, 47.7 × 67.6 cm (18¾ × 26⅝ in.). National Gallery of Canada, Ottawa, Gift of Mrs. Otto Koerner, Vancouver, 1971, 17001.

Fig. 19 Roelandt Saverij, *Mountainous Landscape with Deer Hunt*, 1620–25. Oil on panel, 51 × 77 cm (20⅛ × 30⅜ in.). Stedelijk Museum voor Schone Kunsten, Kortrijk.

Throughout the half century of our enquiry, artists' conception of landscape as a romantic escape from the everyday depends on whether the inspiration is ultimately Flemish or Italian. *Musicians in a Landscape* of 1602 by Gillis de Hondecoeter (fig. 18),[144] recently arrived from Antwerp, marks the onset of our period. The musicians nearly disappear in the swaying rhythms of the forest canopy. There were no forests around Utrecht, and De Hondecoeter's extravagant woodlands reflect

the artistic traditions of his Flemish heritage. This Antwerp native was in Utrecht from 1602 to 1610 before moving to Amsterdam, where there was a flourishing colony of émigré Flemish landscapists.

In Utrecht realism was appreciated primarily for detail, as a way to lend an imagined view an aura of authenticity, suggesting that it might be true, as in the work of Adam Willarts and Roelandt Saverij. These two artists were born in Flanders and, according to a document of 1622,[145] were friends who saw each other nearly every day and worked in parallel ways. Saverij's plausible fantasies of exotic animals are discussed below; his wilderness landscapes, such as *Mountainous Landscape with Deer Hunt* (fig. 19) from the early 1620s,[146] typically evoke the mountains and forests of Central Europe, though they lack the awesome peaks and waterfalls seen in views such as *Falls on the Rhine at Schaffhausen* (cat. 71, fig. 2) from his years in Prague. Willarts's *Ships off a Rocky Coast* (cat. 66) gives every appearance of being a portrayal of some exciting, distant coast, painted with fascinating details that the viewer cannot quite identify but that still provide the stuff of dreams of foreign adventure. However, details that can be traced to drawings from life are based on ones that Saverij brought back from Prague; the castle on the hill is that of Prague, as is the covered bridge. The Dutch viewer would only know that they are not Dutch and are therefore plausible in a scene evoking foreign adventure. The choice of motifs is in keeping with Van Mander's advice for a landscape that engages the eye, combining a castle on a hill with crumbling peasant dwellings and a fish market on the shore.[147] Thus the heroic is juxtaposed to the comic, leaving no room for the tidy ordinariness of middle-class existence.

With Cornelis van Poelenburch's return from Rome, probably in 1625,[148] the dream of foreign parts coalesces into a dream of Italy. Landscapes such as his *Landscape with the Flight into Egypt* (cat. 68),[149] *Nymphs and Satyrs in a Hilly Landscape*

(cat. 54, fig. 1), and *Grotto with Lot and His Daugh-ters* (cat. 69) are permeated with the experience of Italy and contemporary painting there, specifically an appreciation of classical motifs and subjects, hilly or mountainous terrain, and penetrating light that often floods the scene from the rear of the composition, leaving the foreground in shadow, as in *Flight into Egypt*.

The drawings Poelenburch made of Roman ruins, as the *Arch of Septimius Severus* (see Orr, fig. 14, in this catalogue), classical sculpture, and works by Raphael (see cat. 53), demonstrate a commitment to the classical tradition.[150] Poelen-burch occasionally included famous ruins and sculptures in paintings done in Italy, but after his return, the ruins in his paintings are only rarely quotations that can be identified, such as the tomb of the Horatii and the Curatii in *Amaryllis Crown-ing Mirtillo* (cat. 59, fig. 1). They are more likely to be generic, enriching his aesthetic vocabulary, as do the sun-drenched ruins in *Flight into Egypt*.

The nymph and satyrs in the lush Roman landscapes of Carlo Saraceni, Domenichino, and their contemporaries found a Dutch audience through Poelenburch,[151] beginning with *Nymphs and Satyrs in a Hilly Landscape* of 1627 (cat. 54, fig. 1). The caves and natural arches that Poelen-burch drew in Italy (cat. 69, fig. 1), with their contrasts in light and shade and intimations of mysterious encounters, underlie many paintings done back on the flat terrain of Utrecht. In *Grotto with Lot and His Daughters* (cat. 69) and *Arcadian Landscape with Nymphs Bathing* (cat. 54), the viewer is actually inside the grotto looking out. Though never in Italy, Van der Lisse, Poelenburch's tal-ented follower, understood a good stage setting; his *Sleeping Nymph* (cat. 55) snoozes just outside a cave. Carel de Hooch,[152] in Utrecht from about 1628 to his death in 1638, made a specialty of paintings and also etchings of romantic grotto interiors, of which the finest is his *Nymphs Bathing in a Grotto* (cat. 54, fig. 2). With their Roman sar-cophagi and epitaphs, not found in Poelenburch's

grottos, De Hooch's caverns take on the character of the catacombs, especially if tourists with torches are included, as in this scene.[153] The juxta-position of sensuous bathers (inspired if not painted by Poelenburch) and the crumbling tombs and a skull cradled in the foliage in the lower right, to which the women are oblivious, results in an elegiac mood not found in Poelenburch's more lighthearted scenes. In *Grotto with Diana and Her Nymphs* (cat. 69, fig. 2) by the Poelenburch follower Abraham van Cuylenburgh, the mythological story serves as cover for more boisterous goings-on.[154]

The most significant project involving Utrecht landscapists was that of 1635 combining four paintings illustrating Guarini's *Faithful Shep-herd* and four predella-like landscapes installed in the room at Honselaarsdijk that served as Amalia van Solms's dressing room. The Arcadian settings in the paintings by Abraham Bloemaert (cat. 59), Poelenburch (cat. 59, fig. 1), Van der Lisse, and a collaboration by Hendrick Bloemaert and Herman Saftleven (see fig. 15) are given a visual unity that overcomes the differences in the artists' styles by the soft, feathery gray-green foliage and vaguely overcast skies that are more suggestive of the Netherlands than Arcadia. The relationship of the oblong landscapes (three are known) to the narra-tive series is uncertain. Van der Lisse's *Landscape with Shepherds* (fig. 20),[155] exquisitely painted with its elements delicately balanced in the late after-noon sun, complements the monumental narra-tives; whereas Gysbrecht de Hondecoeter's *Rocky Landscape with Hunters* (Gemäldegalerie, Berlin)[156] can be interpreted as complementing the hunting motif of Poelenburch's *Amaryllis Crowning Mirtillo* (cat. 59, fig. 1) and alluding to the palace as a hunt-ing lodge.[157]

With Jan Both's return from Italy to Utrecht about 1642, the shift away from the dominance of figure painters in Utrecht was confirmed. The new preeminence of landscape was established in works such as *Peasants with Mules and Oxen on a Track near a River* (cat. 70). The mood of reverie combined

Fig. 20 Diderick van der Lisse, *Landscape with Shepherds*, 1635. Oil on panel, 49 × 83 cm (19¼ × 32⅝ in.). Gemäldegalerie, Staatliche Museen zu Berlin-Preußischer Kulturbesitz, II.467.

with a structure built around the long diagonals of his colleague in Rome, the great French landscapist Claude Lorrain, pervades his work. However, it was the Dutch artists in Rome who made the light of Italy central to their vision, and it is Both's own sensitivity to the warmth of the golden Italian light and its reflection off the closely observed foliage that lend the view a sense of place.[158] This is Arcadia studied "from life." Von Sandrart, who knew Both in Italy, comments on the artist's desire to come as close as possible to nature, especially in the effects of light in the early morning versus the afternoon and early evening.[159] Both's depiction of an artist with sketchpad in the foreground of some of his paintings, as in *Italian Landscape with Artist Sketching a Waterfall* (cat. 71) or *Landscape with Draftsman* (cat. 71, fig. 1), but not in his drawings, is indicative of his approach. It is not so much the act of drawing as the act of observing that Both conveys and encourages the viewer to share. In *Italian Landscape with Artist Sketching a Waterfall*, in which is seen terrain foreign to the countryside around Utrecht, the artist's presence prompts the viewer to try to see this thrilling spectacle through his eyes.

Figural vignettes in Both's Arcadian views were supplied by collaborators such as Poelenburch, who was responsible for those in the *Judgment of Paris*, while the figures in *Mercury Piping*

Argus to Sleep (cat. 72, fig. 1) can probably be assigned to Nicolaus Knüpfer, to whose own paintings Both contributed, for example the setting of *The Pursuit of Pleasure* (see fig. 7). In Both's imaginary views of Italy, the travelers who blend into the landscapes are by Both himself, though *Italian Landscape with Stable Boys Watering Horses* (fig. 21) is a collaboration between Both and Dirck Stoop,[160] known for his paintings and etchings of horses. The electricity of the painting stems from the tension between their styles: the real-life subject of boys watering a resisting horse set in a hazy, idealized vista of shimmering light that opens out on a stone aqueduct.

Both's most pronounced effect was on Herman Saftleven. Saftleven never went to Italy but absorbed its lessons first through Poelenburch, reflected in the hazy vistas of *Sleeping Hunter in a Landscape* (cat. 73). From 1643 Both's vision influenced Saftleven's stunningly convincing Italianate vistas, exemplified by *Mountain Landscape with Hunters* (fig. 22).[161] These insights were adapted to the Dutch woodlands[162] and, around 1650 after trips to Germany, to imaginary landscapes of the valley of the Rhine.[163]

At midcentury, Both's colleague Jan Baptist Weenix, who had returned from Italy in 1647, drew on the experience of the South in a different way. His engaging views are of the Roman Campagna inhabited by smiling peasants, as in *Mother and Child in an Italian Landscape* (cat. 74), or of exciting harbors with Oriental traders and elegant visitors, as in *Italian Seaport* (cat. 74, fig. 2). They are full

of references to the Roman past through architectural detail and quotable statues such as the *Horse Tamers*. Attractive as these allusions would be for viewers, their specificity limited their inspirational value for stay-at-home Dutch artists, in contrast to Both's warm, slanting rays of light that penetrated many contemporary views of the Dutch countryside, for example the meditative cattle pieces of Aelbert Cuyp. With Both's premature death in 1652, landscape painting in Utrecht lost its force.

Further evidence of the delight in idealized landscapes of the imagination is found in the popularity of representations of the animal kingdom, often in the guise of the Garden of Eden. This taste for the imaginary "garden" or wooded park of animals, presented for the delight of the viewer, is reflected in the States of Utrecht's selection of a *Garden of Eden* (fig. 23) for the princess of Orange. Indeed, the artist, Roelandt Saverij, was the first major European painter to make a specialty of animals as an independent subject,[164] although others quickly took it up, including members of the Hondecoeter family and Hans Saverij, the artist's nephew. Bloemaert and Wtewael had introduced animals into their paintings, as Wtewael did in his *Judgment of Paris* (cat. 50), for years before Saverij's arrival, but they probably thought it beneath them to paint something so dependent on imitation as an independent subject.

The fascination with the representation of animals, especially peaceable kingdoms of animals or birds alone, in which each animal is separately rendered, can be understood as a parallel to a stage in the evolution from the natural history of the late Middle Ages to modern biology.[165] Contemporaneous natural histories, like those of the Middle Ages, made it clear that animals were put in the world for human use and edification, and that in them can be read the wondrous achievements of God. However, artists, like naturalists, were now engaged increasingly in the study of individual

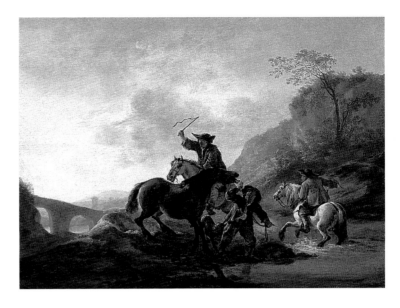

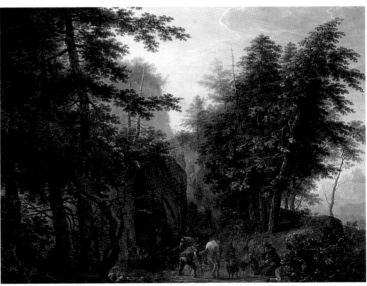

Fig. 21 Jan Both and Dirck Stoop, *Italian Landscape with Stable Boys Watering Horses*, 1647–52. Oil on panel, 41.4 × 51.4 cm (16¼ × 20¼ in.). With Willem Hoogsteder, The Hague.

Fig. 22 Herman Saftleven, *Mountain Landscape with Hunters*, 1645. Oil on panel, 73 × 91 cm (28¾ × 35⅞ in.). Private collection, U.S.A.

specimens *naer het leven*, for their own sake. For a time the new method gave a splendid physical reality to the older worldview, as embodied in the passage from Genesis in which God gives Adam the right to name the animals and thereby have dominion over them. This is a recurrent motif in natural history encyclopedias of the time.[166] It underpins the first work of art devoted to animals

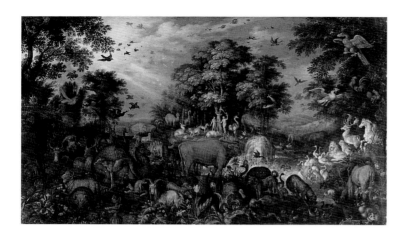

Fig. 23 Roelandt Saverij, *Garden of Eden*, 1626. Oil on panel, 78 × 135 cm (30¾ × 53⅛ in.). Gemäldegalerie, Staatliche Museen zu Berlin-Preußischer Kulturbesitz, 710.

by a Utrecht artist, a series of engravings from 1611 of domestic animals after Bloemaert;[167] the inscription on the title plate begins: "Born to serve the sole God, man is through Him in command of all creatures." This attitude is reflected in Joost van den Vondel's poem introducing *Vorsteliicke warande der dieren* (Princely garden of animals; Amsterdam, 1617), a selection of Aesop's fables;[168] the poet invites us into a wooded pleasure garden to contemplate the birds and animals there for our diversion and edification. The words evoke paintings by Saverij, in 1617 the best animalist in Amsterdam.

Animal kingdom paintings were intended first of all to delight. Many creatures were associated with specific virtues and vices, but there are too many animals in too many variations for painting such as *Landscape with Birds* (cat. 67) or the *Garden of Eden* to be read in an organized way. Vondel's *Princely Garden of Animals* offers an analogy. Each fable has a moral on which one may dwell, but Vondel's aim is to convey both the harmony of the kingdom of the birds or that of animals and the pleasure that visualizing the variety of detail can bring to the visitor. "How pleasantly has Nature painted this meadow," he writes. Saverij's 1626 *Garden of Eden* or his 1622 *Landscape with Birds* offer just such images of harmony and an abundance of

diverting detail that the eye is invited to sample, like Van Mander's bee in a meadow of flowers. The inclusion of a dodo in this *Garden of Eden* for the princess of Orange was surely meant to maximize the painting's capacity to divert.[169] There is no evidence for a menagerie with exotic animals in The Hague; they were found only at the greatest courts, such as those at Prague or Brussels.[170] It was easier to buy an animal kingdom painting than to visit a menagerie, much less own one. However, a garden with aviaries was designed for the court in The Hague in 1622. The animal kingdom composition, tied to the same aesthetic responsible for the contemporary popularity of the Golden Age (fig. 9) and Banquets of the Gods (as cat. 49), as well as to a passing phase in the evolution of scientific attitudes, will hardly outlive Saverij.

By the 1640s the taste for fantasy had waned, replaced by a preference for more realistic compositions. In Van de Passe's *In the Light of Drawing and Painting*, the extensive section on animals—itself a sign of the prestige of the subject in Utrecht—ignores Saverij's paintings but features individual animals derived from those by him (cat. 67, fig. 1) and others, including Wtewael. Thus Saverij's fantasy *Landscape with Birds* gives way to paintings of barnyard fowl by Gysbrecht de Hondecoeter[171] and on a grand scale to Jan Baptist Weenix's still lifes of dead game (cat. 78).

Artifice and Reality: The "Still" Life
In 1678 Samuel van Hoogstraten labeled pictures of flowers or dead animals or in general what he called *still leven* (literally, "natural objects that do not move") as "mere diversions," executed by artists of "weak capacities."[172] These "diversions" were exactly the specialties of still-life painters in Utrecht, and, to the distress of a high-minded writer like Hoogstraten, there was a growing market for them. A realistic-looking bouquet of rare and expensive flowers that actually bloomed at different seasons was the favored subject for still-life painters in Utrecht.[173] Epitomized by

Ambrosius Bosschaert's *Bouquet of Flowers on a Ledge* (cat. 75), these triumphs of artifice over the limitations of reality reigned supreme until the 1640s, when their place was taken by subjects in which realism of effect as well as detail came to the fore, ranging from displays of fish to the life-size hunting trophies by Jan Baptist Weenix. The type of still life based on food and wine or books and bones, which an artist could arrange on a table before his easel and which was painted in many variations by artists in Amsterdam, Leiden, and Haarlem, never constituted an independent subject in Utrecht. Striking still-life details appear in Wtewael's paintings, such as the cheeses and bread in *Lot and His Daughters* (cat. 2, fig. 1), and Duck's *Lady World* (cat. 20) includes objects that convey the transitory in earthly affairs, but Duck, like Wtewael, painted no independent still lifes.[174]

"THE MOST RAREST AND EXCELLENTEST FLOWERS"

In late 1615, when Bosschaert arrived in Utrecht after a successful career as a flower painter in Middleburg (in Zeeland), the bouquet held by a nymph in Wtewael's *Judgment of Paris* (cat. 50) was the extent of flower painting in the city. Nevertheless, the market for flower paintings is suggested by Crispijn van de Passe's beautiful publication on flowers, *Hortus floridus* (*Het Bloemhof*; 1614). The title page of a 1615 English edition, *A Garden of Flowers*,[175] announces:

> A Garden of Flowers, Wherein very lively is contained a true and perfect Discription of all the Flowers contained in these foure followinge bookes. As also the perfect maner of colouringe the same with theire naturall coloures, being all in theire seasons the most rarest and excellentest flowers that the world affordeth; ministringe both pleasure and delight in the spectator and most especially to the well affected practisioner [painter]. All which to the great charges and almost incredible laboure and paine, the diligent Authore by foure yeares experi-

ence, hath very laboriously compiled and most excellently performed; both in their perfect Lineaments in representing them in theire coper plates: as also after a most exquisite manner and methode in techinge the practisioner to painte them even to the liffe.

This text offers many insights into the contemporary appreciation of flower painting, especially the pleasure to be taken in the array of colors and rarity of the species. It is assumed that the desire to capture the beauty of flowers by painting them is a natural reaction and that it is the (would-be) painter's goal to paint them in a lifelike manner. The organization of the flowers into four books, each devoted to the flowers blooming in one season, rather than into types of flowers, is unusual. Among the many species are recent imports, including tulips, marigolds, and sunflowers. Though this last appears prominently in Saverij's 1626 *Garden of Eden* (fig. 23), it is too large for inclusion in delicate bouquets. The desire for colored pictures of flowers that this charming book evokes would be filled in the following years by the paintings of Bosschaert, his sons Ambrosius the Younger, Abraham, and Johannes, his wife's brother Balthasar van der Ast, and Roelandt Saverij.

Bosschaert's elegant *Vase of Flowers in a Niche* of 1618 (fig. 24) demonstrates a significant departure from the small, compact bouquets set on a table that are characteristic of his Middelburg period.[176] The imposing niche, probably adapted from Saverij's use of this device, provides a frame as well as a spatial foil by establishing a setting and a backdrop for a complex play of light and shadow. The contrast of the hard stone with blossoms encourages the viewer to contemplate the latter's fragility. Then, in *Beaker with Flowers in an Arched Window* (cat. 75, fig. 1), Bosschaert boldly cut away the back of the niche.[177] The bouquet appears as if suspended between the architectural clarity and everday solidity of the stone arch and

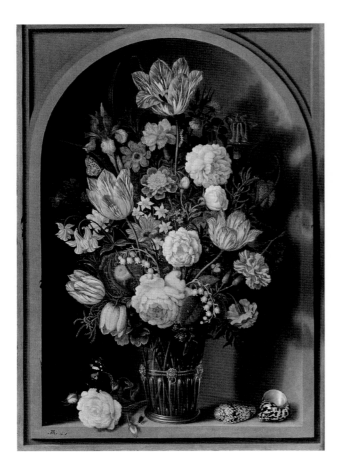

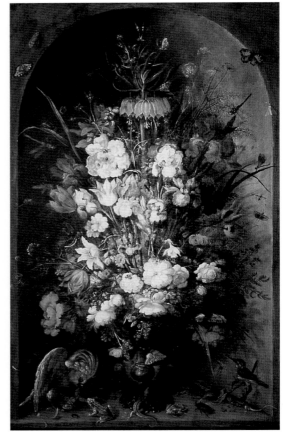

Fig. 24 Ambrosius Bosschaert, *Vase of Flowers in a Niche*, 1618. Oil on copper, 55.5 × 39.5 cm (21⅞ × 15½ in.). Statens Museum for Kunst, Copenhagen, 88.

Fig. 25 Roelandt Saverij, *Vase of Flowers in a Niche*, 1624. Oil on panel, 130 × 80 cm (51⅛ × 31½ in.). Centraal Museum, Utrecht, 2310.

the limitlessness of the imagination conveyed by the pale sky and shimmering landscape fantasy below. Even the walls of the niche dissolve away in *Bouquet of Flowers on a Ledge*, dated 1619 (cat. 75), one of Bosschaert's last works in Utrecht.

The impossible combinations of flowers blooming at different seasons, for example, winter-blooming snowdrops and summer roses, would also delight the viewer. However, the individual blossoms, like the exotic shells, are credible and painted with the detail and an absence of overlapping or shadow that encourages the eye to dwell on each separately. Though rendered with great detail, the blossoms were surely not painted directly from life. The Flemish master Jan Breughel claimed, in a letter written in 1606 to his patron Cardinal Borromeo in Milan, that he painted the flowers in his bouquets from nature as they came into season, causing the execution to stretch over months.[178] In contrast, Bosschaert reused individual blossoms, sometimes over years, a practice that points to working from models, probably watercolor studies, similar to those assembled by his nephew Van der Ast.

Saverij's *Vase of Flowers in a Niche* (fig. 25) is extraordinary in size and complexity,[179] though in other ways it is representative of the artist's late flower pieces. Although Sam Segal has identified in it sixty-three varieties of plants,[180] rare wildflowers as well as the expected cultivars, and forty-four of fauna, ranging from a rare cockatoo to a mosquito, the impression is unified. This is achieved through natural overlapping, subdued colors, and an atmospheric use of light and shadow, so that many details are barely visible.

Saverij had a substantial garden and could

have painted directly from his own plants. Never-theless, the repetition of some blossoms—one of the irises appeared in a bouquet of 1612[181]—means that he kept a repertoire of favored motifs, although no individual studies of flowers are known.

Van der Ast brought together qualities of his mentor Bosschaert and of Saverij.[182] From the tightly composed earlier works, as *Vase of Flowers in a Niche* (cat. 77, fig. 1), his subsequent compositions such as the subtle *Flowers in a Vase with Shells and Insects* (cat. 76) loosen up and become more atmospheric. *Bouquet of Flowers* (cat. 77) conveys an electricity not found in the work of the older masters, as if the flowers are stretching out to meet the oval frame.[183] The variety of Van der Ast's paintings is in part made possible by his reliance on watercolor studies.[184] Each reappearance of a blossom is adjusted to the lighting particular to that bouquet: Compare the lush rose at the base of catalogue 77 to its counterpart in catalogue 76. In the 1620s and early 1630s, variations on these compositions were painted by Ambrosius Bosschaert the Younger,[185] his brother Abraham,[186] Johannes Baers,[187] and the young Jan Davidsz. de Heem (after moving to Leiden).[188]

Utrecht's real preeminence as the center of flower painting in the Netherlands came to an end with Van der Ast's move to Delft in 1632, though the tradition lived on in Jacob Marrel, who arrived from Frankfurt by 1634.[189] Marrel was also a bulb dealer and dealt in the expensive flame tulips he featured in his paintings. They are related to the watercolor drawings he made both for his own use and for inclusion in a tulip book, made as a kind of sales catalogue.[190]

These paintings of flowers were valued first of all for their ability to give permanence to blossoms' fleeting splendor.[191] This appreciation reflects both the commonplace notion of the parallels with the brevity of human life and the goodness of God who created such abundance and variety. Emmanuel Sweerts, a bulb dealer in Amsterdam, probably spoke for many contemporaries when he wrote in the preface to his *Florelegium*, a catalogue of flower bulbs published in 1612, that one of his motivations in representing the flowers was to display "to all eyes, the infinite Power of God, in which one can look as in a mirror, and thereby be moved to understand how short and trivial life is; and on the other hand, how great is God's Mercy, since he shares with us worthless creatures His manifold beautiful creations, the flowers, for our refreshment and comfort."[192] These sentiments, in which sober understanding is a platform for gladness and delight, echo Vondel's in "Princely Garden of Animals." A more immediate desire, however, was to extend the enjoyment of these flowers. Brueghel declared to Cardinal Borromeo that his paintings "will be a fine sight in the winter."[193]

We are only now beginning to understand how rare and expensive the flowers in these bouquets were.[194] Tulips from Turkey and sunflowers from Peru were two of the recent imports sought by horticulturalists.[195] Information on prices of bulbs is limited, except around 1636–37, but a few numbers convey the situation. A skilled laborer made about 200 guilders a year, a sum that enabled him to own his own home. At the peak of his career Bosschaert could receive 1,000 guilders for a flower piece. Saverij's large house in the center of Utrecht was auctioned at his death in 1639 for 5,400 guilders. At the height of speculative frenzy in bulbs, or tulipmania, in early 1637, 1,000 guilders for a flame tulip bulb (the most prized type) was not unusual, and the top bid for a single bulb was 30,000 guilders.[196] No wonder that in gardens the flowers were planted far apart! It was less expensive to own a fine flower painting than to own the flowers. Again in a letter to Cardinal Borromeo, Brueghel wrote that the flowers in his painting "are too important to have in the house."[197]

Given the importance of emblems and other symbolic systems of the time, it is tempting to

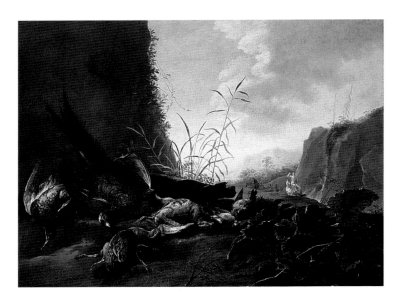

Fig. 26 Michel Simons, *Dead Game Birds in a Landscape*, 1650. Oil on canvas, 92 × 117 cm (36¼ × 46 in.). Private collection, Spain.

think that the flowers in these paintings harbor a complex set of meanings. Yet each painting contains so many different plants and animals that a single interpretation is impossible to decipher. If a message was intended, it was made clear. In 1612, for instance, Crispijn van de Passe the Younger made the design for an engraving featuring a vase of flowers, a putto, bones, an hourglass, and Latin inscriptions, "Memento mori" (Be mindful of death) above, and "Behold, the vicissitudes of life and death are like the glories of a charming flower that remains for only a short time."[198] A flower painting by Bosschaert, like a garden, could prompt meditations; however, in the absence of a key, there are too many possibilities to assume that bouquets were to be read in any organized fashion.

The splendid trophy pieces painted by Jan Baptist Weenix after his return from Italy, exemplified here by two life-size depictions of dead swans (cat. 78; cat. 78, fig. 1), are representative of the tendencies in Dutch still-life painting at mid-century toward refinement and magnificence,[199] under the influence of Flemish painting, and, in the case of trophy pieces, aristocratic prerogative. As a recognized expression of the noble lifestyle, especially in the face of the growing middle class,

hunting was emphatically recreational, not for the purpose of obtaining food. In Utrecht the display of game as an independent subject seems to have its origins in the display of game in a landscape as an attribute of nobility, as in Poelenburch's *Portrait of the Children of the King and Queen of Bohemia in a Landscape* (cat. 60, fig. 1). In Michel Simons's *Dead Game Birds in a Landscape* (fig. 26),[200] the hunter, an elegant, mounted lady carrying on her wrist a falcon (with which only the nobility could hunt) now plays the supporting role, and the aesthetic presentation of the dead game is enhanced by an idyllic Italianate landscape that owes much to Both. Weenix's own *Dead Game in an Italianate Landscape* from 1650 (Centraal Museum, Utrecht)[201] reflects this idealized vision, which touches even Jan de Bont's 1653 *Fisherman's Catch on a Beach* (Centraal Museum, Utrecht).[202]

Rembrandt, Vermeer, Jan Steen, and Aelbert Cuyp, all the subjects of recent or upcoming major international exhibitions featuring the Dutch Golden Age, have one thing in common: a profound debt to painting in Utrecht. Though these debts are various, they suggest how much is to be gained by exploring both the art of Utrecht in the first half of the seventeenth century and the context from which it drew its character. What ties together the images of the supreme sacrifices of the saints or Christ as exemplified by Ter Brugghen's *Saint Sebastian* or Baburen's *Mocking of Christ*, the triumph of love in Bloemaert's *Amaryllis and Mirtillo* or Wtewael's *Andromeda*, an intensely remembered early evening in Italy, as seen in Both's *Peasants with Mules and Oxen on a Track near a River*, or the perfect bouquet, such as Bosschaert's *Bouquet of Flowers on a Ledge*, is the power of the ideal. It is an ideal conjured in the imagination, which, at its most intense, calls on the transforming warmth of light and an exaltation of the senses that is as riveting today as it was then.

Searching for a Role: The Economy of Utrecht in the Golden Age of the Dutch Republic

JAN DE VRIES

A traveler to the Dutch Republic coming from the east would have progressed along sandy roads or perhaps floated down the Rhine, passing villages with their fields of rye and buckwheat, the fortified dwellings of minor nobles, and an occasional regional market town. After long travel, a tower would come into view: not that of an ordinary church spire, but a Gothic tower 112 meters (370 ft.) high, the tallest structure in the Netherlands. In the nearly flat landscape of the region, this tower was visible from a great distance, and as our traveler came nearer, more towers would come into view, thirty-six in all. This forest of church towers signaled the presence of Utrecht, the ancient seat of the bishops of Utrecht. To find a city of comparable size, one would have had to travel eastward 250 kilometers (150 mi.) to Cologne, or 175 kilometers (105 mi.) to Liège. The seventeenth-century walls of Utrecht traced out the same outer limits as had been defined in 1130, enclosing an area of 131 hectares (327.5 acres), which had made Utrecht for centuries the largest city of the Northern Netherlands.

Approaching from the east, a traveler would have found Utrecht at once imposing and familiar. Its size placed it in the select company of only a handful of northwest European cities; its historical development placed it comfortably in the tradition of medieval Europe's episcopal seats. But by the seventeenth century this historical development had suffered a sharp discontinuity; the ancient city of Utrecht had been attached to a new economic and political world, a world that revealed itself to our traveler when he or she, having entered the city from the east (through, say, the Wittevrouwenpoort), passed through the city streets and exited to the west (through the Catharinapoort). From there a new landscape revealed itself and, one might even say, a new society. From Utrecht to the dune coast of the North Sea, a flat landscape of peat bogs and clay-soil pastures stretched out, filled with grazing cattle and criss-crossed by rivers and canals. These waterways were filled with inland vessels moving goods and people between the numerous cities of one of Europe's greatest concentrations of population, industry, and trade.

In this world to its west, Utrecht was neither imposing nor familiar. Its size placed it only in the middle ranks of the dynamic cities of the zone, and its medieval and episcopal history made it socially distinct from the newer, commercially oriented cities so densely seeded across this landscape of polders and watercourses.

Maps 1 and 2 serve to situate Utrecht in the urban hierarchies of 1500 and 1650. At the first date, it is the largest city of the Northern Netherlands; at the second, Utrecht is overshadowed by the dynamic cities to its west. Yet here, it seemed, lay

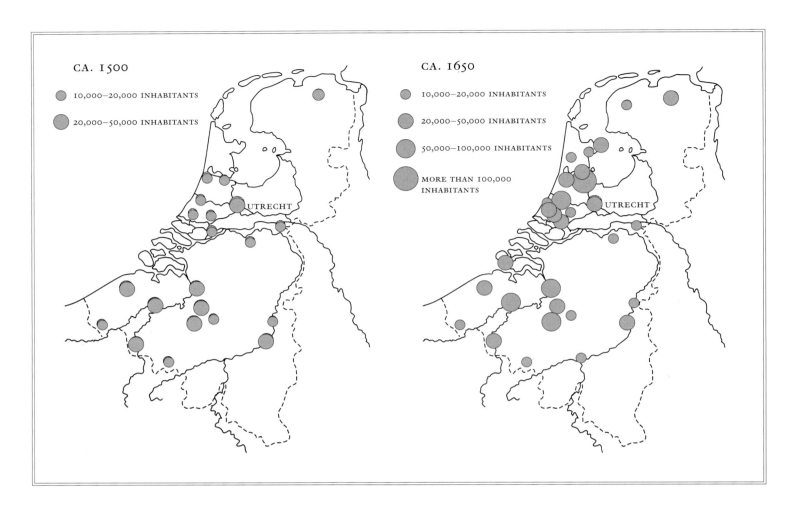

CA. 1500

○ 10,000–20,000 INHABITANTS

◉ 20,000–50,000 INHABITANTS

UTRECHT

CA. 1650

○ 10,000–20,000 INHABITANTS

◉ 20,000–50,000 INHABITANTS

◉ 50,000–100,000 INHABITANTS

◉ MORE THAN 100,000 INHABITANTS

UTRECHT

Map 1 The distribution of urban centers in the Netherlands ca. 1500

Map 2 The distribution of urban centers in the Netherlands ca. 1650

the city's future. The Revolt against Spain and Roman Catholicism surely had brought its past role to an obvious and decisive end: the triumph of Calvinism had brought repeated waves of iconoclastic outbursts to the city, culminating in 1580 with the prohibition of open Catholic worship. In that same year the last bishop died and episcopal organization ceased to operate, after a run of some 850 years. In fact, the substance of Utrecht's traditional functions had eroded much earlier. The territorial rule of the bishops had come to an end in 1528, when Emperor Charles V assumed control of the province, and Utrecht's powerful commercial position, sitting astride the

prime medieval artery of trade between Holland and the Rhineland, had declined already much earlier, as the counts of Holland developed alternative routes that bypassed the city of Utrecht.

Without a prominent role in long-distance trade, Utrecht's economy depended very much on artisanal production and the marketing of regional agricultural produce. And these activities could sustain a city of Utrecht's large size (see Table 1) only so long as the religious and political operations of the city continued to command a large flow of income from the landholdings of nobles and clergy and the tax revenues of the secular authorities. The political economy of Utrecht was distinctly precapitalist. To put it in modern terms, rent-seeking behavior rather than growth-stimulating activities defined the city's economic life. In this environment craft guilds contested with a property-owning patriciate for power in the

Table 1

Population Estimates for the City and Province of Utrecht

	1570s	1620–30	1670s	1795
UTRECHT★	20,000	30,000	30,000	32,294
OTHER CITIES†	14,500	16,000		15,541
RURAL	33,600	38,000		49,307
Total population	68,100	84,000		97,142

Population Estimates for Selected Cities of Holland, the Province of Holland, and the Dutch Republic

	1570s	1622	1670s	1795
AMSTERDAM	30,000	104,932	200,000	217,024
LEIDEN	14,000	22,769	67,000	30,955
HAARLEM	14,000	39,455	37,000	21,227
ROTTERDAM	10,000	19,532	40,000	53,212
HOLLAND	400,000	672,000	883,000	783,000
DUTCH REPUBLIC (in thousands)	1,300–1,400	1,600–1,800	1,850–1,950	2,100

★ The population of Utrecht ca. 1570 is estimated by approximation. Using militia enrollments, Kaplan suggests 17,000; Rommes's estimate is based on partial burial records.

† The other cities of the province of Utrecht (with populations in 1795): Amersfoort (8,584), Rhenen (1,630), Wijk bij Duurstede (1,480), Montfoort (1,316), and the autonomous city of IJsselstein (2,531).

Sources: Utrecht, 1570s, 1620s: Bok 1994, 133. Bok, in turn, is based on Rommes 1990, 244–66, and Rommes 1991, 93–120. All other data: Van der Woude 1980, 102–67; De Vries and Van der Woude 1997, 46–80.

city, generating chronic social conflict which gave the Revolt in Utrecht a distinctive character.[1]

Utrecht had long needed new economic functions, and the Revolt simultaneously highlighted this fact and offered new opportunities for the city to refashion itself. These opportunities can be seen in three distinct developments: the early years of the new Republic witnessed a massive flow of migrants, rich in skills and capital; the appropriation of church property made many assets available for productive purposes; and the new political order encouraged investment and offered support to developmental policies.

Every region of the new Republic could take advantage of these new opportunities to some extent, but nowhere were the growth impulses stronger than in the zone delimited by the Zuider Zee to the north and the Delta to the south, by the North Sea to the west and the sand ridges to the east (see Map 3). In cultural no less than in economic life, this zone formed the Republic's heart. It is the region Johan Huizinga had in mind when in his essay "Dutch Civilization in the Seventeenth Century" he wrote: "Truly, Dutch civilization in Rembrandt's day was largely concentrated in a region not much more than one hundred kilometers square."[2] This zone inscribes what is now often called the Randstad, a circuit of cities that forms the urbanized heart of the modern Netherlands. Even in the Golden Age these cities fashioned a well-connected urban network and constituted one of Europe's greatest concentrations of urban population. About 1650–70 the cities of this zone collectively housed a population approaching 500,000. And the residents in any of the cities in this zone could reach any other city in no more than a day's travel on frequently scheduled intercity passenger barges,

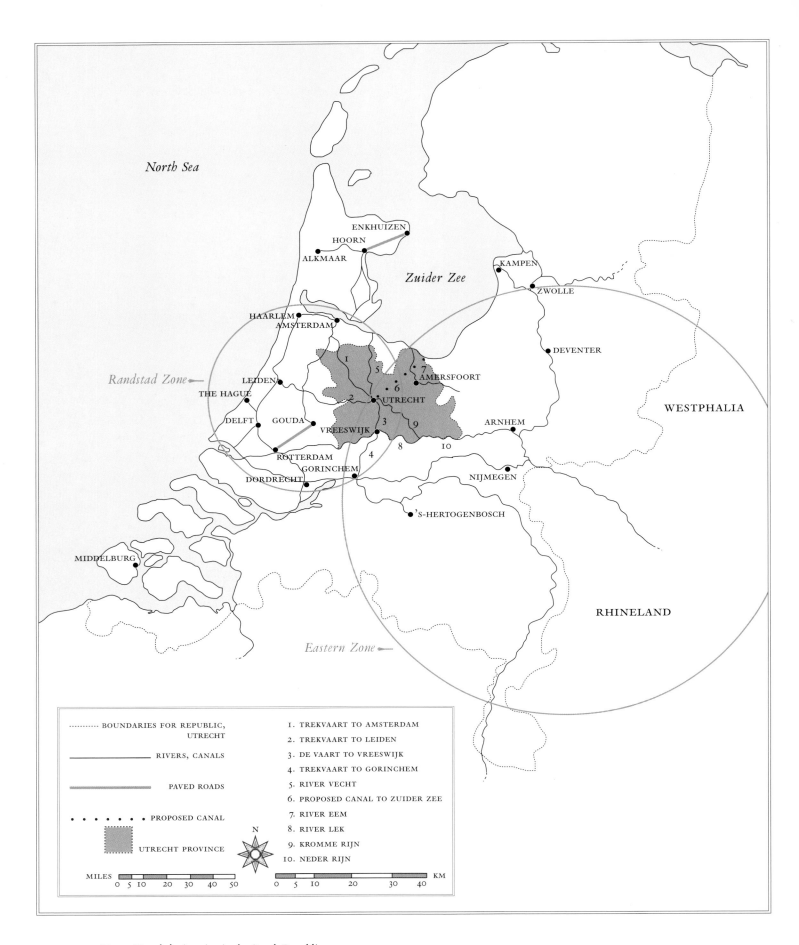

North Sea

Zuider Zee

ENKHUIZEN
HOORN
ALKMAAR
KAMPEN
ZWOLLE
DEVENTER
HAARLEM
AMSTERDAM

Randstad Zone→

LEIDEN
THE HAGUE
DELFT
GOUDA
VREESWIJK
ROTTERDAM
GORINCHEM
DORDRECHT

UTRECHT
AMERSFOORT
ARNHEM
NIJMEGEN

WESTPHALIA

'S-HERTOGENBOSCH

MIDDELBURG

RHINELAND

Eastern Zone→

N

- - - - - - BOUNDARIES FOR REPUBLIC,
 UTRECHT

———— RIVERS, CANALS

▬▬▬▬ PAVED ROADS

• • • • • • PROPOSED CANAL

▓ UTRECHT PROVINCE

1. TREKVAART TO AMSTERDAM
2. TREKVAART TO LEIDEN
3. DE VAART TO VREESWIJK
4. TREKVAART TO GORINCHEM
5. RIVER VECHT
6. PROPOSED CANAL TO ZUIDER ZEE
7. RIVER EEM
8. RIVER LEK
9. KROMME RIJN
10. NEDER RIJN

MILES
0 5 10 20 30 40 50

0 5 10 20 30 40 KM

Map 3 Utrecht's situation in the Dutch Republic

the *trekschuit*.[3] Canals equipped with towpaths were constructed throughout the western and northern Netherlands.

Utrecht participated fully in this construction boom (see Map 3). With Amsterdam it improved a complex of existing waterways to connect these two cities (Map 3, route 1); with Woerden and Leiden it cooperated to construct a costly towpath-equipped route to the west (route 2); alone it improved navigation to the south, digging a canal to the river Lek (route 3), where connections were made with a new canal to Gorinchem and the Delta region to the south (route 4). Once all these routes were in operation, one could depart Utrecht three times per day for the seven-hour trip to Amsterdam, and as often to Leiden, a trip of eight hours. On both routes, one trip was overnight, offering morning arrival at the destination for the traveler prepared to sleep on benches cushioned with straw. To the south, barges departed no fewer than twelve times per day for the short trip to the river Lek, where connections could be made to numerous destinations. The tens of thousands of passengers who annually made use of each of these routes offer testimony to Utrecht's effective integration in the Republic's remarkable urban network.

Yet Utrecht differed from the other cities with which it was so closely connected. All the other cities of Huizinga's "hundred kilometers square" were in the province of Holland. Utrecht alone was not. The boundary separating the provinces of Holland and Utrecht meanders through the polder lands, demarking the arbitrary points of contact and conflict of the colonizing work of the medieval counts of Holland and bishops of Utrecht. Crossing this boundary changed nothing in the landscape, but the passenger on a *trekschuit* from Leiden or Amsterdam or Gorinchem had to reset his watch, so to speak, when crossing this arbitrary line, for Utrecht held fast to the Julian calendar until 1700, whereas Holland had adopted the Gregorian calendar as early as 1583. While this discrepancy lasted, it was ten days earlier in Utrecht than in Holland.

Were there other—more profound—ways in which Utrecht differed from the numerous towns in Holland with which it was seemingly so well integrated? We have already noted Utrecht's unique pre-Revolt status. In her struggle to find new functions in the dynamically developing urban system of the Dutch Republic, Utrecht's distinctiveness is repeatedly confirmed. Crossing this boundary reveals few changes visible to the naked eye, but a great deal that was just beneath the surface was markedly different.

The Political Economy of the City
The single most important decision that faced Utrecht at the dawn of Republican independence was the disposition of ecclesiastical property. In all other provinces of the United Republic parish property was put at the disposal of the successor Reformed Churches, while monastic and episcopal assets were secularized, being administered by provincial agencies *ad pios usus*, such as the support of schools and charities, the salaries of the Reformed clergy, and the pensions of their widows. In both the city and province of Utrecht such property was especially extensive. Its rededication would have brought about an economic shake-up that might be compared to the privatization of an East European communist economy in our own time. But such a move was complicated by one important fact. The largest ecclesiastical property owners by far were the five cathedral chapters of Utrecht, institutions that had for centuries conducted the bishop's secular rule in the province and were populated by members of the leading noble and patrician families. These chapter canons, 142 in total, enjoyed lifetime rights to the income of chapter property (prebends) and the use of houses in their chapters' compounds within the city. The five chapters together enjoyed immunities (land and property outside the jurisdiction of municipal government) that covered one-third

of the city. Finally, these chapters constituted the first (i.e., clerical) estate in the three voting units (clergy, nobility, cities) of the States of Utrecht.

Secularizing the ecclesiastical property of Utrecht required a direct attack on the privileges of elite families and a radical redistribution of power in provincial government. Yet, once the Protestants swept away the old episcopal structure and forbade open Catholic worship, what alternative was there but to abolish these obviously antiquated institutions? And indeed, in 1586, during the brief tenure of the earl of Leicester, Calvinism and popular politics allied to abolish the voting rights of the cathedral chapters. But within two years the ascendancy of patrician power linked with a more Erasmian Protestantism restored the canons to their old rights. All new appointees to these lucrative offices would be Protestants, and in 1618 it was further decided that appointments would rotate strictly between the urban patriciate and the provincial nobility.[4] Thereby, political power was evenly divided between the patrician families of the city and the provincial nobility, most of whose sixty-three member families also maintained houses in the city.

The die was cast. Utrecht would remain a city of the old stamp, dominated by families living on their incomes, securing their futures through appointment to lucrative sinecures. It was not impossible for new families to penetrate this charmed circle, but their admission did nothing to alter the fact that the economic life of the city continued to be shaped to a large extent by the purchasing power of its noble and patrician elite families.

The cynical spectacle of Calvinist cathedral canons settled with lifetime prebendary incomes fits poorly in our Weberian vision of Protestant society. Hence, the antique social patina with which Republican Utrecht remained suffused is sometimes interpreted as a sign of the persisting influence of Catholicism. It would be more correct to see it as a sign of the great attraction of rent-

seeking behavior in every society, regardless of its religious loyalties.

This "peculiar institution" endured so long as the Republic lasted, but not without criticism. The firebreathing leader of Utrecht Calvinism, Gijsbertus Voetius, not mollified by the chapters' generosity in maintaining the city's Protestant churches, insisted that every canon appointed to the Reformed Church consistory turn over his prebendary income to the diaconate. (Many canons joined the more understanding Walloon Reformed Church to avoid this obligation.[5])

The reformers did succeed in secularizing the surplus church property that blanketed the city. After the Revolt the city broke down the walls and gates protecting the chapter precincts and sought to integrate them into the secular city. In this way the old city could accommodate its growing population through "internal colonization" rather than by outward expansion. In addition, no fewer than thirty churches were decommissioned, giving the burgomasters control of much prime real estate with which to attract new industries to the city.

Migrants and the Occupational Structure
New industries required new residents and new skills, which brings us to the second dimension of post-Revolt economic development: migration. Migration was a key factor in the development of an early modern town for two reasons. First, the high mortality rate in preindustrial towns usually prevented the urban population from growing via its own fertility. Demographic evidence for Utrecht is incomplete, but it seems to conform to this somber pattern. The recurring plague epidemics (1623–24, 1636, 1652–57, 1663–68) alone accounted for 12.5 percent of all deaths in Utrecht in the period 1624–70, thereby raising overall mortality rates to levels that ruled out growth by natural increase. Thus, a growing Utrecht required immigrants.

The Republic's other cities required them, too, and benefited from the streams of migrants

Table 2

Origins of New Burghers in Utrecht

Period	Total	Known Birthplace	Eastern Provinces	Germany	Other Foreign	Coastal Provinces
1561–80	921	545	63.1%	12.5%	5.0%	16.1%
1581–1600	995	609	55.0	15.9	14.3	14.9
1601–20	1061	739	47.5	19.9	13.7	18.8
1621–40	1097	633	43.6	28.0	13.4	15.2
1641–50	548	198	38.4	30.8	14.1	14.1

Source: Rommes 1995, 188.

and refugees set in motion by the Revolt. Tens of thousands of Southern Netherlanders moved north, invigorating the textile industries of Haarlem and Leiden and diversifying the commercial life of the port cities—not to mention their role in Dutch art production. A few—but only a few—of these Flemings and Brabanters made their way to Utrecht. Soon after the Revolt a large, steady stream of migrants drawn from the entire littoral of the North Sea—from North Holland, along the German coast, to the Scandinavian lands—made their way to the port cities, where they specialized in shipping, whaling, and commercial activities. Again, very few such migrants had Utrecht as their destination. Utrecht's migrants, as best as we can observe from the lists of newcomers who purchased burgher rights in the city, came overwhelmingly from the provinces directly to the east of Utrecht and from adjacent regions of Germany, especially the Rhineland and Westphalia (Map 3 shows this eastern zone; Table 2 reveals the origins of new burghers). Utrecht was, in short, a *landstad*, a city anchored demographically to the towns and villages of the zone stretching to its east. It possessed no significant drawing power to deflect the other major migrant streams toward it.

Indeed, even the migrant pools to which Utrecht had privileged access often bypassed it or were denied entry by the city. Utrecht often raised substantial barriers to the entry of new migrants. Those wishing to practice a trade as masters (rather than as wageworkers) needed to

purchase burgher rights, and the city raised its price from twelve guilders in 1601 to fifty guilders in 1611, an amount equal to as many days' pay for a skilled workman. This financial barrier was lowered when plague depleted the population in 1623–24, but in 1655 the city denied the purchase of burgher rights to all Catholics, a policy in which it persisted until 1674, when it relented only for Catholics born within the province. As for Jews, the city forbade their residence until 1788.[6] All these restrictive measures reflect a spirit of municipal protectionism consistent with Utrecht's guild-dominated past, but one that was quite out of step with the more open policies of the Holland towns in this century of economic expansion. Utrecht's population grew, probably by about 50 percent between the 1570s and 1620s, but this was only a moderate expansion by the standards of the cities of Holland. Moreover, from the 1620s into the 1670s, while most towns in Holland continued to grow in population, Utrecht seems to have plateaued at the 30,000 level that it would maintain into the nineteenth century (see Table 1).

The second way in which migration is important to a city is in the skills that are brought to the urban economy. The skilled textile workers from Flanders invigorated Leiden and Haarlem, the merchants of Brabant enlivened the port towns, and an elastic supply of seafarers from the North Sea coast allowed their trades to expand with vigor. Utrecht's recruitment zones did not supply these strategic skills. Rather, people from

the eastern lands furnished a wide range of craft skills, most of which served local and regional needs rather than export markets.

The occupational structure of seventeenth-century Utrecht remains an imperfectly understood subject. It was the only large Dutch city without a major export industry or international commercial function. How then did its 30,000 inhabitants support themselves? We can distinguish four basic pillars of Utrecht's economy.

1. *Rural demand*. In almost every Dutch city a large number of families was supported by the provision of basic goods and routine services to its rural hinterland. Shoemakers and tailors, surgeons and brewers, booksellers and goldsmiths—they were all supported by a rural clientele of specialized farmers with a significant disposable income. Utrecht's hinterland formed a varied and productive agricultural landscape, "a paradise of profusion,"[7] with cattle raising and hemp cultivation to its west and grain production and newly introduced tobacco growing to its east. Still, the entire rural population of the province barely exceeded that of its capital city, and Utrecht had to share this market with several smaller market towns. Rural demand was certainly important to the city's guilds. This is revealed by their behavior when they briefly tasted political power in the 1570s: they immediately sought to secure for themselves monopoly power over the Utrecht countryside. The move was blocked by the nobles in the States of Utrecht, but it was attempted again, and again without success, during the political turmoil of 1610.[8]

2. *Elite demand*. Here Utrecht stood out relative to the towns of seventeenth-century Holland in having a large number of rich noble and patrician families whose wealth was based on property ownership, government office, and, of course, appointment to the cathedral chapters, which now functioned more like asset-management funds.

Migrants from the east, where a similar social structure prevailed, moved into a broad array of luxury craft and service occupations. The former patronage of the church had supported manuscript illuminators, painters, and sculptors; they were succeeded under the new regime by bookprinters and -sellers and painters catering to private buyers. They worked beside coach makers and saddlers, sword makers and goldsmiths, glassblowers and engravers, woodcarvers and embroiderers—a long list of specialized crafts dependent on a small, high-income clientele.

3. *Industries with an export dimension*. Utrecht never became known for a single branch of industry, but several of its local specialties did supply larger markets. Utrecht may have housed the Republic's largest single concentration of metallurgical industries.[9] Migrants from the regions of Aachen and Liège, major metallurgical centers, gave Utrecht an advantage in these trades, making the Smiths' Guild (which included locksmiths, tinsmiths, farriers, spur makers, cutlers, cannoniers, and coppersmiths) the second largest of the twenty-one guilds in 1569.[10] These activities were stimulated by military demand for armaments during the long war against Spain. Gunsmiths and cannonball foundries in Utrecht competed with producers in other cities, and in 1629 Utrecht complained to the States General that producers in Holland were being favored in the placement of orders. On the other hand, the commercial hold secured by Holland's traders (Louis de Geer and Elias Trip) over Swedish copper led to the establishment of copper mills in several cities, including Utrecht. Utrecht's pistols and rifles acquired a reputation for high quality and commanded a large price premium in the market. In addition, the city produced pumps, plumbing supplies, typesetting equipment, and, in its mint, a large part of the Republic's money supply.

Utrecht's textile industries were also of more than local importance. Woolens production cer-

tainly could not compare with the dominant Leiden but was of a scale comparable to the other Holland towns.[11] Linen weaving and dyeing, cotton printing, and silk production were also Utrecht specialties. Southern Netherlanders established silk production in Utrecht, and by 1640 the *velours d'Utrecht*, a low-cost silk, had a considerable reputation. Button making, hat making, and leather tanning also appear to have been longtime Utrecht specialties.

4. *Commercial functions.* Utrecht stood at the intersection of two ecological, cultural, and economic zones. As I emphasized at the beginning of this essay (and as Map 3 illustrates), it was a natural gateway city, moving goods and people between the sandy heaths of the east and the polders of the west. Today this hub function is Utrecht's great strength, but in the seventeenth century most of this commercial potential remained unexploited. The flow of goods along the Rhine and its distributaries could easily bypass Utrecht. The rise of Amsterdam pulled traffic flows north, through Utrecht and onto the river Vecht (Map 3, route 5), but Utrecht merchants no longer played a major role in most of these trades. Exceptions, it appears, were the wine merchants specializing in the distribution of German wines (in 1664 Utrecht sought to become the main center for wine from Mainz), and the grain merchants, standing as they did between a zone of surplus production to the east and surplus demand to the west.

Projects to Develop the Economy
Clearly, the most striking weakness in Utrecht's seventeenth-century economy was its merchant and trading sector. This failing did not go unnoticed; throughout the century after the Revolt the city government considered initiatives to transform Utrecht from a medieval *landstad* into a modern commercial city. The failure to break the elite hold on church assets and thereby on provincial political power ensured that these efforts would

continually be frustrated and that few would achieve their objectives. Utrecht did not transform itself. But the proposals and projects came, one after the other.

To begin with, there was the disposition of surplus churches and monastic buildings. These were offered to woolens producers, silk throwers (spinners), and glassblowers, sometimes with financial incentives as well. Then there was the reconstruction of the city, to open up the chapter precincts to commerce. In 1616 a portion of the Mariakerk (church) was demolished to enlarge a market square, the Mariaplaats, and other civic improvements followed.[12]

Among the city's influential and active Calvinist community, investment in the new West India Company in 1621 had a special appeal (because of the company's avowed objective of dismembering Spain's New World empire). Innocent of overseas commercial experience themselves, these Utrecht investors bought 215,000 guilders worth of company shares and remained for the next twenty-five years bitter opponents to every overture of peace with Spain, reasoning that the future of the colonial venture had to be secured before the signing of any peace treaty.[13] By 1674 these investments had become essentially worthless.

In 1626–28 Utrecht invested in navigational improvements on the river Vecht, hoping to stimulate trade, and inaugurated the passenger barge service to Amsterdam. In future years there would be many more such investments: the canal to Vreeswijk, at the river Lek (1649), new locks at Vreeswijk (1654), a towpath along the Oude Rijn to Leiden (1665), the scaled-down result of a new waterway to Leiden proposed in 1655.

The hope that better transport infrastructure would stimulate Utrecht's commercial economy is reflected in all these initiatives and led to the grandiose proposal to dig a broad waterway straight through the sand ridges northeast of the city (see Map 3, route 6).[14] This canal

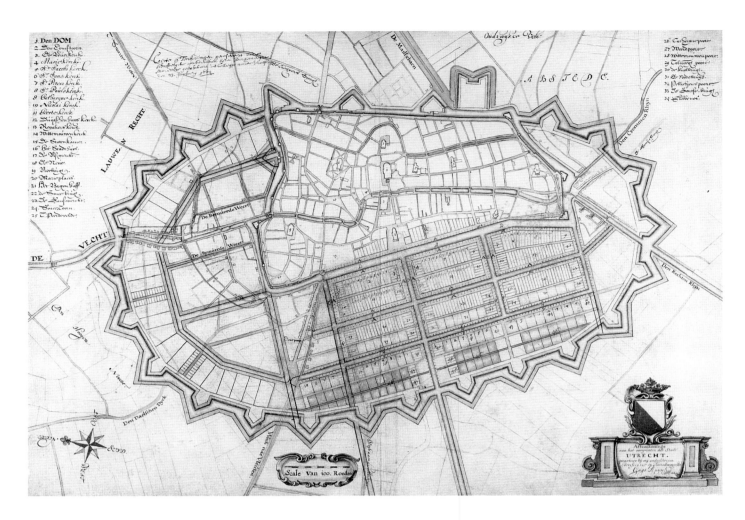

Map 4 The Utrecht expansion project of Burgomaster Moreelse, 1664. The existing city is enclosed by the inner line. The expansion project is enclosed by the outer line.

would connect with the river Eem (route 7) and from there to the Zuider Zee. Its course would be entirely within the province of Utrecht, thereby liberating the city from the merchants of Amsterdam and the tolls levied by Holland at the mouth of the river Vecht. City regents proposed its construction in 1640. It was discussed several times thereafter, most seriously in 1660, when the city fathers commissioned surveys and had elaborate cost estimates made. The project had its opponents among the regents as well; many feared that the canal could never pay its way, and it had to compete with two other expensive projects: the canal to Leiden, built in 1662–65, and a proposal to greatly expand the size of the city.

The proposal to enlarge Utrecht—the first physical expansion since 1130—was not a response to overcrowding in a growing city. On the contrary, Utrecht's population seems not to have grown much after the 1620s. The advocates of expansion saw it as a means of reinvigorating the economy.[15] An earlier proposal to enlarge the city had been made, and rejected, in 1624. In that year the regent—and painter—Paulus Moreelse advocated expansion at the culmination of an era of municipal prosperity and growth. Now, in 1664, Paulus's son, the regent Hendrick Moreelse, returned to the idea and buttressed his plans with a well-developed justification (Map 4).[16] The proposal was not modest; it was to more than double the city's size, build a handsome, spacious residential district, and provide for new industrial zones segregated from the residential areas. These, in turn, would be well integrated with the canals and rivers that served Utrecht, reducing congestion for merchants and industrialists, and positioning the city as an entrepôt for commerce with Germany.

Moreelse argued that this great property

development project (the city would have to spend hundreds of thousands of guilders in digging canals, preparing polder land for building, and extending the city fortifications, streets, and bridges) would attract rich immigrants ("machtige ende rycke luyden") to the new luxury residential district. These new residents would stimulate the economy by the "augmentation of consumption, and the increase flowing therefrom of all public and private incomes."[17] That is, the injection of purchasing power would broaden the tax base (to pay for the extension of the city) and quicken the local economy. The rich settlers, meanwhile, would want to make use of the new industrial terrain and the improved waterways. The plan to dig a canal to the Zuider Zee was distinct from Moreelse's proposal, but it was put forward in the same spirit. Such a canal, with a spacious inland harbor adjacent to the planned industrial zone, would transform, as the projectors put it, this *aelouwe Landstad* (venerable city of the land) into a *landsche Zeestad* (inland ocean port).

In a sense, the Moreelse developmental vision sought to build on the existing economy of the city, which remained based, after all, on the purchasing power of a wealthy elite. Strengthening Utrecht's attraction as a place of residence would be the starting point of what was hoped would be a far-reaching economic development. It is tempting to speculate that this line of reasoning was suggested by the city's experience with its university. The University of Utrecht was founded in 1636 and quickly grew in size.[18] From 1650 it was second only to the University of Leiden in the number of students and faculty. With about twenty graduates per year in the 1650s and 1660s (and about 100 students in residence each year), such an institution's economic impact must not be compared to a modern university, but neither was its impact trivial. The students, many from abroad, brought money to the city. Indeed, in 1637 the city invested in a recreational boulevard, the Maliebaan, just beyond the city walls, to strengthen its appeal to gentlemen scholars.[19] Within a decade of the university's founding, Utrecht's booksellers and printers grew in number from under ten to over forty, making the city a publishing center of note.[20]

The plan to expand the city was, of course, far more ambitious than the establishment of a small academy, and it met with much resistance, not least from regents who feared (not unreasonably) that the existing property in the city would lose value. Despite this, and despite the economic contraction imposed by the Second Anglo-Dutch War (1665–67), a beginning was made to put the plan into effect. Three canals were dug, but the French invasion of 1672 put an end to further implementation.

Louis XIV's invasion sent Utrecht's economy into a tailspin; the French army occupied the city for two years, and the western half of the province formed the military front of the beleaguered Republic, a vast zone of inundated polders. The French occupation drew the curtain on Utrecht's restless striving to refashion its economy. When it ended, the impoverished city found its ability to recover undermined by the larger economic setbacks being suffered by the Republic as a whole.[21] The projected site of luxury residences became a zone of vegetable gardens; the city walls of 1130 continued to enclose Utrecht until well into the nineteenth century; indeed, until the railway age, Utrecht remained a *landstad* of the old type.

Confessionalism and Its Limits: Religion in Utrecht, 1600–1650

BENJAMIN J. KAPLAN

In religious descriptions of the Dutch Republic Utrecht has often played a special role: that of antitype. From the seventeenth century to our own, scholars have commonly portrayed the new country that emerged from the Dutch Revolt against Spain as essentially Calvinist. To be sure, the Republic always had its religious dissenters, and humanist regents resisted stubbornly the imposition of Calvinist theocracy. Still, it was asserted, by 1620 if not earlier, Dutch Calvinists had come to dominate the Republic; it was they who set the prevailing cultural tone for the Dutch Golden Age, with its sober tastes and artistic realism. Utrecht, in this portrait, was the exception that proved the rule. Once the ecclesiastic capital of the Northern Netherlands, seat of a huge bishopric, Utrecht remained "a fervently Catholic city" even after the Reformation; more than half, perhaps as much as three-quarters of its population continued to confess the old faith. No wonder, then, its painters adopted the styles of Counter-Reformation Italy and gravitated toward such "un-Dutch" genres as pastoral and history.[1]

Though the association of genuine Dutch culture with Calvinism has never gone unchallenged, it remains common today, except among specialists in religious history. For over the past few decades, research has accumulated establishing once and for all how very much more complex the religious character of the Republic really was. Indeed, a consensus now exists within the field that religious pluralism was as fundamental a characteristic of Dutch society as its official Calvinism. Catholics and Mennonites, Remonstrants and Lutherans, Jews, skeptics, mystics, waverers, and "Libertines": taken together, these dissenters actually outnumbered members of the Calvinist Dutch Reformed Church.[2] No other land in Europe had such a mix of faiths, which, to add yet more diversity, varied enormously from one town or village to the next. Dutch society was truly a religious "stew," as one contemporary song put it; Werner Helmichius, one of Utrecht's first Calvinist ministers, called it rather a "rude and abominable chaos."[3] Either way, Dutch society as a whole was not nearly as Calvinist as scholars once confidently asserted. The significance of this finding for our understanding of Dutch art is only now being explored.[4]

Viewed in this light, Utrecht seems less a contrast or antitype than a distinctive variant among the rich variety of Dutch cities. It was indeed a center of Catholic life in the Republic, though its Catholic population was not as large as is often said. It had other distinguishing features as well, among them a large Lutheran congregation, few Mennonites, a university, and a Calvinist leadership renowned for its strictness. At

the same time, Utrecht had much in common with other Dutch cities: above all, the peace and amity in which people of different faiths managed to live with one another.

By 1600 the most precarious phase of the Dutch Revolt had ended and with it most of the uncertainty about the parameters of religious life in the new country. In Utrecht these did not differ from elsewhere in the Republic. By virtue of its supporters' steadfastness in times of utmost peril, and the association of Catholicism with the hated Spanish regime, the Reformed Church had won unique status as the official church of the Netherlands. It enjoyed financial support from the government, use of the old parish churches, and, most significantly, a monopoly over the public sphere. At the same time, it was not an "established" church, like its counterparts elsewhere in Europe: no one was required by law to join it or attend its services. Those who disliked the church, for whatever reason, retained "freedom of conscience." This principle meant, at a minimum, that they could believe as they wished; in practice, it usually meant that they could worship God as they saw fit, providing they did so discreetly, within the privacy of their home. In any event, religious worship remained a voluntary matter. People could affiliate with the Reformed Church, with one of the dissenting churches, or, most remarkably, with none at all.[5]

In the years around 1600, the last option was the most frequently chosen. Researchers in city after city have found that at this time a majority of the Dutch did not belong to any church.[6] Such was the case in Utrecht as well. Protestant ideas, spreading since the 1520s, had discredited in the eyes of many Utrecht's once-mighty Catholic establishment; the Reformation of the 1570s and 1580s had then demolished its institutions. The Reformed Church, though privileged, was in severe disarray and had failed to attract a wide following. The sentiments of the urban population were highly fluid, with many people undecided,

perhaps confused, and some clearly disillusioned with religious institutions in general.[7]

From this starting point, the chief development of the period 1600–1650 was what religious historians call the rise of confessionalism. It had three aspects. First, the ecclesiastic structures of religious life were rebuilt. Each of the major confessions (or denominations, as they are also called) implemented an effective system of church governance; each fielded a corps of well-trained, professional clergy and built, if necessary, churches for them to work in; each thus provided its lay followers with regular services and pastoral care. Second, the confessions—Catholic and Calvinist in particular—competed fiercely with one another to win over the doubters and the unaffiliated. In a broader sense, they were competing not just for followers but for legitimacy: each wanted its version of Christian truth recognized as the only truth. This struggle shaped not only the tenor of public religious discourse but life within the churches as well. Definitions of orthodoxy, for example, grew increasingly rigid and precise. Finally, each of the confessions struggled on a second, internal front, to ensure that its purported followers actually obeyed its teachings. Through education, persuasion, and disciplinary measures, church leaders sought to mold not just the behavior but the very thoughts and feelings of congregants.

All of Utrecht's churches—Calvinist, Remonstrant, Mennonite, Lutheran, and Catholic—experienced the rise of confessionalism in its three aspects, and in this sense their development between 1600 and 1650 ran in parallel. None of them failed to grow strong institutionally; none of them succeeded in imposing the desired conformity on their followers. In other respects, including the size of the following they gained, the churches had divergent histories.

For Utrecht's Reformed congregation, the rise of confessionalism had a specially rocky beginning. As of 1600, Utrecht's congregation was not

even Calvinist, properly speaking: it exercised no ecclesiastic discipline over its members; it did not participate in synods or classes (the Dutch equivalent of presbyteries); and its liturgy and teachings differed from those of other Dutch Reformed Churches. This was the legacy of a movement known as Libertinism. Often associated with the Haarlem engraver and writer Dirck Coornhert, Libertinism had followers throughout the Netherlands but nowhere enjoyed such broad and powerful support as it did in Utrecht. As a form of piety, it combined Protestant beliefs with spiritualist ones deriving from medieval mysticism. Perhaps most essentially, it proclaimed the freedom of the individual conscience from clerical control. Libertines claimed that they, not the Calvinists, were genuinely "reformed" Christians. In the 1590s Utrecht's Libertines had complete control of the city's Reformed Church.[8]

Not until 1605 did Utrecht's Reformed Church adopt Calvinist norms, and even then it moved only to the most moderate of Calvinist positions. Ecclesiastic discipline began to be enforced, but with great discretion; synods began to meet, but secular authorities retained effective control over the church; the Calvinist doctrine of predestination was accepted, but only in the loose version formulated by the theologian Jacob Arminius. These changes were meant to end Calvinist-Libertine conflict, and in that they succeeded. By 1610, however, the teachings of Arminius had provoked national controversy. Followers of Arminius, known as Remonstrants, and strict predestinarians, called Contra-Remonstrants, squared off across the Republic. Utrecht emerged as a Remonstrant bastion, more so even than such famous ones as Rotterdam or Gouda. In fact, the real, if unofficial, leader of Utrecht's Reformed Church in these years was Johannes Wtenbogaert, chief organizer and polemicist of the Remonstrant party. Largely due to his efforts, Het Sticht (as the province of Utrecht was known) became a model of Remon-

strant practice, one that the States of Holland attempted to copy in 1614. Utrecht's regents, meanwhile, had special reason to associate the Contra-Remonstrant party with political subversion and acted with unmatched severity to suppress it.[9]

This intolerance generated great bitterness and made the "alteration" of 1618 particularly radical in Utrecht. In that year, Stadholder Maurits of Nassau purged a string of city governments, including Utrecht's, replacing Remonstrant regents with Contra-Remonstrant ones. Among the Utrechters who cooperated closely with Maurits in this act were the painters Paulus Moreelse and Joachim Wtewael. Both were rewarded with positions on Utrecht's new, restructured city council, which Contra-Remonstrants continued to dominate as late as the 1640s.[10] Even Stadholder Fredrik Hendrik, Maurits's successor, could not shake their grip, as he managed to do with ease in many towns of Holland. Thus, while the provincial court and estates remained mixed religiously, for three decades Utrecht's Calvinist consistory could count on the support of the city magistrates, at least for certain goals.[11]

It was the magistrates who took the initiative in 1634 to found an Illustrious School, which in 1636 became the University of Utrecht. Conceived from the start as a bulwark of Calvinist orthodoxy, the university was meant to counter the influence of liberal (*vrijzinnig*) Leiden and, at the same time, to bring a long-sought prestige to its host town. It did both, rising to eminence almost immediately with the appointment of Gijsbertus Voetius (fig. 1) as professor of theology. From the 1630s through the 1660s, Voetius was the most influential theologian in the Netherlands, the informal leader of Dutch Calvinism. In Utrecht he dominated both the university (nicknamed the *Academia Voetiana*) and the Reformed congregation, which he served as minister. Over time, his former students, among them his own two sons, filled the ranks of Utrecht's professoriate

Fig. 1 Anna Maria van Schurman, *Gijsbertus Voetius*, 1647. Colored chalk drawing, 20 × 15 cm (7⅞ × 5⅞ in.). Photograph Iconografisch Bureau, The Hague, 18094.

and ministry. Intellectually, Voetius was a fiery champion of Contra-Remonstrant dogma and of Aristotelian philosophy. The Saturday morning disputations that he ran served as a forum for attacks on all rival truths: Remonstrant, Catholic, and, from 1639, Cartesian. These were lively debates, as the Cartesians had their supporters too in the city. Descartes himself resided briefly in Utrecht, and when the university's professor of medicine, Henricus Regius, began to propound his mechanical philosophy, such an uproar broke out that the city council felt compelled to intervene. Thanks to Voetius and the university, the great controversies of the day became fodder for Utrecht's intellectual life.[12]

As minister, Voetius showed concern for the behavior as well as orthodoxy of his flock. A profound admirer of England's Puritans, Voetius championed in this sphere what he himself called "precision": an insistence that God's law—the Ten Commandments and other biblical injunctions—be observed strictly and completely. Voetius would brook no softening of its demands, no accommodations to human weakness. To the contrary, he equated faith itself with an acceptance of this law in all its rigor. He inveighed regularly against the profanation of the Sabbath; dancing he declared a serious infraction, and in the 1640s he and his consistory waged a campaign to suppress it. Voetius also took aim at the luxury and materialism that he saw prevailing ever more in Dutch society. Lavish feasts; tulip mania; long, curly hairdos; revealing, brightly colored clothes; the spit-and-polish shine of proud burgher homes—none of this squared, in his view, with the sober modesty demanded by God of his people.[13]

Neither Voetius's rigor, however, nor the support of local government made Utrecht's Reformed congregation thrive in these years. Considered from a social perspective, the Contra-Remonstrant victory of 1618 came at a high price: what the congregation won in cohesion and institutional strength it lost in popularity. Few of Utrecht's Remonstrants ever reconciled with it, and other potential members too were repelled by the church's doctrinal rigidity and what they viewed as its sanctimony.[14] Only in the 1650s, with the beginning of the "Further Reformation," did the church gain a new spiritual vigor, and with it a new popularity.

After their expulsion from the Reformed Church in 1619, Utrecht's Remonstrants formed a congregation of their own. Initially they faced persecution that, by Dutch standards, was quite severe: the city government even employed soldiers from the local garrison to break up their furtive gatherings. In 1626 Frederik Hendrik put a stop to this and made clear his will that the Remonstrants should enjoy the same freedoms as other Protestant dissenters. His intervention paved the way for the building in 1629 of a

schuilkerk, or clandestine church, for the congregation. The preferred recourse of all the unprivileged confessions, a *schuilkerk* was a house rebuilt on the inside to function as a church while continuing to look from the outside like any other domicile. Invisible from the street, the *schuilkerk* rarely escaped the notice of its neighbors or of local officials. Still, the pretense that it embodied —that it was just another private house—enabled dissenters to have a proper church life while leaving intact the monopoly of the Reformed Church over the public sphere.[15]

Two other Protestant groups had congregations in Utrecht as well: the Mennonites and the Lutherans. Actually, by 1611 three separate Mennonite congregations had formed, each of them quite small; in 1636 the three united. Compared to their coreligionists in Holland, Utrecht's Mennonites were few and poor.[16] Utrecht's Lutheran congregation, by contrast, was large and prosperous. Often overlooked, it was founded in the 1580s by émigrés from Antwerp, and achieved institutional maturity in the 1610s with the appointment of a permanent minister, a consistory, and deacons. From 1624 it had a proper *schuilkerk*. The congregation had numerous members of social distinction and received support from Lutheran princes in Germany and Scandinavia. Swelled by German immigrants fleeing the Thirty Years War, it attained its peak size in the 1640s.[17]

The chief rival to the Reformed Church, though, was the Roman Catholic Church. For it, the seventeenth century was no youth; to the contrary, its efforts built on an ancient foundation which the Reformation had never undermined completely. Like no other Dutch city, Utrecht bulged with the remnants of medieval Catholicism. Most famous were the five collegiate churches: the Dom, or cathedral, former seat of the bishop (archbishop after 1559); Oudmunster (torn down in 1587); St. Pieter; St. Jan; and St. Marie. Possessing vast wealth, including a quarter of all the land in the Sticht, these churches had

been secularized in the 1580s but not abolished as corporations. Their members, known as canons, now lacked all function but continued to enjoy the income of their rich prebends. As canonries came vacant, the city magistrates and provincial gentry took turns distributing these plums, the spoils of the collapse of Catholicism, to their sons. The old canons did not die out immediately, though, nor did the system for filling vacancies exclude Catholics until 1622. Thus some of the vast wealth of the medieval church remained in Catholic hands, helping to underwrite the survival and eventual recovery of the Church. The same occurred with other religious endowments, as the families that had originally established them retained by law the so-called *jus patronatus*, the right to name their beneficiaries. Decade after decade, Utrecht's Calvinists demanded furiously that all this wealth be turned *ad pios usus*—to pious, Protestant ends, such as charity, education, and the salaries of Reformed ministers. Even before the arrival of Voetius, who took special offense at the existing arrangement, Utrecht's consistory had ruled that no canon could serve as elder or deacon.[18] Naturally, this stance alienated Utrecht's elite. In fact, an element of class conflict had overlain the issue since the 1580s.[19]

In the 1590s Utrecht still teemed with aging priests from pre-Reformation days, supported by their old prebends and benefices. Threatened with loss of this support if they performed Catholic rituals, most of them, to be sure, had lapsed into apathy. Still, pastoral care for the laity never ceased entirely. This was crucial, for where such care did lapse, as in Dordrecht, Catholicism never recovered. Cornelis van Gouda, copastor of the Buurkerk, the most important of Utrecht's four parish churches, served his flock faithfully; so, despite banishment and torture, did the Dominican Roeloff Willemsz. Obyn. The convents, with their protective walls and well-equipped chapels, made perfect sites to hold clandestine services. Catholic lay folk also hosted services in their

homes, where a room might be outfitted for the purpose with a simple altar, some candles, and a devotional image. Initially, worship remained ad hoc, furtive, and mostly small-scale.

The situation began to change in the first decade of the new century, when the pope's apostolic vicar, Sasbout Vosmeer, made Utrecht a center of the Holland Mission, an effort to win the lost Netherlandic provinces back for Catholicism. Utrecht offered Vosmeer several advantages: persecution was mild, priests many, and a large segment of the local elite had remained loyal to the old faith. In addition, the location strengthened Vosmeer's claim to be reconstituting the old archbishopric and to be himself the successor of the pre-Reformation archbishops, due all the powers and privileges they once enjoyed. Philip Rovenius, who succeeded Vosmeer in 1614, pressed this claim further. Resident in Utrecht from 1628, in 1633 he established a vicariate, a replacement for the old cathedral chapter, to help him administer his jurisdiction.[20]

From a lay perspective, Utrecht's role as center of the Holland Mission had important consequences. First, Utrecht's Catholics never lacked for priests. As many as a quarter of all the priests in the Republic resided in the city: about forty in 1622, thirty-six in 1638, forty-five in 1656.[21] Granted that some of them used Utrecht as a base from which to serve surrounding areas, this unique concentration still meant that Utrecht's own Catholics enjoyed regular and increasingly well-organized services. By 1622 Utrecht's old Catholic parishes had been fully reconstituted, each one based in a particular "station," a site of clandestine worship served by a permanent pastor and chaplains. Over time, three of the parishes were divided into multiple stations, while from early on the Jesuits and Dominicans had run stations of their own. Thus Utrecht eventually emerged with fourteen Catholic stations, eleven within the city walls and three in suburbs. A "college of pastors" was formed in 1645 to super-

vise their spiritual life.[22] Second, Utrecht's pastors were men of the highest quality and standing. Adriaen van Orschot, "vir apostolicus," was renowned as an effective missionary; Johannes Wachtelaer doubled as second in command to Rovenius. Like Vosmeer and Rovenius themselves, Utrecht's secular priests tended to come from native patrician families; indeed, a disproportionate number stemmed from Utrecht's own elite, as did Wachtelaer, Abraham van Brienen, Gerrit Pelt, and Herman van Honthorst, brother of the artist Gerard. More than half these men had university degrees in 1622; by 1638 the proportion had risen to three-quarters.[23]

Stations could operate, if necessary, in cramped, improvised prayer rooms, but, increasingly, they were based in elaborate *schuilkerken*. Recent study has shown that many Catholic *schuilkerken* were richly decorated edifices already in the first half of the seventeenth century.[24] The provincial court of Holland scarcely exaggerated when it noted in 1643 that most had "very expensive altars, galleries [supported] on pillars, vaulted roofs, pews, organs, musicians and all sorts of musical instruments and, in sum, everything that might be asked of a chartered chapel."[25] Among Utrecht's *schuilkerken*, St. Gertrude, commonly known as Den Hoek (fig. 2), held preeminence as seat of the apostolic provicar. Located on the Mariaplaats (where Abraham Bloemaert lived), it formed part of a large Catholic complex with housing for priests and "spiritual maidens," or *klopjes*.[26] These were unmarried women who in other circumstances would have joined convents. Forced to remain lay persons, they took oaths of obedience and chastity and wore simple, uniform clothing. They provided a variety of essential services to the Catholic community: caring for the poor, visiting the sick, catechizing children, cleaning and decorating the *schuilkerken*, singing at services. They were the pastors' right hand, and without them the Catholic Church in the Republic could scarcely have functioned. Utrecht had more

Fig. 2 J. Steffelaar, *Interior of the St. Gertrudis* schuilkerk *in Utrecht*, 1896. Oil on canvas, 64.5 × 52 cm (25⅜ × 20½ in.). Rijksmuseum Het Catharijneconvent, Utrecht.

of them than any other Dutch city, except perhaps Haarlem; one estimate, made in 1662, put their number at five hundred.[27]

Of all the *schuilkerken* in Utrecht, we know most about the decoration of Maria Minor, also called Achter Clarenburch. Located in the imposing Huis Clarenburch, it functioned as a replacement for the Buurkerk, from which came, supposedly, several of its artworks, including a statue of the Virgin.[28] Most of its known decoration, though, dated from the 1620s and later. It had two tabernacles, one of chased silver representing the Wedding at Cana, the other made of wood with a painted door showing angels holding a monstrance and venerating the Host displayed in it (fig. 3). By the Utrecht artist Nicolaus

Knüpfer, the painting has been dated to about 1650. There also survives a silver ciborium made in 1656 by Christoffel Jansz. Visscher and a paten made in Antwerp about 1650.[29] All these objects served to hold eucharistic wafers. Most important, the church owned a set of six altarpieces, displayed in rotation over the course of the liturgical year. The series included three paintings by Hendrick Bloemaert: *Calvary* (1645; St. Maria Minor, Utrecht), *The Adoration of the Shepherds* (1647; Old Catholic Church, Utrecht), and *Pentecost* (1652; Old Catholic Church, Utrecht); one by Gerard van Honthorst: *Christ Presented to the People* (1645); and two by unknown artists: an *Ascension* in the style of Honthorst and an *Adoration of the Kings* in the style of Rubens. The church also owned a *Doubting Thomas* (ca. 1625) attributed to Hendrick Bloemaert, a *Calling of Saint Matthew* (1625–30) by Jan van Bijlert, and a portrait of a deceased priest by another Utrechter, Dirck van Voorst (fig. 4).[30]

This partial reconstruction of Clarenburch's decoration says much about the character of Catholic spiritual life in Utrecht. Clearly, devotion to the Eucharist played a central role. This accorded fully with the precepts of the Counter-Reformation, which Rovenius and his troops strove to implant in the Netherlands. The three nonliturgical paintings point to another, more distinctive aspect of Dutch Catholic piety: its celebration of conversion and of the missionary priests who did the converting. As Xander van Eck has shown, artistic themes that captured moments when doubt and wavering were overcome by sudden insight or divine calling appear frequently in paintings owned originally by *schuilkerken*. Perhaps the pastors who commissioned these works meant them to speak in a hortatory, inspirational vein to those many Netherlanders whose religious loyalties were still weak or uncertain. The *Conversion of Saint Paul* that hung in Utrecht's clandestine church of St. Dominic may have served the same purpose.[31]

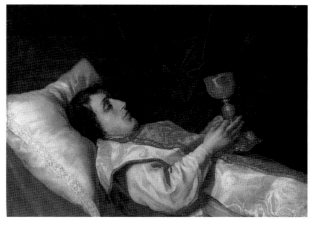

Fig. 3 Wooden tabernacle with door painted by Nicolaus Knüpfer, ca. 1650. Ebony, ebony veneer, oak, and copper; 67 × 57 × 52 cm (26⅜ × 22½ × 20½ in.) (tabernacle), 46 × 28.5 cm (18⅛ × 11¼ in.) (door). Rijksmuseum Het Catharijneconvent, Utrecht.

Fig. 4 Dirck van Voorst, *Portrait of an Unknown Priest*, 1615. Oil on panel, 78 × 107.2 cm (30¾ × 42¼ in.). Rijksmuseum Het Catharijneconvent, OKM S-27.

Fig. 5 Jan van Bijlert, *Holy Trinity with Saint Willibrord and Saint Boniface*, 1639? Oil on canvas, 296.5 × 201 cm (116¾ × 79⅛ in.). Formerly Onze Lieve Vrouwekerck, Huissen, Gelderland, destroyed in 1943.

As for the missionary priests themselves, their celebration spurred demand for portraits. It also manifested itself in a devotion to Saints Willibrord and Boniface, the original missionaries who converted the Netherlands. Promoted heavily by the apostolic vicars, this devotion took a great variety of forms. It had special significance in Utrecht, which had been founded by Willibrord around 690 and made the seat of his bishopric. Jan van Bijlert highlighted this special connection between saint and city in his painting *Holy Trinity with Saint Willibrord and Saint Boniface* (fig. 5). In fact, two tendencies within Dutch Catholicism overlapped in the veneration of these two saints: the cult of conversion and the celebration of

specifically Dutch "national" saints: Servatius, Lebuinus, Plechelmus, Odulphus, and Jerome, as well as Willibrord and Boniface.[32] Promotion of these local saints functioned as an appeal to tradition, a reminder that the Catholic faith had shaped the history and very identity of the Netherlands, and of Utrecht especially. Even Calvinists found it difficult to separate Catholic heritage from civic custom. Utrecht's magistrates repeatedly condemned the celebration in November of the Feast

of Saint Martin, the city's former patron (depicted by Joost Cornelisz. Droochsloot, cat. 31), yet Utrechters of all religions continued, as before, to march with burning torches around the city on Saint Martin's Eve. The Feast of Three Kings remained a popular holiday in Utrecht as well, perhaps helping to explain the profusion of Adorations by Utrecht painters, as that by Abraham Bloemaert (cat. 16).[33] Catholicism had sunk deep roots in communal culture; those roots now helped it to weather the blasts of official Calvinism.

Both figuratively and literally, then, the first half of the seventeenth century was a period of church building. Disorganized groups of believers worshiping furtively (except the Reformed) yielded to congregations with a regular ministry, strong organs of governance, and well-equipped places of worship. This development, experienced by all the confessions, went through its most intense phase in the 1610s and 1620s; by 1650 it was complete.

Unfortunately, we know much less about the outcome of the rise of confessionalism in its other two aspects: the competition among the churches for followers and the attempts by each church to inculcate in its followers its distinctive norms and values. Long curious about the first issue, historians only recently have attached due importance to the second. Previously, historians assumed that those attempts had met with success. Yet even where they held vast coercive powers, religious leaders in early modern Europe never managed to transform their flocks as thoroughly as they wished. In the Republic, they simply lacked such powers. Even the famous discipline meted out by Calvinist consistories could have limited effect because church membership, and with it subjection to that discipline, remained voluntary. Given the extraordinary religious freedom they enjoyed, Netherlanders could not only choose whether to affiliate with a church but having done so could maintain with relative ease a critical distance from the teachings of their purported leaders. Ulti-

mately, they could decide for themselves how to interpret and what importance to assign to prescribed norms. As a result, religious sentiments varied within churches as well as among them.

One way to make sense of this compound diversity is to distinguish within every congregation between a core of committed members who fully internalized the norms of their church and a series of wider but more peripheral circles. Contemporaries did so all the time: Catholic leaders, for example, distinguished between "the devout," "good," and "nominal" Catholics. The first group included those who confessed and took communion at least monthly; it also included the *klopjes* and the householders who risked high fines to allow clandestine services in their homes. "Good" Catholics confessed and communed at least once a year, at Easter, while the nominal ones had recourse to the church chiefly to sanctify birth, marriage, and death with the sacramental rites of passage.[34]

The Reformed Church, likewise, had its core and peripheries. Its elders and deacons certainly belonged to the former; so in Utrecht did the circle of Voetius's friends, among them Utrecht's celebrated savante and artist Anna Maria van Schurman, whose portrait drawing of her friend is illustrated here (see fig. 1). Members of the church (*lidmaten*) showed almost as much commitment, for to gain membership and with it access to communion, they had to pass an examination and submit freely to church discipline. Presumably these members often took their children to services with them; the latter might have felt a genuine faith or simply been doing what their parents commanded. More distinctive to the Reformed Church was the semiofficial category of "sympathizer" (*liefhebber*), composed of adults who attended sermons with some regularity but did not take communion and were not subject to discipline. These sympathizers were a very mixed lot; at one end of the spectrum, they included "members in training"; at the other, as one Calvinist noted, "it often happens that

among the persons who call themselves *liefhebbers* lurk Catholics, Mennonites, Libertines, and atheists."[35] One might, for a variety of reasons, attend a Calvinist sermon without assenting to all its doctrines.

It can be highly misleading, therefore, to categorize people, for example, simply as Catholic or as Calvinist. With this caveat, it remains worthwhile to attempt a sketch of Utrechters' church affiliations. Unfortunately, the current state of research offers few facts; the rest is uncertain extrapolation. In 1620, right after the expulsion of the Remonstrants, Utrecht's Reformed consistory counted about two thousand church members.[36] In all probability, this marked the nadir of the church's popularity for the entire century. In the 1650s, the Reformed church experienced a burst of accelerated growth that raised its membership to about seven thousand; the list of new members suggests it entered that decade at around five thousand.[37] None of these figures include children or *liefhebbers*. To estimate the size of the entire community of Reformed churchgoers one might perhaps double the number of members.

The number of Remonstrants is even less clear. Until 1619, of course, they dominated the official Reformed Church, most of whose members were thus Remonstrant, at least in a general sense. Then began a period of persecution, during which some Remonstrant conventicles attracted more than two hundred attendees. As soon as persecution stopped, active membership shot up, but to what level is unclear. We know only that Utrecht's Remonstrant congregation was deemed one of the four largest and most important in the Republic, alongside those of Amsterdam, Rotterdam, and The Hague; that until 1650 it had three ministers; and that its *schuilkerk* on the Rietsteeg had to be expanded.[38] Utrecht's Lutheran congregation likewise was one of the foremost in the land. Its baptismal registry offers a good indication of its size. Between 1645 and 1650, at the height of the congregation's fortunes, an average of 92.5 bap-

tisms were performed annually. At the prevailing birth rate, the number suggests a Lutheran population of 2,500.[39] For the Mennonites we have but a single figure: as of 1611, the largest of the three congregations, the Flemish, had about 150 members.[40]

Two sources provide information about the number of Catholics in Utrecht: the reports of the apostolic vicars and the municipal government's list of civil weddings performed. In their reports to Rome, the apostolic vicars regularly estimated the number of Easter communicants in various locales. For Utrecht and its suburbs they offered the following figures:

Year	Number of Communicants
1602	12,000–14,000
1622	over 8,000
1635	9,000
1638	9,000

These figures omit preadolescent children, who did not take communion. Including the latter, Vicar De la Torre claimed there were fifteen thousand Catholics in 1656. This often-cited figure is the basis for claims that Utrecht, with a total population of about thirty thousand, was half-Catholic.[41] Unfortunately, as L. J. Rogier and others have shown, the estimates of the apostolic vicars are wholly unreliable: they are often inconsistent and sometimes demonstrably false.[42] By contrast, the list of civil weddings offers reliable but inconclusive evidence. As in Holland, so in Utrecht people who did not want to be married by a Calvinist minister could choose a civil service performed in city hall. Until about 1615 the percentage of couples that took advantage of this option fluctuated wildly; after that it hovered around 25 percent, rising around 1650 by just two or three percentage points. Not everyone who opted for a civil wedding, though, was Catholic; conversely, at least a few Catholics married in the Reformed Church, while others may have had neither form of legal ceremony. Still, if as few as two

Catholic	Civil Wedding (Catholic?)	Calvinist	Remonstrant
Abraham Bloemaert	Willem Adriaensz. van Capel	Jan van Bijlert	Claes van Roeyen
Hendrick Bloemaert	Jacob Duck	Johannes de Bont	Bernard Zwaerdecroon
Thijman van Galen	Aert van der Eem	Jan Gerritsz. van Bronchorst	
Gerard van Honthorst	Carel Hoogh	Hendrick ter Brugghen[b]	
Lumen Portengen	Nicolaus Knüpfer	Joost Cornelisz. Droochsloot	*Mennonite*
Petrus Portengen	Marcus Ormea	Gijsbert Gillesz. de Hondecoeter	Crispijn van de Passe, the Elder
	Willem Ormea	Claude de Jongh	Roelandt Saverij[c]
	Cornelis van Poelenburch	Paulus Moreelse	
	Paulus van Vianen	Hendrik Munniks	
	Abraham Willaerts	Hans Saverij	
	Cornelis Willaerts[a]	Johan de Veer	
		Adam Willarts	
		Joachim Wtewael	
		Peter Wtewael	

a. First marriage in city hall, second in Reformed Church.
b. Ter Brugghen was married and had at least four of his children baptized in the Reformed Church.
If it is true, as suggested (Blankert and Slatkes 1986, 67), that he disapproved of the Contra-Remonstrants
who controlled the church after 1618, his disapproval could not have been strong, since he allowed all the
children born in the 1620s to be baptized by Contra-Remonstrant ministers. In any case, Ter Brugghen was
firmly Protestant.
c. Definite indication only for his parents.

out of three had a civil wedding, the percentage of Catholics could not have exceeded forty-two. Without better evidence one is left to conclude that between 25 and 42 percent of Utrecht's population considered itself Catholic in these years. Rovenius's impressionistic statement of 1616 comes as close to the truth as we may ever get: "the leading and more distinguished inhabitants are mostly Catholic, [and] about a third of the common people."[43] This figure is much lower than previously estimated but still impressive. In absolute terms, Utrecht's Catholic community was second in size only to Amsterdam's; relative to total population it had no equal.

In sum, viewed from a Catholic perspective, Utrecht was indeed the center of religious life in the Republic; viewed as a whole, though, it was hardly a "Catholic city." Based on the evidence above, one might suggest that, as of 1650, Utrecht's total population broke down roughly as follows: 33 percent Calvinist, 35 percent Catholic, 8 percent Lutheran, 8–10 percent Remonstrant, 1–2 percent Mennonite, and the remaining 12–15 percent still unaffiliated with any church. This breakdown was not the same for every social group.

Utrecht's elite, especially its gentry, was known to all contemporaries as largely Catholic, with a disproportionate number of Remonstrants as well. Utrecht's artistic community, however, was only a little more Catholic than its general population. According to Marten Jan Bok, between 1621 and 1650 about 37 percent of Utrecht's painters (*kunst-schilders*) married in city hall.[44] A list of artists with known religious affiliations tends to confirm that in this subcommunity, as in the urban whole, diversity prevailed, not any single religion (see table above).[45]

The question arises, finally, how the different religious groups related to one another. On the one hand, the rise of confessionalism was no quiet or friendly process. Like their counterparts throughout Europe, Utrecht's churches felt locked in a cosmic struggle with one another. The Catholic and Calvinist churches adopted particularly militant stances, blasting their rivals from the pulpit and in print. Voetius even sent his students to Remonstrant services to interrupt the sermons and point out the preacher's errors.[46] No one escaped the sounds of this battle, which on occasion found an echo in the voices of ordinary Utrechters.

Calvinists like Aernt van Buchel, the art lover and scholar, voiced frequent scorn for the "papist superstitions" of their neighbors. In general, though, Calvinists looked to the authorities to take action, rather than taking it on their own. Not so the members of other denominations, who displayed an astounding assertiveness. A Lutheran who found himself next to Voetius on a passenger barge accosted the famous theologian, denouncing him to his face as "a seducer, a false teacher, etc."[47] In 1638 a complaint reached the magistrates that Catholics were harassing old women who worked on saints' days. Catholics who ran hospitals pressured those in their care to observe the same.[48] On several occasions, when the city sheriff attempted to break up a Catholic or Remonstrant service, he and his men faced shouts of anger and contempt from the aggrieved worshipers.[49]

Violence, though, was almost unheard of. In fact, however hostile the religious groups could be to one another as groups, Utrechters tended as individuals to get along well. On this more personal level, the bonds uniting people as neighbors, friends, relatives, and fellow citizens proved at least as strong as the religious divisions separating them. Simon Groenveld has recently suggested that by the 1650s Dutch society was divided into "columns," as it was in the late nineteenth and early twentieth century. Each religious group, he argues, formed a distinct, closed society within the broader one, with its own systems of education and charity and its own subculture.[50] Whatever the wider truth of Groenveld's claim, it certainly does not hold for Utrecht prior to the French invasion of 1672. Few if any social events seem segregated by religion: dances, cockfights, fairs, and celebrations like Saint Martin's Eve brought Utrechters together in whirls of excitement that freely transgressed confessional bounds.[51] Only in the aftermath of the invasion did Utrecht's magistrates create wholly separate systems of charity for Calvinists and Catholics. The magistrates also,

for the first time, passed laws regulating mixed marriages.[52]

Some of the most concrete evidence for the easy intercourse that prevailed, at least before the 1670s, comes from Utrecht's artistic community. The most important teachers at Utrecht's drawing academy, founded in the 1610s, were the Catholic Abraham Bloemaert and the Contra-Remonstrant Paulus Moreelse; together the two friends taught this basic skill to a whole generation.[53] In the painter's atelier likewise, master and student often differed religiously: the Catholic Petrus Portengen studied with Moreelse, the Protestants Bijlert and Ter Brugghen with Bloemaert. Portengen's brother Johan ended up marrying Moreelse's daughter, an example, hardly isolated, of mixed marriage. The relationship between artist and patron frequently crossed confessional lines as well. Bijlert provides some of the most striking examples of this: a member of the Reformed Church whose daughter married one of its ministers, he produced a large number of works for Catholic *schuilkerken*, including altarpieces.[54] That Catholic artists produced on commission for Protestant patrons, including the House of Orange, is well known. Connoisseurs like Aernt van Buchel or, in The Hague, Constantijn Huygens embraced artists on the basis of their work, not their creed.

It is for art historians to define schools and to trace artistic influence; from a social perspective, however, it is clear that Utrecht's artists were not divided along religious lines. Neither was the urban community to which they belonged. Despite the variety of their church affiliations and the even greater variety of their personal beliefs, Utrechters formed a single community sharing a common culture. In this respect, the impact of confessionalism remained limited, even in the home of Voetius and Rovenius. Utrecht was not only a diverse city religiously but, like the Republic as a whole, a pluralistic one. More than Catholicism or any one confession, this pluralism set the religious climate for Utrecht's Golden Age.

The Utrecht Elite as Patrons and Collectors

BEN OLDE MEIERINK AND ANGELIQUE BAKKER

In 1623 the Utrecht painter Dirck van Baburen, inspired by Pieter Cornelisz. Hooft's 1605 play *Granida*, depicted the love story of Princess Granida and the shepherd Daifilo. This picture is probably to be identified with the relatively large painting of the subject mentioned in the 1656 will of the Utrecht nobleman Peter van Hardenbroek.[1] The will reveals that Van Hardenbroek himself is represented as Daifilo, and, presumably, his future wife, *Jonkvrouwe* (a noble epithet comparable to the British use of *Honorable*) Agnes van Hanxelaer, appears as Granida. Van Hardenbroek may have played a role in Agnes's escape from the Cistercian convent of St. Agatha in Hoocht in 1623, echoing in his personal life the kind of fateful encounter that was dramatized by Hooft. This somewhat unusual case is one of the few documented instances of patronage of Utrecht painters in the seventeenth century.

It may be assumed that a not insignificant percentage of the paintings produced in Utrecht at this time was bought by the local elite, but a critical assessment of the patronage practices of this social group is still lacking. In addition, with the notable exceptions of the Guild of St. Eloy and the St. Job's Hospice,[2] no institutions can be linked to the work of well-known Utrecht painters such as Gerard van Honthorst, Hendrick ter Brugghen, and Abraham Bloemaert. Consequently, neither the context within which the paintings were produced nor the motivations of potential patrons can be ascertained.[3] Furthermore, little is known about the specific relationships between individual artists and collectors. We do know, however, that some artists themselves belonged to the political-social elite, as was the case with Joachim Wtewael and Paulus Moreelse, and that some artists had family ties with members of the city council, as was the case with Honthorst and Jan Gerritsz. van Bronchorst. Still, this is not much information on which to base an assessment of patronage in Utrecht.

The Utrecht Elite: The Nobility and the Patrician Class

In the first half of the seventeenth century, a relatively large number of painters were active. Marten Jan Bok has demonstrated that this activity was the result of numerous factors.[4] Even if many paintings were bought by people of various social classes, we can assume that the elite was responsible for enabling the greatest part of this production, as either patrons or purchasers of finished works. This upper class was large. Utrecht was not only the largest city in the Northern Netherlands, but also, until 1559, as the only episcopal see, the most important one in the region (figs. 1, 2). In 1577 Utrecht's population was between twenty-five and thirty thousand.[5] In the

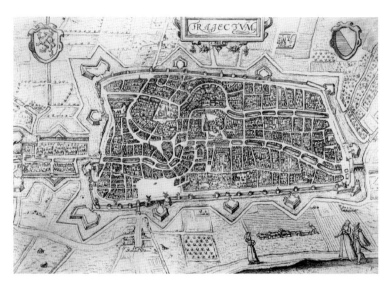

Fig. 1 P. Kaerius, after P. Bastius. *View of Utrecht from the West in 1604.* Engraving in five parts, 1460 × 385 mm (57¼ × 15⅛ in.). RAU, Utrecht, Flehite AC 3-5-1.

Fig. 2 The town of Utrecht. Willem Silvius, *Trajectum*, ca. 1579–80. Engraving, 233 × 319 mm (9⅛ × 12½ in.). RAU, Utrecht, Flehite AC 2-20-1.

following century, however, Utrecht would cede this important position to Amsterdam and the industrial cities of Haarlem and Leiden, which would far surpass Utrecht in population.

Utrecht was also the administrative center of the eponymous province. By the end of the Middle Ages, the regional government was in the hands of the bishop of Utrecht and the three estates: the clergy, the *Ridderschap* (a college of noblemen representing the titled gentry), and the cities. When, in 1528, the bishop was forced to relinquish his secular power to Emperor Charles V, Utrecht became part of the Burgundian Netherlands. Since neither Charles nor his son Philip II was able to exercise personal rule over the province, a deputy, the stadholder, was appointed. After the provinces ceased allegiance to the Spanish king, and the provincial states or assemblies began to exercise their sovereignty, the office of stadholder was maintained. Despite regular protests by the smaller cities, the power of the third estate was almost completely controlled by the city of Utrecht. The city itself was governed by the city council under the guidance of two burgomasters.[6]

Until the Reformation, the first estate was made up of representatives of the clergy, not sur-

prising in an episcopal see. Much of the clerical power was in the hands of the chapters of the five principal churches, the Dom (cathedral), the Old Munster, and the churches of Saints John, Mary, and Peter. The canons, and especially the deans and provosts, played a significant role in the government. The Utrecht nobility was liberally represented among the canons, while the sons of the patriciate occupied many seats in the colleges. The traditional structure of chapters, with canons, deans, and provosts, remained in place after the Reformation, but the members were no longer Catholic, let alone clergy, belonging instead to Protestant aristocratic and patrician families.[7] Accordingly, it was the Protestant Johan van Reede van Renswoude who was dean of the cathedral chapter from 1620 until 1674. The church maintained its substantial holdings, which were considerable even in their reduced worth until the

The Utrecht Elite as Patrons and Collectors [73]

French period (1794 and after), and the revenues benefited the Protestant owners of the prebends.

The *Ridderschap*, which represented the countryside, consisted of men drawn from a group of ten noble families, related by marriage, from Het Sticht (the province of Utrecht) and, to a lesser degree, neighboring provinces. In addition to being noble born, these men had to fulfill a number of requirements to be admitted to the governing college. First, they had to belong to an old knightly family and own a *Ridderhofstede*, or fortified country estate with farms attached. In addition, they were required to own at least twenty-five-thousand guilders' worth of real estate within the episcopal province.[8] Unlike the practice in other provinces, the number of noblemen holding a seat in the *Ridderschap* in the province of Utrecht was limited, often to less than ten.[9]

During the fifteenth and sixteenth centuries, many noble families lived in the city of Utrecht, leaving the country estates largely empty. In fact, a list of 1536 shows that very few of these families lived in their ancestral homes. The majority had settled within the walls of Utrecht, and a smaller number in Amersfoort, Wijk bij Duurstede, and Rhenen.[10]

In view of the power structure, it is understandable that until 1618 one of the two mayors of the city of Utrecht belonged to the nobility. The relatively large amount of power held by the lesser nobility did not please the stadholder, Prince Maurits. In 1618 he succeeded in diminishing the influence of the nobility in favor of the patrician class in the city. It was decided that half the number of the elected would consist of patricians (non-nobles) and that the nobility would no longer occupy one of the two mayoral seats.[11]

The Lack of a Court

During the reign of Charles V, the stadholders belonged to the high nobility, who tended to live at the court in Brussels or Mechlin, in the vicinity of the emperor or his appointed regent. The office of stadholder of Utrecht was combined with that of other provinces, such as Holland, Zeeland, and Overijssel. Even though stadholders, such as Maurits and Frederik Hendrik, had become servants of the States, they kept an independent course and were often in conflict with the regional magistrates.[12] The stadholders Maurits (1589–1625), Frederik Hendrik (1625–47), and the latter's son Willem II (1647–50) lived, not in Utrecht, but in The Hague. Prince Maurits was a bachelor and lived in the medieval castle of the former counts of Holland, a sober residence which he shared with the legislative assembly of the province of Holland and the general assembly of the Republic. Although he had a pied-à-terre in Amsterdam, Haarlem, Leiden, and Delft, he had no residence in Utrecht. The medieval episcopal palace, Het Bisschopshof, which had been used by Maurits's predecessors, stood empty and in 1618 was put at the disposal of the military governors of Utrecht, Ernst Casimir van Nassau-Dietz and his successor, Johan Albert van Solms-Braunfels, a brother-in-law of Frederik Hendrik. Since both also had duties in other parts of the Republic, they were only rarely in Utrecht. However, Johan Albert's widow lived in the Bisschopshof until the beginning of the eighteenth century.[13]

Over time Frederik Hendrik led a life of considerable magnificence. In and around The Hague he built the palaces Noordeinde, Honselaarsdijk, Rijswijk, and Huis ten Bosch. Painters from Utrecht fulfilled an important role in the decoration of these palaces. An inventory from about 1633 of the stadholder's painting collection shows that about 30 percent of the works were by the Utrecht painters Cornelis van Poelenburch, Gerard van Honthorst, Paulus Moreelse, and Roelandt Saverij.[14] The princes of Orange also owned a number of castles in Het Sticht. Frederik Hendrik bought Castle Zuilenstein, east of the city of Utrecht, in 1630. After extensive rebuilding, he gave it to his illegitimate son, Frederik of Nassau (1606–1672), following the pattern estab-

lished by his brother, Maurits, who had bequeathed the family castle Beverweerd, which lies somewhat closer to Utrecht, to his illegitimate son, Lodewijk of Nassau. Castle IJsselstein, to the southwest of the city of Utrecht, remained in the family of the stadholders but was hardly ever occupied.

The court in The Hague owed much of its glamour to the presence of the exiled Winter King and Queen of Bohemia, Frederick of the Paltz and Elizabeth Stuart. Having occupied their throne for just one winter, they found refuge with relatives in The Hague in 1621. In 1629 they bought an old monastery in the town of Rhenen. They demolished the monastery and had a palace built in the mannerist style by the painter-architect Bartholomeus van Bassen. The couple did not enjoy this unusual palace for long: Frederick died of the plague in 1632, and Elizabeth, who was not to die until 1661, lived there only rarely. Frederick and Elizabeth had an extensive collection of paintings, many of which were in Rhenen. In addition to works by Italian painters, there were quite a few works by Utrecht masters.[15]

A Case Study: The Painting Collection Belonging to a Family of the Gentry
At the beginning of this century, Max Friedländer called attention to the unique collection of paintings from Utrecht owned by the Catholic nobleman Willem Vincent, baron van Wyttenhorst.[16] This exceptional collection is still largely in the possession of Van Wyttenhorst's descendants at Herdingen Castle in Westfalen (Germany). Willem Vincent, who is considered the most important art collector and patron of Utrecht,[17] descended from an influential noble family from Cleves that lived at Sonsfeld Castle near Rees, not far from the German-Dutch border.[18] Since 1628 the family had owned two adjacent monastic houses on the north side of St. Janskerk in Utrecht, where Willem Vincent spent much of his life.[19] In 1646 he married the rich widow Wilhelmina van Bronckhorst. She had been married twice before; once to a

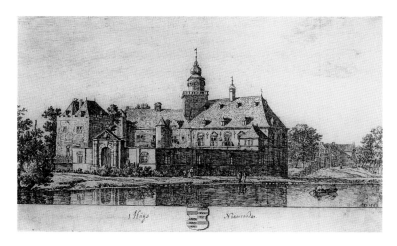

Fig. 3 Herman Saftleven, *Nijenrode Castle*, 1653. Etching, 152 × 283 mm (6 × 11⅛ in.). RAU, Utrecht, TA 667-2.

nobleman from Overijssel, Adolf van Rutenberg, and in 1632 to Bernard van den Bongard III, who at about the same time rebuilt Nijenrode Castle near Breukelen on the Vecht river in a mannerist style (fig. 3).[20] After Van den Bongard died in 1641, Wilhelmina retained the usufruct of the possessions in Breukelen, which included the Nijenrode Castle. Thus Wilhelmina and Willem Vincent had residences both in Utrecht and at Nijenrode Castle.

The Haarlem artist Dirk Matham, who had worked for Van Wyttenhorst on several occasions, made a handsome engraving of Nijenrode accompanied by a Latin subscription. In translation it reads: "To the very learned and noble lord, the Lord Willem Vincent van Wyttenhorst, and in equal manner to his very noble and most excellent wife, Lady Wilhelmina van Bronckhorst, free barons of the Holy Roman Empire, Lords of the city of Nijenrode, Breukelen, ter Lucht, etc., to these, his patrons, has Dirk dedicated and delivered this representation of their ancestral home as an adumbration of his affection."[21] The commendations of Matham appear less exaggerated when one realizes how large the Van Wyttenhorsts' collection was. The size and character of the collection are known primarily through the extensive catalogue that Willem Vincent prepared in 1651.

This unique source, which was updated until

1659, sheds light on how the couple managed their collection. The catalogue describes 180 numbered and 33 unnumbered objects and was used into the eighteenth century for the administration of the collection. In the introduction Van Wyttenhorst wrote that the catalogue served as a "memorial" of the paintings. It listed first the paintings that Wilhelmina brought to the marriage, then the heirlooms of Willem Vincent's family (some of which date to the sixteenth century), and last the paintings the couple bought together. This last category is annotated with the purchase price of each painting, and an estimated value is given for the inherited works. Thus, this document provides valuable information about the prevailing price for paintings.[22]

The paintings Willem Vincent and Wilhelmina bought were accorded the most complete descriptions. By contrast, only a very summary description was given the objects that came down in the family. These included a triptych entitled *The Revelation of Saint John* by Cornelis Engebrechtsz., which is also mentioned by Karel van Mander in his *Schilder-boeck*. This painting, an epitaph in memory of the nobleman Willem van der Does and his family, was made for the Lockhorst chapel in St. Peter's church in Leiden. It descended through the family to Bernard van den Bongard III, Wilhelmina's second husband, from whom she inherited it. In 1651 the painting was found in the *groot salet* (grand salon) in Nijenrode. In 1660 Willem Vincent and Wilhelmina sold the triptych to Wigbold van der Does, a distant descendant of the aforementioned Willem van der Does.[23]

Also hanging in Nijenrode was the well-known triptych by Jan van Scorel, *Entry into Jerusalem*.[24] A portrait of Wilhelmina's mother from 1605 by Paulus Moreelse can also be traced to Wilhelmina's possessions, as can a portrait of Wilhelmina's sister-in-law Bernardina van den Bongard (d. 1652). The paintings that came from the Van Wyttenhorst family were all portraits.

Among these were the 1547 painting of Dirck van Assendelft attributed to Anthonis Mor and the anonymous portrait of Anna van Assendelft, who died in 1630. In 1635 Gerard van Honthorst painted members of the Van Wyttenhorst family.

The bulk of the collection, however, was acquired by Willem Vincent and Wilhelmina after their marriage. The couple apparently cultivated a special relationship with the painter Cornelis van Poelenburch. They owned at least fifty-four paintings by him, purchased primarily between 1650 and 1656, and a separate chapter of the catalogue is dedicated to them. A portion of the works was painted in the manner of Adam Elsheimer, who had died in 1610. Many paintings had subjects taken from classical mythology and the Old Testament. Some had a marked Catholic character, such as a small triptych with an Adoration of the Shepherds in the center and the Annunciation on the wings. An early work by Poelenburch, it was bought from the painter in 1656 for two hundred guilders. A few years later it was given a frame carved from palmwood and furnished with the names of the couple and their coats of arms.[25]

Other paintings by Poelenburch mentioned in the inventory are *Saint Joseph with the Christ Child*, *Saint Anne with Mary as a Child* (St. Anna met het kindike), and *Flight of Mary and Joseph into Egypt*. Almost half of the works by Poelenburch, nineteen, are small portraits of relatives of the couple, of which sixteen survive in Herdingen. Some of these diminutive works on copper, measuring 6¼ by 5⅜ inches, were given to the couple by either the sitters or the sitters' descendants, and others were copied at the request of the Van Wyttenhorsts after older paintings. Produced between 1648 and 1651, these portraits were destined for a portrait gallery in Wilhelmina's private room in the house in Utrecht. As a group they form a good picture of the aristocratic, primarily Roman Catholic circles in which the couple moved.

The Van Wyttenhorsts had at least fourteen paintings, primarily landscapes, by Herman

Saftleven, whom the Van Wyttenhorsts called "artful painter." In 1648 they bought a series of four landscapes representing the seasons. There is also reference to a painting Saftleven made in collaboration with Roelandt Saverij.

The catalogue contains frequent mentions of paintings made by several artists working in collaboration, each contributing his own specialty. A good example of this practice is *The Pursuit of Pleasure (Il Contento)* (see Spicer, introduction to this catalogue, fig. 7). According to Van Wyttenhorst, who bought the picture in 1651, the figures were painted by Nicolaus Knüpfer, the landscape by Jan Both, and the animals by Jan Baptist Weenix.

In 1661 Willem Vincent inherited Gansoyen Castle and the Drongelen and Besoyen manor houses in northern Brabant. That same year he bought the ancestral Horst Castle from the Huyn family. The castle was renovated, a process that took many years. It is likely that in 1665 the renovations were complete enough for the couple to take up residence, for they sold their large house on the Janskerkhof in Utrecht.[26] They also lived often at Gansoyen, judging from the notations in the margins of the catalogue noting which paintings were in Gansoyen and which in Horst Castle.

Wilhelmina died childless in 1669. Willem Vincent remarried and had three children by his second wife. He died in 1674. In 1738 Horst Castle and the painting collection passed by inheritance to the von Fürstenberg family, and this family still owns the majority of the Van Wyttenhorst collection.

The Monumental Aristocratic Portrait Gallery
In 1673 Amerongen Castle (fig. 4), east of Utrecht, was destroyed by the French. The owners, Godard Adriaen van Reede (1612–1691) and his wife, Margaretha Turnor, had it rebuilt as a monumental, moated, cube-shaped manor house.[27] After passing through the entrance hall, one mounts a double staircase to another set of stairs that leads to an upper gallery. This immense space, articu-

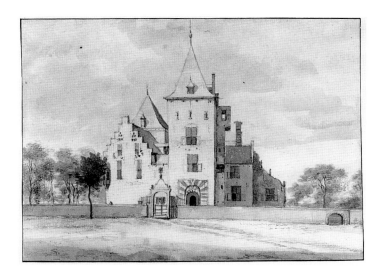

Fig. 4 Roelant Roghman, *Amerongen Castle from the East*, 1646–47. Chalk and wash on paper, 270 × 360 mm (10⅝ × 14⅛ in.). Rijksmuseum, Amsterdam, RP-T-1899-A-4122.

lated by pilasters, is more than two stories high and roofed with a cupola. The walls are entirely covered with paintings, mostly large portraits, among which can be found a complete set of the lords and ladies of Amerongen. Included are not only portraits of Godard Adriaen and Margaretha, painted in 1661 by Rembrandt's pupil Jurrian Ovens, but also those of Godard Adriaen's parents, Godard van Reede and Anna van den Boetzelaer tot Toutenburg. In addition, there are the portraits of the grandparents, Frederik van Reede and Cornelia van Oostrum, as well as the great-grandfather Goerd van Reede and his wife, Geertruid van Nijenrode.[28] Some of these portraits may have been part of the group of thirty-three copies in the legacy of Anna van den Boetzelaer, who died in 1650. Apart from these family portraits, the only other works included in the legacy were "one painting of small importance," two small paintings, and nineteen small prints.[29]

Resembling the monumental portrait gallery in Amerongen is the gallery of full-length ancestral portraits in Zuylen Castle (fig. 5) in the northwest corner of the province of Utrecht. The modernization of the castle must have been begun shortly after the marriage of Hendrik Jan Tuyll

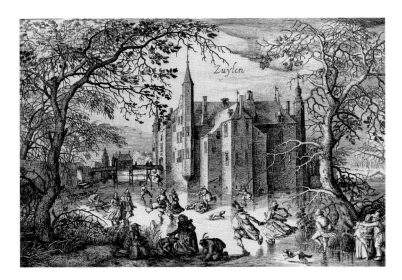

Fig. 5 Hessel Gerrits, after David Vinckboons, *Zuylen Castle in Winter*, from *The Four Seasons*, ca. 1625. Etching, 109 × 243 mm (4¼ × 9⁹⁄₁₆ in.). Rijksmuseum, Amsterdam, RPK 29967.

van Serooskercken to his thirteen-year-old stepsister, Anna Elisabeth van Reede, in 1668.[30] In the course of this renovation a series of ancestral portraits was installed in the hall. Hendrick Bloemaert, son of the well-known Abraham Bloemaert, was commissioned to paint the full-length portraits of six generations of Tuyll van Serooskercken ancestors in historic dress. Each of the paintings was furnished with a heraldic shield. In some cases Bloemaert could rely on older portraits (which are today still at Zuylen) for appropriate garb for the subjects, but for some he had to use his imagination. The series, which still hangs in the hall (now used as the dining hall), includes the portrait of the patron himself, proudly represented with his quarterings and the "new family castle" Zuylen in the background.[31] As was the case in Amerongen and undoubtedly fulfilling the intentions of Hendrik Jan van Tuyll van Serooskercken, the series was later expanded with portraits of the sons and heirs of four successive generations. The portrait collection at Zuylen Castle and the manor house at Amerongen are good examples of an *Ahnengalerie*, or "ancestral gallery." Such a collection can come about in two different ways. First are the "organically grown"

collections, which later generations would augment with new additions. But it also could happen, as at Zuylen, that an entirely new collection was commissioned, in which the likenesses of ancestors were copied after older portraits or medallions. Where these models were lacking, imagination stepped in.[32]

If the nobility was the first group to have an *Ahnengalerie*, later, the increasingly aristocratic regent class considered the *Ahnengalerie* a material expression of dynastic self-awareness. Its emergence should be evaluated against the background of Christian and classical traditions. The installation of a gallery was, on the one hand, the Renaissance revival of a custom of the Roman aristocracy, who had the privilege to place the busts of ancestors in the atrium of their houses.[33] On the other hand, such a group of portraits was related to the tradition of medieval epitaphs and altarpieces, which were commissioned to memorialize deceased family members.[34] During the fifteenth and sixteenth centuries, altarpieces were regularly commissioned by both noble and non-noble families. The religious subject on the central panel was flanked by lateral wings showing kneeling ancestors as donors in the company of their patron saints. An example is the triptych in the Van Wyttenhorst collection by Van Scorel, which shows on one of the lateral wings members of the Van Lockhorst family.[35]

The transition from these epitaphs to the seventeenth-century portrait galleries can be illustrated with a painting in the Amerongen manor house. It shows Goerd van Reede and Geertruid van Nijenrode kneeling, turned toward each other, above their thirty-two quarterings in the lower section. Both the composition and the fact that husband and wife are represented kneeling are unusual in the portrait genre and might indicate that the painting is in fact a single side panel of a triptych.[36] Similar side panels from an early-sixteenth-century triptych can be found at Zuylen Castle in Utrecht. Also in that collection is a panel

dating from 1627 of Jeronymus van Serooskercken (1500–1571) and his wife, represented kneeling within niches and, as at Amerongen, surrounded by heraldic shields.[37] It is possible that the Tuyll van Serooskercken family, newly arrived in Het Sticht and whose nobility was not uncontested, used such a painting to give the family an aura of ancientness. This may also have been the case with a painted epitaph of Adriaen Willemsz. Ploos (cat. 8, fig. 2), which, apart from the donors, shows striking parallels with Hendrick ter Brugghen's *Crucifixion with the Virgin and Saint John* in New York (cat. 8). Marten Jan Bok has recently unmasked this painting as a seventeenth-century pastiche, which the patron hoped would prove the noble origins of his family.[38] It is also possible that the painting in Amerongen is a copy after a Crucifixion scene with Goerd and Geertruid appearing as kneeling donors, but with the Cross omitted.

In the Amerongen case we may assume that the collection of ancestral portraits grew over time. The same is true for the portrait collection of the Van Wyttenhorsts. After all, in addition to a large number of portraits of family and relatives, the couple had inherited a respectable group of sixteenth-century family portraits. The collection of small portraits on copper, preserved in the private sitting room of the lady of the house, is an example of an intentionally constructed gallery.

Painting Collections of the Roman
Catholic Nobility

Since the end of the sixteenth century, access to the most important public offices had been officially closed to non-Calvinists. This meant that a significant portion of the Utrecht nobility was excluded from public service. It is true that a number of Roman Catholics remained in office until the end of the Twelve Year Truce (1609–21), but new Catholic members were not admitted. This notwithstanding, a major portion of the nobility remained Catholic and thereby declined a career in the magistrature.[39] Information gleaned from

Fig. 6 Hessel Gerrits, after David Vinckboons, *Loenersloot Castle in Summer*, from *The Four Seasons*, ca. 1625. Etching, 109 × 243 mm (4¼ × 9⁹⁄₁₆ in.). Rijksmuseum, Amsterdam, RPK 29965.

an ecclesiastic visitation report prepared in 1656 points to the fact that a considerable number of castles in Het Sticht were inhabited by nobles who remained faithful to the Catholic faith. The report mentions not only Nijenrode but also the aristocratic seats of Loenersloot Den Ham, Vronestein, and Heemstede, which will be discussed below.[40]

Insight into the paintings owned by a noble Roman Catholic family can be gained from the inventory compiled at the death in 1632 of Jonker Jacob Amstel van Mijnden. His family lived in the northwestern part of the province in the medieval castle of Loenersloot (fig. 6), which a few years earlier had been enlarged according to the plan of the painter-architect Salomon de Bray.[41] The family also owned a house in Utrecht at 20 Nieuwegracht,[42] which dates from 1519 and which still exists, as well as the small castle of Zuylenburg on the Langbroekerwetering.[43]

In Loenersloot Castle were hung—spread over eleven rooms, including the kitchen—at least sixty paintings, of which almost half were family portraits. There were ten more paintings, seven with a religious theme and three with a classical theme. These included such typical Roman Catholic subjects as the Resurrection and the

Transfiguration of Christ, as well as a sixteenth- or perhaps even fifteenth-century triptych with a representation of the Virgin and Child, with the coats of arms of the Van Wees and Van Culemborg families on the shutters. Another triptych with the coat of arms of Jacob van Mijnden and his two sons and a gilt brass memorial epitaph (now in the Centraal Museum, Utrecht) of Joost Utenengh, who died in 1553, were also mentioned in the inventory.[44] There was further mention of eleven genre pieces, some with a "peasant" theme, something one would not have expected in this context, such as a *keiesnijerij* (Stone Operation, or Cure of Folly), and the satirical topics of a "peasant fat kitchen" and a "peasant lean kitchen," as well as a "weeping peasant." Also noteworthy is a painting of Loenersloot Castle and a series of four paintings of Loenersloot, Nijenrode, Maarssen, and Zuylen.[45] In the city house Loenersloot on the Nieuwegracht could be found only seven paintings, and they were not portraits but religious paintings. This leads to the conclusion that the Amstel van Mijndens considered Loenersloot Castle their principal residence.

In 1645 the Roman Catholic couple Hendrick Pieck and Maria van Winssen ordered a manor house, Heemstede, near Houten (fig. 7), to be built in the traditional castlelike form with towers and a moat.[46] In 1657 they had their city house on the Plompetorengracht entirely rebuilt.[47] On the basis of estate inventories that were drawn up in 1668 of both the city house and the country manor,[48] it is possible to form a good idea of the interior decoration of both houses.

The inventory shows that in the town house, on the principal floor, in the dining room (whose walls were covered with gold leather), hung a landscape overmantel and representations of the twelve sibyls, those mysterious priestesses from antiquity, who since the fifteenth century frequently appeared in painting and who, as we will see, were also present in Nederhorst.[49] There were no other paintings in the hall or in any other

Fig. 7 *The Country Estate Huis Heemstede near Houten*, built in 1645. Rijksdienst voor de Monumentenzorg.

rooms on the main floor. On the next floor, in the yellow room, was a group of seven paintings, and in the so-called grand room, in addition to ten portraits, principally of the De Wael van Vronestein family, was an overmantel depicting the story of Susanna and the Elders. Especially interesting is the mention of a large landscape showing the story of Philip and the Baptism of the Ethiopian Eunuch, which can be compared with Rembrandt's *Baptism of the Ethiopian Eunuch* of 1626 (Rijksmuseum Het Catharijneconvent, Utrecht). H. L. Defoer is of the opinion that the patrons of these paintings are to be sought in Reformatory circles.[50] This is doubtful considering the arrangement of the "white attic" on the next floor. From the inventory it appears that this part of the top floor was set up as a chapel. It is true that an altar is not mentioned, but liturgical objects necessary for the celebration of mass and vestments are included. The fourteen paintings, "large and small," and the framed prints that are listed probably decorated

the church space. It is not at all surprising to find a hidden church here, if one remembers that the adjacent building, 5 Plompetorengracht, belonging to the Catholic family Van Wassenaer van Warmond, was for decades the more or less secret hiding place of the apostolic vicar Philip Rovenius, the highest ecclesiastic functionary in the Republic, who was buried there in the stable.[51]

The same inventory lists the household goods of Heemstede. The chapel was located in one of the towers and had a deal table for an altar. Mention is made of liturgical vestments and treasures.[52] It is strange that, unlike at Loenersloot, no paintings are mentioned at Heemstede. The paintings owned by the Pieck family, on the other hand, were all located in the city house on the Plompetorengracht.[53]

Vronestein Castle, property of the De Waels, related to the Piecks, contained, according to a 1670 inventory, a house chapel. The Roman Catholic persuasion of the inhabitants is evident from the presence of, for instance, an *Ecce Homo* in the bedroom and the portrayals of Counter-Reformation saints such as Ignatius and Francis Xavier.[54] On the gilt-leather walls of the *saletkamer* (grand salon) hung twenty-two ancestral portraits. Probably coming from the house chapel in Den Ham Castle is a triptych of the *Laudes Marianae* (Marian symbols) now in the Archiepiscopal Museum (part of the Rijksmuseum Het Catharijneconvent in Utrecht), which was painted in 1619 by Nicolaes van Borculo. The lord of that time is portrayed on one of the wings with his family.[55]

Painting Collections of the Protestant Nobility
It is not always possible to distinguish clearly between Roman Catholic and Protestant families. When the Orangist Godard van Reede van Nederhorst, who in 1648 signed the peace treaty in Münster on behalf of the province of Utrecht, died, an inventory was made of the household goods of Nederhorst Castle, from which interesting conclusions can be drawn. Among the thirty-

seven paintings were found, in addition to representations of the Twelve Months, twelve sibyls and six French ladies, a *Nativity*, an *Adoration of the Magi*, a *Passion of Christ*, and even an *Annunciation to Mary*.[56] The last is an explicitly Roman Catholic subject, exceptional in Northern Netherlandish painting.[57] This raises the question as to what extent the Van Reedes were convinced Calvinists or only nominally devoted to the Reformation. Such a question is not overly surprising, considering that the Overijssel branch of the family at Saasveld Castle had remained Catholic. Furthermore, the son of the aforementioned Frederik van Reede of Amerongen, Dirk van Reede, converted to Catholicism in 1624 and even joined the Jesuit order. With the assistance of Protestant members of the family in Wijk bij Duurstede, he was given pastoral charge of the region of the Kromme Rijn.[58]

Although the painting collection at Amerongen has never been seriously studied, the extensive collection of family portraits at Zuylen, which comprises a considerable number of seventeenth-century pieces, was recently the subject of an exhibition accompanied by an elaborate catalogue.[59] Extensive inventories were prepared in 1692 at the deaths of the lord at the time, Hendrik Jacob Tuyll van Serooskercken, and Agnes van Reede van Drakestein, who was both his mother and his stepmother-in-law.[60] These inventories mention at least 170 portraits, which had come down from both Hendrik Jacob's grandfather, Gerard van Reede van Nederhorst, as well as from his first wife, Anna Elisabeth van Lockhorst, heiress of Zuylen. The collection was distributed among the castles at Zuylen and Nederhorst and the town houses in Utrecht and The Hague. At Nederhorst, in addition to more than twenty-five undescribed paintings, there were ten paintings of ·lords and ladies of the manor. Among these would have been the large portrait of Gerard van Reede, who died in 1612, painted by Paulus Moreelse, and the portrait of his grandson by Cornelis Janson

van Ceulen, now in the collection at Zuylen Castle. Also mentioned is an overmantel described as "representing the family Van Reede van Neder-horst," which can be identified with the group portrait of Godard van Reede van Nederhorst, his first wife, who died in 1632, and their children, but which also included his second wife (fig. 8).[61] This portrait is omitted from the inventory that was prepared at the death of Godard van Reede in 1649.[62]

The city house in The Hague contained portraits of the king and queen of England, probably William and Mary, a group of five counts of Holland, and a portrait of the deceased. Noteworthy is the mention of two overmantels by Roelandt Saverij. One of these undoubtedly refers to *Allegory on the Marriage of Godard van Reede and His Wife, Emerentia Oem van Wijngaerden*, now preserved at Zuylen.[63] The house in Utrecht contained twenty-two paintings that were not described, which were inherited from the families of Lockhorst and Ledenbergh, and a portrait of the Prince of Orange. The small portraits of the elder Van Nederhorst are to be identified with the portraits done by Gerard ter Borch.

At Zuylen, the notary found in the hall the full-length portraits that have already been discussed, which included members of the Tuyll van Serooskercken family from the fifteenth, sixteenth, and seventeenth centuries. Judging from surviving examples, these were largely seventeenth-century copies. Of interest is a painting by Honthorst depicting the Three Graces, possibly a representation of the daughters of the Van Reede family.[64]

Also found at Zuylen Castle was the portrait of Ernst van Reede (d. 1640), lord of Drakestein, painted in 1628 by Paulus Moreelse, who in 1619 had immortalized the latter's nephew, the cathedral dean, Johan van Reede van Renswoude, and his wife, Jacomina van Eeden.[65] The Van Hardenbroeck family also were patrons of Moreelse. The portraits of Joachim van Hardenbroeck (1565–1605) and his wife, Josina van Amstel van

Mijnden, as well as the portrait of Gijsbert van Hardenbroeck (d. 1627) and his third wife, Johanna van Varick, have been attributed to this painter.[66]

A Bourgeois Family with Aristocratic Aspirations
That ancestry was not the exclusive preoccupation of the nobility is evident from the painting collection of the Strick van Linschoten family, who owned the country seat of Linschoten (fig. 9), situated between the small towns of Montfoort and Woerden. The manor house rises directly from the water of the surrounding moat and was reached via a drawbridge.[67] These last two features were de rigueur for manor houses in Utrecht since the beginning of the sixteenth century. In addition, two towers at the front once rose sharply above the roofline. Yet despite its appearance, the manor was not a medieval castle. The building was newly constructed on its site. The patron was the Utrecht patrician Johan Strick III (1583–1648; cat. 29, fig. 3), who in 1633 as (the Protestant) dean of the Utrecht chapter of St. Marie bought from the chapter the manor house at Linschoten. On the evidence of the donation of stained-glass windows, the building must have been completed in 1647. Subsequently, the house on the Oudkerkhof (no. 33) in Utrecht was sold. The construction of the Linschoten manor must be seen in the context of the rapid aristocratization of burgher society in the Republic. Patricians obtained patents of nobility abroad. Strick also succeeded in securing for himself and his descendants the title of knight. Purely aristocratic aspirations are also evident in the survey of feudal manors and knightly families that he wrote, which is preserved in the family archives.[68] It must have pleased him very much that one year before his death, his eldest son, Johan Strick IV, married Anna Christina Taets van Amerongen, a woman from an old noble family. Johan Strick IV, who became lord of Linschoten in 1648, shared his father's ambitions. In 1654 he commissioned the painter Herman Saftleven to record the castle, with the medieval parochial church of

Fig. 8 Cornelis and Herman Saftleven, *Godard van Reede van Nederhorst and His Family*, 1635. Oil on canvas, 143 × 210 cm (56¼ × 82⅝ in.). Collection Slot Zuylen, Maarssen, the Netherlands, 35394.

Fig. 9 Herman Saftleven, *The Country Estate Huis te Linschoten near Montfoort*, 1654. Oil on canvas, 88 × 128 cm (34⅝ × 50⅜ in.). Collection Linschoten Estate Foundation, Linschoten, the Netherlands.

Fig. 10 Jan van Bijlert, *Johan Strick IV, Lord of Linschoten and Polaner, and His Wife, Christina Taets van Amerongen, with Their Children*, 1653. Oil on canvas, 150 × 189.5 cm (59 × 74⅝ in.). Collection Linschoten Estate Foundation, Linschoten, the Netherlands.

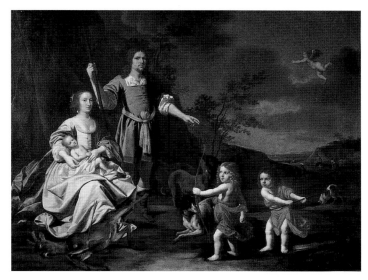

Linschoten in the background. The previous year he commissioned Jan van Bijlert to paint himself, his wife, Christina, and their three young children in a pastoral setting (fig. 10).[69]

The aspirations of the Strick family were expressed in the installation of an *Ahnengalerie*.[70] The collection of portraits was probably formed about 1655 and still exists in large part in Ipenburg Castle near Hannover. Given the similarities in format and arrangement, the paintings must have belonged to the same original grouping. Jan van Bijlert painted the portrait of Johan Strick III in 1647 and that of his wife, Beatrix Gybels van der Goes, in 1655. In about 1655 he also painted the portraits of the four sisters of Christina Taets van Amerongen: Anna Christina, Geertruid, Sibylla, and Eva. Adriana Strick, a daughter of the builder, was in her turn immortalized by Van Bijlert. Dirck van Loonen painted the portraits of her sisters

Cornelia (before 1649) and Beatrix (1655), the latter with her husband, Hendrick van Lochteren (1655). Judging from inscriptions that were added later, the gallery also contained older portraits, such as the likeness of the dynastic founder, Johan Strick I, dating from 1578, and copies of portraits by Gerard van Honthorst representing Dirck Strick and Daniel d'Ablain, the younger brother and the son-in-law of the builder respectively. The collection also includes a few copies after paintings that may represent Johan Strick II and his wife.[71] And, last, Van Bijlert painted the portraits of Johan Strick IV and his wife, Christina Taets van Amerongen. It is possible that these pieces were made to decorate the chimneypiece of a monumental fireplace from about 1664 in the large hall of the Linschoten manor. In its stead

now are the seventeenth-century replicas of portraits Van Bijlert painted of the builder, Johan Strick II, and his wife, Beatrix. The Strick family presumably hoped that the inclusion into their ancestral gallery of portraits of their noble in-laws, the Taets van Amerongens, would increase the status of their own family.

Household Inventories of Burgher Collections
On the basis of seventeenth-century household inventories, it has been possible to form an idea of the patterns of painting ownership of the Utrecht aristocracy. Unlike these holdings, some of which have been preserved, collections of the burgher class have largely been dispersed over time. This was the case of the painting collection of the Martens family (later Martens van Sevenhoven), with the exception of the portraits. In 1972, after the death of the last descendant of the family, the portraits entered the collection of the Centraal Museum in Utrecht.[72]

The Utrecht patrician Karel Martens (1602–1649) descended from a wealthy family, originally from Antwerp. At the end of the sixteenth century, to escape religious persecution, his family went into exile in Amsterdam and settled a few years later in Utrecht. In 1628 Karel Martens inscribed himself as a lawyer in the court of Utrecht, and in successive years he filled the posts of tax collector and pensionary in the service of the States. From 1622 to 1648 Martens kept an account book, which in addition to expenses also recorded information on all sorts of business, including the financial fortunes of the family.[73] He was not only a strict Calvinist but also a passionate art collector. Along with works by Rembrandt, his collection comprised paintings by such Utrecht artists as Ambrosius Bosschaert, Joost Cornelisz. Droochsloot, Gillis Claesz. de Hondecoeter, Jacob Duck, and Joachim Wtewael. His *Album amicorum*, which like his account book has been preserved, contains edifying sentences by preachers and the signatures of Frederik Hendrik and his wife, Amalia van

Solms, as well as drawings by a number of Utrecht artists.[74] It appears that after Martens's death, his widow, Jacoba Lampsins, who like her husband came from a very wealthy family, also invested heavily in art. In 1657 she bought a house on the Nieuwegracht (No. 6) and had the *achtersalet* (back room) decorated in an imposing manner by the prominent artist Ferdinand Bol. In 1892 the various works were offered to the government by the current owner of the building. It was discovered that there was also a painting of Venus and Adonis and an overmantel by Droochsloot. The *Venus and Adonis* was attributed on the basis of the signature to Jan van Bijlert and accordingly given to the Centraal Museum.[75] In 1663 Jacob Martens, the eldest son of Karel and Jacoba, married the rich Utrecht regent's daugher Aletta Pater. She had an important collection of paintings, which included many by her grandfather, Joachim Wtewael, acquired through a bequest from her uncle, Peter Wtewael. Because he died unmarried, his estate was inherited by the two daughters of his deceased sister Antonetta, Aletta and Hillegonda Pater. Between 1661 and 1663 the sisters had two monumental houses built on the Janskerkhof, next door to the houses of Willem Vincent van Wyttenhorst.[76] Aletta had herself portrayed by Cornelis Janson van Ceulen, and the painting, which was completed in 1662, was placed in the large hall of the new house.[77] An inventory drawn up by Jacob Martens in 1669 reveals that, in addition to the twenty-five paintings by Joachim Wtewael and four copies after the latter's work, the family also possessed works by Willarts, Hondecoeter, and Droochsloot.[78]

Works by the last painter were also found in the inventory of the widow of Hendrik van Sijpestein. This collection of thirty paintings was publicly sold in 1657. Among the auctioned canvases were works by Abraham Bloemaert, Roelandt Saverij, and Adam Willarts.[79] Collecting ran in the Sijpestein blood. In 1693 Johan Süpestein had more than one hundred paintings hanging in

his house, of which a remarkable number were genre pieces and very few portraits. The collection included a Hieronymus Bosch, several works by Bruegel, and a portrait of Philip II that hung in the kitchen. The walls of the *salet* (main hall) must have been covered with paintings. Utrecht masters were included as well: a *Naked Old Man* by Joachim Wtewael, a *Musician* and a *Singer* by Paulus Moreelse, a *Shepherdess* by Honthorst, and a *Landscape with a Foal* by Herman Saftleven.[80] The collection of Anthoni de Goyer, canon of the cathedral chapter and tax collector of the States of Utrecht, was less important. He died in 1668 and was buried in the cathedral. An inventory was made of the goods that went to his son, the canon Anthoni de Goyer. In the collection were a *Peasant Kermesse* by Droochsloot, "een stuck schilderije" (a piece of painting) by Weenix, and some paintings by Willarts. Also listed were twenty anonymous works.[81]

Conclusion

Insight into the local demand for paintings is indispensable for an understanding of the success of the Utrecht school in the Golden Age. To obtain such a view, an effort was made to shed light on the circle of wealthy patrons, buyers, and collectors in aristocratic and non-aristocratic milieus, who showed an interest in Utrecht painters. On the basis of existing collections and seventeenth-century inventories, we could form an idea of the painting collections in the city of Utrecht and its environs. Unfortunately, most of the paintings in the inventories were listed with only very summary descriptions, and often without the name of the maker. It is striking that the works of the most well known masters, such as Ter Brugghen, Honthorst, Baburen, and Moreelse, are rarely encountered, although their work is well represented in collections that exist to this day. One could blame this on the nature of the inventories researched, but the fact that these painters were in great demand outside Utrecht must have been an important factor as well. That the works of these painters are well represented in the collections not only of Stadholder Frederik Hendrik and the Winter King and Queen but also of foreign princes illustrates this point. Further historical research of patrons, buyers, and their mutual relationships will lead to a better understanding of the context within which painting flourished in Utrecht.

Artists at Work: Their Lives and Livelihood

MARTEN JAN BOK

For Carol Togneri

The summer of 1620 was a time of tension in the Low Countries. The Twelve Year Truce would come to an end on 10 April 1621, and in the Northern Netherlands preparations had to be made for the resumption of hostilities with Spain. Germany was in turmoil as well. The election of Frederick V, Elector Palatine, leader of the Protestant anti-Hapsburg league in Germany, as king of Bohemia sparked off the Thirty Years War, the greatest and most complex European war of the early modern era. The Spanish government in the Southern Netherlands, in aid of the German emperor and the Catholic states, was trying to gain control of the Rhineland in order to sever the links between its Dutch enemies and the German Protestant forces.

The Dutch standing army, which numbered 30,000 men at the beginning of 1620, was increased to 55,000 in the following year.[1] In addition, every city had its own company of militiamen, which it could bring into the field to defend the borders. Moreover, the Republic supported the mercenary armies of German princes like Duke Christian of Braunschweig (fig. 1) and Count Ernest of Mansfeld.[2] Utrecht diaries of this period speak of continuous troop movements.[3]

To those concerned with the Utrecht art market, which had experienced unprecedented growth during the twelve years of the truce, it probably seemed as though the years of plenty were drawing to a close. After all, had not Karel van Mander, in his *Schilder-boeck* published in 1604, characterized Mars, the god of war, as "that great despoiler of the arts"?[4] Resumption of the war could lead to a collapse of the art market.

On 26 July 1620, amid all these preparations, the Utrecht humanist and art lover Aernt van Buchel (Arnoldus Buchelius) recorded in his diary that he had attended a homecoming party for the young but already successful painter Gerard van Honthorst, and a companion of his.[5] Honthorst had spent several years in Rome and had made a name for himself as a specialist of nocturnal scenes in the style of Caravaggio, which had earned him the nickname "Gherardo delle Notti" (Gerard of the Night). The journey to and from Italy, undertaken by at least half the Utrecht painters of Honthorst's generation, led either through France or along the banks of the Rhine through Germany, and over the Alps.[6] Apparently Honthorst had hoped to arrive home before hostilities broke out and traveling became too dangerous. As it turned out, he was just in time. Exactly one week later, the stadholder, Prince Maurits of Orange, arrived in Utrecht, where he was welcomed by eight companies of militiamen, newly restructured, and the entire garrison comprising sixteen companies

(usually numbering 100 to 150 men each).[7] The next day he marched on to Arnhem, taking with him ten companies of experienced soldiers, who then joined an army of one hundred fifty companies of infantry and thirty companies of cavalry. Their destination was Germany, where the Dutch intended to attack the Spanish army in the Rhineland; the result was a fruitless campaign to save the Palatinate from Austrian and Spanish occupation.[8]

The welcoming party for Gerard van Honthorst took place at an inn called 't Poortgen (The Little Gate), situated on the Ganzenmarkt, in the immediate vicinity of the town hall.[9] The men who gathered there represented the *crème de la crème* of the Utrecht art world: the painters Paulus Moreelse and Abraham Bloemaert, the engraver Crispijn van de Passe, the art dealer Herman van Vollenhoven, the goldsmith Adam van Vianen and his brother Gÿsbrecht van Vianen, former governor of the Moluccas in the East Indies and an early collector of Chinese porcelain, and the brothers Jan and Robrecht Colijn de Nole, sculptors of Utrecht origin who had come from Antwerp to welcome home their Utrecht nephew, Jacob Willemsz. Colijn de Nole, Honthorst's traveling companion.[10] The men praised Honthorst's work and went on to discuss the success of Rubens, which they decided was due primarily to Vorsterman's engravings after his work. They did acknowledge the quality of Rubens's art and his talent, however, although they also maintained that he owed his success more to good fortune than to diligence. Besides, Vorsterman's engravings cost much more than they were worth.[11] Surely, these Utrecht men knew their own worth and did not feel threatened by competition from the likes of Rubens.

Seen from a religious and political perspective, the party was a mixed bunch. Honthorst was a Catholic. Van Buchel was a Catholic who had converted to Calvinism. Moreelse had recently taken part in Maurits's coup d'état and had joined

Fig. 1 Paulus Moreelse, *Portrait of Duke Christian of Braunschweig (1599–1622)*, 1619. Oil on canvas, 126.3 × 87.7 cm (49¾ × 34½ in.). Herzog Anton Ulrich-Museum, Braunschweig, 649.

the Calvinist congregation and been rewarded with a seat on the city council. Bloemaert was a devout Catholic who had worked on the decoration of the cathedral in 's-Hertogenbosch, later painting altarpieces for the Jesuit churches in Brussels and 's-Hertogenbosch. After the coup he had been replaced by Moreelse as dean of the Utrecht Painters' Guild. Van de Passe was a Mennonite. Van Vollenhoven's affiliation is unknown. The Van Vianens and the Colijn de Noles were probably Catholics. The fact that at this particularly tense moment in Utrecht history the Remonstrants were holding secret meetings in the fields around Utrecht, that Remonstrant and Catholic gatherings within the city were being disrupted, that the Lutherans' attempts to build a church were being blocked even though Duke Christian of

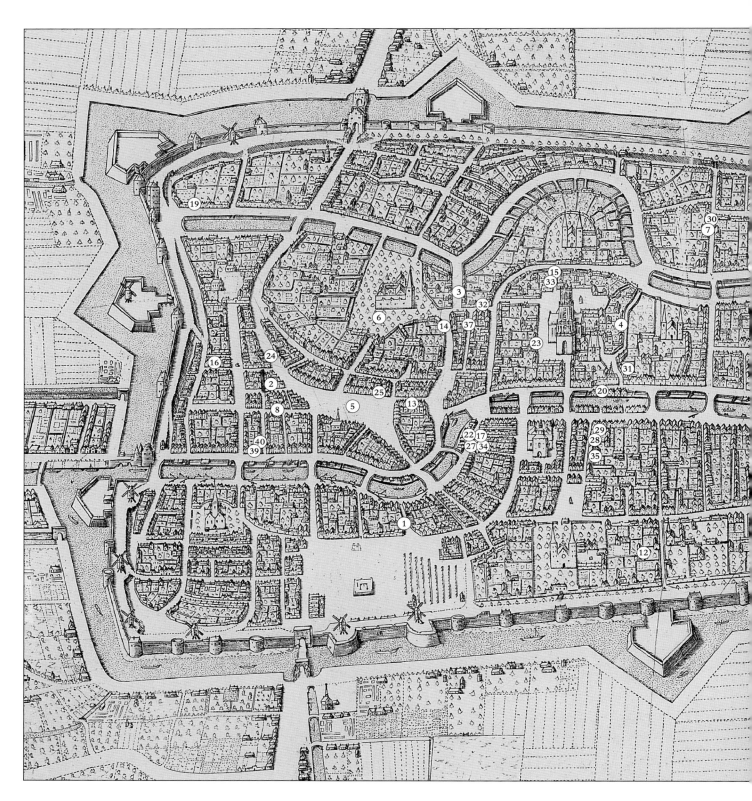

Adam van Vianen, map of Utrecht, detail, 1598. Engraving, 205 ×
490 mm (8⅛ × 19⅜ in.), without margins, on nineteenth-century
paper, printed from the original plate. Utrecht Municipal
Archives, TA.Ab.57.

This map shows the location of the addresses of all Utrecht
painters in this exhibition. Van Vianen's map is not accurate
enough to allow for the exact indication of each individual house.
In cases where only the name of the street on which the artist
lived is known, the middle of that street is indicated. Modern
street names are given in parentheses.

Balthasar van der Ast
 1. Drieharingsteeg: ca. 1620–29
 2. Lage Jacobijnenstraat (Predikherenstraat): 1629–32

Dirck van Baburen
 3. Jansdam: 1621–24

Jan van Bijlert
 4. Oudmunster Trans (Trans): 1627
 5. Neude: 1629
 6. Janskerkhof: 1629–30

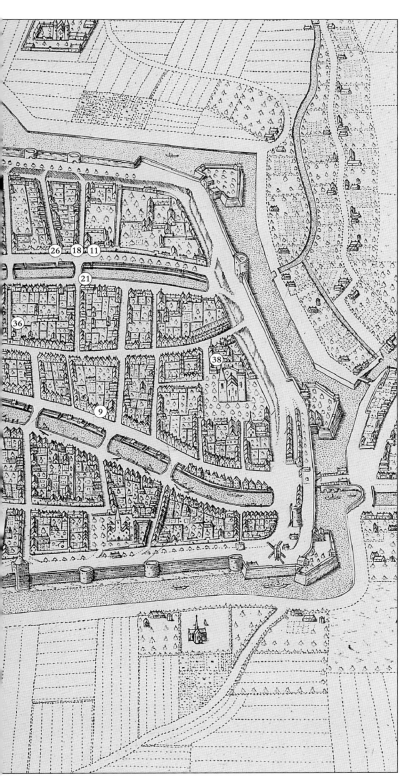

Jan Both
 13. Schoutensteeg: 1642–52

Jan Gerritsz. van Bronchorst
 14. Minrebroederstraat: 1627–45
 15. Domkerkhof (Domplein): 1645–61

Hendrick ter Brugghen
 16. Korte Lauwerstraat: 1616–25
 17. Snippevlucht (Oudegracht): 1626–29

Joost Cornelisz. Droochsloot
 18. Nieuwegracht: 1620–24
 19. Plompetorengracht: 1624–66

Jacob Duck
 20. Donkere Gaard: 1643–48
 21. Nieuwegracht: 1648–67

Gerard van Honthorst
 22. Snippevlucht: 1625
 23. Domkerkhof (Domplein): 1627–56

Nicolaus Knupfer
 24. Voorstraat: 1643–46
 25. Neude: 1646–55

Diderick van der Lisse
 26. Nieuwegracht: 1626
 27. Snippevlucht: 1640–42

Johannes Moreelse
 28. Boterstraat: to 1634

Paulus Moreelse
 29. Boterstraat: 1605–38

Cornelis van Poelenburch
 30. Winssensteeg (Herenstraat): 1631–37
 31. Oudmunsterkerkhof (Wed): 1642–67

Cornelis Saftleven
 address unknown

Herman Saftleven the Younger
 32. Korte Jansstraat: 1633
 33. Pieterskerkhof: 1636–85

Roelandt Saverij
 34. Snippevlucht: 1618–29
 35. Boterstraat: 1621–39

Jan Baptist Weenix
 36. Zuilenstraat: 1655

Adam Willarts
 37. Vuilsteeg (Annastraat): 1612–54
 38. Agnietenconvent: 1654–64

Joachim Wtewael
 39. Oudegracht: 1596–1638

Peter Wtewael
 40. Oudegracht: 1638–64

 7. Winssensteeg (Herenstraat): 1633–41
 8. Loeff Berchmakerstraat: 1650–ca. 1658
 9. Oudegracht: 1660–71

Abraham Bloemaert
 10. Nieuwegracht: 1593
 11. Nieuwegracht: 1597–1617
 12. Mariakerkhof (Mariaplaats): 1617–51

Ambrosius Bosschaert
 address unknown

Braunschweig had already laid the foundation stone—all this did not prevent these art lovers from gathering together and discussing the success of Rubens.[12]

That Utrecht artists spoke of Rubens's fame as the result of successful marketing reflects an important aspect of their own perception of what was important in their profession. They knew that talent was essential to an artist's success, but that diligence and active marketing were also prerequisites. Of those present on that day in July 1620, Bloemaert, Moreelse, Van de Passe, and Adam van Vianen, all born in the 1560s, had laid the foundation on which the arts in Utrecht had continued to expand since the turn of the century, enabling their pupils to contribute to its further blossoming in the years to come. Gerard van Honthorst, Bloemaert's most successful pupil to date, soon began to play a crucial role in turning painting in Utrecht into an export industry, allowing it to compete even with Rubens's workshop in Antwerp. Before the new decade came to an end, Van Vollenhoven, one of Utrecht's first international art dealers, had begun to export paintings to the East Indies.[13] To understand how these men succeeded in turning Utrecht into one of the leading artistic centers of the Low Countries, we need to go back to the adolescent years of the founding fathers.

After the Iconoclasm

Utrecht experienced its last outbreak of the "iconoclastic fury" in the summer of 1580,[14] and in the same year public worship of the Catholic faith was forbidden. As everywhere else in the Low Countries, this brought about a fundamental change in the way artists perceived their role in society. Not only had they witnessed the iconoclasts destroying many of the most important works of their illustrious predecessors, but they had also been forced to accept that Catholic religious institutions, as far as they had survived the Reformation, were not going to replace these lost artworks in the near future, nor were they going to commis-

sion new ones. At the same time, the older generation of Utrecht artists was dying off. In that sense, the death of Anthonis van Blocklandt van Montfoort (1532/33–1583)—the last great Utrecht artist of the sixteenth century and standard bearer of the tradition of Jan Gossaert van Mabuse, Jan van Scorel, and Anthony Mor van Dashorst—meant the end of an era. The Catholic Church would no longer be the main engine of the Utrecht art market. When, a few decades later, the Catholic Church started to reconstruct its religious infrastructure, commissions for Utrecht artists, though not unsubstantial, were on a much more modest scale than they had been in the sixteenth century.

In the years to come, Utrecht artists would have to depend much more on private patrons. At first, however, political and economic conditions after 1580 looked grim indeed. The United Provinces were struggling for survival and the fine arts were not the average burgher's first priority. Of Utrecht painting dating from the 1580s, we know only a few portraits, most of them anonymous, presumably reflecting a serious decline in production rather than a lack of research by modern art historians.[15] All in all, few could have foreseen that, within the span of one lifetime, the Utrecht school of painting would make the city "world famous," to quote Joachim von Sandrart, one of its early chroniclers.[16]

This revival of the Utrecht art market is a multifaceted historical phenomenon, and the relative importance of each constituent part is not easy to establish. It was founded to a large extent on the considerable rate of economic growth experienced by the Dutch Republic since the 1580s.[17] The amassing of impressive fortunes by the merchant elite, as well as the general rise in purchasing power, especially after 1600, created an unprecedented demand for works of art.[18] The influx, after the fall of Antwerp to the Spaniards in 1585, of a cultured and wealthy merchant elite from the Southern Netherlands also contributed substantially to the growth of the art market.

Utrecht certainly received its fair share of this economic resurgence. Yet the fact that the Utrecht school of painting eventually became so influential in the first half of the seventeenth century is also due to a happy combination of local circumstances and historical chance, the latter always being the most difficult variable in the historian's formula.

The local elite of the city, living partly off the ecclesiastical goods previously owned by the clergy, constituted a solid home market for Utrecht artists. Compared with many other cities, Utrecht had a large population, as well as a large and prosperous "hinterland," most of which was a cultural desert because artists did not live in the countryside. These factors must have helped to restore the number of painters active in the city to the level necessary to induce artistic competition within the local artists' community. Owing to this "critical mass"—a term introduced by the economist Michael Montias—Utrecht was able to develop a school of painting with its own artistic character and stylistic dynamism.[19] This school drew on the age-old local tradition of history painting, which had always provided the Catholic Church with altarpieces and other works of devotional art. After all, the skills needed to draw the human body and to arrange figures in a convincing composition did not have to be reinvented. And finally, there was an element of chance, or rather the blessing of Fortuna, as it would have been perceived in those days: the fortuitous presence in Utrecht of a small group of talented artists born at the time of the outbreak of the Dutch Revolt.

Four Utrecht artists played a decisive role in making Utrecht a leading cultural center: the painters Abraham Bloemaert, Joachim Wtewael, and Paulus Moreelse, and the goldsmith Adam van Vianen (1568/69–1627). As youngsters they had witnessed profound religious and political changes in Dutch society; moreover, they were the last to have been trained by masters of the previous generation. Moreelse had been a pupil of Anthonis van Blocklandt van Montfoort, and Bloemaert and

Wtewael had both been pupils of the enigmatic Joost de Beer, who died in Utrecht in 1591.[20] As such, they were a living link with the Utrecht school as it was before the Reformation.

As adolescents these three painters traveled to France and Italy, where they became acquainted with the newest international developments in the arts. When they returned to their native Utrecht in the early 1590s, they combined their skills to further their artistic careers. Thanks to favorable economic conditions they were able to achieve their goal of becoming innovative and influential artists. Adam van Vianen, one of the most creative Dutch goldsmiths of his time, would become Utrecht's link with the mannerist artists in Prague after his brother, Paulus van Vianen, was appointed goldsmith to Emperor Rudolf II in 1603. Just as Utrecht painters had done, Paulus van Vianen had traveled extensively during the 1590s in France, Germany, and probably Italy.

The Guild

Since the Middle Ages the Utrecht painters and sculptors had belonged to the Saddlers' Guild,[21] which originally comprised all the artisans who contributed to making a knight's armor.[22] The Dutch word for painter (*schilder*) still refers to the shields made by these artisans. Having long represented the largest and most prosperous trade within the guild, the painters were used to playing first fiddle. In 1569 the artists (painters and sculptors) constituted almost half the guild's membership, which was eighty-five men strong.[23] This number had undoubtedly dropped since then, but from the early 1590s onward the artists began to reclaim their former position.

The new generation of artists failed at first to penetrate the administration of the guild. Abraham Bloemaert, at that time twenty-seven years old, was appointed dean of the Saddlers' Guild only once, in 1594.[24] He was not reappointed the next year. Even if the younger generation had harbored a plan to make the arts independent from

Fig. 2 Two pages from the first membership roll of the Utrecht Painters' Guild, 1611. Utrecht Municipal Archives, Bewaarde Archieven I, 141.

the more humble crafts in the guild, they would have found that political circumstances blocked such a move. Although the town council did allow the goldsmiths in 1598 to found their own guild, independent of the blacksmiths, the artists were forced to wait until after the beginning of the Twelve Year Truce. In the meantime, the saddlers and the painters of the previous generation kept a tight grip on the reins of the guild's administration.

In 1611 Paulus Moreelse was appointed dean of the guild, becoming the first artist of the new generation to hold the post since Abraham Bloemaert's short-lived administration of 1594. During Moreelse's tenure, the painters and sculptors requested permission from the town council to form their own guild. The initiative was undoubtedly taken by Moreelse himself, supported by Joachim Wtewael, Adam Willarts, and a few others. The new Painters' Guild, also called the

Guild of St. Luke, was granted its charter on 13 September 1611. Moreelse and the other dean serving with him drew up a list of all forty-four members, which included nineteen painters (meaning artists), twelve decorator painters (meaning *Kleerschrijvers*, who painted linen wall hangings), thirteen sculptors, and thirty-three apprentices, of whom thirteen were apprenticed to painters and nine to sculptors (fig. 2). The list was headed by Peter van Sijpenesse (1530–1621), the eldest son of Jan van Scorel and a living symbol of the continuity of the Utrecht artistic tradition.[25]

The new guild soon proved to be a success. In the first decade of its existence the guild doubled in membership. The new members included both homegrown talent and newly arrived immigrants. The immigrants came from the Northern and Southern Netherlands, as well as from Germany (Knupfer). By 1628 even an Italian artist—Lasar Barata—was working in Utrecht.[26]

Lack of source material makes it difficult to trace the growth in the number of artists after 1620 except in the broadest terms. Their numbers continued to grow until sometime in the 1640s,

quickly reaching a point of stagnation after 1650. In their heyday the masters active in Utrecht are estimated to have numbered between fifty and sixty. They probably produced several thousand pictures a year, making the "business" of painting a true branch of Utrecht industry in the first half of the seventeenth century, although its precise value in terms of economic importance for the city can only be guessed at. The painters and other professionals dependent on them—lead-white makers, paint sellers, panel makers, frame makers, art dealers—never made up more than a small percentage of the total professional population. But the high "added value" of their product, as well as the money brought home from sales in other Dutch cities and even abroad, meant that the painters' contribution to the city's economic prosperity was not insignificant.

The reasons mentioned thus far for the successful development of the Utrecht art market are all factors that individuals have little power to influence: the growth of purchasing power, the immigration of a cultivated elite from elsewhere in the Republic, the will of local authorities to permit painters to form their own guild, and the coincidence of a group of talented artists being in the same place at the same time. Nevertheless, we learned from Van Buchel's description of Honthorst's welcome-home party that the Utrecht painters also thought and behaved like businessmen. When discussing Rubens they commented on his marketing strategy and noted the exaggerated prices asked by Vorsterman for his engravings after Rubens. If we look at the Utrecht school of painting as a branch of the city's industry, it is easy to discern the concerted efforts of a group of individuals with a common interest, of which the founding of their own guild was just the beginning. In the years following, the Utrecht artists built up the infrastructure that made possible the further flowering of their local school of painting. In this context, I shall now devote some attention to the training of artists, the importance of repro-

ductive printmaking after their works, collaborative projects, and the art market.

Training

During the first half of the seventeenth century, Utrecht assumed a special role in the Dutch Republic as a center for training artists. More than anyone else, Abraham Bloemaert played an extremely important part as the teacher of young painters.[27] He had dozens of pupils, perhaps even more than a hundred during the course of his long career. Paulus Moreelse and Gerard van Honthorst also had large numbers of pupils, whereas other masters, such as Adam Willarts and Joost Cornelisz. Droochsloot, were active mainly as drawing teachers.[28] Such masters would have been able to make a good living from teaching alone, though they obviously made the bulk of their income from selling works of art. In the mid-1620s Gerard van Honthorst was charging his painting pupils one hundred guilders a year, making him one of the most expensive masters in the Dutch Republic. Some years later Rembrandt van Rijn and Gerard Dou were also asking the same amount. Some masters charged less—Jan van Bijlert (84 guilders), Abraham Bloemaert (72 guilders), and Nicolaus Knupfer (72 guilders)—but were well-paid teachers nevertheless.

In addition to individual training, it was also possible in Utrecht to attend classes at a drawing academy, which for a long time had no real counterpart in the Northern Netherlands. Soon after the founding of the guild, plans were made to set up this drawing school, which probably opened its doors for the first time in 1612.[29] It was given the name *academie*, after the example of the Italian *accademia*. Full-fledged painters as well as pupils were admitted, on payment of a fee, and received lessons in drawing, in particular, drawing from a live model.[30]

Whether Utrecht's drawing academy had a fixed venue is not known, but thanks to a print by Crispijn van de Passe the Younger (1594/95–1670),

Fig. 3 Crispijn van de Passe the Younger, *A Drawing School.* Engraving. From *Van 't Licht der teken en schilderkonst* (Amsterdam, 1643).

Fig. 4 Crispijn van de Passe the Younger, frontispiece of *Van 't Licht der teken en schilderkonst* (Amsterdam, 1643).

we nonetheless have an idea of how these drawing sessions were conducted (fig. 3). Abraham Bloemaert and Paulus Moreelse are portrayed here as masters instructing a group of young artists, who are shown drawing from a live model in a room illuminated by a large lamp. The room depicted was probably imaginary, but because the two teachers were indeed real, we may assume that Van de Passe hereby wished to convey the prominent role played by these artists in the academy. Both men appear again in the foreground of a print used on the title page of a large instruction book of drawing, published by Crispijn van de Passe in 1643 under the title *Van 't Licht der teken en schilderkonst* (fig. 4).[31] Here we see the goddess Minerva as protectress of the fine arts, surrounded by Utrecht's most important masters and several of their pupils. The men portrayed, from left to right, are Bloemaert, Honthorst, two unknown persons, Jan van Bronchorst,

Roelandt Saverij, Joachim Wtewael, and Moreelse. These would have been the "distinguished masters," who, in Van de Passe's own words, conducted Utrecht's "renowned drawing school."[32] Van de Passe's drawing book reflects in print the achievements of the Utrecht drawing academy, in the same way that the posthumously published *Tekenboek* by Abraham Bloemaert does.[33] As if meant to complete the record of the achievements of Utrecht artistic training, the designs made by the goldsmiths Adam and Paulus van Vianen were also published around the same time.[34]

Reproductive Printmaking

Before the Guild of St. Luke was founded, Utrecht had no important engraver and publisher of prints living within the town walls.[35] Utrecht artists who wanted to have their works reproduced in prints had to go to engravers in Haarlem (Jan Saenredam and Jacob Matham, for example), Amsterdam (Jan Muller), and Leiden (Willem van Swanenburg). When the engraver Crispijn van de Passe the Elder (1564–1637) was banished from his residence in Cologne in the summer of 1611 because of his Mennonite faith, Utrecht must have seemed to

him an attractive place of refuge. He had long been a friend of the humanist and art lover Aernt van Buchel, who, after Van de Passe's move to Utrecht in 1611, began to write the Latin inscriptions for Van de Passe's prints on a regular basis.[36] By the spring of 1612 Van Buchel had already written to a humanist friend in Paris that "the famous" engraver Van de Passe had settled in Utrecht and had become friendly with Bloemaert and other artists.[37]

The establishment of Van de Passe's firm in Utrecht must have provided an important stimulus to the local artistic community, if only for the reason that Van de Passe would have provided Utrecht artists with prints after the designs of famous foreign artists, in addition to selling his own publications. Especially during the second decade of the seventeenth century, Van de Passe and his sons (mention has already been made of Crispijn van de Passe the Younger) made many engravings after designs by Utrecht artists, thus contributing to their renown in the Dutch Republic, as well as beyond its borders. In Utrecht, however, there was never such close collaboration as that previously enjoyed in Haarlem by the painter Cornelis Cornelisz. van Haarlem and the engraver Hendrick Goltzius. The Van de Passes were primarily publishers of their own prints and illustrated books; they never had a monopoly on prints made after works by Utrecht artists. Between 1611 and 1620 nearly all Abraham Bloemaert's designs were engraved in Amsterdam by Boetius à Bolswert,[38] and after about 1620 this task was assumed by his eldest son, Cornelis Bloemaert, and later still by another son, Frederick Bloemaert.

In short, it is certain that, especially during the first twenty-five years after the founding of the Guild of St. Luke, the Utrecht art world profited considerably from the presence of engravers and print publishers who, unfortunately, had no real successors. The very talented engraver Hendrick Goudt was able to produce little or nothing, owing to serious mental problems, and

Jan Gerritsz. van Bronchorst decided to specialize as a painter and glass painter. The phenomenon of the so-called *peintre-graveur* who reproduced his own work in engravings and etchings never played an important role in Utrecht. Ultimately, the major print publishers were all based in Amsterdam.

Collaborative Projects
Another important aspect of the business-like behavior displayed by Utrecht artists during the first half of the seventeenth century is the frequent collaboration they engaged in.[39] This practice should not be mistaken for the usual contributions made by apprentices and assistants to the work of their masters.[40] Collaboration, as discussed here, meant full-fledged masters pooling their skills to produce a work of art. This took place in one of two ways: They produced a series of artworks, with each artist painting one or more pictures independently; or they worked together on one painting, the contribution of each depending on his specialty (landscape, figures, still life, architecture, and so on). Division of labor according to this second method experienced a great blossoming in the Southern Netherlands in the second half of the sixteenth century. The rise of independent genres in painting, accompanied by the increasing tendency among artists to specialize, led to more and more collaboration. Rubens, for example, regularly collaborated with artists who specialized in painting landscapes, still lifes, and animals.[41]

Not until 1602 can this second form of collaboration be demonstrated to have occurred in Utrecht, when Adam Willarts and Salomon Vredeman de Vries received a joint commission to paint the shutters of the organ in the cathedral.[42] Willarts would have been responsible for painting the figures and the landscape, and Vredeman de Vries, who came from a family of architectural painters, the architecture.

Of greater importance initially was the collaboration of several Utrecht artists on

iconographically related series of paintings, the first demonstrable instances of which occurred about 1620. The best-known example is a famous series of twelve portraits of Roman emperors, probably commissioned by the stadholder, Prince Frederik Hendrik.[43] In this project, carried out between about 1616 and 1625, the Utrecht artists Hendrick ter Brugghen, Paulus Moreelse, Gerard van Honthorst, Dirck van Baburen, and Abraham Bloemaert all found themselves in the good company of Rubens, Cornelis Cornelisz. van Haarlem, Werner van den Valckert, Gerard Seghers, Abraham Janssens, Hendrick Goltzius, and Michiel Jansz. van Mierevelt. The initiative for this series was probably taken by the patron, which would explain why it took such a long time to complete (see cat. 28, Baburen's *Emperor Titus*). The instigator is not clear in the case of a series of the Five Senses, which was given as the first prize in an archery competition held in Delft in 1631.[44] This series—executed by Honthorst, Bloemaert, Paulus Moreelse, Bijlert, and Ter Brugghen—might have been the result of the artists' own initiative. In any case, it dates from before the death of Ter Brugghen in November 1629.

In 1630 Gerard van Honthorst received a commission from Lord Dorchester for eight paintings. Thanks to the correspondence that has been preserved, we have accurate details on how the commission was carried out.[45] After consulting the English ambassador Sir Dudley Carleton, Honthorst chose to depict themes from the *Odyssey* and sought the help of the best painters in Utrecht.[46] He promised Lord Dorchester that he would paint two of the pictures himself and that the other painters would work "per mio gusto" (according to my taste). Moreover, he guaranteed that the quality of the work would be exceptionally high, owing to his personal supervision and to competition among the artists themselves.[47] The whole series would cost 1,600 guilders. Gerard van Honthorst, therefore, was acting as the leader of a consortium of artists. We find this form of

collaboration a number of times in the 1630s, culminating in the project to decorate Kronborg Castle near Copenhagen with scenes taken from the history of Denmark.[48] This project, commissioned by King Christian IV, was coordinated by the Utrecht engraver Simon van de Passe (son of Crispijn van de Passe the Elder), who had been active in Denmark since 1624.[49] Unfortunately, most of this series has been lost. The drawings and paintings that have been preserved enable us to make only a partial reconstruction of the original ensemble, if indeed it was ever completed. The following Utrecht painters are known to have worked on the Kronborg series: Gerard van Honthorst, Nicolaus Knupfer, Jan van Bijlert, Abraham Bloemaert, Adam Willarts, and Simon Petrus Tilman. Here again, Honthorst was the leader of the group. His contract alone amounted to 37,500 guilders for a total of thirty-five paintings. Tilman negotiated 5,000 guilders for ten paintings.[50]

The second form of collaboration, in which specialists in various genres worked in continually varying combinations to produce paintings together, also occurred frequently in the Netherlands. In a study dating from 1905, the art historian Hanns Floerke discerned more than 350 pairs of collaborating artists.[51] Many of these involve Utrecht painters, but so far only the collaborative projects undertaken by Nicolaus Knupfer with other masters have received the attention of scholars.[52] He appears to have worked not only in twos, but also in threes (with Jan Both and Jan Baptist Weenix). Four artists working together was possible as well: in 1644 the collector Willem Vincent van Wyttenhorst bought a portrait of himself, done by Jacob Duck, Cornelis van Poelenburch, and Bartholomeus van der Helst, in which Both did the landscape in the background.[53] The frequent occurrence of this form of collaboration, increasingly recorded in Utrecht starting in the 1630s, confirms the economic advantages it must have had. Collectors apparently found it at-

tractive as well. The many examples cited above of intensive collaboration between Utrecht artists demonstrate the business-like way in which artists practiced their profession in the mid–seventeenth century.

Art Dealers

Another aspect of Utrecht's artistic infrastructure concerns the way in which art was marketed.[54] Besides the practice of selling pictures directly from their own workshops, it was an age-old custom among Utrecht artists to sell their paintings at the annual fair, at which everyone was free to offer paintings for sale, unbound by guild regulations. At the end of the sixteenth century we first encounter a professional dealer in paintings in Utrecht documents, and from 1611 onward art dealers are found among the members of the Guild of St. Luke. Presumably these art dealers were responsible for coordinating supply and demand between the Utrecht art market and that in other towns in the Dutch Republic,[55] although they undoubtedly played a role in the international art trade as well. In a large shipment of paintings that the Amsterdam merchant Theodorus Rodenburg tried to sell to the Danish king, Christian IV, as early as 1621, we find the work of various Utrecht artists, such as Abraham Bloemaert, Balthasar van der Ast, and Hendrick ter Brugghen.[56] At about this same time, the Utrecht art dealer Herman van Vollenhoven apparently sold Italian paintings to clients in Antwerp, and in 1628 he exported twelve paintings to the East Indies.[57]

Other ways were also open to artists to bring their paintings to the public. In the first half of the seventeenth century, paintings were regularly sold at auction by city officials called "municipal executors." Lotteries were also held in Utrecht at which one could win paintings.[58] Such lotteries were banned in 1644, but one could get around this by holding the lotteries outside the city limits, as witnessed by a lottery of paintings organized by Johannes de Bont in 1649 at Duurstede Castle

to which a great number of Utrecht painters contributed.[59]

The artists working in Utrecht also apparently took steps to sell their paintings in a more institutionalized manner by displaying them to an anonymous audience. In the 1630s, for example, no fewer than thirty-five Utrecht painters donated paintings to the regents' hall of St. Job's Hospice, which apparently functioned as the unofficial (advertising) gallery of the Painters' Guild.[60] The drawback of this scheme was that interested buyers then had to go to the artists' home or workshop to buy something similar to what they had found attractive in the display in St. Job's Hospice. About 1640 this "gallery" was replaced by an official one run by the guild itself, the initiative probably having been taken by the painters who had seceded from the Guild of St. Luke in 1639. At this time the successful "artist-painters" dissociated themselves from the less successful sculptors and woodcarvers and, in 1644, were granted a new charter by the town council. From then on they no longer formally belonged to a craftsmen's guild but to a "Painters' College." In practice, however, this college functioned like a guild, though it now had the outward appearance of being a distinguished society of practitioners of a "liberal art." The Painters' College was fortunate in that the city put at its disposal a large hall in the former Convent of St. Agnes, which it could use for assemblies and as its gallery. All the painters were supposed to have one characteristic example of their work on display (and naturally for sale) in this municipal gallery at all times, so that potential customers could gain a good impression of the kind of paintings one could buy in Utrecht. In 1664 the painters also decided to hold auctions of their work in this hall.

The Artist's Social Position

An artist's training was both lengthy and costly, with the result that only rather well-to-do parents could afford to have their sons trained as artists. This was also true of the recommended study trip

to Italy, which was undertaken by many artists as the final step in their training. Of the Utrecht artists born in the period between 1590 and 1601, for example, at least half went to Italy, some of them staying for years.[61] It was admittedly possible for a painter to support himself with his brush in Rome, but, as in the case of an artist's training, the costs of a study trip to Italy had to be paid before its advantages could be reaped. Yet the study of antiquity and Italian art was by no means the only purpose of this trip. Like members of the upper class who undertook the Grand Tour, artists who traveled did so to learn to speak foreign languages, to polish their manners, and to become acquainted with other cultures. A young artist thus learned to move in the circles in which he would eventually be seeking customers for his work.

After returning to the Netherlands, most of these artists set themselves up as independent master-painters. They hoped to corner their share of the art market, owing to either the high quality of their work or the happy choice of a marketable specialty. Many of them were not successful, and Dutch art history is full of cases of artists who laid their brushes aside and took up other professions. The painters whose work is shown in this exhibition, however, were all successful. With the exception of those who died young, they had long careers as artists and could live comfortably from the income they received from the sale of their work. Only one or two, in the course of a long life, experienced a drop in income because his work went out of fashion (Droochsloot) or because old age and frailty prevented him from working (Willarts). Several of the others died bankrupt, as a result of mental problems (Saverij) or because they found themselves in debt in times of economic depression (Duck, Herman Saftleven, Weenix). The rest, however, led comfortable lives. Artists such as Bloemaert, Honthorst, Paulus Moreelse, Poelenburch, and Joachim Wtewael, for example, became positively wealthy.

Most seventeenth-century artists did not hesitate to view their profession as both a trade and an art. They would undoubtedly be hard put to comprehend the later romantic ideal of the artist as the high priest of Pictura, living if necessary as a recluse in self-inflicted poverty. It did of course happen that some artists begrudged others their success. Samuel van Hoogstraten recounted an anecdote, for example, in which the now virtually unknown painter Adriaen Cornelisz. van Linschoten reproached the court painter Gerard van Honthorst, saying that his late work did not contain one bold stroke of the brush.[62] Honthorst replied that his brushstrokes were better than Linschoten's and that he would show him a stroke the other could not imitate. He then took a handful of ducats from his purse, strewed them over the table, and brushed them back toward himself, thereby demonstrating that he knew how to make money.

Seventeenth-century authors who wrote about the Dutch school of painting thought it natural that artistic success should lead to financial gain. Wealth and social standing were therefore considered to be visible proof of an artist's success. The most successful artists lived in Utrecht's most prestigious neighborhoods, such as those around the Domkerk and the Mariakerk, on the Nieuwegracht, or in the immediate vicinity of the town hall (see map on pp. 88–89). One or two even managed to climb to the top of the social ladder: Paulus Moreelse and Joachim and Peter Wtewael were members of Utrecht's town council; and Diderick van der Lisse became burgomaster of The Hague. Others, who could not hold public office because of their religious affiliation, played a prominent role in church life and on the boards of charitable institutions.

Decline
The Utrecht school of painting began to show signs of stagnation after the middle of the seventeenth century. A number of important masters

had died, and the work of their successors did not usually live up to the high standards set by these masters. After the deaths of Abraham Bloemaert, Nicolaus Knupfer, and Gerard van Honthorst in 1651, 1655, and 1656, Utrecht no longer had any renowned teachers who could attract young artists from elsewhere to the city. The drawing academy declined, artistic innovations failed to materialize, and the artistic center of the Northern Netherlands moved entirely to Amsterdam and other cities in Holland.

The slower rate of economic growth experienced in the Dutch Republic after the mid-1650s led to a sharp reduction in the amount of money being spent on luxury items such as paintings. This decline in the demand for artwork, however, seems to have manifested itself in Utrecht earlier than in other Dutch cities. The occupation of Utrecht by French troops in 1672 and 1673, which was accompanied by large-scale destruction and pillaging, had catastrophic consequences for the Utrecht art market.

In 1675 Joachim von Sandrart wrote that the French occupation had devastated the arts ("destroyed all the Muses") in Utrecht.[63] During the years after 1672, the sharp decline in the purchasing power of Utrecht's elite dealt the final blow to its artistic life. In 1676 the painter Adrianus van Ysselsteyn (d. Utrecht 1684) complained that "for some years now it has been impossible to earn a living as a painter."[64] A considerable number of painters left the city to settle in other Dutch cities or to go abroad. The Painters' College had its assembly hall taken away by the city council, and the artistic infrastructure that had been built in the first half of the century collapsed completely.

In Dutch historiography, the period from 1568 until the Treaty of Westphalia in 1648 is called the Eighty Years War. Of these eighty years, there were still twenty-eight to go when Gerard van Honthorst returned from Italy to Utrecht in 1620. Those present at the inn 't Poortgen could not have foreseen this. Neither could they have predicted that it would be precisely in this period that the Utrecht school of painting would nevertheless enjoy its Golden Age. This was due in part to the happy coincidence of exceptionally rapid economic development and favorable social circumstances, which produced the Golden Age of the Dutch Republic as a whole, but also in no small measure to the efforts of the Utrecht artists themselves. Theirs was an economic as well as an artistic achievement.

Reverberations: The Impact of the Italian Sojourn on Utrecht Artists

LYNN FEDERLE ORR

Of me [Jan Scorel] it will be said throughout the centuries that I was the first who through my example taught the Netherlands who excel in art to visit Rome; for he who has not used up a thousand pens and colors and painted a thousand panels in that school cannot be seen as worthy of the honorable title of right-minded artist.

—DOMENICUS LAMPSONIUS[1]

Italy (said Pliny in his third book) is a landscape holy to the gods, the happiest and best of all Europe, a nurturer of all lands, a ruler over all things, an empress of all nations, and queen of the world.

—WILHELM AND JOHANNES BLAEU[2]

Utrecht, among all the cities of the Northern Provinces, experienced the most vital and multifaceted relationship with Italy. The stunning artistic achievements that mark Utrecht's contribution to the Dutch Golden Age were predicated on the firsthand experience of Italy and, more specifically, Rome. Successive generations of Utrecht painters and printmakers ventured to the Eternal City, returning as exponents of the latest artistic fashion, be it mannerism, Caravaggism, or Dutch Italianate landscape painting. These artists brought home stylistic innovations, theoretical ideas and academic practices, and actual works of art by or after their foreign contemporaries. Popularizing the thematic and stylistic novelties of the Italian baroque, Utrecht's artists produced wonderfully imaginative and luminous images, which, whether landscape or figurative paintings, are very different in nature from those of their Dutch compatriots who had not traveled to Italy. For more than a century, direct contact with the works of modern Italian masters and the monuments of classical antiquity, coupled with exposure to Italy's benevolent climate and beautiful and varied topography, had a determining influence on the evolution of the arts in Utrecht. From there the formal and stylistic vocabulary of Italian art was disseminated to other Dutch artistic centers.[3]

Among members of the artistic community in the Northern Netherlands, the tradition of the trip to Italy was validated in contemporary attitudes toward art as revealed both in the writings of Dutch artists and connoisseurs and by the example of prominent artists, such as Hendrick Goltzius and Pieter Lastman. Nonetheless, more artists went to Italy from Utrecht than from any other city.[4] In the late sixteenth century, travelers included Joachim Wtewael and Paulus Moreelse, both of whom were

in Italy from the mid-1580s through the early 1590s. Almost all the leading artists of the next generation, whether they had trained with Abraham Bloemaert (who had not been to Italy) or with Paulus Moreelse, appeared in Rome in the early decades of the seventeenth century. The figure painters Hendrick ter Brugghen, Gerard van Honthorst, Dirck van Baburen, and Jan van Bijlert were followed by the landscapist Cornelis van Poelenburch. A second wave of Utrecht painters, many of them also landscape specialists, resided in Rome in the 1630s and 1640s, including Hendrick and Cornelis Bloemaert, Andries and Jan Both, and Jan Baptist Weenix. Importantly, the emergence of Utrecht as a thriving and creative artistic center coincided with this period of extensive travel by artists who worked there.

Many questions arise at this juncture, among them: What special ties existed between Utrecht and Italy? Why did so many Utrecht artists go to Italy? Who went? What did these artists hope to find? What did they actually find? What did they take home with them? What effect did they have on the artistic community at home? As suggested here, the answers to these questions delineate a pattern of shared experience that helped to shape the distinct character of the Utrecht school.

The tradition of making the journey to Italy was long-standing among citizens of Utrecht. A number of factors contributed to this tradition, most particularly Utrecht's strategic position among the Catholic cities of Northern Europe. Historically Utrecht had enjoyed a unique relationship with Rome. As often repeated, until the suppression of Catholicism, Utrecht had been the seat of the only archbishopric of the Roman Church in the Northern Netherlands.[5] As the administrative focal point of Catholicism in the region, the city benefited from the concentration of economic, and to a lesser degree political, power that accrued to Catholic religious institutions and the papal representatives. After the official prohibition of the public practice of Catholicism,

Catholic activities simply went underground. And through the efforts of two successive apostolic vicars, Rome's missionary efforts to reconvert the North were carried out from Utrecht; thus close ties between the city and the Church in Rome were maintained.[6]

From earliest times, Utrecht clergymen traveled to Italy. Among the first was Willibrord, who is credited with converting the Netherlands in the seventh century. On his second trip to Rome in 695, he was ordained bishop of Utrecht by Pope Sergius I in S. Cecilia in Trastevere. Willibrord's pupil and successor, Boniface, made the journey three times, in 718, 722, and 736–39. The culmination of Utrecht's influence with the Holy See proved to be the pontificate of Utrecht-born Adrian VI (Adriaen Florisz. Boeyens), elected in 1522.[7] In Rome Adrian appointed his fellow countryman the artist Jan van Scorel curator of the papal sculpture collections, a position he held until Adrian's death in 1523.[8] Over a period of 130 years, this pattern of Utrecht artists traveling to Rome and securing there support from important churchmen repeated itself over and over. Witness, among others, the success of Jan van Santen, called Giovanni Vasanzio,[9] who from 1613 until 1621 oversaw papal building projects for Paul V Borghese; Honthorst's commissions from the papal nephew Cardinal Scipione Borghese; Jan Both's work for Cardinal Antonio Barberini; and Jan Baptist Weenix's connections with the family of Pope Innocent X Pamphili.

Dutch artists were motivated to travel by the encouragement of amateurs, such as Aernt (Aernout or Arnout) van Buchel[10] and Constantijn Huygens,[11] and members of their own profession. The need to enrich oneself artistically through the experience of Italy became a leitmotif in Dutch discussions on art, most importantly in the writings of the painter, historian, and theorist Karel van Mander. Having lived in Rome from 1574 until 1577, Van Mander's own approach to art history and theory had been formed in response

to the Italian tradition, including the aesthetics of Giorgio Vasari and Leon Battista Alberti. Van Mander's *Schilder-boeck* (Haarlem, 1604) incorporates a variety of Italian historical and theoretical material. The third section includes a revised and abridged version of Vasari's *Lives of the Most Famous Italian Architects, Painters, and Sculptors* (1550 and 1568). In the following section, Van Mander imposed Vasari's methodology on a body of information about Northern artists of the fifteenth through late sixteenth century.[12] Van Mander's biography of Van Scorel repeats Lampsonius's praise of the artist for having enriched his native school of art through his own experiences, being the first to bring back to the North the vocabulary of Italian art and the selective canon of the ancients.[13] Believing that Rome, as the capital of painting, had much to teach the Northern artist, Van Mander simultaneously encouraged and cautioned his audience:

> I would strongly urge you to travel,
> had I not the fear that you would go astray,
> for Rome is the city, which above all places,
> could make an artist's journey fruitful,
> being the capital of the schools of Pictura,
> but also the one place where spendthrifts
> and prodigal sons squander their possessions;
> Be reluctant to permit a youth to make
> the journey.[14]

A suggestion of the exciting artistic innovations taking shape in Rome might also have prompted artists to make the journey to Italy. At home in the Dutch Republic, artists could have gotten a taste of Rome's artistic climate, as news of several important artists working in Rome had reached the Netherlands, by either reputation or actual works of art. Scores of prints helped to circulate compositions by the great Italian masters of the sixteenth and early seventeenth centuries, including works by the Carracci, who were prolific printmakers.[15] Almost no prints existed after paintings by Caravaggio,[16] the artist whose works

would have the most powerful effect on the Utrecht figure painters. However, Van Mander had singled him out as "doing extraordinary things in Rome."[17] Caravaggio's pictures, however, did begin to appear in the North very early in the century. For example, Henri II, duke of Lorraine, who reigned from 1608 until 1624, gave Caravaggio's *Annunciation* to the primatial church in Nancy,[18] where the painting could have been seen by artists traveling through Lorraine on their way south. Interestingly, there is no evidence of any paintings by Caravaggio or his Italian followers in Utrecht itself at such an early date. However, by 1617 a number of paintings by or after Caravaggio were brought to Amsterdam from Antwerp by the Flemish Caravaggesque painter Louis Finson.[19] These examples would have appeared in Holland after the Utrecht artists who would become Caravaggio's followers had left for Italy. However, the presence of these paintings, thought to be authentic works by Caravaggio, helped popularize the Italian master's style, creating the taste for Caravaggesque painting that helped to sustain the Utrecht followers once they returned to the North.

Similarly, stylistic developments in the landscape genre, witnessed in Rome in the early seventeenth century, were popularized in the North through actual artworks. For example, Hendrick Goudt, returning from Rome and entering the Utrecht Painters' Guild in 1611, made several prints after paintings by Adam Elsheimer, the German artist resident in Rome from 1600 until 1610.[20] Goudt brought a number of these paintings back with him, reportedly showing them to Joachim von Sandrart in 1625–26, when the latter was apprenticed to Honthorst in Utrecht. Whether or not artists such as Honthorst and Poelenburch were preconditioned by exposure to the artistic fashions current in Rome, once there each found a stylistic vocabulary sympathetic to his own talents and interests.

The journey from Northern Europe to Italy took many weeks and could be treacherous, not

only because of inadequate roads and natural obstacles, such as the Alps, but also because of unscrupulous innkeepers, bandits, and, if traveling by sea, pirates, who preyed on travelers. It has been estimated that fully one-fifth of the young Utrecht artists who undertook the journey never returned, many dying in Italy.[21] The Northerners could choose among several routes south. Catholic travelers could follow the relatively secure "Spanish Road," through the Spanish Southern Netherlands, Lorraine, Franche-Comté, and on to Lombardy and Genoa.[22] To avoid difficulties in Spanish-held territories, Dutch travelers also went by boat to France, and then overland, along the Rhône river, and finally along the Mediterranean coast, either by ship or on land. Alternatively, one could go entirely by sea, following the trade routes to the Mediterranean.

The great influx of Dutchmen to the Italian peninsula in the seventeenth century came on the heels of increasing commercial involvement. Dutch merchants gained access to the Italian grain market as the result of the famines in Italy during the 1590s. With the consent of Ferdinando de' Medici, grand duke of Tuscany, the Dutch utilized the port of Livorno as the delivery point.[23] With the 1609 signing of the Twelve Year Truce, establishing a cessation of hostilities with the Spanish, it became easier for citizens of the Dutch Republic to make their way to Rome through regions under Spanish control and through such other Catholic domains as France and the various Italian states.[24]

Italy held the twin promises of the firsthand experience of its art treasures and abundant patronage, which had lured Northern artists since Rogier van der Weyden, Justus of Ghent, and Albrecht Dürer in the fifteenth century. Although Rome was the ultimate destination, prospects for patronage existed along the way: from the nobility in Genoa, from the Borromeos in Milan, and at the courts of the Savoy in Turin, the d'Este in Modena, and the Medici in Florence, among others. However, at the opening of the seventeenth cen-

tury, Rome in particular experienced a period of regeneration, spurred by the aspirations of the Counter-Reformation church. Striving in the face of spreading Protestantism to reestablish its religious authority and institutional primacy, the Church hierarchy initiated sweeping internal reforms. A new Catholic militancy emerged, which included enlisting art as a tool to assert the iconography of the Church Triumphant. In Rome this translated into building programs of unbelievable scale and grandeur, including the completion and decoration of St. Peter's. Lavish patronage resulted as Church and nobility directed the refurbishment of the Eternal City, including new construction or remodeling of numerous churches, palaces, and public monuments, as well as improvements to the city's infrastructure.[25] As the modern Catholic Church reached a high point of temporal and political power, Rome, not unlike nineteenth-century Paris or twentieth-century New York, filled with the creative power of artists drawn from throughout Europe.

At the beginning of the seventeenth century, the artistic milieu of Rome was rich, variegated, and fluid, as many artists, both Italian and foreign, resided in the city temporarily and then departed. Exponents of three very different styles—mannerism, Caravaggism, and an early form of baroque classicism—vied with each other for influence and patronage. To summarize very briefly, among many Caravaggesque artists, including, until 1606, Caravaggio himself, were his followers Bartolomeo Manfredi, Orazio Gentileschi, and Carlo Saraceni. An emergent classicism was represented by Annibale Carracci, who died in 1609, and his Bolognese followers, such as Domenichino, Francesco Albani, and Guido Reni. Thirdly, a late mannerist faction was represented by the Cavaliere d'Arpino, Federico Zuccaro, and Federico Barocci. Competition was intense for a wealth of public and private commissions, including altarpieces and fresco cycles for churches and decorative works for private palaces. Affluent connoisseurs were also interested in the

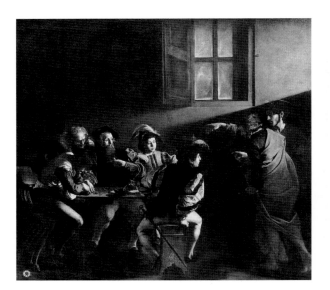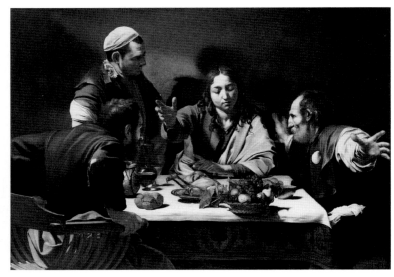

Fig. 1 Caravaggio, *Calling of Saint Matthew*, ca. 1600. Oil on canvas, 322 × 340 cm (126¾ × 133⅞ in.). S. Luigi dei Francesi, Rome.

Fig. 2 Caravaggio, *Supper at Emmaus*, ca. 1601. Oil on canvas, 141 × 196.2 cm (55½ × 77¼ in.). Trustees of the National Gallery, London, NG 172.

new secular subject matter, including still life, genre scenes, and landscapes. The Northern artists not only excelled at these latter categories, which had been introduced into Italy from the North, but made significant contributions to the development of these nascent traditions. As outlined in the often-cited letter written around 1620 by the Marchese Vincenzio Giustiniani to the Northern lawyer Theodoor Ameyden, artists of these greatly divergent styles found appreciation and patronage among Rome's numerous collectors and religious institutions.[26]

The number of foreign artists resident in Rome grew substantially; the number of Dutch artists increased particularly once travel across Europe became easier for citizens from the Dutch Republic. In the year 1617, for example, an abbreviated list of the foreign artists who visited or resided in the city included Honthorst, Baburen, David de Haen, Leonaert Bramer, Wouter Pietersz. Crabeth the Younger, Poelenburch, Theodoor Rombouts, Paulus Bril, Claude Lorrain, and Valentin de Boulogne. By the 1630s the composi-

tion of Rome's foreign artistic community had changed. For example, in 1639 landscape artists predominated; among them were Pieter van Laer, Herman van Swanevelt, Jan Asselijn, Pieter van Lint, Claude, Nicolas Poussin, Gaspard Dughet, and the Utrecht artists Dirck Stoop and Andries and Jan Both. Many artists congregated in the area between the Piazza del Popolo and the Piazza di Spagna, residing on the Via Margutta, the Via del Babuino, then called Via Paolina, or the nearby Via Sistina.[27] The vicinity was popular with foreigners in general, no doubt owing in some measure to papal tax exemptions, which encouraged inhabitation of the relatively new district.[28]

The Italian experience that would most affect the stylistic development of the figurative artists from Utrecht was the works of Michelangelo Merisi da Caravaggio (1571–1610).[29] For their initial adherence to and interpretation of his style, Honthorst, Ter Brugghen, and Baburen have become known as the Utrecht Caravaggisti. The Italian master's innovative stylistic vocabulary had attracted a large number of Italian and foreign followers, who kept the Caravaggesque style fashionable into the century's second decade, long after he left Rome as a fugitive in 1606. Specifically, it was the paintings from Caravaggio's Roman period that most influenced artists from Utrecht, because the output of his later years was

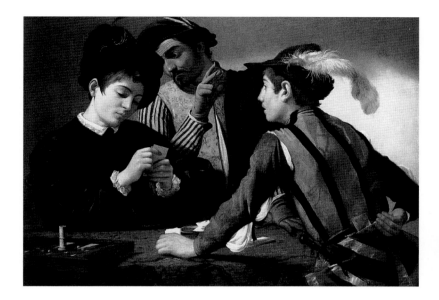

Fig. 3 Caravaggio, *The Cardsharps*, ca. 1594. Oil on canvas, 94.3 × 131.1 cm (37⅛ × 51⅝ in.). Kimbell Art Museum, Fort Worth, AP 1987.06.

Fig. 4 Caravaggio, *Boy Bitten by a Lizard*, ca. 1596–97. Oil on canvas, 68 × 51.5 cm (26¾ × 20¼ in.). Trustees of the National Gallery, London, NG 6504.

Fig. 5 Caravaggio, *Taking of Christ*, ca. 1600–1602. Oil on canvas, 133.5 × 169.5 cm (52½ × 66¾ in.). On loan to The National Gallery of Ireland, Dublin, 14,702.

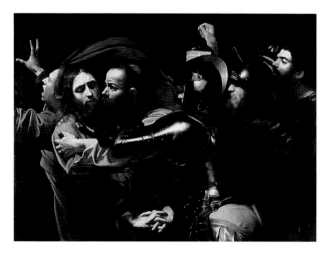

relatively little known to them. Caravaggio left a body of compelling works in Roman churches— many of which can still be seen in situ—such as the paintings depicting the experiences of Saints Peter and Paul in Sta. Maria del Popolo and the *Calling of Saint Matthew* (fig. 1), part of a suite of canvases painted for the nearby S. Luigi dei Francesi, the church of the French community in Rome. Once gaining entrée into the circle of Rome's foremost collectors, including Cardinal Scipione Borghese and Marchese Vincenzio Giustiniani, for whom Honthorst, Baburen, and Cornelis Bloemaert would also work, foreign artists had access to other important religious pictures by Caravaggio, such as the *Supper at Emmaus* (fig. 2) and the *Crowning with Thorns* (cat. 7, fig. 1). Early secular works could also be seen in these collections, including the Borghese *Cardsharps* (fig. 3), originally from the collection of Cardinal Del Monte, and the *Boy Bitten by a Lizard* (fig. 4).

Caravaggio's religious paintings, as exemplified by the recently rediscovered *Taking of Christ* (fig. 5),[30] are characterized by a tragic monumentality, coupled with powerful realism and deep chiaroscuro effects. Caravaggio's secular and religious works are rich in unique contrasts of light and dark, of realism and artifice, and of the theatrical and the poignantly understated. As discussed in the entries in this catalogue, these formal elements resonated with artists from the North, familiar with the painted nocturnes and realistic rendering of details of their own tradition.[31] The grafting of Caravaggio's revolutionary vocabulary onto this tradition is the school of Utrecht's single most important contribution to the evolution of Dutch painting.

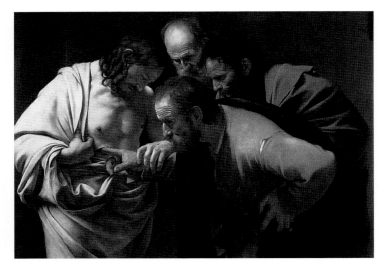

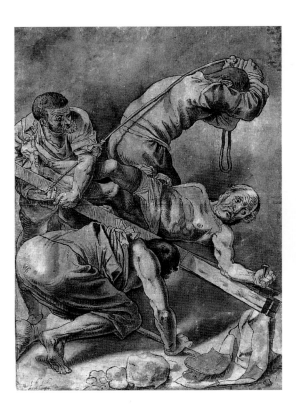

Fig. 6 Gerard van Honthorst, after Caravaggio, *Martyrdom of Saint Peter*, 1616. Pen and brown ink and brown wash on paper, 378 × 265 mm (14⅞ × 10⅜ in.). Nasjonalgalleri, Oslo, NG.K&H.B.15597.

Fig. 7 Caravaggio, *Incredulity of Saint Thomas*, ca. 1600. Oil on canvas, 107 × 146 cm (42⅛ × 57½ in.). Bildergalerie, Potsdam-Sanssouci, GKI 5438.

The Utrecht Caravaggisti studied the master's works closely. Honthorst's early signed and dated drawing recording Caravaggio's Cerasi Chapel painting (fig. 6), suggests how closely. However, although the Utrecht artists adapted Caravaggio's general approach to their own tastes, it is rare to find among their surviving paintings direct quotations from his known compositions. Among important exceptions is Ter Brugghen's *Doubting Thomas* of about 1622–23 (cat. 5),[32] which mirrors the central motif in Caravaggio's painting of the subject (fig. 7), which by 1606 was in Giustiniani's collection. Often Caravaggio's formal vocabulary was filtered through the works of his principal followers, Orazio Gentileschi and Manfredi. As an intermediary Manfredi (d. 1622) was particularly important, as suggested by Von

Sandrart's assertion that Northern artists, such as Gerard Seghers and Nicolas Regnier, followed a "Manfredian method."[33] Manfredi, in such paintings as his *Fortune-teller* (fig. 8) and the *Denial of Saint Peter* (cat. 12, fig. 2), combined Caravaggio's early secular subject matter with the moody theatrical lighting more typical of his mature religious paintings, creating a vital form of Caravaggism quickly assimilated by the Northern Caravaggisti. The compositional formula of large-scale, three-quarter-length figures, shallow stagelike setting, and raking light illuminating the figures within a gloomy space was easily translated into either secular or religious terms. In the hands of less accomplished artists, such as Seghers,[34] the Manfredian method remained obviously formulaic; but as the stimulus for the powerful personal interpretations of a master, such as Baburen (cat. 7), the Manfredian model proved potent.

Among the principal Utrecht Caravaggisti working in Rome, Ter Brugghen alone seems to have attracted little attention to himself. His Roman period remains elusive, except for the mention by Cornelis de Bie that while in Rome Ter Brugghen made the acquaintance of Rubens. This means that the Utrecht artist must have been in Rome prior to the latter's departure for Antwerp in the fall of 1608.[35] The long-held idea that Ter Brugghen could have possibly met Caravaggio in Rome has now to be reevaluated in the

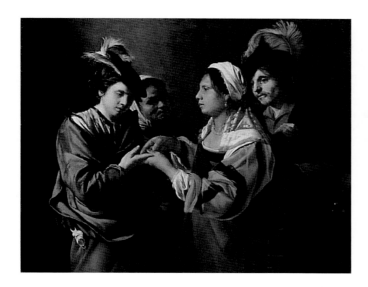

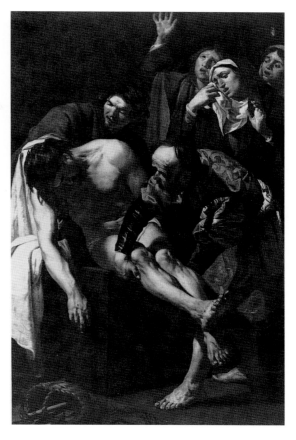

Fig. 8 Bartolomeo Manfredi, *The Fortune-teller*, ca. 1610. Oil on canvas, 121 × 152.5 cm (47⅝ × 60 in.). The Detroit Institute of Arts, Founders Society Purchase, Acquisition Funds, 79.30.

Fig. 9 Dirck van Baburen, *Entombment*. Oil on canvas, 222 × 142 cm (87⅜ × 55⅞ in.). Pietà Chapel, S. Pietro in Montorio, Rome.

light of new archival findings.[36] Evidence does survive of the Roman activities of the other main Utrecht artists of this generation, Honthorst and Baburen. Each left behind a group of distinguished canvases both in important Roman churches and in the collections of an elite circle of wealthy collectors. Of particular significance were Scipione Borghese and Vincenzio Giustiniani, in whose palace Honthorst and then Von Sandrart, Honthorst's student, lived.

Certain artists must have arrived in Rome with letters of introduction that ushered them immediately into such influential circles; others must have relied on the contacts made within the community of foreign artists resident in Rome. One wonders if Honthorst, in Rome from before 1616 until 1620, was not among the first category. Perhaps he was able to make contact with the Utrecht-born Vasanzio, architect to Pope Paul V Borghese, and thus quickly made the acquaintance of the papal nephew, a voracious collector. Two powerful works by Honthorst, *Christ before the High Priest* (ca. 1617; The National Gallery, London)[37]

and the atypical *Saint Sebastian* (cat. 9), demonstrate his skill at working both sides of the baroque coin, Caravaggism and classicism,[38] then fashionable in Rome. Honthorst's success in Rome helped him to win commissions from patrons in other Italian cities, including Cosimo II de' Medici, grand duke of Tuscany, and Piero Guicciardini in Florence.

Baburen, in Italy by 1615 and until about 1620, also found prestigious patronage in Italy and is first documented in Parma in 1615, where he painted an altarpiece depicting the Martyrdom of Saint Sebastian.[39] He went on to secure the support of the Marchese Giustiniani.[40] From the representative of the Spanish king in Rome came the commission for the paintings in the Pietà Chapel of S. Pietro in Montorio, which he carried out with David de Haen. Baburen's altarpiece for the chapel, *Entombment* (fig. 9), still in situ, reveals his careful study of Caravaggio's painting of the same subject.[41]

Fig. 10 Jan Asselijn, *Artists Working Out-of-Doors*, ca. 1640. Chalk, pen and ink, and wash on paper, 187 × 237 mm (7⅜ × 9⅜ in.). Kupferstichkabinett, Staatliche Museen zu Berlin-Preußischer Kulturbesitz, 144.

Fig. 11 After Pieter van Laer, *Bentvueghels at an Inn*, ca. 1635. Pen and ink on paper, 200 × 260 mm (7⅞ × 10¼ in.). Kupferstich-kabinett, Staatliche Museen zu Berlin-Preußischer Kulturbesitz, KdZ 5239.

By 1620 Ter Brugghen, Honthorst, and Baburen had all left Italy to continue their careers in the Dutch Republic. Quickly surveying the evidence, we are left with the impression that these figure painters found much of what they were seeking in Rome, most importantly artistic inspiration and patronage. The next wave of artists from Utrecht, reaching Rome in the 1630s and 1640s, had a very different experience.

Both written accounts and works of art provide a colorful picture of the confraternity of Northern artists, who around 1623 banded together to form the *Schildersbent* (artists' clique or group), nicknamed the *Bent*.[42] Joining forces, these expatriates called themselves the *Bentvueghels* (birds of a feather). They created this group to further professional ambitions and share artistic experiences (fig. 10), and subsequently they presented a unified front against the attempted imposition of both artistic restrictions and taxes levied against them in favor of the Italian members of

the Roman Accademia di S. Luca. But professional concerns formed only one part of the proceedings of the Bent, which became notorious for boisterous and sometimes unruly gatherings (fig. 11). And although the figurative artists were not specifically excluded from membership in the Bent, landscape specialists dominated the Utrecht contingent. Several of them played significant roles in the formation of the Bent and its ongoing activities, most prominently Poelenburch, the brothers Both, and Jan Baptist Weenix.

For landscape painters, as for figure painters, Rome was the center of baroque innovation. The landscape tradition imported by Northern specialists, including Bril and Elsheimer, mixed with the artistic preoccupations of the Italian artists who experimented with the landscape genre, including Annibale Carracci, Domenichino, and Filippo Angeli, called Napoletano. Mannerist stylizations, such as the abrupt stratification of the landscape into three distinctly colored wedges,[43] gave way to more classically ordered compositions. Baroque concerns for pictorial unity resulted in the illusionistic depiction of landscape, with a gentle flow of successive natural motifs from foreground into the far distance. In the 1630s Claude was experimenting with both Northern and Italian stylistic elements, which led to the codification of the classical landscape format in the following decade, as

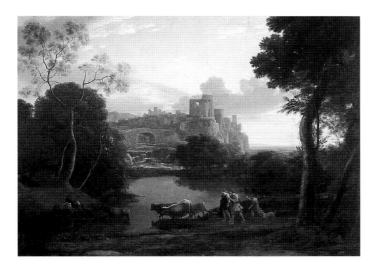

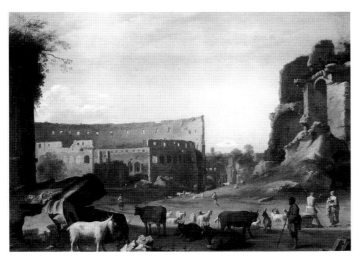

Fig. 12 Claude Lorrain, *View of Tivoli at Sunset*, ca. 1642–44. Oil on canvas, 100.3 × 135.9 cm (39½ × 53½ in.). Fine Arts Museums of San Francisco, Gift of the Samuel H. Kress Foundation, 61.44.31.

Fig. 13 Cornelis van Poelenburch, *Roman Landscape*, ca. 1620. Oil on panel, 44.4 × 60 cm (17½ × 23⅝ in.). The Toledo Museum of Art, 56.52.

Fig. 14 Cornelis van Poelenburch, *Arch of Septimius Severus, Rome*, 1623. Pen and brush in brown ink over black chalk, 291 × 193 mm (11½ × 7⅝ in.). The J. Paul Getty Museum, Los Angeles, 87.GG.86.

seen in the works of Claude (fig. 12), Poussin, and Dughet. Among the Dutch landscape and genre painters, innovation continued particularly in the works of Van Laer, whose Bent nickname was Bamboccio (clumsy doll). His repertoire of subjects, typically low-life scenes observed in the slums of Rome, attracted many Northern followers, called the *Bamboccianti*. The paintings of

Swanevelt also contributed significantly to the evolution of the landscape tradition. The warm sunlight and hazy atmospheric effects in his images of the countryside around Rome, the famous Roman Campagna, were especially influential for the development of Jan Both (cat. 70) and the other Dutch Italianate landscape artists.

In addition to topographical motifs drawn from the beautiful Campagna, Dutch artists incorporated elements of Italian architecture (cat. 74), both ancient and contemporary, into their compositions. Poelenburch created numerous small scenes, such as *Roman Landscape* (fig. 13), featuring generic ancient ruins punctuated by herders and their flocks. Here his aim was surely to capture the poetic nature of an imaginary Arcadian landscape, rather than to document any identifiable ruins. Specific pictorial motifs were often captured in drawings (fig. 14) and sketchbooks. Such drawings functioned as pleasant reminders of Italy and/or source material for later paintings or prints. Dutch artists also took home with them the memory of the magical Mediterranean light. Its golden

Reverberations [109]

evocation made their paintings very popular, whether re-creating colorful views of the Roman Campagna or depicting the canals and cows typical of their native Dutch scenery.

During their Roman sojourn, several Utrecht landscape painters found considerable support among Italian collectors. In the 1620s Poelenburch worked for many of the leading families, and his works are recorded in contemporary inventories of the Orsini, Giustiniani, Colonna, and Patrizi collections.[44] His other major Roman commissions included a fresco cycle painted in the Vatican. Traveling to Florence, Poelenburch also worked at the Medici court and there reportedly met the French printmaker Jacques Callot. In the following decade, Jan Both rose to prominence in Rome. At the request of Philip IV's agent in Rome, Both contributed four works to a suite of landscape paintings for the Spanish king's Buen Retiro Palace in Madrid; this commission, the most important landscape project of the period, he shared with Claude, Poussin, Dughet, and Swanevelt.

Arriving after Both's departure, Jan Baptist Weenix reached Rome by 1643 and was there during the same years as Jan Asselijn, Johannes Lingelbach, and Adam Pijnacker. Weenix alone among this group seems to have attracted prominent patronage, working for the Pamphili family. An inventive artist, he, along with Claude, explored the artistic possibilities of the Italian harbor scene (cat. 74, fig. 2), which became a staple of his output during the remainder of his career. The Utrecht artist Dirck Stoop was probably in Rome at the same time, and his own seaport scenes and hunting parties reflect the innovations of Weenix.[45]

Those artists who did make the trip successfully were often rewarded with commercial success on their return to the Dutch Republic. This proved true for the Utrecht Caravaggisti, and especially for the Dutch Italianate landscape and genre painters of the mid–seventeenth century. Indeed, paintings by Nicolaes Berchem, Asselijn,

and the Utrecht artists Both, Poelenburch, and Jan Baptist Weenix were prized at the expense of artists who depicted the realities of the Republic's own topography, such as the landscapists Jacob van Ruisdael and Jan van Goyen.[46] This preference for Dutch Italianate landscapes and genre scenes continued unabated into the eighteenth century.

Artists returning to Utrecht infused the city with new creative energy. Honthorst and Baburen returned in 1620, the year before the termination of the Twelve Year Truce. Together with Ter Brugghen, who had returned by 1615, they modernized the Utrecht artistic scene. Through the introduction of the Caravaggesque idiom, they updated the approach to figure painting of both historical and secular subjects.

The Caravaggesque vocabulary soon began to appear in the works of Utrecht artists who had not gone to Italy and radiated out from Utrecht, influencing the artistic direction of painters in the Republic's other artistic centers. Notable is the reaction of the older Abraham Bloemaert, who experimented briefly with Caravaggism, as seen in his signed and dated *Supper at Emmaus* (1622; Musées Royaux des Beaux-Arts de Belgique, Brussels).[47] Beyond Utrecht the impact of this foreign style is evident first in Haarlem, as witnessed already in the 1623 *Musical Trio* by Pieter de Grebber (cat. 35, fig. 2). Most important for the subsequent development of Dutch painting, however, the adaptation of Caravaggesque elements began to qualify the youthful works of Rembrandt and Jan Lievens, such as Lievens's *Feast of Esther* (1626; North Carolina Museum of Art, Raleigh).[48] And in the 1650s, Italianate elements appeared in the early works of Johannes Vermeer, traceable to his contacts with Utrecht.[49]

In a similar fashion, the gathering of landscape artists newly returned from Italy in the 1640s, joined by Poelenburch, who had returned twenty years earlier, created a critical mass of landscape specialists who, sharing a common adventure and artistic experience, were at the

forefront of the Dutch Italianate mode. Carel de Hooch, working in Utrecht until his death in 1638, followed Poelenburch's lead, creating landscapes and grotto scenes closely modeled after the other artist's paintings.[50] He provides a transitional figure between Poelenburch and Bartholomeus Breenbergh and Both. After his return to Utrecht in 1641, Jan Both had significant influence on the character of the Dutch landscape idiom. This can be seen in the works of students such as Willem de Heusch (cat. 56),[51] and already established masters, including the Utrecht artist Herman Saftleven (cat. 73), whose stylistic response to Both's warmly colored Italianate views is discernible after 1642. Jan Both proved particularly influential on the development of Aelbert Cuyp, for it was through Both's paintings that Cuyp, who is not known to have gone to Italy, absorbed the taste and imagery of the Roman Campagna and the very specific qualities of its light.

As in the sixteenth century, when Utrecht was the site where the architectural vocabulary of the Italian Renaissance was first introduced into Dutch town hall design,[52] so in the seventeenth century Utrecht was the site from which other Italian innovations were introduced into Holland. The decorative idiom of illusionistic ceiling painting, a staple in Italy, made its first appearance in Utrecht. Honthorst's ceiling panels (fig. 15), perhaps designed for his own house,[53] are realized in an approach the Italians called *sotto in su*, the figures represented as if seen at a raking angle from below. Honthorst's conception draws on the long tradition of Italian ceiling painting, of which Andrea Mantegna's oculus painted on the ceiling of the Camera degli Sposi (1465–74; Palazzo Ducale, Mantua) is the most famous. This tradition was very much alive in seventeenth-century Rome and included the *Musical Concert Sponsored by Apollo and the Muses* by Orazio Gentileschi and Agostino Tassi (fig. 16), completed in 1612 for the Casino of the Muses in the palace of Honthorst's patron Scipione Borghese.[54] Although not suited for the

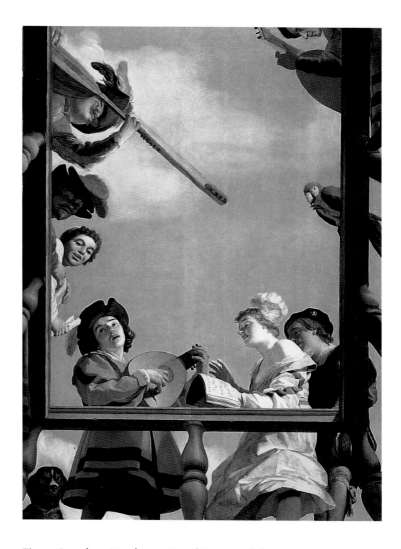

Fig. 15 Gerard van Honthorst, *Musical Group on a Balcony*, ca. 1622. Oil on panel, 308 × 215.9 cm (121¼ × 85 in.). The J. Paul Getty Museum, Los Angeles, 70.PB.34.

smaller scale of Dutch domestic interiors, grand illusionistic wall painting was recognized in the circle of the stadholder as both pleasing decoration and a suitable vehicle to convey the iconography of nobility appropriate to the political and dynastic ambitions of the House of Orange-Nassau. This grand manner was utilized in the cycles carried out for the stadholder at Honselaarsdijk and Rijkswijk in the late 1630s and in the Oranjezaal in the Huis ten Bosch begun in the late 1640s, projects to which Honthorst himself contributed.

Perhaps Honthorst's most successful refinement is found in the large early canvas *The Concert*

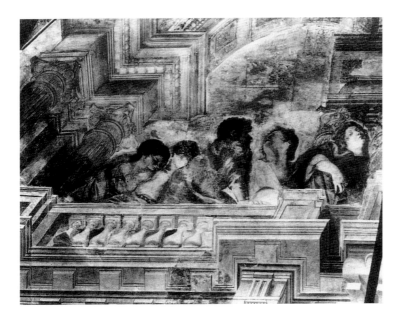

Fig. 16 Orazio Gentileschi and Agostino Tassi, *Musical Concert Sponsored by Apollo and the Muses*, 1611–12. Fresco. Casino of the Muses, Palazzo Quirinale, formerly Palazzo Pallavicino-Rospigliosi, Rome.

(1624; Musée du Louvre, Paris). Meant to be hung on the wall rather than on the ceiling, this work is nonetheless obviously meant to be seen from below. The festively dressed musicians and singers perched on the curtain-draped balcony look down as they serenade the guests below, whose position the viewer assumes.[55] Although Honthorst's pioneering examples did not initiate a long-lived tradition of illusionistic ceiling painting in the Republic, Leonaert Bramer, who had spent several years in Italy, explored the genre. He painted frescoes for a number of buildings, including the now destroyed palaces at Honselaarsdijk and Rijkswijk.[56] Fortunately, a number of drawings by his hand survive to give an idea of such decorative illusionistic compositions.[57] In the 1640s the Utrecht painter Jan Gerritsz. van Bronchorst also painted several related compositions, with musical figures looking over a balcony.[58]

As outlined here, the travelers to Italy brought back novel stylistic traits, expertise in their craft, drawings of what they had seen, and works of art by or after their Italian and other European contemporaries. They also returned with studio practices that differentiated their activities from traditional Northern guild practices. As laid out by Hessel Miedema and Marten Jan Bok,[59] the Utrecht academy and its predecessor in Haarlem are described in contemporary accounts as drawing academies, where artists and pupils gathered to draw from the nude model. This is very much an Italian conception, and most likely a habit acquired in Italy. For example, from comments by the Italian art critic Giulio Mancini, we know that Honthorst adopted this practice while in Rome,[60] as illustrated by his forceful academic study of a nude man (cat. 9, fig. 1). Significantly, among the principal participants in the two academies were artists who had themselves worked in Italy, including Van Mander and Goltzius in Haarlem, and Honthorst, Paulus Moreelse, his son Johannes, and Joachim Wtewael in Utrecht. The association of amateurs, such as Van Buchel and Johan de Wit (who had also traveled in Italy in the 1580s), with the Utrecht academy suggests that it was "not just another training school for artisans"[61] but also served broader purposes. Contact with such learned men not only helped to market one's paintings but could help to elevate the social status of the artist, suggesting that art, not simply a craft, was an intellectual pursuit.

Many of the accomplishments resulting from a trip to Italy served to promote the professional and social aspirations of the individual artist. A veneer of sophistication accrued to the traveler, particularly if beyond the prestige of producing a body of well-placed works his achievements included, for example, the mastery of foreign languages or the acquaintance of noble families and wealthy connoisseurs. These accomplishments ensured the artist's position in the artistic and social milieu of Utrecht, as well as the wider community of the Dutch Republic. Thus, the potential rewards from the required investment of time and money to make such a journey were many, sufficient enough to lure Utrecht's

most promising artists to Italy. Fortunately, the
benefits accrued not only to the individual artists.
And from the last decade of the sixteenth until
the middle of the seventeenth century, this shared
experience of Italian art and culture enriched the
artistic life of Utrecht, producing there a school
of painting of distinctive and dynamic character,
and influential far beyond the city itself.

Emerging from the Shadows: Genre Painting by the Utrecht Caravaggisti and Its Contemporary Reception

WAYNE FRANITS

I begin this essay with a well-known painting by one of the Utrecht Caravaggisti: Gerard van Honthorst's *Soldier and a Girl* (cat. 36). The principal motif here is one encountered in numerous representations of this subject by the Caravaggisti: a dandy in extravagant costume fondling a seminude woman.[1] His facial features and gesture and the exposed upper torso of the woman are subtly revealed by the superb light effects for which Honthorst remains justly celebrated. The man's lusty gaze is directed toward the face of this young woman. Yet his downward glance leads the viewer's eye to his hand, which cups her breast in the approximate lower center of the canvas. Honthorst has thus structured the composition so that the viewer is strongly encouraged to identify with the male protagonist; it hardly seems accidental then that this section of the picture is also the one most brilliantly illuminated by the glowing coal and candle.

The stunning pictorial effects of Honthorst's painting likely explain its renown, for in addition to its presence in the current exhibition it has also appeared in several staged during the 1970s and 1980s.[2] The catalogues accompanying these earlier shows duly noted the painting's spectacular luminosity. Moreover, its source, the smoldering ember, was repeatedly construed as the key motif that unlocked the hidden meaning of the picture for the artist's contemporaries. The ember was linked to a number of moralizing pronouncements by contemporary Calvinist authors who warn that men must be temperate and circumspect so they will not be singed by the pernicious fires of venal love. Most frequently cited in this regard is the work of Jacob Cats, a staunch Calvinist whose many books rank among the most popular published during the Golden Age. Cats's *Spiegel van den ouden ende nieuwen tijdt* (Mirror of the ancient and modern times) of 1632 contains an emblem of a man gazing at a prostitute holding a brazier of coals (fig. 1).[3] The illustration carries the Italian inscription, *O tinge o bruscia:* "It either stains or burns." This cryptic inscription is explained in Cats's accompanying poem in which the reader learns that the ember serves as an admonitory metaphor of the dangers of sexual arousal; this motif is consequently thought to have a similar function in Honthorst's painting.

Although the thematic repertoire of the Utrecht Caravaggisti's genre paintings was limited—as is true of all seventeenth-century Dutch painting—they painted other subjects besides prostitution, among them, figures playing musical instruments (cats. 37, 40, 42), drinking, or gambling (figs. 2, 3). Moralizing interpretations of these pictures also dominate; for example, those depicting figures playing cards or

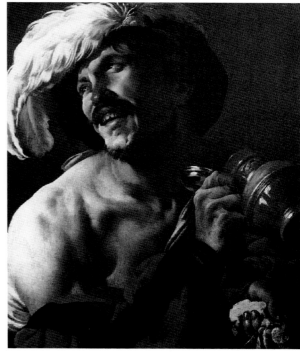

Fig. 1 Emblem from Jacob Cats, *Spiegel van den ouden ende nieuwen tijdt* (The Hague, 1632). Koninklijke Bibliotheek, The Hague.

Fig. 2 Hendrick ter Brugghen, *Merry Drinker*. Oil on canvas, 71.2 × 59.9 cm (28 × 23⅝ in.). Centraal Museum, Utrecht, M.I. 11480.

backgammon are thought primarily to warn viewers about the evils of gambling.[4]

The manner in which genre paintings by Honthorst and his Caravaggesque colleagues in Utrecht are consistently placed within a Calvinistic context necessitates predominantly moralizing readings. Although such interpretations are plausible, they are nevertheless problematic. If depictions of brothels, drinkers, and volatile gamblers were indeed intended to admonish viewers, then we must conclude that artists figuratively operated "in league" with pastors of the Reformed Church to produce effective didactic instruments for the moral improvement of their patrons. If this were true, then why did these very same preachers so strenuously object to what one of them, Willem Teellinck, termed "lichte oft afgodische Schilderien" (indecent or idolatrous paintings)?[5] Their remarks cannot be ignored since they constitute

one of the unusual instances in which the opinions of seventeenth-century viewers (other than artists) about contemporary paintings have survived. The collective pastoral censure of lewd art militates against the long-standing view that brothel scenes (and, by extension, other subjects) by the Utrecht Caravaggisti primarily served to make Calvinist morals visible.

The presence of significant numbers of the gentry in the city of Utrecht as well as its sizable Catholic population ensured that social and cultural conditions there were truly heterogeneous.[6] Despite the presence of a religiously conservative majority on the city council between 1618 and 1651, the need to placate a spiritually and morally diverse citizenry served to frustrate Calvinist efforts to dominate spiritual and secular life in Utrecht. It is no surprise then that the writings of Reformed ministers overflow with diatribes against the city's perceived moral decay, its supposed addiction to prostitution, drinking, gambling, dancing, the theater, prurient literature, and indecent paintings.[7] What for the seventeenth-century Dutch were vociferous (and somewhat exaggerated) protests from a small group of

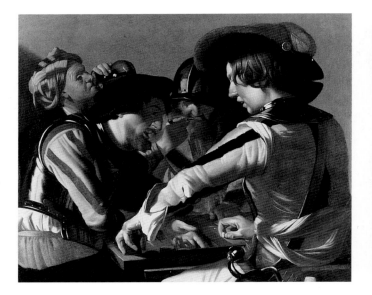 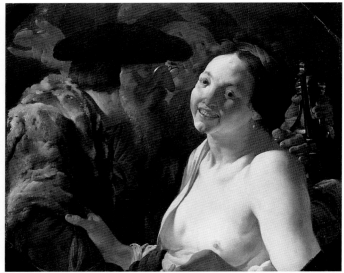

Fig. 3 Dirck van Baburen, *The Backgammon Players*. Oil on canvas, 105.4 × 128.3 cm (41½ × 50½ in.). The Saul P. Steinberg Collection.

Fig. 4 Hendrick ter Brugghen, *Unequal Couple*. Oil on canvas, 74.3 × 89.2 cm (29¼ × 35⅛ in.). Private collection, Boston.

———————————————

Reformed clerics against perceived turpitude have, for twentieth-century scholars, metamorphosed into convictions endorsed by the entire nation. Through our interpretations of Dutch paintings, we have unwittingly allowed Calvinist divines to become the official spokespersons for seventeenth-century Dutch culture. And in doing so, we overemphasize the admonitory aspects of Utrecht paintings (and that of Dutch art in general).[8]

Although Utrecht's ministers condemned the types of activities that found their pictorial counterpart in the art of the Utrecht Caravaggisti—and presumably the art itself—the latter do not literally document historical realities. To the contrary, what is immediately apparent about these paintings is their conventionality as they illustrate only a limited number of themes—some were frequently depicted while others just never took root within the limited artistic repertoire.[9] Among those that proved most popular were pictures of fancifully dressed figures playing wind and string instruments (see cats. 40–42); pictures of armed

men (who can occasionally be identified as soldiers) playing cards or backgammon (fig. 3); and especially, pictures of prostitution, a theme with a number of subcategories, for example, representations of brothels with varying numbers of figures (cats. 35, 38) or feeble, elderly men attempting to seduce mocking strumpets (fig. 4).[10]

While the subject matter and style of these paintings were fashioned by Honthorst and his fellow artists in response to pictorial traditions and aesthetic concerns, the tastes of potential patrons (i.e., affluent citizens of Utrecht and other cities) also played a decisive role in shaping pictorial vocabularies.[11] Since artists worked with a potential or actual audience in mind, their paintings reveal much about the underlying cultural attitudes and interests of the public who bought them. Consequently, genre imagery was, to a considerable extent, determined by the contemporary sociocultural climate, one that was much more heterogeneous than has hitherto been recognized.

Further light can be shed on these observations if we look systematically at a number of portrayals of one theme, in this instance, multifigured brothel scenes. Prostitution flourished in Utrecht along with other large cities in the Netherlands at this time despite the best efforts of municipal officials to combat this age-old profession.[12] Their

efforts did not result in the abolition of prostitution but rather in a change in the outer, public form of the trade; brothels simply moved into less conspicuous settings and became associated with inns, taverns, and music houses.[13] Our detailed knowledge of the practice of prostitution in the Dutch Republic does shed light on contemporary paintings that depict it. Yet it would be a mistake to assume that these paintings accurately portray prostitution as it was actually practiced at that time, as if they somehow illustrate slices of the seamy side of seventeenth-century life. The links between depictions of this sort and historical realities are at best indirect; however, depictions of trollops are clearly tied to contemporary stereotypes and biases as they accord, for example, with pervasive notions of innately aggressive female sexuality.[14]

To the theme of prostitution in Utrecht Caravaggist painting belong representations of five figures or more, as well as those depicting trios (cat. 38) and couples (cat. 36), often cast against neutral backgrounds. The conventions to which the artists adhered in these paintings become immediately apparent: One can easily identify certain salient motifs that appear and reappear with such frequency that they enable us to gauge contemporary reception of such pictures. It is noteworthy that all of these recurring pictorial elements serve as ingredients of seduction. Here I am thinking of such highly conventional elements as procuresses, food (often of a purportedly sexually stimulating nature, such as oysters), strong drink, and, of course, prostitutes (frequently sporting feathers in their hair), who are either bare chested or display pronounced cleavage with nipples crushed by heavy bodices. These buxom strumpets invariably mingle with sartorially splendid dandies.

The cast of characters depicted, as well as the overall carousing air of these canvases (see cat. 35), has led some art historians to conclude that they depict the New Testament parable of the Prodigal Son who squandered his inheritance

Fig. 5 Jan van Hemessen, *Parable of the Prodigal Son*, 1536. Oil on panel, 140 × 198 cm (55⅛ × 78 in.). Musées Royaux des Beaux-Arts, Brussels, M.I. 2838.

on whores and drink.[15] As such, they are said to constitute an updating of sixteenth-century prints and paintings of this popular biblical theme (fig. 5).[16] Although the seventeenth-century images do, to some extent, descend from these earlier representations, this interpretation nevertheless seems symptomatic of the aforementioned scholarly view that genre paintings must have a predominantly moralistic function. But the insistence on identifying imagery of this type with the older moralizing theme in art of the Prodigal Son is misleading primarily because the visual evidence summoned to establish the link is often insufficient. In fact, this reasoning has led to the rather awkward argument that it was no longer necessary for artists to include explanatory details in their pictures that refer back to earlier images of the Prodigal Son since these very same references were implicitly understood as present. Context determines whether a work represents the Prodigal Son or a brothel. Consequently, one cannot automatically assume that seventeenth-century Dutch scenes of prostitution carry the same admonitory content as earlier paintings of the Prodigal Son on the basis of compositional similarities alone or on minor, somewhat ambiguous iconographic details

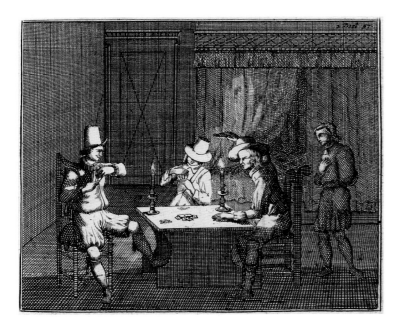

Fig. 6 Illustration from *Het leven van Gusman d'Alfarache* (Rotterdam, 1655). Koninklijke Bibliotheek, The Hague.

(like food and drink), especially in light of the absence of major ones (like the Prodigal Son himself or episodes from the parable depicted in the background) that would support such a reading.[17]

Fortunately, there is another literary source that might shed light on this imagery, namely, picaresque novels.[18] Picaresque novels were conceived as comic tales that revolve around the travels of the principal protagonist. While on his numerous journeys, this protagonist becomes involved in farcical events and intrigues that for contemporary audiences were often lurid in nature. This literary genre originated in Spain during the sixteenth century but quickly spread throughout Europe, including the Netherlands, where a translation of the first picaresque novel, *Lazarillo de Tormes*, was published in Delft in 1579.[19] These extremely popular books feature the adventures of soldiers and rogues, characters whose colorful travels involve them in thievery and other profligate activities including fighting, gambling, and whoring. Particularly noteworthy in picaresque novels is the outlandish clothing that these ruffians wear to impress their peers, apparel that is usually

described in minute detail.[20] Although we cannot posit direct correspondences between specific passages in these novels and the paintings, accounts of the disreputable, often bawdy activities of foppishly dressed yet dangerously armed young rogues and soldiers in the former nonetheless closely approximate the general tenor of the latter (figs. 3, 6).[21]

Another frequently recurring and thus highly conventional motif in genre paintings of brothels by the Utrecht Caravaggisti is musical instruments.[22] When we see strumpets playing violas da gamba or others touching the rounded belly of the instrument or still others joining hands with a client to cast a shadow over the sound hole, the visual juxtapositions hardly seem coincidental (figs. 7, 8). The use of the shape and structure of musical instruments to connote the sexuality of the female body[23] suggests that the meanings of these pictures are not "concealed" below their surfaces, that we do not need to plumb the writings of Calvinist ministers to discover some sort of covert message that sanctions the subject matter's existence within seventeenth-century Dutch culture. To the contrary, their surfaces are replete with significance ranging from the palpability of the female anatomy to the astonishing, sophisticated chiaroscuro effects that reveal and conceal that anatomy in tantalizing ways. These paintings, which succeeded so magnificently in "modernizing" older brothel imagery (fig. 9) by providing it with a fashionable Caravaggesque veneer, must have appealed enormously to elite audiences of "connoisseurs." It therefore strains credibility to claim that affluent viewers scrutinized these images daily in an effort to warn themselves about the evils of venal love or the consequences of surrendering to carnal appetites.

My reference to carnal appetites leads to the final aspect of these paintings that merits attention: their voyeuristic component, that is, their display of semiclad female forms, palpably and alluringly exposed to the gaze of the beholder.

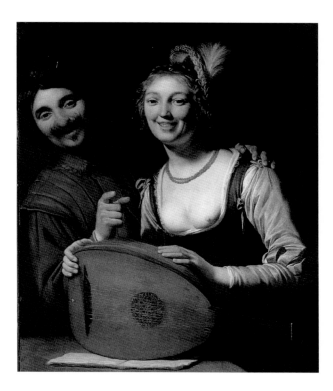

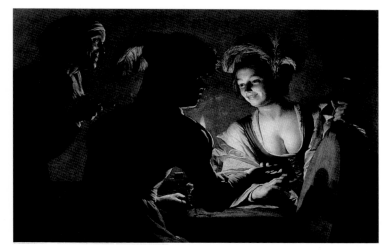

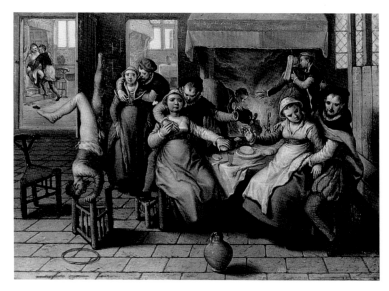

Fig. 7 Gerard van Honthorst, *Allegory of Lust*. Oil on canvas, 93 × 77.5 cm (36⅝ × 30½ in.). Location unknown. Sale, Sotheby's (London), 6 Dec. 1989, lot 99.

Fig. 8 Gerard van Honthorst, *The Procuress*, 1625. Oil on panel, 71 × 104 cm (28 × 41 in.). Centraal Museum, Utrecht, M.I. 152.

Fig. 9 Joachim Beuckelaer, *Bordello Scene*, 1562. Oil on panel, 26 × 35.5 cm (10¼ × 14 in.). The Walters Art Gallery, Baltimore, M.I. 37.1784.

The capacity of depictions of female nudity in seventeenth-century Dutch art to arouse desire in viewers has been examined by Eric Jan Sluijter in a number of important studies.[24] However, the focus of Sluijter's work has been history paintings, particularly the representation of stories from the Bible and mythology that concern men who are seduced by eyeing beautiful, nude women. Viewers of such paintings were inevitably placed in the same voyeuristic position as the men in the pictures themselves, protagonists who usually undergo punishment for their actions. Moral and erotic tension are thereby linked: On the basis of contemporary texts and print inscriptions, Sluijter rightly describes these paintings as meditations on the pleasures and dangers of sight.

As Sluijter himself states, an analogous range of associations was likely evoked by genre paintings. Presumably this would apply to depictions of prostitution. However, the principal difference would seem to be a much less deliberate attempt on the part of artists to moralize as well as a much less pronounced tendency on the part of viewers to construe the paintings moralistically.[25] After all, these pictures usually visualize and at times even affirm erotic pleasure; they cannot be tied to specific religious and mythological tales in which men involved in illicit activities with women suffer harsh consequences for their actions.[26] Thus many of the complaints lodged by moralists and ministers against lewd history paintings seem equally applicable to pictures of prostitution.[27]

Undoubtedly, for some audiences, paintings of seminude prostitutes were scandalous, but for many others, they were provocative, inviting vicarious participation in the activities that emerge so enticingly from the shadows consummately delineated on their surfaces.[28]

In conclusion, the contemporary reception of the genre paintings by the Utrecht Caravaggisti can only be accurately assessed by acknowledging that viewer responses did not simply and exclusively reflect the mores of one institution, namely, the Reformed Church, but were as diverse as the religiously and morally heterogeneous population itself. It is only by paying heed to issues of audience composition and reception that we can begin to grasp the complex interactions of art, culture, and society in the Dutch Republic.

Collecting Utrecht School Paintings in the United States

GEORGE KEYES

This essay focuses primarily on the history of collecting Utrecht school paintings by public museums in the United States. Because most institutions began purchasing Utrecht paintings only following World War II, the first section of this essay deals with those individuals whose acquisition of Dutch old-master pictures embraced, albeit sporadically, painters of the Utrecht school. These individuals were followed by certain pioneering art historians, museum directors, and curators who demonstrated a more concerted interest in this material. Their dedication made American museums particularly rich in Utrecht school paintings from the Dutch Golden Age.

With the opening of the National Gallery of Art in 1941 and the subsequent gift of the Widener paintings the following year, the last of the great American collections assembled during the Gilded Age (the period of rapid industrialization following the Civil War up to World War I) entered the public domain. The wide range of old-master paintings—amassed by such people as Henry Marquand, Isabella Stewart Gardner, Henry Clay Frick, Benjamin Altman, Jules Bache, Michael Friedsam, Andrew Mellon, and Peter A. B. Widener and his son Joseph—assured that many of the premier art museums in the United States would count among the most significant repositories of their kind in the world. These collectors, partly in emulation of the European nobility and strongly guided by dealers such as Joseph Duveen, Charles Sedelmeyer, and Martin Knoedler, focused their interest on celebrated artists. In the case of the Dutch school of the seventeenth century, Rembrandt led the pantheon of sought-after masters, followed by such luminaries as Frans Hals, Pieter de Hooch, Meindert Hobbema, Aelbert Cuyp, Jacob van Ruisdael, Gerard ter Borch, and Vermeer. Because painters from Utrecht were not as well known, none of these collectors owned paintings by artists of the Utrecht school. Its distinctive character clearly set Utrecht apart, segregated from what the dominant taste of the age deemed intrinsically and appealingly Dutch.

Despite this bias, painters of the Utrecht school had earlier managed to find a small niche in American collections of European old masters. On occasion certain ambitious picture lovers of the Gilded Age, Henry Walters[1] and John G. Johnson, for example, acquired pictures by Utrecht masters.

As Walter Liedtke points out in his fascinating essay of 1990 on American collectors of Dutch paintings, the only Dutch Italianate artist who was consistently admired in this country from the time of Robert Gilmor, Jr., onward was Jan Both.[2] The Dutch Italianates and especially Nicolaes Berchem and Jan Both were highly prized during

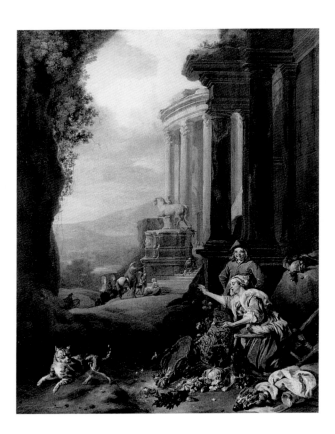

Fig. 1 Jan Baptist Weenix, *Market Sellers with Elegant Travellers Resting before Architectural Capricci Beyond.* Oil on canvas, 55.9 × 44.5 cm (22 × 17½ in.). Konrad O. Bernheimer, Munich-London.

the nineteenth century. Their landscapes commanded huge prices, often exceeding, for example, those paid for major paintings by Jacob van Ruisdael. The very time when the Italianates began to fall into eclipse coincided with the dynamic American collecting activity of the new century. As the desiderata list of Dutch painters shifted, the Dutch Italianates, including such Utrecht painters as Jan Both, Willem de Heusch, Cornelis van Poelenburch, and Jan Baptist Weenix, no longer attracted the notice of aspiring American collectors. That this was not always the case is borne out by earlier nineteenth-century Americans ranging from Robert Gilmor, Jr., of Baltimore early in the century to James Goodwin Batterson (1823–1901) of Hartford, Connecticut,[3] the Edwin B. Crockers of Sacramento, California, and James E. Scripps of Detroit toward the end of the 1800s. Paintings by

or ascribed to Poelenburch are cited as part of American collections as early as 1794.[4] Robert Gilmor, Jr. (1774–1848), a wealthy merchant from Baltimore, owned hundreds of pictures including about 150 Dutch and Flemish works. Of these only two Utrecht artists are cited: Jan Both and Roelandt Saverij.[5]

By contrast with Gilmor's, the collection of Thomas Jefferson Bryan (1802–1870) is well documented, although it, too, has been dispersed despite Bryan's intentions to the contrary. Bryan gifted and bequeathed much of his collection to the New-York Historical Society. He amassed a total of 380 paintings, of which 146 were Dutch or Flemish.[6] While Bryan acquired most of his choicest paintings from the holdings of Alexis-François Artaud de Montor (1772–1849),[7] he also purchased a number of fine Dutch paintings, the most notable of which is Gerard and Gesina ter Borch's *Portrait of Moses ter Borch*, which featured in the final dispersal of Bryan's pictures in 1995,[8] when it was acquired by the Rijksmuseum in Amsterdam. Also included in this sale was a major work by Jan Baptist Weenix (fig. 1), arguably the most important painting by an artist of the Utrecht school in the United States prior to the 1930s.

Louis P. Durr (1821–1880), another avid collector, acquired several hundred European paintings. After his death, 158 of his pictures went to the New-York Historical Society.[9] Among this motley group are works by or ascribed to Herman Saftleven, Jan Both, and one rather unusual *Pastoral Landscape* by Gijsbert de Hondecoeter in collaboration with Jan van Bijlert (fig. 2).[10]

Whereas the median level of quality of Durr's collection was mixed, James E. Scripps's efforts on behalf of the fledgling Detroit Museum of Art (now The Detroit Institute of Arts) have largely withstood the test of time. During the 1880s Scripps (1834–1906) acquired well over one hundred European old-master paintings. In 1889 he gave eighty pictures to the Detroit museum.[11] These were primarily seventeenth-century works,

Fig. 2 Gijsbert de Hondecoeter and Jan van Bijlert, *Pastoral Landscape*, 1635. Oil on panel, 62.9 × 102.9 cm (24¾ × 40½ in.). The Hearn Family Trust.

Fig. 3 Willem de Heusch, *Italian Landscape.* Oil on panel, 43.2 × 39.7 cm (17 × 15⅝ in.). The Detroit Institute of Arts, 89.37.

with a focus on the Italian and Dutch schools. Alongside characteristic works by Pieter de Hooch, Salomon van Ruysdael, Jan Steen, Simon de Vlieger, Karel Dujardin, and others are two fine Italianate landscapes by Jan Both and Willem de Heusch (fig. 3). In his modest way Scripps displayed a catholic taste in his selection of old masters—ranging from Netherlandish, Dutch, and Flemish pictures to Italian gold-ground and seicento painting.

By contrast, John G. Johnson of Philadelphia acquired in much greater depth. As Liedtke indicates,[12] Johnson was one of the first true American collectors of Dutch and Flemish painting. By avoiding competition with the wealthier representatives of the Gilded Age, many of whom were his friends and associates, Johnson focused on Italian gold-ground painting, the Netherlandish primitives, and the less well known Dutch and Flemish masters of the seventeenth century with such success that, to this day, Philadelphia offers an unparalleled survey of this material in the United States. Despite the fact that Johnson acquired

several hundred Dutch paintings, few of these are by Utrecht artists, and they are relatively obscure examples by or ascribed to Hendrick Bloemaert, Jacob Duck, and Jan Davidsz. de Heem. In fact, the most important Utrecht painting in Philadelphia is Jan Baptist Weenix's *Rest on the Flight into Egypt*, acquired by Peter Sutton for the museum in 1984.[13]

Thus in 1933, when the Johnson collection was placed on permanent deposit in the newly opened Philadelphia Museum of Art, prospects for a rich representation of paintings of the Utrecht school in American museums were not promising. Our immediate association of Utrecht with international mannerism, Caravaggism, and Dutch Italianate landscape, now so well represented throughout the country, found little resonance in the United States of the Roaring Twenties. The great crash of 1929 and the ensuing depression of the 1930s did little to foster the art market, although certain museums such as those in Cleveland, Hartford, and Detroit continued to buy into the 1930s despite the deteriorating economy.

During this period the Wadsworth Atheneum, recently endowed with the Sumner bequest in 1927, was in a position to acquire significant European old-master paintings. Its new director, A. Everett Austin, appointed in 1927, charted a radically new course for America's oldest art

museum. As Egbert Haverkamp-Begemann notes, Austin bought with flair, personal style, and courage.[14] Austin greatly admired baroque art and recognized that its importance was seriously underestimated. He also soon realized that his acquisition funds would go further if he bought against prevailing market taste.[15] Although Austin's chief interest was the Italian seicento, he also recognized the merits of Northern painters whose art displayed affinities with the Italian baroque and particularly Caravaggio. He became interested in certain Northern realists whose paintings display a strong vein of Caravaggism—Honthorst and Ter Brugghen, for instance, as well as that rare sensibility—Michiel Sweerts. In 1937 Austin also acquired *Figures among Ruins*[16] by Jan Baptist Weenix who (although admired by Bryan decades earlier) had, like all the Dutch Italianates, become unfashionable. Austin's interest in baroque art for its realism, its dramatic nocturnal lighting, its focus on still life as a subject worthy of admiration, and its forceful rhetoric reflect his own predilections as an artist and an actor. His bold divergence from the accepted pantheon of Dutch old masters found a sympathetic sequel in his successor as director of the Wadsworth Atheneum, Charles C. Cunningham, also a great admirer of Northern European painting.[17] During Cunningham's directorship one outstanding Utrecht picture—Abraham Bloemaert's *Neptune and Amphitrite* —entered the collection. This *maniera*-style painting added new scope to the museum's holdings.

By the time Hartford acquired its Bloemaert in 1964 the American museum world had changed radically. Each aspiring metropolis took pride in its civic and cultural institutions such as museums and orchestras. Likewise, many universities and colleges developed their own teaching museums apace, with the result that the demand for representative but affordable European paintings greatly increased. Moreover, the discipline of art history in the United States fundamentally transformed itself just prior to and during World War II

with the arrival of the many distinguished European art historians who sought asylum and new careers in the New World. Distinguished scholars such as Erwin Panofsky, Jakob Rosenberg, Wolfgang Stechow, and Julius Held introduced to America the conviction that the old masters of the Low Countries offered a field of art-historical investigation uniquely enriched by the actual presence of so many masterworks already in this country. They inspired many young American art historians who chose to specialize in the study of Netherlandish, Dutch, and Flemish art.

Following World War II the United States enjoyed a period of unparalleled prosperity; at last the time was propitious for the Utrecht school in the New World. Charting the acquisitions of civic and university art museums of the 1950s through the mid-1960s, one readily detects the degree to which certain categories of Dutch painting—in this case, expressly Utrecht masters—experienced something of a vogue. At a certain moment Northern Caravaggesque painting was in great demand. Later, primarily during the 1980s, Northern mannerism supplanted this as a primary focus for institutional collecting. During much of this period, but particularly in the early 1960s, in no small measure through the impetus of Wolfgang Stechow, a significant number of Dutch Italianate landscapes were acquired by museums in the United States.

Stechow demonstrated his abiding interest in Utrecht and Dutch Italianate painters in general through a series of exhibitions, recommendations for purchase, and his brilliant acquisition of Hendrick ter Brugghen's masterpiece, *Saint Sebastian Attended by Irene* (cat. 10) for Oberlin in 1953. Although not the first Ter Brugghen to have been acquired by a museum in the United States— that honor goes to Hartford[18]—it reflected a sea change in American taste for Dutch pictures. Little more than a decade later the exhibition *Hendrick Terbrugghen in America* included fifteen paintings by the artist from public collections.

In his foreword to the exhibition catalogue Stechow states:

> The recent meteoric rise of the reputation of Hendrick Terbrugghen forms a fascinating chapter in the history of taste. One of its most revealing aspects is that this revaluation was inseparable from that of Caravaggio not so much because Terbrugghen was one of the many northern followers of the Italian reformer but because he shared with him qualities which make him a great and original artist in his own right.
>
> A mere thirteen years ago there were no more than three paintings by Terbrugghen in America, only one of them in a public collection. Today there are at least fifteen—those presented to the public in this exhibition.[19]

Many of the museum directors who had recently acquired these Ter Brugghen paintings did not restrict their interest in the Utrecht school to this single master. Anthony Clark, director of the Minneapolis Institute of Arts, for instance, also acquired paintings by Abraham Bloemaert, Jan Both, and Gerard van Honthorst.[20]

Clark was not alone in perceiving that buying in the field of baroque art offered tremendous opportunities. Hartford under the directorship of Cunningham has already been cited, but other museums, including those in Indianapolis, Ponce (Puerto Rico), Saint Louis, and Toledo, during the 1950s and 1960s all bought a distinguished selection of paintings by Utrecht masters.[21] Certain of these institutions availed themselves of the excellent advice of Stechow, who continued to investigate the subject, first in the exhibition *Italy through Dutch Eyes*[22] in 1964, and then in his monumental survey of Dutch landscape painting of the seventeenth century of 1966,[23] in which he once again vigorously defended the reputation of the Dutch Italianates.

During this important period of collecting, certain names began to crop up—Bloemaert and Wtewael—indicating that an undercurrent of interest existed for Northern mannerism.[24] In recent years a marked vogue for such paintings, with a strong focus on Haarlem and Utrecht masters, has been evident in the United States with major acquisitions of works by Hendrick Goltzius, Wtewael, and Bloemaert. Extremely important paintings such as Wtewael's *Saint Sebastian* (cat. 2) acquired by the Nelson-Atkins Museum of Art, Goltzius's *Danae* now in Los Angeles and his *Sine Bacchus and Ceres friget Venus* in Philadelphia, and Wtewael's *Mars and Venus Surprised by Vulcan* (cat. 47, fig. 1) at the Getty Museum and his *Wedding of Peleus and Thetis* (cat. 49) at the Clark Art Institute all counted as major acquisitions of these museums. Their purchase commanded considerable publicity and press attention, not to mention serious scholarly study.[25] Years earlier, Stechow demonstrated his prescient eye when he, as guest professor at Vassar College in 1969–70, included in the exhibition *Dutch Mannerism: Apogee and Epilogue*[26] Dutch paintings and graphic arts, evidence that American museums were also acquiring notable drawings by these same masters. Artists of the Utrecht school—above all Abraham Bloemaert and Joachim Wtewael—were well represented in this exhibition demonstrating their central position in the development and dissemination of the late *maniera* style in the Northern Netherlands at the end of the sixteenth century.

In recent years major exhibitions devoted to Rembrandt, Jacob van Ruisdael, Jan Steen, Gerard ter Borch, and Vermeer[27] indicate that general interest in these seminal masters of the Dutch school remains high. By the same token, thematic surveys of Dutch art devoted to genre, landscape, and marine art,[28] plus others addressing iconographic issues[29] and yet another titled *Great Dutch Paintings from America*[30] have all included an ample number of Utrecht painters, suggesting that this city is crucial to a rightful understanding of the totality of Dutch art. In contrast to the ebullient acquisitive years of the 1950s, 1960s, and even the 1970s when Utrecht artists were being

"discovered" by America, we no longer look forward to great undiscovered Dutch old masters. Nonetheless, major works by Utrecht painters continue to appear on the market, still offering serious opportunities to the discerning collector. Nowhere is this more evident than in the fine grouping of Utrecht masters acquired in recent years by the J. Paul Getty Museum.[31]

Although the pace of acquisitions has slowed, the aggregate holdings of Utrecht masters by museums in the United States are impressive testimony to the perspicacity of those museum directors, curators, and scholars who bought with conviction in an area of Dutch painting hitherto poorly represented in America. Today the balance is redressed, and Utrecht, with its unique roster of *maniera* painters, Caravaggisti, and Italianate landscapists, plus its Arcadian and classicizing painters, is richly represented across the United States.

Paintings in the Exhibition

BALTHASAR VAN DER AST
Bouquet of Flowers, cat. 77
Flowers in a Vase with Shells and Insects, cat. 76

DIRCK VAN BABUREN
Cimon and Pero (Roman Charity), cat. 25
Emperor Titus, cat. 28
The Mocking of Christ, cat. 7
The Procuress, cat. 38
Prometheus Being Chained by Vulcan, cat. 52
Young Man Playing a Jew's Harp, cat. 37

JAN VAN BIJLERT
Girl Teasing a Cat, cat. 39
Inhabitants of St. Job's Hospice, cat. 32
Mary Magdalene Turning from the World to Christ (also known as *Allegory of
 the Catholic Faith*), cat. 19

ABRAHAM BLOEMAERT
Adoration of the Magi, cat. 16
Amaryllis and Mirtillo, cat. 59
The Four Evangelists, cat. 3
Head of an Old Woman, cat. 33
Moses Striking the Rock, cat. 1
Parable of the Wheat and the Tares, cat. 18
Saint Jerome in His Study, cat. 14
Virgin and Child, cat. 17
Wedding of Peleus and Thetis, cat. 46

AMBROSIUS BOSSCHAERT
Bouquet of Flowers on a Ledge, cat. 75

JAN BOTH
Italian Landscape with Artist Sketching a Waterfall, cat. 71
Peasants with Mules and Oxen on a Track near a River, cat. 70

JAN BOTH AND CORNELIS VAN POELENBURCH
A Landscape with the Judgment of Paris, cat. 72

JAN GERRITSZ. VAN BRONCHORST
Study of a Young Woman, cat. 44

HENDRICK TER BRUGGHEN
The Annunciation, cat. 15
Calling of Saint Matthew, cat. 4
Crowning with Thorns, cat. 6
The Crucifixion with the Virgin and Saint John, cat. 8
The Liberation of Saint Peter, cat. 11
Democritus, cat. 24
Doubting Thomas, cat. 5
Fife Player (also known as *Flute Player*), cat. 41
Heraclitus, cat. 23
Melancholia, cat. 22
Musical Group (also known as *The Concert*), cat. 40
Saint Sebastian Attended by Irene, cat. 10
Singing Lute Player (also known as *A Man Playing a Lute*), cat. 42
Young Woman Reading from a Sheet of Paper (also known as *Singing Girl*), cat. 43

JOOST CORNELISZ. DROOCHSLOOT
Saint Martin Dividing His Cloak, cat. 31

JACOB DUCK
Lady World, cat. 20
Soldiers Arming Themselves, cat. 34

GERARD VAN HONTHORST
Allegory of Spring (also known as *Allegory of Love*), cat. 58
Artemisia, cat. 26
Denial of Saint Peter, cat. 12
Frederick V, King of Bohemia, as a Roman Emperor, cat. 27
Granida and Daifilo, cat. 57
Musical Group by Candlelight, cat. 35
Saint Sebastian, cat. 9
A Soldier and a Girl, cat. 36

NICOLAUS KNÜPFER
Bordello, cat. 45

NICOLAUS KNÜPFER AND WILLEM DE HEUSCH
Diana and Her Nymphs at the Bath (also known as *Diana Emerging from the Bath*), cat. 56

DIDERICK VAN DER LISSE
Sleeping Nymph, cat. 55

JOHANNES PAUWELSZ. MOREELSE
A Shepherd Playing Pan's Pipes, cat. 65

PAULUS MOREELSE
Allegory of Vanity, cat. 21
Portrait of a Member of the Strick Family (Dirck Strick?), cat. 29
A Shepherdess, cat. 64

CORNELIS VAN POELENBURCH
Arcadian Landscape with Nymphs Bathing, cat. 54
Feast of the Gods, cat. 53
Grotto with Lot and His Daughters, cat. 69
Landscape with the Flight into Egypt, cat. 68
Portrait of Jan Pellicorne as a Shepherd, cat. 60
Portrait of Susanna van Collen as a Shepherdess, cat. 61

CORNELIS SAFTLEVEN AND HERMAN SAFTLEVEN THE YOUNGER
Sleeping Hunter in a Landscape, cat. 73

ROELANDT SAVERIJ
Landscape with Birds, cat. 67

JAN BAPTIST WEENIX
Dead Swan, cat. 78
Mother and Child in an Italian Landscape, cat. 74

ADAM WILLARTS
Ships off a Rocky Coast, cat. 66

JOACHIM WTEWAEL
Andromeda, cat. 51
Judgment of Paris, cat. 50
The Kitchen Maid, cat. 30
Mars and Venus Discovered by Vulcan, cat. 47
Mars, Venus, and Cupid, cat. 48
Saint Sebastian, cat. 2
A Shepherd, cat. 63
A Shepherdess, cat. 62
Wedding of Peleus and Thetis, cat. 49

PETER WTEWAEL
Denial of Saint Peter, cat. 13

Catalogue of
the Exhibition

Body and Spirit: The Impact of the Counter-Reformation

1 ABRAHAM BLOEMAERT
(1566–1651)

Moses Striking the Rock

1596

Oil on canvas, 79.7 × 108 cm (31⅜ × 42½ in.)
Signed and dated lower right: *A. Blommaert fe / a.º 1596*
New York, The Metropolitan Museum of Art, Purchase,
Gift of Mary V. T. Eberstadt, by exchange, 1972. (1972.171)

Provenance: sale, Isidor Sachs coll., Posony (Vienna),
17 Dec. 1872, lot 97; H. Miethke, Vienna, ca. 1890; sale,
Carl Franze coll., Lepke (Berlin), 7 Nov. 1916, lot 63;
C. Glaser coll., Berlin, 1928; sale, Internationales Kunst-
haus, 9 May 1933, lot 241; with Gurlitt (Munich); with
A. Stein (Paris), 1965–66; with Kleinberger (New York);
B. Reid, New York, 1967–70; M. Eberstadt, New York,
1972

Selected References: Broos et al. 1990, cat. 8; Roethlisberger
1993, no. 46 (with earlier literature); Seelig 1997a, no. A7

In a measured way Abraham Bloemaert guides the
beholder's eye through the careful composition
of an excited crowd of people until, in the end, he
discovers the tiny figure of Moses in the far left
background. Following the instructions received
from God, Moses strikes the rock of Mount Horeb
rising on the left-hand side of the picture to pro-
duce water, which saves the lives as well as the
faith of his people (Exod. 17:6).

Moses is one of the most important Old Tes-
tament figures in the Christian tradition. Medi-
eval thought, strongly dominated by typological
analogies, saw in him a prefiguration of Christ in
several ways. In the incident depicted here, the
analogy with salvation is obvious.[1] There is also a
specific connection to the figure of Moses, who

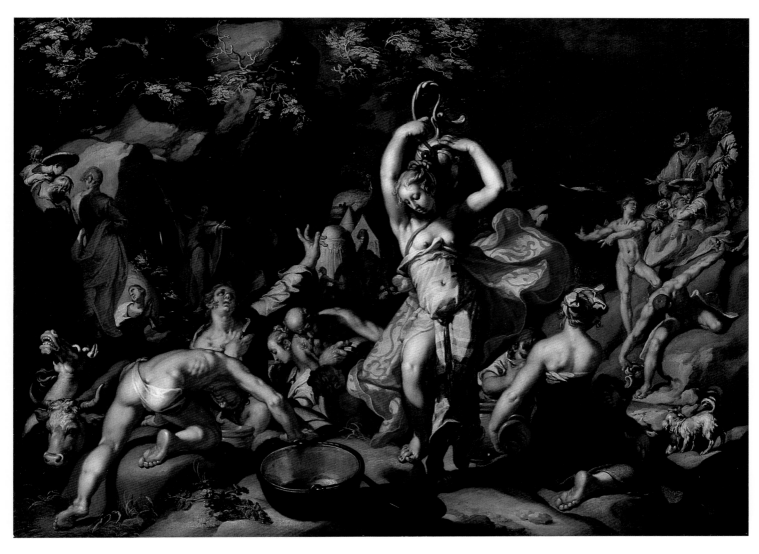

Cat. 1

since the fourth century has been regarded as the typos of Saint Peter. In the context of Dutch history, this would endow the painting with a strong Catholic flavor, the pope in Rome being the successor to Saint Peter. But then again, Moses hardly stands out at all. Although the light picks out parts of the foreground figures in a way that contributes to the sensation of violent movement, the main person, Moses, remains entirely in the shade.

In the absence of precise information on Bloemaert's motivation for painting this work, one is left to assume that the subject was chosen because of the opportunity it provided to display the artist's virtuosity. Other subjects with an occasion to depict a great number of human bodies in agitated but nevertheless well-studied and nicely

rendered poses, such as the Deluge or the Feasts of the Gods (compare fig. 1 and cat. 46), were similarly popular.

Following the Haarlem masters of his generation, namely Cornelis Cornelisz., Karel van Mander, and Hendrick Goltzius, Bloemaert had started out emulating the style of the imperial court at Prague dominated by the Fleming Bartholomeus Spranger (see cat. 47, fig. 3). Bloemaert shared intricacies of the mannerist aesthetic with such painters as Cornelis and Joachim Wtewael so closely that the same gestures and motifs occur in paintings by all of them. In fact, our painting showcases the artist's ability to weave into a unified composition elements of very different origin.[2] The kneeling figure seen from the back

Fig. 1 Cornelis Cornelisz. van Haarlem, *The Flood*, 1592. Oil on panel, 74 × 92 cm (originally only 52 cm high) (29⅛ × 36¼ in.). Herzog Anton Ulrich-Museum, Braunschweig, 170.

Fig. 2 Abraham Bloemaert, *Moses Striking Water from the Rock*. Pen and wash on paper, 340 × 487 mm (13⅜ × 19⅛ in.). Schloßmuseum, Weimar, KK4481.

at the left refers to Michelangelo's famous *Battle of Cascina*, a favorite image with the painters of this generation. Versions of this figure are in paintings from Utrecht as well as from Haarlem, most prominently in Cornelis van Haarlem's *Massacre of the Innocents* of 1592 or his *Flood* of the same year (fig. 1). Knowledge of Renaissance masterworks must have been broadly spread through drawings and other means.[3] In fact, Hendrick Goltzius brought back from Italy plaster casts after two of Michelangelo's figures from the Medici Chapel.[4] Drawing after casts was considered an important step in any artist's education, as is illustrated by the title page

of Bloemaert's *Tekenboek* showing a youth studying a cast.

Even more important than Italian Renaissance art must have been the remains of antique sculpture, particularly the *Laocoon*. A figure combined from the legs of the right-hand son of *Laocoon* and the arms, upper body, and head of the left-hand son can be seen standing completely naked in the background to the right.[5] From a Marsyas figure in a group by Myron (480–440 B.C.) comes the pose of the man in fancy dress at the far right, who recurs, more prominently, as a nude in Bloemaert's *Wedding of Peleus and Thetis* in Munich and, closer to the prototype, in Cornelis's *Flood* (fig. 1). The fact that most of the motifs recur time and again in many of Bloemaert's paintings of this decade and even later conveys an insight into the artist's working method. It also tells something about the expectations of the sophisticated, historically alert viewer, who was served with a fine central figure of Bloemaert's own invention pleasantly merged with well-known classical and Renaissance inventions.

The copy of what may have been the final sketch of the composition[6] shows that the final version was corrected, resulting in a more precise composition of the foreground figures. In the background a whole group absent from the drawing has been inserted between the *ignudi* on the right. This is the group centered on the woman with a gypsy hat.[7] In spite of this concern for the single figure, studying live models to prepare for paintings does not seem to occur in Bloemaert's oeuvre until around 1610, when he received his first commissions for altarpieces.[8] It is the preoccupation with older inventions and compositions —his own as well as borrowed ones—and the persistent work on this visual material that is the most striking feature of his working method. It remains more typical for the artist throughout his career than the single motifs themselves or even general stylistic features.[9]

This persistence results in a very gradual

reaction to stylistic currents. Pictures from the early years of the decade were characterized by huge figures resting in the foreground with their backs to the viewer.[10] By the time of this painting, Bloemaert had come a good deal further to harmonizing the whole of the picture into a single well-balanced and centered composition. With the main subject still hidden in the background—without doubt to allow for the viewer's pleasure of finding him[11]—the composition is not funnel-shaped, as in most of the earlier works (see fig. 2), but meets the eye with a centrally placed main figure turned *en face*, even if it is only staffage.

The painting of 1596 marks a turning point for the highly charged mannerist style of Bloemaert, in terms of the single figure as well as in the treatment of the composition. In the following years he will gradually change the structure of his compositional scheme, here wholly dominated by the figures, so that real landscapes emerge. After his first known painting, the huge *Death of Niobe's Children* of 1591 (Statens Museum for Kunst, Copenhagen),[12] he gave up depicting life-size figures. It will take some time, more than a decade, before he tries his hand again at life-size figures with the *Resurrection of Lazarus* (Manchester City Art Gallery).

—G. S.

2 JOACHIM WTEWAEL
(1566–1638)

Saint Sebastian

1600

Oil on canvas, 169.2 × 125.1 cm (66⅝ × 49¼ in.)
Signed and dated on the rock at left: *IOACHIM WTEN / WAEL FECIT / 1600*
Kansas City, Missouri, The Nelson-Atkins Museum of Art (Purchase)

Provenance: Messrs. Hadfield and Burrowes, England, by 1785; their sale, Greenwood (London), 10 May 1785, lot 79; with Philip Hill (London), to 1807; sale, Christie's (Lon-

don), 20 June 1807, lot 44, bought by Michael Bryan for £13.2.6; with Michael Bryan (London), 1807; Sir Edward Cockburn, Bart., Herefordshire, to 1903; sale, Christie's (London), 25 Apr. 1903, lot 139, bought by Hamblin; with Van der Perre (Paris), 1905–6; with S. A. l'Antiquaille (Paris), 1937; with P. Graupe (Paris), 1938; private collection, France, 1938; sale, Sotheby's (Monaco), 25 June 1984, lot 3305; with Bruno Meissner (Zurich)/Newhouse Galleries (New York), 1984; purchased through the Nelson Gallery Foundation in 1984

Selected References: Broos et al. 1990, 488–92, cat. 73 (entry by Lynn Federle Orr, with earlier literature); Churchman and Erbes 1993, 108; Luijten et al. 1993, 85, 556–57, cat. 228 (entry by Wouter Kloek); Roethlisberger 1993, 1:86; Ward and Fidler 1993, 32 (color pl.), 159; Lowenthal 1995, 72–73, fig. 49

Wtewael's compelling image is the first of several outstanding depictions of the martyrdom of Saint Sebastian by seventeenth-century Utrecht artists. Since the fourteenth century, Saint Sebastian had been venerated as a protector against the plague, and he was a patron of Dutch civic guard groups. Little is actually known of him. The traditional account, probably formed by the late fifth century, is that Sebastian, born in Gaul, was an officer in the Roman imperial guard. When his Christian belief was discovered, the emperor sentenced him to be shot to death with arrows. Left for dead, Sebastian was found and succored by Irene, a saintly widow. After recovering, Sebastian denounced the persecution of Christians, whereupon Diocletian ordered him flogged to death.[1]

Since the early Renaissance, images of Saint Sebastian had typically shown his idealized nude body pierced by arrows. Wtewael depicts an earlier moment, as archers prepare for their attack, so his body is inviolate. The frayed rope that lightly binds Sebastian's wrist to the broken branch of a tree and the two henchmen who tie his leg to its trunk fail to restrain his powerful, twisting body. Triumph over mortality is also expressed by his rapturous gaze at the putto descending with a laurel wreath and branch, sign of the victor.[2] The unstable pose presents his muscular, nearly nude figure in elaborate contrapposto at the

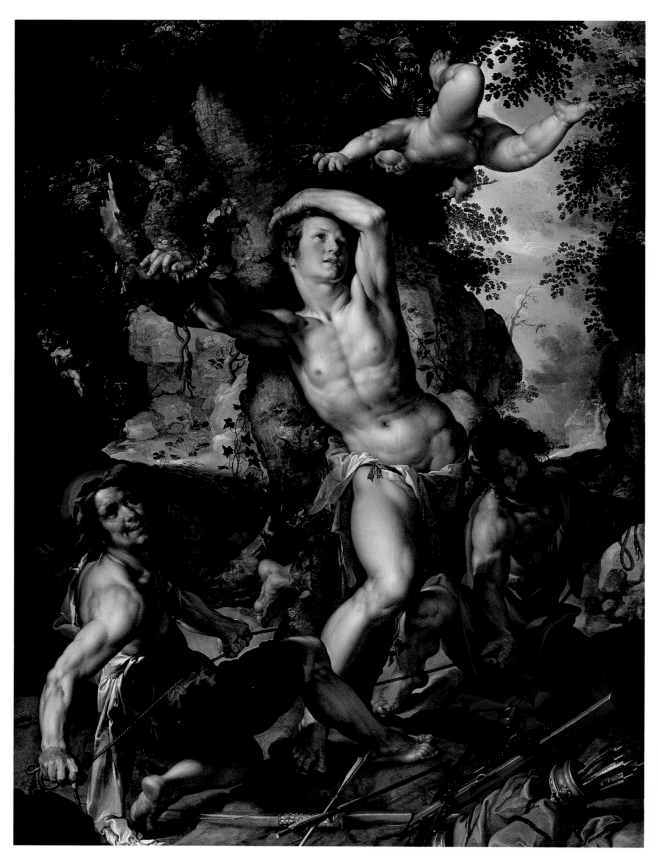

Cat. 2

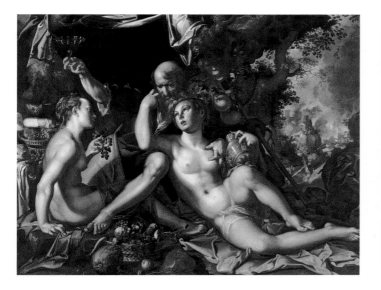

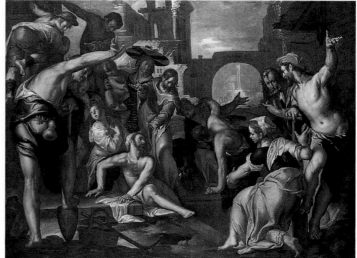

Fig. 1 Joachim Wtewael, *Lot and His Daughters*, ca. 1600. Oil on canvas, 165.1 × 208.3 cm (65 × 82 in.). Los Angeles County Museum of Art, Gift of the Ahmanson Foundation, M.81.53.

Fig. 2 Joachim Wtewael, *The Raising of Lazarus*, ca. 1600. Oil on canvas, 76.8 × 101.6 cm (30¼ × 40 in.). Private collection.

───────────────

composition's core, concentrating attention on the youth's beauty and willing acceptance of his fate.

This painting exemplifies the high artifice and formal conventions of Dutch mannerism, a stylistic trend that had peaked around 1590. It flourished in Utrecht long after subsiding in Haarlem, Amsterdam, and The Hague. The densely worked surface betrays a characteristic *horror vacui*. Our experience of fictive space is manipulated so as to confine us to a shallow foreground but for two breaks into depth. Spatial tensions in this foreground area are intensified by diagonal thrusts, on the surface by Sebastian's form against the angled tree, and in implied depth by lines of force created by the positions of his captors and the angel. The exaggerations of Sebastian's pose and the flaunting of his beauty reflect mannerist ideals of the human form, which was regarded as the prime vessel of aesthetic expression.

Sebastian's physical beauty is erotically charged. The pose, with upraised arms and slung hip, displays his voluptuous body, and the loincloth is suggestively arranged. Wtewael also depicts the angel in a revealing pose.[3] Even the apparent sadism of one of Sebastian's tormentors is noteworthy. The provocative nature of this image is important to a discussion of meaning and function. Eroticism is, to be sure, a major component of much mannerist art. In Wtewael's works, sensuality is pervasive and polymorphous, as his other paintings in the present exhibition demonstrate. In religious subjects, however, he usually mutes it, with the exception of several depictions of Lot and his daughters, which concern incest (fig. 1).[4] Even the extravagantly posed seminude figures in a *Raising of Lazarus* datable about 1600 (fig. 2) observe decorum with proper draperies.[5] His Evangelists, too, are sedate.[6] The *Saint Sebastian*, Wtewael's only other extant single-figure depiction of a saint, presents problems of interpretation. Was it conceived as a sacred or a secular image? Here are the arguments.

The painting may have been intended for a religious setting, such as a clandestine Catholic Church, either in Utrecht, where the Catholic population remained relatively large and powerful, or in another Dutch city.[7] We now know that the Church played a significant role as patron of the arts in the Dutch Republic, even after Catholic services were proscribed in 1580.[8] The vertical format, large scale, and rhetorical power of the painting, together with the exaltation of martyrdom,

would have suited it for Catholic veneration. So would the marked Italianate character of the conception. The saint's muscular form reflects the Michelangelesque ideal, and his heavenward gaze recalls martyrdoms by Correggio, Titian, and others that Wtewael could have seen in Italy in the 1580s.[9] The question arises, however, whether the sensual character of Wtewael's depiction was within acceptable limits, even if understood as an expression in which the life of the senses is explored as a means of understanding and conveying spiritual ecstasy. The Church struggled to define those limits after the Council of Trent passed a decree in 1563 prohibiting lasciviousness in the sacred use of images.[10] Abraham Bloemaert's boldly voluptuous *Penitent Magdalene* (ca. 1595; Musée des Beaux-Arts, Nantes) helps to establish the limits of acceptability in Utrecht around 1600.[11]

Wtewael's *Saint Sebastian* may instead have had a secular function. The prominence of archers and their weapons—arrows, quiver, longbow, and crossbow—lead Lynn Federle Orr and Wouter Kloek to suggest that this picture may have been commissioned by a civic guard company for exhibition in a guild hall.[12] Utrecht supported no prominent civic guard group, but in other Dutch cities Saint Sebastian was commonly associated with militia groups and was depicted in objects they commissioned.[13] As late as 1614, the martyrdom of Saint Sebastian figured in the sculptural program on the facade of the new Saint Sebastian's guild hall in Hoorn.[14] In view of the religious, erotic, and Italianate character of Wtewael's image, however, would it have been appropriate for public display in a setting devoted to the civic guards' official functions? Those groups, like municipal governments, were dominated by Calvinists.[15] Still, Jacob Matham could dedicate the engraving *Saint Sebastian* (Holl. 145) to the Protestant merchant Hendrick van Os.[16]

To sum up, the ambiguous character of Wtewael's *Saint Sebastian* together with the complex religious character of Dutch culture around 1600 leave open questions of function and interpretation. Wtewael's is apparently the only extant large-scale Dutch depiction of the saint from that time.[17] Not until the 1620s did paintings of Saint Sebastian comparable to Wtewael's in scale and power reappear in Utrecht. Hendrick ter Brugghen and Gerard van Honthorst (cats. 9, 10) then take us into another realm, of intense naturalism and deeply experienced emotion.

—A. W. L.

3 ABRAHAM BLOEMAERT
(1566–1651)

The Four Evangelists
ca. 1615

Oil on canvas, 177.5 × 226.1 cm (69⅞ × 89 in.)
Signed lower left, on the book: *A.Bloemaert fec.*
Princeton, The Art Museum, Princeton University. Museum purchase, Fowler McCormick, Class of 1921, Fund, y1991–41

Provenance: sale, Amsterdam, 4 Oct. 1779, lot 29; in Ireland since then; sale, Sotheby's (London), 6 July 1988, lot 27; sale, Christie's (New York), 31 May 1991, lot 51

Selected References: Roethlisberger 1992; Roethlisberger 1993, no. 223

The four Evangelists number among the oldest and most commonly represented figures in the Christian pictorial tradition. The combination of all four as the subject of a single easel painting, on the other hand, is exceptional, though there are precursors in Netherlandish art of the sixteenth century, such as pictures by Frans Floris and Pieter Aertsen (as well as Bloemaert's successors).[1]

Stylistically the Princeton painting is to be placed around the middle of the second decade of the seventeenth century. Space and the composition of figures are much more rational and less ornamental than in the 1612 *Adoration of the Shepherds* (Musée du Louvre, Paris),[2] while the study drawings in Vienna for the figure of Matthew and in

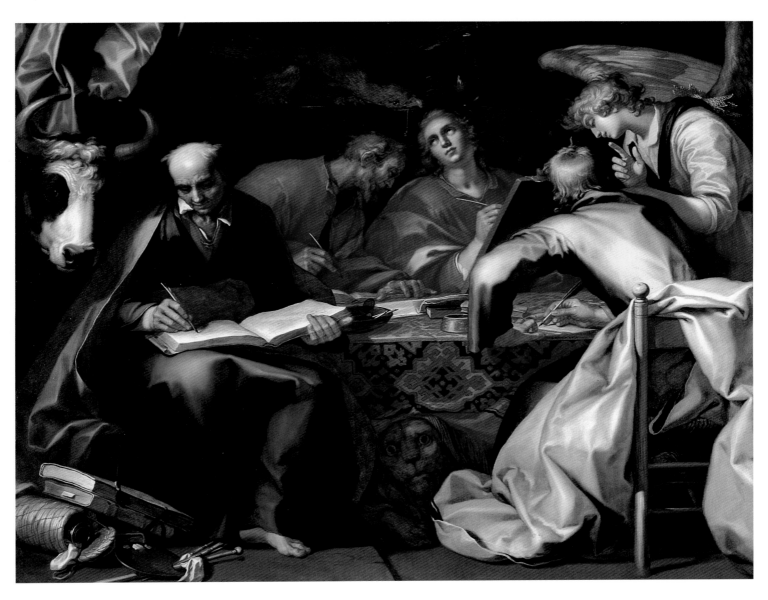

Cat. 3

Groningen for John (fig. 1) are very close to the one for Mary and Joseph of the *Adoration*.[3] As with quite a few undated works by Bloemaert, even a relative chronology is hard to establish. This is because the painter used different styles or stylistic "modes" at the same time, depending on the kind of work he was undertaking. It can be shown that especially for commissioned work he was very capable of furnishing patrons with a style they preferred. For the commissions of the court of the stadholder in The Hague in the 1620s he, together with the court painter Gerard van Honthorst, his pupil, developed a brand of classicism that suited this circle of patrons. He used a style much in

accordance with contemporary Flemish painting for the altarpieces going to Southern destinations.

His paintings for Northern Netherlandish Catholic churches, or what was used as such, are astonishingly different. They first of all betray a more common iconography than some of the Southern works. These included themes highly involved with Catholic teaching like the *Intercession Altarpiece* of 1615 for St. Janskerk in Den Bosch, or with innovative hagiography like the *Vision of Saint Ignatius at La Storta*.[4] Religious paintings for the North, on the other hand, include several versions of the *Adoration of the Shepherds*, a *Crucifixion*, and a *Lamentation of Christ*.[5] If one takes the Amsterdam

 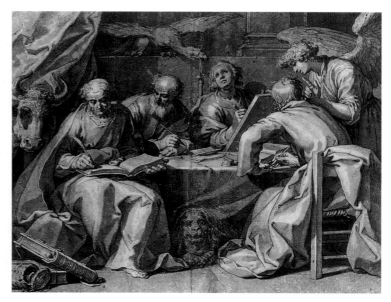

provenance of the Princeton painting seriously, it would be quite fitting that the Four Evangelists too is a subject in no way destined to raise confessional strife.

Furthermore, the style of the Northern religious paintings is much calmer, more contained, and less confrontational than the Southern works. These are clearly emulating works by Otto van Veen and later Peter Paul Rubens,[6] while the Northern ones seem to aim less at addressing the beholder's affection and compassion and more toward conveying a sense of time-honored dignity, resulting in much less active figures and a certain degree of archaism. This, to be sure, is much more apparent in Bloemaert's paintings of the third decade of the century, but some of it might account for the difficulties arising from comparing the *Evangelists* and their nearest dated contemporary, the *Intercession Altarpiece*.

Not quite in congruence with the probable provenance from a Northern *huiskerk* is the fact that there is a very neatly executed preparatory drawing for the whole composition (fig. 2)—clearly to present to the patron. Following late medieval practice, official contracts between artists and patrons were normally based on a drawing like this one. In fact, for most of Bloemaert's official commissions, that is, for paintings for Southern churches and for the court in The Hague, a similar drawing is extant or recorded.[7] On the other hand, that a Catholic patron in the North would resort to this measure of official control over the artist, making use of a written contract, is highly unusual; for none of the paintings known to be done for religious purposes in the North is there a drawing of comparably thorough execution.[8] Typical for Bloemaert's working procedure are changes made even after working out the composition in such a detailed way, some being of minor importance, but some, like the changed figure of Mark, quite radical. An almost identical repetition of the Berlin drawing for an unknown purpose is by a somewhat weaker hand, conceivably from Bloemaert's studio. A graphic reproduction of the Berlin sheet was done some eighty years later in Italy.[9] Although laden with mannerist features (coloring, lack of action, *horror vacui*), there are also aspects of the Princeton painting that seem to foreshadow Bloemaert's further stylis-

tic development. The very shallow stagelike setting, for example, foretells that of the *Four Church Fathers* of one and a half decades later.[10]

More usual than the combination of the four Evangelists in one picture was the formation of a series of single pictures. This was quite common in graphic art and had sometimes been executed in painting, for instance by Anthonie Blocklandt and Joachim Wtewael,[11] and was soon to be picked up by the Caravaggists. Their tendency to depict individual figures on separate canvases to be hung as a series was an adaptation of older Netherlandish pictorial traditions. Early tondi by Bloemaert, for instance, representing heads of Bacchus, Ceres, and Venus are known; combined they form the subject *Sine Cerere et Baccho friget Venus* (Without Ceres and Bacchus, Venus is cold; Terence). The Evangelists as a series of four paintings were treated by Hendrick ter Brugghen and Jan van Bijlert.[12]

Outside of Utrecht Evangelists series were quite common; examples include those of Pieter Lastman and Jan Lievens. A series in Berlin has been attributed to Bloemaert's son Hendrick. Another series in Rouen—with Mark identical to, John comparable with, and Matthew and Luke different from the Berlin series—has traditionally been given to Karel Dujardin, an attribution that is less convincing.[13] Although the painterly quality of the Rouen works seems to be greater than that of the Berlin series, it is hard to tell whether they are by the same hand. Finally, the four paintings from Bloemaert's workshop, each showing an Evangelist in a landscape, clearly are derivatives of the figures of the Princeton canvas. For this purpose Matthew, who in the big painting turns his back, had to be reinvented.[14] His rendering, indeed, is the weakest of the four, which together reveal a pattern of modified copying that best fits the artistic personality of Bloemaert's son Hendrick.[15]

—G. S.

4 HENDRICK TER BRUGGHEN (1588–1629)

Calling of Saint Matthew

1621

Oil on canvas, 102.3 × 136.9 cm (40¼ × 53⅞ in.)
Signed and dated: *HTB* [in monogram] *rugghen fecit. 1621*
Utrecht, Centraal Museum, 5088

Provenance: sale, Graaf van Hogendorp (The Hague), 27 July 1751; sale, Christie's (London), 26 Jan. 1923; with J. Goudstikker (Amsterdam), 1924; purchased from the J. Goudstikker Gallery with assistance from the Vereniging Rembrandt, 1925

Selected References: Utrecht 1952, 50, cat. 75, fig. 58; Nicolson 1958b, 6–7, 9, 12, 16, 40, 44, 54, 71, 72, 84–86, 88, 99–101, cat. A69, 120, figs. 26, 27, and frontispiece; Blankert and Slatkes 1986, 20, 22, 23, 27, 28, 29, 88, 55, 90–92, cat. 5, 102–104, 123, 182, 200, 222, fig. on p. 91; Von Schneider 1933, 35, 36, 73, 141, fig. 11a

Baltimore and London only

Like most of his colleagues, Hendrick ter Brugghen spent years studying in Italy. Greatly influenced by the awe-inspiring beauty of Caravaggio's work, which he had seen in Rome and probably in Naples as well, he was among the first to return to Utrecht, in 1614. In the years that followed, he developed into one of the most gifted and original of the Dutch Caravaggisti. His *Calling of Saint Matthew* is a masterpiece in which the example of the Italian master is unmistakable. The painting became the symbol of Caravaggism in Utrecht. In 1621, the year in which it was executed, Ter Brugghen reached a pinnacle in his artistic development. The two magnificent flute players in Kassel (see cat. 41 and cat. 41, fig. 1) also date from that year.[1]

Both Luke and Matthew recount the episode depicted by Ter Brugghen. "And as Jesus passed by from thence, he saw a man, called Matthew, sitting at the place of toll: and he saith unto him, Follow me. And he arose, and followed him" (Matt. 9:9).[2] Ter Brugghen shows the tax-gatherer at the moment when he is summoned by Christ. Coming to a decision about the entire future life of his new apostle, Christ points to Matthew, whose initial

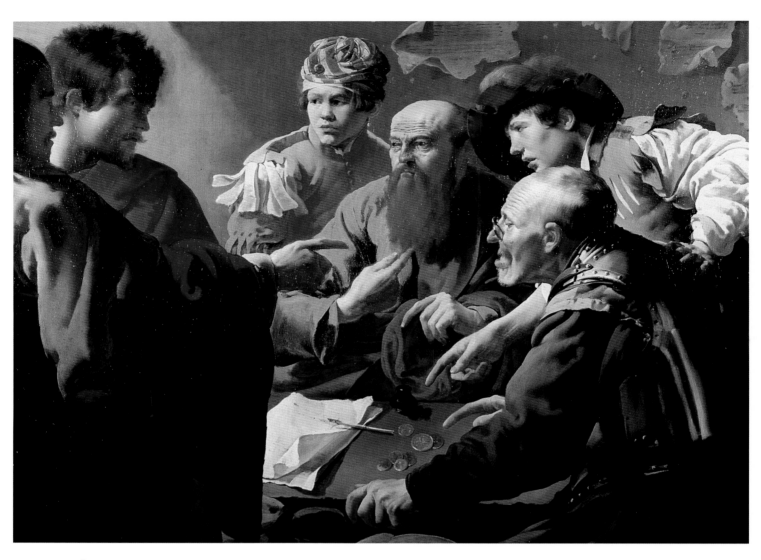

Cat. 4

reaction is to point inquiringly at himself, amazed that he is the one to have been singled out.

The subject of the calling of Matthew is of a piece with the genre of paintings depicting a conversion or a sudden moment of religious insight that was in great demand in Catholic circles in the first half of the seventeenth century. This was the heyday of the decoration of clandestine churches, which had been springing up since 1580, the year in which Catholic services were officially banned.[3]

Ter Brugghen painted two versions of the calling of Matthew. The immediate model for both was the painting commissioned from Caravaggio in about 1600 for the Contarelli Chapel in S. Luigi dei Francesi in Rome (see Orr, fig. 1, in this catalogue).

The fame of that work was instantaneous. Ter Brugghen shows himself to be a follower of the master in both style and iconography, but developed the theme in a highly personal way.

He adopted both Caravaggio's choice of the most dramatic moment in the story and his arrangement of the figures around a table. The realistic faces also testify to the Italian's influence. What Ter Brugghen did not do was to follow Caravaggio in the dramatic lighting of the scene. The latter used a sharp contrast between light and shade as a compositional and painterly device. This chiaroscuro became one of the hallmarks of Caravaggio's oeuvre.

Ter Brugghen's first version, now in Le Havre

Fig. 1 Hendrick ter Brugghen, *The Calling of Matthew*, ca. 1620. Oil on canvas, 152 × 195 cm (59⅞ × 76¾ in.). Musée des Beaux-Arts André Malraux, Le Havre, 77–7.

(fig. 1), is the closest to the Italian model, although the composition is reversed left for right. Christ stands before the table at which Matthew, some young men, and an old man with a pince-nez are seated. He is pointing at his future apostle. Behind Christ are two figures who have turned their backs on the scene. One of them is partly cut off by the edge of the picture. Several elements were borrowed almost literally from Caravaggio. The boy in the plumed hat, for instance, who has turned toward Christ, also appears in this pose in Caravaggio's painting.

In the second version, the one that is in Utrecht, it is Christ who is truncated by the left-hand edge. He is seen partly from the back, while Matthew is depicted almost square-on. Matthew's pointing hand is literally the centerpiece of the composition, and in that respect Ter Brugghen's is a very different compositional solution from Caravaggio's.[4]

The figures in this second version are also different in that they are life-size half-lengths, not the full-lengths of Caravaggio's version and Ter Brugghen's own first version. The foreground has disappeared, making the composition far more compact. The entire focus is on the drama and on the various pointing hands in the center. Those six gesticulating hands form the crux of the action both compositionally and in terms of content. They recall the hands in the painting by Albrecht Dürer in which the twelve-year-old Christ is trying to demonstrate his learning to the doctors.[5] Caravaggio and Dürer were not the only influences on Ter Brugghen. Other sources of inspiration were the money-changers and tax-gatherers of Marinus van Reymerswaele and Lucas van Leyden's cardplayers.[6]

Ter Brugghen's use of color, too, is entirely different. Caravaggio used warm, brown shades; Ter Brugghen placed blue beside violet and pink beside creamy white tones. His soft, atmospheric light does not make for an Italian drama but for a cool, Northern harmony, and gives the picture the silvery luster that has made it so famous.

—L. M. H.

5 HENDRICK TER BRUGGHEN
(1588–1629)

Doubting Thomas

ca. 1622–23

Oil on canvas, 108.1 × 133.2 cm (42½ × 52⅜ in.) Amsterdam, Rijksmuseum, SK-A-3908

Provenance: Although the size of the Ter Brugghen painting of this subject recorded by De Bie (1708, 276) as having been in the sale of the Abraham Peronneau collection, Amsterdam, 13 May 1687 was given as 4 *voet* 4 *duim* by 4 *voet*, approximately 123.4 × 113.1 cm (approx. 48⅝ × 44½ in.), if the height and width have been transposed, as seems to have been the case with other pictures in the Peronneau sale, the size is close enough to have been the present work. Perhaps the picture of Saint Thomas, sold in London 14 Jan. 1809 as Honthorst, from the collection of Sir George Pauncefote; see Fredericksen 1990, 481; this would accord with what is known of the history of the present picture, which is said to have been acquired in England during the early nineteenth century. In 1922 it was reported to have been in the Jackson family for about 100 years—beginning with Samuel Jackson, a London watchmaker. It remained in the Jackson family after Samuel Jackson's death in the early 1880s and for a time

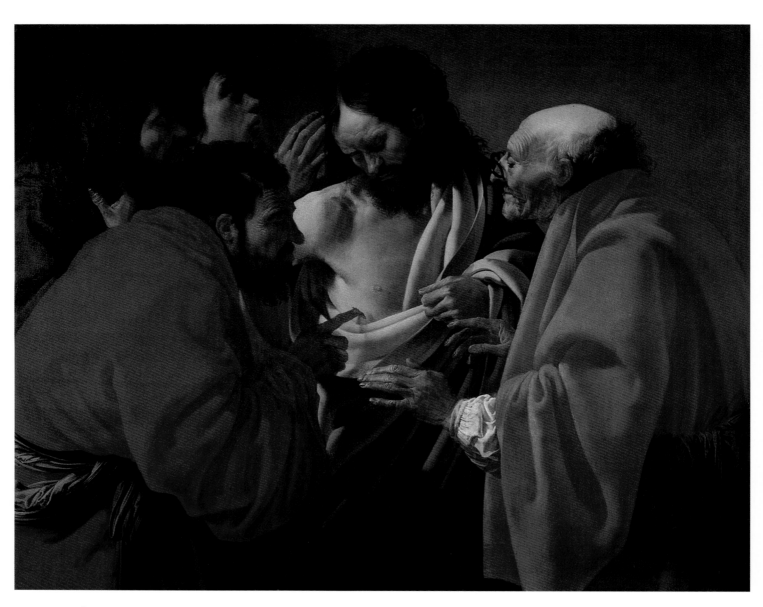

Cat. 5

was with his brother in Brockville, Canada, after having been relined by Gladwell Brothers, London, in 1882. Miss G. Jackson coll., Kitchener, Canada, 1922. The painting was purchased by Colnaghi's (London) in 1956, from A. Y. Jackson, a painter. It was acquired by the Rijksmuseum, Amsterdam, in 1956.

Selected References: A. Y. Jackson 1922; Nicolson 1956, 103–10; Nicolson 1958a, 86; Nicolson 1958b, cat. A2, pls. 50–52; Gerson 1959, 315; Plietzsch 1960, 145; Judson 1961, 346; Gerson 1964, 562; Slatkes and Stechow 1965, 8; Bissell 1971, 290; Van Thiel 1971, 109; Nicolson 1973, 239; Nicolson 1979, 99; Bissell 1981, 66; Bolten et al. 1981, 3–4, 6, fig. 2; Blankert and Slatkes 1986, cat. 12, color illus.; Kitson 1987, 137; Nicolson and Vertova 1989, 1:192, 3: pls. 1149–50

The story of Saint Thomas's incredulity is found only in the Gospel of John (20:24–29). Thomas, who was not present when Christ first appeared to the other apostles after the Resurrection, refused to believe what the others told him: "except I shall see in his hands the print of the nails, and put my finger into the print of the nails, and thrust my hand into his side, I will not believe." When Jesus appeared again, eight days later, he told the unbelieving Thomas, "Reach hither thy hand, and thrust it into my side." In Italian art, this moment was usually depicted with the saint extending his hand toward the wound in Christ's side. In the North, however, the scene was frequently rendered with Christ firmly grasping Thomas's wrist and inserting his finger physically into the wound.[1] Significantly, this more typically Northern formula was taken up by Caravaggio in his *Incredulity of*

Saint Thomas.[2] Indeed, there is little doubt that the present picture was directly influenced by Caravaggio's interpretation of the theme, although Ter Brugghen has modified the Italian master's vigorous depiction of the thrusting of the saint's finger into a more tentative gesture. Furthermore, a pentimento on the saint's hand and finger may indicate that originally Ter Brugghen stopped short of having Thomas actually put his finger into the wound. As with his 1621 *Calling of Saint Matthew* (cat. 4), Ter Brugghen has reversed Caravaggio's composition and, in this instance, added, on the right of the present picture, the archaizing figure of an apostle with spectacles depicted in a typical sixteenth-century Netherlandish manner reminiscent of such artists as Marinus van Reymerswaele.[3]

The Amsterdam picture has normally been dated close to Ter Brugghen's 1625 *Crucifixion* (cat. 8), for the most part because both works seem to have shared now-lost drawings for Christ's head and that of Saint John the Evangelist.[4] Furthermore, both compositions utilize archaizing elements, although the *Crucifixion* is such an unusual picture that it cannot easily—or safely—be used to date other works. Complicating the situation is the fact that the archaizing apostle in the present canvas is closely related to, and perhaps even based on a similar figure on the right side of, the 1621 *Calling of Saint Matthew* (cat. 4).[5]

Although Nicolson[6] and Van Thiel[7] settled on a date close to that of the *Crucifixion*, about 1624, both have had to explain away the unusually strong Italianate character of this picture and, especially, its indebtedness to Caravaggio's depiction of the subject. Initially, however, Nicolson had suggested a date somewhat earlier in the 1620s.[8] One of the more telling elements in support of an early dating, as suggested here, is the way the face of the apostle with spectacles is rendered with an application of fluid strokes similar to that in the analogous figure on the right of the *Calling of Saint Matthew.* Thus, the date of the present picture

should be moved back by at least a few years—to 1622, but probably no later than 1623—to bring it closer to 1621. This is a time when comparable archaizing elements are more common in Ter Brugghen's work, for example, in the *Calling of Saint Matthew* and the 1620 *Crowning with Thorns* (cat. 6). These are more suitable comparisons for our picture since the archaic sources and aesthetic formulations of the *Crucifixion* are quite different from those utilized here. This earlier date would still put the *Thomas* close enough to the *Crucifixion* for several of the same drawings and studies to have been reused.

If the present work does indeed date as early as 1622, then the possibility should be considered that Baburen, recently returned from Rome, was at least partly responsible for Ter Brugghen's renewed interest in Caravaggio's composition. Significantly, it now seems likely that Baburen executed a painting of Saint Thomas in Italy, although none of the pictures of this theme now assigned to him can be sustained.[9] Nevertheless, at least one Italian-period work by a Northern Caravaggesque artist does seem to reflect his style.[10]

—L. J. S.

6 HENDRICK TER BRUGGHEN
(1588–1629)

Crowning with Thorns
1620

Oil on canvas, 207 × 240 cm (81½ × 94½ in.)
Signed and dated on the marble block, lower left:
HTB [in monogram] *rugghen 1620*
Copenhagen, Statens Museum for Kunst, 365

Provenance: perhaps the *Croninge Christi, van Terburg* (Crowning [of] Christ by Terburg) listed in the inventory of Frederik Alewijn, ca. 1665 (Moes 1900, 223), although there are several other Ter Brugghen pictures that would also fit this description; purchased by Gerhard Morell (1710–1771) in 1755, as Honthorst[1]

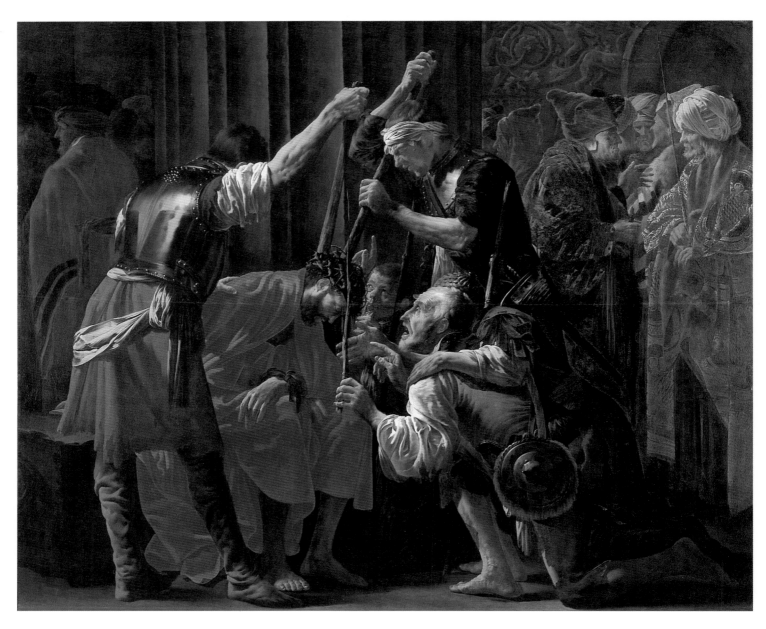

Cat. 6

Selected References: Houck 1900, 520; Von Wurzbach 1906–11, 2:703; Voss 1924, 471; Baumgart 1929, 226–27; Von Schneider 1933, 141, pl. 17b; Isarlo 1941, 234; Royal Museum of Fine Arts, Copenhagen 1951, cat. 105, illus.; Bloch 1952, 16; Utrecht 1952, cat. 72, fig. 59; Nicolson 1956, 104; Schoenenberger 1957, 14, 41, 75, 77, 80, 81; Nicolson 1958b, cat. A18, pls. 6, 7, 10; Gerson 1959, 317; Judson 1959, 85; Judson 1961, 346; Gerson 1964, 563; Slatkes 1965, 14, 44, 67, 95; Van Thiel 1971, 110; Van Thiel 1974, 121; Nicolson 1979, 98; Blankert and Slatkes 1986, cat. 3, illus.; Van Kooij 1987, 7–9, illus.; Copenhagen 1988, cat. 1012; Nicolson and Vertova 1989, 1:190; Broos 1993, 101, fig. 2; Luijten et al. 1993, 106, 107, fig. 190

London only

Although the subject of this picture has some-times been identified as a Mocking of Christ—and indeed it does incorporate mocking elements such as the kneeling old man and the shouting boy—this impressive canvas, the largest surviving work by Ter Brugghen, is, strictly speaking, a Christ Crowned with Thorns. The merging of one narra-tive moment into the next is hardly unusual in Northern European art, especially with these two closely related scenes.

Executed before the full impact of the re-turning Honthorst and Baburen manifested itself in Utrecht, the present work is a product of Ter

Fig. 1 Lucas van Leyden, *Christ Crowned with Thorns* (B. 62), from the Round Passion, 1509. Engraving, 295 mm (11⅝ in.). Rijksprentenkabinet, Amsterdam.

Fig. 2 Lucas van Leyden, *Christ Crowned with Thorns* (B. 69/1), 1512. Engraving, 168 × 128 mm (6⅝ × 5 1/16 in.). Rijksprentenkabinet, Amsterdam.

Brugghen's personal blending of the Roman Caravaggesque manner with archaistic elements drawn from sixteenth-century Netherlandish sources such as the engravings of Lucas van Leyden (fig. 1). In this, Ter Brugghen seems to have been self-consciously tempering his Caravaggism with traditional Northern elements to make the new style more acceptable to conservative Utrecht tastes. Since this painting was executed during a period of growing Dutch nationalism, and it is dated 1620, the year before the end of the Twelve Year Truce, this possibility becomes even more tenable.

It is clear from the various actions depicted here that Ter Brugghen has condensed the most relevant parts of the Gospel of Matthew (27:27–30) dealing with the events of the Mocking of Christ and the Crowning with Thorns and turned the narrative into a single complex composition: "And they stripped him, and put on him a scarlet robe.[2] And when they had platted a crown of thorns, they put it upon his head, and a reed in his right hand: and they bowed the knee before him, and mocked him. . . . And they spit upon him, and took the reed, and smote him on the head." That this simultaneity of action was Ter Brugghen's intention is supported by his use of elements borrowed from different scenes from Lucas van Leyden's 1509 Round Passion (B. 61 and 62), as well as another slightly later Lucas engraving (B. 69).[3] The rendering of the disputing group of figures on the right was apparently suggested by the analogous group in Lucas's *Flagellation* (B. 61),[4] while the armored soldier on the left may be compared with a figure in Lucas's *Christ Crowned with Thorns* (fig. 1).[5] Additionally, the kneeling man handing the reed to Christ in the Copenhagen picture is unusually close to a figure removing the reed from Christ's hand in Lucas's 1512 *Christ Crowned with Thorns* (fig. 2). Above all, it is the faithfulness of these appropriations that lend so pronounced an archaic quality to this work. Significantly, large-scale paintings of the accounts of Matthew 27:27–30, Mark 15:16–19, and John 19:2–3 are relatively

rare in earlier Netherlandish painting,[6] although they are common enough in German art of the fifteenth and sixteenth century.

One of the clearest accounts of the episodes that make up the Crowning with Thorns and the Mocking of Christ is found in Jacobus de Voragine's *Golden Legend*, which intersperses these events with the various disputations that took place.[7] Ter Brugghen has tried to capture the synchronous nature of these actions by representing the disputations as a continuous event—with individuals coming and going—interrupted by the large fluted pier and a pseudo-classical relief before which the action takes place.[8] In keeping with the other graphic sources used throughout this work, the frieze has been borrowed from an engraving of about 1530 by Giulio Bonasone, *Decorative Frieze with Winged Centaur* (B. 353).[9]

Of the two most prominent disputants on the right of the present composition, the lavishly gowned and turbaned figure must represent Pilate,[10] while his opponent in all likelihood is Caiaphas. Both Lucas van Leyden and Albrecht Dürer also included various disputing individuals in their graphic depictions of the Passion, and their use of costumes connotes a similar contrast of types,[11] suggesting this too was Ter Brugghen's intention. Importantly, Pilate's robe is based on the famous late Gothic cope of David of Burgundy, bishop of Utrecht between 1456 and 1496. This liturgical vestment, which was later used by Ter Brugghen in several other works,[12] as well as by other Utrecht artists,[13] is still preserved.[14] Although Ter Brugghen's use of an actual bishop's cope for Pilate may seem unusual, it is in keeping with the stage directions found in mystery plays, which state that Pilate was to be costumed as a medieval bishop.[15]

One of the more striking and expressive elements in this picture is Ter Brugghen's use of gestures. Again it is clear that Caradvaggio is the general as well as the specific source. Other Ter Brugghens, for example both the Le Havre *Calling*

of Saint Matthew (cat. 4, fig. 1) and the 1621 version of this theme (cat. 4), make it clear the Italian master's use of gestures was an important expressive ingredient of Ter Brugghen's early Utrecht style. In the case of the present composition, however, it is likely that Ter Brugghen's source was the gestures in Caravaggio's *Madonna of the Rosary*,[16] at this time still in Amsterdam where it had been brought by the artist and art dealer Louis Finson.[17]

—L. J. S.

7 DIRCK VAN BABUREN
(ca. 1595–1624)

The Mocking of Christ
ca. 1622

Oil on canvas, 106 x 136 cm (41¾ × 53½ in.)
Signed on upper right: *Baburen f*
Utrecht, Rijksmuseum Het Catharijneconvent, 9

Provenance: Provincialaat der Minderbroeders (Weert), by 1900; transferred to Rijksmuseum Het Catharijneconvent, Utrecht

Selected References: Slatkes 1965, no. A17, fig. 16; Blankert and Slatkes 1986, 267, no. 35, illus.; Gregori et al. 1987, 98; Goheen 1988, 54–55, illus.; Nicolson and Vertova 1989, 1:54, 2: fig. 1041; Huys Janssen 1990, 26, fig. 13; Slive 1995, 24–25; *Dictionary of Art* 1996, 3:8

The full expressive potential of the Caravaggesque idiom is realized in Baburen's *Mocking of Christ*. The three-quarter-length, nearly life-sized figures, hemmed in on every side by the edges of the canvas, threaten to explode out of their pictorial confines. This sense of pent-up power is accentuated by the vehemence with which Christ's tormentors carry out their task. Violence written across their faces, their powerful gnarled hands encircle the Savior's head with clenched fists. Treated infrequently during the Italian Renaissance, the Mocking of Christ appeared frequently in sixteenth-century Northern art and was a recurrent theme during the Counter-Reformation,

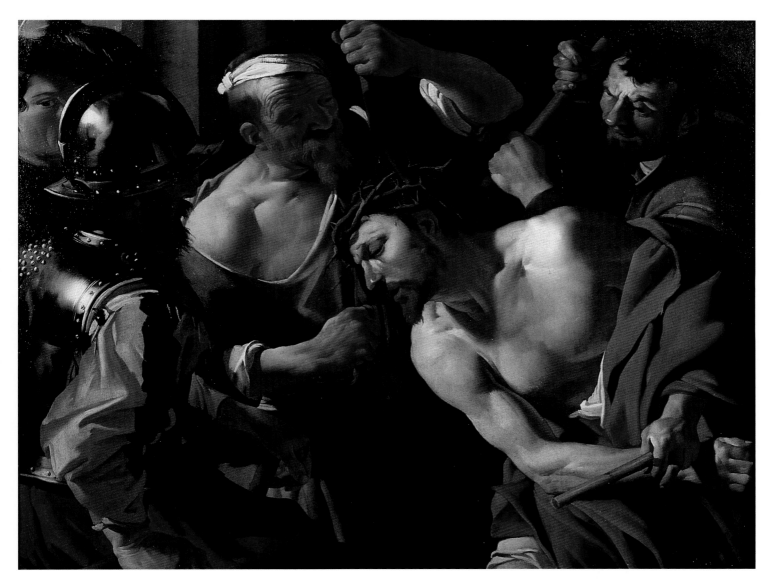

Cat. 7

when meditation on the physical suffering of Christ was seen as an aid to personal devotions. The Caravaggisti favored the subject, with its potential for intense, brutal drama.[1]

One of only a few religious themes treated by Baburen after his return to Utrecht,[2] *The Mocking of Christ* exists in two autograph versions: the present picture and a slightly larger canvas (see Spicer, introduction to this catalogue, fig. 2) now in Kansas City.[3] As frequently with the Utrecht Caravaggisti, it is through the filter of Bartolomeo Manfredi that Baburen absorbed compositional motifs introduced by Caravaggio. A *Crowning of Thorns* with four half-length figures by Caravaggio is recorded in the 1638 inventory of the Roman

collector Marchese Vincenzio Giustiniani.[4] As Baburen was himself patronized by the marchese (his own *Christ Washing the Feet of the Apostles* being cited in the same inventory),[5] he surely must have been familiar with Caravaggio's painting. Known today through a canvas (fig. 1) in Vienna,[6] Caravaggio's treatment of the subject spawned numerous related compositions, most notably by Manfredi, by whom at least twelve depictions of the theme are known.[7]

Manfredi's many variations are staged with from two to nine figures. The central motif of the seated Christ, hunched over at the convergence of the tormenters' sticks, is, however, repeated in each. A conflation of several Manfredi models, the

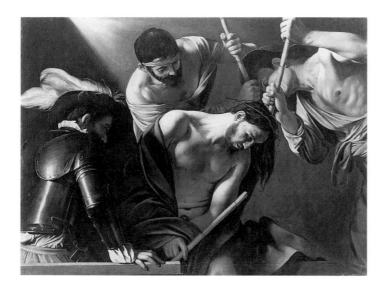

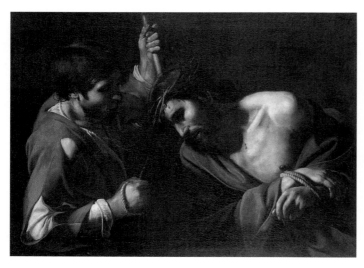

Fig. 1 Caravaggio (?), *Crowning with Thorns*, ca. 1605. Oil on canvas, 127 × 165.5 cm (50 × 65⅛ in.). Gemäldegalerie, Kunsthistorisches Museum, Vienna, 307.

Fig. 2 Bartolomeo Manfredi, *Crowning with Thorns*, ca. 1610–15. Oil on canvas, 82.6 × 110.5 cm (32½ × 43½ in.). Museum of Fine Arts, Springfield, Massachusetts, 95.04.

Baburen design for the positioning of Christ and his two persecutors closely follows the Munich *Crowning with Thorns*, variously given to Manfredi or David de Haen.[8] In another version by Manfredi (fig. 2),[9] the position of Christ is reversed, as it is in both Baburen paintings.

At first glance, Baburen's two depictions of the scene seem almost identical. But subtle, yet crucial, alterations between the painting in Kansas

City and the later painting in Utrecht have changed the compositional and emotional intensity of the image.[10] In the earlier version, Baburen portrayed the soldier at the far left looking away from the central figures, toward two bystanders. This figural arrangement reflects another composition by Manfredi known through a copy in the Musée des Beaux-Arts in Nantes.[11] In the Utrecht version, Baburen's turning of this figure back in toward the center of action condenses the focus.[12] In this later painting, every pictorial element converges diagonally on the head of Christ, giving the viewer no obvious escape from the brutality of the scene.

Baburen's *Mocking of Christ* depicts one in a sequence of events called the Passion of Christ, those sufferings Jesus of Nazareth endured between his internal agony in the Garden of Gethsemane and his Crucifixion on Calvary.[13] On the evening before his death, Jesus was arrested and taken before Caiaphas, the high priest, to answer charges brought against him. Caiaphas demanded of Jesus, "Tell us if you are the Christ, the Son of God." Jesus said to him, "You have said so. But I tell you, hereafter you will see the Son of man seated at the right hand of Power."[14] With this response and its implicit challenge to the authority of the high priest, Jesus foretold the means of his abuse at the hands of his captors. The regalia of kingship—purple or scarlet robe, crown, and scepter—became the Instruments of the Passion.

> Then the soldiers of the governor took Jesus into the praetorium, and they gathered the battalion before him. And they stripped him and put a scarlet robe upon him, and plaiting a crown of thorns they put it on his head, and put a reed in his right hand. And kneeling before him they mocked him, saying, "Hail, King of the Jews!" And they spat upon him, and took the reed and struck him on the head. And when they had mocked him, they stripped him of the robe, and put his own clothes on him, and led him away to crucify him.[15]

Although the early history of both versions of Baburen's *Mocking of Christ* is unknown, the affiliation of the Utrecht version with a Franciscan community seems fitting, given that order's special emphasis on the Passion of Christ.[16] Derived from Saint Francis's own meditations, this preoccupation found compelling form in the writings of Saint Bonaventure, including his *Meditations on the Passion of Christ*.[17]

This thirteenth-century exhortation to visualize Christ's suffering paralleled the emotional approach found in Counter-Reformation teachings and practices, such as Saint Ignatius Loyola's *Spiritual Exercises*.[18] Widely read, Bonaventure's *Meditations* appeared in many Dutch translations. And although seemingly a specifically Catholic subject, such imagery drawn from the last hours of Christ's life would have found favor among Protestants, with their emphasis on the historical life of Jesus as revealed in the New Testament.

Among Caravaggesque treatments of the subject, such as Ter Brugghen's painting of 1620 (cat. 6), Baburen's is a particularly emotional, violent interpretation.[19] Clearly his painterly technique was well suited to the narrative. The coarseness of the figures is conveyed through the broad, animated application of paint, the color scheme dominated by earth tones. Dazzling surface effects, created by rich impasto, track the raking light that falls into the scene from stage left and shimmers in turn across armor, satin, weathered skin, and pale vulnerable flesh. The painter's provocative imagery of starkly contrasting pictorial elements—light and dark, religious and secular, tormenter and victim—is powerful and disturbing.

—L. F. O.

8 HENDRICK TER BRUGGHEN
(1588–1629)

The Crucifixion with the Virgin and Saint John
ca. 1625

Oil on canvas, 154.9 × 102.2 cm (61 × 40¼ in.)
Signed and dated at the foot of the cross: *HTB* [in monogram] *16[2]*[1]
New York, The Metropolitan Museum of Art, Funds from various donors, 1956. (56.228)

Provenance: probably commissioned by Adriaen Willemsz. Ploos, lord of Oudegein, Lievendaal, Tienhoven, and t'Geyn, ca. 1624; most likely the picture listed as no. 137 in the 27 June 1657 inventory of the effects of the Amsterdam art dealer Johannes de Renialme: *Christus aen het Cruys van van der Brugge* (Christ on the Cross by van der Brugge); the art dealer Martin Kretzer, who had owned Ter Brugghen's *Sleeping Mars*, placed the relatively high valuation of fl.150 on the painting; Christ Church, Hackney, East London, ca. 1878[?]–1956; acquired by Nigel Foxell; sale, Sotheby's (London), 28 Nov. 1956, lot 115, illus.; to Goldschmidt; with M. Sperling, 1956

Selected References: Gerson 1957; Virch 1958, 217–26; Nicolson 1958b, cat. A49, pls. 53, 54, 55c, 56, and 57; Nicolson 1958c, 88; Gerson 1959, 317; Nicolson 1960, 470 n. 23; Judson 1961, 347; Gerson 1964, 563; Slatkes 1965, 52–53 n. 27; Slatkes and Stechow 1965, cat. 9, illus.; Van Thiel 1971, 109; Nicolson 1979, 98; Blankert et al. 1980, cat. 11, color illus.; De Jongh 1980, 10; Blankert and Slatkes 1986, cat. 21, illus.; De Meyere 1987a, 350, illus.; Kitson 1987, 137; Schnackenburg 1987, 172; Nicolson and Vertova 1989, 1:190; Schillemans 1993; Bok 1996, 108–11; Slatkes in *Dictionary of Art* 1996, 5:4, fig. 3

Unlike Ter Brugghen's earlier exercises in the use of archaizing elements—for example, the *Crowning with Thorns* (cat. 6) and the *Doubting Thomas* (cat. 5)—the entire formal and aesthetic attitude of the present work is self-consciously old-fashioned. Whereas his earlier applications of sixteenth-century Netherlandish artistic motifs were apparently utilized to make the new Italian Caravaggesque elements acceptable to more conservative Utrecht tastes, a different approach is clearly at work in this canvas. Despite the fact that the artist most frequently cited in connection with this picture is Matthias Grünewald, the straightforward iconic structure, star-studded sky, and low

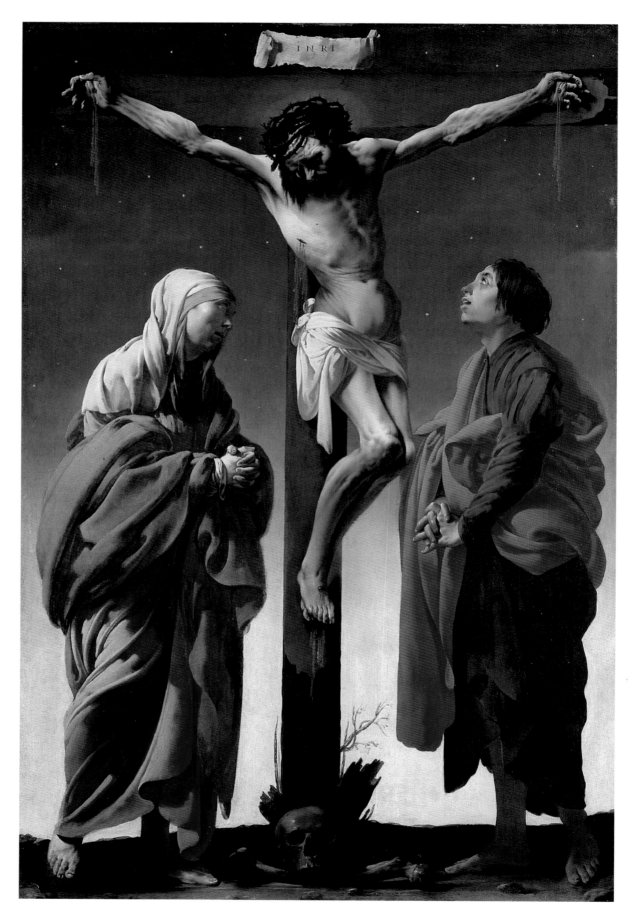

Cat. 8

horizon line of the composition suggest a Northern Netherlandish altar painting rather than a German one.[2] There is no evidence, however, that the painting ever served as an altarpiece during the seventeenth century, although there is a growing body of information that appears to indicate that it was intended as a pseudo-family heirloom for the wealthy commissioner.

It is difficult to find another seventeenth-century Dutch painting of such high quality that is also so deliberately archaic.[3] There are parallels, however, in the graphic arts. Hendrick Goltzius, for example, produced a number of engravings in the style of Albrecht Dürer and Lucas van Leyden. Karel van Mander even tells how Goltzius "aged" an impression of his 1594 *Circumcision*,[4] engraved in the manner of Dürer, by removing his own monogram and darkening the paper with smoke to deceive print connoisseurs and fellow graphic artists.[5]

The present work can be dated to the same period as the 1625 *Saint Sebastian Attended by Irene* (cat. 10), a work with which it shares several formal and coloristic traits. Certainly the unusual way of rendering the grayish flesh tones of Christ's hands and a similar manner of depicting the bound hand of Saint Sebastian link the two works. Another stylistically uncommon element shared by the two is the alabaster-like translucency with which Ter Brugghen endows the entwined fingers of Saint John, in the present picture, and the similar effect found in the cheek and nose of the servant woman in the *Saint Sebastian*. Additionally, the exact repetition of singular and subtle colors—such as the delicate peach tones of Mary's headdress in the *Crucifixion* and turbanlike one of Irene in the *Saint Sebastian*—suggests that the two canvases were executed in Ter Brugghen's studio at the same moment.[6]

There is growing documentation to support the notion that Ter Brugghen was commissioned to make a picture that could pass, at least to the untrained eye, for an early Northern Netherlandish altarpiece. Indeed, it is possible to cite a number of these earlier works that would have been more readily available to Ter Brugghen than those by Grünewald. For example, he must have known, to cite only the most obvious examples, the *Crucifixion* in the chapel of Guy van Avesnes in Utrecht's former cathedral, once associated with the Master of Zweder van Culemborg[7] but more recently assigned to an unknown Utrecht painter active about 1410.[8] Furthermore, various paintings and prints by that enigmatic fifteenth-century Delft artist known as the Master of the Virgo inter Virgines, whose curious blend of reticence and expressionism might have been especially attractive to Ter Brugghen, seems to have contributed to his basic conception. Indeed, the *Crucifixion* by this Delft painter includes a rendering of Christ that has much in common with the present picture.[9] Equally relevant by the Virgo Master is a woodcut illustration of the Crucifixion from about 1495 (fig. 1) from a missal with a Utrecht calendar, which not only presents a similar expressionistic attitude but also shows Mary and Saint John with fingers entwined in a similar gesture of lamentation.[10] The calender assures that it would have been known in Utrecht. One final Northern Netherlands prototype can be found in the *Crucifixion* from the altar of about 1435 known as the Roermond Passion,[11] with its basic iconic composition, expressive rendering of Christ, and star-studded sky. These various formal and expressive relationships reinforce the likelihood that the picture under discussion was painted with the intention of re-creating the appearance of a Northern Netherlandish painting. This is in contrast to other Ter Brugghen works, for example the *Crowning with Thorns* (cat. 6), that make use of archaistic elements drawn from sixteenth-century Northern art—especially the engravings of Lucas van Leyden—blended with Caravaggesque qualities.

The existence of a curious variant of the

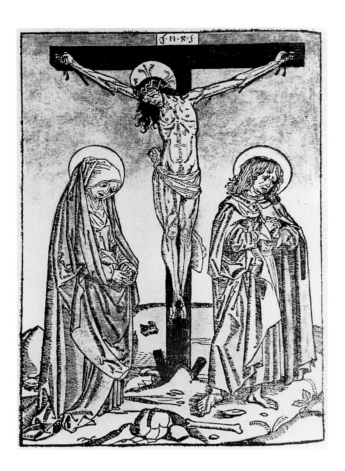

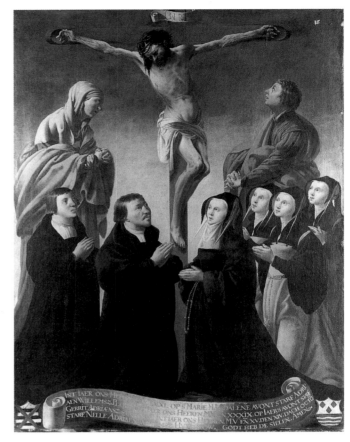

Fig. 1 Master of the Virgo inter Virgines, *The Crucifixion*, ca. 1495. Woodcut, from the *Missale Secundum Ordinarium Traiectensum*, 200 × 145 mm (7⅞ × 5¹¹⁄₁₆ in.). Delft.

Fig. 2 Anonymous (Utrecht?) artist, *Epitaph for the Family of Adriaen Willemsz. Ploos*, 1630–34. Oil on canvas, 106 × 80.3 cm (41¾ × 31⅝ in.). Centraal Museum, Utrecht.

present composition to which sixteenth-century portraits of the ancestors of Adriaen Ploos have been added, the so-called *Epitaph for the Family of Adriaen Willemsz. Ploos* (fig. 2), raises critical questions about the original function of Ter Brugghen's *Crucifixion* as well as the intentions of the commissioner. A good deal is known about Adriaen Ploos. However, the most relevant material with regard to our painting has to do with Ploos's petition for acceptance into the ranks of the Utrecht *Ridderschap* (knighthood).[12] Starting in 1624, Ploos began to assemble documentation that he would later present to prove he was a descendant of the old and noble line of Van Amstel van Mynden. It is likely that one of his first steps was to commis-

sion, probably in 1624 or 1625, the present *Crucifixion*, painted generally in the manner of the Crucifixion scene on an old family epitaph picture Ploos owned. This epitaph came from the family chapel in a Loosdrecht church. When his petition was nearly complete, most likely before 1634 but certainly after 1629 since Ter Brugghen was already dead,[13] Ploos commissioned some unknown (Utrecht?) artist to paint the false epitaph.[14] This memorial picture combines sixteenth-century family portraits—taken from the old epitaph that was in Ploos's possession at least as early as 1624—with Ter Brugghen's *Crucifixion*.[15] The old epitaph must have contained a Crucifixion roughly analogous to the present painting, at least according to the description given by the Utrecht humanist Aernt van Buchel.[16] The false epitaph, or perhaps a more portable version similar to the watercolor variant in a 1641 album,[17] was part of the documentation Ploos submitted in support of his petition in 1634. If this argument is essentially correct, then the

only altar our *Crucifixion* ever graced was the one erected to the ego of Adriaen Ploos or, as he was known after his petition was granted, Adriaen Ploos van Amstel.

—L. J. S.

9 GERARD VAN HONTHORST
(1592–1656)

Saint Sebastian

ca. 1620–23

Oil on canvas, 101 × 117 cm (39¾ x 46 in.)
Signed bottom left corner: *GvH* [in monogram]*onthorst fe.*
London, Trustees of the National Gallery, 4503

Provenance: (?) anonymous sale, Phillips (London), 27 July 1832, lot 138; private coll. (Bristol), by 1928; Mrs. Mabel Berryman coll., 1928

Selected References: Judson 1959, 88–90, no. 68, fig. 28;[1] Slatkes and Stechow 1965, 31–32; Slatkes 1973, 271, 273 n. 37; Blankert and Slatkes 1986, no. 61; Judson 1988, 113, fig. 138; MacLaren and Brown 1991, no. 4503, 192–93, pl. 169; Huys Janssen 1994a, 46, 98; Baker and Henry 1995, 318

Among the most starkly conceived figures of the early seventeenth century, this painting of Saint Sebastian by Honthorst celebrates the beauty and vulnerability of the male body. To those familiar with the story of Sebastian, an early Christian martyr executed in Rome by the emperor Diocletian in 288 A.D., this painting is also understood as a symbol of Christian steadfastness in the face of persecution—a reality that touched most European lives in the years of the Reformation and subsequent Catholic Counter-Reformation. Over the centuries, a rich layering of meaning had accrued to the person of Sebastian.[2] As martyr and one of the principal protectors against the plague,[3] Saint Sebastian appears with great frequency in Christian art (cats. 2, 10). In addition to a complex iconography, the subject presented artists with a rare opportunity to depict the male body nude within an acceptable religious context. These competing interests combine in Honthorst's image of Saint Sebastian in a manner that can best be understood against the religious and artistic backdrop of early seventeenth-century Rome.

As successive epidemics of plague afflicted Europe, the veneration of Sebastian and other "plague saints" had intensified. This devotional impulse was further strengthened later in the sixteenth and seventeenth centuries, the result of the reform movement within the Roman Catholic Church. Traditions, practices, and articles of the Catholic faith, challenged by the Protestants, were reasserted and practiced with novel fervor. New emphasis was placed on the Catholic veneration of the saints and their relics, the practices labeled idolatry by Protestant reformers. To faithful Catholic congregations the piety and commitment of the early martyrs were held up as worthy of emulation. Graphic portrayals of the martyrs' physical suffering were commissioned as tools to inspire and intensify personal religious devotion. Considerable resources were also expended in renovating churches, shrines, and sites dedicated to the Catholic saints.

In Rome, much of this energy focused on the holy places associated with Saint Sebastian, the third patron saint of the Eternal City, following only Saints Peter and Paul in importance. One of the seven great pilgrimage churches in Rome,[4] S. Sebastiano Fuori le Mura stood in ruins after centuries of neglect. Built in the fourth century, the basilica stood over an extensive ancient burial ground, the only Early Christian catacombs continually accessible since ancient times. This venerable site, originally dedicated to Saints Peter and Paul, whose bodies had been hidden there for forty years after the persecution by the emperor Valerian in 258, had been renamed in the ninth century for Saint Sebastian, who had been buried there after his martyrdom. During the pontificate of Paul V Borghese, his nephew (and one of Honthorst's future patrons), Cardinal Scipione Borghese, undertook the restoration of the medieval

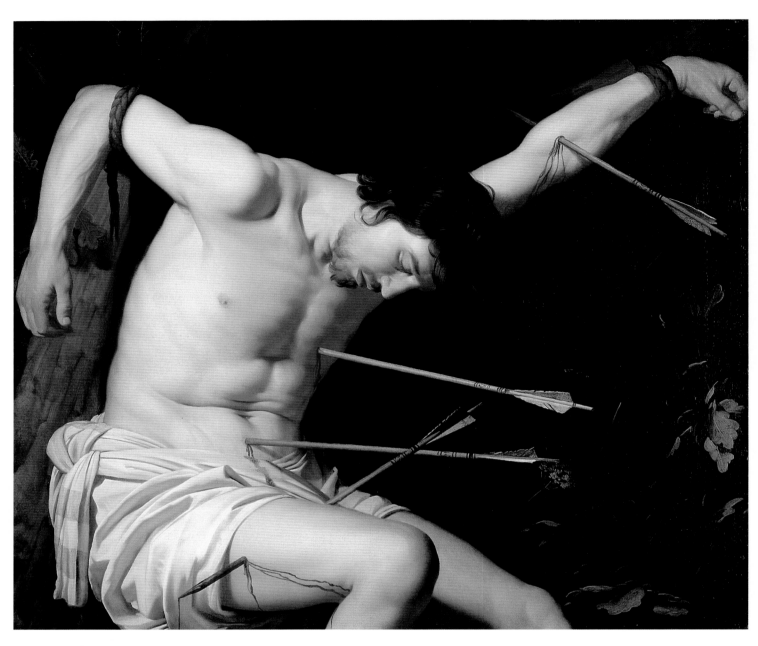

Cat. 9

church. Begun in 1608 by the Italian architect
Flaminio Ponzio, the project was completed under
the direction of Jan, or Joost, van Santen, called
Giovanni Vasanzio in Italian, a Dutch architect
born in Utrecht about 1550.[5]

Other projects relating to the worship of
Saint Sebastian included a commission from the
Barberini family for a chapel in the new Theatine
church of Sant'Andrea delle Valle, ordered in 1604
and inaugurated in 1616.[6] This project included
a subterranean chapel[7] dedicated to Sebastian
and believed to be situated on the spot where his

dead body was recovered from the Roman sewer
called the Cloaca Maxima. Another Barberini
project was the refurbishment of the tiny church
of S. Sebastiano in Palatino.[8] Thus, during Hont-
horst's years in Rome, from sometime before 1615
until 1620, many architectural projects centering
on the veneration of Saint Sebastian and requiring
works of art to decorate them were in the planning
stages or being completed.

Without contemporary documentation, the
London *Saint Sebastian* has proven difficult to date,
tied stylistically as it is to works dating from 1620

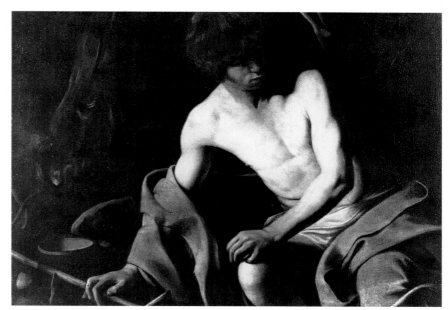

Fig. 1 Gerard van Honthorst, *Male Figure Study*, 1619. Black chalk on brownish paper, 424 × 264 mm (16⅝ × 10⅜ in.). Kupferstichkabinett, Staatliche Kunstsammlungen, Dresden.

Fig. 2 Caravaggio, *Saint John the Baptist*, ca. 1603–5. Oil on canvas, 94 × 131 cm (37 × 51⅝ in.). Galleria Nazionale d'Arte Antica a Palazzo Corsini, Rome, 433.

to 1623, the end of Honthorst's Italian period and his first years back in Utrecht.[9] If done in Utrecht, Honthorst's interest in the subject coincides with a series of plagues in that city.[10] In the context of the North, this slumped, three-quarter-length, seated *Saint Sebastian* is an original conception iconographically.[11] It is also stylistically unique in its classical description of the human figure with sculptural forms and sharp contours—its insistence upon what the Italians termed *disegno*.[12] And indeed it is in Rome that the evolution of this figural motif can be traced.

Discussions of the time he spent in Rome always emphasize Honthorst's artistic relationship with Caravaggio and his immediate followers. However, as has been pointed out, Honthorst's attention was not monopolized by the Caravaggesque. An interest in classical forms and academic practices is evident not only in this depiction of Saint Sebastian, but also in Honthorst's academic drawings from the live model (fig. 1).[13]

Part of the vocabulary of classicists and Caravaggisti alike was a compositional type representing a seminude male figure isolated before a landscape. Numerous examples include Guido Reni's standing *Saint Sebastian* (Galleria di Palazzo Rosso, Genoa),[14] Orazio Gentileschi's *David* (Galleria Spada, Rome),[15] Carlo Saraceni's *Saint Sebastian* (Castle Museum, Prague),[16] and Caravaggio's own seated depictions of Saint John, particularly the version in the Galleria Corsini, Rome (fig. 2).[17] In all of these works the idealized nude form is silhouetted against the landscape, the figure placed just within the pictorial space and thus very close to the viewer. It is this formal device that gives the figure a monumental character and makes the image so powerful.

The three-dimensional quality of the London *Saint Sebastian* has prompted comparison with both ancient and contemporary sculpture.[18] The young Gian Lorenzo Bernini's *Saint Sebastian* (fig. 3) of about 1615, previously in the collection of Don Carlo Barberini, the elder brother of Cardinal Maffeo,[19] also provides striking analogies. As discussed by G. van den Brink,[20] the two works share

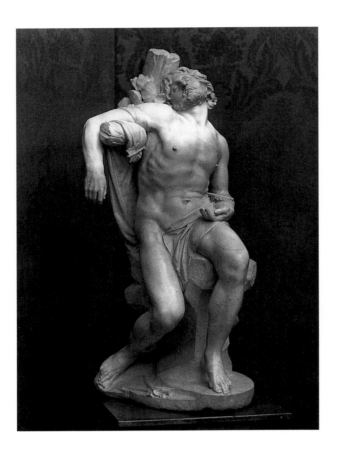

Fig. 3 Gian Lorenzo Bernini, *Saint Sebastian*, ca. 1615. Marble, height 98.8 cm (38⅞ in.). Thyssen-Bornemisza Collection, Lugano, K35.

aspects of the pose, figural type (particularly the physiognomy, including facial hair), and an intense focus, the figure being viewed in isolation. The unusual seated pose of Bernini's Sebastian, which is not conventional within the imagery of the saint and which is also used by Honthorst, has puzzled scholars.[21] In 1968, Irving Lavin discussed the Barberini sculpture in conjunction with Honthorst's *Saint Sebastian*, noting the unusual figural motif that they share and grouping them, together with the Saraceni, as works of a similar nature.[22]

Among these examples, Honthorst's originality is apparent. Synthesizing a variety of visual stimuli, he created a unique, stark interpretation of a popular religious theme. Isolated from all but minimal narrative context, the idealized male form is the focus. With no soldiers or attendant women to divert our attention, we are left to contemplate

the wounds inflicted on the saint's body. Honthorst has achieved a seamless mix of Italian baroque classicism and Northern attention to naturalistic detail. Against the beautifully sculptural body, clearly arranged and sharply contoured, streams of blood chart the shift in the body's pose from standing to seated,[23] create dried patterns on the skin, and drip off the arrow point. Subtle decorative elements such as the curvilinear shape of leaves, the muted stripe of drapery, and the design drawn on the arrow shafts help to relieve the starkness of the image. In its intensity of concentration, precise description of the idealized body, and striking corporeality, Honthorst's *Saint Sebastian* clearly responds to an artistic milieu that at that historical moment could only be experienced in Rome.

—L. F. O.

10 HENDRICK TER BRUGGHEN
(1588–1629)

Saint Sebastian Attended by Irene
1625

Oil on canvas, 175 × 120 cm (68¹⁵⁄₁₆ × 47¼ in.), reduced from 162 × 127 cm (63⅞ × 50 in.) with the removal of later additions from all sides but the right Signed and dated to the right of the three hands at the top left: *HTB* [in monogram] *rugghen fe 16[25]*[1] Oberlin, Ohio, Allen Memorial Art Museum, Oberlin College; R. T. Miller, Jr., Fund, 1953, 53.256

Provenance: most likely the picture listed as "Een Sint Sebastiaen van Ter Brugghe" (A Saint Sebastian by Ter Brugghe) in the collection of Pieter Fris, Amsterdam, who, on 30 Aug. 1668 gave a painting of this subject to Jan de Waale in payment of a debt.[2] Jan de Walé (Waale) sale (Amsterdam), 12 May 1706, lot 43, where it is described, somewhat inaccurately, as "Een doode St. Sebastiaen van Terbrugge" (A dead St. Sebastian by Terbrugge). The inscription on a 1841 dated drawing after the present painting, by Auguste Bigand, in a French private collection, indicates that the painting was in Rouen at that time; château de Laroque, Sarlat, near St-Cyprien (Dordogne), former residence of the archbishop of Beaumont; sold in an estate sale in Sarlat,

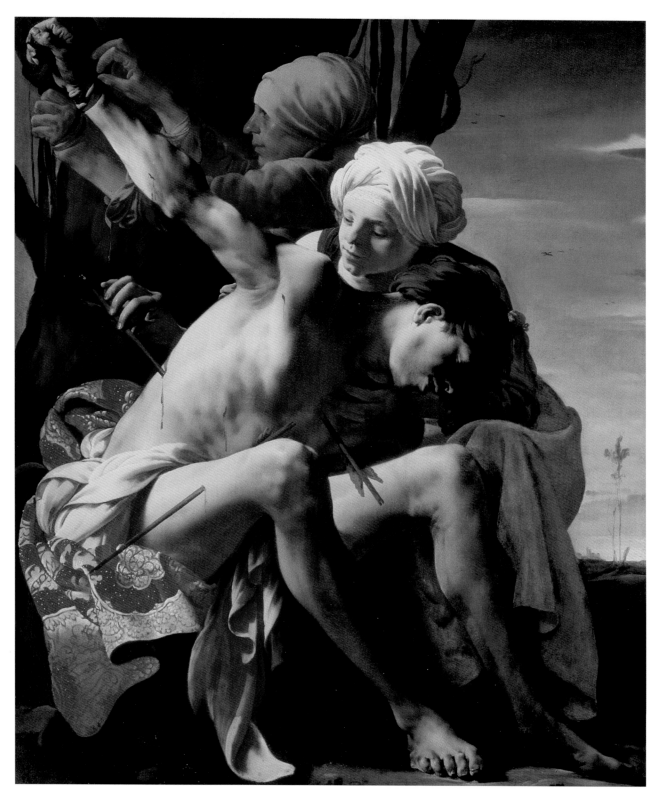

Cat. 10

11 May 1952, to the Nice art dealer Rolan Robert;[3] with F. Mont (New York), 1953

Selected References: New York 1954, cat. 81; (cat. 34 in Urbana); Stechow 1954a, 70–72; Stechow 1954a; Sandoz 1955; Nicolson 1956, 104, 110, 197–98; Gerson 1957, 23 Feb. 1957, illus.; Nicolson 1958b, 5, 10, 13, 17–18, 41, 86–87, cat. A54, pls. 58–61; Virch 1958, 225–26; Judson 1959, 88–90; Gerson 1960, 140; Carr 1964; Gerson 1964, 563; Slatkes 1965, 158, under cat. E18; Slatkes and Stechow 1965, cat. 10; San Francisco 1966, cat. 11; Hentzen 1970; Bissell 1971, 290; Spear 1971, cat. 68; Nash 1972, pls. 25 and 28 (detail); Slatkes 1973, 269–73; Nicolson 1979, 99; Bissell 1981, 67, fig. 175; Hibbard 1983, 168–69, illus.; Blankert and Slatkes 1986, cat. 20, color illus.; Bok 1986b, illus.; Lowenthal 1986, 93–94, fig. 84; De Meyere 1987a, 350, illus. 352; Schnackenburg 1987, 172; Nicolson and Vertova 1989, 1:192, 3: pl. 1154; Conisbee 1996, 202–17

Fig. 1 Dirck van Baburen, *Saint Sebastian Tended by Irene*, 1623. Oil on canvas, 108.9 × 151.9 cm (42⅞ × 59¾ in.). Kunsthalle, Hamburg.

Caesar Baronius's 1586 *Annales Ecclesiastici*,[4] in which the actions of the pious Irene were stressed to a greater extent than in previous lives of Saint Sebastian, was apparently responsible for the popularity of depictions of Saint Sebastian tended by Irene. Although there are representations of the healing of Saint Sebastian before 1615, there is a noticeable acceleration of interest in the subject in Italy and especially in the North after that date.[5] In addition to being the saint most invoked in time of plague, Saint Sebastian was also the patron of Dutch archery companies.[6] His association with the plague may account both for the popularity of the new theme and for the commissioning of the present picture.[7] Unlike earlier depictions of the saint, however, those by Utrecht Caravaggesque artists do not include archers and thus would clearly be inappropriate for a Dutch archery company.[8] Furthermore, the rapid development of the new episode between 1623, the date of Baburen's introduction of the theme into Utrecht (fig. 1), and 1625,[9] the date of the present painting, suggests that powerful external circumstances were involved.

Recent archival information reveals that Baburen had painted a Saint Sebastian in Italy.[10] There is convincing evidence, in the form of a contemporary copy,[11] that this lost picture from 1615 depicted the new theme. However, since it was a functioning altarpiece, the composition was necessarily different from that later used for his 1623 painting of the theme now in Hamburg.

In keeping with the belief that Saint Sebastian was a postfiguration of Christ,[12] the dominant structure of Ter Brugghen's picture, with its strong descending diagonal and the positioning of the three heads, echoes Caravaggio's *Entombment*,[13] while the diagonal position of the saint's arm and his slumping body can be related to scenes of the Deposition from the Cross. This relationship with Christ is supported by other details, most notably the way the gray, bloodless flesh of the saint's bound hand is rendered in the same manner as Christ's hands in the *Crucifixion* (cat. 8).

Convincing statistical evidence now makes it evident that the sudden popularity of pictures of Saint Sebastian in Utrecht between 1623 and 1625 was due to an outbreak of the plague that reached its zenith in 1624.[14] Figures available for Amsterdam and Rotterdam suggest that it struck quite rapidly.[15] This would fit the tight chronological sequence of the most important depictions of the new theme—the 1623 Baburen, the 1624 Van Bijlert, and the present picture.[16] Significant differences between the compositional arrangement of these works, however, suggest different

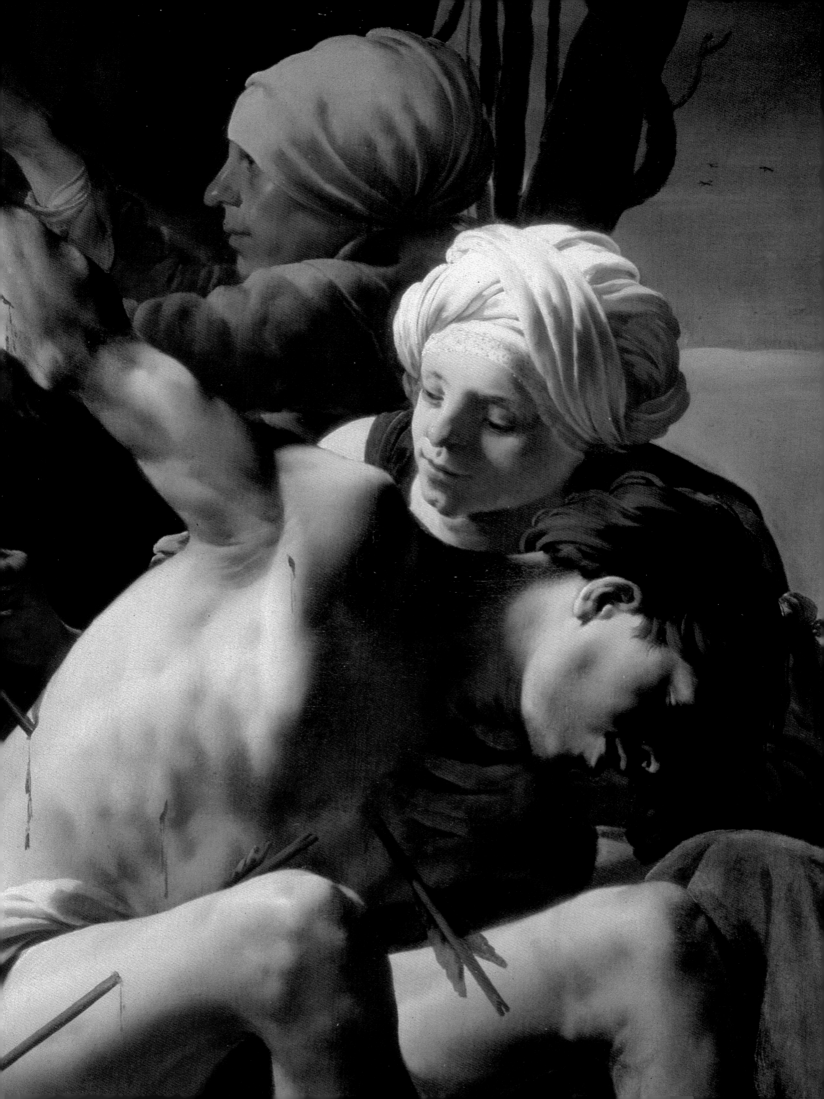

functions. Only the Ter Brugghen, with its steep perspective and low horizon line, indicates that it was meant to be hung relatively high and thus could have served as an altarpiece. If this is the case, perhaps it was intended for a chapel in one of the several hospitals—possibly even the St. Sebastiaanshospital—in or near Utrecht.[17]

—L. J. S.

11 HENDRICK TER BRUGGHEN
(1588–1629)

The Liberation of Saint Peter

1624

Oil on canvas, 105 × 85 cm (41⅜ × 33½ in.)
Signed and dated upper left center near the shoulder
of the angel: *HTB* [in monogram] *rugghen [16]24*.[1]
The Hague, Mauritshuis, 966

Provenance: in the Moltke collection, Copenhagen, by 1778, according to the subscript on a dated engraving of that year by Johann Martin Preisler; sale, Moltke, Winkel and Magnussen (Copenhagen), 1–2 June 1931, lot 14; to Alfred Andersen, Copenhagen, 1931–54; heirs of Alfred Andersen, Copenhagen, 1954–63; with Gallery G. Cramer (The Hague), 1963

Selected References: Royal Museum of Fine Arts, Copenhagen 1856, cat. 28; Royal Museum of Fine Arts, Copenhagen 1931, cat. 14; Von Schneider 1933, 37, fig. 17b; Knipping 1939–42, 2:218, 235; Isarlo 1941, 234; Nicolson 1956, 109–10; Nicolson 1958b, 59–60, cat. A19, pl. 97; De Vries 1963, 33, illus.; Slatkes and Stechow 1965, 12, 43; San Francisco 1966, cat. 9, illus.; Van Thiel 1971, 109, 115; Nicolson 1973, 239; Knipping 1974, 2:413; Nicolson 1979, 99; Van de Watering 1982, cat. 22; Washington 1982, cat. 11; Bernard 1983, 256, illus., 298, no. 256; Tokyo 1984, cat. 12, illus.; Madrid 1985, cat. 7, illus.; Blankert and Slatkes 1986, cat. 18, illus., and 164 under cat. 31; Nicolson and Vertova 1989, 1:192, 3: fig. 1145; Broos et al. 1990, 436, illus.; Huys Janssen 1990, 26, fig. 14; Broos 1993, 96–102, no. 9

San Francisco and Baltimore only

In several ways the present picture is of great importance to Ter Brugghen's mature development. Elements derived from the figures of Peter and the angel reverberate throughout the master's work until 1629, the last year of his life. Indeed, until

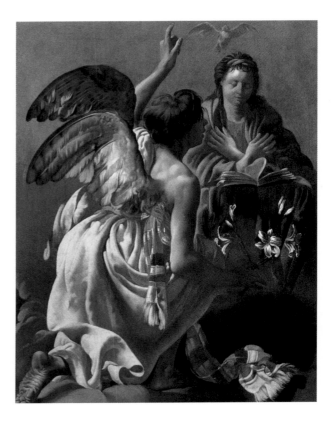

Fig. 1 Hendrick ter Brugghen, *The Annunciation*, ca. 1624. Oil on canvas, 104 × 84 cm (41 × 33 in.). Art Market, London.

the date on this picture became visible, after it was cleaned by the Mauritshuis in 1963, its close relationship to other works by Ter Brugghen bearing the dates 1628 and 1629 led scholars like Von Schneider and Nicolson to date this one late in the decade. Only when the date emerged did it become apparent that the present canvas opened this important stylistic cycle rather than closing it.

Given the 1624 date, it now seems likely that several motifs in The Hague painting are indebted to Baburen's lost 1623 *Annunciation*, known through a copy by Jan Janssens (cat. 15, fig. 1), in Ghent. Thus, both the shadowed profile of the angel and the commanding gesture relate back to Baburen. About the same time as our picture, and probably not much later than 1624, Ter Brugghen painted an *Annunciation* (fig. 1) which, although also indebted to the Baburen in many of the same elements present in The Hague work, utilizes a striking diagonal composition unusual for the

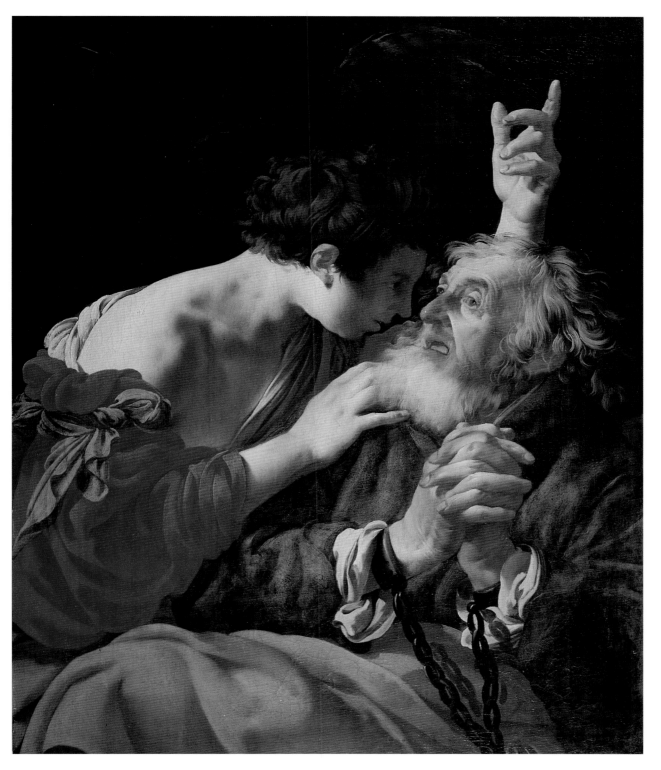

Cat. 11

theme.[2] Both pictures were soon followed by Ter Brugghen's second rendering of the Liberation of Saint Peter, in Tokyo.[3] This poorly preserved picture is closely linked in specific motifs to several other Ter Brugghen paintings, including the present one. Indeed, an extremely similar angel, although in mirror image to the one in our picture, is used. Additionally, the Tokyo composition anticipates aspects of Ter Brugghen's 1629 *Liberation of Saint Peter* now in Schwerin.[4] Furthermore, also in 1629, Ter Brugghen executed his late masterpiece, the Diest *Annunciation* (cat. 15), in which his indebtedness to Baburen once again emerges, but in a way that transcends its source in form and especially in the brilliant use of color.

These important reflections of our picture do not, however, end with this series of closely related themes. In 1628, for example, Ter Brugghen utilized the features of our Saint Peter—in mirror image—for those of King David in *King David Playing the Harp, Surrounded by Angels* in Warsaw and, in the same picture, adapted the pose of the angel in The Hague painting to one of the singing angels on the Warsaw canvas.[5] Significantly, no other painting by Ter Brugghen contributed to the genesis of so many important works by the master than the present picture.

Our painting, along with several others of the same date,[6] also introduces a new complexity in the rendering of drapery folds, most apparent here in the sleeve of the angel. Furthermore, Ter Brugghen also uses a type of physiognomic contrast between youth and old age favored by Caravaggio in such Roman-period paintings as his *Judith and Holofernes*.[7] This Caravaggesque contrast between youth and old age, also found in some of the early Antwerp works of Peter Paul Rubens, was introduced into Utrecht by Baburen in his 1622 *Procuress* (cat. 38) and is also present in his *Backgammon Players* of about the same time (see Franits, fig. 3, in this catalogue).[8] It makes its appearance in Ter Brugghen's work with his 1623 *Gamblers*,[9] although without the extreme focus

that the tight composition provides in the present canvas.

It is likely that the unusually compact composition of the present picture developed out of works such as Ter Brugghen's 1623 *David and the Praise Singing Israelite Women* (North Carolina Museum of Art, Raleigh).[10] In the resulting closeness of the protagonists in our work, Ter Brugghen was seemingly evoking such pictures by Caravaggio as *Sacrifice of Abraham*,[11] in the Uffizi, where the relationship between Abraham and the angel, as well as the gesture, may have contributed to the conception of the present picture. Our work, executed shortly after Baburen's death, continues to reveal aspects of the close working relationship that existed between the two artists while at the same time introducing important elements that reverberate throughout Ter Brugghen's mature development and result in two of his late masterpieces, the Diest *Annunciation* and the Schwerin *Liberation of Saint Peter*.

—L. J. S.

12 GERARD VAN HONTHORST
(1592–1656)

Denial of Saint Peter

1620–25

Oil on canvas, 110.5 × 144.8 cm (43½ × 57 in.)
The Minneapolis Institute of Arts, The Putnam Dana McMillan Fund, 71.78

Provenance: with Charles Davis, by 1906; sale, Christie's (London), 2 July 1906, lot 139; bought by Johnson or Johnston; with Gorry (Dublin), by 1926; art market (Dublin), 1971; with Hazlitt Gallery (London), 1971

Selected References: Judson 1959, 163;[1] Nicolson 1971–73, 39–41, fig. 1; Blankert et al. 1980, no. 16, illus.; Blankert and Slatkes 1986, 32, fig. 28; Judson 1988, 112, fig. 144; Nicolson and Vertova 1989, 1:124, 3: pl. 1244

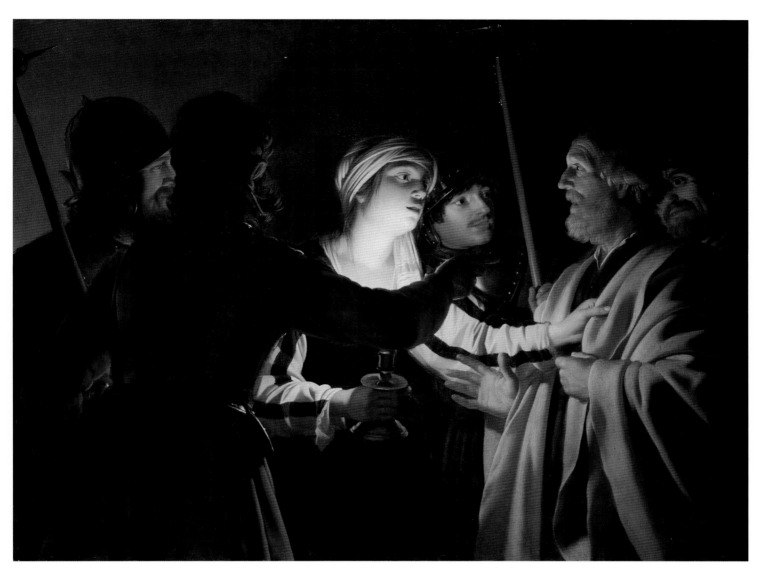

Cat. 12

The essence of Caravaggesque religious painting is drama, physical and psychological. In the hands of Honthorst that usually meant theatrical lighting to illuminate his relatively stationary figures, accentuating both salient gestures and facial expressions. Relying on neither dramatic movement nor grand rhetorical gestures, Honthorst imbued his religious compositions with a quiet solidity in keeping with the gravity of their subject matter. In certain of his early works, such as the *Christ before the High Priest* (The National Gallery, London), painted for the Marchese Vincenzo Giustiniani,[2] and the present picture, Honthorst conveyed with solemn dignity the psychological battle between

his players and the inner struggle that grips his protagonists.

Religious themes had monopolized most of Honthorst's efforts in Italy, where he completed a succession of works in Rome, including altarpieces for the Carmelite churches of Sta. Maria della Scala and Sta. Maria della Vittoria.[3] He also executed religious paintings on commission for various religious houses outside Rome, including Montecompatri, Albano, and Genoa. After his return to Utrecht, however, the artist painted only a handful of religious themes, including this *Denial of Saint Peter.*[4] The style is harder than that exhibited in his Italian works, but the nocturnal setting

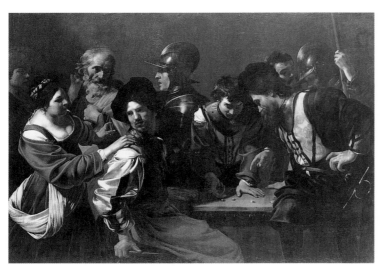

Fig. 1 Gerard van Honthorst, *Denial of Saint Peter*, ca. 1620–25. Oil on canvas, 244 × 137 cm (96⅛ × 54 in.). Private collection, England.

Fig. 2 Bartolomeo Manfredi, *Denial of Saint Peter*, ca. 1612. Oil on canvas, 166 × 232 cm (65⅜ × 91⅜ in.). Herzog Anton Ulrich-Museum, Braunschweig, 495.

is a continuation of a formula developed for his altarpieces in the second decade of the century.

The subject of the denial of Saint Peter is well suited to Honthorst's artistic interest in artificial light sources, because the biblical narrative dictates that it take place at night. As related in the gospels of Matthew, Mark, and Luke,[5] Peter's refusal to acknowledge his acquaintance with Jesus is one of the events leading up to Jesus' Crucifixion. On the evening of the Last Supper, before he was arrested, Jesus gathered his disciples about him and told them that one of them would betray

him to the authorities and that the others would desert him and flee in fear. When Peter protested that this could be so, Jesus said to Peter, "Truly, I say to you, this very night, before the cock crows twice, you will deny me three times."[6] The events transpired as Jesus had predicted and, while Jesus was being questioned before the high priest, Peter joined members of the crowd that had seized him, hoping to hear some word of him.

> Peter followed at a distance; and when they had kindled a fire in the middle of the courtyard and sat down together, Peter sat among them. Then a maid, seeing him as he sat in the light and gazing at him, said, "This man also was with him." But he denied it, saying, "Woman, I do not know him." And a little later someone else saw him and said, "You also are one of them." But Peter said, "Man, I am not." And after an interval of about an hour, still another insisted, saying, "Certainly this man also was with him; for he is Galilean."[7] But Peter said, "Man, I do not know what you are saying." And immediately, while he was speaking, the cock crowed . . . And Peter remembered the word of the Lord, how he had said to him, "Before the cock crows today, you will deny me three times." And he went out and wept bitterly.[8]

This is a scene not of simple denial, but of betrayal; and it is Peter's inner struggle between his loyalty to Jesus and his faith and his instincts for self-preservation that baroque artists attempted to convey.

Honthorst treated the theme at least three times. Other versions are now in the Musée des Beaux-Arts, Rennes,[9] and in a private collection in England (fig. 1);[10] this latter picture is closest stylistically to the present work. Both earlier compositions again show Honthorst's debt to Bartolomeo Manfredi's interpretation of Caravaggio. In them Honthorst used a compositional device exhibited in the works of several Caravaggesque artists, including Manfredi and the Frenchmen Valentin[11] and Tournier.[12] Capitalizing on the genre poten-

tial of the biblical narrative, these artists embroidered upon the incident, casting the prescribed bystanders in the popular role of dandies at a gaming table. As exemplified by Manfredi's *Denial of Saint Peter*, now in Braunschweig (fig. 2),[13] such linkage places the religious event within the context of secular life, which goes on casually unaware of moments of personal inner turmoil. This striving for artistic realism and stylishness is made, however, at the expense of concentration on the religious event itself.

Honthorst's later *Denial of Saint Peter* resolves this conflict of purpose by deleting the gaming scene all together. The emotional impact of the Minneapolis Honthorst is closer to Caravaggio's own interpretation of the theme. That artist's *Denial of Saint Peter* (private collection),[14] dating from his fugitive years in Naples, depicts only three large, half-length figures: a helmeted soldier, a woman, and Saint Peter. Peter's crisis of conscience is very much the central issue, both formally and iconographically. Interestingly, however, in the Honthorst, even with the deletion of the second figural unit, the focus does not shift completely to Peter. Pictorial emphasis remains on the female figure, who is brightly illuminated by the masked candle flame. We see Peter only in the fainter candlelight that bounces off the young woman's face and onto his. The accusation is made in strong light, his betrayal is accomplished in the half shadows.

—L. F. O.

13 PETER WTEWAEL
(1596–1660)

Denial of Saint Peter
ca. 1624–28

Oil on panel, 28 × 45.7 cm (11 × 18 in.)
Signed upper right: *Pet[. . .] / W[. . .]*
The Cleveland Museum of Art, 1997, Gift of Mr. and Mrs. Noah L. Butkin, 1972.169

Provenance: with L. A. Houthakker (Amsterdam), 1970; Mr. and Mrs. Noah L. Butkin, Cleveland

Selected References: Chong 1993, 262 (with earlier literature); Zeder 1995, 27, fig. 4

This dramatic nocturnal scene exemplifies Peter Wtewael's amalgam of the fully developed mannerist style of his father, Joachim, and the new Caravaggist approach. Peter's fusion of these two modes is distinctive in Utrecht during the 1620s.

Simon Peter's denial of Christ during the Passion is recounted by all four Evangelists.[1] In the Gospel accounts, Peter followed Christ after his arrest into the countyard of Caiaphas, the high priest, and waited there. On two occasions young women identified Peter as a follower of Jesus, but he denied it. Later, others recognized him by his Galilaean accent. "But he began to curse and to swear, saying, I know not this man of whom ye speak. And the second time the cock crew. And Peter called to mind the word that Jesus said unto him, Before the cock crow twice, thou shalt deny me thrice. And when he thought thereon, he wept" (Mark 14:71–72).

The nocturnal fire mentioned by Mark, Luke, and John is the setting for eight men and one woman, shown knee-length in the near foreground. Here, as is usual in Peter's works, the influence of Joachim Wtewael is strong. The red, blue-green, and gold triad is familiar from Joachim's works. Figural attitudes and facial types are indebted to Joachim's biblical scenes, such as his *Christ Blessing the Children* (fig. 1) and *Adoration of the Shepherds* (1625; Museo del Prado, Madrid).[2] The emphatic chiaroscuro and the sensitive dramatization of

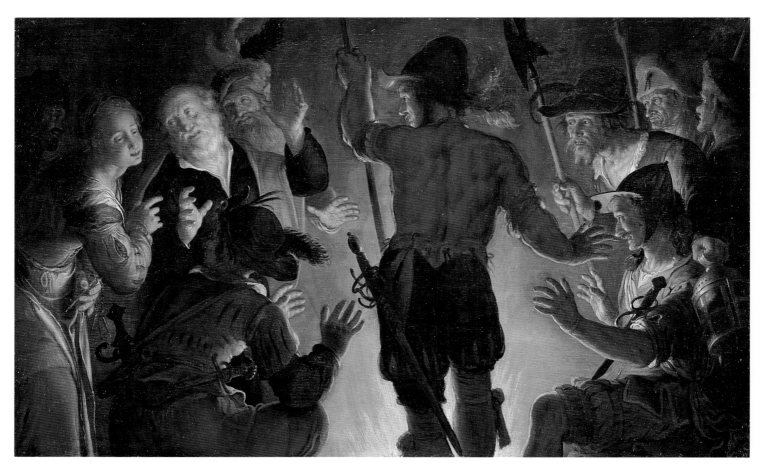

Cat. 13

Saint Peter's conflict, however, reflect awareness of another stylistic current, Caravaggism, important in Utrecht from the early 1620s on.

Honthorst's influence is pronounced. Peter's conception may specifically be indebted to Honthorst's *Denial of Saint Peter*, datable to the early 1620s (cat. 12). There the light source is a single candle, but it is similarly shielded by a foreground figure. Honthorst also shows knee-length figures and chose the same dramatic moment, as Saint Peter is accosted by a young woman. Honthorst, however, emphasizes the woman, her face brightly illuminated at the center of the composition, leaving Saint Peter in shadow. In contrast, Peter Wtewael gives the center to a standing soldier, back to the viewer and silhouetted against the flames. Light thus falls on the circle of bystanders, their brightly lit faces registering varying degrees of curiosity. The exaggerated and distorted facial

features of several soldiers, bordering on caricature, convey their villainy. Saint Peter is at left, emphasized by his fully lit face and white beard. The young woman approaches him almost seductively, not assertively, as in Honthorst's depiction. Comparison with Honthorst's naturalism accentuates the contrivance of Peter's style, evident, for example, in the woman's sinuous pose and the circle of brightly lit and shadowed hands. That device elaborates on Honthorst's characteristic treatment of hands, with fingers outspread against the light. The agitation conveyed through these "speaking hands" expresses in gesture the tensions inherent in the verbal exchange between Saint Peter and the maid.

Peter Wtewael was clearly dependent on a *Denial of Saint Peter* by the Fleming Gerard Seghers, who in turn had been influenced by the Caravaggist Bartolomeo Manfredi in Rome. Seghers's com-

position exists in several versions datable 1620–28.[3] Peter's facial type and pose, the animated gestures, astonished facial expressions, costume details, and the arrangement of the knee-length figures around a central repoussoir figure are features common to both Seghers's and Wtewael's conceptions.

Peter Wtewael's style has a distinctive character, his borrowings having been integrated in an individual manner that combines mannerist and Caravaggesque elements. In the Cleveland painting, for example, caricature and schematic design work together with fresh, perceptive characterization to dramatize Saint Peter's spiritual crisis. The tonality is sensuous, extending from rich, saturated color into delicate light blue and mauve, pastel shades that Peter favored for draperies. The nuanced color and light of the chiaroscuro demonstrate Peter's command of that contemporary technique, most likely based on study of both art and life.

The vestige of a signature confirms the former attribution to Peter, which had been supported by comparison with such signed works as his *Last Supper* (fig. 2).[4] Peter there shows Christ blessing the bread, as some of his disciples react reflectively, others with animated devotion, a few with evident apprehension at Christ's declaration that his betrayer is among them. The light source is again an open flame, which is obscured by a figure. Olivier Zeder calls attention to the tongues of fire that appear over the heads of two apostles in the foreground, anticipating the Pentecost, when the Holy Spirit was manifested among them in this form.[5] In both the Uppsala and Cleveland pictures the fingers of chunky upraised hands are spread similarly against the light, and the darkened backs of the repoussoir figures are broadly painted. The highlighted edges of forms, like knees and draperies, lend the energy of their visual patterns to the tensions of the moment.

All Peter Wtewael's known dated works fall between 1623 and 1628. A recently discovered *Christ Washing the Feet of the Apostles* (Musée des

Fig. 1 Joachim Wtewael, *Christ Blessing the Children*, 1621. Oil on panel, 86 × 114.5 cm (33⅞ × 45⅛ in.). The State Hermitage Museum, St. Petersburg, 709.

Fig. 2 Peter Wtewael, *The Last Supper*, 1628. Oil on panel, 40.5 × 68.5 cm (16 × 27 in.). Universitets Konstsamling, Uppsala, L766.CL5.

Beaux-Arts, Arras) shows him to have developed a sophisticated tenebrist style as early as 1623.[6] The lighting effects in *Denial of Saint Peter* are, however, even more complex, suggesting a date in the mid- to late 1620s.

Of some thirty paintings by or attributed to Peter Wtewael, seven are Passion scenes. To the three subjects already discussed can be added two examples of the Betrayal of Christ, a Way to Calvary, and an Entombment of Christ.[7] The Cleveland *Denial of Saint Peter* exemplifies the devotional character of this group, several of which depend for their impact on nocturnal lighting. Since the

Caravaggesque style seems to have been especially favored for paintings exhibited in clandestine Catholic churches of Utrecht and other Dutch towns,[8] these Passion scenes may have been painted for a Catholic clientele. The dramatic immediacy of the Cleveland painting and the focus on Peter's spiritual dilemma would have been well suited to spiritual reflection.

—A. W. L.

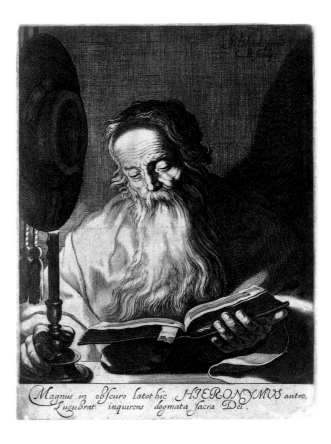

14 ABRAHAM BLOEMAERT
(1566–1651)

Saint Jerome in His Study

ca. 1622

Oil on canvas, 64.4 × 52.7 cm (25⅜ × 20¾ in.)
Signed below the book, to the right: *ABloemaert. fe.*
Milwaukee, Collection of Drs. Isabel and Alfred Bader

Provenance: purchased in 1975 from Jüngeling (The Hague)

Selected References: Nicolson and Vertova 1989, no. 1102; Döring, Desel, and Marnetté-Kühl 1993, no. 31; Roethlisberger 1993, no. 286; Manuth et al. 1996, no. 24

Jerome (ca. 347–419/20) is not solely a saint (veneration began only in the mid–fourteenth century); he is one of the most important writers of all Christian history and is therefore counted among the four most important Western Church Fathers (see Spicer, introduction to this catalogue, fig. 3). His most influential contribution was the Latin translation of the Bible, the so-called Vulgata, which for at least a millennium replaced the original Hebrew and Greek texts in the Occident. Martin Luther and other reformers deeply resented him and rejected especially his writings on the real presence of Christ in the Eucharist.

There are two basic iconographies connected to his person—the Doctor of the Church in his study and the repenting ascetic in the wilderness. It is interesting to note that in Bloemaert's painting there is no trace of the ascetic. Jerome is depicted as a cardinal, a pictorial tradition that is not sustained by the facts of the man's life. His cardinal's hat is hanging on the picture's edge, shading the candle in an unlikely way. The composition is as simple as it is forceful, with the face above the center of the picture mediated by the long beard streaming down to the compositional foundation formed by the horizontal of the book. The reproductive engraving by Bloemaert's son Cornelis (fig. 1) suggests that the painting may have been reduced on all sides, without altering the overall effect very much.

The verses attached to the composition in the print must have been written after the painting was created. Therefore, they are a welcome example of the understanding contemporaries had of the religious content of an artwork such as this. They translate: "Great Jerome here hides in a dark cave; searching in the night he works out God's sacred dogmas."[1] The verb *lucubrare* denotes

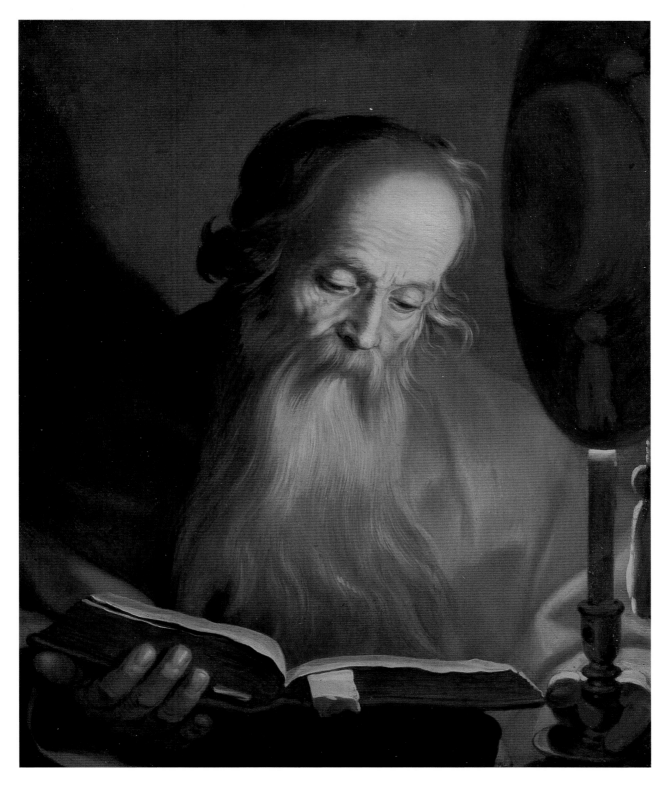

Cat. 14

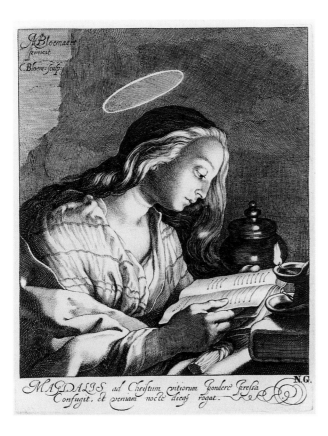

Fig. 2 Cornelis Bloemaert, after Abraham Bloemaert, *Mary Magdalene*, ca. 1625. Engraving, 170 × 135 mm (6¹¹⁄₁₆ × 5⁵⁄₁₆ in.). Prentenkabinet der Rijksuniversiteit, Leiden.

studying by night and had in the Middle Ages been associated directly with scholarly gloss in the form *lucubratio*. Jerome is here understood to have given a final wording to sacred dogmas. The picture, for all its seemingly general subject, was seen by this interpreter as an outspokenly Catholic work.

The term *lucubrare* therefore indicates the fine perception by the caption's author of the Caravaggesque candlelight functioning not only as a formal detail but also as a link to the meaning of the subject depicted. That this is no coincidence is made clear by another print by Cornelis Bloemaert, identical in size and perhaps conceived as a companion to the *Saint Jerome* print, after an unknown painting of about 1622 by his father showing the Magdalene reading by the light of an oil lamp (fig. 2). The text here too alludes to the nighttime setting.

Even among Bloemaert's earliest works, some thirty years before *Saint Jerome*, there are some half-length single figures,[2] but he really turned to producing half-length pictures in the second decade of the seventeenth century.[3] Many of the most important painters of his generation—namely Paulus Moreelse, Cornelis van Haarlem, Hendrick Goltzius—perhaps inspired by what was heard rather than seen of the new Roman painting, then tried their hands at new compositional structures.[4] In fact, a number of paintings from the decades after the turn of the century seem to be inspired by verbal descriptions of the artworks in Rome that became famous about 1600, Caravaggio's *Jerome* for Cardinal Scipione Borghese definitely being among them (Galleria Borghese, Rome).[5] This knowledge must have been enhanced by the few original Caravaggios the Fleming Louis Finson brought with him to Amsterdam in 1616.[6]

After receiving firsthand knowledge of the new style from his former pupil Gerard van Honthorst on the latter's return from Italy in 1620, Bloemaert immediately picked up its inherent power of individualization, as can be seen in *Saint Jerome*, and painted a number of similar pictures, mostly genre, for example the Utrecht *Flute Player* of 1621.[7] In the *Saint Jerome* he fused his Caravaggesque prototype with older Netherlandish traditions of the saint studying by candlelight, as can be seen in the painting of this theme by Aertgen van Leyden.[8]

Although Bloemaert was obviously fascinated by Caravaggism, it is striking that none of his altarpieces, which were mostly commissioned in the decade after Honthorst's return, was painted in the Caravaggesque mode. Instead, he chose a rather classical vein that was apparently better suited to the didactic purposes of the Catholic Reform.[9] Only one larger painting, the *Supper at Emmaus* (1622, from Amsterdam), hardly an altarpiece, dealt with a nighttime scene, while *The Vision of Saint Ignatius* (ca. 1622, for 's-Hertogenbosch; see Spicer, introduction to this

catalogue, fig. 4), the *Adoration of the Shepherds* (1623; see cat. 17, fig. 1), the *Adoration of the Magi* (ca. 1623, for Brussels), and the *Crucifixion* (1629, from Scheveningen) were all rendered in a non-Caravaggesque mode.

—G. S.

15 HENDRICK TER BRUGGHEN
(1588–1629)

The Annunciation
1629

Oil on canvas, 216.5 × 176.5 cm (85¼ × 69½ in.)
Signed and dated lower right, above the dog's head:
HTB [in monogram] *rugghe[n] 1629*
Diest, Openbaar Centrum voor Maatschappelijk Welzijn van Diest, on loan to the Stedelijk Museum van Diest

Provenance: Nicolson associated this painting with a Ter Brugghen *Annunciation* mentioned in a promissory note dated 18 Apr. 1638.[1] In it the painter Lucas Luce authorized the artist Anthoni Kentelingh at Deventer to request the widow of a certain Ryssen at Deventer to hand over to him "soodanich stuck schildery synde de bootschap Maria, gemaeckt by Mr. Hendrick Terbrugghen zalr. die hy op den 5 en deser lopende maent voor de somme van f. 240–gecocht heeft, welcke somme van penninghen by hem alrede toegesonden heeft" (that painting which represents the Annunciation to Mary, made by the late Master Hendrick Terbrugghen, which he bought on the 5th of the current month for the sum of f. 240—which sum of money he has already sent him). However, the appearance of a second, smaller *Annunciation* by Ter Brugghen (cat. 11, fig. 1) has introduced an element of doubt into the situation. Unfortunately, the archives of the church of St. Katherina, or Begijnhofkerk, Diest, where the painting hung until its recent transfer to the museum, were destroyed. Thus, there is no documentary evidence either to support or to disprove the supposition that the canvas "was probably purchased . . . in the second half of the eighteenth century from one of the religious houses suppressed by the Emperor Joseph II."[2] Circumstantial evidence that can be gleaned from the paintings still in the church, however, supports the contention that the Diest *Annunciation* was painted for the Begijnhofkerk. For example, the church seems to have had an ongoing relationship with Theodoor van Loon, whose painting style during the 1620s reveals contact with Ter Brugghen and Utrecht Caravaggism. Van Loon's earliest works for St. Katherina, still in situ, are four canvases from 1623 depicting the four Evangelists. Moreover, most of the paintings in this

small Beguine church, mainly by Van Loon and Frans Franken the Younger, date from the 1620s. Indeed, this otherwise modest church seems to have had substantial funds for pictures only during this period. Thus it is highly unlikely that our Ter Brugghen, which fits not only chronologically and stylistically but also, as we shall see, iconographically, was acquired by the church more or less by accident during the second half of the eighteenth century. The size and structure of the Diest painting suggest that it was originally made as an altarpiece, a function it served until its recent removal to the museum.[3] Perhaps, when Van Loon returned to Italy in 1628, Ter Brugghen received the commission that might otherwise have gone to him.

Selected References: Isarlo 1941, 164, as Jan Janssens; Roggen 1949–50, 278 n. 1, fig. 12, as Ter Brugghen; Pauwels 1951, 154; Bloch 1952, 19, 20, fig. 9; Nicolson 1956, 104, 107–8, 110; Nicolson 1957, 193 n. 1; Nicolson 1958b, cat. A25, pl. 100; Slatkes 1965, 82 n. 100; Von Schneider 1966, n.p.; Walgrave 1967, color pl. 28; Hubala 1970, 175; Bissell 1971, 289; Brussels 1971, cat. 106, illus.; Van Thiel 1971, 110, 116 n. 40; Nicolson 1973, 239; Nicolson 1979, 98; Linnik 1980, 78–79, illus.; Blankert et al. 1980, cat. 13, illus. 108; Bissell 1981, 65–66; Bok and Kobayashi 1985, 14, fig. 4; Blankert and Slatkes 1986, cat. 32, illus.; De Meyere 1987a, 350, illus. 352; De Meyere 1987b, 38, fig. 4; Brown 1988, 93, 94; Nicolson and Vertova 1989, 1:191, 3: fig. 1187; Huys Janssen 1990, 26–27, fig. 15; De Meyere and Luna 1992, 48, fig. 8

The apparent simplicity of this vibrant painting, executed in the last year of Ter Brugghen's life, belies the complexity of its creative genesis and inventive symbolism. Oddly, although it is one of only three works by the artist whose steep perspective and monumental composition indicate that they might have served as altarpieces (see cats. 8, 10),[4] only recently have the more unusual aspects of its iconography been investigated.[5] For example, Ter Brugghen includes a prominently positioned yarn winder, a recumbent dog, and most unusual for an Annunciation, joyous angels holding a garlandlike crown.[6]

The discovery of an earlier *Annunciation* by Ter Brugghen (cat. 11, fig. 1)[7] and Benedict Nicolson's perceptive hint concerning the nature of an *Annunciation* by Jan Janssens (fig. 1)[8] have changed the way we must view the stylistic origins of the picture in Diest. Since the Janssens picture repeats a Baburen altarpiece, it is clear that this

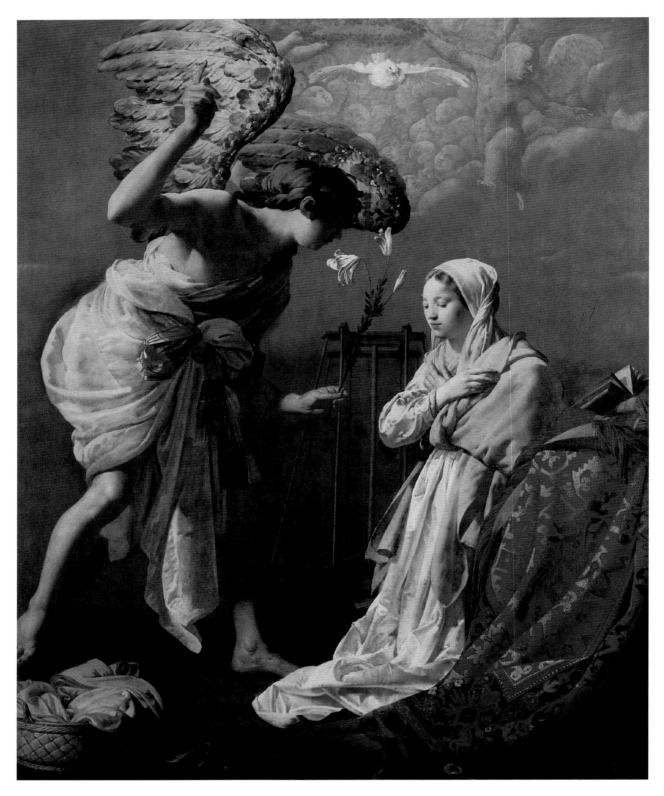

Cat. 15

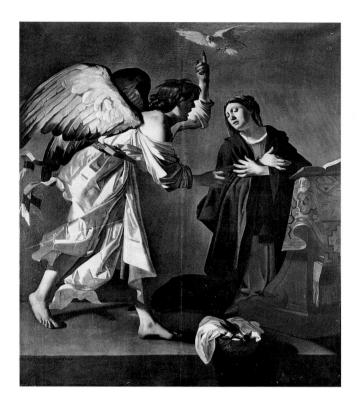

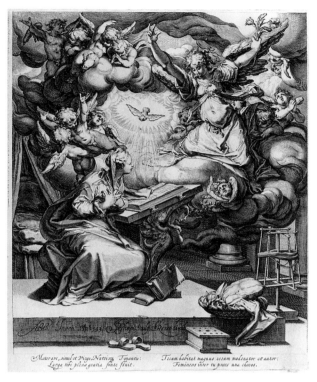

Fig. 1 Jan Janssens, after Dirck van Baburen, *The Annunciation*, original ca. 1623. Oil on canvas, 258 × 222 cm (101⅝ × 87⅜ in.). Museum voor Schone Kunsten, Ghent.

Fig. 2 Jacques de Gheyn the Younger, after Abraham Bloemaert, *The Annunciation*, 1593. Engraving, 342 × 281 mm (13½ × 11⅛ in.), Rijksmuseum, Amsterdam, OB9962.

lost picture played a role in the development of several Ter Brugghens beginning with the 1624 *Liberation of Saint Peter* (cat. 11) and ending with the present work.[9] Ter Brugghen, however, has introduced unique iconographic elements found in neither the Baburen nor his own earlier *Annunciation*, which would have been particularly appropriate to the Beguine community St. Katherina served.[10]

It is likely that the sewing basket Ter Brugghen placed in the foreground of our picture, and thus the yarn winder, at one level reflects the book of James, or Protevangelium (10:1–2), which tells that Mary was sewing when the angel appeared to her. Numerous pentimenti around the yarn winder, and the fact that it lacks yarn, suggest that its placement was a matter of some concern to Ter Brugghen. Indeed, as this device is directly beneath the crown, it gains greater compositional—and thus symbolic—weight.

During the second half of the sixteenth century, the form of the Annunciation began to change to meet the needs of the Catholic Counter-Reformation.[11] In Utrecht this new type, with

numerous joyous angels, is found in Jacques de Gheyn the Younger's engraving after Abraham Bloemaert's 1593 *Annunciation* (fig. 2).[12] There is no precedent, however, for Ter Brugghen's inclusion of an angelic coronation as part of the Annunciation, although it is a common enough symbol for Mary after the Nativity.[13] A study of the theological meaning of Mary's crown reveals that it stood for "the belief that by miraculous dispensation Mary was at once virgin and mother."[14] Thus Ter Brugghen has pushed the moment of Mary's coronation—at least with regard to this aspect of Marian symbolism—back to the very moment of the Incarnation. Significantly, the lilies, traditional symbols of purity, held by Gabriel, are rendered in three stages of unfolding, from bud to full blossom, providing support for this reading of Ter Brugghen's intentions.[15] Crowns, however, have

two other possible meanings, and the fact that Ter Brugghen has positioned the yarn winder beneath the crown suggests that he intended at least one of these meanings to obtain.[16]

The symbolism of the yarn winder was popularized by Leonardo da Vinci in a painting of about 1503, known only through copies and entitled, appropriately enough, *Madonna with the Yarn Winder.* A simplified form of this common device used by Leonardo indicates that it was meant as a prefiguration of the cross.[17] During the sixteenth century, the yarn winder appeared in prints of the Holy Family,[18] and even in an *Annunciation* engraved by Gian Giacomo Caraglio (B. 2) after Raphael.[19] Ter Brugghen was thus following a minor but persistent iconographic tradition in which the yarn winder became a prefiguration of the cross. By placing his empty yarn winder directly below the crown, Ter Brugghen enhances this association. The second theological meaning of the crown now becomes appropriate. It is a symbol of martyrdom. By the unique inclusion of a crown in our *Annunciation,* Ter Brugghen affirms Mary's purity and transforms the yarn winder— not incidentally, a device long associated with female virtue—at the moment of the Incarnation.[20] Obviously, the unusual iconographic program of the Diest *Annunciation* would have been of particular significance to a Beguine community, lending additional support for the provenance suggested above.

The most difficult element in this complex picture is the recumbent dog, not because dogs are obscure symbols, but because they are both ubiquitous and mutable.[21] Dogs, however, are unusual animals to find in an *Annunciation.* Karel van Mander listed no fewer than four different meanings for dogs in his *Wtbeeldinghe der Figuren.*[22] It is likely, however, that Ter Brugghen's dog is simply intended as a symbol of faith and the faithful, which again would be appropriate to the Beguine community for which this altarpiece was made.

—L. J. S.

16 ABRAHAM BLOEMAERT
(1566–1651)

Adoration of the Magi
1624

Oil on canvas, 168.8 × 193.7 cm (66½ × 76¼ in.)
Signed and dated: *A. Bloemaert. fe: / 1624*
Utrecht, Centraal Museum, 2575

Provenance: Martens van Sevenhoven coll. (Utrecht); sale, Martens van Sevenhoven (Utrecht), 1861; Genootschap Kunstliefde (Utrecht), 1861; purchased from the Genootschap Kunstliefde (Utrecht) in 1918

Selected References: De Vries and Bredius 1885, 27–28, cat. 16; Delbanco 1928, 56–59, fig. 28, 76, cat. 28; Blankert et al. 1980, 30, 51, 90, cat. 6, fig. on p. 91, 185; Cologne 1982, 214, cat. 96, illus.; Roethlisberger 1993, 39, 211, cat. 387, 255–57, 258, figs. 543, 545

Baltimore and London only

Depictions of events that took place around the time of Christ's Nativity were extremely popular, and that is especially true of the adoration of the Christ Child by the Magi. Abraham Bloemaert, who was a fervent Catholic, painted several versions of the subject for his patrons. The *Adoration* in the collection of the Centraal Museum in Utrecht is one of his finest and best-known paintings, and is regarded as one of his most important classicist masterpieces.

Bloemaert's Catholicism was a cornerstone of both his work and his life. He painted at least eighteen large works that can be regarded as altarpieces. He also had close ties with the Jesuits. As explained elsewhere in this catalogue, Catholic church services were tolerated in Utrecht only if they were held discreetly. Several of Bloemaert's religious commissions accordingly came from the Southern Netherlands, which had remained Catholic. It is not known who commissioned *Adoration of the Magi.*

The actual adoration of the magi is not described as such in the New Testament. It is a later construct that weaves several events described in the gospel into a rounded story. Matthew, chapter 2, tells of wise men who came from the east,

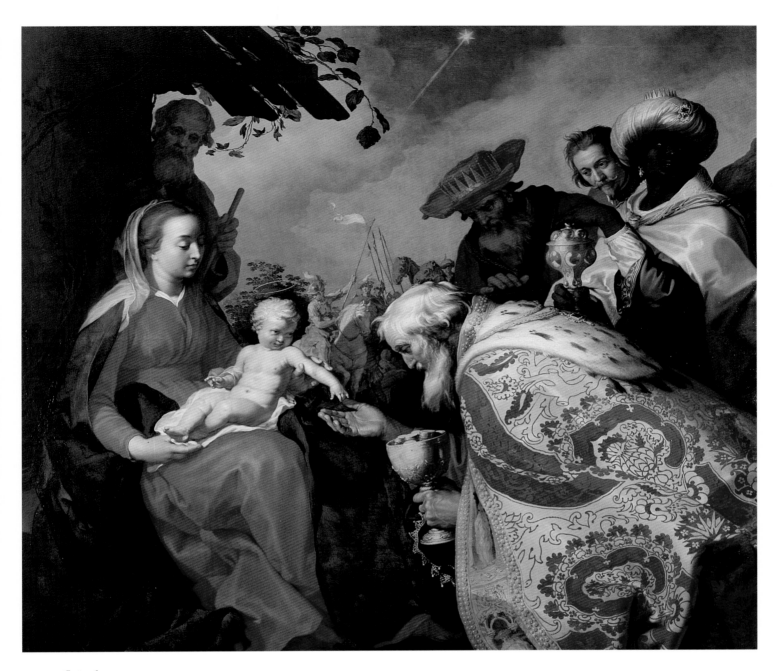

Cat. 16

following a star that led them to the King of the Jews. They were probably astrologers from the Persian court, priests of the Mithras cult. The Christian writer Tertullian was the first to call them kings.

In Bloemaert's painting, the Virgin receives the kings in front of the stable. She is seated on an elevation with the naked Child on her lap. Behind her, peering round the corner of the stable, is Joseph. The blond, flawless Child reaches his hand out toward the king kneeling before him. Accord-

ing to tradition this is Melchior, the most senior of the three. He is portrayed as an old man with gray hair and beard, and is offering the Child a gold goblet filled with gold coins, gold being the symbol of Christ's kingship. Immediately behind Melchior is the middle-aged Balthasar, who is bowing. The myrrh he has brought alludes to the death of the Redeemer. Caspar, the youngest, is presenting the Child with incense, an attribute of divinity.

In addition to the three ages of man, the kings stand for the three races and for the three

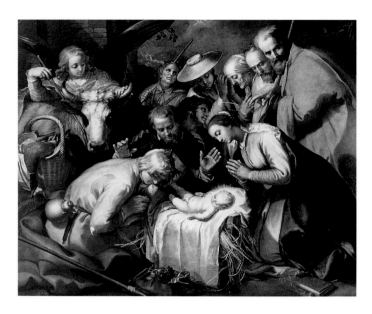

Fig. 1 Abraham Bloemaert, *The Adoration of the Shepherds*, 1615–20. Oil on canvas, 166.5 × 200 cm (65½ × 78¾ in.). Centraal Museum, Utrecht, 14281.

continents known at that time. Melchior, a Caucasian, symbolizes Europe, the brown Balthasar Asia, and Caspar, who is depicted as a Moor, represents Africa. The purpose of this symbolism was to show that Christ revealed himself to all humankind, both young and old, no matter where in the world they lived.

Between the heads of Balthasar and Caspar is the face of a young man with a mustache and a pointed beard. It used to be thought that this was a self-portrait. In itself there is nothing odd about a painter's including his own likeness in a painting. When Bloemaert painted the picture he was, however, fifty-eight years old, and it is unlikely that he would have made himself so much younger. It is more likely that this is a portrait of the patron.[1]

It emerges from a passage by Aernt van Buchel (Arnoldus Buchelius), an antiquarian and historian of Utrecht, that Bloemaert also included a portrait in another painting: not between the kings this time, but among the shepherds adoring the Christ Child. It is not entirely clear from the text whether this was a self-portrait or not, but some believe that, if it is the artist's likeness, Van Buchel might be referring to the one in the *Adoration of the Shepherds* in the Centraal Museum in Utrecht (fig. 1).[2]

One particularly striking motif in the Utrecht *Magi* is the magnificent gold brocade cloak worn by Melchior. Similar garments are found in the work of other Utrecht painters. In Hendrick ter Brugghen's *King David Playing the Harp, Surrounded by Angels* (Muzeum Narodowe, Warsaw), painted in 1628, the king is wearing an almost identical cloak.[3] Three years previously, in his *Saint Sebastian Attended by Irene* (cat. 10), Ter Brugghen had painted the same pattern on a cloth. The fabric is also found several times in works by Jan Gerritsz. van Bronchorst.

These artists were probably inspired by the pattern of pomegranates and thistles on the cope once worn by David of Burgundy, bishop of Utrecht. His cope and other vestments were not destroyed in the Reformation and are now preserved in the city's Rijksmuseum Het Catharijneconvent.[4]

Adoration of the Magi has probably been trimmed on the right, for a studio replica shows that Caspar's retinue was originally larger.[5] One possible reason for cropping the picture was to make it fit the space over the mantelpiece in one of the rooms at 16 Janskerkhof in Utrecht. The catalogue of the Kunstliefde Museum records that the museum bought the picture in 1861 at a sale of paintings belonging to Martens van Sevenhoven, the owner of that house.[6]

Like the original, the copy is on canvas with a twill weave, which owes its distinctive herringbone pattern to the staggering of the weft threads. The choice of this canvas probably had something to do with the large size of the painting. A twill weave is supple, having fewer binding points, and with the threads closer together results in a slightly denser fabric that keeps its shape better over a large surface.[7] The copy must have been made in Bloemaert's studio immediately after the original was painted.

—L. M. H.

17 ABRAHAM BLOEMAERT
(1566–1651)

Virgin and Child
ca. 1628

Oil on canvas, 63 × 51 cm (24¾ × 20⅛ in.)
Signed middle left: *A.Bloemaert. fe.*
Toronto, Art Gallery of Ontario, on loan from a
private collection

Provenance: in the Schönborn coll. before 1857

Selected Reference: Roethlisberger 1993, no. 388

Comparing all of Bloemaert's renderings of the
Virgin with the Christ Child, occuring mostly
in Adoration scenes or otherwise in prints, this
picture stands out for its appeal to the beholder.
It breathes a unique air of simplicity. There is a
remarkable intimacy between mother and Child
into which the beholder is softly included by the
Child's movement. Turning its face toward the
beholder and gazing upward, the Christ Child
reaches with both arms back to his mother. She
is gently holding the Child in front of her, with
big, soft, and very alive hands, while only slightly
lowering her face and thus relaxing the strict
frontality of the pose. The intimacy resulting from
this silent but well-balanced and thought-out com-
position is matched only by the *Adoration of the
Shepherds* of 1623 (fig. 1), but because the pictorial
elements have been reduced, it is all the more
apparent here.

The Child's glance is the only straightfor-
ward motif that signals that this is a religious
painting. On the other hand, the mother's highly
idealized face, together with the headcloth and the
color scheme of the clothing,[1] makes its subject
recognizable at first sight. This does not go with-
out saying in a society that was predisposed
toward secular, patriotic depictions of motherhood
in paintings by such artists as Gerard Dou, who
used and thereby secularized iconographic pat-
terns that had originated in the religious sphere.

A painting of the Virgin was in itself an out-
spokenly Catholic picture. Following the Reform-
ers' rejection of the veneration of the Virgin, after
the Council of Trent this motif became a hallmark
of Catholicism until the present day. Rendered,
as Bloemaert's picture is, in this iconic fashion, the
painting is an example of a devotional object that
was anathema for Protestant ministers and their
followers. It is one of the merits of this outstand-
ing painting that it results in such a strong state-
ment by means that are so simple. Bloemaert's
Virgin and Child, therefore, is one of the many
paintings that had a devotional function and never-
theless could be part of a private gallery. Even the
huiskerken, the so-called hidden churches, were
themselves installed in private Catholic homes.
Later, when bigger buildings could be erected,
these were at least officially owned by Catholic
citizens, not by the Church.[2] Therefore, it is hard
to judge from documents such as inventories, wills,
sales·catalogues, and so forth, whether a painting
was used with religious intent or was primarily
part of an art collection.[3] Protestant officials who
once in a while surprised the partakers of a Catho-
lic mass *in flagranti* were notoriously unattentive to
the furnishings of Catholic meeting places even
when destroying them.[4]

Although this is the only Virgin and Child
by Bloemaert known today, other versions are
mentioned in at least four documents of the seven-
teenth century,[5] one of them being an inventory
of the stadholder's palace,[6] thus suggesting that
the painting could have been valued by Frederik
Hendrik—at least nominally a Calvinist—more as
an example of Bloemaert's art than as a devotional
aid. On the other hand, every single one of the
pictures mentioned could be one of the many ren-
derings of the subject by Abraham's son Hendrick.
For instance, the version in Tokyo with the in-
scription *Blomaert Junio[r] P[inxit]* must be by
Hendrick's hand.[7] In fact, it reproduces the Virgin
in the great altarpiece of the Jesuits' church in
Brussels.[8] The facial type of the Virgin is the same
here and in the 1623 *Adoration* (fig. 1). Nonetheless
it is not the same head but was prepared for the

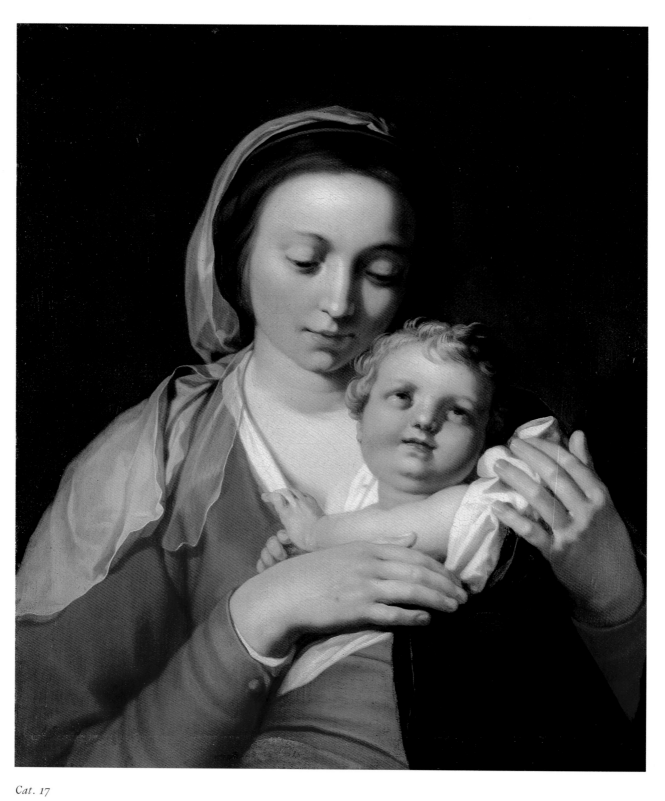

Cat. 17

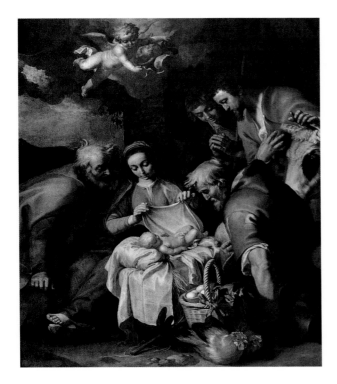

Fig. 1 Abraham Bloemaert, *Adoration of the Shepherds*, 1623. Oil on canvas, 216 × 172 cm (85 × 67¾ in.). St. Jacobus, The Hague.

Fig. 2 Abraham Bloemaert, *A Mother and Child and Studies of Hands and Feet*. Red chalk, heightened with white, 149 × 159 mm (5⅞ × 6¼ in.). Private collection.

latter painting in one of the beautiful studies in red chalk done from life that Bloemaert produced starting about 1612 (fig. 2).[9] The face of the Child with its upward glance, surely prepared in another drawing of the same kind, reappears in exactly the same way in an engraving after Bloemaert.[10] The engraver apparently used this same unknown drawing. As in a few other such cases,[11] the drawing must have been prepared for the painting and reused for the engraving. It, therefore, provides a clue to the date of the painting, since the engraver, Cornelis Bloemaert, left Utrecht in 1630.[12] The slightly stouter appearance of the Virgin, being less a maiden and at the same time calmer in movement than in the *Adoration*, makes a date some years later likely. These features combine with a general stylistic development of Bloemaert's painting to create a brighter, harder classicism in the second half of the 1620s, if one takes into account the different "modes" he was prepared to use for his different patrons.[13] *Virgin and Child*, clearly painted for a Catholic patron, therefore, compares better with the *Crucifixion* of 1629 than with the *Chariclea* painting of 1626 (see cat. 59, fig. 2), although a definite date is hard to fix.

—G. S.

18 ABRAHAM BLOEMAERT
(1566–1651)

Parable of the Wheat and the Tares
1624

Oil on canvas, 100.3 × 132.7 cm (39½ × 52¼ in.)
Signed and dated below the basket: *A. Bloemaert. fe: / 1624*
Baltimore, The Walters Art Gallery, Gift of the Dr. Francis D. Murnaghan Fund, 1973, 37.2505

Provenance: earl of Portarlington, Emo Court, Ireland; art market (Dublin), ca. 1919; Justice James A. Murnaghan, Dublin; the Hon. Francis D. Murnaghan, Baltimore

Selected References: Bodkin 1929; Bowron 1973; Sutton 1986, 8; Bruyn 1987, 86; Zafran 1988, no. 40; Roethlisberger 1990, 17; Roethlisberger 1993, no. 391; Seelig 1995, no. A23

Body and Spirit: The Impact of the Counter-Reformation [181]

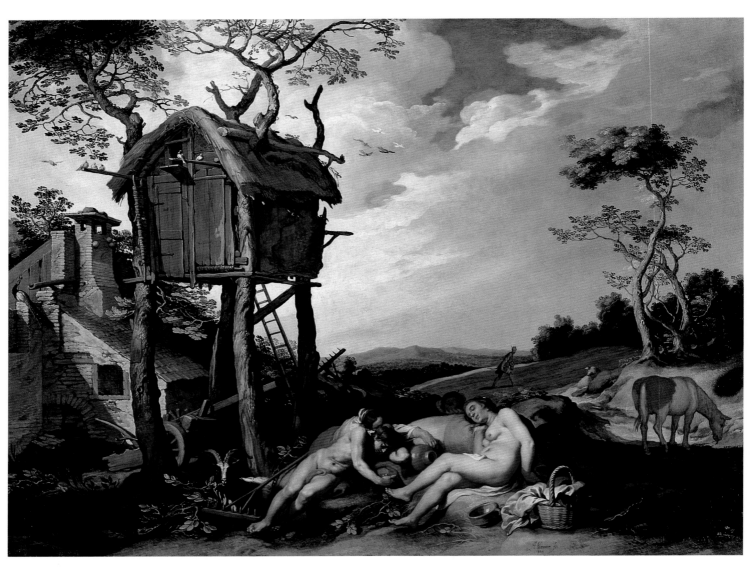

Cat. 18

In this landscape, arguably Bloemaert's finest, the artist combines a sensitivity to nature with a favored subject, Christ's Parable of the Wheat and the Tares. This is one of Christ's teachings that could have particular resonance for someone like Bloemaert, a Catholic of passionate but temperate belief living in an officially Protestant society. The analogy with farming in the parable would also have been attractive to Bloemaert, with his interest in the depiction of rural settings.

> The kingdom of heaven is like a man who sowed
> good seed in his field; but while men were asleep,
> his enemy came and sowed weeds among the wheat
> and went away. And when the blade sprang up and
> brought forth fruit, then the weeds appeared as well.

... And his servants said to him, "Wilt thou have us go and gather them up?" "No," he said, "lest in gathering the weeds you root up the wheat along with them. Let them both grow together until the harvest; and at harvest time I will say to the reapers, 'Gather up the weeds and bind them in bundles to burn; but gather the wheat into my barn.' . . . He that soweth the good seed is the son of man; the field is the world; the good seed are the children of the kingdom; but the tares are the children of the wicked one; the enemy that sowed them is the devil; the harvest is the end of the world; and the reapers are the angels. As therefore the tares are gathered and burned in the fire, so shall it be in the end of the world." (Matt. 13:24–30, 36–40)

This is the best-known version of the sub-
ject associated with Bloemaert. The other six,
illustrated by Jacob Matham's 1605 engraving after
Bloemaert's design (fig. 1), stretch over his career
and are similar to one another in their narrative
motifs—in the foreground, sleeping peasants with
bags of grain, and, to the rear, a field tended only
by the devil.[1]

In addressing the interpretive complexities
of the Baltimore picture, we may begin with the
Latin inscriptions on the two engravings from
about 1605. That on Matham's engraving para-
phrases the biblical account,[2] leaving the reader to
bring to it his own insights. The inscription on the
engraving by Johan Barra after a painting of 1604
(The State Hermitage Museum, St. Petersburg)
is more interpretive: "If the guardian of the
master's animals is not awake, the herds as well as
the guardian will fall prey to the wild beasts. If
the guardian of the people is not awake and the
people, feeling safe, fall to sleep, not even remem-
bering God, Satan will sow his seeds, will govern
and lead the people to become his prey."

This is consistent with teachings of the
Catholic Church that go back to Saint Jerome,
whose reading of the parable has been summa-
rized: "The devil attacks the church at a moment
of weakened leadership by stimulating heresy,
yet the zeal of the faithful to destroy these weeds
is tempered by the Lord who commands that the
wheat and the weeds be allowed to grow together
until the harvest, at which time they will be
appropriately treated."[3] During the Counter-
Reformation, the parable could be understood
as describing the conditions in which heresies
could grow. This was underscored by the inclusion
of a vignette of the parable on the title page of
Beraedt wat Geloove ende Religie men behoort t'aenveerden
(A consultation what faith and religion is best to
be imbraced), the Dutch translation, published in
Antwerp in 1610, of an important contemporary
text written in Latin by the Jesuit Leon. Lessius.[4]
Attacking the claims of the Lutherans, Calvinists,

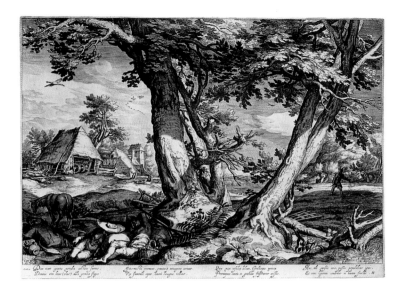

Fig. 1 Jacob Matham, *Landscape with the Parable of the Wheat and the
Tares*, 1605. Engraving after Abraham Bloemaert, 383 × 492 mm
(15⅛ × 19⅜ in.). Rijksprentenkabinet, Amsterdam.

and Anabaptists, Lessius took as his thesis that
"all Religion, all Faith, all Confessions of faith,
besides this only one [Catholicism] are false, hurt-
full, pestilent, and brought in by the Devil, as
author thereof and the Father of lies."[5]

In the Republic the most strident accusa-
tions of heresy were hurled by Protestant against
Protestant.[6] Depictions of the parable by Bloe-
maert and occasionally by others such as Simon de
Vlieger[7] could find a wider audience among reli-
gious moderates who believed in leaving the win-
nowing to God.

The Baltimore painting is the most elaborate
rendering of the parable and is made up of mul-
tiple, potentially significant motifs, all of which
vie for attention and most of which were probably
studied from nature. Karel van Mander, in his
Lives . . . of the Painters published in 1604, com-
ments with approval on Bloemaert's drawings
from life *(naer het leven)* of rural scenes made in
the country near Utrecht.[8] Many of these studies
were later used in preparing finished works. In
some cases a study can be posited on the basis of
the repetition of a motif in finished compositions.
The farmhouse here, for instance, is found also

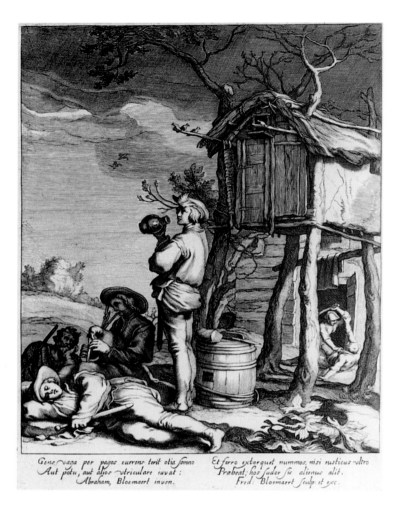

Fig. 2 Frederick Bloemaert, *Vagabonds*. Engraving after a lost drawing by Abraham Bloemaert of 1620–25, 215 × 171 mm (8½ × 6¾ in.). Rijksprentenkabinet, Amsterdam, RP-P-BI-1484.

in *Farmyard with the Prodigal Son Tending Swine* (Kunsthaus, Zurich), dated to 1610–12.[9]

A pen and wash study in the Ecole des Beaux-Arts, Paris,[10] has been identified as the model for the dovecote that dominates the left half of the Baltimore painting. A dovecote could provide birds for the cooking pot with a minimum expenditure of effort.[11] On another plane, as the playthings of Venus, doves carry her associations with easy carnality. The study was used for the equally salient dovecote in Frederick Bloemaert's engraving of vagabonds after his father's drawing (fig. 2).[12] Here the Latin inscription reads, "Unstable folk roving across the country spend their leisure time sleeping, drinking, or amusing

others noisily; with the sword they extort money if the peasant does not proffer it spontaneously; thus they live by the sweat of others."

The pattern of associating the dovecote with idleness was first observed by Joost Bruyn.[13] His claims for moralizing readings of landscape representations may sometimes be pressed too far, but that does not invalidate the cogency of his comments in specific instances. The associations with sloth are fairly consistent. This is in keeping with the Church's interpretation of the parable as outlined and with the idlers in the engraving.

There is an astonishing number of dovecotes in Bloemaert's oeuvre. A few works, for example *Farmyard with Dovecote*, a painting in the Weldon collection, New York,[14] have no other subject. Most appear in rural scenes with biblical subjects.[15] In *Landscape with the Rest on the Flight into Egypt* (cat. 68, fig. 1), the Holy Family pauses at the foot of a dovecote. A broken wagon wheel and discarded wicker cage that was used for carrying poultry to market are intended to evoke the ordinarily lazy world where most people take the moral path of least resistance.

The choice of animals and humans who inhabit the Baltimore farmyard supports this. The goat, prominent at the base of the dovecote, and the peacock, perched on the roof of the farmhouse, both relate to studies by Bloemaert that were engraved in the various series of rural animals beginning in 1611,[16] and are traditionally associated with the sins of lust and proud complacency, respectively.

Sloth, one of the seven mortal sins, is exemplified by the peasants slumbering when they should be working or watchful. This abuse of leisure is the subject of plates in Cornelis Bloemaert's series on leisure, *Otia* (see Spicer, introduction to this catalogue, fig. 5). Elsewhere in Bloemaert's oeuvre, a sleeping peasant is often associated with a dovecote and goats in the settings for stories such as Tobias and the Angel[17] or the Prodigal Son Tending Swine.[18] In the present

painting, the two foremost peasants are naked, with no clothes in evidence.[19] In Bloemaert's other versions of the parable or of other subjects, there are figures who have loosened or removed some of their clothes, but there are no other inexplicably naked figures. These figures never had clothing, so are probably meant to represent Adam and Eve.[20]

It is against the backdrop of the Catholic doctrine of Original Sin that the typological association of the Parable of the Wheat and the Tares with the Fall of Adam and Eve, developed in the late Middle Ages, is to be understood.[21] This is the strand of interpretation associated with Saint Augustine, who understood the weeds in a moral sense as mortal sins, rather than as heresies or heretics.[22] The evidence suggests that the painting intertwines the strands of interpretation associated with Jerome and Augustine, though whether this was the artist's intent cannot be demonstrated.

The mannerist inversion of the main and subordinate motifs and their didactic quality cause the painting dated 1624 to appear to be earlier than the more balanced landscape of the 1605 engraving, for the design of which Bloemaert probably consulted an engraving by Agostino Carracci of about 1580.[23] Nevertheless, the vibrant colors and physical poise of the naked peasants link this painting to the great *Adoration of the Magi* (cat. 16), also dated 1624.

—J. S.

The Wisely Led Life

19 JAN VAN BIJLERT
(1597/98–1671)

Mary Magdalene Turning from the World to Christ

(also known as *Allegory of the Catholic Faith*)

1630s

Oil on canvas, 114.9 × 110.8 cm (45¼ × 43⅝ in.)
Signed at the right: *Jv* [in monogram] *bijlert. fc.*
Greenville, South Carolina, Bob Jones University
Museum and Gallery, 325

Provenance: auction (Dublin), Oct. 1964; purchased by
Julius Weitzner; acquired by the museum in 1965

Selected References: Hope 1965, fig. 25 (as "Jan Jacob
Billiard" [1734–1809]); Posner and Posner 1966, 152;
Bob Jones University 1968, no. 325; Nicolson 1979, 27;
Steel 1984, no. 4; Sutton 1986, 98; Blankert, Montias,
and Aillaud 1988, 146; Nicolson and Vertova 1989, 1:71;
le Bihan 1990, 130; Huys Janssen 1994a, no. 56

Baltimore and London only

When Jan van Bijlert composed this painting, his
task appears to have been to convey an essential
aspect of the Catholic faith, the active role of
the individual soul in seeking redemption. He
achieved this by drawing on various types of
related but more conventional imagery.

At the tender urging of an angel who points
upward toward the unseen (presumably heavenly)
source of a stream of light, an attractive young
woman dressed in the simple working-class cloth-
ing of a serving maid turns toward a crucifix and
away from a large, terrestrial globe upon which
lie a strand of pearls and a shawl edged with
gold thread. Her gesture back toward the globe,
symbolizing for contemporaries worldly values
or earthly temptations, is one of graceful but
emphatic rejection.

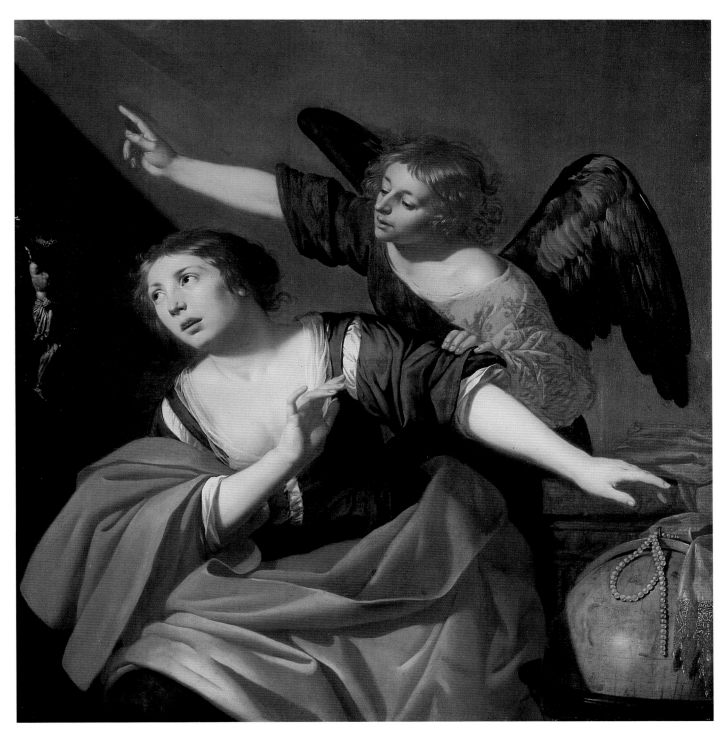

Cat. 19

The painting has traditionally been called *Mary Magdalene Turning from the World to Christ*, though the difficulties with this were already noted by David Steel in 1984.[1] In looking at the picture, the viewer might well think of the Magdalene: The young woman may be intended to suggest a reformed prostitute, but she has none of the other traditional attributes (loose hair and ointment jar) of the Magdalene, who turned to Christ before his death on the cross. Set within contemporary traditions of allegory, the painting is not about one person's conversion but about the necessity of putting worldly concerns aside in seeking Christ's redemptive grace. Paul Huys

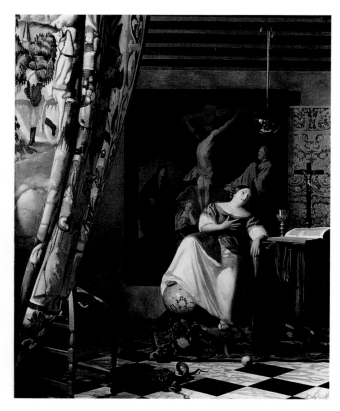

Fig. 1 Paulus Moreelse, *Allegory of Protestant Faith*, 1619.
Oil on canvas, 173 × 128 cm (68⅛ × 50⅜ in.). Museo de Arte
de Ponce, Ponce, 61.0193.

Fig. 2 Johannes Vermeer, *Allegory of the Catholic Faith*, ca. 1671–74.
Oil on canvas, 114.3 × 88.9 cm (45 × 35 in.). The Metropolitan
Museum of Art, New York, The Friedsam Collection, Bequest of
Michael Friedsam, 1931.32.10008.18.

Janssen has justly described this painting as an
allegory of faith. The presence of the crucifix,
as distinguished from an empty cross, indicates
that this is a reference specifically to the Catho-
lic faith.

The young woman and the pearls as symbols
of the life of the senses that she is rejecting have
many counterparts in Van Bijlert's oeuvre. For
example, the prostitute in his *Procuress* (cat. 39,
fig. 3) is dressed similarly though with the addition
of tawdry feathers and jewelry. There are at least
three paintings by the artist in which lecherous
old men offer strands of lustrous pearls to young
women in the hopes of carnal favors.[2] In contrast
to Van Bijlert's simple grouping of a strand of
pearls and what looks like a rich shawl as a distilla-
tion of worldly temptations, Paulus Moreelse has
heaped up symbols of those temptations to be trod

under foot by his personification, *Protestant Faith*
(fig. 1), dated 1619.

The globe is the polar opposite of the cruci-
fix here as it is of the cross in Jacob Duck's *Lady
World* (cat. 20), a painting that offers many points
of comparison with this one. In Duck's painting,
the emphasis is on the materialistic worldly life
from which the woman can hardly free herself;
in Van Bijlert's painting, the woman vigorously
rejects the temptations that would keep her
from Christ.

This is, therefore, the same "struggle
between worldly and godly love" (strijdingen
tusschen de wereltlijcke ende goddelijcke liefde)
that is at the heart of one of the more influential
Catholic emblem books of the time, entitled *Typus
Mundi*, published by the Jesuits in Antwerp in
1627 and dedicated to Saint Ignatius Loyola. Each
emblem is based on oppositions centered on a
globe that is a distillation of the worldly concerns.

This brings us to Johannes Vermeer's *Allegory
of the Catholic Faith* (fig. 2), from 1671–74.[3] Vermeer
has here followed the suggestions for the personifi-
cation of Christian faith given in the 1644 Dutch
edition of Cesare Ripa's *Iconologia*,[4] one of the

most important Italian sources for allegorical language, though its rather abstract associations were less often consulted in the Netherlands. We do not have to review all the details to focus on the elegantly dressed woman who meditates on the crucifix (underscored by the altarpiece behind) while keeping one foot discretely but firmly on the globe. The emphasis here is on accepting Christ rather than on rejecting the world. Set against these related images, the importance of the struggle that the woman exemplifies as the central issue of the present painting becomes more obvious.

Though Van Bijlert was a staunch member of the Reformed Church, he, like many other Protestants such as Hendrick ter Brugghen, produced paintings on Catholic subjects, even altarpieces, such as Ter Brugghen's *Annunciation* (cat. 15). Van Bijlert's *Holy Trinity with Saint Willibrord and Saint Boniface* (see Kaplan, fig. 5, in this catalogue; formerly in Onze Lieve Vrouwekerk, Huissen, destroyed in 1943)[5] was very likely painted about 1639 for the Brotherhood of God's Mercy under the Protection of Saints Willibrord and Boniface. The purpose of this brotherhood was the strengthening of faith through a better understanding among Catholics and potential converts. Therefore, as an allegory of the Catholic faith, the present painting, with its remarkably strong emphasis on the individual's capacity to exercise free will in actions that will affect his or her own hopes for salvation, a capacity denied by Protestants, most strenuously by Calvinists, could also have been painted for this brotherhood.

Placing paintings by Van Bijlert into any kind of chronology is made difficult by the limited number of dated works. The dating of the Greenville painting to the 1630s[6] prompts a comparison of the artist's characterization of the main figure, presumably a young, reformed prostitute, with the young prostitute in the Braunschweig *Procuress* (cat. 39, fig. 3), which bears the date 1626, thus about two years after Van Bijlert's return from Italy. The round, slightly fleshy facial features, curly hair, and overt sexuality of the young woman in the 1626 painting—which provided the basis for assigning a similar date to *Girl Teasing a Cat* (cat. 39)—counter the cooler, classicizing facial types of the Greenville painting. Their clearly drawn features, thrown into relief by the even lighting, contrast with the Manfredi-like use of shadow in the 1626 painting that defines the figures through selective obscurity.

The face of the woman in the present painting is astonishingly like the clearly modeled, engaging faces of women in paintings by Simon Vouet, such as *Lucretia* (National Gallery, Prague),[7] datable to about 1626. Here, Vouet's earlier attraction to the manner of Manfredi has been put aside in favor of the clear, ultimately more flexible classicism of Annibale Carracci, the style he took back to Paris with him in 1627 and on which his subsequent career depended. Paul Huys Janssen, commenting on similarities between Van Bijlert's various representations of the Madonna and Child that he dates in the 1630s and works by Vouet from that decade, when the French master was working in Paris at the head of a large shop, has posited the possibility of a trip to Paris for Van Bijlert around that time. Van Bijlert may well have known Vouet in Rome. The French artist had been there during the whole of Van Bijlert's sojourn in the city. Huys Janssen has shown[8] that there could have been some contact in the 1630s, because Abraham Willaerts, Adam's son and a mediocre seascape painter, was briefly Van Bijlert's pupil before spending some time in Vouet's shop in Paris, returning to Utrecht in 1635. Surely Van Bijlert was in contact with the influential French master first. Though Vouet's paintings, including the Lucretia, were extensively reproduced in engravings, the way that Van Bijlert has painted the firm flesh is also so like Vouet that familiarity with his paintings seems more likely.

—J. S.

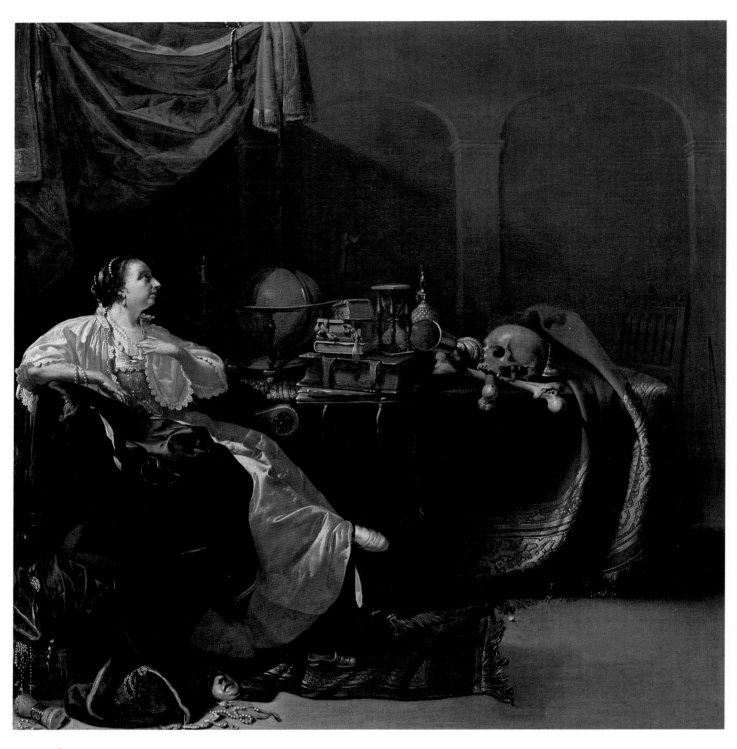

Cat. 20

20 JACOB DUCK
(d. 1667)

Lady World

1640s

Oil on panel, 38.4 × 39.4 cm (15⅛ × 15½ in.)
San Francisco, private collection

Provenance: Sotheby's (London), 24 Feb, 1971, lot 31;
with Leger Galleries (London), 1971

Selected References: De Jongh 1973, 201/1995, 70, 72;
Salomon 1984, 142

Very few paintings done in Utrecht are focused, as is this one, on such an array of realistically rendered objects whose assemblage in a still life invites scrutiny and interpretation. In a space that is more like a stage set than a room in a house, an expensively dressed young woman in yellow satin and pearls lounges at her ease, one mule indecorously off. Her chair is beside a table covered with a carpet throw on which have been carefully arranged objects that are associated in the language of seventeenth-century still lifes with admonitions against the dangers of being seduced by the gratifications and vanities of worldly or earthly existence, including those of the intellect and outward signs of religious observance. Some of the objects represent vanities—the gilt cups, one of which is tipped over (ostentatious consumption), the books (pride in worldly knowledge), the rosary casually draped over the edge of the table (outward show of religious observance?). Others convey transience—the low-burning candle, the hourglass, and the skull and bones. Summing it all up, the terrestrial globe juxtaposed to the cross represents worldly existence.[1]

These objects do not belong to the woman in the sense that they are arranged for her use. A man sitting by a table with these objects might be supposed to be a scholar, perhaps an astronomer, or a philosopher with overtones of Heraclitus, who might meditate on the terrestrial globe as a reminder of the world's folly, as in Ter Brugghen's painting (cat. 23). Since the figure is a woman, of

whom no such contemplations would be expected, the relationship to the globe can only be symbolic.

On the floor in front of the woman there is a different mix of objects: a gold chain, luxurious clothing, a mask (the falseness or misleading face of superficial society and in particular the tawdry illusion of the made-up prostitute),[2] and strands of pearls (with their contemporary associations with voluptuousness and vice)[3] spilling out of a chest. These objects typically represent the vanity of personal appearance, usually of women, as they do, for example, in Moreelse's *Allegory of Vanity* (cat. 21). The woman is not our surrogate within the pictorial space guiding our response to the objects; she herself is part of the beautifully articulated display. Without her, it would simply be a *vanitas* still life.

The allegorical relationship of a woman and a globe or map of the world and other objects symbolizing idle luxury and vanity as either the personification (Lady World) of the vanities of the world or as an example of them (a worldly woman) has been explored in a classic study by Eddie de Jongh.[4] Once one moves beyond the obvious depictions of a woman with a globe balanced on her head, the distinctions can be fine. Where a globe or map of the world is prominently displayed close to the head of a woman in a more or less realistically appointed space, as it is in the Haarlem painter Jan Miense Molenaer's well-known *Lady World* (fig. 1),[5] the apparent realism of the scene is meant as only the thinnest of disguises, to provoke the engagement of the viewer. Sometimes, as in illustrations of the choices before Hercules at the crossroads, before the Christian Knight, or, simply, the Christian, Lady World personifies vice or the false Life of the World as opposed to virtue or the true Life of the Spirit. Hercules and the Christian Knight are presented as inherently strong, but threatened with being brought low by temptation. On occasion the protagonist may be a woman, as she is in Jan van Bijlert's allegory of the Catholic faith (cat. 19), where she is shown overcoming

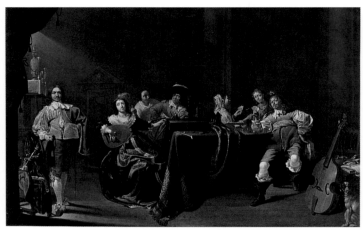

Fig. 1 Jan Miense Molenaer, *Lady World*, 1633. Oil on canvas, 102 × 127 cm (40⅛ × 50 in.). The Toledo Museum of Art, gift of Edward Drummond Libbey, 75.21.

Fig. 2 Jacob Duck, *Merry Company in a Bordello*, ca. 1640. Oil on panel, 46.7 × 73.7 cm (18⅜ × 29 in.). Worcester Art Museum, Charlotte E. W. Buffington Fund, 1974.337.

what contemporaries believed to be the inherent weakness of her sex and rejecting the temptations of the world as she turns to Christ.

Eddy de Jongh and, more recently, Nanette Salomon[6] have suggested that the woman in Duck's painting, who rests her fingers on her chest and looks upward, is renouncing her past life, represented by the objects on the floor, and turning toward the cross and therefore the Christian life, represented by the objects on the table. The woman's upturned gaze undoubtedly is meant to convey a change of heart. However De Jongh's characterization of her as looking up at the cross is not tenable: The cross is not above her eye level. Nevertheless, on the one hand, figures in Dutch paintings who turn their eyes toward heaven are genuinely seeking divine guidance. On the other hand, her body language is not that of renunciation or rejection, as is the body language of Van Bijlert's young woman (cat. 19), but rather is indicative of looseness and lack of discipline. She sits with one leg extended, and the mule, so easily

slipped off, is an attribute of easy virtue, worn by the prostitutes in Bronchorst's *Bordello* (cat. 44, fig. 1) and *Nude Model* (cat. 44, fig. 2).[7] Furthermore, her hand gesture is instructive. She is sitting, not with her right hand to her heart, as is the woman in Vermeer's *Allegory of the Catholic Faith* (cat. 19, fig. 2), but with her left hand touching her pearls.[8] Perhaps Duck meant to leave the moral issues unresolved; perhaps he meant to convey that one can be awakened to the need to reject a destructive lifestyle and to repent without necessarily being able to renounce its gratifications.

Human vanity and susceptibility to the seductions of idleness, easy gratification, and worldly vice are constant themes in Duck's work, his subjects ranging from the lazy reverie of the sleeper in his *Soldiers Arming Themselves* (cat. 34) to the two prostitutes in *Merry Company in a Bordello* (fig. 2), who are using mirrors to cheat a foolish, self-satisfied sucker at cards, to allegorical representations of prostitutes surrounded by objects that symbolize a life of the senses. A certain dry, live-and-let-live humor comes through in these observations of his. Though idlers may be exploited by other idlers, threat of punishment seems to hang over none. The skull and low-burning candle in *Lady World* may be the closest Duck comes to expressing concern for reform.

There are few dated works by Duck, so it is difficult to establish a date for this picture. It shares many visual characteristics with *Merry*

Company in a Bordello, which has been assigned to about 1640:[9] delight in highly articulated surfaces ranging from elaborately folded cloth to the intricate modeling of the gilt pineapple cup found in both paintings; rich fabrics; the subtle play of neutral tones with a few splashes of muted color, principally a fine yellow modulated in the shadows to a burnt orange that is, in turn, stepped down to a rich burnt umber in the still life; and a similar proportional relationship of the figures to the space.[10] Duck lit both scenes from the side, but it is especially in the dramatic use of light in this painting that one may suppose an appreciation of the effects achieved by the Caravaggisti, though the inspired play of light off the golden threads in the carpet throw are all his own. Nevertheless, the major influence on the style of these paintings must come from the earlier paintings of merrymakers in interiors by Pieter Codde and Dirck Hals in Haarlem.[11]

Because it is difficult to date this fine work, and because Duck was active in Haarlem as well as Utrecht in the 1630s and 1640s, we cannot be certain that *Lady World* was painted in Utrecht. It is possible that its moralizing still life and adaptation of the Lady World motif, which are unusual for paintings in Utrecht, are more appropriately understood as a response to the artistic environment of Haarlem. Nevertheless, Duck's painting, arguably his masterpiece, serves as a reminder that artistic environments were fluid.

—J. S.

21 PAULUS MOREELSE
(1571–1638)

Allegory of Vanity
1627

Oil on canvas, 105.5 × 83 cm (41½ × 32⅝ in.)
Signed and dated upper left: *PM* [in ligature] *oreelse fe 1627*
Cambridge, Fitzwilliam Museum, University of Cambridge, PD. 32–1968

Provenance: coll. William, 2d earl of Craven, 1866; coll. George, 3d earl of Craven; coll. William George Robert, 4th earl of Craven; coll. Cornelia Martin, widow of William George Robert, 4th earl of Craven; sale, coll. Cornelia, Countess of Craven, Sotheby's (London), 27 Nov. 1968, lot 103, illus.

Selected References: De Jongh et al. 1976, 190–93, no. 47, illus.; Hoogsteder 1986, 1:162–64, no. 124, 2:37, 3: fig. 168; Sluijter 1986, 508; Sluijter 1988a, 156–57; Sluijter 1988b, 160, 162–63, fig. 12; Tapié 1990, 164–75, no. F.41, illus.; Scarisbrick 1993, 96, illus. (detail)

With this *Allegory of Vanity* Moreelse introduced a new theme in Utrecht painting. The painting represents a young, attractive woman who points to her reflection in a mirror. This mirror is set before her on a table, on which lie pieces of precious jewelry and a small book, whose opened page shows an illustration with a Latin subscription. A painting on the back wall represents two nude figures in a landscape. The theme of the young woman with a mirror was repeated three more times by Moreelse in his later years, twice in 1632 and one in about 1633.[1] All four paintings undoubtedly have the same meaning.

Allegory of Vanity has been extensively discussed by Eddy de Jongh in the catalogue of the exhibition *Tot Lering en Vermaak* (To instruct and to delight).[2] According to De Jongh, the woman represents a "modern Venus." He based this identification on the pinkish red roses in the woman's hair, a flower that is indeed the traditional attribute of Venus. In this case, however, one wonders if the roses are truly meant as an attribute of the goddess of love; none of the women in Moreelse's other three versions have roses in their hair or can otherwise be identified with Venus.

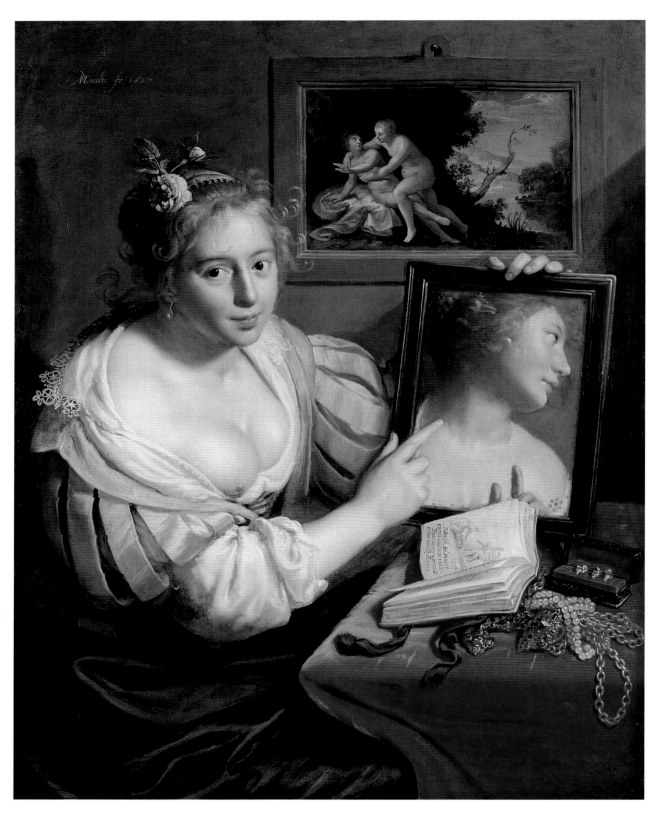

Cat. 21

The small book that lies on the table before the young woman is opened to a page with an illustration of a kneeling woman offering a gift to Venus and Amor.[3] Below this image is a Latin verse of four lines, which can be translated as follows: "The desire of the flesh / does not live for itself but for Venus. / To her she offers gold and jewels / and all riches."[4] The kneeling woman thus appears to represent the desire of the flesh, or Voluptuousness. Because gold and jewels are mentioned, it seems that the young woman with a mirror, who is after all standing before a table with jewels, is to be taken as the personification of Voluptuousness, rather than as a "modern" Venus. The notion that Voluptuousness is one of the central conceits of the paintings is confirmed by the scene in the painting in the background, which represents the naked, sensual nymph Salmacis trying to embrace the objecting Hermaphrodite. Moreelse probably chose this story from Ovid's *Metamorphoses* as one of the few accounts from classical mythology in which the woman takes the initiative in a seduction scene. Salmacis symbolizes here the sensual seductress who eventually succeeds in bringing her victim into her power. She is in that sense the perfect counterpart to the young woman with a mirror.

Eddy de Jongh in his commentary on *Allegory of Vanity* pointed out that the combined motifs of a young woman and a mirror had a long history before 1627, reaching back to the Middle Ages. Women with mirrors could personify positive concepts, such as Veritas (Truth), Sapientia (Wisdom), or Prudentia (Prudence), but also negative ones, such as Superbia (Arrogance), Vanitas (Vanity), or Lascivia (Wantonness). The combination was also used in allegorical representations of the sense of sight. According to De Jongh, the mirror in Moreelse's painting symbolized sensuality and transience. Since the young woman herself is to be interpreted as a personification of Voluptuousness, it seems that the mirror is meant as a *vanitas* symbol. The mirror, after all, reflects not internal, but only external beauty, a deceptive beauty that is preeminently transient. This fits the explanation of the mirror that is provided by Van Mander in his *Wtbeeldinghe der Figuren* (Commentary of figures) of 1604. According to Van Mander, the mirror is a symbol for falsehood in the sense of deception, because it only reflects the appearance, not the truth.[5]

In representing the young woman with a mirror, Moreelse has indicated that he wanted to make clear in a playful manner that the tempting quality of the young woman is based only on her attractiveness and that external beauty is by definition only appearance. A very good friend of Moreelse, the Calvinist Aernt van Buchel, wrote a group of six Latin poems on paintings by the artist. One of these poems was written about a painting that was described as a lascivious Vanitas. This poem, which was probably composed in the third decade of the seventeenth century, reads in translation:

On the painting of the lascivious Vanitas made by P. Moreelse

This is the image of the vain World, and the
 triumph of the flesh,
where the greedy, rapacious demon always
 holds sway.
Riches is busy with Venus, evil furor with Love;
both are in a blind rage, both do not know measure.
Let these be the antidote and cure for immoral
 sorrow:
fasting, tears, or better: contrition over evil.[6]

Even though the motif of the mirror is not mentioned, it is quite plausible that, because the concepts of sensuality, vanity, and riches are combined, the poem was written on one of Moreelse's representations of a young woman with a mirror. Striking is the starkly moralizing tone of the last two lines. Whether Moreelse really meant that his paintings with mirrors should be interpreted in this way is difficult to determine. Certainly the painting in Cambridge was intended as a warning

against the dangers of Voluptuousness and earthly riches. The fact that evil can be conquered by contrition cannot be deduced from the representation, but it must have been an obvious truth for Reformed Protestants like Van Buchel and Moreelse.

Allegory of Vanity in Cambridge was auctioned with the estate of the widow of the fourth earl of Craven. Practically all the Northern Netherlandish paintings in the collection of this family descend via inheritance from Elizabeth Stuart. She bequeathed her paintings to her friend William Craven, because he had invited her after the death of her husband, Frederick V, Elector of the Palatinate, to return to the land of her birth. Elizabeth, daughter of King James I, was married in 1613 to Frederick, who in 1619 became king of Bohemia. After his army was defeated at the Battle of the White Mountain near Prague, he fled with his family to the Northern Netherlands. Frederick and Elizabeth, notwithstanding great financial problems, succeeded in maintaining in The Hague, and later also on their country estate in Rhenen, an impressive court and managed to build an important art collection. Utrecht painters, like Gerard van Honthorst, Cornelis van Poelenburch, and Paulus Moreelse, received commissions from them. Several paintings by Moreelse are mentioned in an inventory of the house in Rhenen of 1633: a portrait of one of the daughters of the couple; a copy after a shepherdess by Moreelse; and another painting of which it was said to be large enough to serve as an overmantel.[7]

Willem-Jan Hoogsteder suggested in his 1986 study of the painting collection of the king and queen of Bohemia that the painting in Cambridge was to be identified with the overmantel mentioned as if in passing in the inventory.[8] Considering the provenance of most of the paintings in the Craven collection, that is indeed very possible.[9]

—E. D. N.

22 HENDRICK TER BRUGGHEN
(1588–1629)

Melancholia

ca. 1627–28

Oil on canvas, 67 × 46.5 cm (26⅜ × 18¼ in.)
Toronto, Art Gallery of Ontario, on loan from a private collection

Provenance: Appeared in the Schönborn coll., Pommersfelden, catalogue as early as 1746, cat. 100, as Honthorst

Selected References: Wurzburg 1746, no. 100; Von Frimmel 1894, 94, no. 256; Longhi 1927, 106, 112; Von Schneider 1933, 39 n. 28; Longhi 1952, 55; Czobor 1956, 230; Nicolson 1956, 109, 110; Nicolson 1958b, cat. A58; Nicolson 1960, 470; Gerson 1964, 563; Knipping 1974, 2:322; Lurie 1979, 284; Schuster 1982, 98–99, fig 41; Finlay 1984, color illus.; Blankert and Slatkes 1986, cat. 25, color illus.; Blankert 1991a, 11, illus. 12; Müller-Hofstede 1993, 44–45, fig. 36

There has been some controversy about the meaning of this dramatically and expressively illuminated depiction of a meditating young woman holding a skull. Benedict Nicolson, who catalogued the work as a Mary Magdalene, made it clear in his discussion of the pose and the secondary elements —the hourglass and the dividers—that his choice of a title was due more to necessity than any conviction about the true subject of this lovely and enigmatic painting.[1] Recent studies have continued the scholarly debate by vacillating between the two main interpretations: Melancholia[2] and Mary Magdalene.[3] The present writer attempted to straddle the scholarly fence by once cataloguing the picture as *Melancholy* while at the same time suggesting that it might have been intended to represent Mary Magdalene as Melancholy.[4] However, the absence of any clear and unambiguous religious symbol makes it unlikely that the figure was intended as a Mary Magdalene. As is frequently the case with new and unfamiliar themes, Ter Brugghen appropriated an existing compositional structure and pose used for depictions of the penitent Mary Magdalene and adapted it to the needs of the Toronto picture. Significantly, several Northern Caravaggesque artists, including

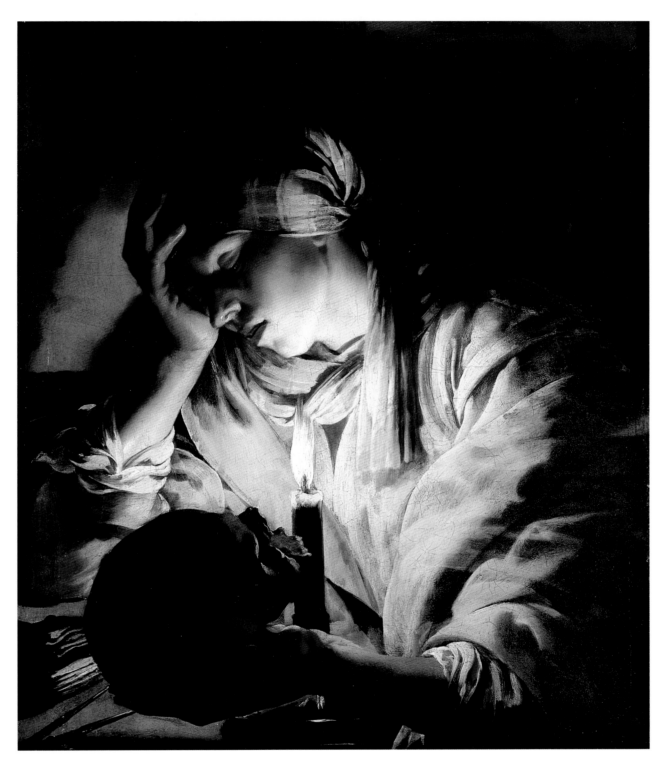

Cat. 22

the Antwerp master Gerard Seghers and the Lorraine painter Georges de La Tour, used closely related nocturnal representations for their depictions of Mary Magdalene,[5] although always with a crucifix or some other overtly religious element to make their intentions clear.

Peter-Klaus Schuster, in his discussion of Georg Pencz's similar painting of 1545, still at Pommersfelden, believed that it represented the penitent Mary Magdalene with the attributes of Melancholy because it included a prominent pair of dividers. Undoubtedly this mathematical instrument is a central symbol of the temperament since Dürer used it in his 1514 *Melancholia I* engraving.[6] Others, however, have preferred to see the Pencz as representing only Melancholia.[7] Like Pencz, Ter Brugghen includes only one completely conclusive object to indicate that he had images such as Dürer's engraving in mind: the dividers. Nevertheless, by including a death's-head as the object of meditation, Ter Brugghen has somewhat obscured his intentions. Skulls, common enough since the sixteenth century for images of meditating and penitent saints, including Mary Magdalene, are unusual in depictions of Melancholia, especially in the North. In Italy, however, Domenico Fetti did render his Melancholia holding a death's-head.[8] Predictably, the figure in the Fetti was also sometimes called Mary Magdalene, despite the artist's inclusion of several singular attributes of the melancholic—most notably the gaunt and sullen dog. Ter Brugghen's inclusion of the dividers on the table before his meditating female—the symbol of geometry and mathematics, a principal concern of the melancholic,[9] but not associated with Mary Magdalene—indicates his prime intention.

Somewhere in the formal background of the Toronto picture are the numerous sixteenth-century Northern depictions of Saint Jerome meditating with a skull. Some, like the one in Amsterdam[10]—by an early-sixteenth-century Leiden artist—even utilize candlelight. Thus,

although Ter Brugghen's theme has its roots in the humanistic traditions of the previous century, and the prevailing mood of the picture is one that we today associate with religious meditation, the seventeenth-century viewer, once having seen the dividers, would identify the painting as a secular one. Indeed, the pose, with one hand to the head, is a traditional one for the melancholic, whose head, so it was believed, was filled with such weighty thoughts—the prime cause of melancholia—that it required support.[11]

Ter Brugghen often utilized the same thoughtful pose for both secular and religious works. In one illuminating instance, he borrowed the figure of Heraclitus, rendered in this typically melancholic posture, from his own earlier *Democritus and Heraclitus* (cats. 23, 24, fig. 1)[12]—and used it, without change, for a 1621 *Saint Jerome Contemplating a Skull*.[13]

Benedict Nicolson, who misunderstood the nature of a 1626 document concerning arrangements Ter Brugghen made for the future of his children, suggested that the present picture might reflect the artist's mood due to illness and perhaps even approaching death.[14] The recent clarification of this document, however, would seem to eliminate this possibility.[15] There is, nevertheless, some evidence, based on the account of the German painter and artists' biographer Joachim von Sandrart, that Ter Brugghen was of a melancholic turn of mind. Von Sandrart, who knew the artist while he was studying with Honthorst, and thus not long before this picture was executed, makes this quite clear.[16] In the final analysis, however, there is no reason to believe that this, or any other picture by Ter Brugghen, had any associations that can be read in a purely autobiographical way, although there will probably always be attempts to do so.

—L. J. S.

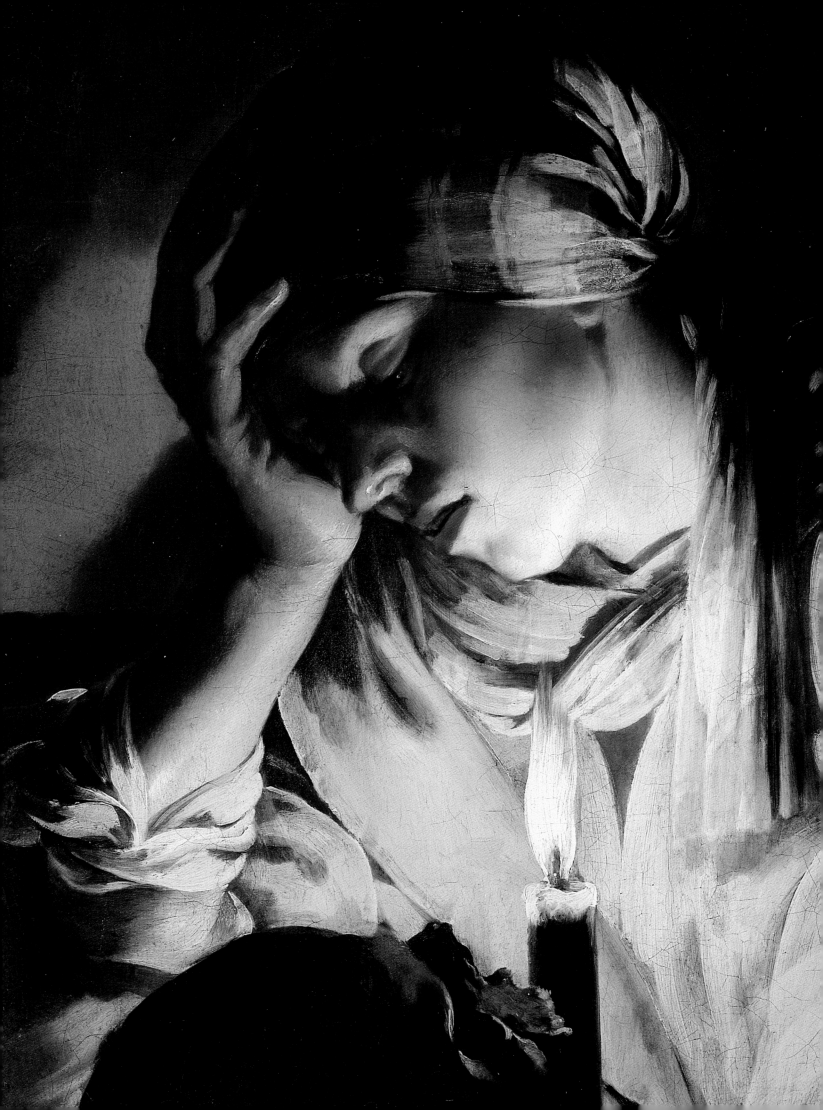

Cat. 23

Heraclitus

1628

Oil on canvas, 85.5 × 69.5 cm (33⅝ × 27⅜ in.)
Signed and dated upper right: *HTB* [in monogram]
rugghen fecit 1628
Amsterdam, Rijksmuseum, SK-A-2784

Provenance: gift of B. Asscher and H. Koetser, 1916

Selected References: Steenhoff 1916, 25–26; Hirsch-
mann 1919, 92, illus.; Weisbach 1928, 151–52, fig. 7;
Von Schneider 1933, 37, 71, 72 n. 12, 141, fig. 14B;
Wind 1937, 181, fig. 24c; De Jonge 1938, 41; Boon
1942, 53, fig. 27; Stechow 1944, 233, fig. 5; Milan
1951, cat. 160, fig. 2a and b; Möller 1954; Salerno
1954, cats. 164, 165, illus.; Nicolson 1956, 108–10;
Nicolson 1958a, 86; Nicolson 1958b, 45, cat. A4,
fig. 95; Gerson 1959, 315; Nicolson 1960, 469–70
n. 19; Plietzsch 1960, 146; Blankert 1967, 52, 63,
99–100, no. 39, fig. 23; Lurie 1979, 280, fig. 3;
Nicolson 1979, 97; Slatkes 1981–82, 182; Blankert
and Slatkes 1986, cats. 29, 30, illus.; Moiso-Diekamp
1987, 485–86, cat. A 1; Slatkes 1987, 324–30, fig. 2;
Nicolson and Vertova 1989, 1:189, 3: fig. 1173

Democritus

1628

Oil on canvas, 85 × 70 cm (33½ × 27½ in.)
Signed and dated at left: *HTB* [in monogram]
rugghen fecit 1628
Amsterdam, Rijksmuseum, SK-A-2783

Provenance: gift of B. Asscher and H. Koetser, 1916

Selected References: Steenhoff 1916, 25–26; Hirsch-
mann 1919, 92, illus.; Rijksmuseum 1920, no. 656B;
Weisbach 1928, 151–52, fig. 6; Von Schneider 1933,
37, 71, 72 n. 12, 141, fig. 14A; Wind 1937, 181,
fig. 24c; Boon 1942, 51, fig. 26; Stechow 1944, 233,
fig. 5; Möller 1954; Nicolson 1956, 108–10; Nicolson
1958a, 86; Nicolson 1958b, 45, no. A3, fig. 94;
Gerson 1959, 315; Nicolson 1960, 469–70 n. 19;
Plietzsch 1960, 146; Blankert 1967, 52, 63, 99,
no. 39, fig. 23; Lurie 1979, 280, fig. 4; Nicolson 1979,
97; Slatkes 1981–82, 182; Moiso-Diekamp 1987,
485–86, cat. A 1; Slatkes 1987; Nicolson and Vertova
1989, 1:189; 3: fig. 1174

Although the real Democritus (ca. 465–ca. 360
B.C.) and Heraclitus (ca. 540–ca. 480 B.C.) are
considered among the more important of the pre-
Socratic philosophers, it is only their later legend,
as told by Cicero and other Roman sources, that
provided the impetus for this important theme
in the visual arts, especially in the Netherlands
after 1600. According to these sources, when the
two philosophers viewed the follies of the world,[1]
Democritus laughed (see cat. 24) while Hera-
clitus wept.[2]

The theme of the laughing and weeping
philosophers began its postclassical history with
Marsillo Ficino (1433–1499), the famous Florentine
humanist, who seems to have actually owned a
painting of Democritus and Heraclitus together,
flanking a globe representing the world.[3] A 1485–90
fresco by Bramante[4]—perhaps the earliest sur-
viving painting of the two philosophers in this
manner—once part of the decorations of the Casa
Panigorala in Milan, appears to reflect the arrange-
ment of Ficino's lost work. This fresco, and thus
the theme, was well known during the sixteenth
century, for it was described by the Milanese
painter and theorist Giovan Paolo Lomazzo in
1584.[5] This is of some importance for Ter Brug-
ghen since he is documented in Milan in 1614,
on his return journey to Utrecht. Significantly,
Ter Brugghen's first painting of Democritus and
Heraclitus (fig. 1),[6] executed before 1621, followed
Bramante's arrangement and depicts the two
philosophers half-length on one canvas and flank-
ing a globe.[7] By including a large bone in the fore-
ground, Ter Brugghen's first picture still stressed
the *vanitas* elements that were inherent in the early
development of the theme, an aspect that all but
disappears in the present pendant pair.

Although the theme is relatively rare dur-
ing the sixteenth century,[8] there is a revival of
painted representations of Democritus and
Heraclitus in the Netherlands beginning in 1599,
due to the efforts of Cornelis Ketel who, according
to Van Mander, painted the two philosophers no

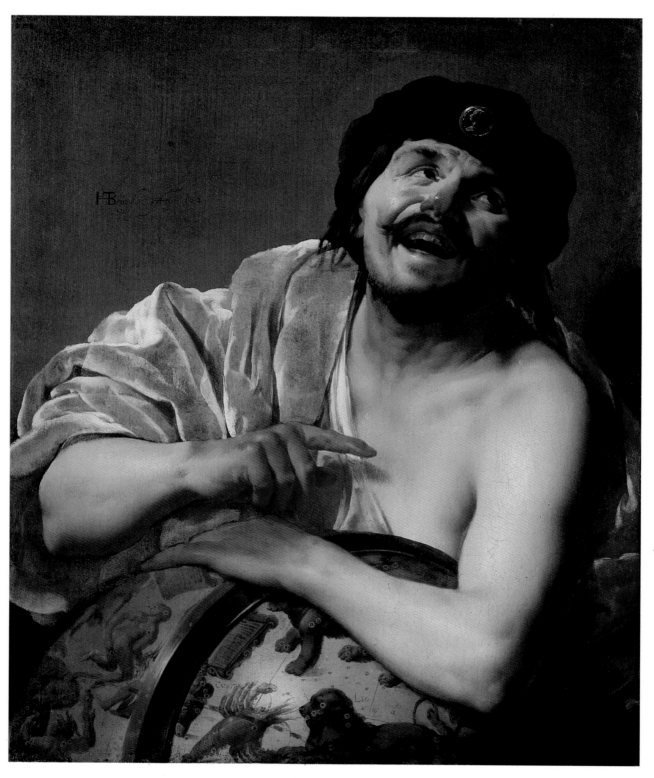

Cat. 24

fewer than three times.[9] Van Mander's praise of Ketel, and the fact that—if Van Mander is to be believed—Ketel, in an apparent feat of mannerist virtuosity, painted some of these without brushes, using only his feet, must have helped call attention to the theme.[10] One of Ketel's renderings of Heraclitus, seemingly one of those painted with his feet, seems to have been part of a pendant pair—possibly the first to give each philosopher his own painting—although only the *Heraclitus* has survived.[11]

In Utrecht the earliest pendant pictures of this theme are an ill-matched pair from the joint workshop of Baburen and Ter Brugghen.[12] Although both works are completely in the style of Baburen, they bear an odd *T.B.* monogram and a date of 1622.[13] The theme quickly caught on in Utrecht especially, as one might expect, among the Caravaggesque painters. Its popularity with those artists who had been to Rome is undoubtedly due to the emphasis Caravaggio placed on physiognomic expression. Indeed, Italian sources tell us that he even made faces in a mirror to more accurately capture fleeting expressions,[14] as in his *Boy Bitten by a Lizard* (see Orr, fig. 4, in this catalogue). A similar interest in realistic physiognomic qualities is evident in the present pair of pictures, especially in the immediacy with which Ter Brugghen has portrayed the ongoing sense of Democritus's broad laugh. Interestingly, the *Heraclitus* combines the traditional pose of the melancholic thinker, found in the artist's earlier depiction of the philosopher as well as the nearly contemporary *Melancholia* (cat. 22), although here combined with an open mouth and a speaking gesture, as if he were lecturing his younger colleague. Unusually for depictions of the two philosophers, their globes also support the fundamental differences between the two. The older Heraclitus leans heavily on a globe representing the earth, the proper element for the melancholic temperament he so clearly is meant to represent. A younger Democritus, in contrast, places his arm lightly across a globe of

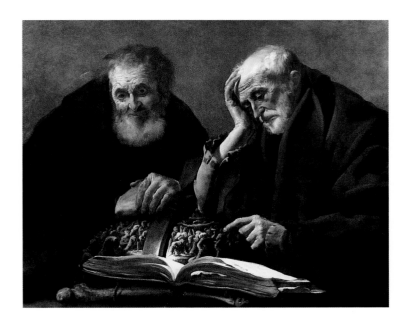

Fig. 1 Hendrick ter Brugghen, *Democritus and Heraclitus*, 1619–20. Oil on canvas, 93 × 111 cm (36⅝ × 43¾ in.). Private collection, Amsterdam.

the heavens and the constellations, a gesture which, with his broad laugh and mocking gesture, clearly characterizes him as being a light-hearted and sanguine-humored type.[15] Thus Ter Brugghen has successfully integrated older beliefs concerning the humors and temperaments into the new Caravaggesque conception, which makes use of realistically observed expressions and poses.[16]

There has been some confusion concerning the way these two paintings were meant to be hung in relation to one another. Weisbach, for example, believed that they should be placed back to back, to demonstrate the philosophers' mutual disdain for each other's views.[17] This, of course, would misplace the reactions of our philosophers, whose derision and scorn are reserved for the world's folly, not for each other. Furthermore, this manner of hanging them would be exceptional, to say the least, as there are no other pendant pairs that are meant to be hung in this way.[18]

—L. J. S.

25 DIRCK VAN BABUREN
(ca. 1595–1624)

Cimon and Pero (Roman Charity)
ca. 1623

Oil on canvas, 127 × 151.1 cm (50 × 59½ in.)
York City Art Gallery, Presented by F. D. Lycett Green
through the National Art-Collections Fund, 1955, 788

Provenance: (?) with Forchoudt (Antwerp), 1675; A.
Heppner coll., 1938; with Bottenweiser (Berlin); sale,
Sotheby's (London), 3 Mar. 1944, lot no. 94; A. Scharf
coll. (London), 1946; Lycett Green coll., on loan to South
Africa, National Gallery (Cape Town), 1952; gift to City
of York Art Gallery, 1955

Selected References: Slatkes 1965, 81–83, no. A22, fig 20;
Brejon 1979, 309; Blankert et al. 1980, no. 15; Blankert
and Slatkes 1986, no. 38, illus.; Nicolson and Vertova,
1989, 1:53, 3: fig. 1069; *Dictionary of Art* 1996, 3:8

Seventeenth-century painters in both Northern
and Southern Europe,[1] and modern art historians[2]
have found the unusual figural motif of this sub-
ject intriguing, its appeal both visual and icono-
graphic. Recorded in several classical texts, the
Caritas Romana, or Roman Charity, is most exten-
sively described in the *Factorum et dictorum
memorabilium libri ix* (Nine books of memorable
deeds and sayings) written in about 30 A.D. by the
Roman author Valerius Maximus.[3] This book of
anecdotes enjoyed a long popularity with the
ancients and was then taken up as source material
by medieval and Renaissance writers, orators, and
artists.[4] Under the chapter heading Filial Piety,
Valerius presents two variations on the theme
of filial devotion, one of Greek origin, one of
Roman. The Roman story recounts how Pero vis-
ited her father, Cimon,[5] in prison, where he was
condemned to die by starvation. Finding him
greatly weakened, she suckled him at her breast
to sustain his life.

The same opinion may be held of the filial piety of
Pero, who, her father Cimon suffering from the same
ill fortune and handed over to similar imprisonment
[to die in prison of starvation], fed him like a child,
although he was already of the greatest age, bring-

ing him to her breast. The eyes of men are fixed
with amazement when they see the painted image
of this deed, and they renew the occasion of the
ancient event by their wonder at this present spec-
tacle, believing that they see living and moving
bodies in those mute delineations of members of
the body. This of necessity must also happen to the
mind when it is admonished to recollect old events
as though they had just happened by the somewhat
more efficacious depictions of literature.[6]

As clearly apparent in this painting, the
erotic imagery is often coupled with an air of dan-
ger and suspense, as the condemned father and his
daughter look about nervously to see if they have
been detected by the jailer seen through the win-
dow. With such narrative details, it is no surprise
that the subject of Roman Charity appealed to
the baroque taste for drama.

The most famous use of this motif is in
Caravaggio's altarpiece of the *Seven Acts of Mercy*
(1606–7; Pio Monte della Misericordia, Naples).[7]
Caravaggio incorporated the ancient anecdote into
his thematic program of the Seven Acts of Mercy,
those charitable acts enumerated by Jesus as
requirements for admittance into the kingdom of
God.[8] Most frequently, however, artists isolated
the Roman Charity motif, as in the paintings by
Bartolomeo Manfredi and Peter Paul Rubens.

Two versions of the theme by Manfredi,
dating from the second decade of the seventeenth
century, are known today:[9] a picture in a private
collection in Milan,[10] and a second canvas that
appeared on the art market in 1963, but whose
present whereabouts is unknown.[11] Both paintings
are in a vertical format and present large-scale,
three-quarter-length figures pushed close to the
pictorial surface, the edges of the canvas cropped
closely about them, allowing for almost no articu-
lation of setting. The composition of the now-lost
picture is most suggestive of Baburen's handling
of the figural group, with the father positioned on
the right side, his daughter leaning down toward

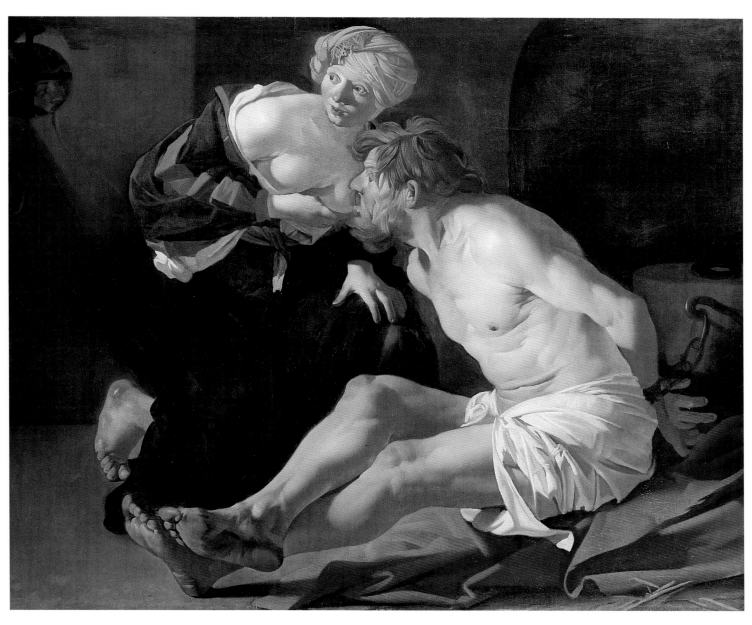

Cat. 25

him, and both Cimon and Pero looking off anx-
iously to the left. Manfredi's pattern of light and
dark is repeated in the Baburen, with the strong
light creating a diagonal path across the figures,
striking first Pero's shoulder, falling then across
her exposed breast, and then across Cimon's face
and naked shoulder. While echoing some aspects of
Manfredi's composition, Baburen's figural types
have little of the grace of their Italian counter-
parts; indeed, his coarsened figures with their
dirty, bony, bare feet seem plebeian in comparison.

Similar differences exist between the York

painting and an important Northern prototype by
Peter Paul Rubens (fig. 1), who treated the subject
of Cimon and Pero several times.[12] Dating from
about 1612, Rubens's early rendering was engraved
by Alexander Voet and seems to have had a specific
influence on Baburen's conception of the scene.[13]
The two works share a horizontal format, with the
protagonists presented in a shallow space defined
by a prison wall, which has a window in the upper
left corner. In both, the full-length figures are
seated on the prison floor, Cimon with his legs
stretched out before him, his feet crossed, and his

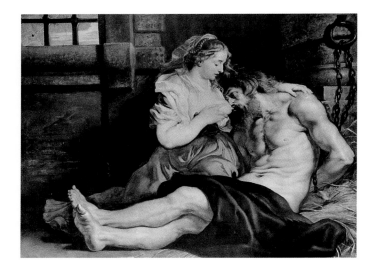

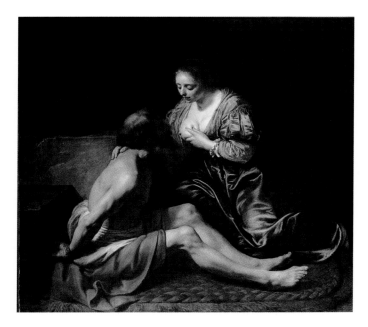

Fig. 1 Peter Paul Rubens, *Roman Charity*, ca. 1612. Oil on canvas transferred from panel, 140.5 × 180.3 cm (55⅜ × 71 in.). The State Hermitage Museum, St. Petersburg, 470.

Fig. 2 Paulus Moreelse, *Cimon and Pero (Caritas Romana)*, signed and dated 1633. Oil on canvas, 148 × 164 cm (58¼ × 64⅝ in.). The National Galleries of Scotland, Edinburgh, 1024.

Quellien,[15] the theme of Roman Charity found particular favor among artists in Utrecht, with examples by Abraham and Hendrick Bloemaert, Ter Brugghen, Gerard and Willem van Honthorst, and Paulus Moreelse (fig. 2). The combined visual and iconographic possibilities of the subject must have recommended it to the Utrecht community. Beyond the titillating scenario, the tale verified the ancient appreciation of filial pity and piety, values akin to the Christian virtue of Charity. It is not surprising that this specific subject found favor in an age that placed special emphasis on charitable works, particularly as embraced by the Counter-Reformation Church with its belief in the duality of good works and faith as a way to salvation.[16]

From a theoretical standpoint, the passage in Valerius also proved provocative. He praised the convincing realism of the Roman painting described, an appealing ancient justification for the verisimilitude characteristic of baroque painting, particularly of the Caravaggesque mode. Valerius also acknowledged the ability of painting to amaze and teach, a fundamental policy of the Council of Trent, enlisting art as a primary tool in Catholic efforts to battle Protestantism. Further, the author touched on the competition between painting and literature, termed *ut pictura poesis*, an issue much discussed in learned circles of the sixteenth and seventeenth century.[17] The rich iconographic layering of the legend of the *Caritas Romana*, which could be read in either Catholic or Protestant terms, coupled with its eroticism and in conjunction with the theoretical concepts developed in the text of Valerius Maximus, made the subject irresistible to many European artists and their patrons.

—L. F. O.

hands chained behind his back.[14] Rubens's figures, however, maintain a courtly elegance and classical beauty. In comparison, Baburen's figures are awkwardly posed, suggesting the awkwardness, both physical and psychological, of their situation. And, unlike almost every prior interpreter, Baburen does not have the daughter rest her hand tenderly on Cimon's shoulder; instead she puts her free hand on her knee to steady herself. These elements, coupled with the artist's broad painterly technique, give the York *Cimon and Pero* its idiosyncratic vitality and edge.

Although also treated by other Northern artists, including Rembrandt, Stom[er], and Artus

Artemisia

ca. 1632–35

Oil on canvas, 170.2 × 147.5 cm (67 × 58⅛ in.)
Signed lower left: *G. Honthorst*
Princeton, The Art Museum, Princeton University,
Museum purchase, gift of George L. Craig, Jr., Class
of 1921, and Mrs. Craig, y1968–117

Provenance: probably painted after 1632 for Elizabeth
Stuart, queen of Bohemia, and presented by her to
Amalia van Solms after 1647; Huis ten Bosch, The Hague
(see below); with François Heim (Paris), "from a French
château"; with S. Nystad (The Hague), 1953; with
K. Koetser (New York), 1956

Selected References: Judson 1959, no. 97; Braun 1966, no. 99;
Blankert et al. 1980, cat. 17; Gaehtgens 1995a

San Francisco and London only

On the death of her husband, the Carian satrap
Mausolos, the grieving Artemisia had his body
cremated and, in a ceremonial act, drank the ashes
mixed with wine. Since antiquity, this legend had
been considered an *exemplum virtutis*, the queen
displaying marital fidelity even beyond the grave.
According to ancient sources, she also built her
consort the magnificent mausoleum at Halicar-
nassus, one of the Seven Wonders of the World.[1]
Through the ritual consumption of his remains,
Artemisia transformed her body into a new tomb
for the dead ruler. Always implied if not explicitly
stated, the gesture undoubtedly also functioned
as a form of public legitimation for the widowed
queen, who continued to govern in Mausolos's
name from 353–350 B.C.

Honthorst transforms the ancient story into
an act of state, with the queen and the priest who
kneels before her—who appears to be derived from
a representation of the Adoration of the Magi—
preparing the libation in great solemnity. The
lighting effectively sets off the main figures from
the entourage, which remains in shadow. The
ceremonial utensils gleam from between Artemisia
and the priest and, together with the splendid
garments, give the whole a great nobility. The
masterly differentiation of textiles and materials,
as well as the various emotions of the characters,
marks Honthorst as the artist who recast Cara-
vaggist realism as courtly classicism.

The unusual subject, as well the question as
to who could have commissioned such a morally
and politically charged history painting from an
Utrecht artist, conveys us into the still insuffi-
ciently explored realm of Dutch court art. Hont-
horst seems to have drawn on two pictorial
precedents for his picture. Already before 1539
Georg Pencz had depicted the mourning Artemisia
in an engraving (fig. 1), showing her burning the
king's body and having the drink prepared.[2] The
act is characterized as an archaic and somewhat
strange custom, but also as something dignified,
worthy of a queen.

The Artemisia legend had come to have a
certain importance since 1562, particularly in
France. Nicolas Houel had written a *Histoire
d'Artémise* for Catherine de' Medici who, after the
death of Henri II, had become regent to her son
Charles IX. Illustrated by Antoine Caron, it was
meant to serve as an iconography of her reign,
with the drinking of the ashes underscoring her
right to act as the king's representative.[3] From
the beginning there had been plans to use Caron's
illustrations as the basis for a series of tapestries.
Not woven until fifty years later, it was during the
regencies of Marie de' Medici (1610–20) and Anne
of Austria (1643–60) that the works came to mani-
fest their full artistic and political potential, in
France and at other European courts.[4]

It is within this context that Honthorst's
painting should be seen. He must have known the
French tapestries, as he incorporates motifs from
one of them into his depiction.[5] This citation from
a work made for the French monarchy certainly
seems to indicate that his patron came from aristo-
cratic circles.

It is striking that just at the time Honthorst
was painting his picture a number of other repre-
sentations of Artemisia drinking Mausolos's ashes

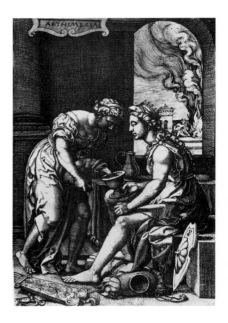

Fig. 1 Georg Pencz, *Artemisia*, before 1539. Engraving, 191 × 134 mm (7½ × 5¼ in.). Private collection.

Fig. 2 Gerard van Honthorst, *Elizabeth, Queen of Bohemia, Electress Palatine*, 163(4?). Oil on canvas, 216 × 148.5 cm (85 × 58½ in.). Kurpfälzisches Museum, Heidelberg, L157.

Fig. 3 Gerard van Honthorst, *Elizabeth, Queen of Bohemia, Electress Palatine*, 1642. Oil on canvas, 205.2 × 130.8 cm (80¾ × 51½ in.). Trustees of the National Gallery, London, 6362.

appear in Holland. Both Rembrandt and his pupil Jacob Backer painted the subject in the mid-1630s.[6] These differ strongly, however, from Honthorst's cool, "courtly" classicism, so suited to the taste of a princely patron.[7] Already in about 1610–15, Peter Paul Rubens had painted an "Artemisia" that appears to have been in the possession of Louise de Coligny, widow of William the Silent and mother of the stadholder, Prince Frederik Hendrik, at the Noordeinde palace in The Hague.[8] There must therefore have been an aristocratic clientele here that commissioned these works on royal grief and the claim to power.

Both the moment at which it was executed and the painting's underlying political theme thus lead one to suspect that Honthorst painted his picture specifically for Elizabeth Stuart, queen of Bohemia and Electress Palatine (1615–1661), who lost her husband in 1632.[9] The daughter of James I of England, she had married Frederick V, Elector of the Palatinate, in 1611 and, at the instigation of the Bohemian Protestants, was crowned with him in Prague in 1619. Queen for only one winter —hence her epithet, the "Winter Queen"—she had gone to live in exile in The Hague. Here she met Honthorst, who soon became a kind of court painter to the impoverished but nonetheless class-conscious pair, creating a large number of works for them.[10] Immediately following the Elector's death, Honthorst painted Elizabeth's portrait; despite the loss of both husband and authority she is shown in full regalia (fig. 2). On the tenth anniversary of Frederick's death in 1642, Honthorst once again depicted her in a large-scale work, this time dressed in her widow's weeds and with only a red rose as an attribute, symbolizing her love and eternal grief (fig. 3).

As Scheurleer has shown, Honthorst's *Artemisia* hung in Huis ten Bosch in The Hague from about 1654 on.[11] The palace had been built by Amalia van Solms, widow of Frederik Hendrik and at one time lady-in-waiting to the Winter Queen, and the central domed hall was entirely decorated with paintings celebrating the reign of her dead spouse. Contemporaries often compared this room to the great mausoleum at Halicarnassus. It thus seems probable that Elizabeth gave the *Artemisia* to Amalia after the stadholder's death in 1647. It

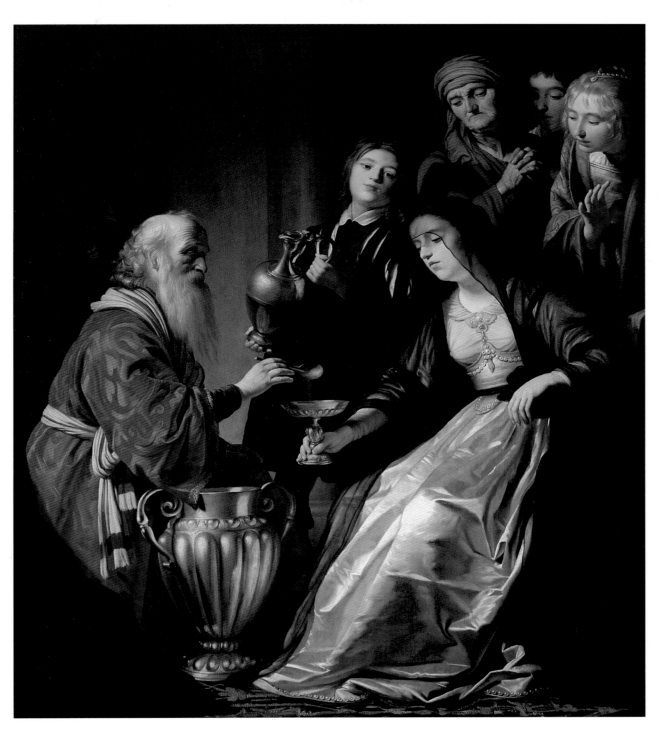

Cat. 26

found a prominent place in the west wing of the palace, over the fireplace in the *voorkamer*, in the so-called Oranjezaal. The mourning queen was a reminder not only of Amalia's grief but also of the justification of her claim to represent the interests of the House of Orange in the absence of a male ruler.

—B. G.

27 GERARD VAN HONTHORST
(1592–1656)

Frederick V, King of Bohemia, as a Roman Emperor

ca. 1635

Oil on canvas, 73.7 × 57.2 cm (29 × 22½ in.)
London, National Portrait Gallery, 1973

Provenance: Sir Ernest George, R.A., coll.; sale, Sotheby's (London), 7 Mar. 1923; purchased by the trustees, 1923

Selected Reference: Piper 1963, 130, no. 1973

The youthful king is depicted in half-length, dressed in the garb of a Roman imperator. His armor is covered by a scarlet mantle, gathered at the left shoulder with a golden clasp. Wearing long black curls and a fashionable beard, he is crowned with a laurel wreath—in a military context the highest distinction for a victorious commander and in ancient Rome reserved for the emperor alone. His sensitive and melancholy gaze, however, seems to contradict the iconography of the conquering hero.

And indeed, the topos of the triumphant general was anything but appropriate to Frederick V. In 1613 he had married Elizabeth Stuart, the only daughter of James I of England, thereby strengthening his role as leader of the Protestant Union in Germany.[1] However, when he assumed the Bohemian crown in opposition to Emperor Ferdinand in 1619, he lacked a firm base of support and, following the Battle of the White Mountain near Prague, was forced to relinquish his kingdom

to his Hapsburg adversaries after having ruled only for a year. Ironically referred to as the "Winter King," he was sent into exile in 1621 and lost all his possessions in Germany in the ensuing Thirty Years War. As the grandson of William of Orange and cousin of the stadholder, Prince Frederik Hendrik, he and his large family were given asylum in Holland. Despite financial difficulties and political failure, he and his wife managed to lead a happy life in their residences in The Hague and Rhenen (in the province of Utrecht), surrounding themselves with all the trappings of a brilliant court. Frederick died suddenly in 1632, during a campaign with Gustavus II of Sweden in which he had hoped finally to fulfill his religious mission. The portrait seems to recall that event.

As a Protestant leader against the emperor, Frederick V was a part of the great religious and political struggles of the Thirty Years War. During his exile in Holland, however, artistic representation had to substitute for real power.[2] The works executed for him by Bloemaert, Poelenburch, Van de Venne, Mierevelt, Lievens, and above all Honthorst betray his need to convey the status and decorum of a ruling house by means of the historicizing portrait.[3] Honthorst painted a large number of family portraits for Frederick and Elizabeth, among others two large-scale pictures for the English king. One of these is a kind of *court masqué*, with the Bohemian couple dressed as Celadon and Astrée and accompanied by their children (1629).[4]

The subject of this pastoral derives from the extremely popular French romance *Astrée* by Honoré d'Urfée (1567–1625), which tells the love story of a shepherd and the daughter of the Amazon queen through a combination of Arcadian and courtly motifs. The book had a great impact on the lifestyle of Europe's courts, and it is not surprising that it was a favorite of the Winter King. There are letters from him to Elizabeth signed "your poor Celadon."[5]

Thus, Frederick had himself portrayed as Celadon and the queen as Astreé, whom he leads

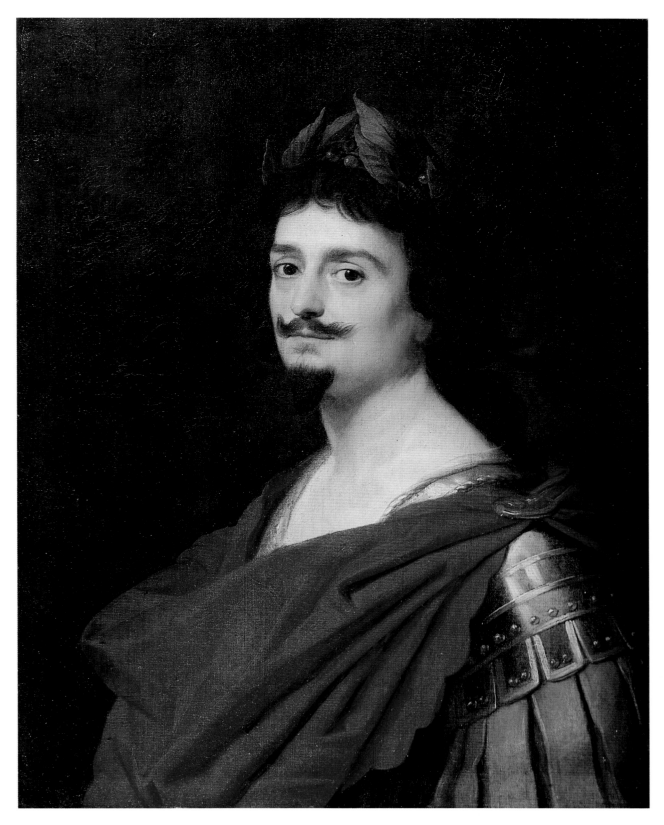

Cat. 27

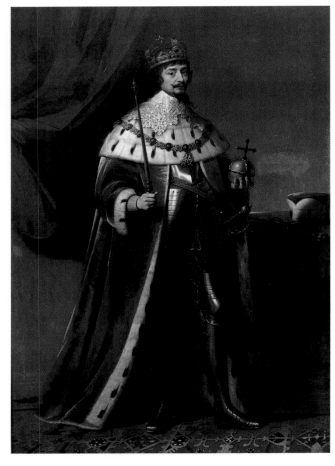

Fig. 1 Gérard van Loon, *L'Histoire métallique des XII provinces . . . pour l'année 1632, La mort de Fréderic V*, 1732.

Fig. 2 Gerard van Honthorst, *Posthumous Portrait of Frederick V, Elector Palatine, as the King of Bohemia*, 1634. Oil on canvas, 215.7 × 147.2 cm (84⅞ × 58 in.). Kurpfälzisches Museum, Heidelberg, L156.

to the fountain of love. The depiction of six of their children in allegorical costume, however, has nothing to do with the literary source. The king appears here in invented Roman garb, with a golden tunic and red cloak. David Piper has correctly pointed out the physiognomic resemblance between our portrait and the depiction in the English painting.[6] It is therefore possible that the former reproduces an earlier likeness of the king. It remains a question whether the garment worn in the present portrait was also meant as a reference to Celadon.

A commemorative medal was produced in the immediate wake of Frederick's death, illustrated in Van Loon's *Histoire métallique* (fig. 1).[7] The obverse shows the royal couple in profile, the king clothed as a general. On the reverse, an emblem of the setting sun refers back to medieval imperial iconography and thus to Frederick's legitimate claim to power.[8]

The Winter King also appears as a half-length figure in antique military attire in an allegorical painting of 1635, probably commissioned from Willem van Honthorst by the widowed Elizabeth for her palace in Rhenen.[9] The deceased commander greets his family from the heavens, a sure sign of his apotheosis. A comparison with

Rubens's *Death and Apotheosis of Henri IV* (1625) in the Medici gallery in the Louvre suggests itself.[10] This type of raiment and the laurel wreath also belong to the iconography of glorification. It was most likely the Winter Queen, too, who asked Honthorst for a posthumous full-length portrait depicting Frederick in armor and Elector's robe, with all the insignia of his lost authority (fig. 2).[11]

The correspondence between this last work and our portrait makes a dating of about 1635 plausible. In this portrait *à l'antique*, the Winter King appears to belong to an imaginary gallery of emperors, as would be appropriate to the representational and legitimizing needs of a reigning monarch.[12] Honthorst's posthumous likeness is also part of this tradition. The depiction of the luckless king as a victorious leader, dramatically lit and with a suggestive gaze, may be meant as a reminder of his tragic death in the midst of the "Protestant struggle." The various posthumous

paintings of the king, which all appear to have been commissioned by his widow, are undoubtedly meant to keep the memory of both the person and his vocation alive. This picture was probably in the possession of Lord Craven, a faithful family friend. It entered the art market from the family collection in 1923.

—B. G.

28 DIRCK VAN BABUREN
(1595–1624)

Emperor Titus

1622

Oil on panel, 69.9 × 52.7 cm (27½ × 20¾ in.)
Signed and dated upper right: *Babu. fecit / Ano 1622*;
later inscription upper left: *IMP.XI.*
Berlin, Stiftung Preußische Schlösser und Gärten Berlin-Brandenburg, SPSG GK I 1982

Provenance: before 1680 already in the possession of the Grand Elector Friedrich Wilhelm; listed in the inventory of Schloß Caputh, near Potsdam, in 1698; Stadtschloß Berlin, 1700–1750 and 1786–1926; Schloß Charlottenburg, 1750–86

Selected References: Oldenbourg 1917; Fock 1948–49; Börsch-Supan 1964; Slatkes 1965, no. A 16; Börsch-Supan 1967; Van Dulen 1989; Börsch-Supan 1992

London only

Baburen's likeness of the Roman emperor Titus (A.D. 41–81) is part of a cycle of twelve imperator portraits now preserved in Jagdschloß Grunewald in Berlin. Along with a number of other important Dutch works housed there, the series is a reminder of the close ties between the Houses of Orange-Nassau and Brandenburg-Prussia.

The portraits were painted by various artists from both the Northern and Southern Netherlands between about 1616 and 1625.[1] The works are arranged chronologically according to the emperors' dates. The sequence begins with *Julius Caesar*, by Peter Paul Rubens (fig. 1), and continues with *Augustus* (Cornelis Cornelisz. van Haarlem),

Tiberius (Gerard Seghers), *Caligula* (Werner van den Valckert), *Claudius* (Hendrick ter Brugghen), and *Nero* (Abraham Janssens), followed by *Galba* (Paulus Moreelse), *Otho* (Gerard van Honthorst; fig. 2), *Vitellius* (Hendrick Goltzius?), *Vespasian* (Michiel van Mierevelt), and *Domitian* (Abraham Bloemaert). Baburen's portrait is the eleventh in the series, indicating that the cycle follows the succession of the first twelve Roman emperors as described by the historian Suetonius in about A.D. 120.

The emperor is depicted as a victorious commander, dressed in gold-and-black armor and a scarlet toga. He is crowned with a laurel wreath and shown turning to the left, as if attracted by something outside the picture, which he follows with interest. The sinews of his neck stand out, indicating the momentary nature of the pose. The impression of immediacy is further underlined by the dramatic lighting that leaves Titus's chin and cheeks in darkness while brightly illuminating his forehead and chest. Both the sharpness of the modeling and the ocher-colored "leathery" skin lend him an energetic and somewhat rough character generally associated with men of battle. All this would seem to put particular emphasis on the emperor's military accomplishments, celebrated, for example, by the triumphal march through the so-called Arch of Titus after the conquest of Jerusalem (A.D. 70). At the same time, the lively expression gives the portrait an extraordinarily contemporary air, as if the model—a Dutch bravo—had been taken directly from the streets of Utrecht.

Baburen appears to have painted this work shortly after returning to Utrecht from Rome. Because the first commissions in his native city were for history and genre paintings in the Caravaggist mode, this is something of an oddity. Leonard Slatkes places the portrait, both chronologically and stylistically, between *A Boy Musician* of 1621 and *The Lute Player* of 1622.[2] Why this artist was given the assignment in the first place and

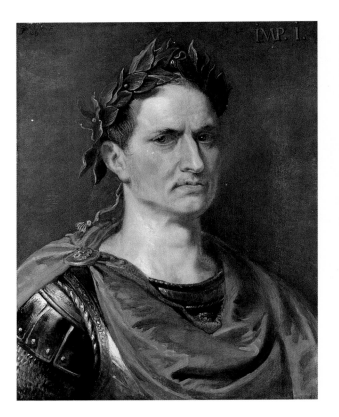

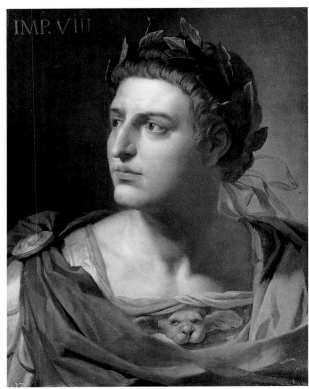

Fig. 1 Peter Paul Rubens, *Julius Caesar*, ca. 1619. Oil on panel, 68.2 × 52 cm (26⅞ × 20½ in.). Stiftung Preußische Schlösser und Gärten Berlin-Brandenburg, Berlin, AUI 972.

Fig. 2 Gerard van Honthorst, *Otho*, after 1620. Oil on canvas, 68 × 52.5 cm (26¾ × 20⅝ in.). Stiftung Preußische Schlösser und Gärten Berlin-Brandenburg, Berlin, AUI 979.

what this could have indicated can no longer be stated with any certainty.

Baburen's stay in Rome had, of course, given him the reputation of a connoisseur of antiquity. He was also known as an innovator who, with Honthorst, had brought the ideas of Caravaggio to Utrecht. He could thus guarantee his patron that the portrait would be true to the sources in form and at the same time "modern" in style. The artist turned to well-known portrait busts and medallions, probably known to him at firsthand, to give his likeness historical and physiognomic authenticity.[3] He was also inspired by Titian's half-length portrait of Titus, one of a twelve-part emperor cycle in the Palazzo del Tè in Mantua.[4] Rather than adopting Titian's pose exactly—with the

emperor looking back over his shoulder—Baburen chose a three-quarter profile instead, in accordance with the rest of the series. We do not know if Baburen actually knew Titian's cycle or if he knew it only through Aegidius Sadalaer's engravings (fig. 3).

The fundamental question is, however, who was Baburen's patron, and what could such a series of Roman emperors have signified in Republican Utrecht?[5] A number of conjectures can be made. Not all the portraits are signed and dated. In some cases there is still no definitive attribution. Slatkes has proclaimed Moreelse's *Galba*—dated 1618—to be the earliest in the series, followed by Rubens's *Caesar* of 1619. Bloemaert's *Domitian* seems to have completed the cycle in about 1625. Although the portraits are similar in format and palette, they are still obviously the product of varying artistic concepts and contexts.[6] Rudolph Oldenbourg criticized the series for its lack of unity in both form and content.[7] Helmut Börsch-Supan believed Rubens to have been the *spiritus rector* of the cycle,

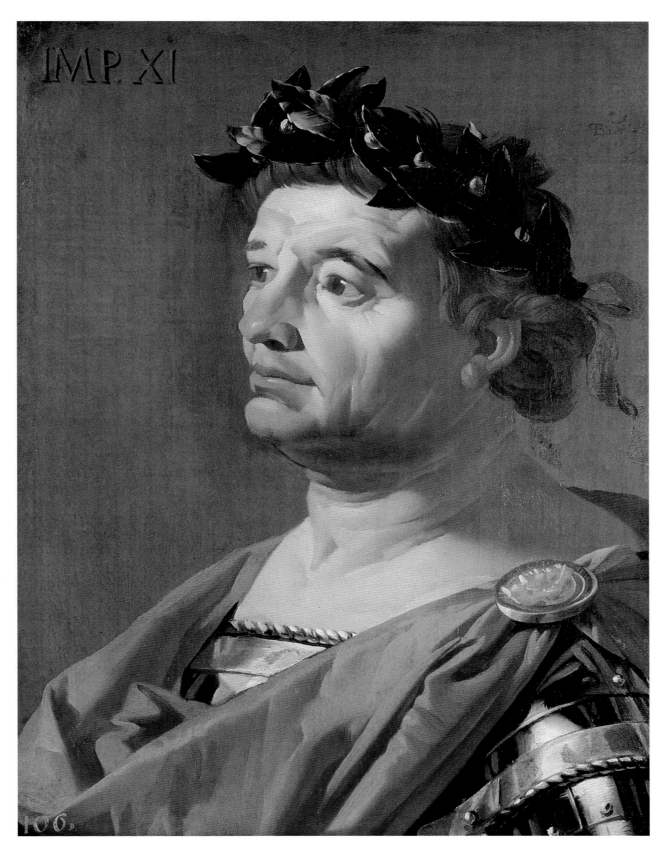

Cat. 28

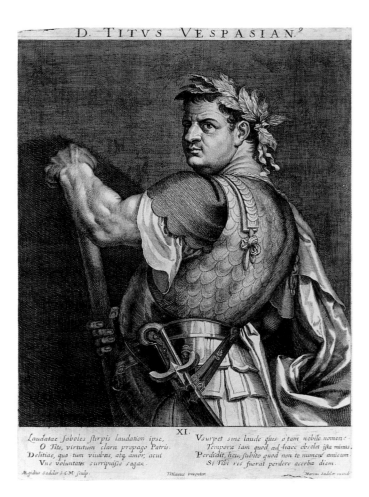

XI.

Laudatae Soboles stirpis laudatior ipse,
O Tite, virtutum clara propago Patris.
Delitiae, quo tum viuebas, atq amor, acui
Vna voluntates surripuisse sagax.

Vsurpet sine laude q̃iis o tam nobile nomen?
Tempora iam quod ad haec obsolet ista mimus,
Perdidit, heu, subito quod non te numine amicum
Si Tibi res fuerat perdere acerba diem.

Ægidius Sadeler s. C.M. sculp. *Titianus inuentor.* *Marcus Sadeler excud.*

Fig. 3 Aegidius Sadalaer, after Titian, *Emperor Titus*, ca. 1593.
From a series of engravings of Roman emperors. Engraving,
345 × 238 mm (13½ × 9⅜ in.). Kupferstichkabinett, Staatliche
Museen zu Berlin-Preußischer Kulturbesitz.

responsible for all decisions regarding format,
palette, and pose in the individual works.[8] This
premise has not been generally accepted.

We know the cycle was in Berlin even before
1680, when it was published in mezzotint by
Johann Friederich Leonard. In 1698 it was listed in
the inventory of Schloß Caputh in Brandenburg as
the property of Elector Friedrich III, grandson of
Stadholder Frederik Hendrik (stadholder 1625–47)
and heir to a large portion of the Orange estate.[9]
This gave rise to the assumption that the portraits
came originally from Frederik Hendrik's own col-
lection and that it was he who had commissioned
them. They are not, however, mentioned in his
1632 inventory, or in any documents on the Orange
legacy.[10] Because of their early dates, it is now

thought that it may have been Frederik Hendrik's
stepbrother, Maurits of Orange (stadholder 1589–
1625), who commissioned them, and that they
found their way to Berlin not through inheritance
but by another route.

In 1965 Slatkes proposed that the first of the
emperor portraits was the direct result of political
events.[11] In 1618 Maurits of Orange had disbanded
the mercenary army occupying Utrecht, thereby
demonstrating his strength as the undisputed
military leader of the United Provinces. According
to Slatkes, it was in gratitude for his support that
the first commission (for a portrait of the Roman
emperor Galba) went to Paulus Moreelse, a mem-
ber of Utrecht's provincial government. To com-
plete the series, assignments were then given to
other painters or appropriate likenesses were
added to it.

This theory is convincing, particularly as it
confirms an observation already made by Olden-
bourg in 1917.[12] He recognized in the cycle's cre-
ators "a remarkable cross section of Flemish and
Dutch painters" and pointed out how each por-
trait could be assigned to one of the various
important schools or cities in the Netherlands.
Bloemaert, Baburen, Ter Brugghen, and Hont-
horst, for example, were all from Utrecht; Rubens,
Seghers, and Janssens came from Antwerp;
Cornelis Cornelisz. and Goltzius were from
Haarlem; while Valckert and Mierevelt came from
Amsterdam and Delft respectively. Although the
Northern and Southern provinces were already
politically divided by 1620, the cycle thus seems
to suggest cultural continuity. Slatkes remarked
further that half of the artists who worked on
the series made up a kind of lineage of Utrecht
painting, with family members including not only
Mierevelt, his pupil Moreelse, and the latter's
follower Baburen, but also Bloemaert and his stu-
dents Ter Brugghen and Honthorst. Given this, it
seems safe to assume that what the patron wanted
in his cycle was a strong Utrechtian flavor.

Traditionally, cycles of Roman emperors

were designed to create a fictional ancestry for Europe's ruling houses; their aim was to make a genealogical and ideological connection between the past and the present. This series, for example, was later used in just this way by the Prussian kings, who displayed these works with marble statues of the first twelve Brandenburgian Grand Electors. The armor and laurel wreath clearly emphasize the (triumphant) military character of this particular pedigree. In the context of the Northern provinces and of Utrecht respectively, the portraits were probably meant as a statement of the stadholder's power and to underline the fact that he and his military might were the guarantee of future security. It seems likely that they were meant to fulfill the same purpose for the Oranges. One need only recall the family portraits commissioned by Maurits that were to replace the so-called Nassau Genealogy tapestries.[13]

—B. G.

Pleasures and Duties: Contemporary Life

29 PAULUS MOREELSE
(1571–1638)

*Portrait of a Member of the Strick Family
(Dirck Strick?)*

1625

Oil on canvas, 121.6 × 96.9 cm (47⅞ × 38⅛ in.)
Signed and dated upper right: *Aᵒ 1625 / PM [PM* in
ligature]
Allentown, Pennsylvania, Allentown Art Museum,
Samuel H. Kress Collection, 1961.39G

Provenance: Sir William and Lady F. A. J. Hutt coll.,
Appley Towers, Isle of Wight; sale, Christie's (London),
20 June 1913, lot 105 (sold by order of the trustees of
Sir William and Lady Hutt, to Asher Wertheimer); Asher
Wertheimer coll., London; sale, Asher Wertheimer coll.,
Christie's (London), 18 June 1920, lot 31 (to Clements
for £1,890 (?); with Lewis and Simmons (London); with
John Levy Galleries (New York); with Kleinberger & Co.
(New York); with Knoedler & Co. (New York); Samuel H.
Kress Foundation (New York), 1938 (K1133); on loan to
the Allentown Art Museum, 1960

Selected References: De Jonge 1938, 26, 89, no. 77a, fig. 63;
Frankfurter 1939, 13; San Francisco 1939, no. 83; Allen-
town 1960, 108–10, illus.; Eisler 1977, 126–27, no. K1133,
fig. 115; Wilson 1980, no. 53; Adams 1985, 296; Sutton
1986, 1, 342, fig. 1; Huys Janssen 1994b, 323–24; Ishikawa,
in Ishikawa et al. 1994, 145–49, cat. 19, illus.; Ekkart and
Domela Nieuwenhuis 1995, 17, fig. 6

Paulus Moreelse owes his reputation as one of the
most important Northern Netherlandish portrait
painters of the first half of the seventeenth cen-
tury to his monumental three-quarter-length
pieces, of which this male portrait in Allentown
is a representative example. In addition to these
knee-length portraits, we also know of more than
sixty bust portraits, as well as some hip- and full-
length portraits. The very earliest portraits that

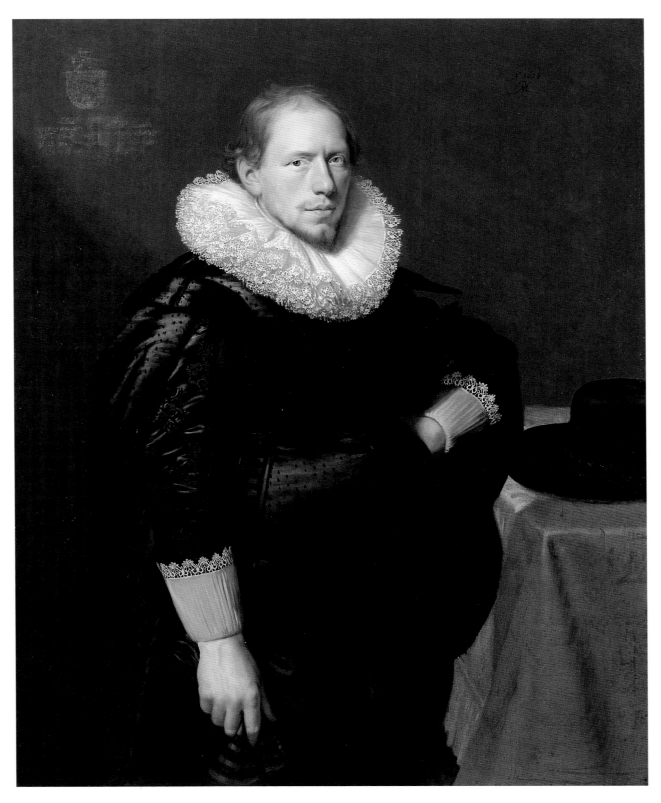

Cat. 29

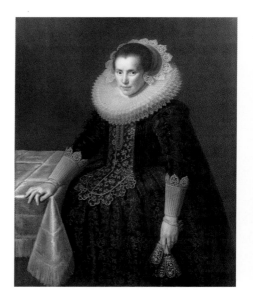 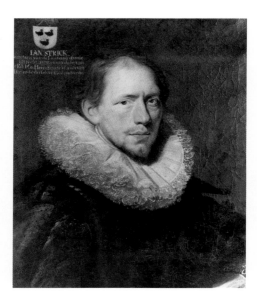 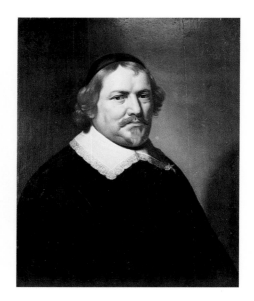

are known to be by him date from 1600 and shortly thereafter.[1] Although these portraits do not yet show the quality of his later work (Moreelse only fully developed as a portrait painter after 1610), as early as 1604 he is mentioned by the artists' biographer Karel van Mander as a very good portrait painter.[2] A prestigious commission in 1616 for an Amsterdam civic guard portrait shows that he was also greatly appreciated outside Utrecht.[3]

The male portrait from Allentown has as a pendant a female portrait from the same year (fig. 1). The compositional formats Moreelse chose for the two portraits are found in most of his other knee-lengths. In the case of married couples, the sitters are turned toward each other, not looking at each other but always gazing at the viewer. The husband is always represented to the left of his counterpart, in order that his spouse, following the conventions of the time, appears to his left.

The male portrait in Allentown was identified by P. G. L. O. van Kretschmar in 1968, after of a fragmentary copy (fig. 2) had been discovered, to which had been added a family escutcheon and the inscription of a name.[4] An identical coat of arms and inscription were once in the upper left corner of the original in Allentown but had vanished by 1913 when the painting appeared in a London auction as the portrait of an unknown man. The portrait of a woman in Allentown, of which no copy is known to exist, presumably never had an inscription. According to the inscription on the copy, the male portrait in Allentown represents Jan Strick (1556–1604) from Utrecht, who between 1583 and 1588 was secretary of the States of Utrecht. However, since Jan Strick had died in 1604 and therefore could not have sat for the 1625 portrait, we must assume that the inscription was incorrect. Nor could it have been a posthumous portrait, since the clothes worn by the man conform to the fashions of 1625.

It is very likely, though, that the portrait does represent a member of the Strick family. The copy, after all, forms part of a series of portraits of other members of the Strick family, most of which carry correct identifying inscriptions.[5] A possible candidate for the male portrait in Allentown was proposed in 1968, namely Dirck Strick (1592–1633),

the youngest of the three sons of Jan Strick. The eldest of these, Adriaan (1578–1623), cannot be considered, since he died before the date of the portrait. The identification with the middle son, Johan (1583–1648), is considered unlikely, since a portrait of him by Jan van Bijlert (fig. 3) was already known, and the same person would not have been portrayed twice.[6] The lack of resemblance between the man in the 1625 portrait by Moreelse and Johan Strick in Bijlert's portrait of 1647 was probably a factor in this conclusion.

The identification of the painting in Allentown as a portrait of Dirck Strick has so far been challenged only once, in 1994, by Chiyo Ishikawa.[7] She entitled the painting *A Member of the Strick Family* and offered three arguments why the 1968 identification by Van Kretschmar was not completely convincing. In the first place, she pointed out that the lack of resemblance between the man in the portrait by Moreelse and Johan Strick in the Bijlert painting could be due to the aging of the model. Second, according to the inscriptions, the sitter is named Jan, which is a contraction of Johan. It seemed to her more likely that two sitters with the same first name had been confused, rather than that a Dirck and a Jan had been interchanged. Ishikawa's third argument touched on the fact that the copy portrait is still with Johan's descendants. In view of these arguments it is not surprising that Ishikawa considered Johan Strick to be the most likely candidate for the portrait. In the absence of convincing evidence, however, she did not exclude the possibility that the portrait could also be of Dirck. In the end it remains uncertain which of the two brothers is represented in the portrait. On the other hand, we do know to which social class of Utrecht's population they belonged.

The Strick family had been a prominent burgher family in Utrecht since the middle of the sixteenth century, and several members had succeeded in obtaining important posts in the magistracy.[8] Johan Strick (1583–1648), one of the two candidates for the portrait by Moreelse, aimed

even higher than his ancestors. He is a typical example of a pragmatic seventeenth-century politician, who saw in the changing political climate in his city new opportunities to increase his own and his family's status. Following his election in 1605 as canon secular of the chapter of Oudmunster, he rose within that body to first become a scholastic (superintendent of the archives) and in 1631 a dean. Because he had in 1618, at the time of Prince Maurits's unlawful actions against the Remonstrants, chosen the side of Orange, he had good prospects for further promotions. In January 1620 he was selected to represent the chapter of Oudmunster in the States of Utrecht, and later he was even sent to The Hague to take a seat on behalf of the States of Utrecht in the States General. In 1633 he bought from the chapter the country estate of Linschoten, which allowed him to be called lord of Linschoten. A year later he bought in France the additional title of knight. Even if this did not gain him admission into the Utrecht nobility, he did assume an aristocratic lifestyle and constructed a beautiful country house on his estate of Linschoten which, with its moat, towers, and drawbridge, resembled a noble manor. This house was completed in 1647, one year before his death.

In 1648 he was succeeded as lord of Linschoten by his son, who also was named Johan (1625–1686). This son shared the same aristocratic pretensions. Indeed, in 1649 he bought three additional country estates. That he enjoyed projecting himself as an aristocrat is evident in the group portrait that Jan van Bijlert (see Olde Meierink and Bakker, fig. 10, in this catalogue) painted of him and his family in 1653, a painting often mistakenly called a pastoral portrait.[9] In this painting Johan Strick and his wife and children are represented in classicizing fancy dress and with hunting attributes set in a landscape. Since hunting was a privilege of the nobility, the non-noble Johan Strick is here displaying his aspirations. However, it must also be admitted that the manner in which

he chose to be portrayed is not entirely inappropriate, as he had a license to hunt on his own property.

Dirck Strick, the second candidate for the Moreelse portrait, had a somewhat less distinguished career.[10] Nevertheless, he also acquired several posts that gave him a certain status in society. In February 1620 he became treasurer of the suppressed convent of St. Paul and later became a deputy of the city of Utrecht with the States of Amsterdam. In March 1620 he married a woman from Utrecht, Henrica Ploos van Amstel. Dirck Strick died in October 1633.

—E. D. N.

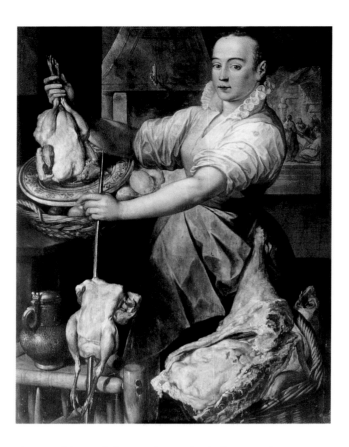

Fig. 1 Joachim Beuckelaer, *Kitchen Maid with Christ, Martha, and Mary*, 1574. Oil on panel, 112 × 81 cm (44⅛ × 31⅞ in.) Kunsthistorisches Museum, Vienna, 6049.

30 JOACHIM WTEWAEL
(1566–1638)

The Kitchen Maid

ca. 1620–25

Oil on canvas, mounted on a period oak panel, 102.9 × 71.8 cm (40½ × 28¼ in.)[1]
Signed lower right, on the skewer: *Jo* [in monogram] *wte wael fecit*
United States, private collection

Provenance: Museum Feukner, 1902; R. Bohlmann, Braunschweig; with Walter Hauth (Frankfurt), 1929; Pfeiffer, Braunschweig; private coll., South America, by 1947; sale, Sotheby's (New York), 17 Jan. 1992, lot 22

Selected References: Lowenthal 1986, 148–49, A-84 (with earlier literature), pl. 119; Luijten et al. 1993, 604, under no. 275

A kitchen maid dressed in seventeenth-century Dutch costume confronts us in the foreground beside a laden table, as she prepares chickens for the spit. Her well-furnished kitchen gives way at the right to another one, with Christ in the house of Martha and Mary. Wtewael painted only two other known kitchen scenes with biblical subjects, *Kitchen Scene with the Parable of the Great Supper* (Staatliche Museen, Berlin)[2] and *Kitchen Scene with the Supper at Emmaus* (Baron Clamor von dem

Bussche coll., Hünnefeld bei Osnabrück).[3] All three pictures reflect a type popularized in the sixteenth century by Pieter Aertsen and Joachim Bueckelaer, featuring contemporary kitchen scenes with background biblical scenes. Indeed, Beuckelaer's *Kitchen Maid with Christ, Martha, and Mary* (fig. 1) may have been Wtewael's model.[4] Wtewael's contemporary viewers would have been familiar with the rhetorical structure of these images. Typically, there is a thematic relationship between foreground and background.[5] Here, the comely cook surrounded by fleshy meat, fowl and fish with exposed entrails, and sinuous vegetables signifies the pleasures of the flesh. Seductions can deflect one from the true spiritual path just as the fascinating and gruesome foreground details can distract the viewer from the scene with Christ. On a simple narrative level the maid is a woman responsibly performing the day's work, but there

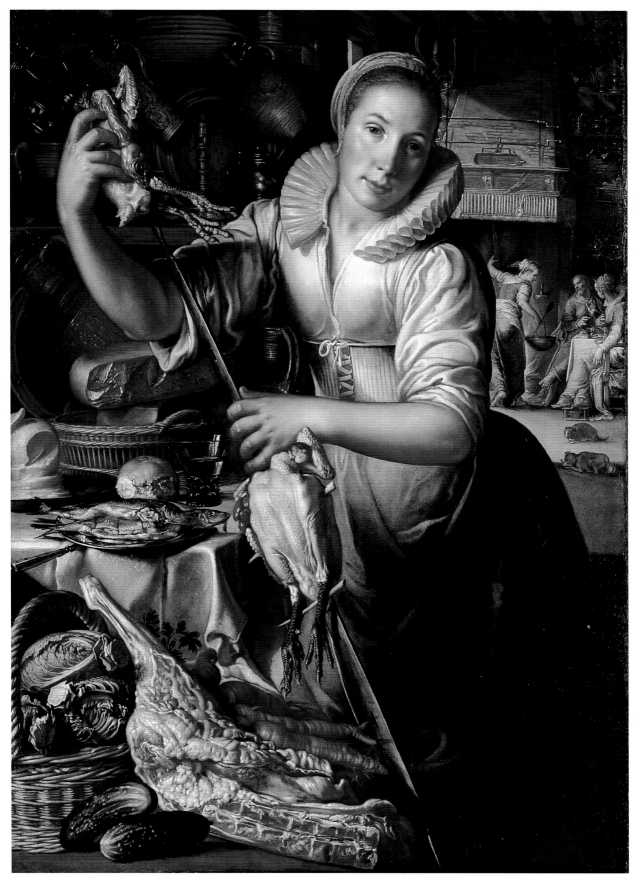

Cat. 30

is a suggestive innuendo as well. Her pose, with thrust hip, is matched by her task, the placing of chickens on a long skewer. The motif has erotic implications, not only because of the phallic skewer but also because of the colloquialism *vogelen* (to bird), "to fornicate," and *kip* (chick), "a loose woman."[6]

The foods on the table beside the maid are also visually compelling and symbolically rich. Their resonance is not arcane but rather would have been widely familiar in Wtewael's time. Bread was the staff of daily life, and wine was synonymous with pleasure and inebriation, but they also signify the saving Eucharist. Fish was common to Dutch tables, but it is also a symbol of Christ, fisher of humankind. The knife has been used to cut the butter and cheese, but as is usual in Dutch still lifes, it offers itself to our grasp. A venerable symbol of discriminating judgment, it invites us to make a choice between the wanted and the rejected, implicitly between right and wrong.[7] The butter and cheese bring to mind the Dutch proverb "Zuivel op zuivel is 't werk van den duivel," or "Butter with cheese is a devilish feast," a warning against overindulgence.

In the formal structure of the picture, the tabletop still life leads into the background, where the faithful find Christ, Martha, and Mary. The foreground vessels and foods are detailed and colorful, placing them and the kitchen maid in a vivid present. In contrast, the background scene of Christ, Martha, and Mary is painted more summarily in pastels. It, too, is set in a kitchen, furnished with racks of pewter and a large open hearth, yet formal treatment distances the scene from immediate experience. The biblical passage (Luke 10:38–42) concerns Christ's praise for Mary's quiet attentiveness over Martha's busyness. Wtewael shows Mary warming her feet on a *stoof*, a small foot warmer, as Martha bustles by the fire. Christ is partaking of bread and wine—the spiritual food of the Eucharist—like that in the foreground still life. The relatively small size and

Fig. 2 Joachim Wtewael, *Moses Striking the Rock*, 1624. Oil on panel, 44.5 × 66 cm (17½ × 26¼ in.). Ailsa Mellon Bruce Fund, © Board of Trustees, National Gallery of Art, Washington, 1972.11.1(2610)/PA.

subtle handling of the biblical scene deftly impart the moral lesson. The biblical subject had wide appeal, which suggests nondenominational import.[8]

The emphasis placed on contemplation is appropriate to the ideal mode for experiencing this painting. We know that the seventeenth-century Dutch took the time to look at images reflectively.[9] Enjoying the purely visual attractions of this painting was certainly important. That was not inconsistent, however, with another level of perception, of recognizing opposing value systems and an implied choice between them.

The proposed date of about 1620–25 is based on comparison with a number of other works by Wtewael of this period, including two paintings of the Adoration of the Shepherds in Bologna (1620; Francesco Molinari Pradelli coll.) and Madrid (1625; Museo del Prado).[10] Wtewael's *Moses Striking the Rock* (fig. 2)[11] is also relevant to the kitchen scene. In all of those paintings, figures are convex in form, poses are sinuous and graceful, and women's faces are smooth, serene ovals. Deftly painted, supple background figures are also common to this group.

On the whole, the painting demonstrates Wtewael's continuing commitment in the 1620s to mannerist devices, which here include the sudden jump into illusionistic depth, resulting in the sur-

Fig. 3 Hendrick Bloemaert, *Poultry Cook*, 1634. Oil on canvas, 114.8 × 90 cm (45¼ × 35⅜ in.). Centraal Museum, Utrecht, 5461.

more closely related to Netherlandish and Italian images of single figures at work, prevalent from the early sixteenth century on.[12]

Wtewael's *Kitchen Maid* bears an unusually beautiful signature, painted as if engraved on the steel skewer.

—A. W. L.

31 JOOST CORNELISZ. DROOCHSLOOT (after 1585–1666)

Saint Martin Dividing His Cloak

1623

Oil on panel, 58 × 85 cm (22⅞ × 33½ in.)
Signed at left: *Joost. Cornel / Droch. Sloot. 1623*
Amsterdam, Rijksmuseum, SK-A-1930

Provenance: Peter Wtewael?, very likely the painting listed in the 1661 inventory of the part of his estate to be apportioned to Aletta Pater, no. n.10 (see the following); very likely the "small picture of St. Martin by Droochsloot," belonging to Aletta Pater and her husband, Jacob Martens (Utrecht) in 1669;[1] W. Burroughs-Hill (Southampton), 1900

Selected References: Van Luttervelt 1947b, 122; Müllenmeister 1973, no. 123; Van Thiel et al. 1976, 199; Muller 1985, 126–27

face juxtaposition of figures of markedly different sizes. That stylistic conservatism is consistent with Wtewael's indebtedness to sixteenth-century iconographic conventions and creation *uyt den geest* (from the imagination). The still-life elements, however, were clearly done *naer het leven* (from life). In this respect, Wtewael was in step with contemporary trends. The *banketje*, or "little banquet," on the table closely resembles independent still lifes by the Haarlem painter Pieter Claesz., just developing in the early 1620s.

By the 1630s, as we see in Hendrick Bloemaert's *Poultry Cook* (fig. 3), the complexities of the Aertsen-Beuckelaer tradition, revitalized by Wtewael, had given way in Utrecht to a simpler genre representation. The painting shows Bloemaert's awareness of the tradition represented by Wtewael's *Kitchen Maid*, but the conception is

In 1623, the year he first served as deacon of the Painters' Guild, Droochsloot painted the first of at least three representations of Saint Martin of Tours,[2] the former patron saint of Utrecht and of beggars,[3] as an exemplar of charity. The Utrecht painter Maerten Stoop represented the saint in a similar painting from the 1640s.[4] Martin was a young Christian nobleman of about seventeen years when he encountered naked beggars in Amiens and divided his cloak with one. Droochsloot's beggars are not naked. They are what his contemporaries would consider the deserving poor—cripples and mothers with babes in arms and are clearly distinguished from the able-bodied peasants brawling in front of an inn at the left who ignore Saint Martin. In many places wine was

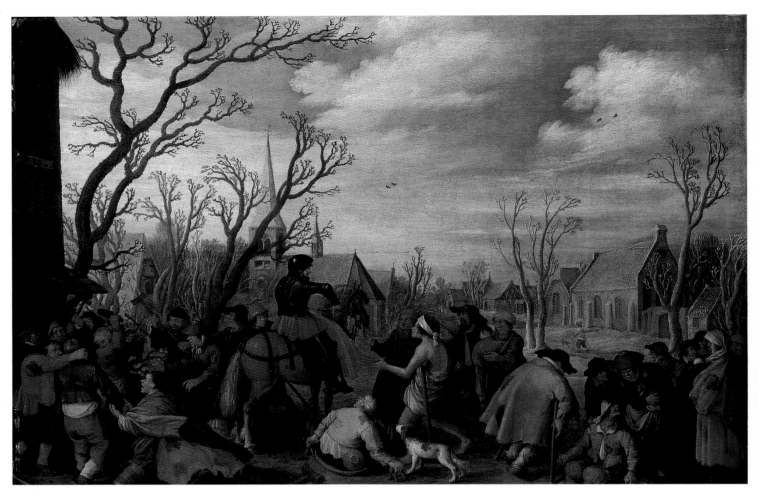

Cat. 31

traditionally distributed to the poor on the saint's feast day, 11 November, and representations of it, for example a famous painting by Pieter Baltens,[5] include brawling, intoxicated beggars. The Feast of Saint Martin was, not surprisingly, associated with the distribution of clothing to the poor. That 11 November was also considered the first day of winter[6] explains the leafless trees in Droochsloot's painting.

Saint Martin Dividing His Cloak exemplifies an important aspect of the pious Christian life, that of performing acts of charity, which was common ground for Protestants and Catholics. (This picture or another "small picture of Saint Martin by Droochsloot" was hanging in the bedroom of a Protestant household, that of Joachim Wtewael's granddaughter.) Charity toward the poor was important for both Protestants and Catholics, but the relationship of personal acts of charity to one's own hopes for salvation was different. Perhaps in consequence, in Utrecht, where a significant percentage of the social elite remained Catholic, the representation of charity is very much influenced by the Church's teachings on good works, which a Catholic strives to perform on the road to salvation, a teaching that had a perceptible effect on the outlook of many civic charitable institutions governed by the Catholics. (For commentary on the tendency of institutions influenced by Catholic teachings to emphasize the traditional representation of the good works or works of mercy to be done, while those influenced by Calvinism tended to put more emphasis on the portrayal of the governors of the institution, who had demonstrated their status as the elect of God by doing good works, see Spicer, introduction to this catalogue.)

Droochsloot is the only artist of any signifi-

cance in Utrecht to focus extensively on representations of the poor, and there is a pattern in his work: A large percentage of his representations shows the poor as either deserving recipients of charity or good works—as people whom the buyers of the paintings ought to help—or as an undeserving rabble. Droochsloot was not a Catholic, but like many other Protestant artists, was ready to serve a market for pictures that would appeal to Catholics.

The virtue of performing good works is central to his *Good Samaritan* of 1617 (Centraal Museum, Utrecht),[7] one of the first known paintings by the artist after he became a master in 1616 and one that, in its composition, looks directly back to the greatest Utrecht master of the sixteenth century, Jan van Scorel. The theme was given a more complete treatment in 1618 by *The Seven Acts of Mercy* (fig. 1),[8] commissioned by the *huiszittenmeesters* (administrators of poor relief) from the SS. Barbara and Laurentius Gasthuis (hospice) in Utrecht. This is Droochsloot's most characteristic subject, and at least five other versions are known.[9] The subject of seven acts of mercy or charity goes back to Christ's Sermon on the Mount (Matt. 25:34–36) in which feeding the hungry, giving drink to the thirsty, clothing the naked, housing the stranger (or the homeless), caring for the sick, and ministering to those in prison are referred to as acts of the "righteous" upon which a Christian's salvation at the Last Judgment depends. In the Middle Ages, burying the dead, a critical service in time of plague, was added to make up the seven. Two other paintings by Droochsloot, *The Parable of the Wedding Guest without Wedding Clothes* and *The Parable of the Unfaithful Servant*, both of 1635, belonged to the St. Barbara Hospice and now belong to the Centraal Museum in Utrecht.[10]

Droochsloot also did a number of pictures focusing on a single work of mercy, such as housing the homeless[11] or, especially, feeding the hungry. Provided by parish poor-relief organizations, relief

Fig. 1 Joost Cornelisz. Droochsloot, *The Seven Acts of Mercy*, 1618. Oil on canvas, 189 × 295 cm (74½ × 116⅛ in.). Centraal Museum, Utrecht, 11230.

Fig. 2 Joost Cornelisz. Droochsloot, *Beggars Fed at Table*, 1623. Oil on panel, 24 × 35 cm (9½ × 13¾ in.). Location unknown.

tables were intended primarily for local residents who had fallen on hard times.[12] *Beggars Fed at Table*, also 1623 (fig. 2),[13] largely cripples and a woman with a child, are represented as beneficiaries of charity, eating in circumstances quite beyond anything that their own state of want would permit: A woman sets pewter dishes of food on a table and one cripple drinks from a glass. Other paintings depicting jolly peasants feasting and drinking in the open air while ignoring the cripples and other beggars in shabby clothes who look on are perhaps a play on the parable of the Rich Man and Lazarus that spoke to a feeling on the part of the social elite that the well-off peasantry was not doing its

part in poor relief. Other related subjects include depictions of cripples at the pool of Bethesda, a popular topic,[14] the procession of the lepers on Copper Monday,[15] peasants on their way to church,[16] and a number of paintings of, simply, carousing peasants at a village fair.[17] Given the pattern outlined here, the recent summation of Droochsloot's subject matter as principally feasting, jolly peasants[18] calls for refinement.

The bleak winter setting of *Saint Martin*[19] is the focus of other paintings, such as a *Scene on the Ice*, also dated 1623.[20] Apparently the only landscape painter in Utrecht during the first half of the century to be interested in representing aspects of everyday life, Droochsloot was also the only one to evoke winter.

Again practically the only artist to do so, Droochsloot produced a few compositions depicting contemporary events, chiefly military. *Prince Maurits Disbanding the Utrecht Militia (Mercenaries) in 1618* (see Spicer, introduction to this catalogue, fig. 1—this version dated 1625 being one of several)[21] is the best known. The setting, the city square known as De Neude with the guardhouse and the St. Cecilia cloister at the left, draws attention to the absence of cityscapes or architectural subjects in Utrecht during the years of artistic prominence except as background.

There are no records of Droochsloot's training, but his paintings of peasants reflect two sources of influence: peasant scenes by the Amsterdamer David Vinckboons are clearly behind Droochsloot's earliest dated painting, *Village Revelries*, 1615,[22] and sixteenth-century German woodcuts, specifically Hans Sebald Beham's raucous, mocking 1539 woodcut, the *Large Peasant Kermis (Feast of Saint George)*,[23] are the basis for Droochsloot's *Village Carneval* (Sotheby Mak van Way [Amsterdam], 20 Nov. 1956). By the time he painted our version of Saint Martin, Droochsloot's approach was characterized by a recurring repertoire of broadly painted, conventionally modeled figures with rounded facial features like those of Vinckboons. Two of these cripples, for example, appear in other paintings of 1623 and 1625.[24] In terms of color, passages of crimson or salmon orange are mixed into the monotones of poverty.

Of Droochsloot's pupils,[25] the most important was Jacob Duck (see cat. 34), whose early paintings reflect Droochsloot's broadly painted, broad-featured peasants. The early paintings and etchings of raucous peasants by Andries Both, brother of Jan Both, who joined the Painters' Guild briefly in 1624 before setting off for Italy, surely owe their rough, broadly stroked character to Droochsloot's paintings and early etchings. In the conventionally pleasant paintings of peasant life by Joost's son, Cornelis Droochsloot, among them his 1664 *Village Street* (Rijksmuseum, Amsterdam),[26] the probing of want and charity are reduced to bland patronizing.

—J. S.

32 JAN VAN BIJLERT
(1597/98–1671)

Inhabitants of St. Job's Hospice
1630–35

Oil on canvas, 76.3 × 115.3 cm (30 × 45⅜ in.)
Signed: *Jv* [in monogram] *bijlert . fecit*
Utrecht, Centraal Museum, 7372

Provenance: St. Jobsgasthuis coll. (Utrecht), ca. 1630–35; estate sale, Erfhuis (Utrecht), 8 July 1811 (purchased by P. M. Kesler); P. M. Kesler coll., 1811–44; sale of the P. M. Kesler and C. Apostool colls. by J. de Vries, A. Brondgeest, and C. F. Roos (Amsterdam), 13–15 May 1844 (purchased by J. Prins); sale, J. de Vries, A. Brondgeest, and C. F. Roos (Amsterdam), 18 Oct. 1849 (sent in by Sanden[burg?] Matthiessen; sold to Weimar); art market (United States), 1931; with J. Vuyk Gallery (Paris), 1934; purchased by the Centraal Museum, Utrecht, from the J. Vuyk Gallery (Paris), 1934

Selected References: Bok 1984, 31, 34–42, fig. on p. 37; Schwartz 1986, cat. 28, 68, 71–74; Döring, Desel, and Marnetté-Kühl 1993, 272, cat. 94, 273; Huys Janssen 1994a, 15, 33, 60–61, fig. 22, 235–37, cat. 177

Cat. 32

A group of men in simple attire stand behind a stone balustrade. The man closing off the scene on the extreme right is better dressed than the others, and his hair is not so unkempt. On his black cloak he has a silver badge that bears an image of Job and identifies him as the principal (*huismeester*) of St. Job's Hospice. He, the beadle, and the housemaster (*binnenvader*) have posed with several of the residents for this group portrait, one of the finest works ever produced by Van Bijlert, who was at the height of his powers between 1625 and 1635.

St. Job's was founded in Utrecht in 1504 as the first hospital in the city specifically for syphilitic patients. During the sixteenth and seventeenth centuries, it gradually became an almshouse for old men, and in 1649 it ceased treating patients with venereal disease. The house was run by a confraternity that elected a first and a second principal from among its members each year. They were

responsible for the day-to-day running of the establishment and the supervision of the staff.[1]

The hospice organized two collecting days each year in order to fund the care and treatment of the residents. These collections were a vital source of income, so there was considerable protest when the Utrecht city council abolished them in 1635. At the beginning of that year, the council had also decided that it would no longer help defray the cost of treating syphilitics, but to avert financial ruin, did agree to continue paying an annual sum toward general operating costs.[2]

Van Bijlert depicted seven of the residents seeking alms. The three men on the right hold various positions within the hospital. To the left of the principal is the beadle, Jan Feasz. van Zijll, who was buried in the city's Buurkerk in June 1635. Documents show that by 1633 he had been working in the hospital for some time. The graybeard to

the left of him is wearing a lace collar, which sets him apart from the residents and has given rise to the idea that he is the housemaster. The last housemaster recorded in the archives was Peter Erasmus, who took up his post in 1624 and lived in the hospice from then on. He died in December 1630, so if the identification is correct, the painting must have been executed before then.[3]

The residents are wearing black, red, and brown doublets over white shirts with small, plain collars. Two of them have collecting boxes, and one holds out an alms dish. A fourth old man points up to heaven in allusion to the reward awaiting the generous giver. The man to the right of him raises his eyes in gratitude. The men doing the collecting and the three others are looking in every direction but at the viewer.

Given the composition, the painting must have hung high up on a wall, as an overmantel or overdoor. The grouping of figures behind a balustrade was nothing new: The Utrecht Caravaggisti had done the same with musical companies. The subject, though, is certainly an innovation. A group portrait of indigent people is utterly unique in seventeenth-century portraiture. The setting, too, is unusual. The event is firmly linked to a specific place, but instead of setting it in Utrecht, Van Bijlert gave it a hilly, Italianate background.

It is possible that Van Bijlert painted the scene to mark the abolition of the practice of collecting alms. He had special ties with the hospice, and must have been aware of the decisions taken by the city council. In 1634 he became a regent of the hospice. It was a lifetime appointment, and he is listed as a member of the confraternity as late as 1669. He served as principal from 1642 to 1643.[4]

Between 1622 and 1642, Van Bijlert and thirty-five other artists in Utrecht donated a painting apiece to the hospice.[5] These paintings hung in the regent's chamber, which was completely refurbished in 1626 and 1627. Among the seven pictures depicting events from the biblical story of Job was Jan van Bijlert's contribution, *The Miserable Comfort of Job's Wife*, painted in 1628.[6]

A painting of the residents of St. Job's Hospice appealing for alms is not recorded in the surviving inventories of the hospice. Given the subject, though, it could hardly have been painted for any other body. This conclusion is supported by a handwritten inventory of a collection of paintings belonging to P. M. Kesler, in which this particular work is listed with the following annotation: "This picture was painted by Bijlert for the hospice, but when the building was turned into a barracks in the French period, this and several other works were removed and bought by me at a public auction."[7]

Jan van Bijlert was the most sought-after portrait painter in Utrecht after 1637, the year in which Gerard van Honthorst left for The Hague. A year later Paulus Moreelse died. Prior to 1637, he and Honthorst had dominated the Utrecht market for this genre. There are at least forty known portraits by Van Bijlert, no fewer than fifteen of which, including replicas and portraits (see Olde Meierink and Bakker, fig. 10, in this catalogue; cat. 29, fig. 3),[8] were painted for the Strick van Linschoten family.

—L. M. H.

33 ABRAHAM BLOEMAERT
(1566–1651)

Head of an Old Woman
ca. 1632

Oil on panel, 37.5 × 28 cm (14¾ × 11 in.)
Signed upper left: *A. Bloemaert fe.*
New York, Richard L. Feigen

Provenance: sale, Lempertz (Cologne), 14 Nov. 1963, lot 475; sale, Christie's (London), 24 Apr. 1981; with Phillips (London), 1994

Selected References: Nicolson 1989, no. 1103; Roethlisberger 1993, no. 519; Seelig 1997a, no. B171

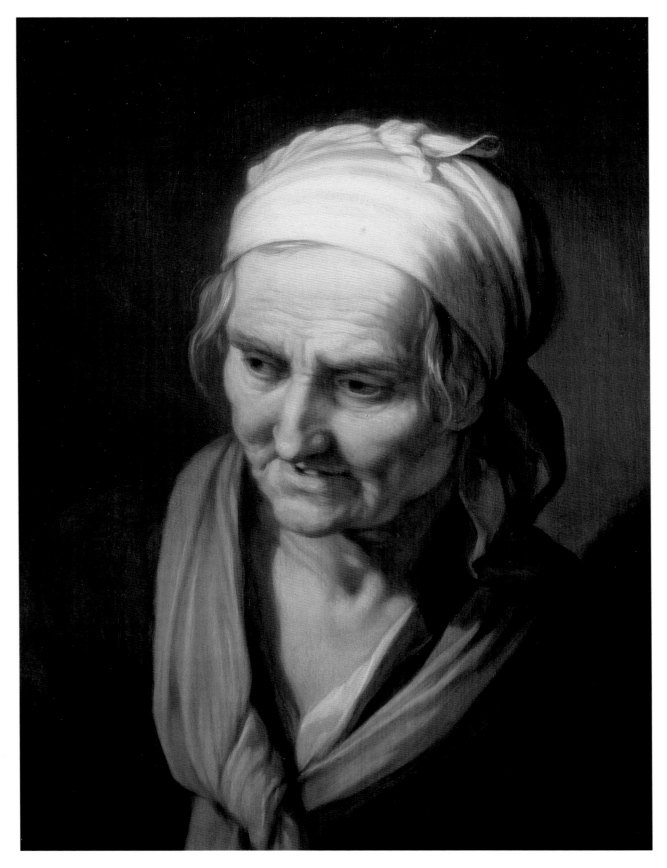

Cat. 33

As the social status as well as the dress of the sitter make clear, *Head of an Old Woman* is not a portrait in the conventional sense. Instead, it belongs to a category of paintings called by contemporaries *tronies*, "heads." These often involved studying a live model so that physiognomic verisimilitude could be given to a type of figure that might appear in genre or history paintings.[1] In workshops like that of Rubens, studies done in this way would later be inserted into larger paintings for a figure in the appropriate role. They would normally first be prepared as a preliminary stage of a certain project, but could later be used again and again.[2]

In Bloemaert's workshop this role must have been filled by his great supply of study drawings collected over decades of artistic production. They were of an importance hardly to be overestimated. His painted *tronies*, on the other hand, must be understood as paintings in their own right. Only one of them can be found to have been inserted into a bigger composition later on, the *Old Woman* shown here. It is identical to the head in *Old Woman with a Rooster*.[3] This is a half-length life-size genre painting that is very much in keeping with the Utrecht tradition. Since in no other case is Bloemaert known to have repeated his own paintings, it is highly unlikely that this picture is by his hand. Copying the master's *tronie* into a genre painting rather seems to be a fitting assignment for a pupil. Even the son's *Tekenboek*, a printed book of drawing models ranging from eyes, ears, and hands to entire compositions, reproduced only one of the painted heads, that of an old man.[4] Almost all of what is reproduced in this book, in fact, is from the visual material the workshop was using, and that was drawings.[5] In general, physiognomic studies of old men seem to have played a much greater role than those of women. In the *Tekenboek* (fig. 1) there are only about a dozen heads of old women,[6] while studies of old men abound.

Bloemaert created a number of paintings with heads of old men (fig. 2) and women that are so closely related to each other that they form a coherent group apart from his other work. In addition to the age and social status of the sitters and the fact of their being busts, they also stand out for their tonal color scheme and thoughtful expression. In addition, the light coming from outside the picture picks out only certain areas while reflecting in the undefined background in such a way that the dark side of the figure is outlined as clearly as the bright side. All of these paintings, amounting to twenty-two plus a few doubtful ones,[7] show the same kind of peasantlike person. In fact, some of the faces reappear several times, though never in identical form. Even more striking is the fact that most of them are dated, with the dates spanning no more than a decade, from 1632 to 1641. Figures and faces of old people belonged to Bloemaert's standard repertoire from the very beginning of his career, as in the Munich *Peleus and Thetis*, a *Judgment of Paris*, or an *Apollo and Daphne* of the 1590s, to name only a few.[8] They were compulsory for figures like the 1622 *Saint Jerome* (cat. 14) or in the 1624 *Adoration of the Magi* (cat. 16). Even though the type of face—at least compared with these last ones—remained the same, Bloemaert did not develop the type of picture represented by *Head of an Old Woman* until he himself approached his seventies. Nevertheless, a mere biographical motivation to paint these pictures seems unlikely, considering the very limited time span in which they were produced. More likely, they are a reaction of the painter to public interest in this particular type of picture.

Remarkable is the fact that the heads seem to deviate from the Utrecht tradition of single-figure genre paintings in several ways. First of all, virtually none of the paintings that could in Utrecht be called *tronies* really show busts like Bloemaert's or even heads alone.[9] They are mostly half-length figures.[10] Furthermore, most of these Utrecht-type genre paintings are life-size, while with Bloemaert most of the heads are rendered decisively smaller than life.[11] Indeed, the interest in individual

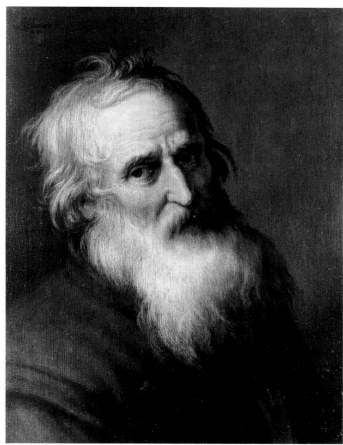

Fig. 1 Frederick Bloemaert, after Abraham Bloemaert, *Studies of an Old Woman*, ca. 1650–56. Etching, 206 × 166 mm (8⅛ × 6½ in.). *Tekenboek*, fol. 14. Staatsbibliothek-Preußischer Kulturbesitz, Berlin.

Fig. 2 Abraham Bloemaert, *Head of an Old Man*, 1635. Oil on panel, 37.5 × 27.5 cm (14¾ × 10⅞ in.). Gemäldegalerie Alte Meister, Dresden, 1235.

physiognomies of old people is not relegated to Utrecht alone, but has, with regard to Jan Lievens, been rated as "a general sign of a turn toward realism in Dutch painting in the third and fourth decades of the seventeenth century," a judgment that shows that the old Utrecht master was still following contemporary developments.[12]

In at least three cases Bloemaert created his *tronies* as pendants, with a man's and a woman's head. This again enhances their sense of realism since it refers to portrait painting, in which it was common to portray married couples in separate paintings compositionally related to each other.

At the same time the pendants are linked to the Utrecht tradition of combining single-figure genre paintings as pairs, as evidenced most prominently perhaps in Hendrick ter Brugghen's Kassel *Flute Players* of 1621 (cat. 41 and cat. 41, fig. 1).[13] This playing on tradition and picture type demonstrates Bloemaert's openness to being inspired by other artists' work. It also proves that in Bloemaert's case the pictures are not studies to be integrated into narrative paintings, as with the Rubens workshop, but must be seen as artworks of independent standing.

—G. S.

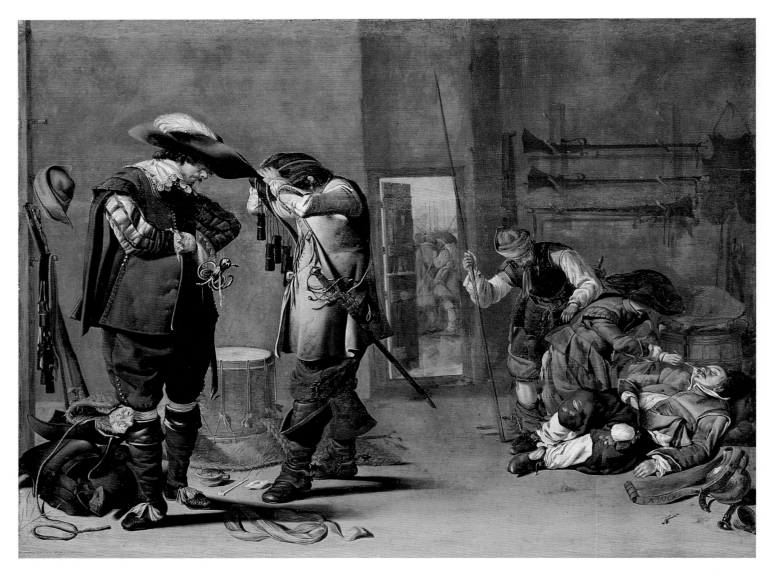

Cat. 34

34 JACOB DUCK
(d. 1667)

Soldiers Arming Themselves
mid-1630s

Oil on panel, 43 × 57 cm (16⅞ × 22⅜ in.)
Signed lower right, on the sword belt: *JA* [in ligature]
DVCK
The Minneapolis Institute of Arts, The Ude Memorial
Fund and Gift of Bruce B. Dayton, 88.2

Provenance: with H. Shickman (New York), ca. 1974;
private coll.; with H. Shickman (New York), 1982;
The Minneapolis Institute of Arts, 1988

Selected References: Playter 1972, 124; Salomon 1984, 74–75,
78–80, 87; Sutton 1984, 189–90, pl. 38; *Dictionary of Art*
1996, 9:364

Though he painted merry companies and an occasional allegory (cat. 20), Jacob Duck is primarily known for his paintings of soldiers; he is the only Utrecht artist to have extensively treated this subject.[1] This composition of soldiers arming themselves for a day's march is, as Peter Sutton has argued,[2] probably one of Duck's earliest forays into depicting guardrooms. In it he seems under the spell of the pioneers of Dutch guardroom scenes, or *coortegardie*, Willem Duyster and Pieter Codde, whose innovative works created in Amsterdam from the mid-1620s to early 1630s Duck undoubtedly knew while living in nearby Haarlem in the mid-1630s.[3] The moody quality of Duck's soldiers echoes that of the introspective soldiers

of Duyster,[4] while the vaguely and sparsely defined room is similar to those in Codde's early guardroom and merry company scenes.[5] In addition, it was Codde who developed the subject of soldiers mustering to join massed troops seen through a doorway, which Duck is known to have treated only in the present work.[6]

Differences in the class and rank of the soldiers in this painting are suggested by their clothes. The musketeer who slips a bandolier of charges over his head and the officer on the left are well dressed; the beautifully rendered slit sleeves of the latter reveal the use of fine material.[7] At his feet lies an orange sash, customarily worn by officers in the Dutch army.[8] By contrast, the men on the opposite side of the room are poorly dressed foot soldiers. The pikeman, although he holds his weapon and helps another with his preparations, is not himself prepared for battle; his right legging is not properly tied up but droops around his ankle. Both the kneeling and the sleeping soldier wear pants that are tattered and unmended, by implication reduced to this state from months of trudging through the countryside.[9] The ragged state of their clothing may be intended as an unfavorable reflection on them as soldiers ill-prepared for the discipline of war.[10]

Duck similarly distinguished classes of people in a painting in Los Angeles from the mid- to late 1630s (fig. 1), one of his few paintings set in a village out-of-doors, a pictorial device frequently used by his teacher Joost Cornelisz. Droochsloot (cat. 31, fig. 1). Like Droochsloot, Duck suggests the peasants' coarse lives through broadly painted and sketchy forms, while the elegant young couple is painted in a refined manner that reflects their station in life.

Working within a rich but limited palette of ochers, grays, and local color, in the present work Duck paints an image of striking beauty. The smooth, tangible volume of the leather jerkins on the officer, musketeer, and sleeping soldier, which can be found in similar passages in the works of

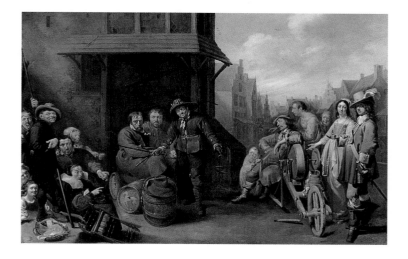

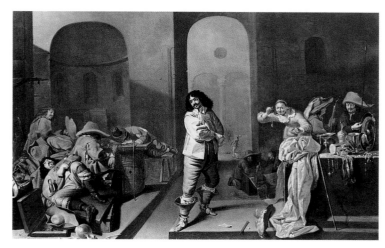

Fig. 1 Jacob Duck, *A Street Scene with a Knife Grinder and an Elegant Couple*, mid-1630s. Oil on panel, 45.7 × 69.9 cm (18 × 27½ in.). Los Angeles County Museum of Art, Gift of Arnold S. Kirkeby, 58.50.1.

Fig. 2 Jacob Duck, *A Guardroom Scene with Sleeping Soldiers and a Raiding Party*, mid-1630s. Oil on panel, 49.5 × 74.5 cm (19½ × 29⅜ in.). Otto Naumann, Ltd., New York.

Dirck van Baburen and Abraham Bloemart, reveals Duck's appreciation of the aesthetic qualities and tactility of this material.

Duck is one of several Utrecht artists to treat the theme of sleep (see cats. 18, 55, and 73). In *Soldiers Arming Themselves* a kneeling comrade tickles the sleeping soldier's nose with a piece of straw. As Nanette Salomon has discussed, the sleeping soldier, unlike the one collapsed in exhaustion on the barrel behind him, dreams of an erotic encounter, which Duck emphasizes through

the placement of the soldier's right hand.[11] The soldier's sleep is likely deepened by the tobacco and beer lying before him, the latter in a jug over which is draped a sword belt that bears the artist's signature and echoes the sleeping soldier's form.

Duck explored the possibilities of the theme of sleep in numerous paintings, depicting both soldiers and women.[12] In *A Guardroom Scene with Sleeping Soldiers and a Raiding Party* of the same period, a splendidly dressed officer reaches for his sword, his displeasure apparent at a group of soldiers collapsed amid pipes and gaming tables (fig. 2).[13] These sleeping soldiers are oblivious to the other soldiers raiding war booty. The viewer is encouraged to laugh at these hapless soldiers who lose everything as they sleep, a sleep made all the more ridiculous because of their awkward sleeping positions. Yet Duck also makes a moral point: These soldiers are slothful, and because of their lack of vigilance lose all that they have.[14]

Such mockery is typical of Duck's guardroom scenes, yet the humor is muted in the present painting. None of the men addresses the viewer to point out the sleeping man, a feature common in Duck's other barracks paintings. These soldiers are in fact unaware of our presence; they focus on their preparations. This is in contrast to the typically comical, even theatrical, protagonists of Duck's other paintings. Initially Duck painted a drummer beating reveille in the doorway, whom he subsequently removed; perhaps the drummer's noisy entrance would have eliminated the need for the more subtle action of the kneeling soldier and disrupted the somnambulant mood in which the soldiers prepare themselves to join the company forming outside the door.

—Q. G.

35 GERARD VAN HONTHORST
(1592–1656)

Musical Group by Candlelight
1623

Oil on canvas, 117 × 146 cm (46⅛ × 57½ in.)
Signed and dated upper left: *GHonthorst fe. 1623*
Copenhagen, Statens Museum for Kunst, 378

Provenance: Magnus Berg coll., Copenhagen, by 1739; Royal Danish Kunstkamer (Copenhagen), 1739; Statens Museum for Kunst (Copenhagen), on loan to Kronberg Castle (Elsinore, Denmark)

Selected References: Nicolson 1958b, 73; Judson 1959, 67, 69–70, 129, 248, no. 197, illus.;[1] Braun 1966, 175–76, no. 45; Blankert and Slatkes 1986, 58, fig. 55; Heiberg 1988, no. 1039, pl. 25; Müller-Hofstede 1988, 34; Nicolson and Vertova 1989, 1:48, 125, 3: pl. 1268; Cavalli-Björkman 1992–93, no. 7; Welu and Biesboer 1993, 224–25, fig. 17b

Painted shortly after Honthorst's return to Utrecht, the Copenhagen *Musical Group by Candlelight* is typical of those candlelit musical companies that first appeared in his oeuvre in Italy. The contemporary inspiration for such genre scenes, populated by half-length, almost life-size figures, originated in the daylit musicians, fortune-tellers, and cardsharps of Caravaggio.[2] Filtered through the imagination of his follower, Bartolomeo Manfredi, Caravaggio's secular figures were united with the moody nocturnal settings found in Caravaggio's own religious paintings, such as the famous *Calling of Saint Matthew* in S. Luigi dei Francesi, Rome (see Orr, fig. 1, in this catalogue). Writing in 1675, Honthorst's former pupil, Joachim von Sandrart, identified the considerable influence that Manfredi had on Northern artists of Honthorst's generation, calling the style *Manfrediana methodus* (Manfredian method).[3] Although Manfredi's nocturnal genre scenes proved essential for Honthorst, the Dutchman's merry festivities are always more wholesome and lighthearted, without the atmosphere of threat that hangs in the air of Manfredi's scenes of gambling soldiers, cheats, tawdry fortune-tellers, and gypsies. In Honthorst's hands the style evolved further, his signature a torch or candle providing the only illumination for

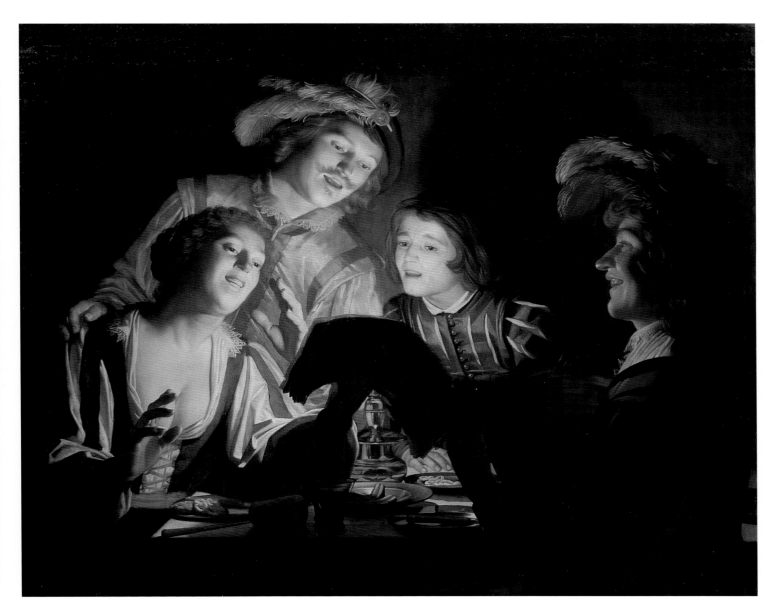

Cat. 35

the figures within the scene and adding greatly to its theatricality. These nocturnes, following on his many religious pictures painted as night scenes, earned the master the nickname "Gherardo delle Notti," Gerard of the Night, among his Italian enthusiasts.

Trends in Roman art provided the immediate stimulus for Honthorst's secular subjects, but such Italian impulses were grafted onto a long Northern tradition of genre scenes featuring seated revellers, cardplayers, and musicians. In the sixteenth century, this subject matter manifested itself in France, Germany, and the Low Countries, as well as in Italy.[4] Frequently, genre figures sharing music

appeared within the context of series representing the Five Senses to personify Hearing.[5] Such imagery is found, for example, in the graphic works of Hendrick Goltzius, to which the Copenhagen picture has been compared.[6] But for Honthorst's generation, such music-making companies, while still imbued with those traditional associations, could be enjoyed at face value.[7]

A gentle mood pervades this particular company of music makers; they are certainly more decorous than those sometimes raucous groups depicted in the surviving examples from Honthorst's Italian years, or the nearly contemporary *Merry Company (The Prodigal Son)* (fig. 1). Such boisterous

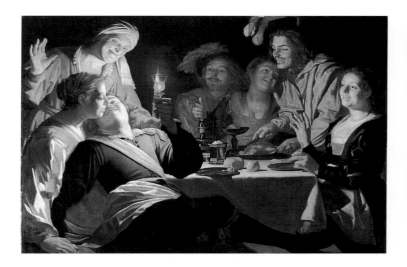

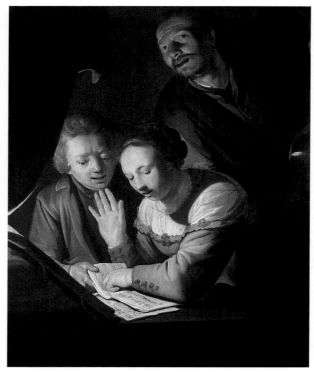

Fig. 1 Gerard van Honthorst, *Merry Company (The Prodigal Son)*, signed and dated 1622. Oil on canvas, 130 × 196.5 cm (51⅛ × 77⅜ in.). Bayerische Staatsgemäldesammlungen, Alte Pinakothek, Munich, 1312.

Fig. 2 Pieter de Grebber, *Musical Trio*, signed and dated 1623. Oil on canvas, 95 × 79.5 cm (37⅜ × 31¼ in.). Private collection, U.S.A.

depictions have been variously interpreted by modern scholars as somewhat fanciful scenes from everyday life or as illustrations of the dissipation of the biblical Prodigal Son.[8] In comparison, the Copenhagen *Musical Group* is a poetic, not a moralizing, image of harmony and pleasant companionship.[9] Pictures of this type proved widely popular in Utrecht and beyond, and initially occupied much of Honthorst's activity on his return to the North.

Coinciding with Honthorst's success, his fellow Utrecht painters, Hendrick ter Brugghen (see cat. 40) and Baburen, both of whom certainly knew the works of Caravaggio and Manfredi during their years in Rome, introduced such subject matter into their own repertoire.[10] Beyond Utrecht, the vogue for nocturnal, Caravaggesque merry companies evolved in other Dutch cities. For example, Pieter de Grebber's *Musical Trio* (fig. 2) of 1623[11] attests to how quickly the innovations of Utrecht reached Haarlem, where they found fertile ground among artists such as Frans Hals and Judith Leyster. Similarly, novel formal

devices, such as darkened repoussoir figures silhouetted against the intense light of the masked candle, were adopted by Honthorst's contemporaries. Even artists who had not gone to Italy, including Rembrandt and Jan Lievens, were quick to incorporate these elements into their work.[12]

Beyond the significance of such paintings for helping to popularize contemporary Roman pictorial fashions in the North, Honthorst's spirited nocturnes delight us as descriptions of the pleasant social interaction between handsome young men and their attractive female companions. Characteristically Honthorst, the figures in the Copenhagen *Musical Group* have broad, smooth, open faces with laughing eyes. In unison the participants focus on the words in a songbook.[13] The figures crowd around the masked light source, which reflects off their radiant faces. As the light dances across details of feathers, striped fabrics, and the slashed sleeves of the fanciful dress, it creates an animated pattern of light and dark suggestive of the flickering quality of candlelight itself.

—L. F. O.

36 GERARD VAN HONTHORST
(1592–1656)

A Soldier and a Girl

ca. 1622

Oil on canvas, 82.6 × 66 cm (32½ × 26 in.)
Braunschweig, Herzog Anton Ulrich-Museum, 178

Provenance: Duke Anton Ulrich coll., Schloß Salzdahlum, probably by 1710; seized by Napoleon's army (Paris), 1807–15;[1] transferred to Herzog Anton Ulrich-Museum (Braunschweig), 1882

Selected References: Judson 1959, 236–37, no. 179;[2] Braun 1966, 150–51, no. 27; De Jongh et al. 1976, no. 28, illus.; Müller, Renger, and Klessmann 1978, no. 15, illus.; Klessmann 1983, no. 178, illus.; Blankert and Slatkes 1986, no. 62, illus.; Davies 1989, 19, no. 29, illus.; Blankert 1991b, 514, fig. 13; Bauer 1993, 14–16, fig. 6; Wright 1995, 22, fig. 10

Baltimore and London only

A distillation of Honthorst's nocturnal groupings, the Braunschweig *A Soldier and a Girl* is a virtuoso display, equating fire and lust. Explicitly sexual, the painting is characterized, nonetheless, by the good-natured mood that pervades most of Honthorst's merry companies, prodigal sons, concerts, and scenes of mercenary love. Ever the courtier, Honthorst proceeds with elegance and charm. His players, while self-absorbed in their pleasure, are not presented as base creatures, but are clean, well-dressed, and attractive, if not to say wholesome. As Franits notes in this catalogue, it is not surprising that this picture has been included in so many exhibitions. Its sensuality warms us as surely as Honthorst intended it to do.

Compositionally, Honthorst embellished a motif seen earlier in his own output (fig. 1),[3] but poetically explored in the works of El Greco. Dating about 1570–75, El Greco's remarkable *Boy Blowing on a Firebrand* (fig. 2) was in the Farnese collection in Rome until 1622[4] so Honthorst could have seen it during his years in that city. The topos of a figure blowing on a firebrand, appearing first in the paintings of Jacopo Bassano in the mid-1560s[5] and then isolated by El Greco, recalls a motif described in an ancient Roman text, Pliny the Elder's *Natural History.*[6] Such dialogue between ancient writings on art and artists of the Renaissance and baroque periods is termed *ekphrasis.*[7] Descriptions gleaned from those ancient texts not only provided information about what types of subject matter were thought worthy by the ancients, but also have, since the Renaissance, presented artists with tantalizing challenges to their own skill. For example, Pliny wrote about "Antiphilus, who is praised for his Boy Blowing a Fire, and for the apartment, beautiful in itself, lit by the reflection from the fire and the light thrown on the boy's face."[8] Honthorst's interpretation of the image reveals an artful approximation of how firelight looks and how, radiating from the source, it describes the differing surfaces on which it falls. A subject shared among a number of the Northern tenebrist artists, variations appeared in works by Ter Brugghen and Matthias Stom[er], Jan Lievens, Georges de La Tour, and Godfried Schalken.[9]

Although El Greco also embellished the theme,[10] Honthorst contributed to the evolution of the original motif in transforming the boy blowing on a firebrand into the figure of a young woman blowing on a burning coal held in a pair of tongs. She is accompanied by her dashing young man, and the simple genre motif has been changed into an image whose meaning is unambiguously sexual—fire and passion simultaneously fanned, as implied by flying sparks. Honthorst has adapted the prototype so as to appeal to the contemporary Dutch vogue for amatory subjects.

A sequence of scholarly discussions links the imagery of the Braunschweig Honthorst to the emblematic literature of its day.[11] The variety of cited texts, including the authors Jacob Cats, Daniel Heinsius, and Otto van Veen, reveals a vast literature on the topic of love. Yet the numerous references quoted all strike cautionary notes, warning men about the dangers and brevity of carnal love. In his section called Whores and their

Fig. 1 Gerard van Honthorst, *Young Man Blowing on Coals*, ca. 1620. Oil on canvas, 76.2 × 63.5 cm (30 × 25 in.). Private collection, Brussels.

Fig. 2 El Greco, *Boy Blowing on a Firebrand*, ca. 1570–75. Oil on canvas, 59 × 51 cm (23¼ × 20⅛ in.). Museo e Galleria Nazionale di Capodimonte, Naples, Q192.

tricks (*Hoeren en slimme streken van de selve*), Jacob Cats warned:

It shall soil or burn. Friend watch your hands . . .
Thus I am in danger where I place my fingers;
Your coal does as a woman, she burns, or she soils.[12]

The love of woman, or more specifically the attention of a prostitute, is likened to fire—short-lived and all-consuming, leaving nothing in its wake but pain and a sullied reputation. Honthorst drew on a rich emblematic tradition that equated fire and lust, but in this painting he emphasized the enjoyable aspects of his scene at the expense of moralizing.

Although much has been written about the grounding of Honthorst's *Soldier and a Girl* in seventeenth-century Dutch literature, little has been said about the pictorial means the artist used to bring this meaning to life. By confining his half-length figures so tightly within the borders of the canvas, they are pushed up against the window of the pictorial space. Consequently, the viewer feels very close to the lovers, embarrassingly close. Similarly, Honthorst's manner of painting is well suited to his subject. The beauty and warmth of the artist's palette captures the essence of the exchange between this young pair. The creamy consistency of the paint built up thickly on the canvas gives a physicality to the surface of the painting itself, allowing the viewer to experience something of the tactile pleasure the couple shares. Regardless of any underlying moralistic traditions associated with this image, it is still unequivocally a celebration of the senses and of the ability of the artist to convey the life of the senses through the manipulation of brush and pigment.

—L. F. O.

Cat. 36

37 DIRCK VAN BABUREN
(ca. 1595–1624)

Young Man Playing a Jew's Harp
1621

Oil on canvas, 65 × 52 cm (25⅝ × 20½ in.)
Signed and dated: *TB* [in monogram] *aburen.fecit /
Anº 1621*
Utrecht, Centraal Museum, 11188

Provenance: purchased from the P. de Boer gallery
(Amsterdam), 1953

Selected References: Slatkes 1965, 88, 95–96, fig. 30, 112–13,
cat. A9; Bok 1986a, 173–75.

Dirck van Baburen's *Young Man Playing a Jew's
Harp* is among the first of many single, half-length
musicians introduced into the Dutch Republic by
the Utrecht Caravaggisti. Together with *The Flute
Player* by Abraham Bloemaert (fig. 1) and the two
flute players painted by Hendrick ter Brugghen
(cat. 41 and cat. 41, fig. 1), it is one of the earliest
Dutch examples of the type.

The idea of depicting an isolated musician as
a half-length came from Caravaggio and his follow-
ers. The origin of this idea can be traced to north-
ern Italy, more specifically to Giovanni Girolamo
Savoldo and artists from Bassano's workshop. Who
deserves the honor for introducing the subject in
the North is not known, but it was very probably
Baburen, or perhaps Ter Brugghen or Honthorst.
Although Bloemaert painted one of the earliest
surviving examples of this new subject with his
Flute Player, he was certainly not the originator.
He never visited Italy, so he must have picked up
the theme secondhand.[1] In his choice of subject
matter, Bloemaert was in at the birth of the new
Caravaggist tradition, but in execution and color
scheme, his *Flute Player* is a late-mannerist work.
This gives it a lonely position among the series of
musicians painted in such numbers in Utrecht in
the early 1620s. Moreelse, Honthorst, Ter Brug-
ghen, and many other Caravaggisti depicted half-
length musicians. Baburen, too, painted other
musicians, among them his *Singing Lute Player*

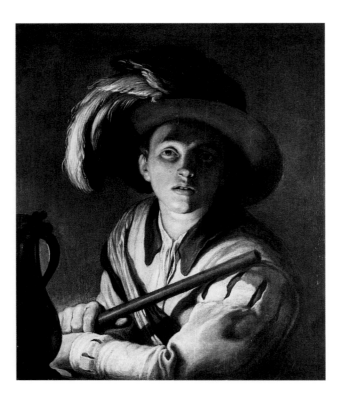

Fig. 1 Abraham Bloemaert, *The Flute Player*, 1621. Oil on canvas,
69 × 57.9 cm (27⅛ × 22¾ in.). Centraal Museum, Utrecht, 6083b.

of 1622 (cat. 42, fig. 1). The subject became popu-
lar in other Dutch cities, including Haarlem and
Leiden. Frans Hals, for instance, executed his
famous *Buffoon Playing a Lute* in about 1623.[2]

Young Man Playing a Jew's Harp dates from
1621, the year in which Baburen returned from
Italy. It is impossible to say for certain whether
he painted it there or in Utrecht, but it is widely
assumed that it was the first work he produced
after coming home.[3] There are dated works by
Baburen from this painting until his death in 1624.

To play the Jew's harp, one clenches it
between the front teeth. The oral cavity serves as
the sound box for a strip of metal that is set into
or made as an integral part of a wooden or metal
frame that is twanged with the finger. The posi-
tions of the player's tongue and lips, sometimes
combined with light exhalation, determine the
various harmonics that can be extracted from the
instrument.[4]

The shape of the Jew's harp is difficult to

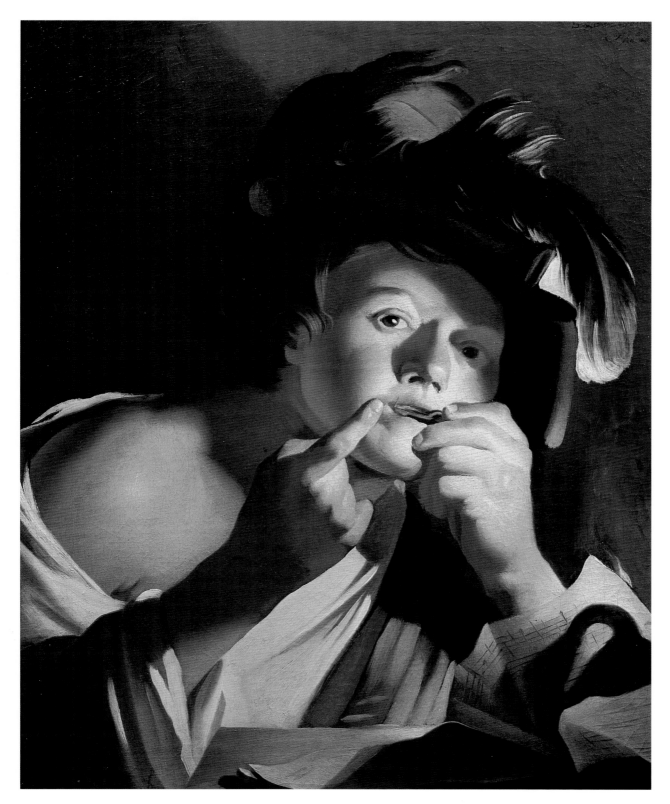

Cat. 37

make out in the painting, but the boy's pose is distinctive. He is holding the harp to his lips with his left hand and plucking the tongue of the instrument, which is bent at right angles at the end, with the index finger of his right hand.

The boy is wearing the flamboyant attire of a street musician, similar to the costumes of other musical figures painted by the Caravaggisti. Beneath a blue-and-yellow striped doublet or cloak, he has on a loose-fitting white shirt, which has slipped off one shoulder. On his dark hair he has a hat with a turned-up brim held in place by a badge to which a huge blue-and-brown ostrich feather is attached.

The restless effect evoked by this nonchalant attire is reinforced by the fluttering sheets of music from which the boy is playing. His face and bared shoulder are illuminated by the light from a smoking candle that can just be glimpsed behind the sheet music. Compared with the musicians painted by Baburen's colleagues in Utrecht, *Young Man Playing a Jew's Harp* is a free and expressive work.

On the grounds of the rapid and slick execution, the Baburen specialist, Leonard J. Slatkes, suspects that this painting is a joint work by the master and one of his assistants. He does not doubt the date and signature, however, and assumes that Baburen was responsible for the lion's share. He suggests that there may have been an earlier version that was fully autograph.[5]

There are several copies of a painting of a flute player by Baburen. One was auctioned in Dordrecht in 1915, with a copy of *Young Man Playing a Jew's Harp* as its companion piece, and it is therefore believed that this was the original pairing.[6]

—L. M. H.

38 DIRCK VAN BABUREN
(ca. 1595–1624)

The Procuress
1622

Oil on canvas, 101.5 × 107.6 cm (40 × 42⅜ in.)
Signed and dated on the lute: *TB* [in monogram]*aburen fe 1622*
Boston, Museum of Fine Arts, M. Theresa B. Hopkins Fund, 50.2721

Provenance: (?) coll. Maria Thins, Gouda/Delft, before 1641–80; (?) coll. Catharina Bolnes, Delft, 1680–88; (?) coll. Johannes Johannesz. Vermeer, Delft, 1688–1713; (?) coll. Sir Hans Sloane, Chelsea; coll. Lt. Col. R. F. A. Sloane-Stanley, Cowes, Isle of Wight; sale, Christie, Manson, and Woods (London), 25 Feb. 1949, lot 52, bought by Colnaghi (London); Roger Thesiger (Buckinghamshire); Museum of Fine Arts (Boston), 1950

Selected References: Slatkes 1965, no. A12, fig. 17; Van de Pol 1988a, 118, illus.; Montias 1989, 57, 122, 146–47, 188, 192, 195, fig. 21; Broos et al. 1990, no. 5; Cavalli-Björkman 1992, no. 1, illus.; Slive 1995, 25, fig. 21; Wheelock 1995b, 16–17, 37–38, 200–203, illus.

This popular picture has appeared in numerous exhibitions and publications, its good-natured sensuality appealing to modern audiences as it must have appealed to Baburen's contemporaries. Baburen has updated the look of the well-worn theme of mercenary love, a favorite with Northern artists since the early sixteenth century.[1] Repeating the format and rhythms of Caravaggio's *Cardsharps* (see Orr, fig. 3, in this catalogue), the Boston *Procuress* confronts the viewer with three bawdy players whose large scale and palpable vitality seem to spill over into our own space. Like actors from Central Casting, they assume the roles of pliant girl, eager client, and exacting procuress. The painting, still imbued with the traditional moralizing undertones associated with the biblical parable of the Prodigal Son,[2] would seem to show Baburen's intention to emphasize not the negative consequences of the action underway, but rather the sensuous pleasures exhibited. The viewer is invited to share vicariously in this sensual world by experiencing the earthy colors and figural types realized in Baburen's broad vigorous technique.

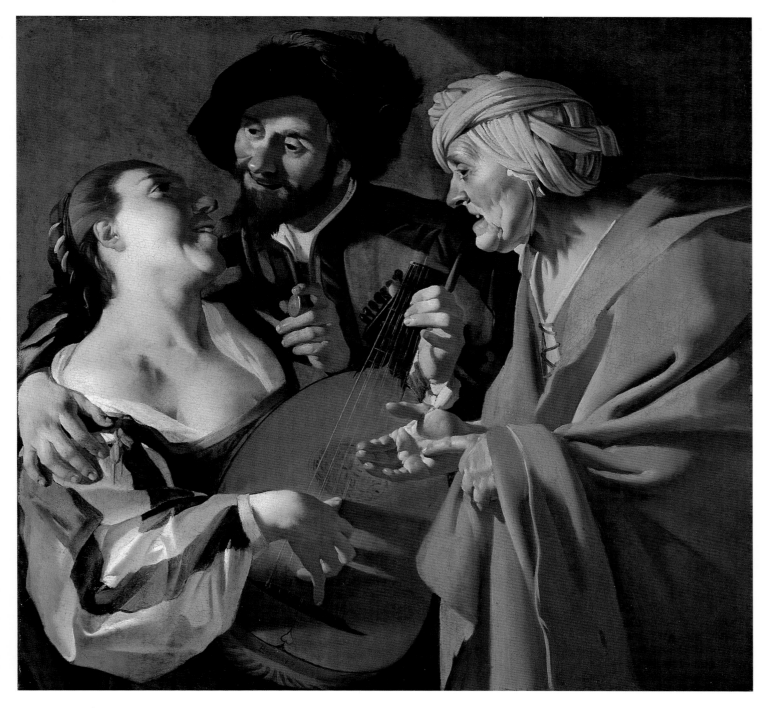

Cat. 38

The earthiness of these figures lends the scene an air of authenticity. The modern viewer would be wrong, however, to interpret this and similar paintings by contemporary masters, including Honthorst, Duck, and Knüpfer (see cat. 45) as realistic portrayals of the milieu of the seventeenth-century prostitute. For all their convincing illusionism, achieved through formal devices, for example the abrupt truncation of the figures suggesting that they extend beyond the picture frame, Baburen's characters belong to a long tradition of brothel scenes. As conventional stereotypes, the men are swaggering, greedy, and/or gullible; the women fall into one of two distinct categories: the procuress, who is old, degenerate, and ugly; or the prostitute, who is attractive, sometimes more, sometimes less willing, and always immoral.

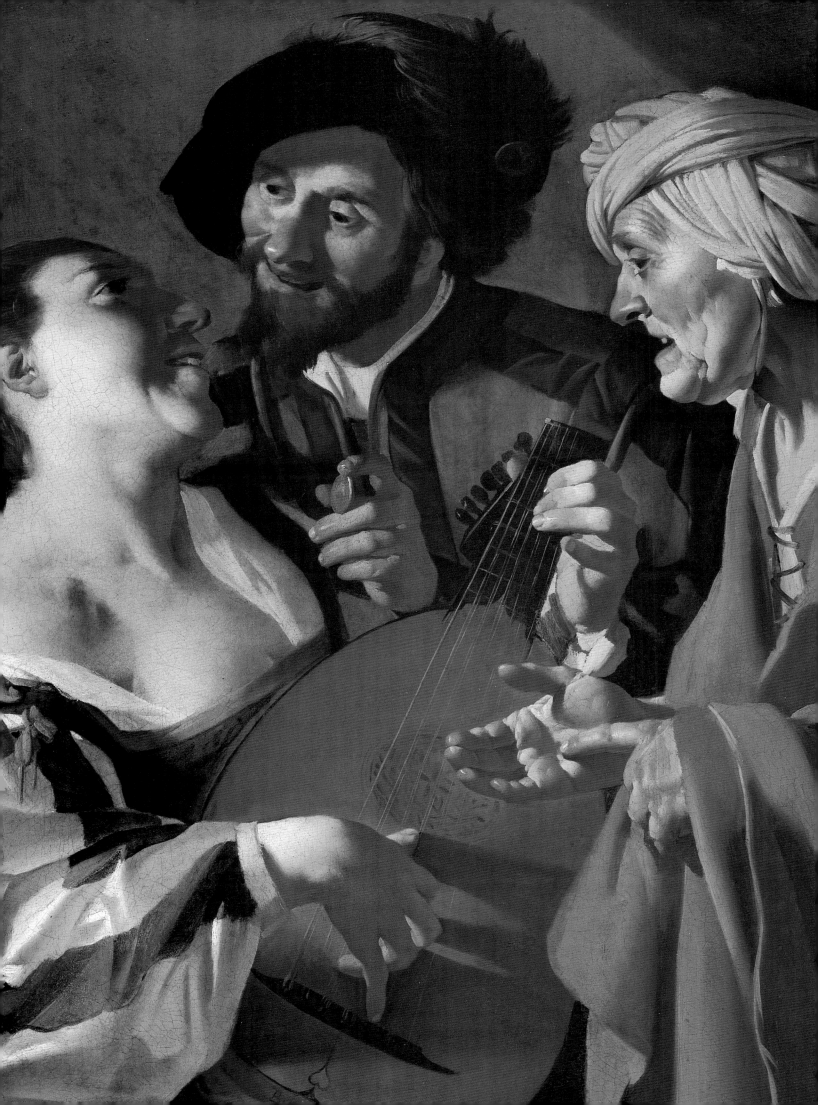

Recent studies examining the actual circumstances of brothels in Utrecht and the wider Dutch Republic have revealed a world as sordid as the sex industry of our own time, particularly in ports such as Amsterdam, which by the seventeenth century was the third largest city in Europe, after London and Paris.[3] Lotte van de Pol has sketched a grim picture of the lives of Dutch women who, forced into prostitution in order to provide for themselves, dealt with poverty, violence, venereal disease,[4] and continuing persecution by the authorities (it has been estimated that between 10 and 40 percent of the prostitutes in Amsterdam were arrested every year).[5] But the seventeenth-century artist is not interested in social realism. In paintings of the period, the shabby one- and two-room brothels, dark cellars, and dance halls of reality become festive meeting places for gaily dressed courtesans and their cavalier companions, or the gathering places of raucous students (see Spicer, introduction to this catalogue, fig. 6). Combining beauty, finery, delectable food—such as oysters—drink, and music, the painters evoke in their brothels a pleasurable, but entirely fictional, atmosphere. In images such as this by Baburen, the unsavory is made palatable for the consumption of members of polite society, who purchased such paintings.[6]

Much of the fascination with Baburen's *Procuress* stems from its quotation almost half a century later in two paintings by Johannes Vermeer of Delft: *The Concert* (fig. 1)[7] and *A Young Woman Seated at a Virginal* (about 1675; The National Gallery, London).[8] Two possible routes of contact between Vermeer and the Baburen image have been established. Recent archival research has verified that, among the effects dispersed on 27 November 1641 in the divorce settlement of Maria Thins, Vermeer's future mother-in-law, was "Een schilderije daer een was copplerste die in de hant wijst" (a painting of a procuress pointing in the hand),[9] most certainly the same image as that of the present painting. It appears that Maria Thins

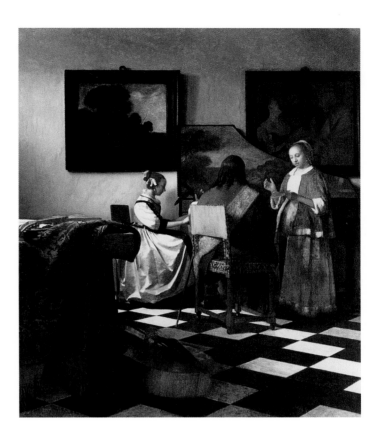

Fig. 1 Johannes Vermeer, *The Concert*, ca. 1660–65. Oil on canvas, 69.2 × 63 cm (27¼ × 24¾ in.). Isabella Stewart Gardner Museum, Boston, P21W27.

owned several other Utrecht paintings, which had been acquired by her family before her divorce from Reinier Bolnes.[10] Significantly, she also had direct family ties in Utrecht and in fact was related through her cousin, Jan Geensz. Thins, to the Utrecht mannerist Abraham Bloemaert.[11] Jan Geensz. Thins is recorded as having owned a painting of a Nativity by Bloemaert that, in a document dated 1644, was willed by Thins to his daughter.[12]

In his fascinating re-creation of the Thins family history and connections, John Montias speculated that Vermeer may have been apprenticed to the elder Bloemaert or some other Utrecht master.[13] Vermeer's association with the school of Utrecht would help to explain the character of his early works, including the *Saint Praxedis* (1655; The Barbara Piasecka Johnson Collection Foundation),[14] *Christ in the House of Mary and Martha*

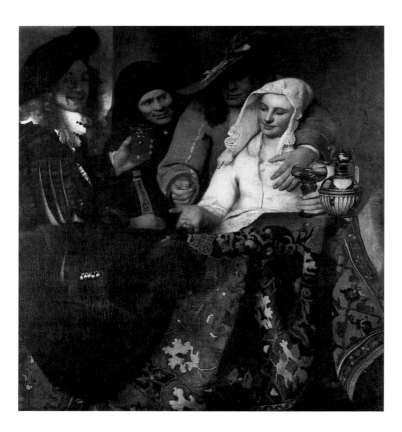

Fig. 2 Johannes Vermeer, *The Procuress*, signed and dated 1656.
Oil on canvas, 143 × 130 cm (56¼ × 51¼ in.). Staatliche
Gemäldegalerie, Dresden, 1335.

of subject matter and the painting's large format.
The direct quotation of Baburen's *Procuress* in
Vermeer's small-scale paintings of the 1660s has
led modern art historians to a wider reading of
those elegant and intimate interior scenes. The
coarse imagery of Baburen's characters provides
the counterpoint to Vermeer's genteel figures,
who are nonetheless also engaged in amorous
dialogue.[19]

—L. F. O.

39 JAN VAN BIJLERT
(1597/98–1671)

Girl Teasing a Cat
ca. 1626

Oil on panel, 41 × 32 cm (16⅛ × 12⅝ in.)
Signed upper right: *Jv* [in monogram] *bijlert fc*
Baltimore, The Walters Art Gallery, W. Alton Jones
Foundation Acquisition Fund, 37.2659

Provenance: sale, Phillips (London), 7 July 1992, lot 77;
with Lingebauer (Düsseldorf)/Alazraki (New York),
1992–93; purchased through the W. Alton Jones Fund
in 1993

Selected References: Huys Janssen 1994a, no. 106; Corrin
and Spicer 1995, 73; Spicer 1995, 15

(about 1655; National Galleries of Scotland,
Edinburgh),[15] and *Diana and Her Companions* (about
1655–56; Mauritshuis, The Hague),[16] which have
a decidedly Italian flavor and share much in com-
mon with the late, classicizing style of Bloemaert.
Montias goes on to suggest that it was possibly
Bloemaert who introduced Vermeer to the Thins
family.

In 1653 Vermeer married Maria Thins's
daughter, Catharina Bolnes, and sometime before
1660 the couple moved into Maria's house in Delft,
which was owned by her cousin, Jan Geensz.
Thins. It is at this point, if not sooner, that
Vermeer must have become familiar with either
the Boston *Procuress* or a copy of it.[17] Vermeer pro-
duced his own interpretation of the theme, the
signed and dated *Procuress* of 1656 (fig. 2).[18] Here
the influence of Baburen's Utrecht vocabulary is
immediately apparent, including both the choice

"Die met het katje speelt, wordt er af gekrabd"
(Whoever plays with a little cat will be scratched)
is one of many seventeenth-century Dutch sayings
that are based on the perception of cats as unpre-
dictable, independent, untrainable, choleric, and
lascivious.[1] The subject of a child or young woman
playing with, teasing, or being scratched by a cat
was popular with Dutch artists,[2] and children in
everyday clothes with cats or kittens appear often
in the work of Haarlem painters such as Judith
Leyster,[3] Dirck Hals, and Jan Miense Molenaer
(fig. 1).[4]

Treatments by Utrecht artists include this
painting and a later one by Jan van Bijlert.[5] Two
lost paintings from the same years by Hendrick

Cat. 39

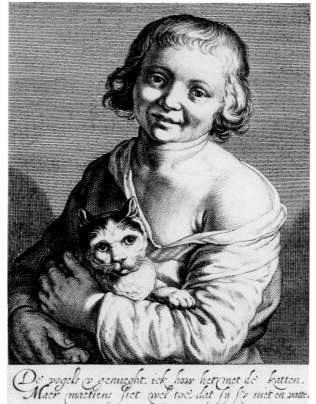

De vogels v̄ genueght, ick houw het met de katten.
Maer maetiens siet wel toe, dat sy sv niet en vatte.

Fig. 1 Jan Miense Molenaer, *Boy Scratched by a Cat*, 1629–30. Oil on panel, 37 × 30 cm (14⅝ × 11⅞ in.). Musée Départemental des Vosges, Epinal.

Fig. 2 Cornelis Bloemaert, *Boy with a Cat*. Engraving after a lost painting by Hendrick Bloemaert ca. 1625, 144 × 114 mm (5⅝ × 4½ in.). Rijksprentenkabinet, Amsterdam, RP-P-BI-1431.

Bloemaert, *Gypsy Girl Stroking a Cat*[6] and *Boy with a Cat* are known from engravings (fig. 2).[7] The latter is accompanied by the verse: "You enjoy the birds, I prefer cats, / But watch out girls, that they do not catch you."

As these depictions suggest, the treatment of the subject in Utrecht was different. These are not scenes from the everyday life of children; the voluptuous yet cheerful mood of the Walters's picture suggests a boudoir or brothel. In the place of mischievous children at play, we have sensual youths whose blowsy expressions are accompanied by broad expanses of exposed, tender skin, generally that of the shoulder with its peculiar suggestions of vulnerability (see Spicer, introduction to this catalogue). Their gaze drawn to the girl's exposed skin, viewers vicariously anticipate the scratch of the claws on their own skin, giving an immediacy to the comparison between the dangers of being scratched by a cat and the dangers of sexual seduction.

The frequency of paintings by artists in Utrecht of young people playing with cats calls attention to the dearth of paintings of children training dogs to do tricks such as sitting up,[8] a frequent subject in other Dutch artistic centers. Children in Utrecht probably owned dogs, so this absence supports the assumption that paintings of the training of dogs were not candid renderings of everyday life but intended to be perceived as effective analogues of the virtue of tractability, the openness to being trained thought so important in children, especially by Calvinists. According to Calvinist writers, even the smallest amount of unsupervised play was potentially corrupting.[9] Cats do nothing else. (For discussion of the

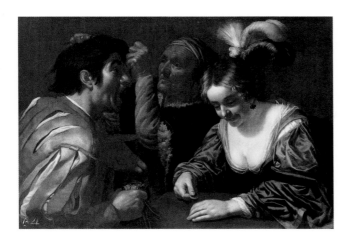

Fig. 3 Jan van Bijlert, *The Procuress*, 1626. Oil on canvas, 78 × 110 cm (30¾ × 43¼ in.). Herzog Anton Ulrich-Museum, Braunschweig, 188.

overarching issues of moralizing intentions in Utrecht art, see Spicer, introduction to this catalogue.)

The good-humored mood of this and other Utrecht pictures of the life of the senses contrasts with the languid, often melancholic, and more starkly sensual mood of Caravaggio's *"Concert of Youths"* of about 1595 (cat. 40, fig. 1),[10] which Van Bijlert would have seen in Rome in the collection of Cardinal Francesco Maria del Monte. The artist apparently adapted Caravaggio's depiction of the rear view of the boy's naked shoulder and arm for the shoulder and arm of the girl in the present painting. Her ready grin and alert posture are complemented by her coy gesture in lifting her elbow away from her body just enough to allow a glimpse of her naked breast. Nevertheless, the resulting alteration in the foreshortening of the figure's forearm is awkward and is imperfectly masked by the added drapery.[11] Van Bijlert and the other Utrecht painters who were in Rome may have brought back drawings of works by Caravaggio and other painters, but there is no evidence that Caravaggio's composition was known to the wider public in Utrecht. This adaptation was, therefore, very likely not meant as a quotation to be recognized, except possibly by other artists who had seen the original, but rather as private homage

to an expressive solution by the earlier artist[12] (see essay by Orr, in this catalogue).

Girl Teasing a Cat was likely painted about 1626, shortly after Van Bijlert's return to Utrecht in 1624 when the influence of the Roman experience was still strong. The girl's creamy, plump, sensual face recalls the prostitute in Van Bijlert's *Procuress*, dated 1626 (fig. 3),[13] a work also exhibiting Caravaggesque tendencies. The basis for Huys Janssen's dating to 1635–45 is not clear. However, Van Bijlert's other known *Girl Teasing a Cat* (location unknown)[14] appears (in reproduction) to be stylistically related to his classically cool *Young Woman with a Lute* (Herzog Anton Ulrich-Museum, Braunschweig),[15] both of which can be assigned to the 1630s, when the influence of Caravaggio had faded.

—J. S.

40 HENDRICK TER BRUGGHEN
(1588–1629)

Musical Group
(also known as *The Concert*)
ca. 1626–27

Oil on canvas, 99.1 × 116.8 cm (39 × 46 in.)
London, Trustees of the National Gallery, Purchased with the aid of the National Heritage Memorial Fund, the Pilgrim Trust, and the National Art Collections Fund, 1983, NG 6483

Provenance: said to have been purchased by Lord Somers (1651–1716), Lord Chancellor of King William III, ca. 1700; Lord Somers; by inheritance to the Hon. Mrs. E. Hervey-Bathurst, Eastnor Castle, Ledbury; art market, 1982

Selected References: Pevsner 1935, 30, fig. A; Birmingham 1938, cat. 451; London 1938, cat. 169; Longhi 1952, 55; Utrecht 1952, cat. 82, fig. 64; London 1952–53, cat. 633; Nicolson 1953, 52; Czobor 1956, 230; Nicolson 1956, 109–10 n. 34; Nicolson 1958b, cat. A37, pl. 72; Gerson 1959, 317; Slatkes 1965, 132; Van Thiel 1971, 103; Brown 1976a, cat. 20; Brown 1977, cat. 16, color illus.; Nicolson 1979, 99; Bissell 1981, 68; Blankert and Slatkes 1986, cat. 23, color illus.; Kitson 1987, 137; Nicolson and Vertova 1989, 1:192, 3: fig. 1155; Blankert 1991a, 11–13, figs. 3, 3a; Slatkes 1996, 5, fig. 4

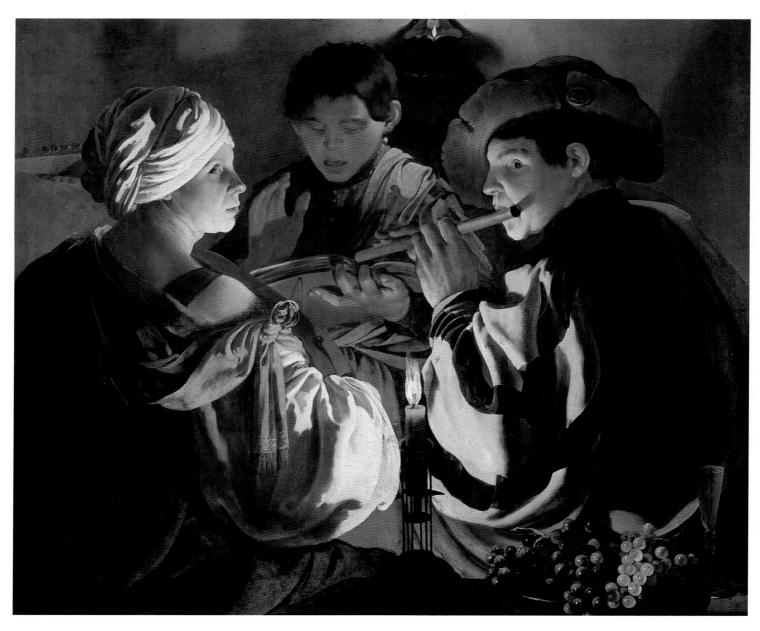

Cat. 40

Musical subjects of this type are normally called "concerts," yet because this term carries suggestions of a public performance,[1] and given the makeup of the group depicted here, this is not what Ter Brugghen intended, and a more neutral title is called for. That a similar situation prevailed in Italy is indicated by Caravaggio's *"Concert of Youths"* (fig. 1), in the Metropolitan Museum of Art, New York, a work comparable to the present picture. Significantly, the Caravaggio was listed as "una musica" in the 1627 inventory of Cardinal Francesco Maria del Monte,[2] a title unlike "con-

cert," that carried no hint of a performance but suggested a broader, more allegorical view of music.

There has been considerable debate concerning the date of the London painting. Benedict Nicolson, when he first began his Ter Brugghen investigations, believed it should be dated relatively early, about 1622–23.[3] Later, however, he recognized that the composition, and especially the execution, required a later date, toward the end of the master's relatively short career.[4] Nevertheless, some scholars have continued to subscribe to a

date in the early 1620s despite the fact that the picture is one of only two late works by Ter Brugghen that make use of an unusual and sophisticated double light source.[5] Furthermore, although the composition differs greatly from comparable works painted about 1623,[6] it does compare favorably with pictures like *Esau Selling His Birthright* of about 1627,[7] with which it shares the placement of the main light source along the central axis. That Nicolson was correct in his late dating of the present picture is further supported by its affinities with the 1626 *Musical Trio* in St. Petersburg.[8] Indeed, our painting may even be seen as developing out of the *Musical Trio*,[9] although the mood here—unusually serious for the activity—is very different from the Russian canvas. A close examination of the 1626 picture reveals that it was begun as a duet; the male foreground figure was clearly added over the two already completed figures.[10] The present picture, in contrast, although also containing numerous changes and pentimenti,[11] was conceived of as a trio from the start.

Both this canvas and the *Musical Trio* have sometimes been compared with Gerard van Honthorst's Merry Company pictures (cat. 35) and even procuress scenes with nocturnal settings.[12] Ter Brugghen certainly was aware of this important Utrecht development, and the influence of Honthorst's 1625 *Procuress*[13] on the St. Petersburg picture is apparent in the repoussoir placement of the foreground figure as well as in the use of artificial light. Our picture, however, while also utilizing nocturnal effects, is quite different in compositional arrangement and mood from Honthorst's. Equally removed from Honthorst is what might be termed the "cast of characters,"[14] suggesting that Ter Brugghen had quite different intentions. Supporting this contention is the unusually formal pyramidal structure of the present composition. This, and the juxtaposition of the two sleeves with the candle, lends a decorous and even serious air to the picture, especially when contrasted with a

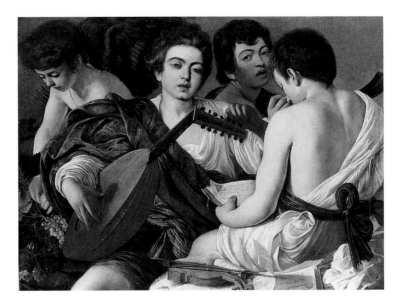

Fig. 1 Michelangelo Merisi da Caravaggio, "*Concert of Youths*," ca. 1595. Oil on canvas, 87.9 × 115.9 cm (34⅝ × 45⅝ in.). The Metropolitan Museum of Art, New York, Rogers Fund, 1952.52.81.

typical Honthorst Merry Company. By including a secondary light source high in the pictorial space, Ter Brugghen effectively limits the depth of his composition. Caravaggio, significantly, used a corresponding device with his notorious cellar light in which he threw a diagonal band of light across the dark back walls of his compositions. Despite Ter Brugghen's limited depth, which serves to project the figures outward, and the fact that the two foreground musicians have turned toward the viewer, we are neither engaged by nor invited into the scene in the manner of a Honthorst.

The beautifully rendered bowl of grapes and the tall partially filled glass of wine are so elegantly located that their tactile qualities are almost overlooked; they are effectively elevated by their placement to a more symbolic realm. These traditional Bacchic motifs are key elements in our understanding of Ter Brugghen's musical depiction.

Despite attempts to draw relationships between the London painting and other Utrecht musical groups, it is much more likely that Ter Brugghen had Caravaggio's early "una musica" in mind. Both the Caravaggio and the present picture use the same methods of music making: voice,

strings, and wind. Early theorists of music, starting with Boethius (ca. A.D. 480–524), established this musical hierarchy.[15] The human voice, because it was considered to be natural music and required no instrument to express itself, was assigned to the highest category. Next came artificial or instrumental music, in which strings were assigned the highest position and winds to the lowest category.[16] Caravaggio, like Ter Brugghen, indicated the Bacchic origins of music by including the grapes sacred to Bacchus, the god of wine; however, he also included Eros, the god of love.[17] Ter Brugghen only provides us with grapes and their product—a tall glass partially filled with wine—to indicate his symbolic intentions.[18] By including Eros, Caravaggio alludes to the long-established relationship between love and music. Unlike Caravaggio's cast of characters, however, Ter Brugghen's family-like mix of sexes and ages seems to provide a more discrete and perhaps more moral product of this aspect of the power of music.

—L. J. S.

41 HENDRICK TER BRUGGHEN
(1588–1629)

Fife Player
(also known as *Flute Player*)
1621

Oil on canvas, 71.3 × 56 cm (28⅛ × 22 in.)
Signed on the hat medallion: *HTB* [in monogram]
Kassel, Staatliche Museen, Gemäldegalerie Alte Meister, GK 179

Provenance: perhaps one of the "twee Speelders van Ter Brugge" (two musicians by Ter Brugge) listed as lot 5 in the supplement to the catalogue of the collection of the Dutch historian and jurist Petrus Scriverius (1576–1660), sold at the Kayzers Kroon (Amsterdam), 1663.[1] There has been uncertainty about what occurred after the picture under discussion and its pendant appeared in the sale of the G. Winkler coll. (Leipzig), 1768 (lots 306, 307). At that time their sizes were given as 2 *Fuss* 7 *Zoll* ×

2 *Fuss*. Using the old Saxon standard of one *Fuss* equaling 28.3 cm yields 73.1 × 56.6 cm, extremely close to their present dimensions.[2] When the pictures next appeared in the Gottfried Winkler, Jr., sale in 1819, Nicolson believed them to be copies, since by his estimate they measured only 31 × 24 cm; however, he must have forgotten to transcribe the measurements into centimeters, for both pictures were listed as 31 × 24 *Zoll*, exactly the same measurements as in the 1768 sale. The difference is considerable since they actually measured approx. 73.1 × 56.6 cm. Faced with what he believed to be paintings too small to fit the present work and its pendant, Nicolson dismissed the possibility that the pictures stayed in the Winkler family. However, in the sale of the collection of the son of the earlier Gottfried Winkler, Verst. Gottfried Winkler, Weigel (Leipzig), 18 Oct. 1819, lot 8, our picture, listed as H. Brugghen, in a black frame, is described as "a young man playing a flute, on his head a feathered hat." Believing the picture too small to be the original, Nicolson listed it as a copy. In the same sale, as lot 154, again identified as by H. Brugghen and also in a black frame, was a picture the same size as lot 8, described as a "Neapolitan shepherd," an acceptable enough nineteenth-century description for the pendant. Like its companion, the size was given as 73.1 × 56.6 cm. The black frames are dutifully listed in both lot descriptions.[3] According to annotated sales catalogues, both lots went to what must be the same buyer, a certain "Kustner." It is likely, however, the pictures remained in the Winkler family, for our painting and its pendant are listed, again with the same sizes and descriptions, in the sale of Herrn Gottfried Winklers des Sohnes, Banquiers (Leipzig), 23 Apr. 1834, lots 15 and 16, sold, according to annotated catalogues, to Melly. Nicolson, however, listed these as copies; thus, our painting and its pendant remained with the Winkler family for at least three generations. The picture next appeared, as Nicolson correctly noted, in the G. C. Melly sale (Leipzig), 10 May 1861, lot 93. Edward Habich sale: *Katalog der . . . Gemälde-Sammlung des . . . Edward Habich zu Cassel . . . Versteigerung zu Cassel*, Cologne, 1892, Kassel, 9–10 May 1892, lot 143

Selected References: Houck 1900, 520; Von Wurzbach 1910, 2:703; Braune 1914, 263; Collins Baker 1927, 196–202; Longhi 1927, 110; Von Schneider 1933, 37, 141; Bloch 1940, 91–109; Schaffhausen 1949, cat. 172; Milan 1951, cat. 172; Utrecht 1952, cat. 80, fig. 51; Nicolson 1956, 105, fig. 5; Nicolson 1958b, cat. A14, pl. 20; Gerson 1959, 317; Bauch 1960, 34–35; De Mirimonde 1960, 114; Gerson 1964, 562; Slatkes 1965, 96, 165; Białostocki 1966, 591–95; Von Schneider 1966, color pl. XI; Slatkes 1969, 300; Bissell 1971, 288, fig. 21; Van Thiel 1971, 101, 110; Nicolson 1973, 240; Bissell 1981, 65, 69; Kettering 1983, 36–38, 137 n. 13; Blankert and Slatkes 1986, cat. 10, illus.; Moiso-Diekamp 1987, 487, cat. A3; Schnackenburg 1996, 1:79, 2: pl. 6

London only

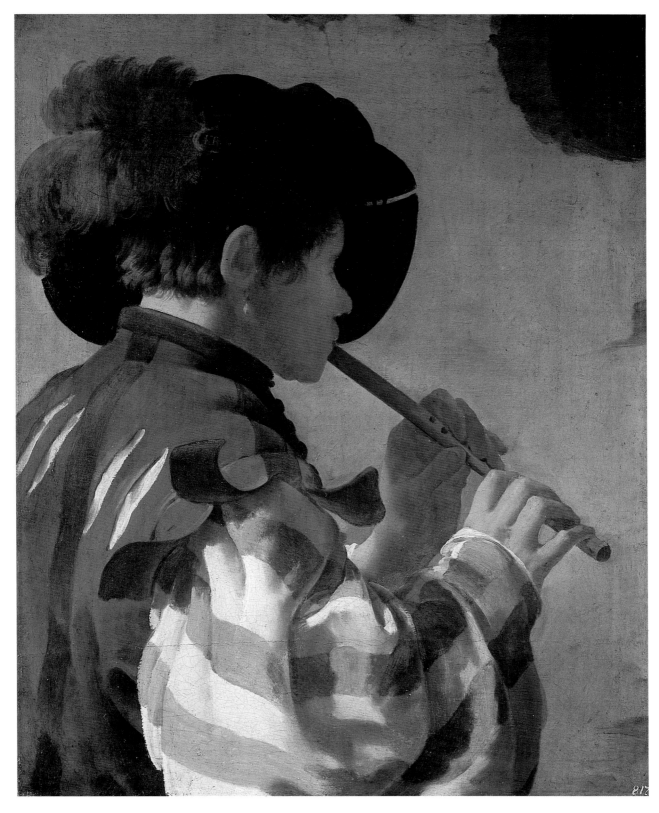

Cat. 41

Despite the objections of Pieter Van Thiel concerning the authentic pendant relationship of this picture to the closely related *Flute Player* (fig. 1), also in Kassel, there is no physical evidence to suggest that the present painting has been cut down by more than a few centimeters on any one side.[4] Although we cannot be certain these are the pictures that appeared together in the Scriverius sale, their unbroken common provenance in the Winkler family collections since before 1768 lends some support for their authenticity as pendants. Furthermore, there is convincing stylistic evidence to support the 1621 date of the present picture required by its pendant relationship with its fully signed and 1621-dated partner.[5]

Although the Kassel painting and its pendant have usually been identified simply as flute players, and indeed the instruments they play are members of the flute family, there are significant differences in the character and associations of the two instruments depicted. The nature of these differences is supported by the contrasting costumes worn by the players. In the present Kassel picture, the instrument is a short transverse one identifiable as a fife.[6] Appropriately, our fife player wears a costume that, although it has been variously identified as either Burgundian or theatrical, comes closest to the elaborate dress of sixteenth-century Swiss and German mercenaries, the *Landsknechten*.[7] Thus, the costume is appropriate to the instrument played.[8]

His opposite number plays a straight flute or recorder[9] and is accordingly dressed in an off-the-shoulder, togalike garment, which, like similar costumes in the early Roman work of Caravaggio, may be categorized as *all'antica* and supports the Arcadian mood of that picture. In Italy the straight flute is traditionally associated with the pastoral in art and *poesia*.[10] Thus, although the two canvases are authentic pendants, they present the viewer with an antithetical relationship comparable to what we find in Ter Brugghen's later

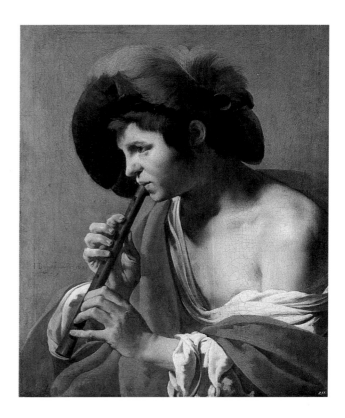

Fig. 1 Hendrick ter Brugghen, *Flute Player*, 1621. Oil on canvas, 71.5 × 56 cm (28⅛ × 22 in.). Staatliche Museen, Gemäldegalerie Alte Meister, Kassel, GK 180.

pendants of *Heraclitus* and *Democritus* (cats. 23 and 24).[11]

A close study of Ter Brugghen's works reveals that he was unusually sensitive to the various applications of musical meaning and musical symbols—as opposed to the technical elements such as accurate fingering or other elements connected with musical technique.[12] Not only were Ter Brugghen and his Utrecht colleagues more subtle and varied in these elements than has been previously recognized, but his use of costume seems to support his meaning. Unfortunately, the study of the costumes used in many of these paintings remains in its infancy.

The present picture and its pendant are among the earliest paintings to make use of the new genre subject matter of Utrecht Caravaggism as it developed after the summer of 1620 when Honthorst and Baburen returned from Rome.

As such, they differ from Ter Brugghen's earlier religious and history pictures like the *Crowning with Thorns* (cat. 6), and follow the example of Baburen's 1621 *Young Man Playing a Jew's Harp* (cat. 37), the first of the Utrecht Caravaggesque musicians.[13] So dramatic in aesthetic focus is Ter Brugghen's change that it can only be attributed to the artistic climate fostered by his newly returned colleagues.

—L. J. S.

42 HENDRICK TER BRUGGHEN
(1588–1629)

Singing Lute Player

(also known as *A Man Playing a Lute*)

1624

Oil on canvas, 100.5 × 78.7 cm (39⅝ × 31 in.)
Signed and dated at right: *HTB* [in monogram] *rugghen fecit 1624*[1]
London, Trustees of the National Gallery, NG 6347

Provenance: Two listings in seventeenth-century inventories might fit this picture. The first is the painting described as "een luytenslager van Hendrick ter Brugge" (a lute player by Hendrick ter Brugge) in the Gerard Uylenburgh collection, Amsterdam, 1674.[2] The second is from the Utrecht estate of Johan van Sijpesteijn, Utrecht, drawn up on 26 Sept. 1693, no. 32, "een beeldt speelende op de luyt" (a figure playing on the lute) "van Terbruch."[3] Said to have come from the Solly Flood collection, southern Ireland; purchased by James A. Murnaghan from a Dublin art dealer ca. 1926; Thomas Agnew and Sons Ltd (London)

Selected References: Nicolson 1956, 108; Nicolson 1957, 198–202; Nicolson 1958b, cat. A26, pl. 44; Judson 1961, 347; Nash 1972, pl. 26; Brown 1976a, cat. 19; Nicolson 1979, 99; Bissell 1981, 92–93 n. 16; Moiso-Diekamp 1987, 480–89; Nicolson and Vertova 1989, 1:193, 3: fig. 1146

Perhaps no subject is more directly associated with Utrecht Caravaggesque art than paintings like the present one representing a single musician. Often referred to as theatrical, these musicians are theatrical only in the most general sense of the word,

and the relationship of their flamboyant costumes to those actually used on the Dutch stage, or performances of any kind, remains problematic. What is certain, however, is that the costumes in these works—including the present picture—are far removed from typical Dutch clothing of the period. Thus it is likely that these colorful costumes served at some level as a distancing device that removed the picture, and thus its subject matter, from the realm of the everyday. Despite the fact that we tend to refer to such paintings as "genre," it is unlikely that the patrons who commissioned and purchased such works would have thought of them as "scenes of everyday life."

Although Caravaggio's early painting of a lute player, in the State Hermitage Museum, St. Petersburg, perhaps made for his first Roman patron, the music-loving Cardinal Francesco Maria del Monte, is undoubtedly the starting point for the development of the single-figure musician, it is equally clear that once they returned home to Utrecht, Baburen, Ter Brugghen, and Honthorst quickly transformed the Italian master's subject matter into something quite different. Dressed in a costume that can be described as *all'antica*, Caravaggio's young *Lute Player* is surrounded by an elegant still life of flowers and musical instruments whose elements have been associated with *vanitas* and love. Typical Utrecht single-figure musicians, however, including the present one, lack secondary elements that often make their meaning uncertain. An engraving by Salomon Saverij after Ter Brugghen's 1624 *Singing Lute Player* (Musée National des Beaux-Arts d'Alger, Algiers)[4]—a painting that was probably the pendant of the present work—has an added subscript that extols only the pleasurable aspects of music making: "I play expertly on the sweet, full strings of the lute / Thereby I can also sing lustily and know that it sounds good."[5] Such texts, of course, do not mean that this is the only possible association for works such as this one, but they do provide a general

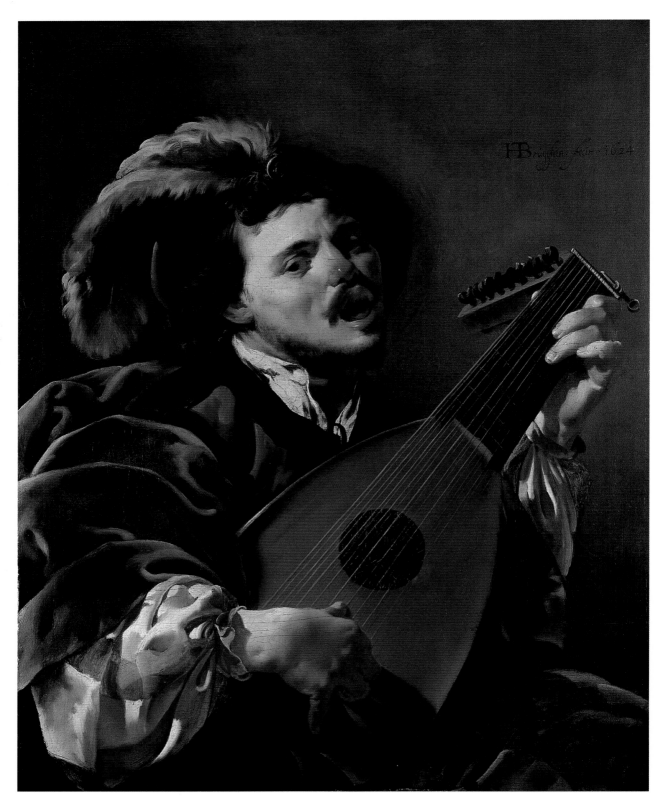

Cat. 42

guide as to how, at the most obvious level, the painting was apparently perceived by Ter Brugghen's contemporaries.

The numerous pentimenti and adjustments,[6] spirited brushwork, and lively paint surface, not to mention the full signature and date, attest to the fact that the present canvas is the prime version of this striking and popular composition. Unlike his earlier single-figure musicians, for example the unusually reticent Kassel *Fife Player* of 1621 (cat. 41), the mood here is open and outgoing, following the lead of Baburen's 1622 *Singing Lute Player* (fig. 1),[7] probably the first rendering of this specific musical theme in Utrecht. That Ter Brugghen was looking at what his innovative studio partner was doing at this moment is confirmed by his inclusion of a motif similar to that used for the lute-playing prostitute in Baburen's 1622 *Procuress* (cat. 38), the long shadows cast by our musician's hand.[8] The reticence that characterized Ter Brugghen's 1621 musical subjects, and continued in the presumed pendant, the Algiers *Singing Lute Player*, has vanished from the present composition. Significantly, since both compositions survive in autograph and partially autograph repetitions, as well as one of the master's rare drawings—for the Algiers composition—it is likely that several pendant pairs were produced by Ter Brugghen and his workshop, attesting to the popularity of the theme.

Despite the many similarities between the London and Algiers *Lute Player*s, there are also significant differences. The Algiers musician turns away from the viewer in a manner similar to the lost profile Ter Brugghen used in his earlier *Fife Player* (cat. 41) in Kassel. Although we think of pendant paintings as harmoniously answering each other, this is not always the case in the pendants of Ter Brugghen. Indeed, he often used the related instruments both to link and separate contrasting pairs. In the different flutes used for the Kassel pendants, for instance, each has its own special associations and meaning. Antithetical pendants are not as unusual as they may at first seem, especially

Fig. 1 Dirck van Baburen, *Singing Lute Player*, 1622. Oil on canvas, 71.4 × 58.6 cm (28⅛ × 23 1/16 in.). Centraal Museum, Utrecht, 11481.

when one recalls the great popularity of *Heraclitus* and *Democritus* (cats. 23 and 24), the weeping and laughing philosophers whose contrasting responses to the follies of the world were so popular with Utrecht artists. Given this attitude, the pairing of an outgoing, extroverted musician, as in the present picture, with a reticent one who turns his back on the viewer, as in the Algiers composition, is not that unusual, especially in Ter Brugghen's oeuvre.

It has been difficult to sort out the various versions of this composition because of inconsistencies in the sizes and the poor reproductions provided in auction catalogues. Although four versions of this composition are listed in the latest edition of Nicolson, a letter in the archives of the National Gallery, London, stated that he believed, correctly in this writer's opinion, there are only two versions plus the prime one exhibited here.

—L. J. S.

43 HENDRICK TER BRUGGHEN
(1588–1629)

Young Woman Reading from a Sheet of Paper

(also known as *Singing Girl*)

1628

Oil on canvas, 78.5 × 65.5 cm (30⅞ × 25¾ in.)
Signed on the bottom of the sheet of paper: *HTB* [in monogram] *rugghen fe.* [in ligature]; dated between the fingers of her right hand: *1628*
Basel, Öffentliche Kunstsammlung Basel, Kunstmuseum, 611

Provenance: most likely the painting sold Nothnagel (Frankfurt am Main), 27 Sept. 1779, lot 31: "Ein junges Frauenzimmer, wilches mit einer vergnügten Miene einen Brief lieset, von Verbruggen" (A young woman with a cheerful expression reading a letter, by Verbruggen), *2 S. 4z H × 1S 10 zoll B* (French *Fuss* and *Zoll*, approx. 75.6 × 59.4 cm); sale (Milan), 30 Jan. 1900, lot 123; Gustav R. M. Stehelin-Kellermann coll.; legated to the Freiwillige Museumsverein, 1902

Selected References: Göthe 1910, 343; E. W. Moes, in Thieme-Becker, 5:113; Roh 1921, pl. 6; Drost 1926, 143; Collins Baker 1927, 201; Stechow 1928, 277; Von Schneider 1933, 37, 140; Isarlo 1941, 234; Milan 1951, cat. 174; Bloch 1952, 16; Utrecht 1952, cat. 84, fig. 61; Nicolson 1956, 109–10; Nicolson 1958b, cat. A6, pl. 99; Plietzsch 1960, 146, illus.; Von Schneider 1966, no. XVII, color illus. on the cover; Nicolson 1979, 100; Blankert and Slatkes 1986, cat. 28, color illus.; Boerlin 1987, 32, color illus.; Klessmann 1987, 607; Ten Doesschate-Chu and Boerlin 1987, cat. 28, color illus.; Nicolson and Vertova 1989, 1:194, 3: fig. 1182; Blankert 1991a, 18–19, fig. 9

London only

Despite the fact that the activity depicted in this painting has usually been described as singing, neither the rendering of the woman's features—especially her mouth—nor the sheet of paper she holds supports this identification. Even a quick comparison with the several certain singing figures in the present exhibition, the *Singing Lute Player* (cat. 42) and the boy singing from a part book in the *Musical Group* (cat. 40), as well as other works by Ter Brugghen,[1] reveal important differences in expression and, especially, in the rendering of the mouth. Furthermore, there are none of the usual indications on the paper she holds to suggest that it is meant to represent music. Indeed, the gray blocks of tone clearly indicate that Ter Brugghen intended them to represent a text. By contrast, in works such as his 1626 St. Petersburg *Musical Trio*,[2] musical notes are clearly visible, leaving no possible question as to what the sheet is meant to be. By rendering his text as tonal blocks, Ter Brugghen follows Dirck van Baburen who, in his 1622 *Young Christ among the Doctors*,[3] introduced this conceptual way of rendering a text, written or printed.

Another reason for interpreting this picture as representing reading rather than singing is the absence of the typical Utrecht singing gesture in which one open hand is raised to keep time. In other Ter Brugghen works this gesture makes the musical nature of the activity clear where an instrument is not involved as, for example, in his 1627 *Boy Singer* in Boston.[4] The gesture, however, also appears in other musical depictions, such as the singing boy in the *Musical Group*.

The activity of this fancifully dressed young woman—either reciting or reading a text—is not unique in Utrecht art. In 1628, the same year that this picture was done, Abraham Bloemaert painted a related theme in his *Shepherdess Reading a Poem*.[5] Unlike our picture, however, the text is legible in the Bloemaert, and either the object or the author of the pastoral love poem, a young shepherd with a straight flute, is depicted. It should be further noted that, unlike Bloemaert's typically costumed shepherdess, Ter Brugghen's young woman is exotically dressed in an unusually rich and brightly colored costume and with a headdress that suggests a turban.[6]

During the previous year, 1627, Ter Brugghen painted an *Allegory of Taste* (fig. 1), in which the same model appears wearing a related, although more elaborate version of the turbanlike headdress.[7] Close examination of these paintings suggests that with some adjustments Ter Brugghen could have used the same drawing or drawings made for the Getty work for the present picture.

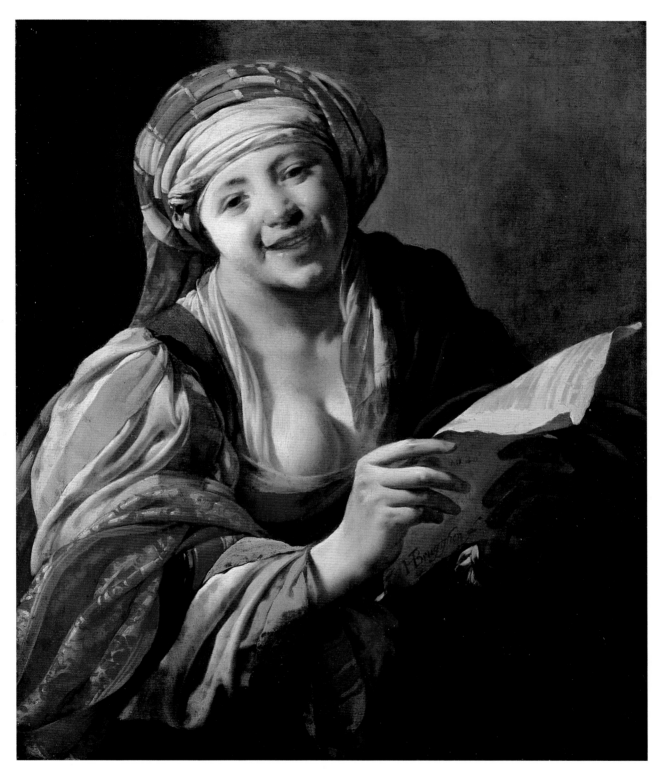

Cat. 43

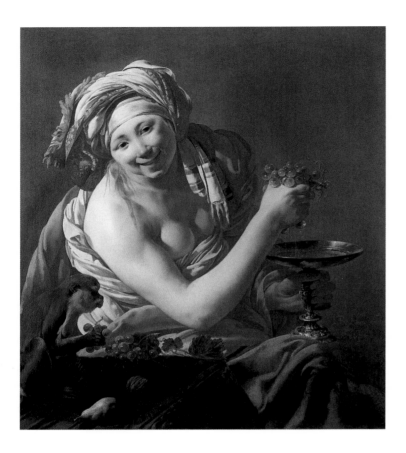

Fig. 1 Hendrick ter Brugghen, *Allegory of Taste*, 1627. Oil on canvas, 102.9 × 90.2 cm (40½ × 35½ in.). J. Paul Getty Museum, Los Angeles, 84.PA.5.

This approach is not unusual in Ter Brugghen's work, and in at least one case, the *Democritus* (cat. 24), where the drawing has survived, it can be documented.[8] Quite unlike the Getty picture, however, is the exceptionally fluid brushwork and unusually spirited quality of the execution found in the painting in Basel. In these elements this work comes closest to that of another late work by the artist, the Toronto *Melancholia* (cat. 22). These connections with other allegorical pictures suggest that Ter Brugghen had some specific meaning or association in mind that eludes us today. It is, of course, possible that the Basel picture once had a pendant,[9] or was even part of a series now lost or unrecognized, which would have provided a context for the young woman and given meaning to her activity.

—L. J. S.

Study of a Young Woman
1640–1645?

Oil on canvas, 56.5 × 49 cm. (22¼ × 19¼ in.)
Coral Gables, The Lowe Art Museum, University of Miami, Gift of Mr. E. E. Shaffer, 55.001.000
Provenance: with E. & A. Silberman galleries (New York), 1954; E. E. Dale Shaffer (Miami Beach), 1955
Selected References: Held 1985–86, 50; Döring 1993, no. A25
Baltimore only

When Julius Held initially attributed this painting of the head of a young woman to Bronchorst,[1] he considered it a study. More recently it has been treated as a fragment of a destroyed painting or a replica of a passage of a larger composition.[2] In the absence of supporting evidence, it is not clear why this should be so. The lack of gesture, the handling of the shirt drawn back off the shoulder and treated more as drapery than as clothing, the focused lighting from the left onto a neutral background without any suggestion of context, and the typicality of the figure within the artist's oeuvre point to this painting's being what the Dutch called a *tronie*—a study of a model posed in the studio, made in order to learn a certain type of figure without there necessarily being a specific composition in the artist's mind. It is therefore parallel in intention to Abraham Bloemaert's *Head of an Old Woman* (cat. 33).

The open-mouthed, slack-jawed character of this model, who may well be a prostitute, as were many models, fits with the voluptuous impression of Bronchorst's paintings of revelers from the mid-1640s, as in *Bordello with Young Man Playing a Theorbo-Lute* of 1644 (fig. 1).[3]

After years spent as a glass painter[4] and, from the mid-1630s, an etcher, Bronchorst took up oil painting only about 1638. His earliest known dated painting is from 1642, *Solomon Worshiping False Gods* (Bob Jones University Museum and

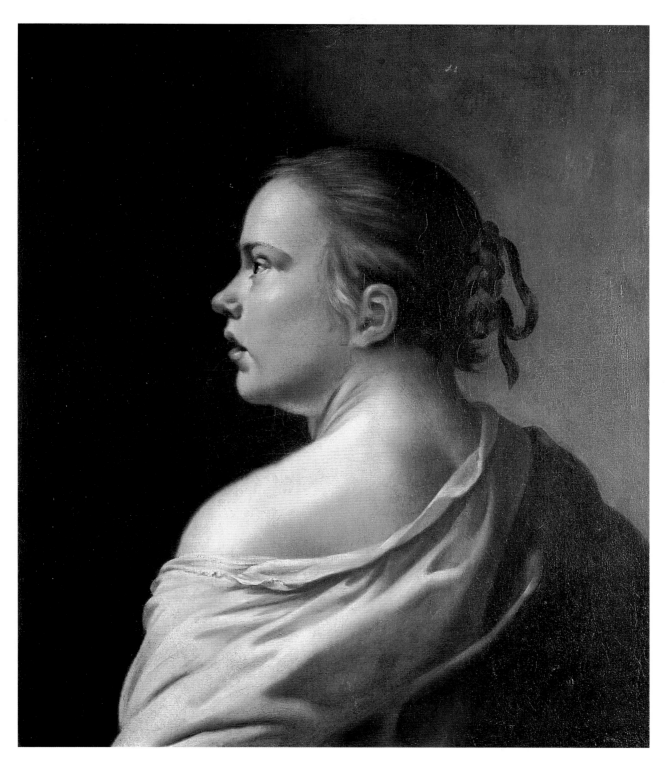

Cat. 44

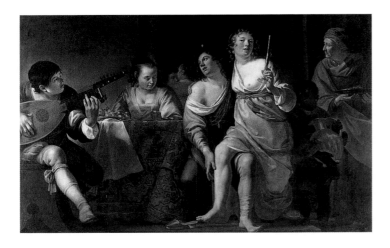

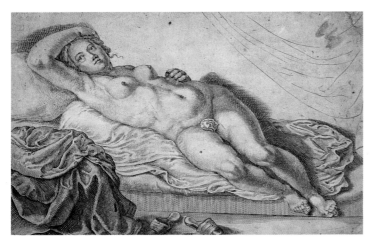

Fig. 1 Jan Gerritsz. van Bronchorst, *Bordello with Young Man Playing a Theorbo-Lute*, 1644. Oil on canvas, 141.5 × 218 cm (55¾ × 85⅞ in.). Herzog Anton Ulrich-Museum, Braunschweig, 190.

Fig. 2 Crispijn van de Passe the Younger after Jan Gerritsz. Bronchorst?, *Nude Model*. Engraving in *Van 't Licht der teken en schilderkonst*, part 3, pl. 12, 1644, 195 × 300 mm (7¹¹⁄₁₆ × 11¹³⁄₁₆ in.). Rijksprentenkabinet, Amsterdam, RP-P-1981-62.

Gallery, Greenville, S.C.),⁵ and shows the influence of the Utrecht Caravaggisti, especially of Honthorst. As Thomas Döring notes, the Greenville painting is, however, already a fully mature work, suggesting that the artist's development before 1642, of which up to now nothing has been known, was rapid. Although he continued to work as a glass painter, his oeuvre as a painter in oil grew steadily thereafter, escalating after he moved to Amsterdam in 1652.

 That *Study of a Young Woman* could be seen as reflecting an aspect of the learning process prompts speculation on Bronchorst's development before 1642, as does the inclusion of his portrait among those of prominent Utrecht artists on the title page of the drawing manual *Van 't Licht der teken en schilderkonst* by Crispijn van de Passe the Younger, which was published in 1643.⁶ This remarkable expression of esteem is supported by the recorded praise of Bronchorst's draftsmanship by Gerard van Honthorst and by Joachim von Sandrart, a fellow student in Honthorst's drawing academy (probably between 1625 and 1628), who recalled Bronchorst's diligence and ascribed to it his becoming a perfect painter and a good etcher.⁷ Bronchorst's only identified drawings⁸ are compositional studies, primarily in brush and wash, associated with his later paintings. These factors together lead to the proposal that the twenty-four engravings (with no indication of the "inventor" or draftsman) of a voluptuous, nude, young female model such as that illustrated here (fig. 2) that make up most of part three of *Van 't Licht der teken en schilderkonst* (this part, devoted to nude women in various poses, published in 1644) are very possibly after drawings by Bronchorst. Many of the poses have the imprint of the academy. The round, fleshy facial type with upturned nose and flaring nostrils, "rosebud" mouth, and hair drawn back in a bun can be compared with those of the model in Bronchorst's painted study under discussion as well as those of the prostitutes in *Bordello*. The sexually provocative detail of the mule from which the prostitute in *Bordello* has just slipped her foot is paralleled in various plates by discarded mules or a shift that call attention to the fact that the model, probably a prostitute, has just undressed. That in some plates, as here, the woman is clearly lying on a bed increases the sense of invitation. Barely draped nudes appear in other paintings by Bronchorst, among them the *Sleeping Nymph Spied upon by a Shepherd* (Herzog Anton Ulrich-Museum, Braunschweig)⁹ and *Two Frolicking Nymphs* (private collection, Bremen).¹⁰

 The execution is sketchier here than in the

finished paintings, as is noticeable in the hair around the face. The artist had difficulty in deciding how to paint the fold in the skin under the chin. The single stroke of brown paint would be more appropriate in a brush drawing or in a large painting of coarse male figures such as Baburen's *Prometheus Being Chained by Vulcan* (cat. 52) where similar shading is found; here it detracts from the overall impression.

—J. S.

45 NICOLAUS KNÜPFER
(ca. 1609–1655)

Bordello

ca. 1650

Oil on panel, 60 × 74.5 cm (23⅝ × 29⅜ in.)
Signed lower left: *NKnüpfer*
Amsterdam, Rijksmuseum, Gift of the Rijksmuseum Foundation, A-4779

Provenance: duc d'Orléans, Palais Royal, Paris; sale, London, 1792; Count André Mniszech, Paris; Adolphe Schloss, Paris, cat. 283; sale, Charpentier (Paris), 25 May 1949, lot 28; private coll., Verviers, Belgium; sale, Sotheby Parke-Bernet (London), 10 Dec. 1980, lot 62; with Hoogsteder (The Hague), 1981

Selected References: Waagen 1837, 519 (as J. B. Weenix; see n. 1); Von Bode 1883, 174 (as J. B. Weenix, but closely related to Knüpfer); Von Wurzbach 1906–11, 1:301; Thieme-Becker, 21:38; Schneede 1968, 49–50, fig. 7; Kuznetsov 1974, 188–89, cat. 51; Robinson 1974, 22, 74, fig. 17; Rijksmuseum 1982, 27, fig. 1, illus. on cover; *Chronique des arts* 1983, 29, fig. 40; Busch 1983, 259, fig. 3; Brown 1984, 183, illus. 197; Sutton 1984, xxxix, illus.; Van Thiel et al. 1992, 61, illus.

In a room lit by two high windows to the right and an invisible light source to the left, eight splendidly dressed characters—four men and four women—are seen enjoying themselves. Two of the men stand on a table covered with a carpet, looking at something outside the window. The man in the right foreground, who appears to be quite drunk, falls into the lute player's lap while attempting to draw his sword.

The most promiscuous behavior, however, is exhibited by the threesome on the high canopy bed, whose posts reach almost to the beamed ceiling. They brandish their glasses and tug at each other's clothes. The woman at the left, completely inebriated and dressed only in her petticoat, balances the man's feathered hat on her toes, at the same time grabbing him under his pseudo-Roman tunic. Her bare-breasted and disheveled blonde companion attempts to escape the man's attentions, but he hinders her flight with his foot.

Playing cards and clay pipes lie strewn about the floor, and the fruit has rolled out of its metal bowl onto the table; a grapevine rests precariously on the edge of the copper tub at the lower left that serves as a repoussoir device, leading the viewer's gaze into the picture. Beneath it, as it were between the viewer and the activities depicted, the painter, Nicolaus Knüpfer, has set his name.[1]

It is not difficult to decide if the artist actually observed the scene he so skillfully, if indiscreetly, reproduces. The ledge that closes off the bottom of the picture is a clue that what we are in fact witnessing is the performance of an unknown play.[2] The painter lived and worked in a city characterized by its strong Catholic presence,[3] and any arbitrary rendering of such orgiastic debauchery would certainly have come into conflict with both the Church and the law.[4]

There are two traditional sources for the representation of such merry scenes. The majority are based on the tale of the Prodigal Son, who frittered away his inheritance on prostitutes,[5] and since the Middle Ages had been meant to illustrate the biblical injunction to moral discipline. During the Reformation, however, the subject became increasingly popular in itself. Frequently depicted outside the context of the didactic cycle, the Prodigal's adventures were eventually transformed into an independent theme.[6] This, on the other hand, had begun to develop its own theatrical modus since the early sixteenth century.[7] As Konrad Renger has shown, the second iconographical

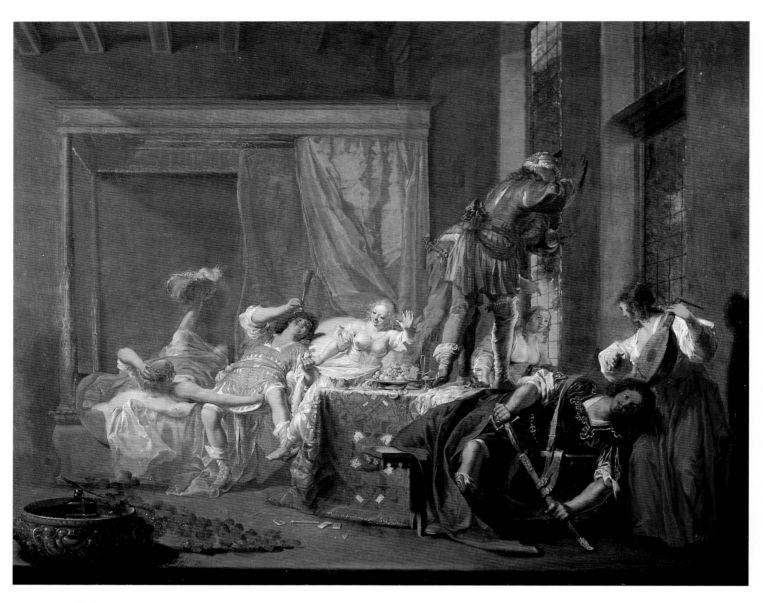

Cat. 45

strand—also of medieval origin—is the legend of Sorgheloos, a carefree man who wanders through life with neither virtue nor temperance, wasting his money.[8]

In the extensive dramatic literature on the theme of the Prodigal Son from about the middle of the sixteenth century we find a combination of both narrative traditions, elaborated on freely by various invented scenes. These removed the incidents ever further from their biblical roots, and the original parable became more and more a simple pretense for depicting lascivious activities.[9]

Even though our picture contains all the usual elements of these Prodigal Son depictions—feathered hat,[10] glass, and drawn sword—it is not just a secularized version of the biblical saga. What we see instead is the performance of an unknown play, or a morally neutral, even humorous, view of libertine life, set against the now merely formal background of the ancient chronicle.

In the stage plays themselves the Prodigus is often depicted as a rich, expensively dressed bon vivant, who is cleverly duped by the whores and their cronies.[11] The language used in the brothel is

often remarkably direct. In Robert Lawet's version of 1583, for example, the Prodigal Son shamelessly asks Dame World *(vrouw werelt)* if he may go to bed with her women, upon which he learns that they are "ready for anything" *(vrij voor alle zake)*. Promises are made to help him forget his troubles, while he vows to use the women *(ghebruucken)* for his pleasure. The final stage direction calls for the curtain to be dropped as the actors retire in order to "sleep" *(slapen)* with one another.[12]

It was in this literary context that Knüpfer's lascivious picture was painted in about 1650,[13] that is, in the last years of his life. The artist had taken up the subject before in a much less explicit painting[14] and in a drawing of a merry party similar in composition (fig. 1). Inspiration for our work certainly came from such artists as Jan van Bijlert, who often treated the theme in a comparably frank manner,[15] Maerten Stoop,[16] and Jan Steen.[17] Compared with these depictions of the same subject by other artists, the relatively small scale of Knüpfer's panel combined with a fairly large number of figures produces a certain density of narrative. This is enhanced by his fine brushwork and his clearly ordered sense of composition.

This picture is a fine example of the connections with the low-life scenes painted by the Utrecht Caravaggisti.[18] In Utrecht art as a whole there seems to be a much more relaxed view of sexuality than in the cities of the province of Holland. It is noteworthy that while the subject of the Prodigal Son plays almost no role in Utrecht, it was much more widespread in other parts of the Netherlands.

Knüpfer's painting matches the stylistic high point of his time. There is hardly a trace of either his teacher Bloemaert or Utrecht Caravaggism, whose waning coincided with Knüpfer's arrival in the city. The space has been formulated with often very thin layers of color, and little attention has been paid to detail: all the artist's talent has been employed in the delineation of the figures and their immediate environs. At the same time, his

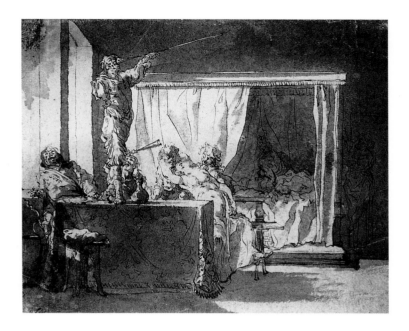

Fig. 1 Nicolas Knüpfer, *Brothel Scene*, 1645–50. Pen and brush in brown ink, 272 × 322 mm (10¾ × 12⅝ in.). Rijksprentenkabinet, Amsterdam, A-3687.

handwriting is highly individual and unmistakable. He has used a reduced palette, limited to shades of brown in the surrounding areas, while the main figures—the Prodigal Son and his lovers—form the brightest part of the picture. With the help of Knüpfer's characteristic garish orange, seen here in the man's costume, they become the visual climax of the painting.

The artist has also used a refined painterly technique in the background—on the trim and underside of the canopy and on the bed curtains: here he has scratched the fringe and pattern into the wet paint with the handle of his brush, creating light lines. The same trick was used, for example, at just this time in Amsterdam, by Rembrandt and his pupils.[19]

The skillful play of views from above and below, the anatomical foreshortening, and the ingenious disposition of light and shadow all bear witness to Knüpfer's powers of observation and his excellent training. A prime example is the group formed by the two central figures, the man on the bed (the Prodigal Son) and the woman lying next to him. They are related to one another in

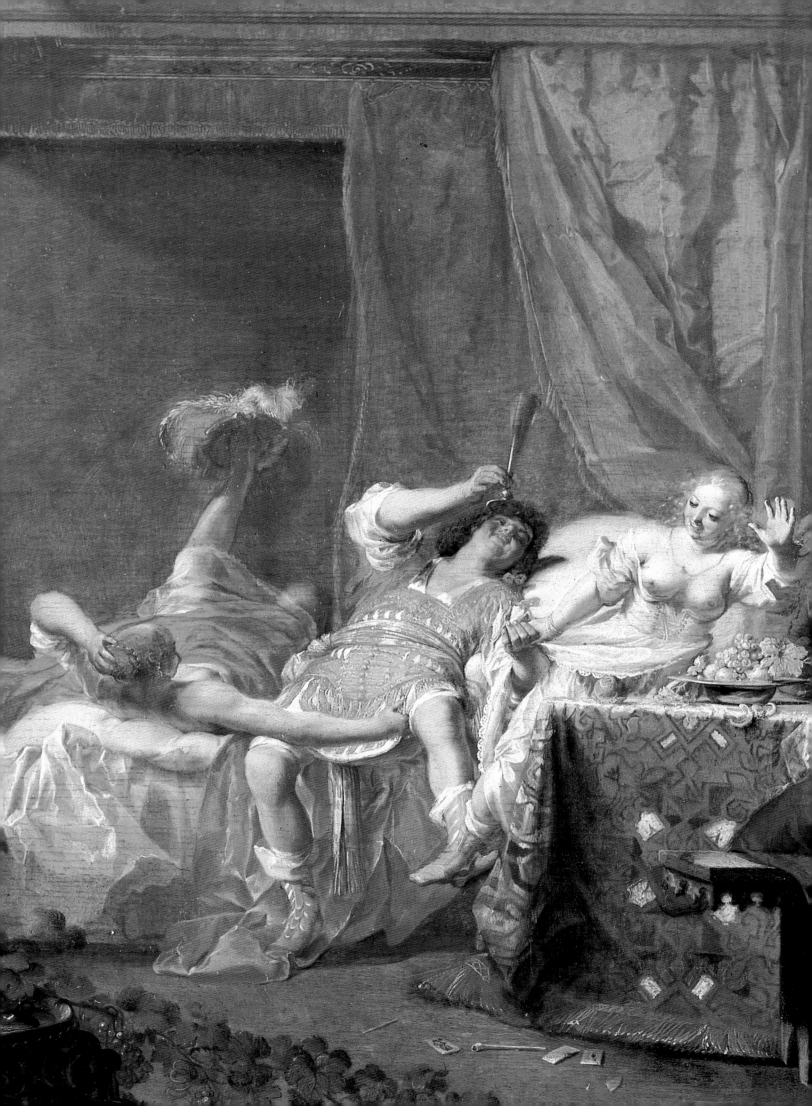

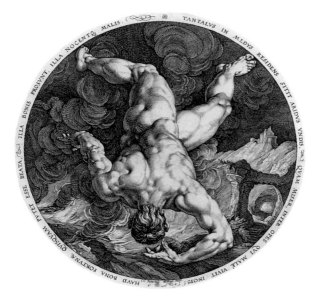

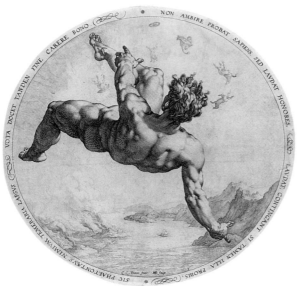

Fig. 2 Hendrick Goltzius, after Claes Cornelisz. van Haarlem, *Tantalus* (Holl. 309) and *The Fall of Phaëthon* (Holl. 308), 1588. Etchings, 330 mm (13 in.). Staatliche Graphische Sammlung, Munich, 31005 and 31007.

opposing ways and both faintly echo Hendrick Goltzius's famous circular engravings, the so-called *Disgracers* of 1588, particularly *Tantalus* and *The Fall of Phaëthon* (fig. 2). Since the subjects of Goltzius's prints are those people who have measured themselves against fate and lost, the citation may give this picture something of a warning character after all. This is underlined by the fact that the prone woman is depicted from a sort of bird's-eye perspective which, given the connection between the sexual act and the word *bird* in Dutch, takes on a literal form.[20] Such mental leaps and wordplays would certainly not have been lost on the seventeenth-century viewer.

—M. R.

Noble Ideals: Arcadian and Mythological Imagery

46 ABRAHAM BLOEMAERT
(1566–1651)

Wedding of Peleus and Thetis

ca. 1595

Oil on canvas, 30.7 × 41.8 cm (12⅛ × 16½ in.)
Signed and dated lower right: *A. Blommart 159[—]*
The Hague, Mauritshuis, 1046

Provenance: coll. H. Becker, Dortmund, 1965; with
Cramer (The Hague), 1973

Selected References: Broos 1993, no. 2; Roethlisberger 1993,
57–63, no. 4

San Francisco and Baltimore only

The incident depicted is the wedding of the mor-
tal hero Peleus with the immortal Nereid Thetis,
which is attended by all the gods.[1] The wedding
couple is to be seen in the center behind Neptune,
who is identified by his trident. The nude figures
of Ceres and Diana are stretched out across the
foreground; the sleeping youth at the left is prob-
ably Bacchus. Some more figures may be identified:
Jupiter and Juno to the right at the table, Mars and
Venus to the far left, and especially Mercury step-
ping down from the clouds. The connoisseur will
not have missed the allusion to Giambologna's
floating *Mercury* statue. Quite strange in this con-
text of mythological figures is the female lutenist
seen from the back. By gesture and costume the
figure does not belong to the presence of Greek
gods, where Apollo should play the ancestor of all
lutes, the lyra, but in genre scenes like those by
Gerrit Pietersz. in which, indeed, the motif of the
canopy held by tree trunks, appearing in all three
of Bloemaert's *Peleus and Thetis* paintings, can be
found more than once.[2]

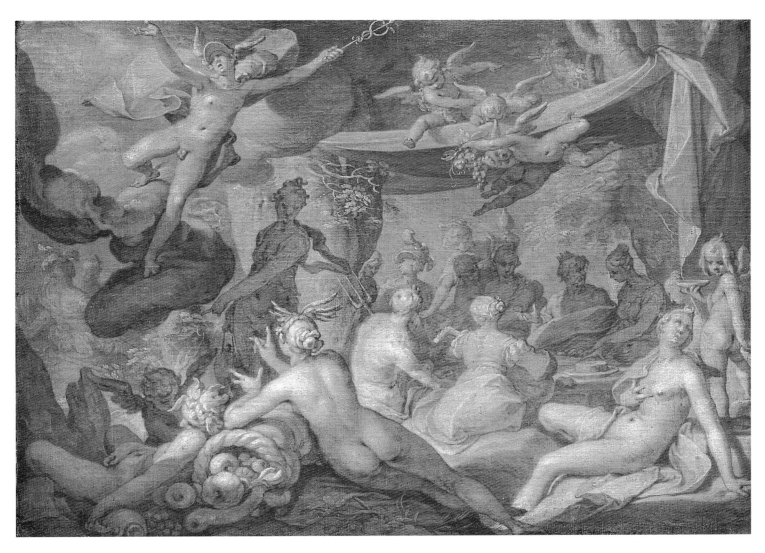

Cat. 46

The close relation of this lute player to pastoral images of Gerrit Pietersz. is significant, since it gives visual evidence of the close connection of the subject of the Feast of the Gods with the concept of a primeval Golden Age, later destroyed by strife, which in turn is the basic subject of Arcadia. In this way the Feasts could be read not only as warnings against an immoral life of leisure and well-being as Van Mander would have us believe,[3] but also as an admonition to regain peace as the necessary foundation for a new Golden Age.[4] In fact, Arcadian idylls or single Arcadian figures seem to have succeeded the Feast of the Gods as pictorial subjects. Except for Bloemaert's late version (fig. 1), the latter simply disappear in the second decade of the seventeenth century, while Arcadian pictures reach their peak of production in the third decade.[5]

Banquets of the Gods were among the subjects most favored by Bloemaert's generation (others being the Flood or other richly peopled scenes from the Bible; see cat. 1), since they gave the opportunity to depict heroically naked figures in all kinds of poses. Not by chance, it was a large scale drawing showing the Marriage of Cupid and Psyche (of greater dimensions than Bloemaert's painting) by Bartholomeus Spranger,[6] painter to the emperor in Prague, and reproduced in an engraving by Hendrick Goltzius,[7] that triggered the exaggerated style in the Northern Netherlands

 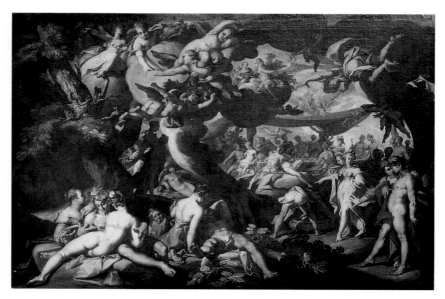

Fig. 1 Abraham Bloemaert, *The Wedding of Peleus and Thetis*, 1638. Oil on canvas, 193.7 × 164.5 cm (76¼ × 64¾ in.). Mauritshuis, The Hague.

Fig. 2 Abraham Bloemaert, *The Wedding of Peleus and Thetis*, ca. 1595. Oil on canvas, 101 × 146.5 cm (39¾ × 57⅝ in.). Alte Pinakothek, Munich, 6526.

that has variously been termed *high mannerism*, *ultima maniera*, *hypermanierisme*, and the like.[8]

Outside Prague, the style had its two centers in Haarlem and Utrecht, the main artists in the latter city being Joachim Wtewael and Abraham Bloemaert. Wtewael made a number of renderings of the Wedding of Peleus and Thetis,[9] some of them on copper plate, advertising his ability to paint figures on an extremely small scale. Bloemaert himself painted at least four Banquets of the Gods. Indeed, among Bloemaert's early works to be bought by prestigious patrons, the emperor himself and one of his diplomats, Count Simon zur Lippe,[10] Van Mander mentions two *Banquets of the Gods* of which one or both may or may not be among the paintings still extant.[11] Already in January 1591 the Utrecht humanist Aernt van Buchel noted having seen a *convivium deorum* by Bloemaert.[12]

The importance of Spranger for Bloemaert concerning this subject is marked by a drawing with the figure of Fame from the Munich painting

(fig. 2), which bears a dedication by Bloemaert to the Prague master.[13] This drawing points to an early date for the Munich canvas,[14] which is closely linked to the dating of the smaller painting. But then again, considering the workshop methods of Bloemaert, the drawing could easily have been used half a decade later. Both Peleus and Thetis paintings, especially in composition but also in figure style, seem to be not as radical as paintings dated 1592 and 1593.[15] A dating about 1595 seems more fitting, and comparison with the *Moses* painting of 1596 (cat. 1) may bear this date out. Bloemaert was still exploring the subject in 1638 when it was definitely out of fashion and carved a new composition from the story (see fig. 1), fitting very nicely into the then-current court art.[16]

Perhaps the most striking feature of the small canvas from the Mauritshuis is the fact that it is painted only in white and rose. Bloemaert displayed this restrained color in a number of other works in these years and once more toward the end of his career, always on rather a small scale.[17] In his case these monochrome pictures were not models for engravers, as they were for Anthony van Dyck or Rembrandt. None of them was reproduced. They must instead be compared to the showpieces of technical skill produced by Hendrick Goltzius and other masters

of Bloemaert's generation. Goltzius, for instance, created pen drawings on canvas the size of full-scale paintings, amazing the emperor and his entourage.[18] Van Mander relates that Cornelis Ketel, another Haarlem master, painted without a brush, using his fingers and later even his toes instead.[19] When Van Mander's book was published in 1604 experiments like these were highly approved of by connoisseurs, as his comments suggest. In his eyes, Ketel was showing that his art was able to overcome even insufficient means. In a much less spectacular, much more subtle way, Bloemaert's *rosaille* can be seen as springing from the same intention of reducing the means, to make the artistic achievement all the more obvious.

—G. S.

47 JOACHIM WTEWAEL
(1566–1638)

Mars and Venus Discovered by Vulcan
1601

Oil on copper, 20.8 × 15.7 cm (8³⁄₁₆ × 6³⁄₁₆ in.)
Signed and dated, lower center: *IOACHIM WTE / WAEL [F]ECIT 1601*
The Hague, Mauritshuis, 223

Provenance: possibly Jan van Wely, Amsterdam, or Melchior Wijntgis, Middelburg, by 1604; Stadholder Willem V, Het Loo Palace, by 1763; Royal Cabinet of Paintings, Mauritshuis (The Hague), by 1842

Selected References: Broos 1993, 26, 332–37, cat. 40 (with earlier literature); Luijten et al. 1993, 149, fig. 7; Broos 1994, 28, 48, 55 (color illus.); Lowenthal 1995, 13, 21, 35, 66–67, fig. 15 in color

On a copper plate smaller than a page of this book, Joachim Wtewael depicted a moment of high drama in the lives of the gods: Mars and Venus have been discovered *in flagrante* by her husband, Vulcan. News of her infidelity had reached him through Apollo, the sun god, who sees all; here he plays his viol from on high at left. Vulcan planned his revenge, forging a gossamer bronze net and

spreading it over Venus's bed, catching the unsuspecting lovers fast in each other's arms. We see Vulcan triumphantly exposing his prey to the other deities—Diana, Minerva, and Jupiter—who regard the embarrassed pair with interest and amusement. Mercury, who admitted he would readily have changed places with Mars, raises the canopy for a better look, as Cupid takes aim at him from the foot of the bed.[1]

The subject of Mars, Venus, and Vulcan is significant for Wtewael; he depicted it at least four times. His biographer Karel van Mander, writing shortly before 1604, described an outstanding small, vertical painting on copper recently delivered to Jan van Wely, "full of charming, fine work, and so detailed, . . . Another *Mars and Venus* also by him is with Melchior Wijntgis in Middelburg."[2] The present painting, dated 1601, is very possibly one of the two mentioned by Van Mander. The style of the other known example (fig. 1), however, indicates a later date, about 1606–10.[3]

Since the fifteenth century the subject of Mars and Venus discovered by Vulcan had been depicted in book illustrations, drawings, and prints, and from the mid–sixteenth century in paintings. Some are discreet, while others anticipate Wtewael's explicitness.[4] Titillation, distanced and legitimized by the story's classical origin, surely contributed to its popularity. Evidently Wtewael preferred small copper plates as supports for his depictions. Such cabinet pictures, worked with a miniaturist's technique, are typically viewed at close hand, in a private encounter between viewer and viewed. The technique is ideally suited to this subject, with both viewer and deities becoming voyeurs.

Wtewael specialized in cabinet pictures on copper, a type that enjoyed international renown.[5] As his works in this exhibition demonstrate, however, he was evidently comfortable working on various supports in all sizes. Indeed, Van Mander remarked on Wtewael's versatility, writing that one could not say where the artist is more

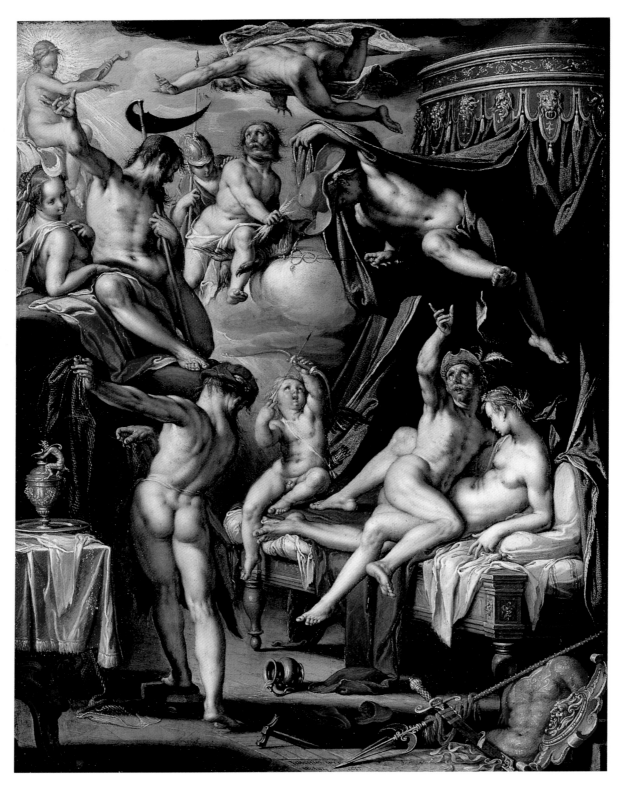

Cat. 47

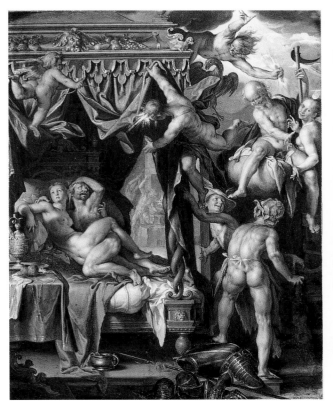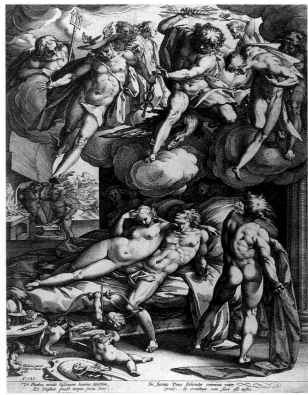

Fig. 1 Joachim Wtewael, *Mars and Venus Surprised by Vulcan*, ca. 1606–10. Oil on copper, 20.3 × 15.6 cm (8 × 6⅛ in.). J. Paul Getty Museum, Los Angeles, 83.PC.274.

Fig. 2 Hendrick Goltzius, *Mars and Venus Surprised by Vulcan*, 1585. Engraving, 421 × 310 mm (16⁹⁄₁₆ × 12³⁄₁₆ in.). Philadelphia Museum of Art: Gift of Mr. and Mrs. Morris L. Weisberg, 1986-172-1.

outstanding, in large works or in small.⁶ He adjusted his technique with apparent ease, from the breadth demanded in sizable canvases like *Saint Sebastian* (cat. 2) and *Andromeda* (cat. 51) to the meticulous refinement demanded on a small scale.

The furnishings depicted in the Mauritshuis painting, dating from Wtewael's time, nod toward classicism. The bed canopy is decorated with masks that recall those in plate D of Crispijn van de Passe the Younger's *Oficina arcularia* (Utrecht 1621; Holl. 174). The sphinx forming the base of the table also reflects Van de Passe's designs. The elaborate ewer and basin on the table are like surviving examples, as is the jeweled pendant that hangs over the edge.⁷

These objects help to bring Venus's boudoir

to life, but they also contribute to an important pictorial strategy. An alert viewer would have noticed wry comments in the details. The ewer and basin, for example, were used for cleansing, yet the handle is formed by a satyr, a creature given to Dionysian revelry. The chamber pot is overturned, its contents spilt.⁸ Just beside Vulcan's hammer and Mars's weapons, discarded beside the bed, lie slippers, which in Northern European folklore are signs of the power of women, in aphorisms like "Hij zit onder de pantoffel," equivalent to "She's got him under her heel."⁹ The proximity of Venus's slippers and the men's paraphernalia signals the interplay between the sexes that enlivens the picture, even in the inclusion of the chaste Diana among the deities. According to Homer, the goddesses did not witness the scandal, out of modesty (*Odyssey* 8.324).

As in the classical texts, the adulterous pair is exposed to ridicule, but there is no explicit moralizing. The inscription on Hendrick Goltzius's engraving *Mars and Venus Surprised by Vulcan* (fig. 2),

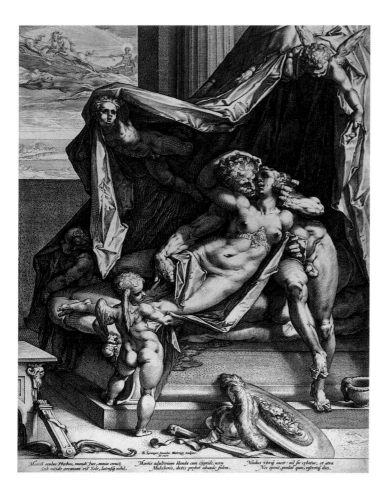

Fig. 3 Hendrick Goltzius, after Bartholomeus Spranger, *Mars and Venus*, 1588. Engraving, 441 × 313 mm (17⅜ × 12⁵⁄₁₆ in.). Philadelphia Museum of Art: The Muriel and Philip Berman Gift, acquired from the John S. Phillips bequest of 1876 to the Pennsylvania Academy of the Fine Arts, with funds contributed by Muriel and Philip Berman, gifts (by exchange) of Lisa Norris Elkins, Bryant W. Langston, Samuel S. White 3rd and Vera White, with additional funds contributed by John Howard McFadden, Jr., Thomas Skelton Harrison, and the Philip H. and A. S. W. Rosenbach Foundation, 1985-52-1465.

however, compares Apollo's revelation of illicit love to God's knowledge of the sins of humankind.[10] Van Mander drew a similar lesson from the story.[11] The degree to which such didacticism carried over to the paintings is, however, debatable. There is an inherent conflict between the picture's seductive charm and the negative exemplum it presents, which can best be understood in the context of seventeenth-century ideas about conscience. They held that engaging the passions with a sensual image opened a pathway to reason and

judgment. The strategy was to intrigue the viewer and then suggest a moral with wit and delicacy. Van Mander's reactions, ranging from delight in Van Wely's picture to moralizing interpretation of the myth, offer insight into the likely range of perceptions among Wtewael's sophisticated viewers.

Goltzius's engraving clearly served Wtewael as model. Both depict a climax that neither Homer nor Ovid had described, the moment at which Vulcan withdraws the net from the lovers. Wtewael also imitated Goltzius's compositional scheme, varying the conception, however, by adopting Vulcan's pose but placing him at left. Like Goltzius, Wtewael shows Cupid aiming at Mercury, but he moved the boy to the bed. In a second engraving by Goltzius, a *Mars and Venus* after a design by Bartholomeus Spranger (fig. 3), we find a similar canopied bed and table, and a putto lifts the bed curtains to reveal the lovers as Mercury does in Wtewael's painting. Long after the 1580s, Wtewael continued to work in a high mannerist style, with a complex spatial dynamic, risqué subject, and flaunted artifice, nowhere so apparent as in Vulcan's exotic costume of leather apron and stylish hat.

A preparatory drawing for The Hague painting (Gabinetto Disegni e Stampe, Uffizi, Florence) shows the conception in process, with the major elements in place.[12] Apollo and the bearded god are not yet in evidence, nor is the table at left. The bodies of Mars and Venus are missing too, having at some point been excised. A preparatory drawing for the Getty painting (private collection, Europe) suffered the same censorship.[13] Scruples over the subject had long kept the Hague painting sequestered. At the Mauritshuis it had been relegated to storage, to be cleaned and placed on exhibition only in 1983.[14]

—A. W. L.

48 JOACHIM WTEWAEL
(1566–1638)

Mars, Venus, and Cupid

ca. 1610

Oil on copper, 18.2 × 13.5 cm (7³⁄₁₆ × 5⁵⁄₁₆ in.)
Amsterdam, Stichting Collectie P. en N. de Boer

Provenance: possibly sale, W. A. Kien van Citters (Amsterdam), 21 Aug. 1798, lot 34, sold to Van der Schley for fl. 2.5; Dr. Betty Kurth, Vienna, 1929; sale, Lempertz (Cologne), 11–14 Nov. 1964, lot 233

Selected Reference: Lowenthal 1986, 125–26, A-52 (with earlier literature and possible early provenance), pl. 73, and color pl. 16

Wtewael was the most important exponent in the Netherlands of mythological cabinet pieces painted on copper, a type exemplified by this delectable painting of Mars, Venus, and Cupid. We enjoy a privileged view of the famous couple and her child. The plain dark background, with interior space suggested only by a green curtain, enhances intimacy, as the figures press close to one another and to us in the immediate foreground.

Wtewael depicted the story of Mars and Venus caught *in flagrante delicto* by her husband, Vulcan, in other copper cabinet pieces (cat. 47). Here, he shows us a tryst, otherwise devoid of narrative. Sweeping compositional rhythms and a rosy tonality help to convey the pleasures of love and wine. Opposites clearly attract. Wtewael contrasts the expanse of Venus's soft flesh with Mars's clothed, muscular physique, revealed by his clinging tunic. Her simple gold-and-pearl necklace and veil, which veils little, contrast with his elaborate costume and dragon-crested helmet.[1] Mars's energetic embrace meets with Venus's receptive response, her knee raised as she leans against him. Cupid, in lost profile, is actively engaged, offering one of his arrows as if asserting his role as an agent of love.

The copper support contributes to the picture's opulent physicality and creates a perfect vehicle for an image of lovers. Copper could, of course, be used for any subject matter, and it was.

Hendrick Goltzius, for example, painted *Christ on the Cold Stone* on copper (1602; Museum of Art, Rhode Island School of Design, Providence).[2] Wtewael's preference for mythological themes in miniature is, however, exceptional among Dutch mannerists. Of fifty-eight pictures known from the first two decades of his activity, between about 1592 and 1612, thirty were painted on copper, and over half of those are mythologies. Such pictures were evidently as much in demand in his time as they are today. They were meant to be seen at close range, probably even to be handled. The heft of the metal and the subtly gleaming paint surface it enabled were usually enhanced by glowing color. The smooth, flat copper lent itself well to meticulous execution, with delicate impasto. Such effects, manifesting Wtewael's technical skill as a miniaturist, are especially evident here in Mars's helmet and sword. They are combined with delicately brushed passages, like Venus's hair and veil, Cupid's wings, and Mars's rolled-up sleeve.

Copper had been used as a support for oil paintings since the early sixteenth century, and it became widespread in the 1570s and 1580s, when Northerners like Bartholomeus Spranger working in Italy helped to popularize it. Princely collectors, like Spranger's chief patron, Holy Roman Emperor Rudolf II, were well known for favoring such pictures.[3] Copper cabinet pieces were available to middle-class collectors as well, as we know from Karel van Mander's enthusiastic descriptions of paintings by Wtewael in private hands.[4]

It is not difficult to understand the allure of such a painting for Dutch collectors. This one offered aesthetic, sensual, and intellectual pleasures. The romance of Mars and Venus was in effect legitimized by its classical pedigree, which humanists would have appreciated. Cachet conferred by aristocratic patronage redounded to bourgeois collectors, for whose domestic interiors such small-scale works were ideally suited. Would such collectors have had a larger sense of the subject and its implications, and, if so, would that

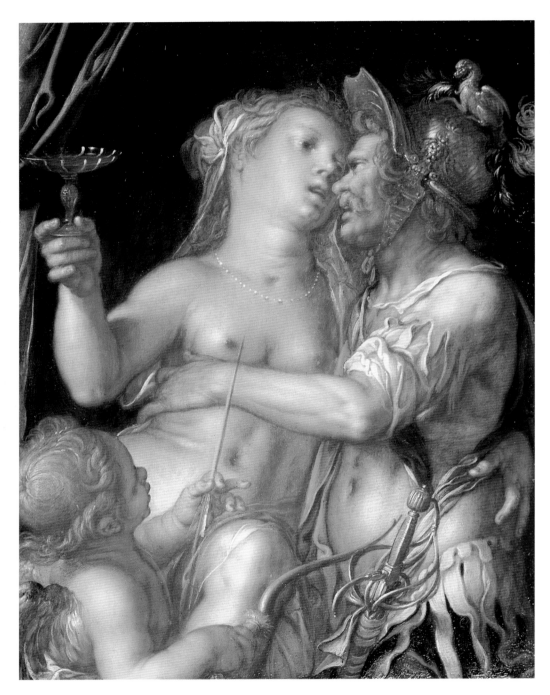

Cat. 48

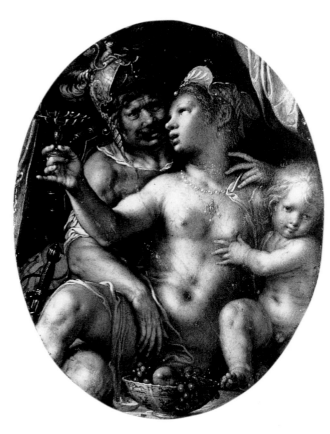

Fig. I Joachim Wtewael, *Mars, Venus, and Cupid*, ca. 1600–1605. Oil on copper, oval, 13 × 10.2 cm (5⅛ × 4 in.). Private collection.

have colored their response? This was, after all, an illicit love affair, derided by the other deities. Wtewael's moralizing contemporaries frowned on it. The seductive power of such pictures was, for instance, acknowledged by Dirck Coornhert, who wrote in 1586 that contemplating pictures of "a naked Venus" produces "fiery impurity, burning desire, and hot passion."[5] Others believed, however, that only when the lower passions were engaged could the voice of conscience be heard. The dramatist Gerbrand Adriaensz. Bredero claimed that "Vice, like sickness, must be known before its cure" (*The Spanish Brabanter*, 1617).[6]

Wtewael depicted Mars, Venus, and Cupid on an even smaller copper plate, in oval format (fig. I), accompanied by a bowl of grapes and apples.[7] Fruit and love were a familiar combination in the seventeenth century, sometimes signifying lust, at others the fruits of heaven, with the former implications here.[8] As in the De Boer paint-

ing, this is surely the earthly, not the heavenly, Venus.[9] This oval *Mars, Venus, and Cupid* might well be the one mentioned in the inventory of Margaretha Bosmans, the widow of the Amsterdam goldsmith Jan Niquet, prepared in December 1612.[10]

There are many connections between the De Boer painting and contemporary Netherlandish engravings, which would have been readily available as sources. Hendrick Goltzius's *Mars and Venus* after Bartholomeus Spranger (cat. 47, fig. 3) also depicts the couple's intimacy with Cupid nearby; the inscription castigates their adultery.[11] A *Mercury and Venus* by Pieter de Jode after a design by Spranger (Holl. 97) is almost the same size as Wtewael's painting. The figures occupy proportionately the same area, and the pretty facial types, Venus's turned head, and the intimate poses are similar. Mars's costume repeats elements of those in Hendrick Goltzius's engraved *Roman Heroes*, especially *Publius Horatius* (1586; Holl. 162). An engraving by Crispijn van de Passe the Elder of *Mars Offering His Flaming Heart to Venus* (Holl. 381) shows Venus, Mars, and Cupid in half-length but resembles Wtewael's design in the figure grouping, in reverse, and the curtained corner.

—A. W. L.

49 JOACHIM WTEWAEL
(1566–1638)

Wedding of Peleus and Thetis
1612

Oil on copper, 36.5 × 42 cm (14⅜ × 16½ in.)
Dated lower right: *1612*
Williamstown, Massachusetts, Sterling and Francine Clark Art Institute, 1991.9

Provenance: possibly George Smith, London; his sale, Christie's (London), 10 Apr. 1880, lot 63 (as by Brueghel and Van Balen; sold to Waters); Scandinavian art market, ca. 1930; European private coll.; sale, Sotheby's (London), 11 Apr. 1990, lot 19; with Amells (Stockholm)/ Newhouse Galleries (New York), 1990–91

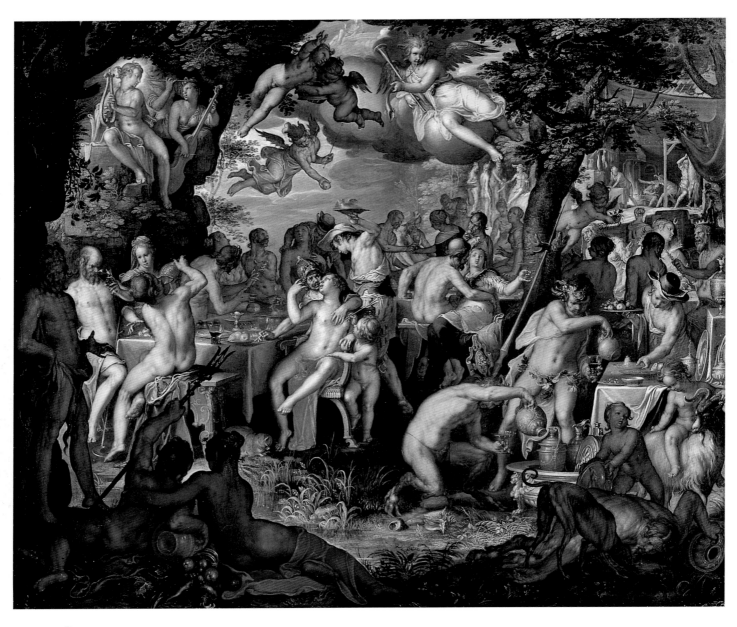

Cat. 49

Selected References: Kern 1992, 115, illus.; Froitzheim-Hegger 1993, 131–32, fig. 12; Lowenthal 1995, 67–68, fig. 46; Kern et al. 1996, 7, 24–25, color illus.

Karel van Mander tells of the wedding of the legendary hero Peleus and the Nereid Thetis and its consequences in the *Wtlegghingh*, his explanation of Ovid's *Metamorphoses*.[1] All the Olympians were invited except Eris (Discord), who, in revenge, tossed onto the banquet table an apple inscribed, *For the fairest*. Minerva, Venus, and Juno all claimed it, and only the Judgment of Paris settled the dispute.[2] Wtewael shows the wedding feast in full swing, just before Eris's dramatic interruption.

A radiant Apollo serenades the company at upper left, as Mars and Venus, embracing just left of center, set the tone of abandon. A cat, symbol of sensuality, lies at Venus's feet. Even wise Minerva, to the right, leans back and raises a glass. Nearby, Bacchus and a satyr each pours wine from a jug. Wtewael discreetly wreathed Bacchus's loins with grapevines, but the satyr's loincloth was added by a later hand. His arousal resonates with two suggestive shells at his feet. In the shadowed foreground at left is Hercules, who regards Neptune and Ceres. At right, a dog drinks from a puddle befouled by a drunken satyr. Further back, deco-

rum prevails, as Jupiter and the chaste Diana converse at the head of the table. Cooks bustle about in an open structure in the background. In the heavens, Fama, with two golden horns, rests on a cloud, and Isis surveys all from her rainbow.

Jupiter ordered Paris, son of King Priam of Troy, to resolve the dispute among Minerva, Venus, and Juno, shown as silvery figures in the middle distance. This painting therefore inverts the emphasis of Wtewael's *Judgment of Paris* (cat. 50), where the judgment has pride of place and the wedding feast is a background vignette.

Hendrick Goltzius's engraving after Bartholomeus Spranger of the *Wedding of Cupid and Psyche* (fig. 1) gave impetus to the invention of divine wedding feasts in the following decades.[3] The wedding of Peleus and Thetis, a subject closely related to Spranger's, forms the main subject of eight known paintings and at least five drawings by Wtewael.[4] He depended heavily on the Spranger-Goltzius engraving in a *Wedding of Peleus and Thetis* of 1602 (fig. 2), situating the banquet in the heavens on curling clouds with a landscape glimpsed below. Wtewael also used a horizontal format and based the distribution of figures, numbering about one hundred, on the engraving but varied their poses and placement.[5] By 1610, in another *Wedding of Peleus and Thetis* (Museum of Art, Rhode Island School of Design, Providence), Wtewael chose a terrestrial setting and fewer, more full-bodied figures, a precedent he followed in the Clark painting two years later. The dense composition of the Providence panel gives way to more spaciousness in the Williamstown copper, a simplification that exemplifies Wtewael's stylistic development at that time.

The date of 1612 makes the Williamstown painting Wtewael's latest known use of copper as a support. The copper plate is evidently the largest Wtewael used, and its nearly square proportions are unique among his works. In size and proportions it most closely resembles his Braunschweig *Wedding of Peleus and Thetis* (31.3 × 41.9 cm). The

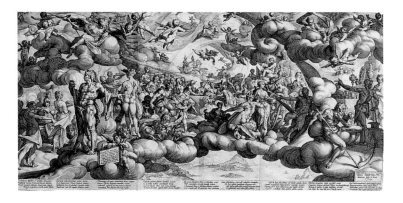

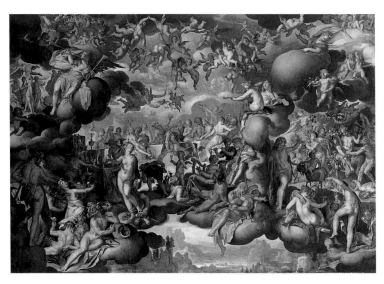

Fig. 1 Hendrick Goltzius, after Bartholomeus Spranger, *The Wedding of Cupid and Psyche*, 1587. Engraving, 433 × 855 mm (17¹⁄₁₆ × 33⅝ in.). Holl. 322. The Art Museum, Princeton University, Princeton, 34-686.

Fig. 2 Joachim Wtewael, *The Wedding of Peleus and Thetis*, 1602. Oil on copper, 31.3 × 41.9 cm (12⅜ × 16½ in.). Herzog Anton Ulrich-Museum, Braunschweig, 174.

Williamstown and Braunschweig paintings are thus the same width, but the former is about five centimeters higher, a small difference but one that significantly affects the proportions.

This is the only known instance in Wtewael's works of a date without a signature. Its absence, and the picture's unusual proportions, could be explained if the composition originally extended further to the right. The evidence, however, is to the contrary. The paint surface is in excellent condition, with no evidence of damage that would have resulted had the copper panel been cut after

the painting was completed.[6] The original size and shape of the painting have evidently been preserved, a conclusion supported by the integrity of the composition, with forms like Hercules' elbow, at left, and the handle of the ewer, at right, coming *just* to the edge.

Copper plates have many advantages over panels and canvases as supports. Since the surface is smooth to begin with, elaborate preparation is unnecessary. Copper is less sensitive than wood to changes in temperature and humidity, and it is more resistant to damage and deterioration than canvas. Of course the plate is vulnerable if dropped, but if carefully treated, paintings on copper can remain brilliant and sound, like this *Wedding of Peleus and Thetis*.[7] Practical benefits went hand in hand with the aesthetic satisfaction of a lustrous surface worked with exceptional finesse to ensure the popularity of the technique.

The story of the wedding of Peleus and Thetis could carry various meanings. Van Mander interpreted the tale as a warning against the ruin that follows from jealousy and discord among rulers. That political meaning is pertinent to the large canvas commissioned of Cornelis van Haarlem by the city of Haarlem for the Prinsenhof (1593; Frans Halsmuseum, Haarlem).[8] Wtewael's small painting most likely had more subtle implications, with delight and didacticism entwined. The splendid wedding feast is visualized in rich color and elaborate design, creating an image with powerful sensory appeal, in keeping with the pleasures of food, wine, and love. But the unsavory motif of the satyr and the dog reveals the dark side of overindulgence. Eris, too, dims the mood of levity, her looming form set against the sky. Hercules, who had met a moral crossroads, stands apart from the guests but gestures significantly toward them, calling our attention to the spectacle. He also gestures toward a small but meaningful detail, the vessel holding salt, a sign of moderation, in the delicate still life near Venus and Mars. Neptune's trident functions as a pointer too.

An alert viewer's enjoyment might well have been enhanced by the deftness with which Wtewael countered indulgence with intimations of restraint.

—A. W. L.

50 JOACHIM WTEWAEL
(1566–1638)

Judgment of Paris
1615

Oil on oak panel, 59.8 × 79.2 cm (23½ × 31⅛ in.)
Signed and dated, lower left: *Jo* [in monogram] *wte.wael / fecit / An° 1615*
London, Trustees of the National Gallery, NG 6334

Provenance: Lord Donegal, from 1889; Henry Doetsch, London; Doetsch sale, Christie's (London), 22–25 June 1895, lot 344; with Ronald A. Lee (Hampton Court); Claude Dickason Rotch, by whom bequeathed to the National Gallery, 1962

Selected References: Lowenthal 1986, 134–35, A-63 (with earlier literature), pl. 91, color pl. 18; MacLaren and Brown 1991, 1:502–3, 2: pl. 427; Baker and Henry 1995, 730; Damisch 1996, 280–81, fig. 97

Following the dispute among Venus, Juno, and Minerva at the wedding of Peleus and Thetis (see cat. 49), Jupiter ordered Mercury to take Paris and the goddesses to Mount Ida to resolve the quarrel over who should have the golden apple inscribed, *For the fairest*. Each goddess bribed Paris, Juno offering wealth and Minerva tempting him with victory and wisdom. But Venus won, having promised Paris Helen of Sparta, wife of Menelaus. In revenge, the disappointed Juno and Minerva plotted the destruction of Troy. Thus the judgment set in motion events that led to the Trojan War, which Van Mander reckoned a time of "endless evil, sorrow and wretchedness, which overcame the Greeks and the barbarians and made itself master of them."[1]

Wtewael depicts the climax and refers to past and future events. At the center is Paris, the Trojan prince who had been abandoned and raised

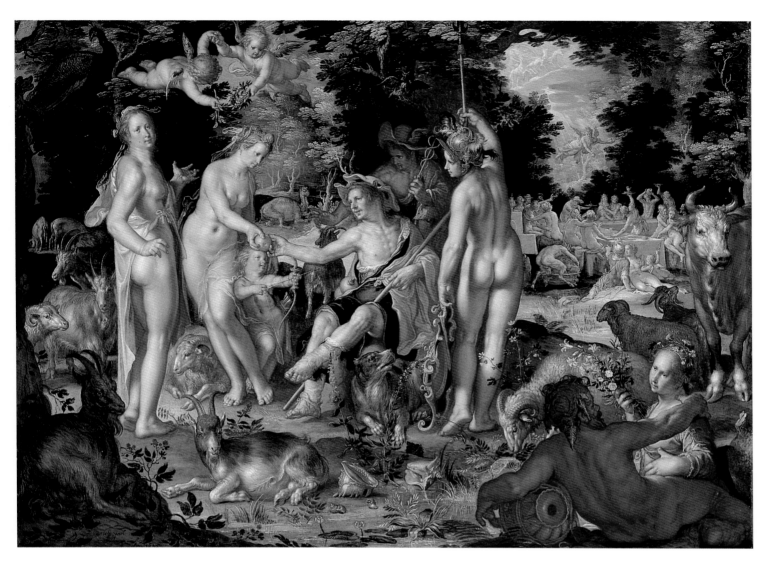

Cat. 50

by shepherds, after a prophecy that he would bring about the ruin of Troy. Paris, here a princely shepherd, resplendent in red and blue-green, awards the prize to Venus, as Cupid aims an arrow at Paris, alluding both to the triumph of love and to the coming war. Mercury, behind Paris, seems to approve his choice, and two putti above Venus mark her victory with a laurel wreath and branch. The inclined poses of Paris, Venus, and Cupid bring them close, leaving the rejected goddesses standing alone. At left, Juno, near her treed peacock, appeals to us with a rhetorical gesture. Minerva, her owl hovering over Mercury's head, looks enviously at Venus. In the background, the wedding of Peleus and Thetis appears like a silvery, pastel dream, with Mars and Venus,

the deities of war and love, defining the theme in small.

This work of the mid-teens is a paradigm of Wtewael's style at the time, restrained and classicizing in its centrality and order, but full of lingering mannerist artifice. Such a picture seems ideally suited to conservative, aristocratic taste in Utrecht. The composition is structured, with the central figure group set off by angled repoussoirs in the lower corners, a reclining goat at the left and, at right, a river god embracing a nymph (Flora?). The pictorial surface is dense with color and pattern. Bright crimson tints cheeks and toes, shells and flowers, tassels, draperies, and hats in a decorative leitmotif. The foliage, a filigree of dark, bronze, and light greens, is richly animated.

Noble Ideals: Arcadian and Mythological Imagery [283]

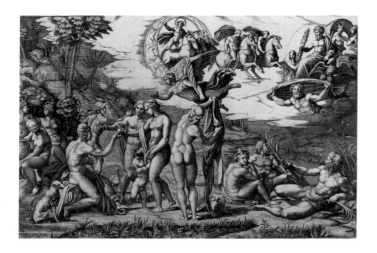

Fig. 1 Marcantonio Raimondi, after Raphael, *The Judgment of Paris*, 1510–15. Engraving, 298 × 441 mm (11¾ × 17⅜ in.). B. 245. The Metropolitan Museum of Art, New York, Rogers Fund, 1919. (19.74.1).

Fig. 2 Joachim Wtewael, *Studies of Heads*, ca. 1615. Black chalk on blue paper, 208 × 248 mm (8³⁄₁₆ × 9¾ in.). Sir Brinsley Ford, CBE FSA, London.

Wtewael uses a familiar landscape formula, with two openings into the woods, one marked by a reclining camel, the other by the wedding feast and Apollo's chariot.

Characteristically, Wtewael imbeds highly naturalistic elements in a scene otherwise conceived in the mind's eye. Flora, fauna, and shells are painted with the utmost delicacy and verisimilitude. Paris's flock of sheep and goats is joined by his dog, pigs, a cow, and the exotic camel. Each

beast is shown in a typical pose, as Van Mander advised: "There is nothing better than to refer to nature in order to make no faults; there you can find a model for everything. Notice how each creature lies, runs, steps, turns itself."[2] The chambered nautiluses and other shells beside the stream also appear to have been studied from life. They are attributes of Venus, recalling the circumstances of her birth and signifying her sensuality.[3] The figure style, too, combines naturalism and artifice. Bodies are more relaxed in pose and more normally proportioned than in Wtewael's earlier works, but anatomical fantasy, as in the knobby structure of Paris's chest, survives.

The Judgment of Paris was the most popular mythological theme in European art of Wtewael's time.[4] It is the main subject of six known paintings by Wtewael.[5] The Judgment of Paris also figures as a background vignette in several of his depictions of the Wedding of Peleus and Thetis.[6] One explanation for the theme's popularity is that it called for the depiction of three sumptuous female nudes on display before a male judge.[7]

Marcantonio Raimondi's famous engraving of *The Judgment of Paris* after Raphael (fig. 1) lies behind most later depictions of the subject, including Wtewael's.[8] There were many intermediary prints and paintings, including a canvas by Abraham Bloemaert from about 1592,[9] but the many similarities between Wtewael's London panel and the engraving suggest that he knew the print or an image very close to it. As in the engraving, Wtewael shows a seated Paris offering the apple to Venus, who is accompanied by Cupid. The poses of the goddesses are varied—frontal, in profile, and from the rear. The poses and anatomies of Minerva, in back view in both print and painting, are particularly similar. In each, Mercury is behind Paris, a reclining river god occupies the lower right corner, and Apollo in his chariot surmounts all.

A study of three heads (fig. 2) shows Wtewael exploring poses and facial expressions for

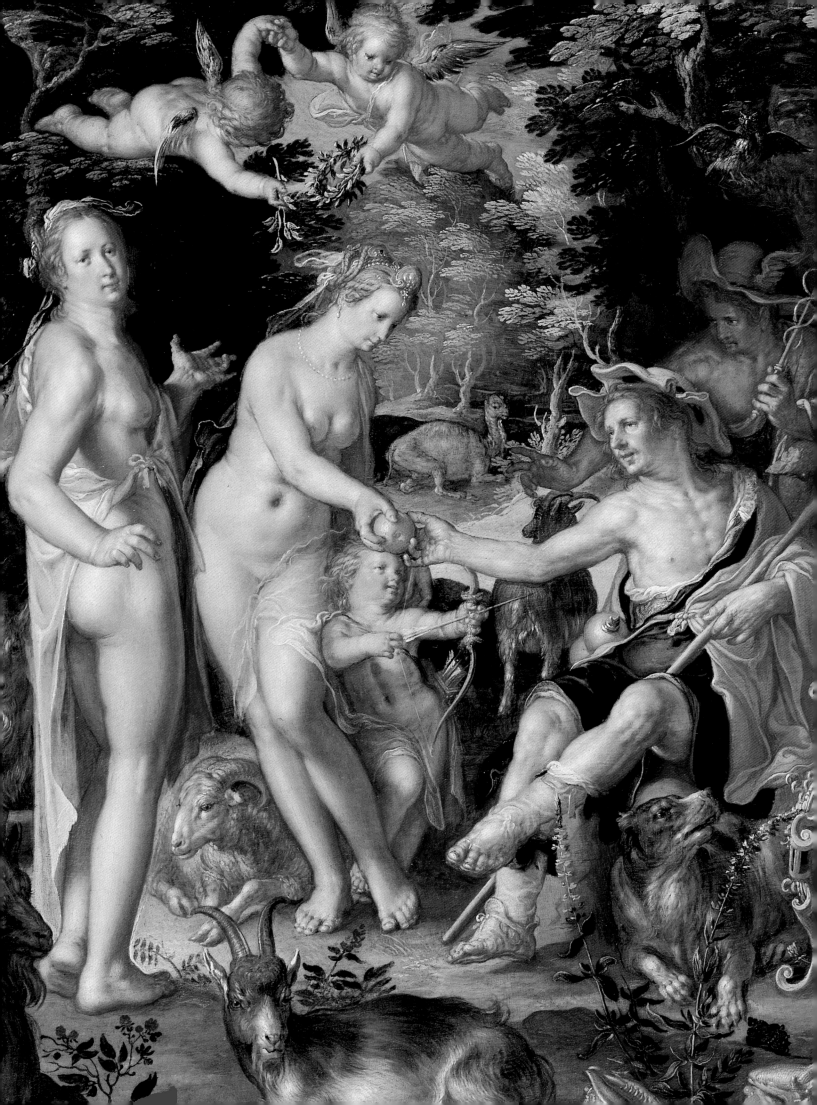

Paris and the goddesses in the London painting and a closely related *Judgment of Paris* from about the same time.[10] The woman's head, at upper left, is tilted left like Juno's in the London picture, where also tendrils of hair escape her veil. The relationship between head and shoulders has been rethought in the painting, with the body turned in profile. The other two heads, studies for Paris, reverse the figure in the London painting and correspond more closely with his counterpart in the other judgment scene. This is Wtewael's only known preparatory study for heads, or indeed figural details of any kind, and the technique, black chalk on blue paper, is also most unusual for him. Probably inspired by Venetian drawings, it is another aspect of the importance for him of Italian art.

The Judgment of Paris is basically a fable of choice: kingship, warlike prowess, or love? Since Paris's choice had dire consequences, the story became an exemplum of poor judgment, of the error of yielding to the temptations of sensuality and love. As with many depictions of mythological themes, the unhappy outcome is not depicted, but rather is left to the literate viewer to remember. This strategic approach to didacticism had the advantage of luring the viewer with an engaging image and simultaneously of implying the dangers of its seductiveness. This is not to say that all depictions of the Judgment of Paris carried heavy-handed moralizing. Delight in the picture was not incompatible with a subtle lesson.

—A. W. L.

51 JOACHIM WTEWAEL (1566–1638)

Andromeda
1611

Oil on canvas, 180 × 150 cm (70⅞ × 59 in.)
Signed and dated at left, on the rock, beside the chain: *Joachim wte / wael fecit / Anno 1611*
Paris, Musée du Louvre, R.F. 1982-51

Provenance: possibly the painting listed in Wtewael family inventories in 1656, 1661, and 1669; possibly Jacob Carel Martens, Utrecht; and his sale (Utrecht), 9 Apr. 1759, lot 38; possibly sale, Johann Matt. von Merian (Frankfurt am Main), Dec. 1711, lot 153; a château in Alsace, by the early 19th century; sale, Palais des Congrès, Etude Denesle (Rouen), 13 Dec. 1981, lot 37; with Matthiesen Fine Art (London), 1981; given by the Société des Amis du Louvre, 1982

Selected References: Lowenthal 1986, 130–31, A-59 (with earlier literature), pls. 82–83, color pl. 17; Segal 1988, 80; Boyer 1989, 75–76, no. 41; Broos et al. 1990, 491, fig. 3; Luijten et al. 1993, 85, fig. 144

Andromeda was doomed to pay with her life for her mother's boasting. Intended as a sacrifice to the monster sent by Neptune to ravage her father's land, she stands manacled to a rock, looking hopefully toward her savior. Having asked for Andromeda's hand in exchange for slaying the beast, Perseus, airborne astride Pegasus, menaces the creature with his sword and Medusa shield. Encouraged by the people of the seaside town beyond, Perseus will kill the monster, be declared a hero, and claim Andromeda as his prize.[1]

Andromeda, a full-length nude in the near foreground, dominates the complex space of the large canvas in a pose that reveals the soft contours of her slender body. Ivory flesh touched with rose, windblown hair, and a yearning expression convey her beauty and vulnerability. The size and relative simplicity of her form contrast with the cluttered beach at her feet and especially with the fantastic drama enacted to the right. The fabulous sea creature, winged, finny, and iridescent, snarls at the apparition above, as Perseus and Pegasus threaten from on high. An expansive sea and a streaky sky

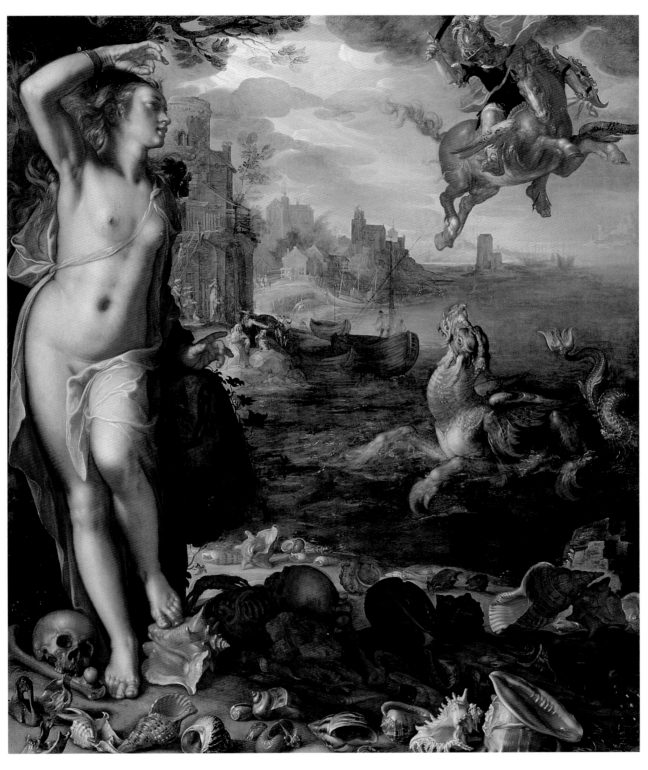

Cat. 51

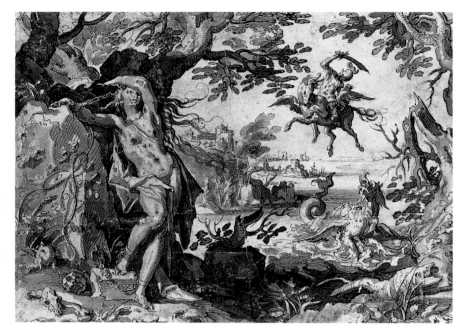

Fig. 1 Jan Saenredam, after Hendrick Goltzius, *Perseus and Andromeda*, 1601. Engraving, 238 × 177 mm (9⅜ × 7 in.). Holl. 365. Rijksmuseum, Amsterdam, RP-P-OB-10601.

Fig. 2 Joachim Wtewael, *Perseus and Andromeda*, ca. 1610–11. Pen, brown ink with brown wash, and white heightening, 158 × 203 mm (6¼ × 8 in.). Graphische Sammlung Albertina, Vienna, 8133.

stretch to the horizon, as we move from foreground browns and greens into silvery grays. Wtewael's skills as figure painter, landscapist, and storyteller come into play in this large, important canvas from his middle years.

The subject of Perseus and Andromeda was popular in Netherlandish prints around 1600, perhaps because it had veiled topical significance, as we shall see. Paintings are rarer.[2] Wtewael follows the conventions established in several Dutch engravings, in the vertical composition and the placement of the full-length nude with respect to the landscape, Perseus, and the monster. The engraving by Jan Saenredam after Hendrick Goltzius (fig. 1) is one of several that could have served Wtewael as model.[3] This one may have inspired the torsions of Andromeda's pose as she regards Perseus. The Dutch examples were ultimately indebted to Venetian ones, with Paolo Veronese's

Andromeda (ca. 1584; Musée des Beaux-Arts, Rennes) especially pertinent to Wtewael's.[4] The two have in common not only the twisting figure of Andromeda, one arm manacled overhead, but also a maritime city in the background, a sequence of brightly lit and shadowed planes in the landscape, and a threatening sky. If Wtewael did not see that painting itself in Italy in the late 1580s, he seems to have known it through direct copies as well as derivatives.

As in the Saenredam-Goltzius engraving, the foreground of the Louvre painting is littered with human bones, including a skeleton. The human remains indicate that others had died on the promontory, but, according to Ovid, Andromeda was the monster's only victim. Wouter Kloek suggests that the juxtaposition of the skull and the shell at Andromeda's feet might allude thematically to sex and death, the classic opposition of Eros and Thanatos.[5] On a more immediate level, the bones inspire a shiver as Andromeda anxiously awaits release.

The meticulously depicted shells at her feet introduce striking naturalism into a conception dominated by the calculated and incongruous; thus Wtewael worked both after nature (*naer het*

leven) and from his imagination (uyt den geest). The presence of both modes in the same painting is not unusual; the still life in Wtewael's *Lot and His Daughters* (cat. 2, fig. 1) and the flowers, animals, and shells in his *Judgment of Paris* (cat. 50) also coexist with artifice. Among the shells in the Louvre painting are a *Nautilus pompilius* and a *Turbo marmoratus*, specimens from the Indian archipelago like those avidly sought by Dutch collectors.[6] Wtewael's shells are so prominent, varied, and numerous that they raise the question of a shell collector's patronage for the painting.[7] Iconographically, the shells contribute to the erotic undercurrent.[8]

The story of Perseus and Andromeda, as with all myths, lends itself to multiple interpretations. In the *Wtlegghingh*, or explanation of Ovid's *Metamorphoses*, Karel van Mander interpreted the story of Andromeda as an exemplar of piety, Perseus having humbly given thanks to the gods after his triumph.[9] The story could have political significance too. Netherlanders identified with Andromeda as victim and saw in Perseus a parallel to their political saviors from Spain, especially the princes of Orange.[10] That meaning is consistent with Wtewael's Orangist sympathies. In 1610 he had taken part in a revolt against the Utrecht city government, siding with forces partial to Prince Maurits.[11] In a political reading, the bones at Andromeda's feet could allude to Netherlandish victims of the war against Spain. In addition to having didactic or topical resonance, the subject also afforded an opportunity to represent a beautiful female nude awaiting salvation by her courageous lover, certainly a factor in its popularity.

A drawing of Perseus and Andromeda in the Graphische Sammlung Albertina (fig. 2) is probably a preparatory study for the Louvre painting, representing a stage in the development of the format and the relationships among the characters.[12] The organization of the central elements resembles that of the painting, but the poses of Andromeda, Perseus, and the monster have been varied, so that

Andromeda and Perseus face each other. The landscape is more extensive on both sides, expanding the composition laterally and suggesting that Wtewael at this point was exploring the possibilities of a horizontal composition. A small copper painting of "Andromeda Saved by Perseus," sold at auction in Amsterdam, 7 September 1803, as attributed to Wtewael, is untraced today. The picture measured about nine by eleven inches.[13] Given the horizontal format, it was perhaps even more like Wtewael's drawing *Perseus and Andromeda* in the Albertina than is the Louvre picture.

Lynn Federle Orr has pointed out similarities between the pose of Andromeda in the Albertina drawing and that of Wtewael's *Saint Sebastian* (cat. 2).[14] Wtewael's efficient and witty mining of his own repertoire of poses is a characteristic mannerist appropriation. The fact that both Andromeda and Sebastian were intended victims who triumphed over adversity gives meaning to the adaptation.

—A. W. L.

52 DIRCK VAN BABUREN
(ca. 1595–1624)

Prometheus Being Chained by Vulcan
1623

Oil on canvas, 202 × 184 cm (79½ × 72½ in.)
Signed and dated lower left: . *Teodoor de Baburen fecit An[o] 1623*; lower right: .*T.D. Baburen fecit / An[o] 1623*
Amsterdam, Rijksmuseum, SK-A-1606

Provenance: sale, Isaak van der Blooken (Amsterdam), 11 May 1707 (Hoet 1752, 1:98, no. 15); sale, Joan de Vries, burgomaster of Amsterdam (The Hague), 13 Oct. 1738, as Honthorst (Hoet, 1752); coll. Scholl, Mainz, 1820; gift of Dr. J. von Loehr, 1893

Selected References: Hoet 1752, 98, 563; Swillens 1931, 89; Von Schneider 1933, 42; Raggio 1958, 44ff.; Slatkes 1965, A22, 26, 38, 79–81; Slatkes 1966, 182; Van Thiel et al. 1976, 92; Blankert et al. 1980, no. 14; Garas 1980, 275; Slatkes 1983, 33; Nicolson and Vertova 1989, 1:53, 2: fig. 1063; Manuth 1990, 186; Sutton 1990, under no. 91

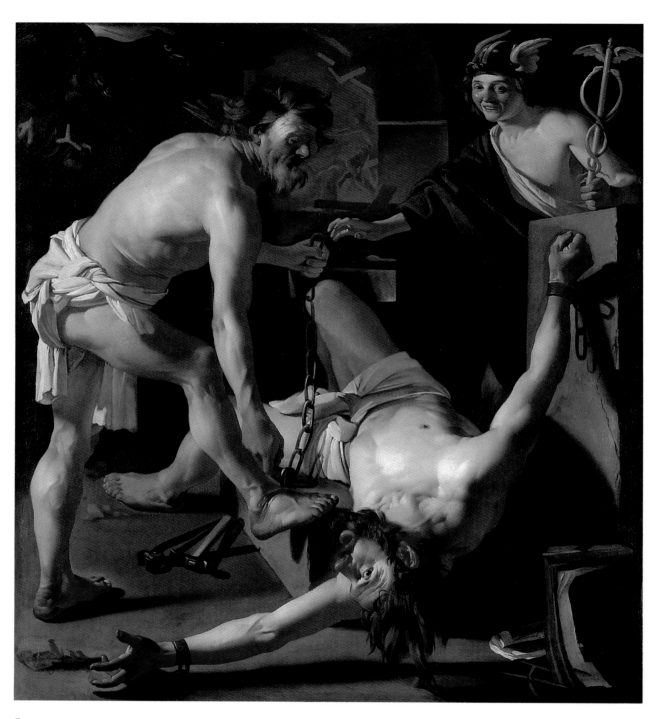

Cat. 52

The story is told by Aeschylus, Hesiod, Hyginus, and other ancient writers of the Titan Prometheus, who angered Jupiter by passing on to mankind the use of fire, metallurgy, mathematics, and other useful arts.[1] Jupiter punished him by having Vulcan, the smith of the gods, chain him to a boulder in the Caucasian mountains. Every day Jupiter's eagle would peck out his liver, which grew again overnight. According to Aeschylus, when Prometheus would not give Jupiter's messenger, Mercury, information that Jupiter wanted, Jupiter hurled him into Tartarus (Hades). Eventually Jupiter relented and agreed to let Hercules free Prometheus, from the mountains or from Tartarus, depending on who is telling the story. Of the famous sixteenth- and seventeenth-century repre-

Fig. 1 Abraham Bloemaert, *Prometheus (or Tityus) Chained*. Black chalk, 76 × 95 mm (3 × 3¾ in.). Marianne and Frank Seger, Toronto.

Fig. 2 Jacques de Gheyn III, *Prometheus Chained to a Rock*, 1637–41. Oil on canvas, 143 × 220 cm (56⅜ × 86⅝ in.). Sint Eloyengasthuis, Utrecht.

sentations of this story, the most influential in the Netherlands was the painting of *Tityus* (Museo del Prado, Madrid) by Titian. (The story of Prometheus was often confused with that of Tityus, who was punished for sexual transgressions by being chained to a rock at the mouth of Tartarus and having a vulture eternally eating out his liver.) The Titian was commissioned about 1548 for the audience hall of the Hapsburg governor of the Spanish Netherlands at Binche as part of an allegorical program to show how the Hapsburgs punished degenerate enemies of Catholicism.[2] The image gained currency in an etching by Cornelis Cort,[3] which was, however, slightly altered by the introduction of a torch so that the protagonist looked like Prometheus. In 1618 Rubens's great *Prometheus*, painted in 1612 (Philadelphia Museum of Art),[4] entered Sir Dudley Carleton's collection in The Hague. A small study, *Prometheus (or Tityus) Chained* by Abraham Bloemaert (fig. 1), reflects these famous prototypes.

Baburen's composition differs fundamentally from them.[5] On the one hand, the location of the scene in Vulcan's forge and the prominence of

Vulcan are hard to explain on the basis of earlier representations of Prometheus. On the other, potential prototypes of Vulcan's forge do not include Prometheus.[6] It has gone unremarked that in the flames visible through the opening at the rear of Vulcan's forge can be seen two figures, one tied to a wheel.[7] If the flames are those of Hades, the man on the wheel could be Ixion, damned with Tityus, and thus the chained figure could be Tityus. The presence of Mercury points, however, to Prometheus.

The casual combining of features of Prometheus and Tityus as well as the preeminent position of Vulcan as forger of Prometheus's shackles point the way to a rethinking of both Baburen's sources of inspiration and the possibility of a commission. The only other painting of the subject known to have been done in Utrecht during the period of our enquiry may hold the key. That painting, *Prometheus Chained to a Rock* (fig. 2), attributed to Jacques de Gheyn III, a wealthy patrician, Latin scholar, and artist who in the mid-1630s moved from The Hague to Utrecht,[8] bears an inscription on the frame stating that it was presented in 1643 to the Sint Eloyengasthuis (the hospice for old and infirm members of the Smiths' Guild) by the guild's deacons and housemaster. The building was refurbished in the early 1640s, the guildhall itself (where the paintings owned by the guild were installed) in 1643. A consideration

of its unprecedented composition lays to rest the assumption that the subject of De Gheyn's painting had no connection with the guild:[9] Prometheus is depicted from the back so that, instead of his agony under the eagle's assault, as in every other version, it is the precisely painted iron manacles that stand out.

Saint Eloy (Eligius) of Noyon, who died in 660, was a blacksmith and goldsmith as well as a bishop. The anonymous *Portrait of Saint Eloy as Bishop and Smith* given in 1621 to the *gasthuis*[10] combines the two traditional representations of the saint, showing him in his regalia and holding the heavy hammer of a blacksmith. A similar representation appears on the exterior of Amb. Francken's altarpiece of 1588 for the altar belonging to the Smiths' Guild in Antwerp cathedral.[11] Since the gold- and silversmiths of Utrecht had split off to form their own guild in 1596, the *Smedensgilde* incorporated trades dealing with the harder metals, for example, ironsmiths, swordsmiths, armorers, locksmiths, gunsmiths, trumpet makers, clockmakers, and makers of mathematical instruments.[12] One of the largest guilds in the city with an average of 268 members in the period between 1632 and 1650,[13] it was also one of the most prosperous.

In 1637 Utrecht's Calvinist town council had decreed that hospices, as public places, had to take down "papist" images. In 1643 they specifically prohibited the smiths' hospice from keeping the guild's portrait of Saint Eloy over the fireplace in the guildhall. Very likely, *Prometheus* was commissioned after 1637 and installed in 1643 as a substitute for Saint Eloy and as a not-so-subtle expression of frustration with the control of the council. A comparison may be drawn with Titian's lost painting *The Cyclopes Hammering out Weapons in Vulcan's Forge* done as an allegory of the weapons industry in Brescia for the town hall there.[14]

One other contemporary painting by a Utrecht artist of Vulcan the smith, celebrated in Van Mander's traditional mythological reading as the God of Iron, discoverer of the arts of metallurgy, and blacksmith and armorer to the gods,[15] may have involved a commission for smiths. In 1619 Bloemaert painted a *Venus and Cupid in the Forge of Vulcan* (Historisches Museum der Stadt Hanau, Schloß Philippsruhe).[16] In the foreground is a great pile of armor, a trumpet, swords, pincers, and manacles, all made by guild members.[17] In sum, the unusual focus found in Baburen's painting on Vulcan, his forge, and tools, and, in the foreground, the mathematical instruments representing the wisdom Prometheus gave to mankind point to a commission in some way connected to smiths; further research may clarify this.

In 1707 the present painting was sold with another painting described as "Where Adam and Eve lament death." Leonard Slatkes suggested that Adam and Eve could be lamenting the death of their son Abel.[18] If this second painting were truly a pendant, the connection between the mythological and the biblical might have been the fall from grace of those who in their pride defy God or the gods.[19]

Baburen's *Apollo and Marsyas* (Prince Schaumburg-Lippe, Bückeburg Castle),[20] similar in dimensions, theme, and composition to *Prometheus Being Chained by Vulcan*, has been proposed as part of the same grouping.[21] The prostrate Marsyas, strung up so that his head and outflung arm are in the lower right corner, offers striking parallels to the dramatically foreshortened, chained Prometheus. But, without concrete evidence, it is hard to believe that Baburen would repeat a singular composition (not even reversing it) in the same grouping.

This comparison of Prometheus and Marsyas prompts the question of the origins of this effective figure of defeat. Baburen's earliest known use of the motif, the fallen Malchus in his painting *The Capture of Christ with Peter's Attack on Malchus* (Gemäldegalerie, Weisbaden),[22] is dated by Slatkes to about 1615, during the artist's stay in Italy. As scholars have pointed out,[23] Baburen pays homage

to Caravaggio's powerfully expressive *Conversion of Paul* (Sta. Maria del Popolo, Rome), in which the saint, on his back with his head toward the viewer and arms thrust out in accepting self-abnegation, is vividly foreshortened. The many related Caravaggesque subjects include the master's own *Martyrdom of Saint Matthew*, versions of the *Crucifixion of Saint Peter*, *Judith and Holofernes*, and the *Death of Cato*.[24] Baburen's immediate model for this *Vulcan* as well as for his *Mocking of Christ* (cat. 7) was possibly the expressive compositional solution of Bartolomeo Manfredi.[25]

Writing about the work of Manfredi, Joachim von Sandrart in his *Teutsche Academie* of 1675 describes a painting (now lost) that impressed him: *Tityus* shown in foreshortening chained to the floor of Hades, his chains ripped apart by Hercules, who releases him in defiance of Cerberus.[26] K. Garas, who cited this neglected reference as evidence of a more immediate model for Baburen,[27] concluded in a brief aside that Baburen's painting probably represented Tityus. However, Hercules freed Prometheus, not Tityus. According to Hyginus, Hercules, grateful to Prometheus for aiding him in his eleventh labor, freed him just before setting out on the twelfth, the capture of Cerberus in Hades. It is possible that the painting Sandrart saw was actually a "Prometheus," perhaps with Tityus-like motifs, that could have looked remarkably like Baburen's painting: a god bracing himself to break, rather than forge, the chains of a recumbent, foreshortened figure. The appearance of that painting can be imagined from the fresco *Prometheus Freed by Hercules* of 1602 in the Palazzo Farnese.[28] Based on the design of Annibale Carracci, the fresco would have preceded Manfredi's painting and looks enough like Baburen's to merit consideration.

In the spirit of Caravaggio and Manfredi, Prometheus's straining hand grasps at the air, as if to rip a hole in the canvas. This is the sprawl of defeat, in which all decorum is abandoned. Vulcan in his turn is all angular movement, the veins

visible in his old legs and his feet dirty. In keeping with Caravaggio's sensuous mixing of the vulgar and the divine, Baburen characterizes these supernatural beings as having the reddened necks and hands of peasants who work outside.

Prometheus Being Chained by Vulcan, painted in 1623, the same year as *Granida and Daifilo* (cat. 57, fig. 1) and probably *Cimon and Pero* (cat. 25), shares the brusqueness and calculated awkwardness of the one and the smoothly applied broad strokes of dusky creamy paint of the other. Baburen died the following year, so these paintings take on a special importance as the culmination of his short career. The Amsterdam painting is signed and dated twice. The flamboyant, calligraphic signature at the lower right may have been preceded by the abbreviated signature on a piece of detritus on the shop floor, which was covered up, very possibly by the artist, and only uncovered when the painting was cleaned in 1972.

—J. S.

53 CORNELIS VAN POELENBURCH
(1594–1667)

Feast of the Gods

ca. 1630

Oil on copper, 38 × 49 cm. (15 × 19¼ in.)
The Hague, Mauritshuis, 1065

Provenance: Vigné de Vigny, Paris, before 1773; sale, Vigné de Vigny et al. (Paris), 1773 (to Paillet); Louise François de Bourbon, prince de Conti, Paris, 1773(?)–76; sale, prince de Conti (Paris), 1777; Louis-César-Renaud de Choiseul, duc de Praslin, Paris, 1777; sale, duke of Praslin (Paris), 1793 (to Desmarest); with Pierre Joseph Lafontaine (Paris), 1793(?)–98; sale, Lafontaine (Paris), 1798; anonymous sale (Paris), 1802 (to "le bruien"); anonymous sale, Jurg Stuker (Bern), ca. 1979; with Bruno Meissner (Zurich), 1980; with Noortman (London and Maastricht) 1980–83; gift of Robert Noortman, 1983

Selected References: Sluijter-Seiffert 1984, 92–93, 129–32, 226, cat. 20; Sluijter 1986, 70, 209, 411; Sluijter-Seijffert, Catherine, and Van Leeuwen 1993, 113; Broos 1993, no. 29; Froitzheim-Hegger 1993, 148

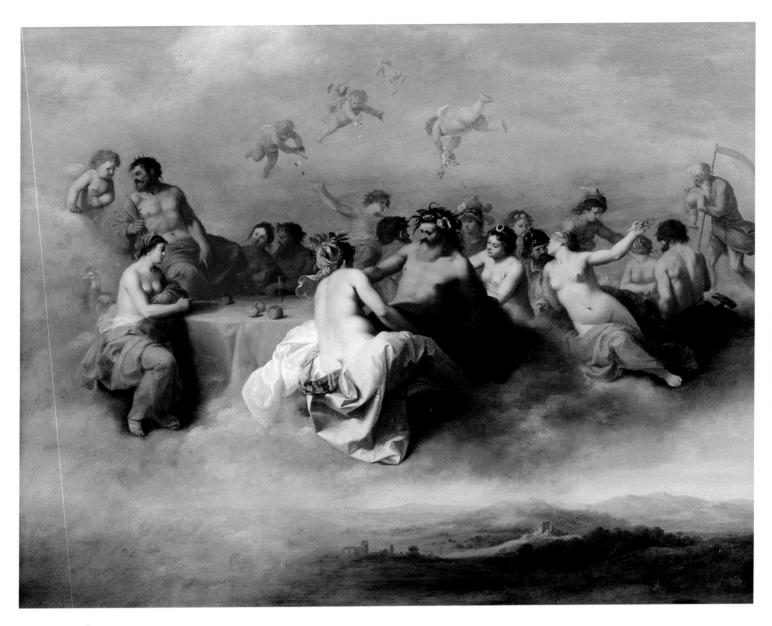

Cat. 53

The subject of the banquet of the gods, uniquely popular in Utrecht, is here set in the heavens above the clouds; opening out below is a panoramic landscape with ruins and a mountain, presumably the gods' home, Mount Olympus itself, rising in the distance. The banquet of the gods specifically as a wedding celebration is represented in this catalogue by two versions of the *Wedding of Peleus and Thetis* by Joachim Wtewael (cat. 49 and cat. 49, fig. 2), another by Abraham Bloemaert (cat. 46), and the latter's early tondo, the *Marriage of Cupid and Psyche* (see Spicer, introduction to this catalogue, fig. 10). The selection of one of the several

versions of the banquet of the gods (see Spicer, introduction to this catalogue, fig. 11)[1] by Poelenburch as part of the gift of paintings presented in 1627 by the province of Utrecht to Prince Frederik Hendrik and Amalia van Solms reflects not only the high esteem in which Poelenburch was held as a painter but also the perception that the subject was representative of the school.

This painting has recently been described as "a gathering of the gods"[2] because the little food in evidence hardly constitutes a banquet. It is called a banquet here for two reasons. Other Dutch paintings of the sixteenth and seventeenth centu-

ries in which a group is seated around a table with a white tablecloth represent a meal, though seldom the middle of one with people eating (which was rather sloppy until forks were widely in use). The moment depicted may be just before the meal— a pious family saying grace—or the postprandial relaxation of adults enjoying their ease when, as here, the table may have been cleared of all but a few pieces of fruit. If the gods gather "in council" or for other purposes, which they often do in paintings by Poelenburch, they simply lounge on the puffy clouds as if on modern beanbag furniture. This painting is one of a group by Poelenburch of similar works with many variations on the mythological tales of the wedding banquets of Peleus and Thetis and Cupid and Psyche. Contemporaries apparently saw these paintings as a generic type of which the prototypes were festive wedding banquets. The version now in Dessau that belonged to Frederik Hendrick and Amalia cannot be specifically associated with either of these Olympian weddings. It, and another, no longer identifiable version of the subject that was also in their collection, were, however, both called "banquet of the gods" (*banquet der goden*) in one inventory of the couple's collections and "wedding party of the gods" (*bruyloft van de goden*) in another.[3]

Clockwise from the lower left the figures in the Mauritshuis painting are Juno, Jupiter turning to speak with Cupid, an unidentified couple, Apollo, Minerva, a female deity wearing a garland of flowers, Mercury, another female deity, Saturn eating one of his children, Vulcan, Venus, Mars, Diana, an unidentified male deity, Neptune, and Ceres. The couple with no particular attributes but who are well placed at Jupiter's left hand (his consort, Juno, with her peacock, is at his right) may be meant to suggest Proserpina and Pluto or possibly Peleus and Thetis. As they do in the *Triumph of Love* that Poelenburch sold to Willem Vincent, baron van Wyttenhorst (Schloß Wilhelmshöhe, Kassel),[4] the putti sprinkling rose

Fig. 1 Cornelis van Poelenburch, *Cupid Presenting Psyche to Venus at a Banquet of the Gods*, 1630s? Oil on panel, 32.7 × 40.4 cm (12⅞ × 15⅞ in.). Jill and John Walsh, Malibu.

petals suggest that this is intended as a romantic occasion.

Ceres, benign goddess of the harvest and therefore of abundance, sits with her broad, sensuous back toward us at the center of the composition, balanced visually by Juno at the left and Venus at the right. Eris, goddess of discord, plays no role in Poelenburch's interpretations of the banquet theme, but Ceres often appears, either by herself in the foreground with her cornucopia of fruit by her side, as in *Cupid Presenting Psyche to Venus* (fig. 1)[5] or with Bacchus and Venus to convey the famous dictum *sine Cerere et Baccho friget Venus* ("Love freezes without food and drink"),[6] for instance in the artist's 1624 *Banquet of the Gods* (private collection, London).[7] Poelenburch's featuring of Ceres and the association of abundance with the celebration of love and beauty tie his interpretation of the banquet of the gods to the theme of the Golden Age and the celebration of *otium*, or ease, and the harmony that it engenders. There is no moralizing here,[8] no suggestion that leisure is decadent.

Poelenburch was certainly aware of the

Fig. 2 Cornelis van Poelenburch, *Cupid Pointing out Psyche to the Three Graces*. Counterproof? after Poelenburch's own red chalk drawing after the lost red chalk study by Raphael, 1620–25? Red chalk, 186 × 146 mm (7⅜ × 5¾ in.). Rijksprentenkabinet, Amsterdam, A2198.

earlier representations by other Utrecht artists, but his composition looks back to Bartholomeus Spranger's *Wedding of Cupid and Psyche* captured in Goltizus's famous engraving of 1587 (cat. 49, fig. 1) for the setting in the clouds. Unlike Spranger's linear, twisting, intestinal forms, Poelenburch's clouds are wonderfully wispy and convincing. The figural conception of Poelenburch's various compositions is informed by the solid forms and natural proportions of Raphael's *Wedding Banquet of Cupid and Psyche*, painted in 1516–18 with the help of assistants, on the ceiling of the loggia devoted to the story of Psyche in the Villa Farnesina in Rome. The importance for Poelenburch of this composition, the prototype for all later interpretations including Spranger's, is registered in a red chalk drawing (fig. 2)[9] that can be ascribed to him. This appears to be a counterproof (made to reverse the figures) of his own (lost) copy of Raphael's (or Giulio Romano's) lost red chalk drawing for the

pendentive, *Cupid Pointing out Psyche to the Three Graces*,[10] painted with Giulio's help. The drawing, its composition reversed from the painting, has the flattened quality of a counterproof and the even character of line of a copy, but it is in keeping with another red chalk drawing made, on the back of a typical landscape that is surely by Poelenburch (Rijksprentenkabinet, Amsterdam, 1954:186),[11] after a study of a figure from Raphael's fresco, *Fire in the Borgio*. Von Sandrart, who knew him, says that in Italy Poelenburch looked to Adam Elsheimer for his landscapes but to Raphael for his figure style ("die Bilder aber auf Raphael manier zu machen").[12]

Poelenburch's homage to Raphael can be seen in the way he adapted the foremost Grace. This figure, like the related one of Hebe in Raphael's *Wedding Banquet*, is a brilliant encapsulation of feminine grace that will inspire artists for centuries: in the three-quarter rear view, the line of her rounded back descends through the buttocks, down the leg bent back to accentuate the curving line of the calf, and on to the graceful arch of the instep with the slight suggestion of tension concentrated in the ball of the foot pressed into the cloud for balance. The lower half of her body was taken over directly for a *Venus, Bacchus, and Ceres* in Kassel from the artist's shop (Schloß Wilhelms-höhe). Poelenburch's adaptation of the figure for Ceres in *Cupid Presenting Psyche to Venus* is more typical. Here Raphael's discrete rear view is set aside, and Poelenburch offers a characteristically unencumbered appreciation of Ceres' softly rounded, ample buttocks as she leans slightly forward.[13] The graceful ascending lift of her right heel accenting the line of the calf is pure Raphael; the upturned sole of her left foot, which Raphael would have thought vulgar and indecorous no matter how dainty, provides a refined variation on the dirty upturned soles with which Caravaggio and his followers hoped to shock the viewer.

The only drawing that has been associated with the Mauritshuis composition is a sheet (loca-

tion unknown) with rows of tiny nudes drawn summarily in chalk including figures like those of Ceres, Diana, and Venus, as well as those of Ceres and Psyche from *Cupid Presenting Psyche*. These nudes have been described as studies from life by Poelenburch.[14] It is most unlikely, however, that the artist would make drawings from life on such a small scale. In addition, many of the figures are partial, as if cut off by a hillock or by another figure. This is clearly a model sheet based on other larger studies or on paintings, a kind of "cheat sheet" for studio use in devising figural groups for paintings.[15]

The painting is neither signed nor dated. Its authorship has never been in question; its dating has. It has been assigned to Poelenburch's Italian period, therefore by 1625,[16] as well as to about 1630.[17] The two dated Banquets from the Italian period, those of 1623 (Wadsworth Atheneum, Hartford)[18] and 1624 (private collection, London), share a general crispness of execution set off by a sky that tends to an intense blue in the Hartford painting, qualities reflected to a lesser degree in the *Landscape with the Flight into Egypt* dated 1625 (cat. 68). The much more subtle atmospheric quality of the Mauritshuis composition with soft wisps of lavender-gray-tinged clouds rising around the gods like a fog bank suggests closer connections to the smoke-filled sky and lavender-tinged grotto walls of *Grotto with Lot and His Daughters* of 1632 (cat. 69). The soft gray tonality of Jupiter's salmon drapery, Saturn's lavender drapery, and the gray blue of Venus's drapery harmonize with the mist and assure the prominence of Ceres, closest to us—"golden-yellow Ceres" as Virgil evokes her in the *Georgics*—with her multicolored silk scarf similar to that worn by Susanna van Collen (cat. 61) and, in her hair, the intense pinpoints of clear color in the red poppies and blue cornflowers, which are set off by tiny, sharp shafts of wheat.

—J. S.

54 CORNELIS VAN POELENBURCH
(1594–1667)

Arcadian Landscape with Nymphs Bathing
1640s

Oil on a six-sided panel, 34.3 × 29.5 cm (13½ × 11⅝ in.)
Monogrammed lower left: *C.P.*; inscribed by a later hand in black ink on the verso: *Boudoir* (?)
New York, private collection

Provenance: possibly, sale (Amsterdam), 12 Sept. 1708, lot 28; Empress Joséphine, château de Malmaison, inv. 1811, no. 313, red wax seal on verso; Jules Duclos, Paris, by 1855 until after 1863; Roussel, Brussels, after 1878; sale, S. Luc (Brussels), May 1893, lot 61; with Galerie Sankt Lucas (Vienna), 1988–89

Selected References: Hoet 1752, 126, no. 28; Blanc 1863, 1:7; Duparc and Graif 1990, no. 55

In Greco-Roman mythology nymphs are benign, often playful, and sensuous spirits of the natural world who have taken the form of young women. They may dwell anonymously in the mountains, woodlands, or water; the best known are the followers of the chaste huntress, the goddess Diana. The painting *Diana and Her Nymphs at the Bath* (cat. 56), by Nicolaus Knüpfer and Willem de Heusch, datable to the 1640s, shows them disporting themselves with their leader.

Many of Poelenburch's landscapes with nymphs have specific subjects such as Diana and Actaeon or the story of the nymph Callisto, but landscapes with bathing nymphs (or women who have simply removed their clothes), generally undated and with no specific subject, were the subjects most frequently painted by Poelenburch and his workshop after he returned from Italy in 1625.[1] The earliest datable example is *Nymphs and Satyrs in a Hilly Landscape* (fig. 1),[2] on which the abraded date can best be read as 1627. Though the generic representation of nymphs in a landscape without a specific mythological subject is not characteristic of Dutch painting before then, and though he surely picked up a taste for unaccompanied nymphs while he was in Rome under the influence of the art of Elsheimer, Domenichino,

Cat. 54

Annibale Carracci, Francesco Albani, and the Fleming Paulus Bril, none of Poelenburch's extant representations can be assigned with certainty to his years in Italy (1617–25). The ruin-filled landscapes specifically datable to those years are populated instead with contemporary herders and their charges.

Of the Utrecht artists influenced by Poelenburch, the most important were Diderick van der Lisse, for whom see *Sleeping Nymph* (cat. 55), and Carel de Hooch, whose paintings, made in the mid-1630s, of grottos with ancient sculpture and bathers can be represented by *Nymphs Bathing in a Grotto* (fig. 2). Johan van Haensbergen[3] was the most able of Poelenburch's later followers who continued reworking such compositions to the end of the century.

Poelenburch's own compositions of nymphs typically comprise several figures in different but usually contained and languid poses, standing, lounging, or drying themselves, perhaps beside a pond. One or more figures may be only partially visible over a rise. No specific studies can be associated with these figures. The repetition of figures in various compositions[4] and the existence of numerous red chalk studies and afterstudies of figural groupings, many of them apparently by the artist himself, indicate, however, a workshop repertoire of nude and classically draped figures that reflects Poelenburch's own drawings after antique sculpture and Raphael, influences that are discussed at catalogue 53, *Feast of the Gods*.

In this painting of nymphs, the composition is focused on the young woman walking away from us and the mouth of the cave open toward the pond. The graceful outlines of her body and classical balance of her pose suggest those of the ancient armless and headless statue of Venus recorded in Poelenburch's drawings made in Rome, etchings of which were included in Jan de Bisschop's *Signorum veterum icones* (The Hague, 1668).[5] The view of a female nude seen from the back, often found in Poelenburch's paintings, has a remarkably sensu-

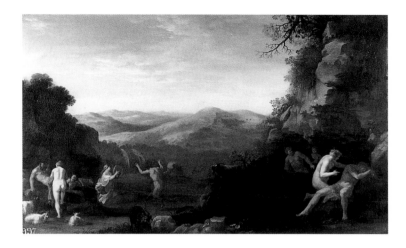

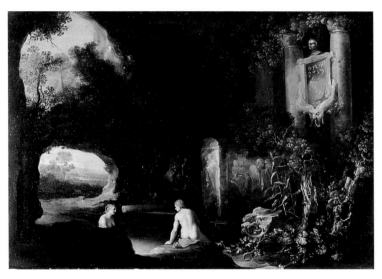

Fig. 1 Cornelis van Poelenburch, *Nymphs and Satyrs in a Hilly Landscape*, 162[7]. Oil on panel, 39.3 × 63.5 cm (15½ × 25 in.). The Royal Collection, Her Majesty Queen Elizabeth II, 2628.

Fig. 2 Carel de Hooch, *Nymphs Bathing in a Grotto*, 1630s. Oil on panel, 43 × 58 cm (17 × 22⅞ in.). Private collection.

ous appeal; perhaps because seen from the rear, it is inherently less sexual. There is no need to avert the eye and every reason to linger on the nymph's smoothly painted, creamy skin and rounded forms, the soft contours of her buttocks enhanced by the fall of light from the upper left.

The Arcadian landscape is marked by a mountainous terrain, ruins, and luminosity that are decidedly not Dutch. It is startling to realize that our vantage point is actually from within a cave, the shadows of which darken the foreground

and define the rocks arching over our heads. Like the waterfalls of Jan Both's paintings (see cat. 71), such caves are not part of the reality of the Dutch landscape. Poelenburch's pen and wash drawings of Italian grottos and natural arches (cat. 69, fig. 1) with their brilliant contrasts of light and shadow show how much they fascinated him.[6] Here the dark frame of the cave's entrance, with its subtle modulations of lavender and green set off by the crisp detailing of the cascading vines and ruff of prickly foliage in the shadows in the lower left, sets off the luminous, warm light of late afternoon that is flooding the cave and throwing a long shadow behind the standing bather.

The ruins, a pattern of overlapping, pierced, crumbling stumps of masonry, dusty salmon in this light, contribute a sense of the past rather than a specific allusion to any well-known remains, though they may have been inspired by drawings that the artist made in Rome.[7]

The painting may be dated to the mid-1640s, as Frederic Duparc and Linda Graif have proposed, in part on the basis of the warm, slightly yellow light. This quality is not characteristic of Poelenburch's landscapes from the first years after he returned from Italy, such as his 1625 *Landscape with the Flight into Egypt* (cat. 68) and *Grotto with Lot and His Daughters* (cat. 69) of 1632, but calls to mind the nearly golden lighting of the Italianate landscapes of Poelenburch's friend Jan Both (who returned from Italy in 1642), such as *Peasants with Mules and Oxen on a Track near a River* (cat. 70).

These paintings of nymphs were meant for private enjoyment. Among the more than fifty paintings by Poelenburch inventoried in the 1650s in the collections of Willem Vincent, baron van Wyttenhorst, were eleven landscapes with unidentified figures, at least some of which were in the *cabinet*, a private chamber, of his house in Utrecht. The notation, *Boudoir*, on the back of the present panel must refer to its location in the Empress Joséphine's boudoir at Malmaison, where it is cited in the inventory of 1811. The frame dates from this

period and is assumed to have been designed for Malmaison.[8] That this painting is illustrated by a line engraving in Charles Blanc's book of 1863 reflects the continued favor that these Italianate views enjoyed in the mid-nineteenth century, a taste discussed by George Keyes in this catalogue.

The panel is, and was designed as, an irregular hexagon,[9] the shape possibly prompting the choice of a grotto setting that would subtly accommodate the "roof" angles. The significance of this shape can now be clarified: It indicates that the panel was intended to grace the center door of a small chest or table cabinet (*kunstkastje* [Dutch] or *Kunstschrank* [German]) of a type especially popular in seventeenth-century court circles, typically made of an exotic wood, and used for keeping precious objects.[10] The present painting would have been accompanied by small horizontal paintings of related subjects made by assistants for the drawer fronts.

Knowing that the painting was a door helps the viewer to read the artist's amusing play on interiors and exteriors: The perspective of the viewer about to open the door is from *inside* the shadowed recesses of the cave looking out. In a related example, Nicolaus Knüpfer used a play of outside and inside for the painted door of a tabernacle made for a hidden Catholic church in Utrecht; his visionary angels adoring the consecrated Host (see Kaplan, fig. 3, in this catalogue) reveal the miracle taking place inside the tabernacle.

—J. S.

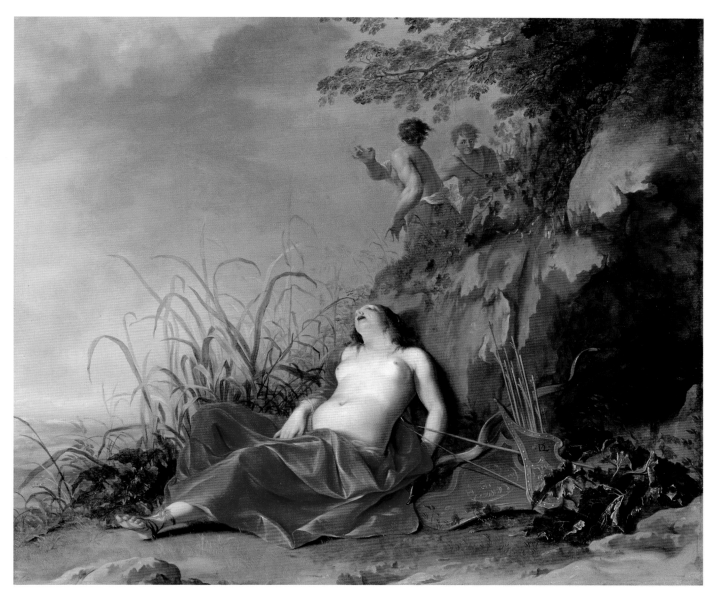

Cat. 55

55 DIDERICK VAN DER LISSE
(1607–1669)

Sleeping Nymph
1640s–1650s

Oil on panel, 44 × 51.8 cm (17⅜ × 20⅜ in.)
Signed on the quiver: *DL* [in monogram]
The Hague, Mauritshuis, 1092

Provenance: possibly, in the estate of Diderick van der Lisse, The Hague, 1669 ("A painting with a sleeping woman"); possibly, sale, Q. van Biesum (Rotterdam), 18 Oct. 1719, lot 215 ("A sleeping Venus with satyrs, by L. V. D. [*sic*]"); sale (Düsseldorf), 23 Mar. 1939, lot 19; coll. Schwarzenraben family, Westphalia, 1939; sale, Dorotheum (Vienna), 6 Oct. 1942, lot 75 ("Diana"); private coll., Cape Town, South Africa; sale, Sotheby's

(London), 3 Dec. 1969, lot 25 (to Butôt); F. C. Butôt, Sankt Gilgen, 1969–92; bequest of F. C. Butôt, 1993

Selected References: Hoet 1752, 1: no. 215; Butôt 1972, 62; Salerno 1977–80, 1: no. 46, 3:46 n. 4; Bol, Keyes, and Butôt 1981, 81; Sluijter 1986, 131, 464, illus.; Broos 1993, 195, no. 23

Among the painters in the 1630s and later who were influenced by Poelenburch's Arcadian vision, Diderick van der Lisse was the most gifted. His *Nymphs and Satyrs Dancing before Ruins*, one of the two works he contributed to the Faithful Shepherd (*Il Pastor fido*) series commissioned by Prince

Noble Ideals: Arcadian and Mythological Imagery

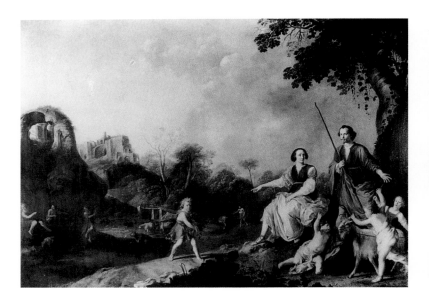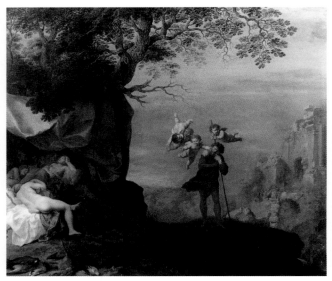

Fig. 1 Diderick van der Lisse?, *Portrait of a Family in Pastoral Costume in a Landscape with Ruins.* Oil on canvas, 110 × 154 cm (43¼ × 60⅝ in.). Location unknown.

Fig. 2 Cornelis van Poelenburch and Alexander Keirincx, *Landscape with Cimon Watching the Sleeping Iphigenia,* 1632–36. Oil on panel, 41.2 × 47.3 cm (16¼ × 18⅝ in.). Centraal Museum, Utrecht, 11137.

Frederik Hendrik in 1635, may be the most evocative pastoral landscape painted by a Dutch artist. In the 1640s Van der Lisse worked in Utrecht, Amsterdam, and The Hague, settling in the last, where he remained. As he came from a wealthy family and his wife was from the lesser nobility, it is not surprising that Van der Lisse took on civic functions appropriate to his patrician social standing, culminating in his becoming burgomaster in 1659. His Arcadian reveries, painted primarily to please the eye, the subjects generally too vague to define,[1] were surely intended chiefly for members of his own class, the aristocracy, or to suit himself. The present amusing picture, so different from the works for the prince or the elegant *Portrait of a Family in Pastoral Costume in a Landscape with Ruins* (fig. 1),[2] may fall into the last category.

A sleeping nymph or, more precisely, a naked or partially undraped woman asleep outdoors and observed by a voyeur—shepherd, satyr, or simply the viewer—was a common subject for artists in Poelenburch's circle. Whether a specific story is intended or none at all, there is always a titillating aspect to it. Not only is the woman vulnerable to surprise, but also the viewer, like any observer in the painting, is free to look and to fantasize without reproach. (Sleep as a prod to sexual fantasy is reversed in Jacob Duck's *Soldiers Arming Themselves* [cat. 34], where it is the sleeper who is presumed to be having the fantasies.)

Whether the present scene is meant to represent a specific subject or simply a general allusion to mythological or pastoral stories to evoke an atmosphere of sexual tension is not clear. The options as established by pictorial precedent can be quickly reviewed. This is not Venus or a basic water nymph, neither of whom handled weapons. Elsewhere Van der Lisse represented the explicitly aggressive subject of a satyr uncovering a sleeping nymph,[3] but these are shepherds who seem uncertain about what they should do next, not satyrs who would know. In the context of mythology, the weapons indicate that this might be either the chaste, virgin huntress, Diana, or one of the nymphs who hunted with her. The angle of the sleeper's head precludes our seeing whether she wears the crescent moon proper to Diana herself. Arcadian shepherds would be aware that to see Diana naked, even by accident as did poor

Actaeon, is to court death. Maybe they, like the viewer, cannot tell without waking the sleeper whether she is Diana or simply a hunting nymph to whom no titillating taboo is attached.

The present composition also draws on one of the tales of sex and intrigue told by Boccaccio in the *Decameron*.[4] (Written about 1350, the *Decameron* was one of the first books to be printed, in 1471. An edition of Dirck Cornherts's partial translation into Dutch, *50 Lustige historien . . . Bocatijj*, was published in 1632.) Jan van Arps's play, *Chimon. Op de Reeghel: Door Liefde verstandigh*, appeared in 1639. The conjunction of these publications may have prompted contemporary interest in the story.[5] The underlying theme is the transforming power of beauty. The protagonist is Cimon, the son of a noble Cypriot, who prefers to live as a rough shepherd but whose sense of self, goals, capacity for judgment, everything in fact, are transformed when he chanced upon the well-born Iphigenia asleep at the edge of a meadow, accompanied by sleeping attendants. Transfixed by her beauty (she had very little on), he is instantly determined to become worthy of her. In consequence Cimon is restored to the natural qualities of his noble rank.[6] In various paintings,[7] among them *Landscape with Cimon Watching the Sleeping Iphigenia* (fig. 2), Poelenburch depicted Cimon leaning on his staff (as he does in the story), looking at the sleepers. There is a drawing of the subject by Van der Lisse.[8] Poelenburch seems to be responsible for introducing the prominent quiver and still life of hunting catch in the foreground and, therefore, the associations of Iphigenia with the noble, chaste huntress, Diana, and her followers.[9]

None of these subjects fits the present painting exactly. Ben Broos has proposed that a more general theme of erotic tension created by spying on an unaware and naked woman underlies this and another very similar painting by the artist.[10] This cogent assessment might be refined: Van der Lisse is here gently mocking his own subject. Our sleeper's head lolls back and her mouth is open;

most people snore in this position. Real people may sleep with their mouths open; refined ladies or deities would not. In this irreverent vein, one might note that she wears gold bangles. Bangles do not fit the image of a serious huntress. Perhaps the viewer was meant to enjoy the discovery that, underneath it all, this may not be an unattainable mythological beauty who is normally in this state of draped undress but rather a flesh-and-blood woman who is usually dressed and who happens to have removed her clothes. Similarly, the so-called nymph in Honthorst's 1623 *Satyr and Nymph* (Art Gallery of Ontario, Toronto, on loan)[11] is not a nymph at all, but an eager young woman, as the telltale embroidered cuff of a sleeve on the shift she has removed makes clear. It has been suggested that the Mauritshuis painting is the one listed in the inventory of the artist's possessions at his death as "a painting with a sleeping woman." Indeed.

The setting includes enough of a hillside with a cave opening at the right to suggest the hilly terrain of the Mediterranean basin. Compositionally, the diagonal around which the picture plane is organized creates just enough instability to lend a sense of energy to the setting and to provide conventional compositional shelter for a recumbent figure.[12] Technical examination indicates that the panel has been cut on the top, bottom, and left edges;[13] this is reflected on the surface in the awkward way the plants are chopped off along the left edge. The palette of soft earth tones suffused with gray complements the modulated salmon of the drapery. Among the works in the present exhibition, the effect comes closest to Poelenburch's *Feast of the Gods* (cat. 53) from the same collection. There are no datable works after the *Pastor fido* series, so it is very difficult to propose a dating.

—J. S.

56 NICOLAUS KNÜPFER
(ca. 1609–1655)

WILLEM DE HEUSCH
(ca. 1625–1692)

Diana and Her Nymphs at the Bath
(also known as *Diana Emerging from the Bath*)

ca. 1645

Oil on panel, 60 × 74 cm (23⅝ × 29⅛ in.)
Signed below medallion on fountain wall: *NKnüpfer*
Prague, National Gallery, DO 4152 (Z 476)

Provenance: Nostitz coll., Prague, documented from 1765 to 1945

Selected References: Parthey 1863, 667, cat. 4; Würbs 1864, 10, cat. 53; Von Frimmel 1889, col. 721; Von Frimmel 1892a, 134; Berger 1905, 29, cat. 116; Von Wurzbach 1906–11, 2:300; Von Frimmel 1910, 6; Renckens 1950, 75; Kuznetsov 1974, 191, cat. 67; Pigler 1974, 2:76; Šíp 1976, 170–71; Šíp 1978, 18, cat. 26; Sluijter 1986, 103, 440 nn. 103–7; Helsinki 1987, 124, cat. 135; Seifertová 1989, 50–51, cat. 31; Seifertová 1993, 228, cat. V/2–44; Slavíček 1994, 56–57, cat. 15

In a wooded mountain landscape with a distant view, a fountain rises beside a pool. It consists of a stone basin for catching the water and a decorated masonry wall. In the foreground at the right, a kneeling nude and a standing half-draped figure are shown undressing a third. Diana, identified as the goddess of the hunt by the silver moon on her head, is preparing to bathe with her nymphs.[1] Adorned with precious pearl necklaces and bracelets, she gazes heavenward in anticipation of the cooling waters. A young, fully clothed woman showers red and white petals over the fountain balustrade onto the figures below. As one of the naked beauties emerges from the water combing her hair, another can be seen swimming on her back. Finally, a woman half-wrapped in an orange robe can be seen attempting to climb into the basin.

The fountain is decorated with a garland of flowers, stretching from one corner column to the other, Diana delicately holding one end. The upper part of the wall is ornamented with a stone medallion with a deer's head and a quiver of arrows, two further attributes of the goddess. The deer's head recalls an episode in the story of Diana in which she turned Actaeon into a deer after discovering him watching her and her nymphs bathing.[2] Here Actaeon's head is made into a particularly witty trophy over the fountain. It is here that the artist —with great assurance if not hubris—chose to place his signature: NKnüpfer.

The scene takes place at the foot of a hill whose ridge divides the picture along the diagonal, leading the spectator into both the natural surroundings and the narrative space. The landscape is illuminated by the invisible, but obviously setting, sun. The mountains in the distance are wrapped in mist. Transparent silhouettes of trees frame the view into the distance at the right and left. A handful of birds soar in the sky.

Diana and her nymphs at the bath had been an increasingly popular subject for painting since the early sixteenth century.[3] Since the content was unsuited to the transmission of either moral or pedagogic values, it is safe to assume that these pictures, produced in large numbers, served a mainly decorative purpose. They furnished hunting rooms, and they clearly provided a source of pleasure for male patrons and viewers. By the second quarter of the seventeenth century, as Dutch self-confidence grew, the mythological aspect of the subject had become a mere pretense.[4]

An examination of Nicolaus Knüpfer's oeuvre—both works that have survived and those that are recorded in the literature—reveals that the artist treated the theme of Diana and her nymphs in only one other painting, this time in the form of a hunting party.[5] In addition, he made a drawing during the preparatory phase of the Prague painting depicting Diana posing in the opposite direction (fig. 1). It is not known if he ever executed a painting corresponding precisely to this drawing, or whether he simply rejected this composition in favor of the solution in the Prague picture. Although Knüpfer was a talented draftsman, it is uncertain how he actually used his own

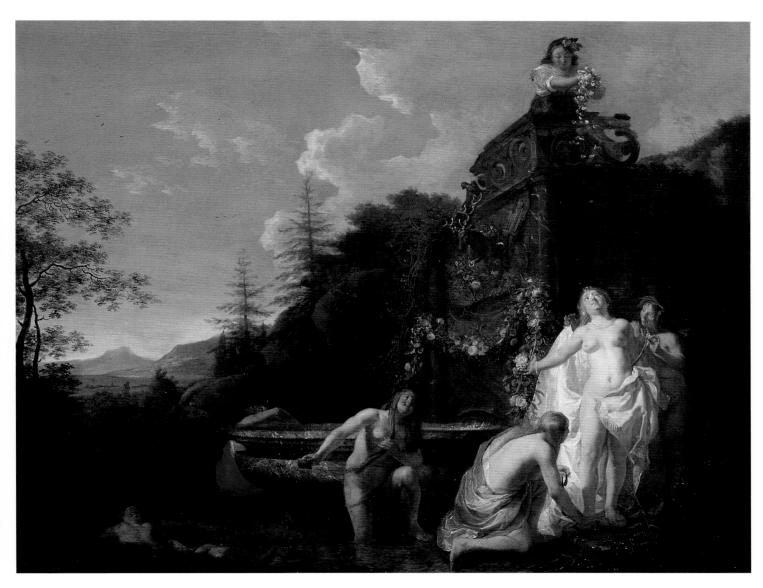

Cat. 56

drawings. Most of his twenty-seven surviving sheets are executed in pen and wash, mostly in brown tones. Some of these sheets are unusually large. We know of only one instance where he used a preparatory drawing for a picture.[6]

Again and again, however, the artist devoted himself to the representation of the female nude.[7] There is a great physiognomic similarity between many of these figures, leading one to suspect that the model—in the present painting as well—was Knüpfer's wife, Cornelia Back from Montfoort,[8] whom he married in 1637 and who was dead already in 1643.[9] We know of many examples of

artists employing their wives as models. The most well known is certainly Rembrandt, who used his two spouses dozens of times in paintings, drawings, and etchings. In addition to being cost-effective, this practice had the obvious advantage that the model was always available. If our assumption is correct—that the artist here represents his wife as Diana—and taking into account the fact that for mortals (such as the viewer) Diana meant death—as she did for Actaeon—then this picture is a particularly charming homage to his deceased wife.

Nicolaus Knüpfer is known as a talented

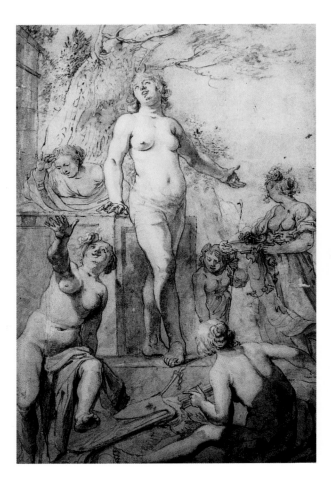

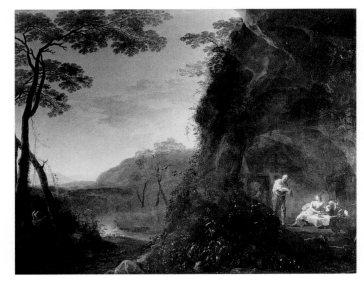

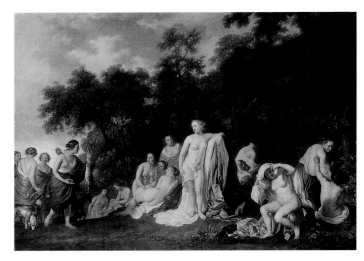

Fig. 1 Nicolaus Knüpfer, *Diana and the Nymphs*. Pen and brush in brown, heightened in white, 313 × 205 mm (12⅜ × 8⅛ in.). Musée Fabre, Montpellier, 1196.

Fig. 2 Nicolaus Knüpfer, Willem de Heusch, and Abraham van Cuylenburgh, *Jupiter and Mercury at the House of Philemon and Baucis*, 1643. Oil on panel, 79 × 102 cm (31⅛ × 40⅛ in.). Signed bottom center: *NKnüpfer / AvC* [Abraham van Cuylenburgh] *1643 / GDH* [Guillaume de Heusch]. Musée des Beaux-Arts, Nîmes, LP1672.

Fig. 3 Jacob van Loo, *Diana and Her Nymphs*, 1644. Oil on canvas, 97.5 × 132 cm (38⅜ × 52 in.). Statens Museum for Kunst, Copenhagen, 1876 (1922 catalogue, no. 344).

figure painter. He was particularly fond of demonstrating his ability through skillful anatomical foreshortening, as here in the strongly foreshortened thigh of the nymph emerging from the water. Painting a head thrown back in the manner of Diana's also requires practice and great proficiency. As confident as he was in the area of the human body, however, he was much less sure of himself when it came to the depiction of landscape, and

this explains the presence of a second hand in the work under discussion. It is most likely—and stylistic comparison confirms—that the painter here was Willem de Heusch,[10] a pupil of the already famous Jan Both and like him a successful landscape painter who had traveled in Italy. It was not unusual for a number of artists to cooperate on one painting.[11] In the case of Knüpfer and Heusch there is even one documented instance. A picture in Nîmes, *Jupiter and Mercury at the House of Philemon and Baucis* (fig. 2), is signed not only by both Knüpfer and De Heusch but also by a third artist, Abraham van Cuylenburgh. Heusch was responsible for the landscape, Knüpfer for the figures, and Cuylenburgh for the cave in which the

characters have gathered around a table. In addition, De Heusch himself painted a *Diana and Her Nymphs* in a landscape at least once.[12] Here we find trees with sketchy foliage similar to those seen in the Prague painting.

The picture in Nîmes, executed in 1643, is also useful in dating the Prague *Diana*. Knüpfer's technique is not yet as refined as it would be in later years and is in fact quite similar to that found in our picture, making an attribution to the mid-1640s plausible. This dating is also favored by a 1644 painting of the same subject (fig. 3) by the Amsterdam artist Jacob van Loo, which exhibits a similar linking of landscape and figure and which, like Knüpfer's panel, was stylistically on the level of the latest development of his time.

Knüpfer's position in the art of Utrecht in the second quarter of the Golden Age is not easy to describe, in part because he arrived in the city as an adult. Although he is documented as having joined Abraham Bloemaert's workshop for some time, his work shows little influence of any particular artist. Some iconographic and compositional similarities with Jan Steen, who may have been his pupil, are obvious. In addition, stylistic similarities with works by Dirck Stoop have on occasion led to some confusion. Knüpfer's style is very self-defined and mature. He must have been acquainted with what remained of the Utrecht Caravaggisti by the time he arrived in Utrecht. As we learn from this picture in particular, despite the fact that he was a foreigner, he appears to have been an integral part of the art community.

Only a small fraction of his paintings appear to have been commissioned. The majority of his works represent mainstream subjects, which must have been absorbed by the steady art market in the city.

—M. R.

57 GERARD VAN HONTHORST
(1592–1656)

Granida and Daifilo

1625

Oil on canvas, 144.7 × 179 cm (57 × 70½ in.)
Signed and dated at lower right: *GH* [in monogram] *onthorst . fesit 1625* and *Nr 110*
Utrecht, Centraal Museum, 5571

Provenance: possibly from the coll. Stadholder Frederik Hendrik, prince of Orange, and Amalia van Solms, Honselaarsdijk Palace, 1625–75; coll. Stadholder Willem III, prince of Orange, Honselaarsdijk Palace, until 1702; on the verso, in the center of the original canvas but now hidden by the lining canvas: the crowned monogram of Willem III / *N°. 41;* coll. Frederick I of Prussia and his heirs, Honselaarsdijk Palace, 1702–46, Schloß Berlin (Berlin), 1746–1856 (Berlin or elsewhere), until 1918 or later; with Dr. Benedict & Co. (Berlin), 1927; coll. J. J. M. Chabot, Brussels, 1927; lent by J. J. M. Chabot, Brussels, to the Centraal Museum, Utrecht, 1927–43; purchased from the estate of J. J. M. Chabot with the assistance of the Vereniging Rembrandt, 1943

Selected References: Judson 1959, 93 nn. 1, 3, 100–101, 105, 118, 215, cat. 132, 219, fig. 38; Braun 1966, 38, 51 n. 1, 66, 99–100, 200–202, cat. 62; Börsch-Supan 1967, 178, fig. 36, 198, cat. 127; Kettering 1983, 2, 8, 104–107, 112, 166 n. 49, 183, 189, fig. 156; Blankert and Slatkes 1986, 20, 24, 38, 122 n. 8, 188, 190 n. 1, 252, 300–302, cat. 67; De Meyere 1988a; De Meyere 1989, 93–96; Van den Brink and De Meyere 1993, 21, 24–26, 29, 132, 172, figs. 172–76, cat. 27, 180

Baltimore and London only

The scene in this masterpiece by Gerard van Honthorst is taken from a pastoral play, *Granida,* by Pieter Cornelisz. Hooft. Completed in manuscript form in 1605 and first published in 1615, the play was one of the most popular pastorals in Dutch literature. It tells of the love between the beautiful Persian princess Granida and the shepherd Daifilo. The two meet by chance when Granida loses her way out hunting.

She has come to abhor the corruption and dishonesty at court, and idealizes the rustic existence of shepherds as a life where only true feelings count. She sees Daifilo as the embodiment of this pure and lofty ideal, and immediately falls in love with him. When they first meet he gives her a

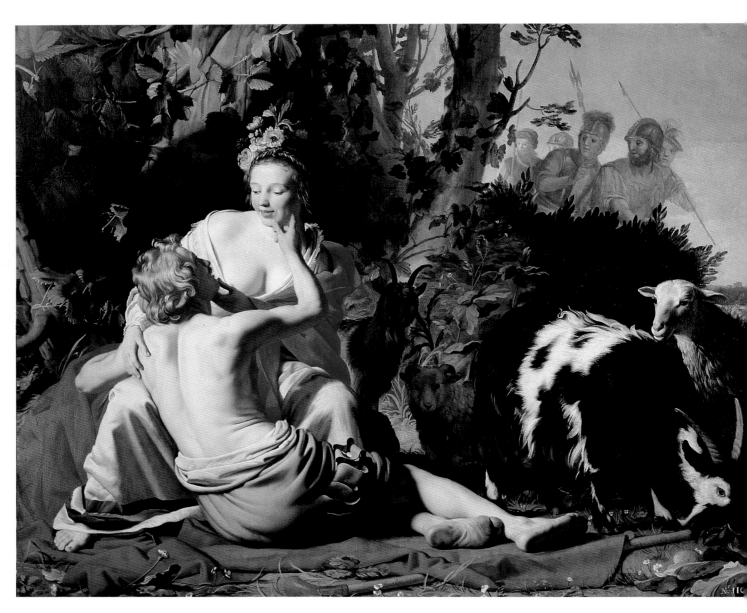

Cat. 57

drink of water from a shell, and she takes him back to her father's palace. There he becomes the servant of Tisiphernes, a courtier who is vying for Granida's hand. Another suitor is Prince Ostrobas, who challenges Tisiphernes to a duel to settle the matter. The victor is Daifilo, who had donned his master's armor. He and his beloved Granida flee the court in order to live simple but idyllic lives as shepherds in Arcadia. On their way there they are ambushed by one Artabanus, who is determined to avenge the killing of his friend Ostrobas.

This is the moment depicted by Honthorst. The soldiers have crept up on the lovers unno-ticed, for they have eyes only for each other. Daifilo exclaims:

> My sun, brighter than the other
> I hold you in my arms and wonder whether it
> is true.
> My soul is so moved, alas, that I cannot enjoy
> The boundless joy to the full.
> I scarce believe my state has risen so high,
> And constantly think that perhaps I am not
> Daifilo at all.[1]

The story has a happy ending. Tisiphernes appears and fights alongside Daifilo, vanquishing

Artabanus. The couple's love so moves the king that he gives his blessing to their marriage.

By showing the flight of Granida and Daifilo to Arcadia, Honthorst chose one of the few pastoral scenes in the play, for much of the action takes place in or around the royal palace. It was an unusual choice.[2] Most artists preferred the first meeting between Granida and Daifilo, when he gives her a drink of water. One was Honthorst's colleague in Utrecht, Dirck van Baburen, whose *Granida and Daifilo* of 1623 is the earliest depiction of the opening scene of the play (fig. 1).[3]

Honthorst, who became famous for his Caravaggist work, demonstrates with this painting that he was also a full-fledged and important classicist. In this love scene, there are no chiaroscuro effects, no shallow, neutral backgrounds, and no half-lengths. The evenly lit, balanced composition with two large, full-length figures in a landscape is an out-and-out classicist work with bright, cool colors, an even handling of line, sharp contours, a refined use of detail, and an idealized depiction of the figures.

The dirty soles of Daifilo's feet alone testify to the lingering influence of Caravaggio. It is a simple fact of life that shepherds who go around barefoot get their feet dirty. The priests of S. Luigi dei Francesi in Rome rejected the altarpiece they had commissioned from Caravaggio in 1602 in part because Saint Matthew was extending a bare, dirty foot toward the celebrant and the congregation. The Italian master then painted a second version for the Contarelli Chapel in which the Evangelist did observe the rules of decorum.[4] The question of decorum, of course, was of little if any concern to Honthorst, who was portraying a shepherd, not an evangelist.

The provenance of the painting is largely known until the eighteenth century. Until 1702 it belonged to Stadholder Willem III, the owner of Honselaarsdijk Palace.[5] It is mentioned in a palace inventory dated 1707 as item number 110: "Overmantel by Honthorst, being the fable of

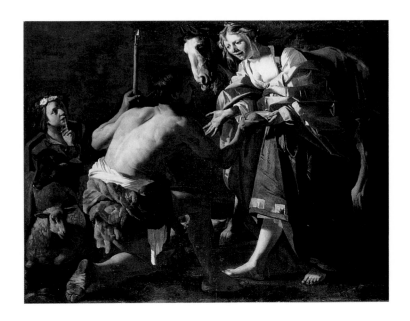

Fig. 1 Dirck van Baburen, *Granida and Daifilo*, 1623. Oil on canvas, 165.7 × 211.5 cm (65¼ × 83¼ in.). Private collection.

Angelica and Medoro from Ariosto . . . [in] His Majesty's antechamber on the ground floor."[6] That inventory number is marked on the lower right corner of the picture, but knowledge of the true subject had evidently been lost.[7] It was not until 1928–29 that Wolfgang Stechow identified it as a scene from Hooft's *Granida*.[8]

In the year the painting was completed, the ground floor of the palace consisted of a central hall giving onto the apartments of Prince Frederik Hendrik and Amalia van Solms. It is not known whether the work was already hanging there in 1625, but there is a good chance that it was. There is an attractive hypothesis that it was painted for the marriage between Frederik Hendrik and Amalia van Solms in 1625. A picture of an idyllic love affair would have made an ideal wedding present. If, however, it had been hanging in the stadholder's apartment before 1707, and before that in Frederik Hendrik's, it could not have been a gift from the prince to his bride, or it would have been in her apartment. It must, instead, have been a gift from some nobleman acquainted with the pastoral mode that was flourishing at the time.[9]

—L. M. H.

58 GERARD VAN HONTHORST
(1592–1656)

Allegory of Spring
(also known as *Allegory of Love*)
ca. 1624–26

Oil on canvas, 129.5 × 112 cm (51 × 44 in.)
Munich, Arnoldi-Livie

Provenance: private coll., Hamburg, by 1966; sale,
Kunsthaus am Museum-Carola von Ham (Cologne),
20–23 Mar. 1991, lot 1070, pl. 17; with Arnoldi-Livie
(Munich)

Selected References: Van der Brink and De Meyere 1993, 11,
no. 28, illus.; Judson 1995, 128–29, illus.[1]

Decorative, convivial, and lusciously colored,
this pastoral allegory is quintessential Honthorst.
Once back in Utrecht, Honthorst increasingly
replaced the tenebrist effects of his early pictures
with a gentle, diffused lighting in a paler palette.
The sheer pleasantness of such compositions as
this *Allegory of Spring* makes it no surprise that
pastoral art found favor among the patriciate in
Utrecht and the court of Prince Frederik Hendrik
in The Hague, as well as among courtiers and
aristocracy across Europe. Scenes of pretty shep-
herdesses and their swains engaged in music and
dalliance and removed from the realities of con-
temporary life provided a pleasing respite from
the formalities of court. Honthorst followed a
long-established tradition, both literary and artis-
tic, manifest in Italy's cultural centers during
the early Renaissance, and spreading throughout
Europe in subsequent centuries. In the seven-
teenth century, this bucolic idiom found a particu-
larly Dutch voice in the pastoral poetry, theatrical
works, popular folk songs, and emblematic litera-
ture of the period.[2]

Dutch artists adapted the established cast of
figural types to serve the specific needs and taste
of Dutch society (cats. 60, 61). Widely conversant
in pastoral imagery, Honthorst painted single pas-
toral figures, portraits casting the sitter in pasto-
ral guise, and scenes based on specific passages

from pastoral literature. His *Granida and Daifilo*
(cat. 57) of 1625, with characters borrowed from
Pieter Cornelisz. Hooft's play *Granida*, is one of
the most important Dutch pastoral works of the
period. While postdating Baburen's depictions of
the scene,[3] Honthorst's artistic temperament is
more sympathetic to the sensual pastoral figures
he portrays. Following an international vogue,[4]
such decorative paintings were commissioned by
enthusiasts in the Dutch Republic. Collectors
included the stadholder, Prince Frederik Hendrik,
and his wife, Amalia van Solms, who owned Hont-
horst's *Granida and Daifilo*, as well as a "chimney-
piece with shepherdesses," by Honthorst cited in
the 1632 inventory of their household possessions.[5]

Always a figurative artist, Honthorst keeps
the landscape details in the Munich *Allegory of
Spring* to a minimum; an abbreviated tree, painted
like a stage flat, provides the only setting. Yet this
is sufficient to transport his players to some dis-
tant *locus amoenus*, a "pleasant place," which is the
required setting for pastoral encounters.[6] The
Munich painting shares this pictorial device with
other works by the master, including the *Shepherdess
Adorned with Flowers* (1627; Seattle Art Museum),[7]
and a *Pastoral Concert* (fig. 1) of 1629.[8] Drawing on
the pastoral vocabulary for their subjects, these
paintings also exhibit similarities of compositional
arrangement, spatial development, figural type,
and blond decorative color scheme, forming a dis-
tinct group in Honthorst's oeuvre.

The present *Allegory*, however, lends itself to
a more complex iconographic reading than do the
generic shepherd and shepherdesses in the other
two pictures. Rich in images whose multileveled
meanings would have been appreciated by the
seventeenth-century viewer, the Munich picture
has been interpreted as an allegory of Spring—
the young flower-bedecked woman, the personifi-
cation of the season, welcoming the appearance
of the warm winds of winged Zephyr, who bears
flowers and herbs, as enumerated in Cesare Ripa's
Iconologia.[9] Forming a circle of supple poses, the

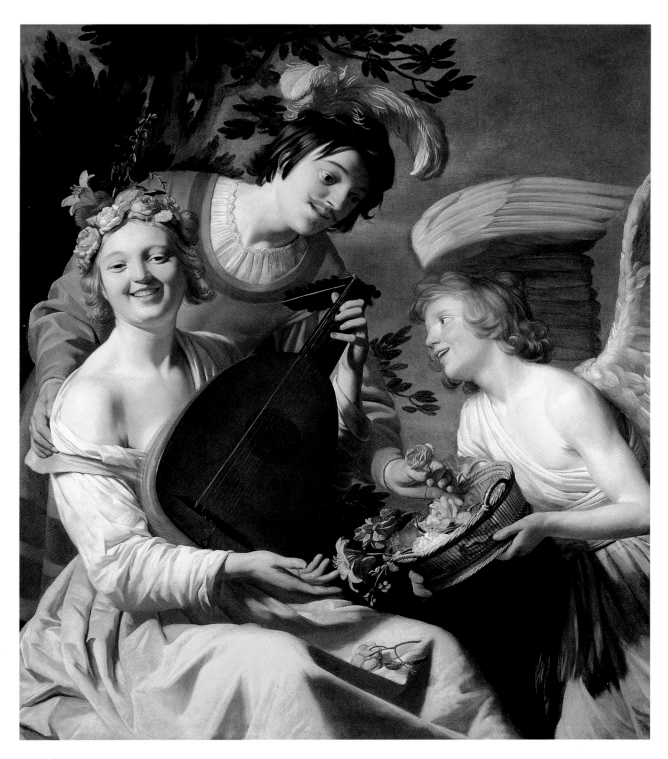

Cat. 58

figures are linked by rhythmic gestures that explain their interrelationship. The principal figure, a lovely fair girl with the characteristic Honthorst gummy grin, confronts the viewer good-naturedly as she acknowledges a winged youth with a basket of flowers. She is joined by a solicitous male companion, who picks a rose for her from the offered basket,[10] creating a counterbalance to the inclined position of the blond boy.

J. Richard Judson's most recent interpretation, reading the symbolism of the various figures as an allegory of Love, seems particularly convincing.[11] Of foremost importance for this reading is the prevalence of summer roses, woven into the lady's hair, filling the basket held by the shepherd, and strewn in her lap. The roses, the very symbol of love, are depicted without their wounding thorns: This is a scene of harmony, as is further suggested by the young girl's musical instrument. The appearance of the lute in themes of love was a commonplace by Honthorst's day. For example, it is a lute that Cupid holds while pointing to a courting couple in the distant landscape in Crispijn van de Passe the Elder's engraving of 1611, *Amor Docet Musicam* (Love teaches music; fig. 2).[12] As summarized by Judson,[13] the lute had several standardized meanings within Dutch emblematic literature of the day, ranging from promiscuity and the female genitalia to harmony. But assuredly, this is not the realm of the music-playing courtesan seen in so many of Honthorst's paintings (for example, Franits, fig. 7, in this catalogue), but rather the idealized pastoral realm of poetic harmony and sensual pleasure. Within the context of such a reading, Honthorst's winged figure is immediately identifiable as Cupid, who comes forth to facilitate the encounter between shepherdess and swain.

—L. F. O.

Fig. 1 Gerard van Honthorst, *Pastoral Concert*, signed and dated 1629. Oil on panel, 113 × 95 cm (44½ × 37⅜ in.). Museum der bildende Künste, Speck von Sternburg Collection, Leipzig, 1616.

Fig. 2 Crispijn van de Passe the Elder, *Amor Docet Musicam* (Love teaches music). Engraving, from Gabriel Rollenhagen, *Nucleus Emblematum* (Cologne, 1611; Utrecht, 1613). Koninklijke Bibliotheek, The Hague.

Cat. 59

59 ABRAHAM BLOEMAERT
(1566–1651)

Amaryllis and Mirtillo

1635

Oil on canvas, 115.3 × 140.4 cm (45⅜ × 55¼ in.)
Berlin, Stiftung Preußische Schlösser und Gärten
Berlin-Brandenburg, GK I 3833

Provenance: Honselaarsdijk, 1694, 1707, and 1719; trans-
ferred to Berlin and Potsdam palaces, 1742; Jagdschloß
Grunewald, since 1932

Selected References: Börsch-Supan 1967, no. 121; Van den
Brink and De Meyere 1993, no. 12 (with extensive litera-
ture); Roethlisberger 1993, no. 513; Seelig 1997a, no. B162

London only

Amaryllis and Mirtillo is one of a series of four
paintings illustrating Giovanni Battista Guarini's
Pastor fido, a play first staged in 1585 at the wed-
ding of Duke Charles Emmanuel of Savoy with
Catharina of Austria. Bloemaert's picture shows
the happy end of the play, the wedding by which
the state of peace and absence of sin is restored
to Arcadia. The play was enormously popular
all over Europe and was translated time and again.
A Dutch translation, by no means the first one,
was done by Hendrick Bloemaert in 1650, its po-
etry being praised by Joost van den Vondel and
others.[1] But already in 1623 Constantijn Huygens,
secretary to Frederik Hendrik, had published a

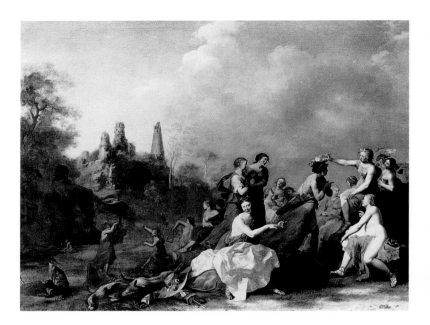

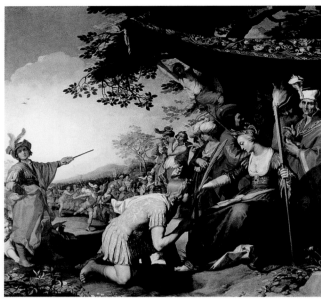

Fig. 1 Cornelis van Poelenburch, *Amaryllis Crowning Mirtillo*, 1635. Oil on canvas, 116.5 × 148.5 cm (45⅞ × 58½ in.). Gemäldegalerie, Staatliche Museen zu Berlin-Preußischer Kulturbesitz, 956.

Fig. 2 Abraham Bloemaert, *Theagines Receiving the Palm of Victory from Chariclea*, 1626. Oil on canvas, 157.5 × 159.5 cm (62 × 62¾ in.). Mauritshuis, The Hague, 16.

translation of parts of the play.[2] According to the inventory of 1694, Bloemaert's painting was part of a fixed installation in a room in Frederik Hendrik's palace at Honselaarsdijk that combined four scenes of *Il Pastor fido* with four landscapes of the same width but much lesser height probably mounted below them.[3] Today they are, sadly, divided between two different institutions in Berlin. The scenes are by Diderick van der Lisse, Cornelis van Poelenburch (fig. 1), Herman Saftleven (with figures by Hendrick Bloemaert; see Spicer, introduction to this catalogue, fig. 15), and Abraham Bloemaert; the landscapes, only three of which survive, are by Adam Willarts, again Diderick van der Lisse (see Spicer, introduction to this catalogue, fig. 20), and Gillis de Hondecoeter. But even this room at Honselaarsdijk cannot have been the original setting since it was built in the 1640s, long after the pictures had been painted, and it included paintings of the 1690s as well. Therefore, the arrangement as given in the 1694

inventory must be seen as a reuse of the series, with later additions perhaps replacing some losses.[5] But the identical date 1635 on one of the landscapes (Willarts) and one of the *Pastor fido* scenes (Saftleven), as well as the same width, make it very likely that at least these eight paintings by altogether probably nine artists also originally belonged together.

This was not the only case in which official commissions were given to have paintings done by different artists and combined to form a series. Of these series the one with the twelve emperors (see cat. 28) is the most haunting because of the number and status of the artists involved and because nothing is known about the commissions. In the great hall of Honselaarsdijk Palace a beautiful Rubens *Diana Resting after the Hunt* was combined with other Diana pictures by Christiaan Couwenbergh, Jacob van Campen, and Paulus Bor,[6] but this may not have been a deliberate combination; a whole room full of Rubens paintings would certainly have been preferable but was not obtainable. (Strangely enough, there were at least three paintings of Diana at Honselaarsdijk by the court painter Gerard von Honthorst, but none was used for this purpose.[7]) The greatest of all Dutch series, if it may be treated as such, is surely

the furnishing of the central hall of the Huis ten Bosch as a monumental epitaph for Frederik Hendrik after his death in 1647. This project once again involved painters from both the Northern and Southern Netherlands.[8] The grand-scale commissions given by the Danish king Christian IV to Danish, German, and Netherlandish painters—of which the so-called Rosenborg (1620s) and Kronborg series (1630s) are best known—are also to be seen in this tradition.

Frederik Hendrik for his part, in 1625 successor to Maurits as stadholder, was an admirer of French court culture as he had witnessed it in his youth at the court of his godfather Henri IV. One of his first commissions for paintings as stadholder must have been the first of Bloemaert's *Theagines* pictures dating from that year; the second one, *Theagines Receiving the Palm of Victory from Chariclea* (fig. 2),[9] was painted the following year. With this series Frederik Hendrik intended to echo the series by Ambroise Dubois in Fontainebleau. The *Theagines* pictures illustrate another favorite literary work, though of antique origin, with similar Arcadian implications: Heliodorus's *Aethiopica*. In the three paintings from 1625, 1626, and 1628 Bloemaert can be seen to develop, in close accord with Honthorst, not only a classicist style playing at times with Caravaggesque elements, but also an iconography that centered on the pastoral, or more precisely Arcadian, idyll.[10] The fusion of genre elements and portraits with literary and historical scenes resulted in a remarkably concise and complex art, one that has only recently been given the attention it deserves, since it did not fit into the view of Dutch art inherited from the nineteenth century. There has never been a doubt with scholars, though, that this "Dutch" court art was mainly practiced by Utrecht artists.[11]

Bloemaert's *Amaryllis and Mirtillo* is a happy example of this court style, since it combines an idyllic air and genre figures with the literary subject, personified only by the two main actors and underscored by the quasi-classical temple architecture in the middle distance to the right. The overstretched proportions of this architecture as well as that of some of the smaller figures are the only details betraying the painter's age, almost seventy, since they must have been executed by a hand of more modest abilities.[12] In the skillfully simplified composition the terrain falls away so steeply that only a very abbreviated background landscape is needed, and the colorful main figures, therefore, appear silhouetted against the gray but serene sky. They are seen slightly from below and possess dimensions that are just a little bigger than the other figures, which imbues them with a monumentality fitting the subject.

Bloemaert apparently kept his study drawings together and made use of the same motifs over a period of decades, so that a single motif cannot give a sufficient clue for dating a painting.[13] In this case, however, a remarkable number of details can be found in contemporary works of the painter: the head of the female figure turning her back appears in *Landscape with the Expulsion of Hagar* (private collection) of the same year.[14] In 1638 the female figure behind Mirtillo reappears as Ceres, one of the main figures in The Hague *Wedding of Peleus and Thetis*, this last reformulation of a favorite mannerist subject (cat. 46, fig. 1). Finally, the head of Amaryllis can be found not only as Juno's in the same painting but is used for Apollo's in the large, late *Judgment of Midas* in Berlin,[15] giving another clue to this picture's dating, if any more were needed.

By its simplicity and clearness, the composition of Bloemaert's *Amaryllis and Mirtillo* has a much greater force than the other three contributions to the cycle. As was the case with his first commission by the stadholder, when he was preferred to the court painter Honthorst for a literary subject, a decade later Bloemaert was still a good choice for a figure painter.

—G. S.

60 CORNELIS VAN POELENBURCH
(1594–1667)

Portrait of Jan Pellicorne as a Shepherd
1626?

Oil on copper, 9.8 × 7.6 cm (3⅞ × 3 in.)
Monogrammed at the left: *C.P.*
Baltimore, The Walters Art Gallery, 38.226

Provenance: Valckenier-Pellicorne family; A. I. Valckenier, 1731–84, by inheritance; Stefan von Anspitz, Vienna; with K. W. Bachstitz (The Hague), 1938; gift of A. J. Fink Foundation, Inc., in memory of A. J. Fink, 1963

Selected References: Bridgman et al. 1965; Wilson 1980, no. 61, 62; Sluijter-Seijffert 1984, 110, 244; Bruyn et al. 1986, 2: under no. C65; Van den Brink and De Meyere 1993, under no. 10; Spicer 1997c

Jan Pellicorne (1597–after 1653), a wealthy Amsterdam merchant, and Susanna van Collen (1606–ca. 1637) were married 17 February 1626.[1] It was most likely in celebration of this event that this delicate miniature and its pendant were commissioned. For a discussion of their execution, see *Portrait of Susanna van Collen as a Shepherdess* (cat. 61). These pendants are the earliest identified portraits of a married couple in pastoral costume,[2] a type of *portrait historié* that seems to have first been developed by painters in Utrecht for the social elite—these two were members of the regent class—and then adopted by painters elsewhere in the Dutch Republic. The potential importance of these portraits for this theme has escaped previous attention.

The young couple are represented in the fanciful, romantic garb of make-believe shepherd and shepherdess. His leopard-skin cape slung casually over a type of gathered shirt and jacket with slashed sleeves associated with gallants or soldiers, the strap across his chest, presumably attached to a quiver of arrows, and tousled hair all suggest manly bravado. The presence of his demure companion and his own fashionable, tended mustache and goatee and rather tentative facial expression make it clear that this is a gentleman in disguise. Her loose blouse, striped silk scarf, and the pearls

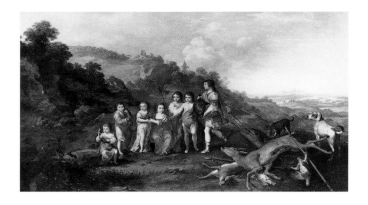

Fig. 1 Cornelis van Poelenburch, *Portrait of the Children of the King and Queen of Bohemia in a Landscape*, 1628. Oil on panel, 38 × 65.3 cm (15 × 25¾ in.). Museum of Fine Arts, Budapest, 381.

in her uncapped, loosely filleted hair would suggest to contemporaries an escape from societal expectations to the imaginary, carefree life of simple (but elegant) shepherds. Such allusions look back to the poet Virgil and contemporary plays drawing on his themes in celebrating the carefree lives of shepherds in a romantic, make-believe distant past in Arcadia, where they spent their time languidly tending their sheep, making music, and wooing their sweethearts; see Spicer, introduction to this catalogue.

The only comparable portrait that can be dependably attributed to Poelenburch is his 1628 *Portrait of the Children of the King and Queen of Bohemia in a Landscape* (fig. 1),[3] of which a replica or copy also dated 1628 was sent to Charles I of England and Henrietta Maria by the queen of Bohemia, Elizabeth Stuart, sister of Charles, who was living in exile in The Hague.

Only a few pastoral portraits precede these, and no earlier pastoral portraits of a couple have been identified. Nevertheless, it is unlikely that Poelenburch, by whom no earlier portraits are known and whose well-known depiction of nymphs bathing (see cat. 54) follows a different tradition, devised this romantic application of the pastoral theme to marriage portraits. The originator of this form was probably Gerard van Honthorst, when he was working for the queen of Bohemia in The Hague. After the Baltimore pic-

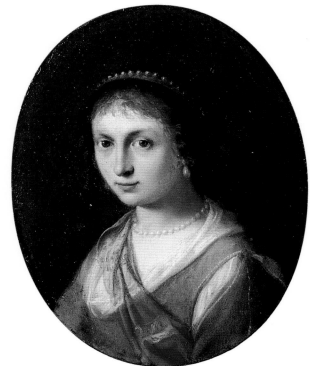

Cat. 60

Cat. 61

tures, the earliest recorded portraits of a married couple in the pastoral mode are those (now lost) by him of Charles I and Henrietta Maria as shepherd and shepherdess,[4] probably painted shortly after Honthorst arrived in London in the summer of 1628. He went with the recommendation of his patroness, Elizabeth Stuart, whose husband, Frederick of Pfalz, the exiled king of Bohemia, is, in Roman attire, the subject of a fine portrait by Honthorst (cat. 27). Elizabeth's delight at receiving copies of these portraits is described in a letter she wrote from The Hague in 1628.[5] A date of 1628–30 has also been proposed for another portrait from Honthorst's shop for a member of the queen of Bohemia's circle, *Catharina Elisabeth von Hanau as a Shepherdess* (fig. 2). Other portraits of the family in a pastoral or "antique" mode ensued.

The use of a pastoral mode for marriage portraits had special significance because it highlighted the role of romance and love rather than duty in marriage.[6] Its novelty at this time brings home how recent is the association of love in its

combination of affection and desire as an accepted aspect of marriage. Such associations might suggest that some of these portraits commemorate a betrothal; in the case of the Baltimore portraits, this is surely not the case. In a representation of a betrothed couple, their positions on the left and right would normally be reversed. One form of the decorum consequent to the traditional social superiority of men over women was that the man should take the right-hand position of precedence when in public with his wife. Indeed, a woman who did not know her place was referred to as "trying to take the right side."[7] In portraits of couples this hierarchy is expressed through the husband's place on the heraldic right, as in the present portraits. During courtship, a man of breeding was expected to cede his natural right to precedence and to offer his intended the position on his right.[8]

The romantic masquerade of Poelenburch's portraits can be contrasted with the aura of everyday responsibilities and material rewards conveyed by Paulus Moreelse's contemporary portraits of

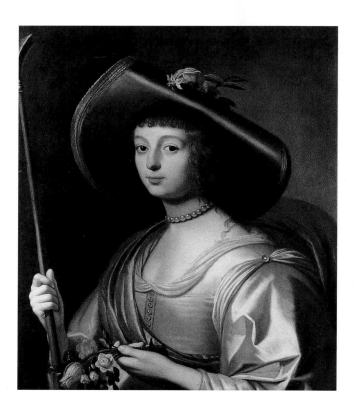

Fig. 2 Gerard or Willem van Honthorst and workshop, *Portrait of Catharina Elisabeth von Hanau as a Shepherdess*, 1628–30. Oil on canvas, 72.8 × 60 cm (28⅝ × 23⅝ in.). The Walters Art Gallery, Baltimore, 37.2457.

members of the Strick family, dated 1625 (cat. 29 and cat. 29, fig. 1). After some six years of marriage and two children, Jan Pellicorne and Susanna van Collen commissioned a similarly imposing pair of portraits (Wallace Collection, London)⁹ from an Amsterdam artist in Rembrandt's circle. Surely intended for reception rooms, those portraits, with their conventionally restrained, if expensive, regent-class attire, serious facial expressions, and the presence of their son and daughter next to their chairs, convey the couple's wealth and social position in a public way. The Walters miniatures descended in the Pellicorne family and were surely made as intimate, personal mementos for the young couple to be displayed (the ebony frames are thought to be original) in the type of private room called a *cabinet*,¹⁰ so one can imagine the couple's treasuring Poelenburch's miniatures as reminders of a more lighthearted time in their lives.

—J. S.

61 CORNELIS VAN POELENBURCH
(1594–1667)

Portrait of Susanna van Collen as a Shepherdess
1626?

Oil on copper, 9.8 × 7.6 cm (3⅞ × 3 in.)
Signed: Traces of a monogram near the middle
right edge
Baltimore, The Walters Art Gallery, 38.227

Provenance: Valckenier-Pellicorne family; A. I. Valckenier, 1731–84, by inheritance; Stefan von Anspitz, Vienna; with K. W. Bachstitz (The Hague), 1938; gift of A. J. Fink Foundation, Inc., in memory of A. J. Fink, 1963

Selected References: Bridgman et al. 1965; Wilson 1980, no. 61, 62; Sluijter-Seijffert 1984, 110, 244; Bruyn et al. 1986, 2: under no. C65; Van den Brink and De Meyere 1993, under no. 10; Spicer 1997c

The pendant paintings of Jan Pellicorne and Susanna van Collen are Poelenburch's finest and earliest known portraits.¹ The pair can be dated to 1626—after the couple's marriage in that year and most likely before the birth of their first child that December—on the basis of their apparent age here in relation to that in later portraits and with recognition of the appropriateness of the pastoral theme for "young marrieds" (for which see the preceding entry). The artist's earlier paintings are represented here by his *Landscape with the Flight into Egypt* from 1625 (cat. 68).

From technical examination it can be established that Poelenburch initially painted the couple in everyday attire and only afterward introduced the pastoral costume. In the early 1960s it was observed that, when the portrait of Susanna was examined in a raking light (a light from the side), there was a profile of an underlayer of paint unrelated to the surface layer. The electron-emission radiograph taken and published in 1965 (fig. 1)² revealed subsurface details of the paint layers. The sitter was originally portrayed with a starched ruff collar and a lace cap, and her hair was pulled back from her forehead.³ Recent electron-emission radiographs taken of her husband indi-

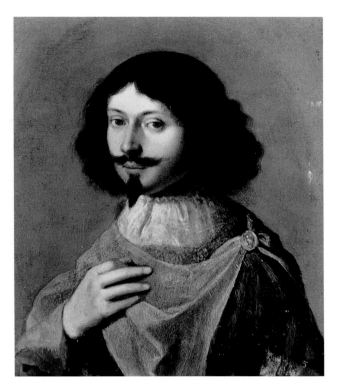

Fig. 1 Electron-emission radiograph (printed in reverse) of *Portrait of Susanna van Collen as a Shepherdess.* The Walters Art Gallery, Baltimore, 1965.

Fig. 2 Cornelis van Poelenburch, *Portrait of a Man in a Classical Mantle (Frederick, King of Bohemia?)*, 1630s? Oil on copper, 12.9 × 10.6 cm (5⅛ × 4⅛ in.). With Lindsay Fine Art, London.

cate that he was originally painted with a white collar and neatly combed hair.[4]

Poelenburch presents the sitters in the conventional format for bust-length marriage portraits from this period, angled toward each other and united by a common light source, the traditional one from over the painter's left shoulder. The delicate tonal orchestration of a rich range of gray green, olive, ochers, and dark brown set off by vibrant passages of salmon in her silk scarf and his slashed sleeve is unparalleled in the artist's later portraits as is the exquisite finesse of execution in both portraits, seen for example in the band of reflective light introduced under Susanna's chin to accentuate the curve. Poelenburch's choice of copper for the support was surely intended to contribute to the enamel quality of the surface, so desirable in an object intended for close study.

Although the execution does not rival that of the Baltimore pair, a single portrait that can be compared to these is the previously unpublished *Portrait of a Man in a Classical Mantle (Frederick, King of Bohemia?)* (fig. 2). The intended visual field was also oval, and again the artist visibly altered the neck of the subject's costume. The sitter's pose, angled toward his right, and the gesture of the right hand on his heart, a graceful if conventional expression of fidelity, probably signify that this sentimental and intimately scaled portrait was addressed to the person for whom it was commissioned, most likely the subject's wife, and had no painted companion. If this is Frederick (for whom, see Honthorst's portrait, cat. 27), it would have been intended for his wife, Elizabeth Stuart, and perhaps even commissioned after his death in 1632.

The *Portrait of Susanna van Collen* can be compared to Poelenburch's only known dated portrait from the 1620s, his 1628 *Portrait of the Children of the King and Queen of Bohemia in a Landscape* (cat. 60, fig. 1). In portraying both the young wife, Susanna, and these small children, the artist subtly enlarged

their dark eyes set in softly featured faces to convey wide-eyed childish innocence and vulnerability.

Most of Poelenburch's remaining portraits are from the 1640s and early 1650s, the majority painted between 1644 and 1651 for Willem Vincent, baron van Wyttenhorst, of his family. Formerly in the collection of Schloß Herdringen, these paintings are now in the Westfälisches Landesmuseum, Münster. [5]

—J. S.

62, 63 JOACHIM WTEWAEL
(1566–1638)

A Shepherdess

ca. 1623

Oil on circular panel, diam. 49.5 cm (19½ in.)
Signed on the staff: [———] wael fec

A Shepherd

1623

Oil on circular panel, diam. 49.5 cm (19½ in.)
Signed and dated on the staff: *Jo* [in monogram] *wte wael fe 1623*
Cambridge, Massachusetts, Courtesy of the Fogg Art Museum, Harvard University Art Museums, Melvin R. Seiden Purchase Fund in honor of William W. Robinson, 1992.59 and 1992.60

Provenance: sale, Sotheby's (London), 7 Oct. 1981, lot 15; with P. and D. Colnaghi and Co. (London), 1981–85; sale, Christie's (New York), 15 Jan. 1985, lot 16; with Seiden & de Cuevas, Inc. (New York)

Selected References: Lowenthal 1986, 150, A-86, A-87 (with earlier literature), pls. 120, 121; Buijsen and Grijp 1994, 205

The smiling young woman and her pendant companion represent Arcadian fantasies, in vogue in Utrecht in the 1620s, featuring pastoral figures in half-length. Both figures hold staffs and other accoutrements that identify them as a shepherd and shepherdess, but they are hardly rough-and-tumble peasants. She has evidently arranged loose sprays of flowers and berries beneath the wide brim of her straw hat. Her mauve and gold

chemise and red cloak have ever so casually slipped from one shoulder. The bagpiper's blue-green and red cloak are also worn with panache, and the feathers stuck into his hat brim are neatly tied with a crimson bow. His fine features are set off by a trim goatee and mustache.

The circular shape of Wtewael's pair is unusual, Johannes Moreelse's *Shepherd Playing Pan's Pipes* (cat. 65) being more typical. In other respects, however, Wtewael's panels are characteristic amorous, bucolic fantasies. The form of the swelling bagpipes coupled with the staff make the shepherd's intentions clear, while his beloved signals her response by pressing the lamb to her partly exposed breast so as to accentuate its fullness. Both figures lean forward, and the intimate effect is intensified by the dark backgrounds that omit all reference to nature, strangely enough a standard feature of Arcadian half-lengths.[1]

Wtewael's pair exemplifies the *geestige* shepherd and his shepherdess, playful and spirited, as opposed to the contemplative poets and women who also peopled Arcadia. In pastoral literature, the roguish shepherd sings bawdy songs, but his pictorial counterpart is usually more decorous.[2] Wtewael's shepherd is urgently sensual, but he has a certain witty finesse. The young shepherdess's amorous nature is expressed by her voluptuous embrace of the lamb, but she is sweetly diffident. The ambiguous mix here of sophistication, mischievousness, Eros, and charm endows these roundels with a complexity characteristic of Wtewael.[3]

That the shepherd is a bagpiper is in keeping with his roguish character. An anonymous engraving from *De Bloem-hof van de Nederlantsche ieught* (The flower garden of Netherlandish youth; Amsterdam 1608, 1610) depicts a shepherd playing bagpipes, and in the accompanying poem the lover Coridon woos his sweetheart with both flute and bagpipes.[4] In later Utrecht pastoral images, however, flutes or pipes, not bagpipes, were the preferred instruments of both shepherd rogues and poets. Wtewael's choice of bagpipes for his

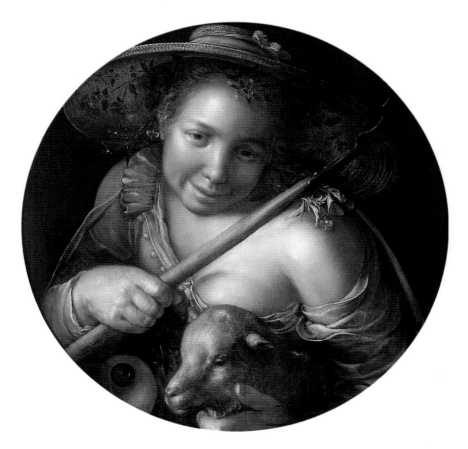

Cat. 62

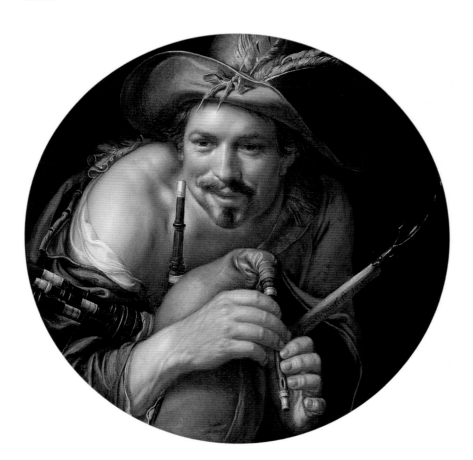

Cat. 63

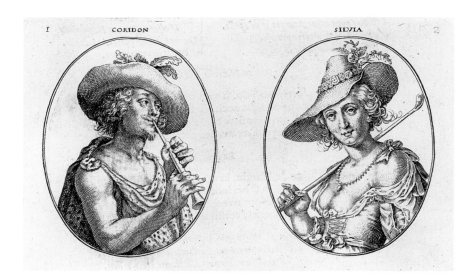

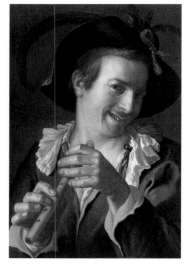

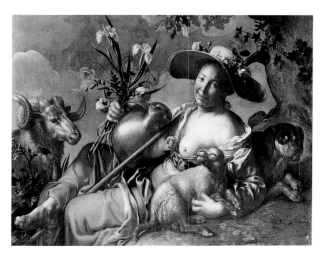

Fig. 1 Crispijn van de Passe the Elder, *Coridon* and *Sylvia*. Illustrations to *Le Miroir des plus belles courtisannes de ce temps* (Amsterdam, 1635). Engraving, 112 × 151 mm (4⅜ × 6 in.). Rijksmuseum, Amsterdam, Fr. 1369.

Fig. 2 Peter Wtewael, *A Flute Player*, 1623. Oil on panel, 56.8 × 36.2 cm (22⅜ × 14¼ in.). Bob P. Haboldt & Co., New York.

Fig. 3 Peter Wtewael, *A Shepherdess with a Lamb*, ca. 1627–28. Oil on canvas, 105.5 × 134 cm (41½ × 52¾ in.). Private collection.

shepherd is unusual.[5] It can perhaps be explained by the fact that the type was only formulated in the early 1620s. Iconographic schemes were not set, and, as Alison Kettering observes, artists were perforce flexible in their interpretation of the newly popular Arcadian literary mode.[6] By 1635, however, when Crispijn van de Passe the Elder published *Le Miroir des plus belles courtisannes de ce temps*, he showed Coridon and his beloved Sylvia in a manner that typified the mature conceptions of the Utrecht painters (fig. 1). In many respects Van de Passe's images accord with Wtewael's earlier conception—Coridon's bared shoulder, feathered hat, and ardent expression, and Sylvia's décolletage, her wide-brimmed, flower-bedecked hat, and her staff. Van de Passe's Coridon, however, plays a recorder, another instrument with erotic connotations.[7]

Kettering credits Wtewael with having introduced an important precedent for the Arcadian shepherd type in his *Adoration of the Shepherds* (1598; Centraal Museum, Utrecht), a graceful pastoral youth, his chemise exposing a shoulder in the style of the shepherd *all'antica*, his wide-brimmed hat worn at a rakish angle.[8] Although our shepherd bagpiper is no youth, he otherwise fits the description and so shows Wtewael contributing even more specifically to the development of the pastoral shepherd type. Wtewael's depiction of Paris as a shepherd in a *Judgment of Paris*, in 1615 (cat. 50), may also have contributed to that development. The earliest known Arcadian half-length figure is Paulus Moreelse's *Shepherdess* of 1617 (cat. 64, fig. 1). Ter Brugghen's pastoral *Fife Player*, of 1621 (cat. 41), came a few years later, soon to be followed by Wtewael's pair of 1623, which is thus quite an early example of the genre.

Wtewael's shepherd and shepherdess bear significantly on works by Joachim's son Peter Wtewael. An early work by Peter, a *Flute Player* (fig. 2), also signed and dated 1623, shows him treating the same subject matter, but with a robustness that contrasts with Joachim's more nuanced style. Peter's hardy painting technique, vigorous and less illusionistic than Joachim's, is consistent with his musician's open smile and direct appeal to the beholder and with the vivid tonality. Many of the foregoing features characterize Peter's pendant canvases *A Shepherd with Bagpipes* and *A Shepherdess with a Lamb* (fig. 3), which were perhaps inspired by Joachim's roundels and probably painted around 1628.[9] These large works show Peter, with typical élan, imaginatively developing Arcadian imagery with full-length figures in landscapes.

Joachim Wtewael's latest known dated works are from 1628, so these panels are works from his last active decade.[10] A lingering mannerist approach is evident here in the saturated local color, the contrived formal design, and the slightly claustrophobic compositions. Typically, however, Wtewael combined the artifice of mannerism with keen observation of nature, as in the illusionistic textures of straw, fleece, flowers, and berries. That duality, with the artist working *uyt den geest* (from the imagination) and *naer het leven* (from life) in the same painting, had been apparent even in his earliest works.

—A. W. L.

64 PAULUS MOREELSE
(1571–1638)

A Shepherdess
ca. 1627

Oil on canvas, 70.7 × 59 cm (27⅞ × 23¼ in.)
Belgium, private collection

Provenance: coll. B. Bates (Aylesbury), 1769; sale, Christie's (London), 23 May 1986, lot 27, illus.; with Johnny van Haeften (London), 1986–87; with Noordman (Maastricht), 1987

Selected References: Burlington Magazine 128, no. 1004 (Nov. 1986): IX, illus.; Van Haeften 1987, no. 15, illus.

The young blonde woman who looks at the viewer with a seductive smile is recognizable as a shepherdess from the shepherd's crook she rests on her shoulder. In addition, she wears a straw hat decorated with ears of wheat, a poppy, and a cornflower, and she holds a small bouquet of flowers in her right hand. The neckline of her loosened white shirt is so low that it exposes one of her nipples.

The pastoral genre was extremely popular in seventeenth-century painting.[1] The earliest Northern Netherlandish pastoral paintings were executed in about 1610 by Pieter Lastman. In these pastoral scenes with small figures in an idealized landscape the emphasis is on the lovemaking of shepherd couples. Paulus Moreelse is reputedly the first artist in the Netherlands who in 1617 codified the theme of the isolated waist-length shepherdess (fig. 1).[2] In 1622 he repeated his realization of the theme, and from then on he quickly became the most important practitioner of this type of pastoral painting in Northern Europe. About twenty waist-length shepherdesses by Moreelse's hand have survived. His waist-length shepherds seem to have been less popular; a group of only five is known.

That the pastoral paintings by Moreelse were much appreciated in his time is evidenced by the 1627 gift from the States of Utrecht to Amalia van Solms, which consisted of two paintings, one by Roelandt Saverij and one by

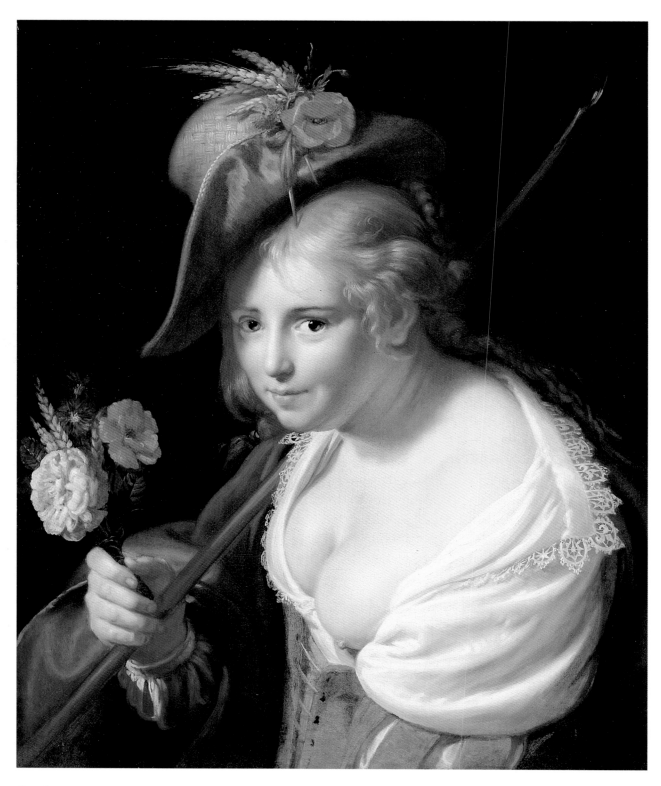

Cat. 64

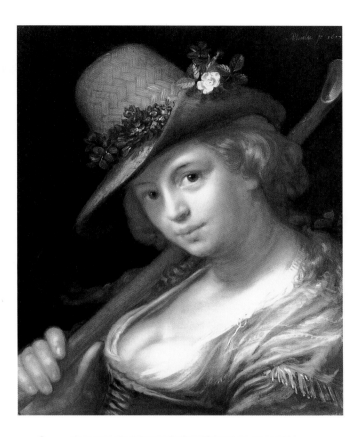

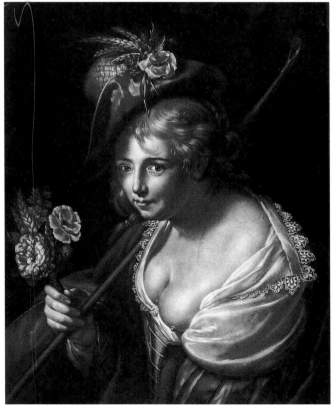

Cornelis van Poelenburch, and two pendants representing a shepherd and a shepherdess by Moreelse. This gift to Amalia is putatively connected with the installation in November 1626 of Prince Frederik Hendrik as stadholder of the province of Utrecht.[3] The stadholder on that festive occasion was equally the recipient of splendid gifts. Amalia van Solms, who was not present at the ceremony, received the gifts only in April 1627. Of the two pendants by Moreelse, only the 1627 shepherd in Schwerin has been preserved.[4]

Moreelse's elaboration of the compositional type of the isolated, waist-length shepherdess probably derives from sixteenth-century Dutch, German, and Italian paintings with representations of half-length women, for example a Venus or a Diana. It is also possible that portraits of Venetian courtesans were a source of inspiration.

A Shepherdess dates probably from the same period as *Allegory of Vanity* of 1627 in Cambridge (cat. 21). The use of color and light in the two paintings is similar, and the faces of the two figures correspond to a type that was used by Moreelse between 1625 and 1630. Of the many shepherdesses painted by Moreelse, ours shows the most resemblance to those painted in the years 1626–28, for instance the shepherdess with a shell in Pommersfelden.[5]

In comparing *A Shepherdess* with *Allegory of Vanity* one is led to wonder if the painting of the shepherdess also lends itself to a moralizing interpretation. After all, *Allegory of Vanity*, which depicts a woman of the same seductive type as our shepherdess, seems to contain a warning against sensuality and earthly riches. Yet *A Shepherdess* lacks exactly those attributes that would point

to such a reading. However, the rendering of the attractive shepherdess leads to reflections on the transience of external beauty, which, as in painting itself, is based on deceptive appearances. With her deeply cut bodice and her seductive smile, the shepherdess in Moreelse's picture presents herself as a pastoral courtesan. In this she joins the beguiling and gay shepherdesses we know from seventeenth-century songbooks and pastoral poetry.[6] The shepherdesses in these poems are pastoral sweethearts, who lead a carefree life in an idealized Arcadia and who spend their time in romance and lovemaking.

C. H. de Jonge, who in 1938 dedicated a study to the oeuvre of Moreelse, did not know the shepherdess discussed here. It is therefore not surprising that she published a monogrammed replica with the date 1633 as an original.[7] It is highly probable that this copy originated in Moreelse's studio but was largely executed by collaborators. This was a common practice with Moreelse. In similar fashion his studio produced a monogrammed replica of the 1630 shepherdess that now hangs in the Rijksmuseum.[8]

The English engraver William Pether (ca. 1738–1821) produced in 1769 and 1774 two mezzotint prints after *Shepherdess* (fig. 2).[9] From the subscriptions on the prints it can be deduced that at that time it was thought that Moreelse's *Shepherdess* was painted by Rubens and that the picture represented the painter's second wife, Hélène Fourment. Not only in the eighteenth century but also at the end of the nineteenth century, did scholars such as C. G. Voorhelm-Schneevoogt and Max Rooses think that the two prints were engraved after an original painting by Rubens.[10]

Two other shepherdesses by Moreelse were considered in the eighteenth century to be portraits of the wives of Rubens.[11] The mistaken attributions and identifications of the three shepherdesses are probably based on the resemblances that were perceived between the shepherdesses

of Moreelse and portraits that in the eighteenth century were thought to have been painted by Rubens and to represent Isabella Brant or Hélène Fourment. More than that, it also shows an admiration for the pastoral paintings of Moreelse.

—E. D. N.

65 JOHANNES PAUWELSZ. MOREELSE
(d. 1634)

A Shepherd Playing Pan's Pipes
before 1634

Oil on panel, 73 × 57.8 cm (28¾ × 22¾ in.)
Signed upper right: *JPM* [in ligature]
New York, private collection

Provenance: private coll., Stockholm; with Johnny van Haeften (London), 1989; private coll., the Netherlands; with Haboldt & Co. (Paris), 1995

Selected References: Burlington Magazine 131, no. 1031 (Feb. 1989): XXVII, illus.; Maastricht 1989, 66, illus.; Nicolson and Vertova 1989, 1:15, illus.; Buijs and Van Berge-Gerbaud 1991, 104; Van den Brink and De Meyere 1993, 80, 216–18, illus.

The smiling young man is recognizable as a shepherd by the shepherd's crook that leans against the wall in the background and the sheepskin draped over his left arm. The luxuriant wreath of vine leaves girdling his head and the flute emphasize the pastoral character of the representation.

Shepherd Playing Pan's Pipes appeared in 1989 on the art market as a work by Paulus Moreelse, but shortly thereafter was attributed to his son, Johannes Moreelse.[1] This new attribution, which is undoubtedly correct, must have been based primarily on the monogram in the upper right corner of the painting, which shows a strong relationship to signatures in several other works by Johannes, for instance the fully signed *Democritus* and *Heraclitus* in the Centraal Museum in Utrecht.[2] There is also a strong relationship between the style in which the present shepherd is executed

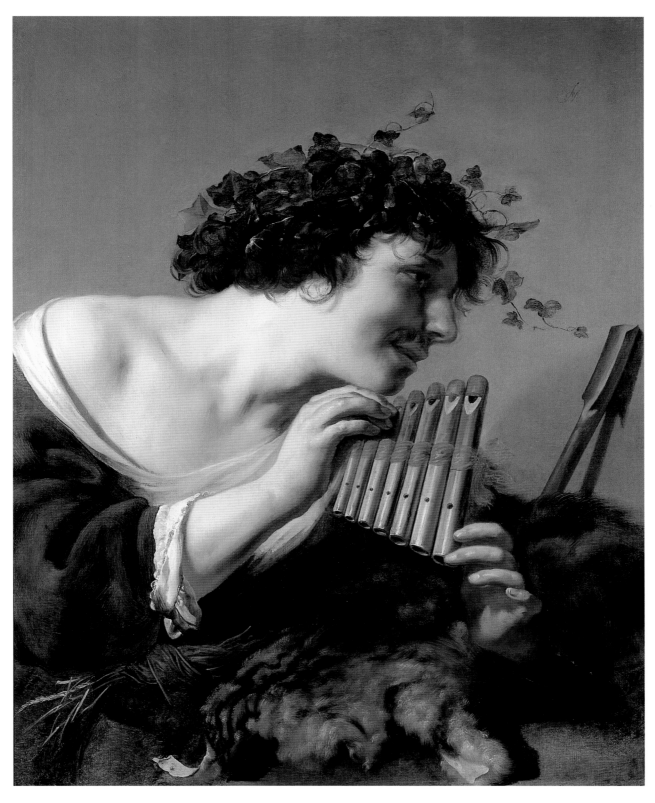

Cat. 65

and that of the two pendants in Utrecht. For instance, the manner in which the highlighted lines on the hands and the flute are rendered returns, if with a somewhat broader stroke, in the two paintings in Utrecht.

Johannes Moreelse took the theme of the half-length pipe-playing shepherd from the oeuvre of his father, who, so far as is known, was the one who introduced it as a subject in Dutch art in 1622 and depicted it two more times in 1636.[3] Nonpastoral flute players had already been chosen as subjects for paintings in 1621 by such painters as Hendrick ter Brugghen, Abraham Bloemaert, and Dirck van Baburen. The sudden popularity in 1621 of the theme has been attributed to the return of Baburen, who would have brought the subject from Italy.[4] Others surmise that Gerard van Honthorst introduced the theme in Utrecht.[5] There is also the possibility that the motif became popular in Utrecht through the presence of an early-sixteenth-century Italian painting of a half-length flute-playing boy.[6] The way in which the subject came to Utrecht is therefore not very clear, but there is no denying that from 1621 on the waist-length flute player was a favorite theme with Utrecht artists. It is most probable that Paulus Moreelse took one of the nonpastoral flute players as a point of departure for his two 1622 flute-playing shepherds. In this way he created the perfect counterpart for the shepherdesses he had been painting since 1617.[7]

There are convincing signs that *Shepherd Playing Pan's Pipes* by Johannes Moreelse once had a shepherdess as a pendant. In 1908 a reduced copy of the shepherd was offered for sale in the auction of the collection of Evert Moll, with a pendant of a young woman with a straw hat, a shepherd's crook, and a floral wreath in her hands.[8] The original of this shepherdess is no longer known. Whether this painting was by the hand of Johannes Moreelse or by that of his father cannot be ascertained on the basis of the copy.[9]

The wind instrument that the shepherd holds in his hands has until now always been described as a pan flute. The flute, however, is of a very unusual type, as it is made up of seven recorders tied together, each with one finger hole. A pan flute made up of recorders without finger holes can be played quite well.[10] But this instrument with its finger holes is barely manageable, since one cannot easily combine the rapid playing of the various flutes with the closing of the holes. Nor do the holes add much to the potentialities of the instrument.[11] One suspects that the pan flute is a fantasy instrument. Perhaps Johannes Moreelse knew that there are pan flutes composed of recorders, without realizing that these were without holes.

In 1938 C. H. de Jonge was the first to pay attention to the oeuvre of Johannes Moreelse.[12] She was of the opinion, however, that the painter was to be identified with Paulus's brother Johannes, who was harbormaster of Utrecht. Only in 1974 did Karen Fremantle discover that the monograms on Johannes's paintings should be read as Johannes Pauluszoon Moreelse and that the painter was therefore a son and not the brother of Paulus.[13]

At present seven signed or monogrammed works by the hand of Johannes Moreelse are known; of three other compositions only copies or reproductive prints have survived. An additional group of five unsigned works has been assigned to him, as well as two monogrammed portraits, all of which, save one, are difficult to place in Johannes's oeuvre.[14] Because no dated works by Johannes Moreelse are known, no one has dared to establish a chronology for his oeuvre. Presumably the *Shepherd Playing Pan's Pipes*, which shows somewhat diminished Caravaggist characteristics than are found in most of the other paintings of Johannes Moreelse, is a very late work of the painter, who died in December 1634.

Peter van den Brink recently pointed out the possibility that *Shepherd* and its pendant are

identical to "2 stucx schildereij van een spelenden herder ende een singende harderin geschildert by den jongen Morelisse" (two-piece painting of a shepherd playing and a shepherdess singing painted by the young Moreelse), mentioned in the inventory of 1656 of the estate of Catharina de Gabry, widow of Cornelis van Werckhoven.[15] This hypothesis is not very convincing since the shepherdess is not depicted singing.

—E. D. N.

Fantasies of Arcadia and Eden: Landscapes of the Imagination

66 ADAM WILLARTS
(1577–1664)

Ships off a Rocky Coast
1621

Oil on panel, 62 × 122.5 cm (24⅜ × 48¼ in.)
Signed and dated on the boulder in the foreground:
A. Willarts. f / 1621
Amsterdam, Rijksmuseum, SK-A-1927

Provenance: sale, F. Muller & Co. (Amsterdam),
6 Nov. 1900, lot 351

Selected References: Jantzen 1910, 108; Bol 1973, 77; Preston
1974, 68; Van Thiel et al. 1976, 605; Van de Watering
et al. 1981, under no. 14; Spicer 1997b

Adam Willarts's rugged coastal scenes transport
the viewer far from the gentle undulations of the
Dutch dunes to the coasts of foreign lands with
their promise of adventure and excitement.[1] In
some cases his descriptive realism conveys suffi-
cient evidence for a positive identification of loca-
tion, general historical circumstances, or even
a specific historical event, for example *James I
Bidding Goodbye to the Elector Palatine and the Princess
Elizabeth at Margate in 1613* (fig. 1), painted in 1623
and surely on commission.[2] Most of the time,
however, Willarts's views mix suggestive motifs
so that prospective buyers would find a vicarious
thrill in bringing their own associations to their
enjoyment of the scene.

Willarts's predilection for the English coast
probably reflects both his own sojourn in London
before settling in Utrecht by 1602 and also, from
1620, the residence near Utrecht of Elizabeth as
exiled queen of Bohemia. Scenes further afield,

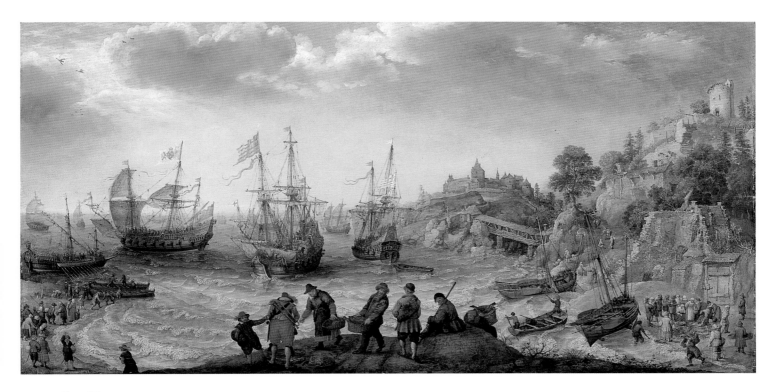

Cat. 66

such as the 1617 *Dutch Defeat of the Spaniards off Gibraltar in 1607* (Rijksmuseum, Amsterdam),[3] are reconstructions or fantasies. (His son, Abraham, who followed his father's specialty, actually went to sea with the Dutch fleet, so it is surprising to see that his paintings largely imitate the codes for foreign climes developed by his father.)

The precision of the details suggests that they are closely observed and that the scene as a whole reflects an actual view. The war ships, the most salient feature of the composition, fly British flags, though that bearing the arms of the sovereign is too far off to be identified as Stuart or Tudor (as it would have been when Willarts left England). No ship flies the new Union Jack, made mandatory in 1606.[4] The appearance of the warships is plausible, though influenced by the broader proportions of Dutch warships, which in turn were influenced by the design of merchant ships. The lone Spanish galley in the lower left,[5] identical to one found in *Battle between Spanish and Dutch Ships off the Spanish Coast* (1622; Musée des Beaux-Arts, Brussels), seems more a titillating touch of the Enemy than a serious

threat. In front of it are two sloops, landing boats belonging to the warships. Beached at the lower right next to the villagers examining the fishermen's catch are two Dutch pinks, used for coastal fishing.[6]

Nevertheless, details in the landscape surrounding this inlet indicate that the apparent realism of discrete elements disguises an impossible fantasy. Introducing an implicit sense of the momentous to the scene, the castle on the ridge is one of the many adaptations in Willarts's paintings of Saverij's drawings of Prague Castle, the Hradčany, studies made in the decade 1603 to 1613 during which Saverij served as an imperial court painter.[7] The immense palace complex looming above the city of Prague was, and is, the city's most striking monument. Few Dutchmen would, however, recognize its profile,[8] and such a particularized motif would simply suggest that a real, though clearly foreign place is portrayed.[9] The covered bridge had an actual counterpart below the Hradčany, over a deer preserve in a ravine behind the castle. The crumbling

Fig. 1 Adam Willarts, *James I Bidding Goodbye to the Elector Palatine and the Princess Elizabeth at Margate in 1613*, 1623. Oil on canvas, 121.9 × 196.9 cm (48 × 77½ in.). The Royal Collection, Her Majesty Queen Elizabeth II, 2557.

fortifications at the right are surely inspired by Saverij if not patterned on lost drawings by the artist. Saverij had brought back with him from Prague his own drawings made in Bohemia or in the Alps of cottages, rock formations, views in Prague, Bohemian peasants, and Hungarian officers, and drawings by his colleague in Prague, the goldsmith Paulus van Vianen, who had been born in Utrecht. Willarts began using these motifs in 1614, so he must have known Saverij before the latter moved to Utrecht in 1618. In 1622 he indicated that he went to Saverij's house nearly every day (see Biographies, in this catalogue). In the present painting, the peasant at the left with a bundle under his left arm is based on a copy sheet made by Willarts after studies by Saverij and Paulus van Vianen.[10] Herman Saftleven also had copies of these drawings and used them in his paintings meant to evoke the valley of the Rhine.

Willarts's approach to making his compositions appealing for the viewer recall Karel van Mander's advice that, to maintain credibility and to provide the variety that holds the viewer's attention, visually compelling imagery needed motifs studied from life, specifically, variety in terrain and detail, such as castles on ridges and broken-down cottages. The implication of this advice is that neat, regular, urban motifs redolent of middle-class values are inherently less interesting than is either the heroic and foreign (the castle on a ridge) or the comic (the cottage).[11]

The romance of the painting under discussion is thrown into relief by comparing it with the painting (fig. 1) depicting the beginning of the voyage of the young Elector Palatine, Frederick V, and his bride, the Princess Elizabeth Stuart, across the channel from England following their wedding in 1613, a marriage (symbolized by the crossing) that was seen as heralding a stronger alliance of the Protestant powers. Foolishly accepting the crown of Bohemia, Frederick was ousted a year later, in November 1620. The couple took refuge in the Netherlands, and spent the years until Frederick's death in 1632 vainly trying to regain their former footing and the support of the English crown. The year in which the departure scene was executed, 1623, was their nadir. James sought to arrange a marriage for the Prince of Wales with a Spanish (Catholic) princess, which necessarily involved a retreat from any political support for Protestant causes, and Frederick formally lost his status as elector of the Holy Roman Empire. Although only one version of the *Arrival of the Elector Palatine and the Princess Elizabeth at Vlissingen* (also known as Flushing) can be traced back to Elizabeth (that at the National Maritime Museum, Greenwich),[12] and the provenance of this picture is unknown before the mid–nineteenth century, one might imagine that it was anxiously commissioned by Elizabeth or a supporter for her father or someone at court as a reminder of the respect once shown her husband and herself. In the scene at Margate, the low, white chalk cliffs, the royal ship, the *Prince Royal*, the costumes of the court, are all painted with accuracy and decorum, as a setting for the expression of status, not for visual excitement.

After Gillis de Hondecoeter left for Amsterdam about 1610, Adam Willarts was the only painter of note in Utrecht who specialized in land-

scape until Saverij arrived from Amsterdam. Why an artist who specialized in coastal views and seascapes, the earliest known being from 1608,[13] would choose to live in inland Utrecht is not clear. Although the present painting, dated 1621 and the earliest landscape in the exhibition, shares the even, cool, low-wattage Dutch light of contemporary landscapes painted in Haarlem, it also displays affinities with Roelandt Saverij's *Landscape with Birds* dated 1622 (cat. 67). The Flemish heritage these artists shared (both were born in Flanders) is shown in their preference for nature that expresses a taste for the heroic potential in life, usually through exaggeration and dramatic gesture. In the work of both, this is coupled with a Dutch love of precise detail derived from the close observation of reality. The result is often curiously persuasive images that, when examined, prove to be impossible.

An orchestrated use of earth tones binds together the irregular shapes of the land around the inlet. The warm salmon of the foreground anchors the composition and shades off into recessive, cooler greens on the rising hill at the right. In rendering the crumbling ruins, Willarts has here applied pale ochers and yellows, olives, and touches of blue green with short strokes of a loaded brush in order to imitate masonry. Not surprisingly, the effect bears comparison not only with Saverij's ruins but also with the cottage in Bloemaert's contemporaneous *Parable of the Wheat and the Tares* (cat. 18), though each artist finds a different range of tone.

—J. S.

67 ROELANDT SAVERIJ
(1578–1639)

Landscape with Birds
1622

Oil on panel, 54 × 108 cm (21¼ × 42½ in.)
Signed and dated on a stone slab lower center:
ROELANT . / SAVERŸ . EE / . 1622 .
Prague, National Gallery, DO 4246

Provenance: Count Felix Vrsovec (Wrschowetz), Prague, by 1700–1719; Count Anton Johann von Nostitz-Rhienek and by descent in the colls. of the house of the counts of Nostitz, Prague, 1719–1945; acquired by the National Gallery, 1945

Selected References: Elsenwanger 1781, 132; von Frimmel 1892a, 128; von Frimmel 1892b, 23; Erasmus 1908, no. 116; von Frimmel 1910, 7; Thiéry 1953, 190; Białostocki 1958: 71; Šíp and Blažíček 1963, no. 31; Šíp 1964, 166–67; Šíp 1965, no. 107; Šíp 1969, 36–37; Šíp 1970, 280; Šíp 1976, 152; Spicer 1979, 143; Haak 1984, 214; Mai et al. 1985, no. 39; Müllenmeister 1988, no. 148; Seifertová 1993, no. V/2-78; Slavíček 1994, no. 36 (with earlier citations)

Roelandt Saverij was apparently the first European to make independent pictures of birds a speciality; this is his masterpiece in the genre. Saverij's *Birds in a Clearing* (The State Hermitage Museum, St. Petersburg),[1] painted in 1600 in Amsterdam, is not only his first dated painting but possibly the first European easel painting just of birds. A delicate little *Birds by Twisted Roots* (Hessisches Landesmuseum, Darmstadt)[2] can be dated to the artist's years in Prague, between 1603 and 1613, when he was in the service of the emperor Rudolf II, but it was after Saverij returned to Amsterdam and more particularly from 1618, the year he settled in Utrecht, that he began to produce extravagant avian fantasies.[3]

The two earliest paintings have realistic premises, but the later ones are pure fantasy. The birds assembled here on a swampy inlet in the shadow of a ruin range from the domestic barnyard rooster and hen to two large ostriches at the left and two cassowaries at the far right. Others can be identified as a pelican, rail, ruff, sand bittern, mute swans, crane, crowned cranes, eagle, peacocks, egrets, ducks, gulls, geese, turkeys, and

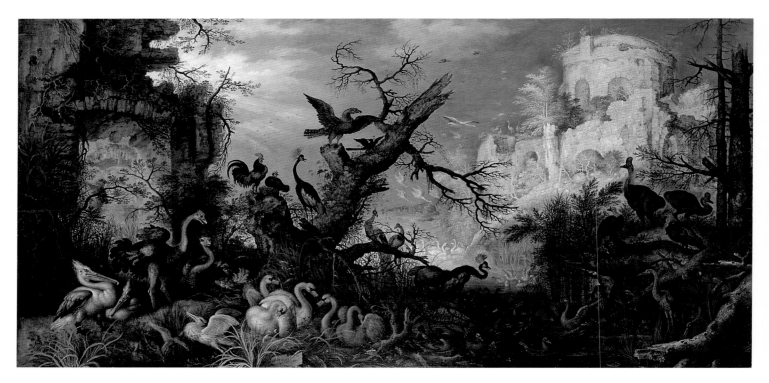

Cat. 67

herons. The following year Saverij dated a second version of the present composition (Bayerische Staatsgemäldesammlungen, Munich),[4] in which a whole zoo of mammals has been added. A resting lion, two deer, and a turtle surround the pelican couple at the left. It is not an improvement.

In 1958 Jan Białostocki put forward the attractive thesis that Saverij's bird fantasies were inspired by the artist's studies of Persian manuscript illuminations depicting assemblages of birds, and specifically by a version of *The Language of the Birds* that had been given to Rudolf II.[5] This seductive proposal has proved irresistible to some writers,[6] but it was formulated at a time when Saverij's oeuvre was not well understood. Białostocki, for instance, was not aware of the two early paintings cited above. The similarities are coincidental. There is no evidence that non-European art in Rudolf's collections was accessible in such a way as to make such influence possible.

These fantasies can best be thought of as avian equivalents of Wtewael's *Golden Age* (see Spicer, introduction to this catalogue, fig. 9). Harmony and abundance are expressed in the very extravagance of this consummate mannerist orchestration. Jan Breughel and other Antwerp artists who subsequently took up the painting of birds tended to allegorize the subject as the Element of Air or a Concert of the Birds. Saverij did not, though a few of his paintings include in the sky or to the rear tiny figures representing the Fall of Icarus or the Abduction of Ganymede, perhaps intended to reward the observer with a find. Many of the birds do have a role in emblematic literature, but there are just too many birds shown in too many combinations for there to be a program.

The contemporary viewer's reaction to these paintings was probably not so much moral as social. In the Netherlands the keeping of swans, accented here in the foreground, was a prerogative of the nobility,[7] and the keeping of more exotic birds, especially large ones, would suggest great wealth.

Saverij had known Rudolf's famous menageries[8] and made drawings there, but in the Netherlands there were as yet no zoos, though in Amsterdam, where ships from the Indies docked, an inquisitive artist would surely have been able to satisfy his curiosity. Actually, in 1622–23, thus contemporary with the picture at hand, a walled

pleasure garden with aviaries along one side was constructed for Prince Maurits, stadholder of Utrecht, on the south side of the court in The Hague.[9]

This leads to the question of the artist's immediate models. Many of Saverij's drawings of animals that formed a repertoire of motifs for his animal fantasies are extant,[10] but there are no drawings of birds.[11] Among the animal motifs derived from Saverij that Crispijn van de Passe the Younger proposes as models for young artists in *Van 't Licht der teken en schilderkonst*[12] are four *Swans* (fig. 1) identified as based on a drawing by Gillis de Hondecoeter that was itself based on studies by Saverij, including one used in the Prague *Landscape*. Hondecoeter was probably acquainted with Saverij in Amsterdam; his own animal paintings are often dependent on Saverij's.

If the animals are real although their propinquity possible only in the imagination, the setting is impossible. The ruins at the right are close to the Roman ruin traditionally called "the Temple of Minerva Medica," drawn by many visitors in the sixteenth and seventeenth centuries. It collapsed in the nineteenth century. Saverij was clearly fascinated by ruins, and his many drawings of Romanesque ruins in Bohemia may make him the first modern artist to be so, but these ruins are Roman, not Romanesque. Because he never went to Italy,[13] he must have relied on drawings or prints by others.

As in most of Saverij's animal fantasies, there is a world of detail beyond the animals themselves to reward the eye. There are feathers everywhere, as there may well have been in the aviary in which some of the birds were studied. An ostrich has just sent some into the air, the swans' nest is littered with them, and a swan's feather has floated down onto the stone slab bearing Saverij's signature. Insects abound; one can count six dragonflies, a butterfly, and two grasshoppers. Delicately painted moss hangs from the dead tree at the center. The single jarring note is the way in which the dead

Fig. 1 Crispijn van de Passe the Younger, *Swans*. Engraving from *Van 't Licht der teken en schilderkonst* (Amsterdam 1643, pl. 10), after a drawing by Gillis de Hondecoeter after Roelandt Saverij, 230 × 180 mm (9 × 7 in.).

trunk has been awkwardly extended. In the second version in Munich, this passage is resolved by the addition of a nest.

The successful orchestration of so much detail is made possible by the subtle range of tones in the foreground, primarily off-white to black with ochers and slate blues predominating, all set off by the sharp staccato effect of the red beaks punctuating the surface. Saverij uses his trademark backlighting from behind the ruin at left to flood the pale ocher and salmon ruins at the right rear with a warm light. The two dead trees at the right edge were painted over the sky and ruins; their harsh linear forms set off the soft crumbling surfaces of the ruins and also serve to close the field of vision at the right.

At the end of the seventeenth century, this

Landscape with Birds and a *Garden of Eden with Adam Naming the Animals* of 1618 (also in the National Gallery, Prague)[14] were both recorded in one of the great noble collections in Prague, that of Count Felix Vrsovec, from whom they were purchased by Count Anton Johann von Nostitz-Rhienek in 1719.[15] Because these are both excellent paintings and it is documented that Saverij remained in contact with collectors in Prague as well as with the emperor Matthias, supplying two paintings to the prince of Liechtenstein (who had residences in Bohemia and Vienna) in 1628, and because only good paintings by Saverij (not the shop pieces or imitations that later flooded the market) and virtually nothing by other Utrecht painters seem to have made their way into these great collections, it may reasonably be supposed that it was Saverij himself who supplied them.

Saverij signed most of his paintings. The signature is always in block letters as here (probably originally in imitation of Pieter Bruegel), though the spelling of his first name might vary (Roelant with a *d*) and the *y* sometimes has two dots over it (making it the equivalent of *ij*), as it does here. Such variations were common at the time. What is not common is that, instead of *FE* as an abbreviation for *fecit* (made it), Saverij has clearly written here and in several other cases *EE*; see, for example, *Deer and Bison in a Woodland Clearing*, also dated 1622 (Dordrechts Museum, Dordrecht).[16] As both the Latin abbreviation and whole word were in common usage, Saverij may have been amusing himself at the expense of custom and expectation, as he often did in other ways—between two deer standing together in that same painting, Saverij has mischievously inserted a third head.

—J. S.

68 CORNELIS VAN POELENBURCH
(1594–1667)

Landscape with the Flight into Egypt
1625

Oil on canvas, 48.2 × 71.1 cm (19 × 28 in.)
Signed and dated: *C.P. / 1625*
Utrecht, Centraal Museum, 8391

Provenance: coll. the marquesses of Bute, Luton House, Mount Stuart, 1838, 1883; with C. Benedict Gallery (Paris), 1938; coll. Vitale Bloch, The Hague, 1940; purchased from the Vitale Bloch coll., The Hague, 1940

Selected References: Blankert 1978, 5–7, fig. 20, 71–72, cat. 20; Blankert et al. 1980, 20, 30, 187, 190, cat. 45, fig. on p. 191, 256; Sluijter-Seijffert 1984; Sutton 1987, 7, 31, 32, 281, 292, 398, 399, 402, 406–408 cat. 69, 477, 536, figs. 23, 69; Van den Brink and de Meyere 1993, 16, fig. on 243, 242–44, cat. 47

Cornelis van Poelenburch was one of the many pupils of Abraham Bloemaert. His apprenticeship probably began in 1610 and lasted until he left for Rome in 1617.[1] From the 1620s on, Poelenburch and almost all his fellow pupils went south in search of inspiration, but their master sought his models far closer to home. Bloemaert lived and worked almost all of his long, productive life in Utrecht. Sketchbook in hand, he was the chronicler of the Utrecht landscape, touring the countryside around the city and recording the farmhouses and other buildings. In his *Landscape with the Rest on the Flight into Egypt*, painted between 1605 and 1610, he combined numerous buildings and accessories from the area around the city (fig. 1).[2] More than half of the picture is taken up with farmhouses, which are grouped around a tree-lined yard. In the distance, there are yet more houses that are part of a village. Under the tall trees on the left is a large dovecote and behind it, seen through the tree trunks, a barn.

While in Rome, Poelenburch concentrated on painting the Italian Campagna. The first Northern painter to capture the mood of Southern climes convincingly, he immortalized the broad, idyllic landscape around Rome in the superb, warm sun-

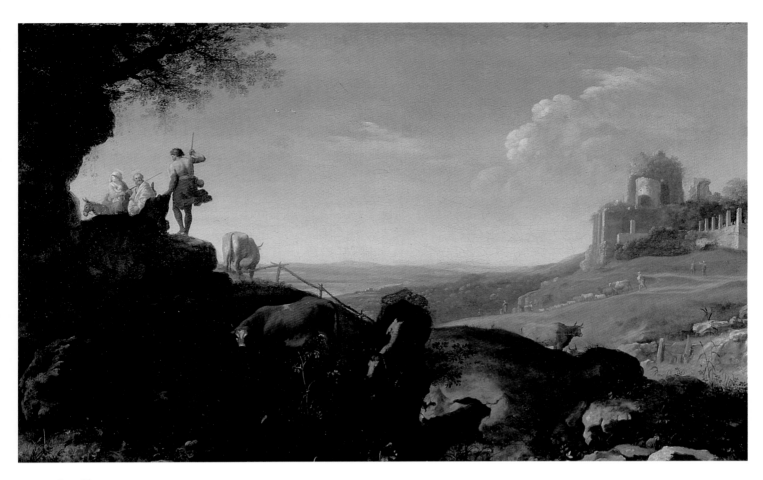

Cat. 68

light so characteristic of Mediterranean regions. When, after about eight years, he returned to his native Utrecht, his work was markedly different from that of his teacher.

Poelenburch continued working in the style he had developed in Italy, painting endless variations on a limited number of themes. *Landscape with the Flight into Egypt* is a typical example of the kind of painting that brought him so much fame after his return home in about 1625, the date on the picture,[3] or a little later. There was an eager market for his work. It is not known whether he painted this particular scene in Rome or after settling in Utrecht again. Rome seems the more likely, because almost all Poelenburch's dated landscapes were made in Italy.[4] But this is his first work on canvas, so it might have been painted back in Holland. All the demonstrably earlier (because they are dated) paintings are on copper or panel. The support of *Landscape with the Flight into Egypt*

is, however, a rarity in that Van Poelenburch almost never used canvas.[5]

For this painting, Poelenburch has furnished his landscape with a scene of the Flight into Egypt. Joseph and Mary left Bethlehem in haste with their newborn son after Herod ordered all male infants under the age of two to be put to death (Matt. 2:13–18). Poelenburch painted Mary seated sidesaddle on a donkey with Jesus in her arms. She is looking straight ahead, while Joseph, walking beside her, is looking back at a herdsman they have just passed. They are on the point of disappearing behind a rocky outcrop, but because they are so magnificently lit by the setting sun, they immediately capture our gaze. This was the first time that the artist employed this kind of lighting. The subtle effect is further enhanced by the hillside in shadow. As a dark repoussoir, it divides the painting diagonally in two. In the dark triangle, Poelenburch painted all sorts of grasses

and large leafy plants. The right side of the composition is closed off by an immense, overgrown ruin.

As with Bloemaert, the narrative is of secondary importance. The Italian Campagna was Poelenburch's main subject, as was the Utrecht countryside for Bloemaert in his *Rest on the Flight into Egypt*.

—L. M. H.

69 CORNELIS VAN POELENBURCH
(1594–1667)

Grotto with Lot and His Daughters
1632

Oil on panel, 35.5 × 52 cm (14 × 20½ in.)
Dated on rock in water, lower center: *16[3]2*
Montreal, Mr. and Mrs. Hornstein

Provenance: probably, sale, Chevalier de la Roque (Paris), Gersaint, Apr. 1745; probably, sale, Comtesse Koucheleff (Paris), Drouot, 18 Mar. 1875; private coll., Belgium; with B. Meissner (Zurich)

Selected References: Sluijter-Seijffert 1984, 83–84, no. 48; Duparc and Graif 1990, no. 54

According to the account in Genesis (19), when God was about to destroy the city of Sodom by fire because of its wickedness, angelic messengers told Lot to take his family and flee into the hills without looking back. Lot's wife did look back and was changed into a pillar of salt. Lot and his daughters escaped, fleeing first to another town and then up into the hills above the valley now laid waste by fire, taking refuge in a cave. To perpetuate the family line in their isolation, the daughters determined to "make [their] father drink wine" so that he would be too drunk to know that he had committed incest. The Moabites and the Ammonites were his descendants by his daughters.

Wtewael (cat. 2, fig. 1) and other painters of history, such as Goltzius and Rubens, embellished the brief biblical narrative by turning it into a boldly lascivious image of seduction.[1] Indeed this story is the only one of the six episodes of seduction in the Bible, all in the Old Testament,[2] that has been traditionally represented as a dalliance. It is the only commonly depicted biblical scene that readily permits the appearance of nubile, willing young women, unclothed and seductive. Visually, it is the closest biblical subject to the mythological Feast of the Gods. Other Old Testament subjects that focus on naked figures include Adam and Eve in the Garden of Eden, who are naked but chaste, and the Flood, whose victims are either preoccupied with survival or dead.

In contrast to Wtewael's figures in explicit frontal poses, Poelenburch's trio is turned away. The impression here is less sexual but more suggestive and sensuous.[3] The seductive rear view of a young female figure is found often in Poelenburch's oeuvre; see, for instance, *Arcadian Landscape with Nymphs Bathing* (cat. 54). Poelenburch painted other versions of the subject of Lot and His Daughters that emphasize the figures.[4]

The primary mood of the composition is borne by the grotto, the charged and sensuous atmosphere of its dark, lavender-tinged walls

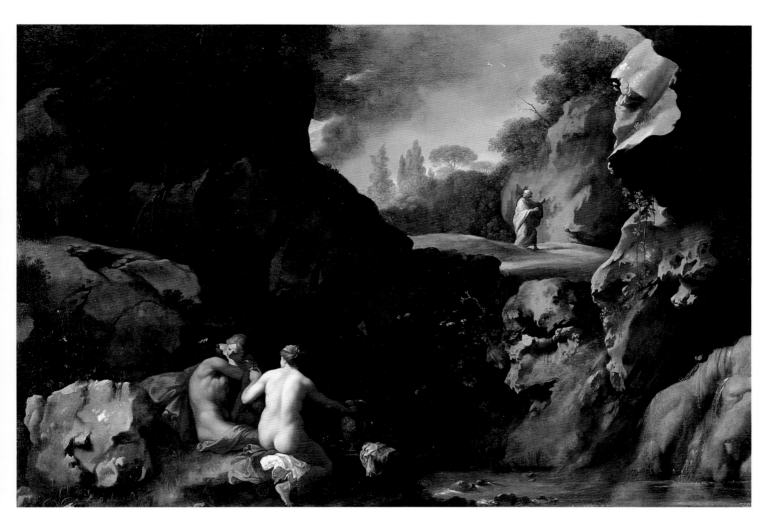

Cat. 69

augmented by the seduction taking place within. The orchestration of color, light, and detail is the work of the artist at his best. A warm light of mysterious origins illuminates the figures and picks out tiny flowers and bits of dark green foliage growing between the rocks and also the thin, white ripples in the stream running through the floor of the grotto. The world beyond the grotto entrance plays off these contrasts: A glimpse of flames dusky with the smoke coming from the smoldering cities below is set off by the still, salt-white figure of Lot's wife.

Grottoes or caves, dependent as they are on mountainous or hilly terrain, are inherently foreign to the Dutch experience and therefore inherently romantic. Poelenburch's brown ink and wash studies of cave entrances and natural arches in Italy (fig. 1)⁵ are remarkable in capturing the

patterns created by the intense light. The paintings in which he used those effects are nearly all datable to the years after he returned to Utrecht in 1625. The very character of the grotto as both interior and exterior permits an orchestration of space that is much more subtle than the predictable layering of open planes to be found in his 1625 *Landscape with the Flight into Egypt* (cat. 68), *Nymphs and Satyrs in a Hilly Landscape* from 1627 (cat. 54, fig. 1), and *Portrait of the Children of the King and Queen of Bohemia in a Landscape* of 1628 (cat. 60, fig. 1).⁶ Poelenburch made an ingenious use of a grotto entrance in *Arcadian Landscape with Nymphs Bathing* (cat. 54). His *Amaryllis Crowning Mirtillo* (cat. 59, fig. 1), datable to 1635, is differently conceived and no other dated landscapes from the 1630s are known, so a more precise assessment of the chronology is impossible.

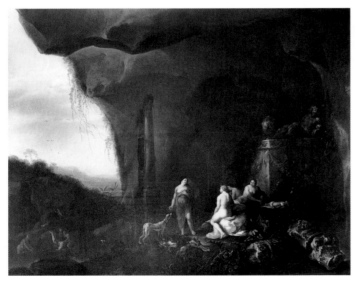

Fig. 1 Cornelis van Poelenburch, *Natural Arch*, 1620–24. Brown ink and wash, 427 × 385 mm (16⅞ × 15⅛ in.). Rijksprentenkabinet, Amsterdam, A293.

Fig. 2 Abraham van Cuylenburgh, *Grotto with Diana and Her Nymphs*, 1649. Oil on panel, 60.3 × 74.3 cm (23¾ × 29¼ in.). New Orleans Museum of Art, gift of Richard L. Feigen in honor of Dr. and Mrs. Richard Levy, 78.296.

Within a few years, other painters, among them the talented Carel de Hooch, represented by *Nymphs Bathing in a Grotto* (cat. 54, fig. 2), and in the 1640s Abraham van Cuylenburgh, developed the subject of the grotto with bathing nymphs (fig. 2) into a specialty.[7]

—J. S.

70 JAN BOTH
(d. 1652)

Peasants with Mules and Oxen on a Track near a River

1642–43

Oil on copper, 39.6 × 58.1 cm (15⅝ × 22⅞ in.)
Signed on a stone at the left edge and toward the bottom:
JB [in monogram] *oth*
London, Trustees of the National Gallery, NG 959

Provenance: imported into England by John Smith in 1826; in the coll. of Artis, London, by 1835, and sold by him to Wynn Ellis in 1845; Wynn Ellis Bequest, 1876

Selected References: Smith 1829–42, no. 107; Hofstede de Groot 1907–27, no. 226; Brown 1976, no. 16; Burke 1976, 73 no. 53; MacLaren and Brown 1991, 52

Vaguely evocative of the Roman Campagna, this splendidly preserved painting on copper, probably executed in the years immediately after Both returned to Utrecht from Rome in 1642, is a consummate example of the artist's capacity to create deeply satisfying formal compositions out of almost nothing. From the thin bit of roadway visible at the left, a series of oblique lines and wedges of delicately modulated light and shadowed areas fans out across the rising hillside and dissolves in the undulations of the river that itself disappears in the middle distance. The dark compositional anchor of the sturdy mules plodding toward us is set off by the contrast with the warm early morning light flooding the scene from the right, behind the closest trees, and picking out the filigree of the interwoven branches and the edges of the

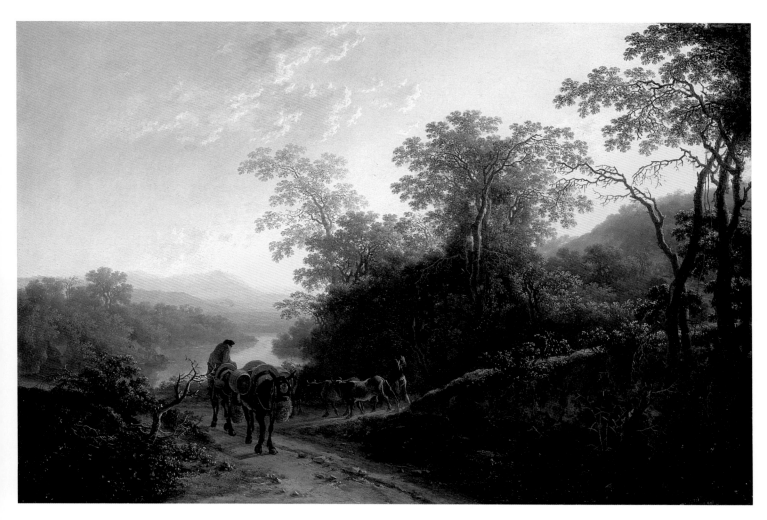

Cat. 70

dusty, late-summer foliage and brambles growing by the roadway.

The languid calm conveyed by this painting is partially the result of its horizontal format, but points of comparison with the "upright" series of four landscape etchings that Both made probably about 1642–44 raise interesting questions about the artist's approach to his subject matter.

The etchings, represented here by *Mountainous Landscape with Two Mules* (fig. 1), share both general and specific compositional arrangements and motifs with the paintings assigned to the 1640s. Whether the compositions of the etchings were derived from those of the paintings or from common preparatory drawings, or whether the paintings and etchings are simply composed as

variations on the same types need not be resolved here.[1] For example, in the etching and the painting, virtually the same mules are to be seen on the roadway and call attention to the dominant oblique angles around which both compositions are built. We are obliged to acknowledge "traffic" coming toward us. This perception of impending or potential contact with the plodding mules encourages in viewers a sense that they are actually on that roadway in Italy. This accessibility, which is also found in later paintings such as *Italian Landscape with Hunters* (fig. 2), in which the figures are attributed to Jan Baptist Weenix, can be contrasted with the sense of distance in mythological scenes such as the Arcadian *Landscape with the Judgment of Paris* (cat. 72). Could a figural group

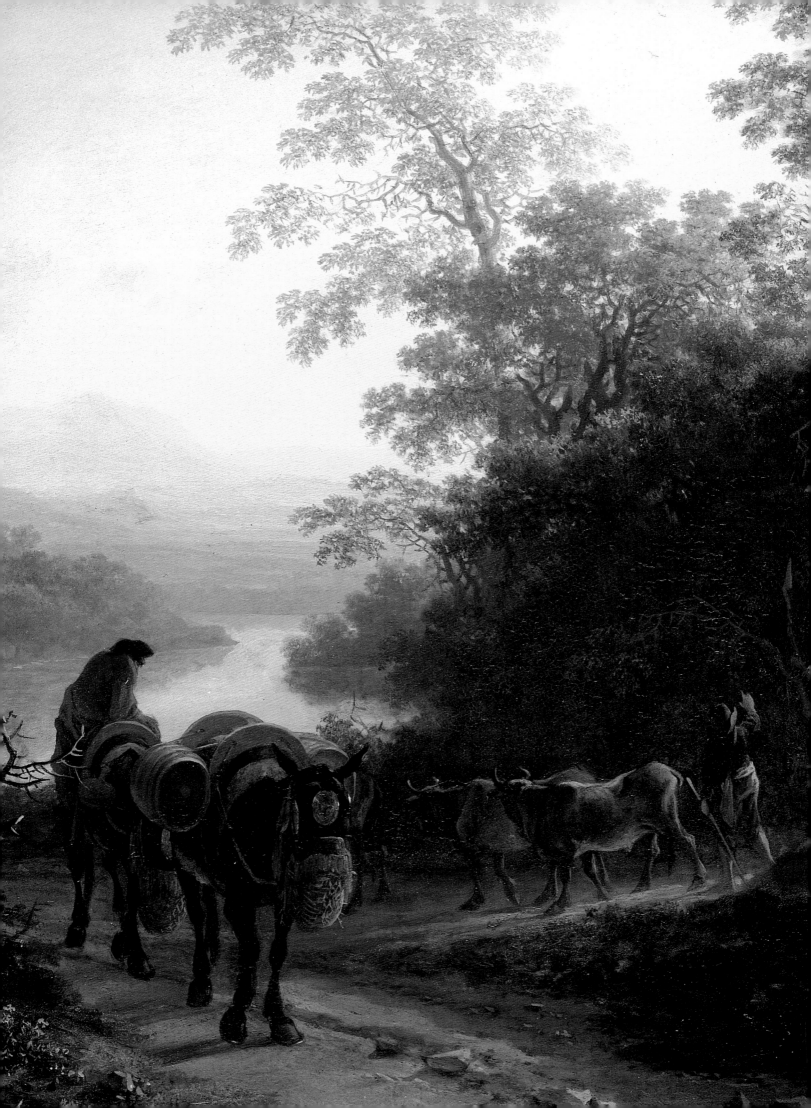

Fig. 1 Jan Both, *Mountainous Landscape with Two Mules*, ca. 1642–45. Etching, 259 × 200 mm (10¼ × 7⅞ in.), Holl. 4. Centraal Museum, Utrecht, 616.

Fig. 2 Jan Both and Jan Baptist Weenix, *Italian Landscape with Hunters*, ca. 1650. Oil on canvas, 114 × 145.1 cm (44⅞ × 57⅛ in.). National Gallery of Canada, Ottawa, 18940.

of the Judgment of Paris or of Mercury and Argus (cat. 72, fig. 1) be convincingly substituted for the drivers and animals in the present painting? Probably not. Both was apparently paying closer attention to characterizing his landscapes than one might have thought.

Both's landscapes of mythic Greece (Arcadia) and of contemporary Italy are differently conceived. There should not, of course, be any identifiably Roman ruins in ancient Greece, nor any landscape artist making sketches—and, probably, no mules—but the most striking difference is that there are no well-worn tracks or roadways to be exploited for their forceful diagonals and oblique angles pushing toward the rear of the composition. Waterfalls, as in Both's *Italian Landscape with Artist Sketching a Waterfall* (cat. 71), are unlikely in Arcadian scenes because, amazingly enough, nothing in Greco-Roman mythology or

pastoral literature ever took place near one.[2] The paths and roadways used by seventeenth-century travelers often follow rivers; in mythical Greece, the idyllic setting of the Judgment of Paris on Mount Ida or of Mercury piping Argus to sleep, for example, is more likely to be a clearing, possibly with a pool, essentially a nurturing *locus amoenus.*

The dating to 1640–43 proposed by Burke in his monographic study (1976) and accepted by MacLaren and Brown (1991) allows for the painting to have been executed in Rome or in Utrecht; nevertheless, the similarities with the etchings done in Utrecht tip the scales toward dating after 1642.

—J. S.

Cat. 71

71 JAN BOTH

(d. 1652)

*Italian Landscape with Artist Sketching
a Waterfall*

1645–50

Oil on canvas, 74.5 × 89.7 cm (29⅜ × 35⅜ in.)
Signed on mound below the figures: *J Both fe*
Cincinnati Art Museum, Mr. and Mrs. Harry S. Leyman
Endowment, 1981.413

Provenance: possibly coll. Floris Drabbe (Leiden), sale
1 Apr. 1743, lot 44; Gerret Braamcamp, Amsterdam,
1743–71, sale (Amsterdam), 31 July 1771, lot 24, with
companion piece, to Pieter Locquet; sale, Locquet,
without the companion piece (Amsterdam), van der
Schley-Yver, 22–24 Sept. 1783, lot 35, to van der Hoop;
sale, Claude Tolozan, with companion piece (Paris),
23–26 Feb. 1801, lot 12; Corneille-Louis Reijnders,
1801–21, sale (Brussels), 6 Aug. 1821, lot 6, to Nieuwen-
huys; William Beckford, Bath, England, by 1835; James
Morrison, Basildon Park, England, by 1857; Charles
Morrison, Basildon Park, by 1926; by descent to Walter
Morrison; sale, Sotheby's (London), 27 Mar. 1974, lot 12,
to Richard L. Feigen; with Feigen (New York), 1974–81;
purchased through the Leyman Endowment, 1981

Selected References: Hoet 1752, 2:79, no. 44; Smith 1829–42,
part 6, 172, 173, no. 4; Waagen 1857, 311; Hofstede de
Groot 1908–27, 8:448, no. 88; Trnek 1986, under no. 23;
Scott 1987, no. 8

San Francisco and Baltimore only

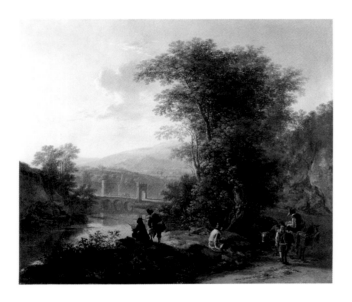

Fig. 1 Jan Both, *Landscape with Draftsman*, 1645–47. Oil on canvas, 107 × 120 cm (42⅛ × 47¼ in.). Mrs. Edward W. Carter, Los Angeles.

Fig. 2 Roelandt Saverij, *Falls on the Rhine at Schaffhausen*, 1606–7. Colored chalks on paper, 385 × 535 mm (15⅛ × 21 in.). *Atlas van der Hem* 46, fol. 11. Österreichische Nationalbibliothek, Karten-sammlung, Vienna.

For his contemporaries, the appeal of landscapes painted by Jan Both after his return to Utrecht from Italy in 1642 lay in their capacity to evoke the romance of lands far to the south, a foreignness that was achieved in various ways. An intense light is generally characteristic of these views from the 1640s, as is a hilly terrain, qualities found in the present painting and in the two other landscapes from the 1640s that are exhibited here, *Peasants with Mules and Oxen on a Track near a River* (cat. 70) and the Arcadian *Landscape with the Judgment of Paris* (cat. 72).

In his evocations of contemporary Italy, Both introduced specific motifs that would have been recognizable by the art-buying public as Italian or at least foreign. For example, the Ponte Lucarno and the adjacent Tomb of the Plautii of 2 A.D. near Tivoli outside Rome[1] are the object of the draftsman's attention in his stunning *Landscape with Draftsman* (fig. 1).

Dependent as it is on a mountainous terrain, the waterfall is inherently foreign to the Nether-

lands, and its power and changeability could provide a thrilling contrast to the flat, predictable fields of home. The thundering waterfall seems to have been first recognized as being worth painting by Pieter Bruegel and Girolamo Muziano working at Tivoli outside Rome in the 1550s,[2] but it was Roelandt Saverij who, long before he settled in Utrecht, turned the waterfall into one of the great themes of baroque art in a series of famous draw-ings made in the Alps in about 1606 in preparation for paintings for the gallery of Emperor Rudolf II in Prague. Saverij brought back a book of these drawings with him to Amsterdam in 1613, but it was only after his death in 1639 that they appear to have become available to other artists. They were copied and reinterpreted by the Dutch landscap-ists. Rembrandt, who had an album of these draw-ings in his collection, and his circle were familiar with them. One of the most impressive of these studies is Saverij's *Falls on the Rhine at Schaffhausen* (fig. 2).[3] After Saverij returned to the Netherlands, he occasionally included a small woodland cascade in his landscapes, as in his fine *Forest Interior with the Temptation of Saint Jerome* dated 1617 (private collection, London),[4] painted in his last year in Amsterdam, but there are no more representations of thunderous alpine falls.

Waterfalls and surging, rocky streams play a minor but interesting role in Both's paintings,[5]

though they are absent from his etchings and, apparently, from his drawings. In the Cincinnati painting, as in the *Landscape with a Cascade* (Galleria Pallavicini, Rome),[6] painted in the closing years of his Italian sojourn, a great boulder masks the actual falls so that the rising mist and spray create a delicate, remarkably suggestive aura around the dark rocks, very different in effect from the threatening impression of massive power that an unobscured view would offer. Some of Both's most effective paintings of flowing water are not of cataracts or swift streams. An example is the immense canvas that might best be titled *Gorge with Cataracts* (Museo del Prado, Madrid),[7] one of a series commissioned from Claude Lorrain, Both, and others by Philip IV of Spain and completed in 1639–40 for the palace of Buen Retiro outside Madrid. Another is Both's well-known *Italian Landscape with a Draftsman* (Rijksmuseum, Amsterdam).[8] Of course in the Netherlands even a stream rushing pell-mell downhill would be a novelty. Judging from Both's choice of motifs, he wanted to excite and delight his viewers but not threaten them.

The draftsman, his companions looking on, is like a signpost within the composition, directing his attention and ours toward the falls, making us want to see what he sees. The deft execution of these figures is in a manner consistent with the rest of the painting and therefore, as Mary Ann Scott observed, they are clearly by Both himself and not by a collaborator. Other artists sometimes painted the figures in Both's Italianate landscapes and Arcadian views. A fine example of the former is the *Italian Landscape with Hunters* (cat. 70, fig. 2)[9] of about 1650, in which the rather suave figures have been plausibly attributed to Jan Baptist Weenix.

The introduction of an artist at work into a landscape composition, which Both did in at least a few paintings, for example, the painting illustrated here as figure 1, and the *Italian Landscape with a Draftsman* in Amsterdam already mentioned, is not as common by this time as one might think.

Within Both's known frame of reference, Claude Lorrain's occasional inclusion of such a figure, as in his painting *Coastal Scene with an Artist Studying from Nature*, also at the Cincinnati Art Museum, has been reasonably posited as a model.[10] By contrast, although Saverij in his studies from nature often drew himself pondering some site, he does not reappear in his paintings. As one might expect, there are no artists depicted in Both's views of Arcadia. The differences between Both's evocations of the ancient Greece of myth (among them the *Judgment of Paris*) and of contemporary Italy (for example, the present painting) are discussed under catalogue 70, his *Peasants with Mules*.

A dating to the second half of the 1640s, thus a little later than the other two Boths catalogued here,[11] can be argued on the basis of the more colorful, saturated palette. The combination of forest greens with salmons and browns and the crisp reflections of a penetrating but cooler light off the edges of foliage and trees call to mind the only two known dated paintings by Both from 1649 and 1650.[12] There is no drawing known for either the landscape or figures, but the relative elaborateness of the underdrawing, visible in part to the naked eye and more extensively in an infrared reflectograph,[13] may suggest that the artist composed directly on the primed canvas. Between at least 1743 and 1801 the Cincinnati painting had as its companion *Italian Landscape with Ferry* (Rijksmuseum, Amsterdam),[14] which has the same dimensions but has little in common compositionally.

—J. S.

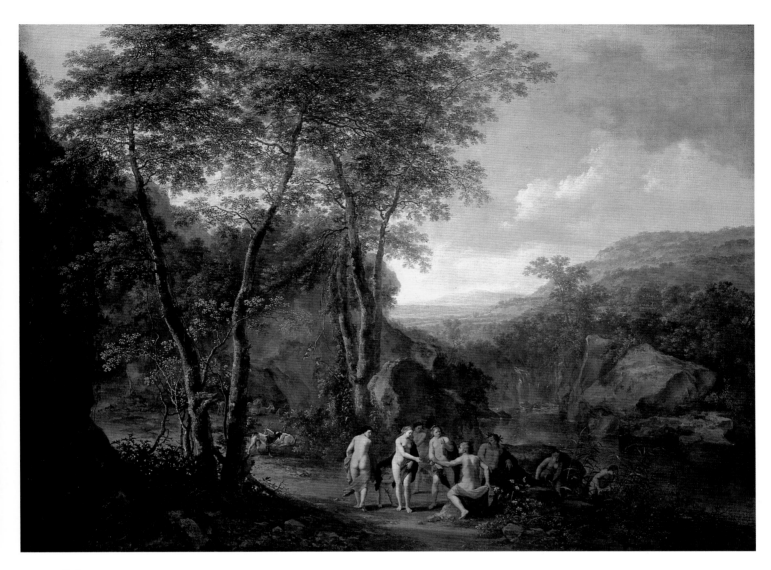

Cat. 72

72 JAN BOTH
(d. 1652)

CORNELIS VAN POELENBURCH
(1594–1667)

A Landscape with the Judgment of Paris
1645–50

Oil on canvas, 97 × 129 cm (38¼ × 50¾ in.)
Signed on the rocks in the left foreground:
JB [in monogram] *oth*
London, Trustees of the National Gallery, NG 209

Provenance:[1] perhaps, the Both landscape of the same size
with figures by Poelenburch in the Benjamin da Costa
coll., The Hague, by 1752; sold (The Hague), 13 Aug.
1764, lot 2, bought by Theodati; sale, Randon de Boisset
(Paris), 27 Feb. and following, 1777, lot 99, bought by
the prince de Rohan Chabot; sale, duc de Chabot (Paris),
10 Dec. and following, 1787, lot 20, bought by Dulac; in

the collection of the first Baron Gwydyr, Grimsthorpe
Castle, by 1812; sale, Lord Gwydyr (London), 8–9 May
1829, lot 83, bought by Alexander Baring; sold by Smith
to Richard Simmons by 1835; Richard Simmons Bequest,
1847

Selected References: Smith 1829–42, no. 7; Hofstede de
Groot 1908–27, no. 23; Blankert 1965, under no. 50;
Stechow 1966, 150; Burke 1976, no. 49, under no. 101;
Sluijter 1986, 72, 222; MacLaren and Brown 1991, 53

Jan Both signed this idyllic landscape, but it
takes its subject, the Judgment of Paris, from the
group of clearly modeled, almost sculptural figures
gathered by a small mountain lake, figures that
are painted in a different style and are by Both's
friend, Cornelis van Poelenburch.[2] Poelenburch's
figure style can be assessed in his own *Feast of the*

Gods (cat. 53) and *Arcadian Landscape with Nymphs Bathing* (cat. 54).

The story of the Judgment of Paris is important in its own right;[3] these are not simply incidental figures, here to animate a landscape. This beauty contest (and the choice of love and beauty over wisdom or worldly power) is the subject of other paintings by Poelenburch[4] and other Utrecht masters, including Joachim Wtewael (cat. 50). According to Homer, Apuleius, and other classical authors, the shepherd Paris was guarding his sheep on Mount Ida when Jupiter sent his messenger, Mercury, to ask him to determine which goddess was the most beautiful, Juno, Jupiter's wife, Minerva, the goddess of wisdom, or Venus, the goddess of beauty. The bribes offered Paris by the goddesses reflected the divine prerogatives of each: power, wisdom, or the most beautiful woman in the world as wife. Jupiter had asked Paris to perform this diplomatically difficult task because he combined the healthy instincts and natural intelligence of a rough shepherd with the innate taste and nobility of a born aristocrat. Paris, unaware that he was the son of the king of Troy, had as an infant been abandoned to die on Mount Ida because his mother dreamed that she had given birth to a firebrand and that the flames would engulf the city. Found and raised by simple shepherds, he lived to fulfill his mother's dream. Choosing Venus, Paris came into his reward by abducting Helen, the most beautiful woman in the world and wife of a Greek king, thus provoking the Greek invasion and the destruction of Troy.

In the London painting, the group of Paris and the three goddesses is taken over from Marcantonio Raimondi's famous engraving *The Judgment of Paris* of about 1517 made after Raphael's design (cat. 50, fig. 1),[5] itself inspired by two Roman sarcophagi. The river god and nymphs to the right of the main group are only indirectly inspired by the engraving. The influence of this engraving across centuries and schools provides a perfect example of Raphael's success in reformulating the language of classical sculpture for wide access and of the impact of Marcantonio's reproductive engraving in creating the vehicle for this access.

Some artists, for example, Claude Lorrain,[6] show the figures at least partially clothed; Raphael's figures are nude, though the chaste and modest Minerva has her back to us. As befits her dignity, she is rarely shown unclothed. According to some authors, the goddesses disrobed for the judging, but the nudity of Raphael's Paris, which makes no narrative sense, indicates the essentially aesthetic goal of the episode as portrayed, that is, the elevation of beauty.

The idyllic, benign character of this Arcadian landscape underscores this theme. Everything known about these artists' patrons indicates that the subject and composition were chosen for the pleasure of the viewer. The story played a romantic role in the poetry and plays of prominent contemporary Dutch writers such as Joost van den Vondel, Jan Hermans Krul, and Pieter Cornelisz. Hooft. There were also writers such as Karel van Mander, ever the moralizer, who emphasized the destruction and discord that followed.[7] Van Mander wrote his explanations of mythological subjects for the benefit of other artists, but it is not clear that he was often consulted.

The warm, light-filled landscape suggestive of eternal late summer is characteristic of Both's Italianate landscapes that drew on his experiences in Italy. That the imaginary setting is not supposed to be contemporary Italy but the ancient Greek world and is treated subtly differently from the way contemporary Italy is evoked is discussed under Both's *Peasants with Mules and Oxen on a Track near a River* (cat. 70) and in the introduction to this catalogue.

Though the subject, proportions, and lighting of Poelenburch's figures are consistent with the character and mood of Both's landscape, the firm, sculptural, light-reflecting modeling of the primary figures results in their appearing to be slightly detached from Both's fractured, light-

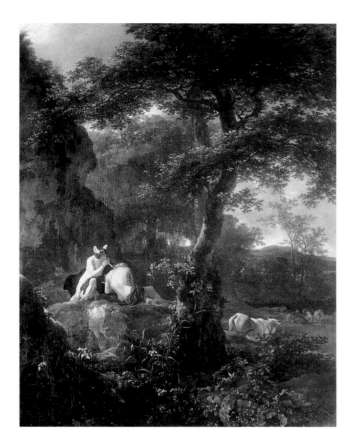

Fig. 1 Jan Both, Nicolaus Knüpfer?, and Jan Baptist Weenix, *Mercury Piping Argus to Sleep*, 1650. Oil on canvas, 169 × 128 cm (66½ × 50⅜ in.). Bayerische Staatsgemäldesammlungen, Munich, 140.

beautifully integrated with the landscape both compositionally and in terms of technique. Both's other collaborations with Knüpfer and Weenix include providing the architecture and bits of landscape (and Weenix the animals) in Knüpfer's 1651 *Pursuit of Pleasure (Il Contento)* (see Spicer, introduction to this catalogue, fig. 7),[10] for Willem Vincent, baron van Wyttenhorst, and in Knüpfer's *Seven Works of Mercy* (Staatliche Kunstsammlungen, Gemäldegalerie Alte Meister, Kassel).[11]

Included in this exhibition are two other paintings produced through collaboration. That of the brothers Herman and Cornelis Saftleven, *Sleeping Hunter in a Landscape* of 1642 (cat. 73), offers the smoothest transitions. In Knüpfer's *Diana and Her Nymphs at the Bath* (cat. 56), the landscape setting convincingly attributed to Both's follower, Willem de Heusch, is so completely subordinated to the figures that there is no rivalry.

—J. S.

absorbing surfaces. This painting can be contrasted with landscapes from this period for which Both painted the figures himself, among them *Italian Landscape with Artist Sketching a Waterfall* (cat. 71). There the broadly stroked foreground figures, usually rough travelers, are executed in a painterly manner consistent with that of the rest of the painting.

Other representative examples of Both's collaborations, generally datable to his last five years, 1647–52, include *Italian Landscape with Stable Boys Watering Horses* (see Spicer, introduction to this catalogue, fig. 21), the horses and boys by Dirck Stoop; *Italian Landscape with Hunters* (cat. 70, fig. 2),[8] in which the more slickly painted figures and dead game are given to Jan Baptist Weenix; and *Mercury Piping Argus to Sleep* (fig. 1), dated 1650,[9] in which the figures attributed to Nicolaus Knüpfer and the cow attributed to Weenix are

73 CORNELIS SAFTLEVEN
(1607–1681)

HERMAN SAFTLEVEN THE YOUNGER
(1609–1685)

Sleeping Hunter in a Landscape
164[?]

Oil on panel, 36.8 × 52.1 cm (14½ × 20½ in.)
Signed and dated lower right: *Saft/Levens 164[?]*
Boston, Abrams Collection

Provenance: sale (Brussels), 13 Dec. 1774, lot 37; sale (The Hague), 27 Sept. 1791, lot 30, bought by Coclers; sale, Christie's (London), 25 Apr. 1952, lot 83; Walter Chrysler coll., Provincetown, Mass.

Selected References: Schulz 1978, no. 646, fig. 29; Schulz 1982, no. 28, fig. 10; Sutton 1984, no. 97, pl. 91; Sutton 1987, no. 96, pl. 76; Zwollo 1987, 404–5; Robinson 1991, 158, fig. 1

Within the protective outline of a shaded hill, a hunter naps under the watchful eye of his nervous hound. As the signature records, this handsome

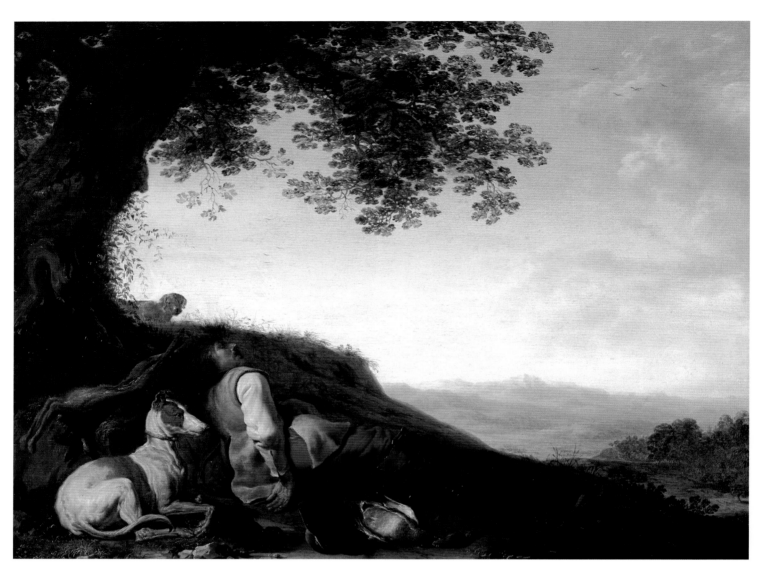

Cat. 73

picture is a seamless collaboration of the brothers Cornelis and Herman Saftleven, one of only a few collaborative works by them.[1] Rarely does a painting produced by two separate hands exhibit such a cohesive effect. Compositional contrasts are not the result of disparate techniques or style but, rather, are formal choices selected to heighten the poetry of the image. The pleasing results suggest a comfortable working relationship, each brother painting the elements at which he excelled: Cornelis responsible for the figure, animals, and still-life elements and Herman providing the landscape setting.

Prolific artists, the Saftleven brothers treated an impressive variety of subjects, but each became identified with one or two specifically. Although he started with peasant interiors, Herman's strength was landscape. He portrayed the natural scenery in a variety of modes, reflecting the shifts of Dutch taste during the course of the century. His hundreds of landscape, topographical, and botanical drawings evidence an acute eye for detail and nuance.

Cornelis became known for his rural genre subjects, as revealed in both his paintings and in almost two hundred surviving figure drawings.[2] Characteristic of Cornelis's skillful draftsmanship is a preparatory figural study of *A Sleeping Hunter* (fig. 1), also in the Abrams collection.[3] The date, *1642*, inscribed on the drawing helps to establish

a date in the 1640s for the painting, a date that corresponds well with our understanding of the stylistic development of the two brothers.[4] Drawn *naer het leven*, from life before the model, the confident contour lines and hatched shading strokes give a masculine strength and vitality to the human form, even in this resting position. Although typical in the assuredness with which Cornelis manipulated the media, here black chalk and gray wash, this drawing is atypical in that it is directly related to a painting. In the finished composition, the pose is adjusted slightly to integrate the figure within the landscape: The hunter's head has rolled back and to the left, resting uncomfortably on the barrel of his musket; this accentuates his right shoulder and the awkward drape of his arm at his side.

It is interesting to note that this very specific pose also appears in the engraving by Frederick Bloemaert (fig. 2) for figure 106 of the *Tekenboek* (Drawing book).[5] Based on Abraham Bloemaert's drawings[6] and designed as a primer for artists, the *Tekenboek* was published between 1650 and 1656. Of the initial 120 images engraved for the *Tekenboek*, Frederick followed Abraham's drawings closely in every case but one. For illustration 106, Frederick isolated one of two figure studies on the original sheet[7] and set it into a fully developed landscape. In spite of obvious differences—Bloemaert's figure is a nude woman—the resultant image is curiously reminiscent of the composition of the present painting, the Abrams *Sleeping Hunter*. Note for example the relative positions of head, shoulder, right arm, and left hand, the manner in which the figure is couched within the profile of the hill, and the division of the composition into light and dark and near and distant components. Marcel Roethlisberger suggests that Frederick might have had in mind Venetian sources depicting nudes within the landscape,[8] but perhaps Frederick found a solution closer to hand: the Saftleven painting, dating from the 1640s. Whether or not Cornelis knew the original drawing by Abraham

Fig. 1 Cornelis Saftleven, *A Sleeping Hunter*, signed and dated *CSL* [in monogram]/*1642*. Black chalk and gray wash on paper, 168 × 238 mm (6⅝ × 9⅜ in.). Abrams Collection, Boston, TL33561.70.

Fig. 2 Frederick Bloemaert after Abraham Bloemaert, *A Recumbent Female Nude in a Landscape*, ca. 1650–56. Engraving, 163 × 210 mm (6⅜ × 8¼ in.). Figure 106 from the *Tekenboek*, Rijksprentenkabinet, Amsterdam, 303-A-15.

Bloemaert is open to speculation. However, the motif of a rising hillock with one or two reclining figures is common in Bloemaert's output, as for example in the Baltimore *Parable of the Wheat and the Tares* (cat. 18), and could have been known to the Saftlevens, particularly after they took up residence in Utrecht around 1634.

Another correspondence exists between

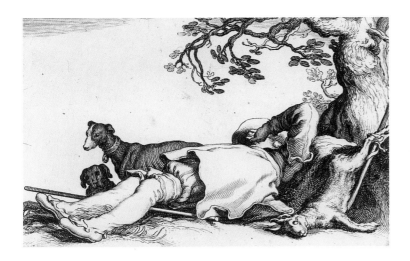

Fig. 3 Cornelis Bloemaert, after Abraham Bloemaert, *A Reclining Hunter*, ca. 1620–25. Engraving, 99 × 151 mm (3⅞ × 5⅚ in.). Figure 6 from the *Otia* series, Rijksprentenkabinet, Amsterdam.

the Abrams picture and the imagery of Abraham Bloemaert. Parallels of mood and theme link the *Sleeping Hunter* with Cornelis Bloemaert's *Otia*,[9] a series of genre prints, each with verse, focusing on the theme of rest or leisure. An image of a shepherd stretched out atop a boulder introduces the topic: "Leisure . . . provides delight and makes us fit for work."[10] The verse accompanying the sixth print, *A Reclining Hunter* (fig. 3), reads "Happy who completes work which he started, he is entitled to enjoy leisure safely."[11] Although there are only generic compositional concordances—a hunter reclining under a tree, two dogs, and a dead hare—the sentiment is quite similar: Having procured dinner, the hunter takes a well-deserved rest, relying on his dog to keep watch.

The theme of sleep appeared with great frequency in Dutch paintings of the period.[12] A multitude of meanings can be ascribed to different stock motifs, depending, not surprisingly, on the environment and moral character of the sleeping figures, as suggested by their profession, activity, or social milieu. Compare, for example, the present picture and Diderick van der Lisse's *Sleeping Nymph* (cat. 55). Bloemaert's sympathetic appraisal of a hunter resting in the landscape finds resonance in the Abrams *Sleeping Hunter in a Landscape*, both in

Cornelis's reclining figure[13] and in the peaceful setting Herman has fashioned for the hunter to take his rest. Apparently reconstituting the formal elements in Poelenburch's *Landscape with the Flight into Egypt* (cat. 68), Herman achieved a more gentle, poetic effect. The placid diagonal of the hilltop is countered only by the delicate lacy foliage of the tree and, realized in warm earthy colors, the precision of the foreground details gives way to the cool haze of the horizon.

—L. F. O.

74 JAN BAPTIST WEENIX
(1621–1659)

Mother and Child in an Italian Landscape
ca. 1650

Oil on canvas, 66.7 × 80 cm (26¼ × 31½ in.)
Signed upper left: *Gio: Batta: Weenix*
The Detroit Institute of Arts, Gift of Mrs. John A. Bryant in memory of John Arthur Bryant, 41.57

Provenance: (?) Johann Christop Werthner coll., Amsterdam, before 1791; sale (Amsterdam), 16 July 1792, lot 39; John Arthur Bryant coll., by 1941

Selected References: Ginnings 1970, 1:38, 2:133, no. 22; Sutton 1984, 355, fig. 1; Sutton 1987, 354, figs. 130–33; Broos et al. 1990, no. 70, illus.; Duparc and Graif 1990, no. 63, illus.; Van den Brink and De Meyere 1993, 269 n. 8, fig. 54.2; Slive 1995, 241–43, fig. 329

The cheerful warmth of Dutch Italianate landscape painting is immediately ingratiating. We can hardly imagine how such works with their glimpse of the benevolent Mediterranean climate must have affected the seventeenth-century viewer who had not experienced the luxury of Italy itself. Removed from the flat, monochromatic realities of the typical Dutch topography, Jan Baptist Weenix found in the terrain outside Rome, the famous Roman Campagna, a rich variety of natural forms and glowing color. Out of the artist's imagination comes this picturesque vision of a voluptuous Italian peasant mother and her child seated at the foot

Cat. 74

of an ancient column before a thickly atmospheric, pastel landscape. Although after returning from Italy he painted traditional Dutch scenery, such as dunes, beaches, and rivers, as well as portraits and still lifes of dead game (cat. 78), it is for such Italianate scenes as the Detroit *Mother and Child in an Italian Landscape* that Weenix is most renowned.[1]

Weenix rephrased the same compositional elements many times in a corpus of pleasing Italianate works, such as the Dublin *Sleeping Shepherdess* (fig. 1).[2] His formula consists of a triangular figural motif (often a large, single, seated figure positioned in a lower corner),[3] supported visually by the backdrop of architecture or trees and played off against a sharply receding view into the hazy distance. Frequently narrative elements, such as people, buildings, or ships, enliven the horizon line in the middle ground. This tripartite ordering of the composition gives a structural predictability to Weenix's landscape genre scenes, as does his recurrent use of certain figural groups, such as the seated mother and child.[4] However, the variety of narrative details within each component, coupled with Weenix's consummate handling of color and

Fig. 1 Jan Baptist Weenix, *The Sleeping Shepherdess*, ca. 1656–57. Oil on canvas, 72.5 × 61.1 cm (28½ × 24 in.). National Gallery of Ireland, Dublin, 511.

Fig. 2 Jan Baptist Weenix, *Italian Seaport*, signed and dated 1649. Oil on canvas, 68.2 × 87.2 cm (26⅞ × 34⅜ in.). Centraal Museum, Utrecht, on loan from the Rijksdienst Beeldende Kunst, The Hague, 10248.

subtle lighting effects, ensured him continuing success with collectors, such as the wealthy Utrecht collector Willem Vincent, baron van Wyttenhorst.[5]

Architecture often plays an important role in Weenix's compositions, organizing elements within the pictorial space and as a foil for the figurative elements. In addition, the architecture sets the mise-en-scène, frequently establishing the location as some distant Italian seaport or the Roman countryside. In particular, the ruins of antiquity presented the artist with a foreign architectural vocabulary infused with historical and potentially romantic associations. Though some were fanciful constructions, specific quotations of existing monuments, ancient or contemporary or both, do appear in Weenix's paintings, as in the beautiful *Italian Seaport* (fig. 2) of 1649.[6] The description of

the architectural members, whether real or fanciful, a structure's form, and the way light falls across its weathered surfaces are always rendered carefully.[7]

Weenix's preoccupation with light and atmosphere is characteristic of the period, particularly in the works of artists of his generation who had traveled to Rome, such as Jan Asselijn, Nicolaes Berchem, who was Weenix's cousin, and the Utrecht painter Jan Both (cats. 70, 71). Weenix himself made the journey to Italy after drafting a will in October 1642, in which he stated that he made the trip to "experiment with his art."[8] While in Rome, a host of exotic artistic influences came to bear on Weenix's traditional Dutch subject matter. Among the sizable community of foreign artists residing in Rome, he surely would have encountered the expatriate Frenchman, Claude Lorrain. Patronized by the Eternal City's cultural elite, for whom Weenix also worked,[9] Claude was at the forefront of innovations in the emergent landscape tradition. The two artists also shared an early interest in the depiction of harbor scenes. In comparison to Claude's poetic interpretation of the landscape, Weenix's compositions seem more earthy and matter of fact, peopled by robust peasant types.

More sympathetic to Weenix's Dutch training and artistic character was the work of his fel-

low Dutchman, Pieter van Laer, whose nickname, Bamboccio, "clumsy doll," became synonymous with his large following.[10] This influential artist popularized a type of genre painting that depicted Italian street scenes and the low-life denizens of Rome's slums. Weenix's own Italianate genre scenes are more cheerful and colorful than Bamboccio's dark, Caravaggesque images, but the influence is apparent, not only on Weenix, but also on many other Dutch artists, including Berchem, Asselijn, and Both who, along with Weenix and Karel Dujardin, formed the second generation of Dutch Italianate painters.

These various stylistic influences are evident in the Detroit *Mother and Child in an Italian Landscape*, which dates from Weenix's Utrecht period. Weenix settled there before 1649, when he joined two other Italianate artists, Poelenburch and Both, as elected officers in the Painters' College. Thus, just as in the 1620s, with the return of Ter Brugghen, Honthorst, and Baburen from Italy, the late 1640s found Utrecht the creative center of an innovative facet of Dutch painting, this time landscape painting—a new wave of innovation also stimulated by a shared artistic experience in Italy.

—L. F. O.

Artifice and Reality: The "Still" Life

75 AMBROSIUS BOSSCHAERT
(1573–1621)

Bouquet of Flowers on a Ledge
1619

Oil on copper, 28 × 23 cm (11 × 9 in.)
Signed on the sill, lower right: *AB* [in monogram] *1619*
[date is faint]
Los Angeles County Museum of Art, Mr. and Mrs.
Edward Carter Collection

Provenance: U. Palm, Stockholm, before 1934; with
G. Stenman (Stockholm); Dr. E. Perman, Stockholm, by
1936; Mrs. John Goelet, Amblainville, France, to 1965;
with Newhouse Galleries (New York), 1976

Selected References: De Boer 1934, no. 251; Bergström 1956,
62, 65, 69; Bol 1960, no. 46; Walsh and Schneider 1981,
no. 4; Segal 1990, under no. 34; Taylor 1995, 137

In the brief three and a half years that he spent in
Utrecht, from December 1615 to the late summer
of 1619, that is, between his early career in
Middelburg and his last two years in Breda, the
flower painter Ambrosius Bosschaert produced
some of his most important works.[1] It was at this
time that he began experimenting with the open
sky as a backdrop, a simple, astonishingly effective
device. The brilliant but hazy luminosity of the
sky combined with the utter fantasy of the impos-
sibly elevated vantage point stand in marked
contrast to the material concreteness of this
drinking glass, *roemer* in Dutch, filled with flowers.
The almost magical physical intensity of these
flowers was achieved through the application
of multiple subtle glazes.[2]

As in so many of the flower pieces by
Bosschaert and his contemporaries, this is not

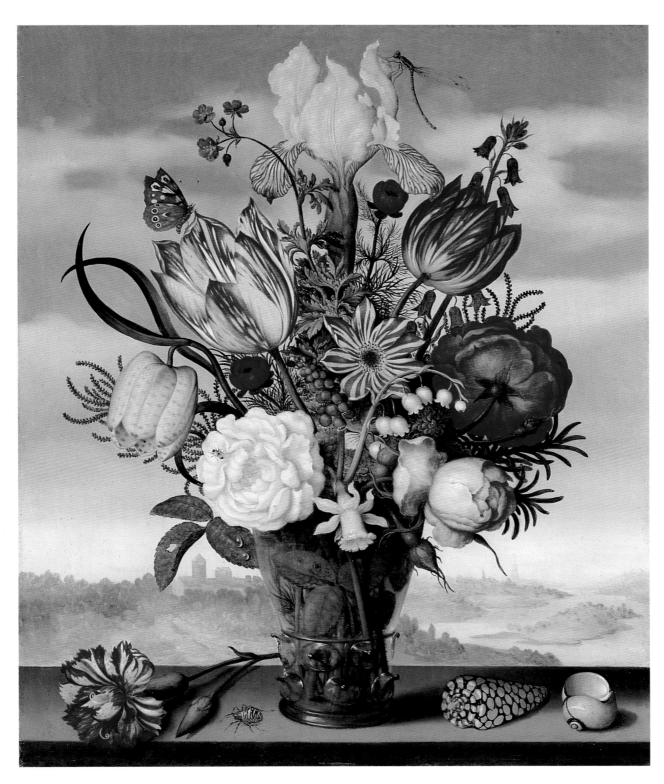

Cat. 75

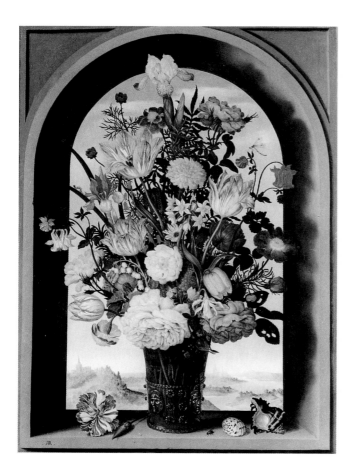
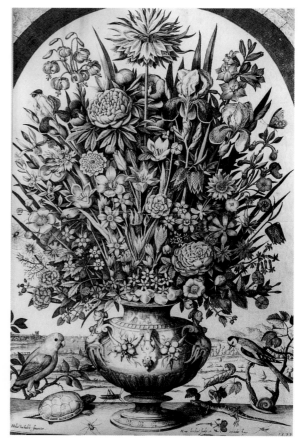

Fig. 1 Ambrosius Bosschaert, *Beaker with Flowers in an Arched Window*, ca. 1619. Oil on panel, 64 × 46 cm (25¼ × 18⅛ in.). Mauritshuis, The Hague, 679.

Fig. 2 Hendrick Hondius, *Vase of Flowers in an Open Niche*, 1599. Engraving after a design by Elias Verhulst, Holl. 24, 620 × 450 mm (24⅜ × 17⅝ in.). Graphische Sammlungen Albertina, Vienna.

a bouquet that the artist set on a table near his easel to paint from life. The Dutch scholar Laurens J. Bol observed that Bosschaert approached these still lifes as if they were group portraits: He maintained the visual integrity of each blossom by avoiding much overlapping and by even lighting,[3] and the flowers were also studied separately, as their presence in other paintings attest. For example, the artist had introduced the yellow fritillaria at the left in his *Vase of Flowers in a Niche* (see Spicer, introduction to this catalogue, fig. 24), painted in 1618,[4] and in the Mauritshuis's famous *Beaker with Flowers in an Arched Window* (fig. 1), datable to 1618 or 1619.[5] The variegated flame tulip at the left also appears in the Copenhagen

painting.[6] It is likely that Bosschaert produced watercolor drawings such as those made by Balthasar van der Ast, his brother-in-law and follower, but none can be identified today. In addition, many of the species do not bloom at the same time of year. Crispijn van de Passe the Elder's splendid publication on flowers, *Het Bloemhof* (The flower garden, also issued as *Hortus floridus*), published in various editions in Utrecht and Arnhem in 1614–15, is organized according to the growing seasons. The anemone, fritillaria, and variegated flame tulip are classified as spring blooming, the yellow iris, white rose, bellflower, and carnation (variegated, on sill) as summer blooming, the grape hyacinth and daffodil as winter blooming.

Just as the flowers are those in which a horticulturist would take pride, especially the extremely expensive flame tulips, the subject of so much financial speculation in those years, so are the shells. A *Conus marmoreus* (?) from East

India on the left and a *Polymita pictar* from Cuba on the right[7] were both appreciated by contemporary conchologists. The nature-lover is further rewarded by Bosschaert's skill in rendering a spider on the ledge, a tiny burying beetle on the white rose, a butterfly, and, perched so lightly on the iris, a dragonfly, whose nearly transparent wings create a subtle counterpoint to the whole, the transparent drops of dew on the leaves of the rose at the bottom left, and the glass itself, filled with stems and water. Bosschaert began introducing these tiny drops of water only after he moved to Utrecht, and they likely reflect his appreciation of the dewdrops in Saverij's flower pieces.[8]

Many of the individual flowers and insects were among the myriad motifs in the natural world that were the subject of moralizing commentary, especially Calvinist, in the seventeenth century.[9] Nevertheless, other contemporary writers interested first of all in flowers, such as Crispijn van de Passe in the preface to *Het Bloemhof*, comment on them rather as a source of "both pleasure and delight." The character of Bosschaert's art suggests that, regardless of whatever interpretive predilection some viewers might bring to these paintings, his intention and Crispijn van de Passe's were aligned.

The luminous landscape view that is spread out to the rear in the present painting and in that in the Mauritshuis really have no precedents in Netherlandish still-life painting. The terrain is in some ways reminiscent of the Rhine valley or of the hills surrounding the Vltava as it passes through Prague, and the sky with its wisps of white cloud bears comparison with Saverij's *Landscape with Birds* of 1622 (cat. 67), but the execution of the landscape, almost suggesting a watercolor in its softness, cannot be assigned to Saverij and is probably by Bosschaert himself. As Sam Segal has suggested,[10] the format of the ledge or arched window with a vase of flowers overlooking a landscape is probably taken most immediately from earlier print sources, such as the highly decorative

engraving by Hendrick Hondius after a design by the Delft artist Elias Verhulst (fig. 2).

There are six flower pieces known to be by Bosschaert that are set against a cloud-streaked or overcast sky.[11] All are set in open, arched windows except the present painting, which is also the only one of the six bearing a date. A rough sequence can be proposed for Bosschaert's flowers using, as bookends, the two paintings that do not have a landscape in the background, the Copenhagen *Vase of Flowers in a Niche*, cited above, and the exquisite 1621 *Bouquet of Flowers in a Glass Vase*, Bosschaert's last dated painting, which was recently acquired by the National Gallery of Art in Washington, D.C.[12] If one posits a progression from the slightly drier, more precise rendering of the Copenhagen painting to the lusher, softer rendering of the Washington painting, the Mauritshuis *Beaker with Flowers in an Arched Window* (fig. 1), with its taller, more elegant proportions, like those of the 1618 painting, would follow the Copenhagen piece, and thus be datable to about 1618 or 1619. The Carter painting, dated 1619 and close to the Mauritshuis painting in style, would follow that, having been executed not many months before the artist left Utrecht in the late summer of 1619. Tentatively assigned to 1619 or 1620, and thus possibly after Bosschaert moved to Breda, would come four paintings of roses, three of them essentially variations on a single composition, in which there is a softer focus and a looser organization of blossoms. Scholars have placed these paintings in the brief Breda period, but no explanation has been given. In the most recent commentary,[13] one of the paintings of roses is described as having been executed "when Bosschaert was working in Breda," but in the same catalogue entry, that painting is dated to "ca. 1618/1619," which implies Utrecht.

—J. S.

76 BALTHASAR VAN DER AST
(1593/94–1657)

Flowers in a Vase with Shells and Insects
ca. 1628–30

Oil on panel, 47 × 36.8 cm (18½ × 14½ in.)
Signed on ledge, lower right: *B van dr Ast*
London, private collection, on loan to the National
Gallery, L655

Provenance: Percy Meyer, London

Selected References: Bol 1960, 38, 73, no. 26; *National
Gallery Report* 1995, 16–17

Throughout his career Balthasar van der Ast responded in a fresh manner to the innovations of other artists, particularly those of his brother-in-law and teacher, Ambrosius Bosschaert, and Roelandt Saverij, with whom Van der Ast joined the Painters' Guild in Utrecht in 1619.[1] This impressive flower piece continues the tradition of Bosschaert's flower bouquets. As in Bosschaert's *Beaker with Flowers in an Arched Window* (cat. 75, fig. 1), blossoms rising implausibly high out of their vessel are surmounted by a majestic iris. Exotic shells lie on the table, where a few petals of a pink cabbage rose have fallen. However, where Bosschaert painted brilliantly colored works composed symmetrically about an axis, Van der Ast generally created looser compositions with a limited range of color and subtle tonal gradations that more closely approximate reality. Van der Ast also departs from Bosschaert's example by introducing into this still life elements not particularly emphasized by his teacher. The grasshopper, the bee, and the spider that creeps along the yellow rose all reflect the work of Roelandt Saverij, whose flower pieces teem with twisting lizards, buzzing airborne bees, moths and butterflies, and grasshoppers ready to spring, creatures that Van der Ast readily incorporated into many of his paintings. Saverij's stylistic influence on Van der Ast is strongest in the early 1620s, when both were recent arrivals in Utrecht, but for the rest of his

career Van der Ast followed Saverij's taste for burgeoning insect life.[2]

As is true of so many flower paintings of the early seventeenth century, the flowers in this beautifully varied arrangement would not all have bloomed in the same season. The tulips, pinks, fritillaria, lilac, and snapdragons shown all bloom in the spring; the roses, irises, and delphiniums bloom in the summer. A few flowers, such as the carnation and the daisy, flower throughout much of the year. This arrangement, then, is a carefully constructed fantasy. The rounded blooms, the tulips, carnations, and roses, mostly in warm reds and pinks, are tightly packed at the bottom, near the vase. From this group, the iris, snapdragons, and flame-striped tulip appear to soar.

Flowers in a Vase with Shells and Insects would have been appreciated not only for its harmonious arrangement of colorful flowers but also for its other wonders of nature. The exotic shells, two species of the *Conidae* (cone) family and a pyram, come not from the nearby North Sea but from the coasts of the Indian Ocean, and were prized by wealthy collectors.[3] The Dutch found wonder also in the world of insects, a wealth of evidence of the marvelous complexity of God's creation. The bee that dives precariously close to the table and the grasshopper are clearly carefully studied from life, although the position of the bee so near the table shows how little Van der Ast knew about insect behavior. The artist's careful attention to the bee's anatomy is consistent, however, with the rapidly developing interest in scientific inquiry about insects that occurred in Europe in the late sixteenth and early seventeenth centuries, a development to which several artists contributed meticulously drawn studies.[4] While in Prague, Roelandt Saverij would have seen drawings of insects and other creatures made for Rudolf II's *Wunderkammer* by artists such as Joris Hoefnagel and Jacques de Gheyn the Younger and may have imparted his knowledge of those studies to painters in Utrecht.

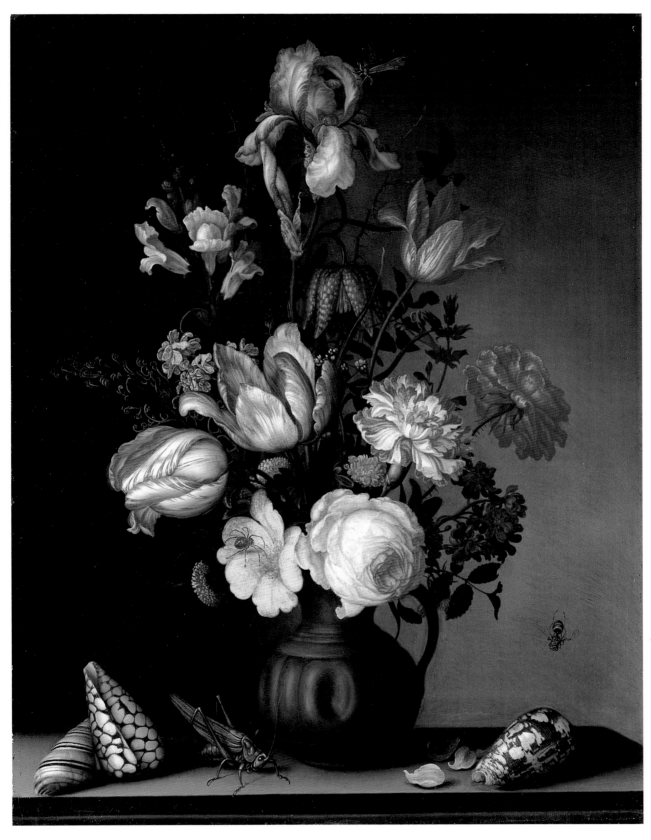

Cat. 76

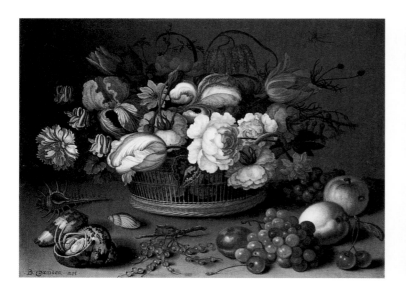

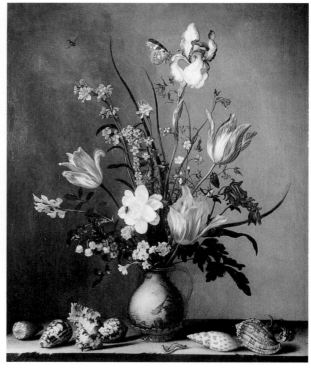

Fig. 1 Balthasar van der Ast, *Basket of Flowers*, ca. 1622–23. Oil on panel, 17.8 × 23.5 cm (7 × 9¼ in.). Gift of Mrs. Paul Mellon, National Gallery of Art, Washington, 1992.51.2.

Fig. 2 Balthasar van der Ast, *Flowers in a Wan-li Vase with Shells*, ca. 1630–35. Oil on panel, 53.5 × 42.7 cm (21 × 16⅞ in.). Mauritshuis, The Hague, 1108.

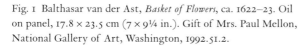

As an example, the grasshopper in the present painting is strikingly similar to a grasshopper on a sheet of life studies of insects and petals executed by Jacques de Gheyn the Younger in 1600, which, with other sheets of similar studies, was gathered into a small album collected by Rudolf II. Saverij may have seen this album; an undated painting by him draws on some of De Gheyn's studies.[5]

To create his fantastic arrangements, Van der Ast must have relied on drawings or models of the flowers; the frequency with which some blossoms appear in paintings from different periods of his career is evidence of his reusing a model.[6] The red-and-white variegated tulip at the bottom left in the present painting is a Zomerschoon (Summer Beauty) that appears in several paintings by Van der Ast,[7] among them the *Basket of Flowers* at the National Gallery of Art in Washington, D.C., which, with its pendant, can be dated about 1622 or 1623 (fig. 1).[8] The compositional type of the Washington pair, a basket filled with flowers or fruit, is one Van der Ast popularized in the early

1620s in works such as this and *Still Life with a Basket of Fruits*, dated 1622 (North Carolina Museum of Art, Raleigh).[9] The format was used by other still-life painters in the mid- to late 1620s, particularly Johannes Bosschaert, who likely studied with Van der Ast.[10] The soft handling of the flowers in the Washington painting is consistent with Van der Ast's pronounced use of glazing in the early to mid-1620s and is a hallmark of his work. Another example of this soft, velvety quality is *Vase of Flowers in a Niche*, signed and dated 1621 (cat. 77, fig. 1). Van der Ast's use of glazes at this time extended also to the delicate water droplets and translucent skins of ripe grapes that are prominent in many paintings, including a still life he worked on for two years (the painting is dated 1620 and 1621) in the Rijksmuseum in Amsterdam,[11] the North Carolina still life cited above, and the pendant to the Washington still life illustrated as figure 1 here. In contrast, the blossoms in *Flowers in a Vase with Shells and Insects* are somewhat crisper in appearance and characteristic of Van der Ast's later works, both in Utrecht and afterward in Delft. This tight handling of form is especially

apparent in *Flowers in a Wan-li Vase with Shells* (fig. 2), which probably dates from his Delft period.[12]

Despite its stylistic similarities with figure 2, *Flowers in a Vase with Shells and Insects* was probably painted in Van der Ast's last years in Utrecht and not in Delft, to which he moved in 1632.[13] The present painting shares with works from his early period in Utrecht compositional principles not found in works from his Delft period. Here, for instance, he employs a pattern of light across the back wall—dark on the left and light on the right —that he developed in the early 1620s, in apparent emulation of Saverij's approach to painted light.[14] Through this division of light Van der Ast creates the optical illusion of space by contrasting the background with the high-value tones on the left and the low-value tones on the right of the vase of flowers. In comparison, in his later, Delft-period paintings, Van der Ast achieves a sense of space primarily through loose arrangements of flowers placed against walls flooded with light, as, for example, in figure 2. In addition, *Flowers in a Vase with Shells and Insects* is closely framed by the edges of the picture space, whereas generous space often envelops Van der Ast's Delft compositions. In these later works Van der Ast expanded the zone of space above and around his arrangements and populated it with an occasional darting butterfly or bee. [15]

With its exotic shells, minutely observed insects, and beautiful blossoms, *Flowers in a Vase with Shells and Insects* functions as a collector's cabi-net, one appreciated through repeated observa-tion. Many seventeenth-century viewers, steeped in a culture that saw the natural world in meta-phorical terms, would find a deeper meaning in this image, one centered on the butterfly and iris. Butterflies, because of their transformation from a caterpillar in the cocoon,[16] were often associated with the Resurrection of Christ or of the soul. The butterfly alighting on an iris, a flower thought to represent heaven and an association here

reinforced by the colors blue and white, would prompt the viewer to consider these wonders of God's creation and remember that he or she, like the flowers, will fade and can only overcome death through a life focused on God.[17]

—Q. G.

77 BALTHASAR VAN DER AST
(1593/94–1657)

Bouquet of Flowers

ca. 1630

Oil on oval panel, 53 × 38 cm (20⅞ × 15 in.)
Signed on pedestal: *B. vander. ast*
New York, private collection

Provenance: M. Salvador Merquita, Buenos Aires, 1915; with Edward Speelman (London)

Selected References: Bol 1960, 73, no. 24; Mitchell 1973, 72, illus. (with incorrect caption; correct caption at no. 39); Adams 1988, 33, illus.

Baltimore only

In this splendid example of his mature style, Van der Ast demonstrates a mastery in achieving ever-new variations of a favored compositional type. The artist[1] has drawn on many elements found as well in his slightly earlier *Flowers in a Vase with Shells and Insects* (cat. 76). The luxuriant round blossom of the cabbage rose, with its even, soft color and floppy stem, is tucked into the lip of the vase, red-and-white variegated carnations and tulips, with their more linear, vertical, explosive shapes and stiffer stems, are the primary focus of the middle of the bouquet, and the pinnacle is dominated by an iris with a long, rigid stem, its intricate shape and purple blue coloring set off by variegated tulips with red "flames" on an orange base, its preeminence signaled by a butterfly.[2] A cool gray surface provides a neutral foil for the vibrant color and fragility of the blossoms, for the intricacies of the shells, and for one small, nervous creature.

Fig. 1 Balthasar van der Ast, *Vase of Flowers in a Niche*, 1621. Oil on panel, 30.8 × 19.7 cm (12⅛ × 7¾ in.). Christie's (London), 7 July 1995, lot 21.

Yet the two paintings convey different moods: The wonderfully refined, delicate containment of the earlier piece is replaced here by radiant energy. A recognition of the surprisingly subtle calculations that must have gone into composing this bouquet, the result of strategies that we normally associate with the more intellectual demands of history painting, is a step in understanding the enduring satisfaction of the greatest flower paintings. Fundamental to the dynamic character of this painting are the brilliant colors and the approaches to composition and lighting.

In contrast to catalogue 76, where the balanced, symmetrically arranged flowers and still-life details are aligned parallel to the picture plane, here the whole is organized around a subtle but pronounced diagonal that sweeps from the tip of the lizard's nose at the lower left back into space to the upper right. Because the table is seemingly pressed up against the frame, the lizard, poking over the front edge of the table beyond the frame and into our space, implicitly calls attention to the existence of a spatial continuum uniting the two realms. Then, just as the shells angle back from that point, so do the flowers draw the eye upward and backward through the strategically drooping pink roses (which would normally be tucked into the vase with their fellows), up through the rising, flaring lines of the tulip, which serves as a pivot point for the eye's ascent, to the crimson phlox at the right and behind the iris. The flowers at the right, particularly the two drooping carnations that provide ballast for the roses on the left, retreat into shadow. In addition to the assertion of depth, the arrangement of flowers and shells responds at the same time to the two-dimensional surface and to the decorative demands of the oval frame; Van der Ast's capacity to keep these factors in balance is unrivaled.

The lighting here is almost directly from the left of the vase, rather than from the more common angle over the viewer's or artist's left shoulder, as in *Flowers in a Vase with Shells and Insects* and in any composition using a niche, for example the artist's 1621 *Vase of Flowers in a Niche* (fig. 1). This side lighting emphasizes the visual movement from left to right within the arrangement, and the combination of the lighting and orientation recalls the dramatic solutions of contemporary history painting, for example Ter Brugghen's *Calling of Saint Matthew* (cat. 4) or the *Annunciation* (cat. 15), so greatly influenced by Roman baroque painting.

The particular effect of side lighting can be measured on three flowers. The white bellflowers at the left catch the light first. The side lighting floods the inside of the bouquet, picking out the pot marigold (?) in the center, which is overlapped

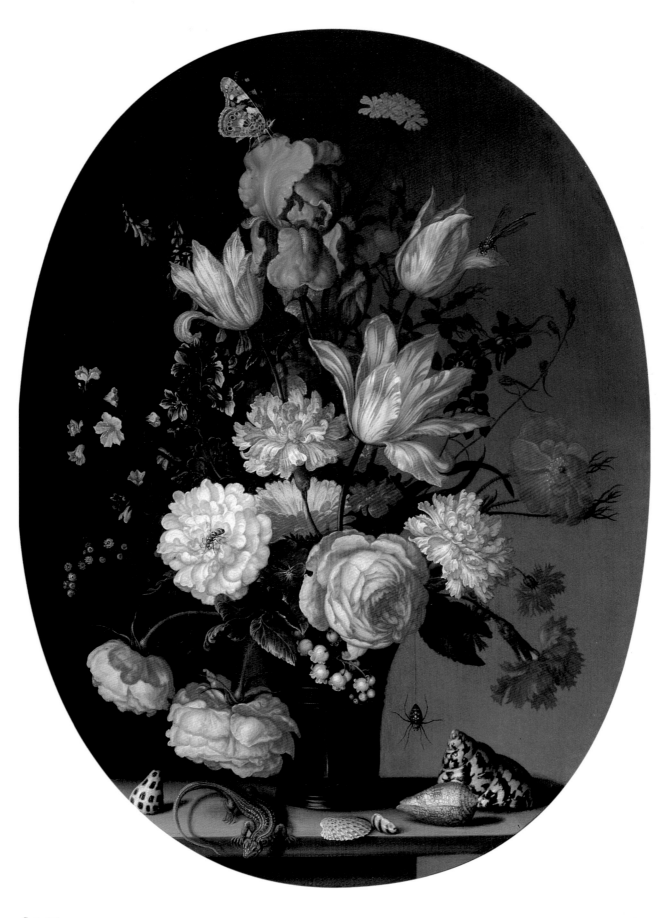

Cat. 77

by the stem of a striped carnation. The particularly sophisticated layering of flowers, which effectively suggests depth, is less developed in Van der Ast's earlier paintings. In *Vase of Flowers in a Niche* (fig. 1), the marigold, like other flowers in the painting, is painted in an even light with no suggestion of its playing naturally across the densely packed bouquet. Here, every petal of the central rose is outlined in delicate shadow by the direction of the lighting, quite in contrast to its counterpart in catalogue 76, which, because of the different lighting, one does not immediately recognize as exactly the same blossom. Alerted by the identical curling petal at the bottom, one can trace their similarities. Likewise, the iris and the tulip with splayed petals can be identified in other bouquets although the lighting is different.[3] This repetition of flowers and the fact that some of these, for example the lily of the valley and iris, do not bloom at the same time of year mean that Van der Ast was working at least in part from drawings, of which almost five hundred by him are known,[4] and not (or not simply) from a vase of flowers before him. In these circumstances, the orchestration of an internally consistent and persuasive play of light is remarkable.

The conviction conveyed by minutely observed detail extends to the insects—dragonfly, wasp, spider dangling provocatively in space, as well as the butterfly—and the various shells displayed on the ledge,[5] but it is the little lizard, apparently adopted from Saverij's flower pieces, that puts the question, is this outside or inside?

This ambivalence and other clues about the plausibility of this and related bouquets would have delighted the seventeenth-century viewer as they do us today. Every viewer then would have been aware of the encouragement found in emblem books and other contemporary moral tracts to contemplate, in the fragility of flowers,[6] the transitoriness of this material life and its pleasures. The variegated flame tulips, especially, were unbelievably expensive in those years of specula-

tive frenzy in tulip bulbs that culminated in 1637.[7] Most viewers would probably have brought this awareness to their perception of these paintings, as to the appreciation of a garden. It was, however, surely the delight for the eye that such paintings, like the flower garden, provided that was their primary attraction (see Spicer, introduction to this catalogue).

Because most of Van der Ast's few dated paintings are from the early 1620s, his later stylistic evolution remains a matter of conjecture. This painting was possibly produced in his last years in Utrecht before he moved to Delft in 1632, though a dating shortly thereafter cannot be excluded. The present work exhibits the airiness of those assigned to the Delft years, such as the Mauritshuis *Flowers in a Wan-li Vase with Shells* (cat. 76, fig. 2), but experimentation with the diagonal so beloved of the Caravaggisti seems to be found only in works assigned to the late 1620s.

—J. S. / Q. G.

78 JAN BAPTIST WEENIX
(1621–1659)

Dead Swan

1650

Oil on canvas 155 × 142 cm (61 × 55⅞ in.)
Signed and dated lower middle: *Geo Battista Weenix 1650*
Heino-Wijhe, Collection Hannema-de Stuers Foundation

Provenance: Daneby Seymour, Knoyle House, Hindon, Wiltshire; Martin B. Asscher (London)

Selected References: Stechow 1948, 188, 198; Hannema 1967, 78, no. 363, fig. 38; Sullivan 1979, 68, fig. 6; Sullivan 1984, 31, 63, 69, fig. 66

The skillful diversity of Jan Baptist Weenix is evident in the two works in this exhibition. Introducing several new motifs into the repertoire of Dutch painting, including Italian harbor scenes, Weenix also made important contributions to the evolution of the Dutch game piece. In this he was

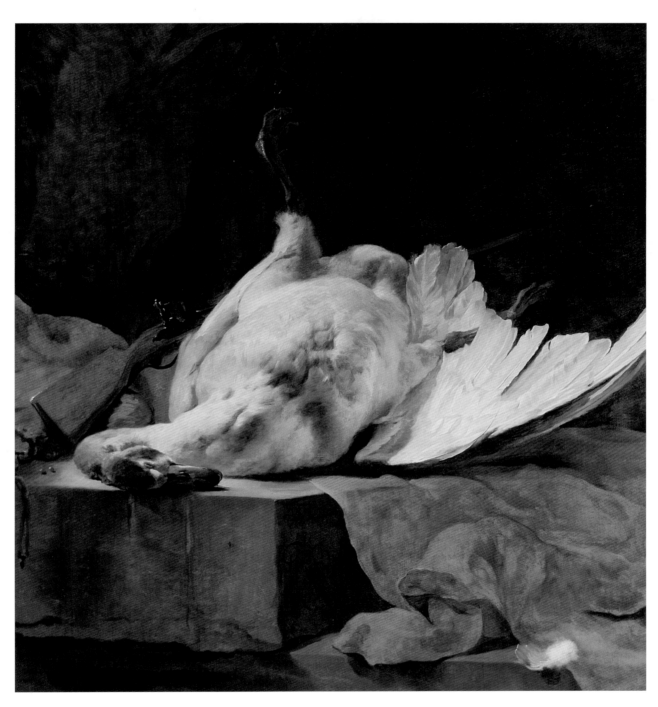

Cat. 78

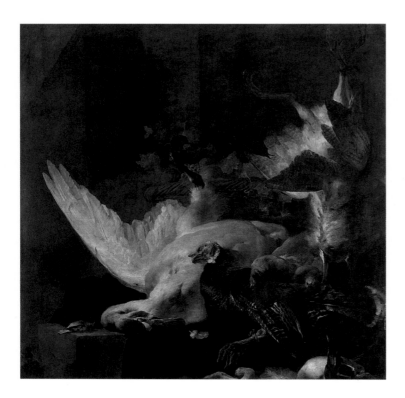

Fig. 1 Jan Baptist Weenix, *Still Life with a Dead Swan*, ca. 1651. Oil on canvas, 152.4 × 153.7 cm (60 × 60½ in.). The Detroit Institute of Arts, gift of Ralph H. Booth, 26.22.

followed by his son, Jan Weenix. As seen in this *Dead Swan*, whether he is describing the subtlest nuances of texture or the milky atmosphere of the Roman Campagna, Jan Baptist Weenix's powers of observation were remarkably acute. In such imposing still-life compositions, he adapted Flemish decorative elements and a fluid painterly technique to the more sober Dutch approach and attention to surface detail. The result is a work monumental in both its scale and calm dignity. The painting is very much a trophy piece, as is the magnificent bird represented.

As suggested, formal devices impart to this image of a dead bird surprising dignity. An understanding of the iconography attached to the swan and other large game birds makes it apparent that this is not at all fortuitous. In Europe hunting has long been a sign of nobility, and a host of laws governed who could hunt what, where, and when. Laws established hunting seasons, regulated the quantity of catch, and specified the type of hunt-

ing gear to be used. For example, as noted by Scott Sullivan, "The use of greyhounds was permitted only twice a week, while the total number of dogs was limited to five. Those not qualified to hunt were forbidden even to own such noble dogs."[1] Such restrictions guaranteed that stocks would not be depleted and that the aristocracy maintained its privileges. By the mid-seventeenth century, the privilege of the hunt was one of the most important distinctions of nobility not yet usurped by the rising Dutch burgher class. The *Ridderschap*, the college of noblemen representing the titled gentry, held its monopoly of hunting rights until 1716, and before that time species such as swan, duck, pheasant, and the heronlike bittern could be hunted legally only by the aristocracy.[2] Of course, as a symbol of rank, hunting was viewed not as a means of procuring food but as sport, a courtly pastime. And leisure, in addition to land, title, and lineage, was one of the principal attributes of nobility.[3] The association of hunting with the aristocracy suggests then that such large pictures of dead trophy birds were painted for a noble clientele or for the ambitious burgher eager to acquire the accoutrements of nobility. Weenix himself acquired a landed estate outside Utrecht, a country manor called *Huis ter Mey*.[4]

The Hannema-de Stuers painting dates from after Weenix's Italian sojourn and exhibits the broad, fluid brushstroke characteristic of large-format pictures from this moment in the artist's career. As one of the latest paintings in this exhibition, *Dead Swan* looks ahead to the increasingly decorative quality that pervaded Dutch art in the later seventeenth century. Flemish models, particularly as seen in the animal paintings of Frans Snyders and Jan Fyt, provided Weenix with stylistic elements that heighten the complexity and surface elegance of his game pieces. This influence is particularly apparent in Weenix's famous trophy piece, *Dead Deer* (ca. 1655; Rijksmuseum, Amsterdam).[5] In that painting, as in *Dead Swan*, the animal is strung up by a leg, providing the

requisite vertical and diagonal elements to enliven the pictorial field. The Rijksmuseum painting also has a narrative element, a dog and cat sniffing and snarling at the dead animal and at each other. In contrast, the Hannema-de Stuers picture is simpler in composition, consisting only of the noble bird. The placement of a gun alongside the carcass echoes the arrangement of the swan and suggests the role of the unseen hunter.

In composition and in its reliance on baroque diagonals and rich chiaroscuro effects, the present work has been compared with the similarly beautiful canvas (fig. 1) in Detroit.[6] In both, the life-size bird has been arranged diagonally on a stone block, the solid coldness of which serves to accentuate the soft, downy plumage of the creature. Particularly in the Hannema-de Stuers composition, the block juts out toward the viewer at a sharp angle to the pictorial surface, increasing the illusion of projecting and receding space. A complex play of diagonals, both into and across the pictorial surface, marks each composition, most eloquently in the graceful curving neck and spread wing. And in each the massiveness of the swan's body is countered by a whimsical detail—a delicate, isolated feather.

—L. F. O.

Biographies

MARTEN JAN BOK

The memory of a good number of the twenty-five artists treated in the following short biographies would be well served with a thorough biographical monograph. Not just to rescue them from oblivion—their works are usually better testimony to their art-historical relevance than are their biographies—but because a better knowledge of their *faits et gestes* would ultimately lead to a better understanding of their place in (art) history. To describe and analyze the intricate network of ever-changing artistic interconnections between artists, as well as the role of patrons, art dealers, and the art market in general, we would do well to have the historical facts in place. The question of who did what, when, and why is just as crucial to the art historian as it is to the journalist or police detective. In art history, as in any other field of scholarship, hypotheses need to be tested and theories challenged. This may sound like old-fashioned historiography, but those who have engaged in this kind of research know that the discovery of a simple piece of paper can solve a scholarly debate that has gone on for decades. Sound evidence tends to be more rewarding than spectacular hypotheses.

The historiography of the lives of the "most eminent painters" often goes back to contemporaneous authors. Later historiographers and scholars accumulated more and more biographical facts, allowing us in many cases to describe the lives of these painters in sometimes astonishing detail. A publication such as this one, however, is intended neither to present every shred of unpublished biographical evidence nor to dig too deeply into the gold mine of seventeenth-century documents surviving in Dutch archives.

In the following biographies I have had to limit myself to the main biographical data—the chronology of birth, marriage, and death, for example—giving but the barest outline of the artists' "milieu." Wherever possible I have included the professional background of the artist's father, as well as his teachers, his journeys abroad, the location of his house in Utrecht, his religious affiliation, and any political offices he held. I have refrained from listing the names of all pupils and other artists with whom the artist in question was in contact, and I have omitted lists of children and biographical details of their lives. However interesting this information might be to the genealogist or historical demographer, the simple fact that lack of birth control usually led to a dozen children per marriage forbids the inclusion of these facts in a book of this scope.

I have consulted all the commonly used sources in the literature, such as the collections of artists' biographies by Karel van Mander (1604), Cornelis de Bie (1661), Arnold Houbraken (1718–21), and others. I also used the important biographical dic-

tionaries by Alfred von Wurzbach (1906–11) and Ulrich Thieme and Felix Becker (1908–50). Unless specifically stated, references to all the relevant literature from before 1950 can be found there and need not be summed up here. In the last fifty years much biographical material has come to light. In those cases where other authors have undertaken extensive research on an artist in the course of writing a monograph, I refer to their publications, giving explicit references mainly to material as yet unpublished.

References to archival material have been made in such a way that the original documents can be easily consulted. To avoid confusion, Dutch words in archival references have been left untranslated. In those cases in which documents have been published before, references to the publications have been added.

In the seventeenth-century Netherlands, patronymics were commonly used (as they still are today in Russia and Iceland). The patronymics "son of" and "daughter of" are usually abbreviated in written texts, as in "Janszoon" (Jansz.) and "Jansdochter" (Jansdr.). The patronymic cannot be used without the Christian name and should not be confused with a surname. Thus the famous Haarlem painter Cornelis Cornelisz. may be addressed simply as "Cornelis" but not as "Cornelisz." The prefix "van" in family names is sometimes dropped if the name is used frequently (Van Honthorst = Honthorst).

The Dutch language did not have a fixed spelling in the seventeenth century, and even in our own time, Dutch spelling is updated almost every generation. One should therefore not be surprised to find a name spelled in different ways, even in the same document.

Throughout the seventeenth century the province of Utrecht used the Julian calendar. This ran ten days behind the Gregorian calendar, which at that time had already been adopted by the province of Holland, as well as several other Dutch provinces. I have converted Julian dates to Gregorian dates only in cases where confusion might arise concerning the chronology of the events described.

Balthasar van der Ast
[MIDDELBURG 1593/94–1657 DELFT]

Balthasar van der Ast was born in Middelburg in 1593 or 1594.[1] His father, Hans van der Ast, a merchant made wealthy from knitted apparel, died a widower in 1609, and Balthasar was taken into the care of his sister, Maria van der Ast, and her husband, the still-life painter Ambrosius Bosschaert. Bosschaert is generally thought to have been his teacher.

By 1615 Bosschaert had moved to Bergen-op-Zoom, and by the next year he was living in Utrecht. Balthasar may have followed his brother-in-law to Utrecht, where we first encounter him in the summer of 1618.[2] He joined the Guild of St. Luke the following year. Van der Ast stayed in Utrecht for almost fifteen years, playing a very active role in the artistic life of the city. By 1622 his reputation as an artist had reached the Utrecht humanist and art lover Johan de Wit in Rome, through letters from Aernt van Buchel.[3] In the same year he was named among the artists who used to frequent Roelandt Saverij's home on an almost daily basis.[4] He undoubtedly shared Saverij's interest in flowers and animals, and the two were still in close contact in 1629.[5]

In the 1620s Van der Ast lived in the Drieharingsteeg, a small alley between the Oudegracht and the Vredenburg.[6] His sister Maria, a widow since the death of Ambrosius Bosschaert in 1621, later moved to this house from Breda,[7] which had fallen into the hands of the Spanish in 1625. Apparently Maria no longer envisioned a future for herself and her children there. The Bosschaerts stayed in the Drieharingsteeg until about 1634. In 1629 Balthasar van der Ast moved to the Jacobijne-straat, where he bought a house that he named den Indiaenschen Raven (The Parrot) from the art

Joan Blau, map of Utrecht, detail, 1649. From *Toonneel der Steden van de Vereenighde Nederlanden, Met hare Bechrijringen.* The Bancroft Library, University of California, Berkeley.

This map shows the location of public buildings, main streets, and canals.

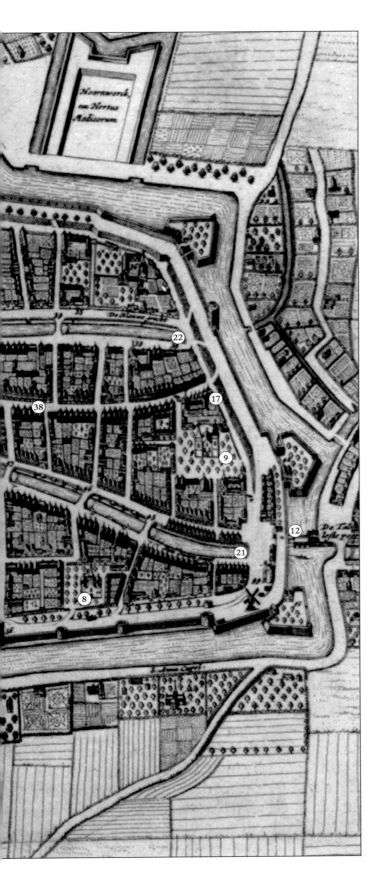

Churches

1. Dom (Cathedral)
2. Oudmunsterkerk (collegiate church, demolished in 1587)
3. Mariakerk (collegiate church)
4. Pieterskerk (collegiate church)
5. Janskerk (collegiate church)
6. Buurkerk (parish church)
7. Jacobikerk (parish church)
8. Geertekerk (parish church)
9. Nicolaaskerk (parish church)

City gates

10. Weerdpoort
11. Wittevrouwenpoort
12. Tolsteegpoort
13. Catharijnepoort

Other public buildings

14. Town hall
15. Provincial Court (former Abbey of St. Paul's)
16. Duitse Huis (Teutonic Knights)
17. Agnietenconvent (St. Agnes's Convent),
 Painter's Hall: 1644–1672
18. St. Job's Hospice
19. 't Poortgen (inn)
20. 'Kasteel van Antwerpen' (inn)

Canals

21. Oudegracht
22. Nieuwegracht
23. Kromme Nieuwegracht
24. Drift
25. Plompetorengracht

Main squares

26. Stadsplaats
27. Vredenburg
28. Neude
29. Ganzenmarkt
30. Domkerkhof
31. Mariaplaats
32. Mariakerkhof
33. Janskerkhof
34. Pieterskerkhof

Main streets

35. Voorstraat
36. Steenweg
37. Springweg
38. Lange Nieuwstraat

dealer Lucas Luce.[8] He did not stay there long, however. In 1632 he moved to Delft, where he registered as a master painter.[9] There he married Margrieta Jansdr. van Bueren and acquired citizenship in 1633. The house in Utrecht was first rented to the innkeeper Pieter Willemsz. and finally sold in 1639.[10] Balthasar van der Ast died in Delft in December 1657 and was survived by two daughters.

Dirck van Baburen

[WIJK BIJ DUURSTEDE CA. 1595–1624 UTRECHT]

Dirck van Baburen was born in Wijk bij Duurstede in about 1595.[1] He came from a respectable family: his parents, Jasper Petersz. van Baburen and Margaretha van Doyenburgh, had served the lady of Vianen as footboy and maid before they married and settled in Wijk bij Duurstede, where Jasper van Baburen worked as a tax collector until he resigned in 1599. The family probably moved to Utrecht, where Dirck was registered as an apprentice to the painter Paulus Moreelse, in 1611.

After completing his training in Utrecht, Baburen traveled to Italy, where he is recorded in Parma in 1615. From there he went to Rome, where he and his companion David de Haen worked on the decoration of the church of S. Pietro in Montorio in 1617. Baburen enjoyed considerable success. Among his patrons were Marchese Vincenzo Giustiniani and Cardinal Scipione Borghese.

The two artists were still living in Rome in 1619 and 1620, but Dirck van Baburen must have returned to Utrecht at about the time the Twelve Year Truce came to an end in 1621. His friend De Haen stayed in Rome, where he died in 1622. In Utrecht Baburen must have been an immediate success. Already in 1622 he contributed a portrait of Titus to a famous series of portraits of Roman emperors (cat. 28). In this project he found himself in the company of such famous masters as Rubens, Hendrick Goltzius, Cornelis Cornelisz. van Haarlem, Hendrick ter Brugghen, and Paulus Moreelse.[2] Constantijn Huygens, secretary to the stadholder, considered him to be one of the most talented painters of his generation. That others thought so as well is evidenced by the high prices fetched by his paintings throughout the seventeenth century.

Dirck van Baburen died a bachelor and was buried in the Buurkerk in February 1624. He may have been a victim of the plague, which killed hundreds of Utrecht inhabitants that year.[3]

Jan van Bijlert

[UTRECHT 1597/98–1671 UTRECHT]

Jan van Bijlert was born in Utrecht in 1597 or 1598, the son of the glass painter Herman Beerntsz. van Bijlert and Elisabeth Willemsdr. van Laeckervelt.[1] Like his elder brothers, Jan van Bijlert was initially trained in his father's craft. According to Von Sandrart, he continued his training with Abraham Bloemaert, whose studio he must have entered in the early 1610s. His brother Beernt continued their father's workshop in the family house, de Drij Witte Ruijten, on the Oudegracht.[2]

After completing his training in Utrecht, Van Bijlert traveled to France and Italy, where he spent many years. In Rome he is first recorded in 1621, when he was living in the Via Margutta with three other Netherlandish painters. He was one of the founding members of the society of Netherlandish artists in Rome and may have been the "Joan Harmans" who was given the nickname "Aeneas" by his fellow *Bentvueghels*.

Van Bijlert was still abroad in October 1623, although he must have returned to Utrecht soon after that. By February 1625 he was enrolled in the local militia, and one night, while on guard duty, he witnessed a brawl in which his comrade Ellert Duyck was stabbed to death.[3]

In June 1625 he married Margrieta Kemings, who lived in Amsterdam but was related to Utrecht neighbors of the Van Bijlerts. The couple settled in Utrecht, at first in rented quarters. We can trace them through the addresses given in connection with the registration of the baptisms of their children: the Oudmunster Trans (1627), the Neude (1629), and the Janskerkhof (1629–30). By 1630 Van Bijlert had settled down: He became a member of the Guild of St. Luke, joined the Reformed Church, and in 1633 bought a house in the Winssensteeg. He was soon accepted as a respected burgher and was appointed dean of the guild for the first time in 1632, also becoming a regent of St. Job's Hospice in 1634. At the same time he began taking on apprentices. His pupil Abraham Willaerts, son of the painter Adam Willarts, later continued his studies with Simon Vouet in Paris.

As an artist Jan van Bijlert was a dedicated follower of fashion. Although he concentrated on painting figures, he worked in all of the styles that were popular in the market during his lifetime. He did have some success, though, and like several of his Utrecht contemporaries, he saw his work enter the collections both of the stadholder and of Frederick, the former king of Bohemia. He also contributed to the decoration of Kronborg Castle in Denmark and collaborated in other projects in Utrecht.

In 1641 Van Bijlert and his wife sold their house in the Winssensteeg, and a year later he is again recorded on the Janskerkhof. In 1650 they lived in the Loeffberchmakerstraat, where Margrieta Kemings must have died in 1657 or shortly thereafter. About this time their only surviving daughter, Elisabeth, was already a widow, having lost her first husband, a canon of the cathedral chapter, whom she had married in 1644. In 1656 she was married again, this time to the Reformed minister Arnoldus Finson, son of the painter David Finson.

In 1660 Jan van Bijlert, then about sixty-two, married Cecilia Gelove. She was the widow of the housepainter and paint dealer Jelis van Thiel. Van Bijlert soon became active in the paint trade, which his wife conducted from her house on the Oudegracht. He was still active as an artist, though, and continued to serve on the board of the Painters' Society throughout the 1660s. Jan van Bijlert died in Utrecht in November 1671 and was buried in the Nicolaaskerk.

Abraham Bloemaert

[GORINCHEM 1566–1651 UTRECHT]

Abraham Bloemaert was born in Gorinchem on Christmas Eve 1566.[1] His father, Cornelis Bloemaert, was a sculptor and architect. Soon after Abraham was born his parents moved to 's-Hertogenbosch, where Cornelis contributed to the restoration of the Janskerk, which had recently been damaged during the "iconoclastic fury" of 1566. A few years later they returned to Gorinchem, where Abraham's mother, Aeltgen Willems, may have died.

In 1576 the Bloemaerts were living in Utrecht. Abraham was apprenticed to several Utrecht masters, none of whom taught him very much. In 1581 or 1582 he traveled to Paris, where he worked with "Iehan Bassot" and "Maistre Herry," artists of whom we know nothing. He finished his studies with Hieronymus Franck. In the mid-1580s Bloemaert returned to Utrecht, where he probably worked for his father. In 1591 Cornelis Bloemaert was appointed city engineer of Amsterdam, and his son Abraham moved there with him. He set up a studio of his own in a former convent and produced his first major works, for which he must have received immediate acclaim. Although his stay in Amsterdam lasted less than three years, he must have made many contacts with collectors and other artists, from which he would profit in later years.

In May 1592 he married the Utrecht "maid"

Judith van Schonenburch, who was almost twenty years his senior. She came from wealthy Catholic patrician stock and appears to have brought some property to the marriage, in which Bloemaert received a life interest after she died of the plague in 1599 without having borne him any children.

After the death of his father in 1593 Abraham Bloemaert settled in Utrecht. He was immediately appointed dean of the Saddlers' Guild, to which the artists also belonged. For twenty years —from 1597 to 1617—he rented quarters in the former Convent of Mary Magdalene.

In 1600 Bloemaert married Gerarda de Roij, the daughter of a wealthy brewer. She bore him at least eight children. Indeed, according to an early source, their number might have been as high as fourteen. Their sons Hendrick, Cornelis, Adriaen, and Frederick all became artists, after being trained by their father. But they were not his only pupils. Karel van Mander, in his detailed biography of Bloemaert dating from 1604, stresses that Bloemaert was a dedicated teacher who wanted to provide young artists with a better training than he himself had received. During his long career he may have taken on over one hundred apprentices. Together with Paulus Moreelse he trained the generation of artists that made Utrecht an artistic center of international importance. Among his pupils were Hendrick ter Brugghen, Gerard van Honthorst, Cornelis van Poelenburch, Jan van Bijlert, Jan Both, and Nicolaus Knupfer. Many of these probably took drawing lessons at the Utrecht "academy," which was founded about 1612 and where Bloemaert and Moreelse were the principal teachers.

In 1617 Bloemaert bought a large and expensive house on the prestigious Mariakerkhof. This square was the nucleus of Utrecht's Catholic community, of which the artist was an active member. He was a devout Catholic and worked for the Jesuits and other patrons in the Southern Netherlands. This also explains why he never played a prominent role in Utrecht politics. In the revolutionary year of 1610 he was listed as a reliable citizen in the roster of militiamen, but this was of little use after the old council was restored to power.[2] And when in 1618 he was elected dean of the Painters' Guild, the Contra-Remonstrant coup of that same year meant his removal in favor of Paulus Moreelse, who was a Protestant.

In the 1620s and 1630s Bloemaert was still playing an active role in the Utrecht art world, which by that time was dominated by his former pupils. He was held in great esteem: In 1626 his studio was visited by Elizabeth Stuart, the former queen of Bohemia. He sold her a portrait of her dog Babler. Rubens visited him the following year. Bloemaert's sons Cornelis and Frederick both became engravers, and their work helped to spread his fame. His collected drawings, published as the *Tekenboek* (Drawing book) was used in the training of artists until the nineteenth century.

Abraham Bloemaert died in Utrecht in January 1651 and was buried in the Catharijnekerk.

Ambrosius Bosschaert
[ANTWERP 1573–1621 THE HAGUE]

Ambrosius Bosschaert was baptized in Antwerp on 18 November 1573.[1] His father, also named Ambrosius Bosschaert, may have been a painter as well. Shortly after 1587 the family left Antwerp for religious reasons and settled in Middelburg. Between 1593 and 1613 an Ambrosius Bosschaert is listed as member of the board and dean of the Middelburg Guild of St. Luke, but it is unclear whether this refers to the father or the son.[2] At any rate, the younger Ambrosius Bosschaert soon developed into a skillful still-life painter.

About 1604 Ambrosius Bosschaert married Maria van der Ast. They had at least six children, of whom the sons Ambrosius (III), Johan, and Abraham followed in their father's footsteps. His daughter Maria eventually married the painter Jeronymus Sweerts, son of the famous botanist and engraver Emanuel Sweerts. After the death of

Maria van der Ast's father in 1609, her younger brother, Bartholomeus van der Ast, is thought to have been apprenticed to his elder brother-in-law. He too became a still-life painter and worked as an assistant in Bosschaert's studio until he moved to Utrecht around 1618.

In addition to being a painter, Ambrosius Bosschaert was also an art dealer. He is known to have traded with Antwerp, Frankfurt, England, and Ireland, sometimes dealing in large cargoes containing numerous paintings. Works by important masters such as Paolo Veronese and Georg Flegel passed through his hands. His business must have been profitable, enabling him to buy a large house in Middelburg in 1611. He left Middelburg soon afterward, however, and is recorded in Amsterdam (1614), Bergen-op-Zoom (1615), and Utrecht (Dec. 1615–before Aug. 1619) before he finally moved to Breda in 1619.

Ambrosius Bosschaert went to Utrecht at a time in which flowers were becoming very fashionable, as witnessed by the publication in Utrecht of Crispijn van de Passe's *Hortus floridus* (1614).[3] In the end, though, Bosschaert resided in Utrecht for only four years. The fact that in 1616 he refused to pay his dues to the Guild of St. Luke suggests that he never really intended to settle in Utrecht. Nevertheless, the influence he exerted through his pupil Bartholomeus van der Ast and through his sons Ambrosius (III) and Abraham Bosschaert was enduring.

Bosschaert died in The Hague in 1621, during a visit to deliver a flower piece he had sold to Prince Maurits's butler for the impressive sum of one thousand guilders. He fell ill while staying in the Hague residence of the Utrecht nobleman Frederik van Schurman, father of the well-known *femina universale* Anna Maria van Schurman.

After the death of their father, the sons were most probably sent from Breda to Utrecht, where they were apprenticed to their uncle, Bartholomeus van der Ast. Bosschaert's widow did not move to Utrecht until 1628.

Jan Both
[UTRECHT ?–1652 UTRECHT]

Jan Both was born in Utrecht, the son of the glass painter Dirck Joriaensz. Both, who had moved to that city from the nearby town of Montfoort in 1603 or 1604.[1] Jan's year of birth is not clear.[2] According to a contemporary genealogy by the Utrecht burgomaster Cornelis Booth, Jan was the fifth child of Dirck and Anna Andriesdr. Schinckels.[3] His only elder brother, the painter Andries Both, was their fourth child, concerning whom we have two documents that give his age, though unfortunately each suggests a different year of birth (about 1606 according to one document and about 1612 according to the other).[4]

Whenever they were born, the boys grew up in the center of town, where their father had bought a house in the Schoutensteeg in 1616.[5] According to Von Sandrart, who knew them well, both Andries and Jan Both were apprenticed to Abraham Bloemaert and studied at the Utrecht *academie* in the mid-1620s.[6]

After completing his training in Utrecht, Jan Both traveled to Italy, according to Von Sandrart together with his brother. Andries is documented in Rome from 1635 onward.[7] Jan is first mentioned in Rome only in 1638, and at Easter 1639 he lived with Andries in the Strada Vittoria, where they remained until after Easter 1641. On 6 September of that year Jan Both and the Utrecht painter Jan Jansz. van Causteren witnessed a notarial deed drawn up for their fellow artist Isaac Jansz. van Hasselt, also from Utrecht.[8] Soon afterward the Both brothers left Rome for Venice, where Andries drowned in a canal on 23 March 1642.[9] Jan must have returned to Utrecht soon thereafter.

In Utrecht Jan Both probably moved in with his father in the Schoutensteeg. At some point he joined the Painters' Society, and records show him to have been an officer in 1649. He also began to

take on apprentices, one of whom, Hendrick Verschuring, must have arrived very soon after Both settled in Utrecht.[10]

According to Von Sandrart, Jan Both and his brother had cooperated closely while in Rome, Jan doing the Italianate landscapes and Andries painting in the figures. The death of Andries put an end to this collaboration, but in Utrecht Jan found others to work with him.[11] In 1644 the collector Willem Vincent, baron van Wyttenhorst bought a portrait of himself, done by Jacob Duck, Cornelis van Poelenburch, and Bartholomeus van der Helst, in which Both painted the landscape in the background.[12] Jan Both became good friends with this collector, and in 1648 he gave Van Wyttenhorst a portrait of himself done by Poelenburch.[13]

Jan Both died a bachelor in July 1652.[14] He was buried in the Buurkerk.[15]

Jan Gerritsz. van Bronchorst
[UTRECHT 1603–1661 AMSTERDAM]

According to contemporary sources, Jan van Bronchorst was born in Utrecht in 1603.[1] He was the only son of the gardener Gerrit Jacobsz. van Bronchorst and Feysgen Claesdr. van Doorn. The family lived in modest circumstances, but apparently the parents could afford to have their son apprenticed to the glass painter Jan Verburgh. According to the author Cornelis de Bie, the boy was eleven years old at the time, so this must have taken place about 1614.[2]

Bronchorst was subsequently apprenticed to two more glass painters before traveling to France in 1620. There he stayed a year and a half with the Artois glass painter Peeter Matthijs, before going on to Paris, where he studied with the glass painter Chamu. We may suppose that he had received excellent training by the time he acquired Utrecht citizenship in the summer of 1622 and went to live with his parents in the Muntsteeg.

After the death of his mother in 1626, Bronchorst married Catalijntje or Leonora van Noort, the daughter of a brewer. They rented a house in the Minderbroederstraat, where in 1627 their first son, Johannes, was born. Although no documents have been found concerning Van Bronchorst's membership in the Reformed Church, we may assume that he was indeed a member, considering that his parents and his wife were members and that all the couple's children were baptized in the Reformed Church.

Being a glass painter in the Dutch Republic in the seventeenth century usually meant gloomy economic prospects. The heyday of Dutch glass painting ended with the Reformation. Protestant churches could do without stained glass and, under the prevailing political conditions, Catholic churches had to be decorated in a modest fashion. Glass painters had to content themselves with small commissions, such as heraldic images in private homes. The accounts of the city of Utrecht reveal that this was the kind of work Bronchorst did after he came back from France. It cannot have been very satisfying. Von Sandrart recalls that in the mid-1620s Bronchorst became a student at the Utrecht *academie*, where artists were given "advanced" drawing lessons. This paid off. In 1636 he started making engravings after the work of Cornelis van Poelenburch, who had grown up in the same neighborhood as Bronchorst. A year later he came into contact with Constantijn Huygens, the stadholder's secretary, concerning engravings of the Siege of Breda. Finally, in 1639, Bronchorst began painting, which meant that he had to join the Painters' Guild. He never gave up glass painting, however.

Jan Gerritsz. van Bronchorst's income began to rise. In 1642 he could afford to buy a house in the Minderbroederstraat, probably the house he was already living in. Three years later he moved to the prestigious Domkerkhof, where Gerard van Honthorst also lived, and became a neighbor of the painter Herman Saftleven. There he must have worked on four large windows for the Amsterdam Nieuwe Kerk, which had been damaged by fire in

January 1645. In 1651 he was paid the enormous sum of 12,500 guilders for this project. By then he had moved to Amsterdam, where he acquired citizenship in 1652 and rented a house on the Rozengracht, the artistic district of the 1650s. Rembrandt also moved there in 1658.[3] Bronchorst invested his capital in Utrecht, however. In 1653 he bought the house on the Domkerkhof for 6,000 guilders.

In his last years Bronchorst worked on impressive commissions: the organ shutters of the Nieuwe Kerk, a monumental stained-glass window for the Oude Kerk, and the decoration of the new town hall. His career became one of the great success stories of the Utrecht school. Jan Gerritsz. van Bronchorst died in the last weeks of 1661. His widow returned to Utrecht, where she lived on the Domkerkhof until her death in 1677.

Two of Bronchorst's sons became artists. Johannes van Bronchorst, a great talent, died in 1656 at an early age. Gerard became a painter in Utrecht, but gave up painting when he was elected to the city council.

Hendrick ter Brugghen
[THE HAGUE? 1588–1629 UTRECHT]

Hendrick ter Brugghen was born in 1588, probably in The Hague.[1] His parents, Jan Egbertsz. ter Brugghen and Feysgen Dircx, came from Utrecht, but his father had been bailiff of the States of Holland since about 1585, and we may assume that his family lived with him in The Hague. Jan ter Brugghen is last recorded there in 1602. A year later he was living in the village of Abcoude, halfway between Utrecht and Amsterdam, as assistant marshall of the Nederkwartier district.[2] By that time Hendrick ter Brugghen may already have been apprenticed to Abraham Bloemaert, although it is unclear exactly when and for how long Ter Brugghen studied with him.

In the spring of 1607 a certain "Henrick ter Brugge" is named as a cadet in the army of Count Ernst Casimir of Nassau-Dietz.[3] This soldier is probably our artist, whom we sometimes find addressed as the "honorable and steadfast" (erentfesten) Hendrick ter Brugghen, an epithet used only for soldiers.[4] Assuming that the cadet and the artist are one and the same person, 1607 would then be the first year in which he could possibly have traveled to Italy.[5] After his return to Utrecht in the fall of 1614, Ter Brugghen himself declared that he had spent "several" (ettelicke) years in Italy.[6] If there is any truth in Cornelis de Bie's statement that Ter Brugghen met Rubens in Rome, then Ter Brugghen must have left soon after April 1607, since Rubens returned to Antwerp in October 1608.[7] Unfortunately, there are no documents concerning Ter Brugghen's years in Italy. The only thing we know for certain is that in the summer of 1614 he stayed in Milan with the Utrecht painter Thijman van Galen. From there they traveled home through Switzerland, crossing the Alps through the St. Gotthard Pass, in the company of the Utrecht painter Michiel van der Zande and his apprentice Frans van Knibbergen.

In Utrecht Ter Brugghen and Van Galen were registered as master painters in 1616. In October of that same year Ter Brugghen married Jacomijna Verbeeck, the stepdaughter of his elder brother, the innkeeper Jan Jansz. ter Brugghen. Their marriage took place in the Reformed Church, where at least four of their eight children were later baptized. Hendrick ter Brugghen himself was probably not a member, however, and his wife did not join the congregation until a month after her husband's death. We may assume that Ter Brugghen considered himself a Protestant but that he rejected orthodox Calvinist principles. His treatment of explicitly Catholic subjects in his paintings suggests that he was not unsympathetic to their message.

At the time of her marriage the bride lived with her mother and stepfather in het Casteel van Antwerpen (The Castle of Antwerp), one of Utrecht's most prominent public houses, situated

on the Oudegracht. Hendrick ter Brugghen lived in rented quarters in the Korte Lauwerstraat, and for the first ten years of their marriage they stayed in that neighborhood.[8] By 1626 they had moved to the Snippevlucht, a narrow street in the center of town, not far from his brother's inn. There he rented a large house named de Ringh (The Ring) from the notary and councilor Johan Wtewael, brother of the painter Joachim Wtewael.

When in the summer of 1627 Peter Paul Rubens visited Utrecht he stayed at het Casteel van Antwerpen. According to Ter Brugghen's son, Richard ter Brugghen, who in 1707 published a pamphlet defending his late father's reputation as an artist, Rubens paid Ter Brugghen a visit while in Utrecht. Richard boasted that the great Antwerp master had said that on all his travels through the Netherlands he had met only one real painter: Hendrick ter Brugghen. Whether or not these were in fact Rubens's words, Ter Brugghen's reputation is confirmed by the prices his paintings fetched at auction during the seventeenth century. Soon after the painter's death, the prince's secretary, Constantijn Huygens, listed him among the great masters of the Dutch Republic. It is unfortunate, however, that we know so little about the thoughts, opinions, and personality of this extraordinary master. Joachim von Sandrart, who knew him during his last years, later wrote that he was a man of "profound but melancholy thoughts."[9]

Hendrick ter Brugghen died on 1 November 1629 at the age of forty-two, during an epidemic of the plague. He was buried in the Buurkerk. He left his wife pregnant, and when a daughter was born in March 1629 she was named Henrickgen, after her father.

Joost Cornelisz. Droochsloot
[UTRECHT AFTER 1585–1666 UTRECHT]

Joost Cornelisz. Droochsloot was born in Utrecht; the year of his birth has traditionally been given as 1586.[1] Although that was almost certainly the year in which his parents, Cornelis Petersz. Droochsloot and Aeltgen Beerntsdr. Coop van Groenen, were married, it is not certain that this was also the year of the artist's birth.[2] He is not recorded until 1616, when he registered as a master painter in the Utrecht Painters' Guild, at which time he may have been anywhere from twenty to thirty years old.

Droochsloot's father, a carpenter from the village of Ouderkerk, became a citizen of Utrecht in 1581 after marrying his first wife.[3] In the same year he bought a house in the Predikherenstraat, close to the Neude.[4] There the artist was probably born and there he grew up. The identity of his teacher remains unknown.

In 1618 Joost Droochsloot married Agnietgen van Rijnevelt, the daughter of an officer. Their wedding party must have been combined with that of his sister Petertgen, whose marriage was registered only a week earlier.[5] The couple was married in the Reformed Church, and their numerous children were baptized in various Reformed Churches in Utrecht. Parenthood, though, proved to be a tragic experience for Droochsloot and his wife. Of the twelve or thirteen children known to have been born to the couple, only one, the painter Cornelis Droochsloot (b. 1640), reached maturity.[6] The others all died at a very young age, most of them shortly after birth.

Throughout his career, Droochsloot's principal theme was the representation of the poor, often as recipients of charity. His most important commission in this vein was the *Seven Acts of Mercy* done for the St. Barbara and St. Lawrence Hospice (see cat. 31, fig. 1). In 1618, while still a newlywed, he must have witnessed Prince Maurits's disbanding of the Utrecht mercenary companies, which took place a stone's throw from his parental home (see Spicer, introduction to this catalogue, fig. 1). The fact that he painted this event several times in the years after it happened

testifies to his keen commercial spirit, which is also evidenced by the arrangements he made to finance the house he bought in 1620. The municipal auctioneer and art dealer, Jan Willemsz. van Rhenen, sold him the house on the Nieuwegracht and the corner of the Magdalenastraat with a mortgage to be paid off in twelve annual installments, each installment consisting of paintings worth a total of 150 guilders.[7] We may assume that such arrangements prompted Droochsloot to turn to the mass production of the Flemish-style village scenes on which he had a monopoly on the Utrecht market throughout his career.

In the early 1620s Droochsloot's career ran smoothly. He worked for several public institutions and in 1623 was elected dean of the guild. The following year he was able to move to the Plompetorengracht, where he bought a house with a large garden containing a summerhouse.[8] Yet his rather coarse style was soon to be superseded by the more elegant manner of a younger generation of Italian-trained artists, most notably Cornelis van Poelenburch.

Just as Bloemaert, Moreelse, and Honthorst did, Droochsloot augmented his income by taking on many pupils. Unlike the others, however, he specialized in giving drawing lessons, which paid less than painting lessons.[9] All in all, Droochsloot lived the life of a respected burgher. We find him elected a lifelong regent of St. Job's Hospice in 1638, dean of the guild again in 1641 and 1642, deacon of the Reformed Church in 1642,[10] and sergeant of the local militia in 1650 and 1651.[11] Nevertheless, his workshop declined and he was forced to take out several mortgages on his house.

Agnietgen van Rijnevelt died in the spring of 1665, followed by her husband a year later. Both were buried in the Buurkerk. Their son Cornelis, who was a close imitator of his father, failed to continue the workshop and abandoned his own family in 1673,[12] at which time his children were placed in the city orphanage.

Jacob Duck
[D. 1667 UTRECHT]

Jacob Duck was the second son of Jan Jansz. Duck, a native of the village of Vleuten, and Maria Bool.[1] His year of birth is unknown, but considering that his parents married in 1596 and that he himself married in 1620, we may infer that Duck was born in the last years of the sixteenth century.[2] His father's profession is unknown, but his mother was a cloth merchant, running the business from their house on the Donkere Gaard, in the shadow of the cathedral tower.[3]

Duck was a late convert to the art of painting. In 1611 his parents apprenticed him to a goldsmith, and he registered as a master in 1619, the year before his marriage.[4] It is unclear, however, whether he was ever very active in that trade. Yet already in 1621 he was taking drawing lessons, apparently with Joost Cornelisz. Droochsloot.[5] Eight years later he donated a painting of a musical company to St. Job's Hospice, also registering as a master painter at about that time.[6] The Guild of St. Luke reduced his entrance fee because he was already a full member of the Goldsmiths' Guild.[7] By 1631 Jacob Duck was referring to himself explicitly as a painter,[8] even though he retained his membership in the Goldsmiths' Guild. In 1642 he was still listed as a member, although the deans had released him from the obligation to attend guild meetings on the condition that he donate a specimen "of his art" to their guild hall.[9]

In April 1620 Jacob Duck married Rijckgen Croock in a civil ceremony. We may safely assume that they were Catholic. Duck's uncle Jacob Bool was a priest and received a prebend from the chapter of St. Mary.[10] His brothers Johan Duck and Cornelis Duck, both of whom were arrested at one time for residing illegally in Utrecht, were also priests.[11] Because the records of Catholic baptisms in this period in Utrecht have been lost, no

records survive of the baptisms of the couple's children, of whom there were at least eight.

Rijckgen Croock was a cloth merchant, like her mother-in-law. Her father, Jacob Croock, was a linen merchant, and after his death in 1643 she took over the business.[12] At that time she and her husband were living on the Donkere Gaard, probably in his parents' house.[13] Duck's parents moved to the Mariakerkhof after the death of Maria's brother, Jacob Bool. There they befriended Abraham Bloemaert, who witnessed the signing of their will in 1638.[14] Four years later this favor was returned by Jan Jansz. Duck, when he witnessed the signing of Bloemaert's will.[15]

Rijckgen Croock died in June 1648.[16] By that time they had moved to the Nieuwegracht by the Magdalenabrug, where they rented from Willem van Weede, a relative of Bloemaert.[17] For a long time Duck lived with six unmarried daughters, until in the early 1660s one of them—Weijntgen Duck—became pregnant by a man who refused to marry her.[18] Her son, Hendrick Willebrinck, was Duck's only grandchild.[19]

Jacob Duck died on or shortly before 22 January 1667 and was buried in the chapel of the former Convent of Mary Magdalene.[20] His daughters expected his debts to exceed his assets and refused to accept the inheritance.[21]

Gerard van Honthorst

[UTRECHT 1592–1656 UTRECHT]

The life and career of Gerard van Honthorst is the greatest success story in the history of the Utrecht school of painting.[1] Born in 1592 as the son of the decorative painter Herman van Honthorst and Maria Willemsdr. van der Helm, he acquired both international fame and a considerable fortune. Since the early sixteenth century the Honthorst family had produced a number of painters, and until the Reformation members of the most successful branch of the family had regularly served the local government as councilors. Most of the Honthorsts remained true to the old faith, however, including Gerard van Honthorst and his descendants.

Gerard van Honthorst must have received his first training from his father, who is listed among the founding members of the Utrecht Guild of St. Luke in 1611 and who served the guild as treasurer in 1616 and 1617.[2] According to all contemporary sources, Gerard continued his studies with Abraham Bloemaert, after which he traveled to Italy, where he is first recorded in 1616. He may have arrived there earlier, however, as it is unlikely he would have stayed with his master beyond his twentieth birthday.

According to Joachim von Sandrart, his pupil and biographer, Honthorst won great esteem in Rome with his nocturnal scenes in the Caravaggesque style. One of his principal patrons was the collector Marchese Vincenzo Giustiniani, in whose palace Honthorst lived and worked for several years. Another important patron was Cardinal Scipione Borghese.

In 1620 Honthorst returned to Utrecht, where he was welcomed by the elite of the Utrecht artistic community. At a welcome-home party in the inn 't Poortgen (The Little Gate) his work met with a favorable reception. Before the year was out Honthorst had married Sophia Coopmans, the daughter of the innkeeper. Honthorst joined the Guild of St. Luke and set up his own workshop, probably in a house in the Snippevlucht, a narrow street close to the town hall and to his parents-in-law's inn. His reputation grew rapidly, and within a year Sir Dudley Carleton, the British envoy to The Hague, sent a painting by Honthorst to the collector Lord Arundel in London. In Utrecht Honthorst was commissioned to design cartoons for a stained-glass window to be donated by the chapter of Oudmunster to the nearby Buurkerk.[3] He also began to take on apprentices, and by the time Von Sandrart had come to him from Frankfurt in about 1625 he had a large studio. According to Von Sandrart, Honthorst had as many as twenty-

five pupils, each of whom paid apprenticeship fees of one hundred guilders a year. In 1625 he also became dean of the guild, a post he retained until 1630, with the exception of the year 1627. He may eventually have replaced Bloemaert and Moreelse as the principal teacher at the Utrecht drawing academy.

In the spring of 1627 Honthorst bought a large medieval house on the Domkerkhof. It had long belonged to the patrician branch of the Honthorst family, and with the house the artist also bought part of their social standing. When Rubens visited Utrecht a few months later, he found Honthorst indisposed and unable to guide him around Utrecht's major studios—one would assume because Honthorst was in the midst of moving. Whatever the reason for his indisposition, however, Honthorst nevertheless arranged a banquet for Rubens before the latter traveled on to Amsterdam.

In 1628 Gerard van Honthorst was invited by King Charles I to go to London to work on the decoration of the Banqueting House in Whitehall. In six months' time Honthorst and his assistant, Joachim von Sandrart, completed a large *portrait historié, King Charles I and His Wife, Queen Henrietta Maria, as Apollo and Diana* (now at Hampton Court). On 25 November 1628 the king rewarded Honthorst with three thousand guilders, a silver service, a horse, honorary English citizenship, and a lifelong pension of one hundred pounds a year.[4] The only desideratum was a title.

In the years to come Honthorst continued to work for the English court and expanded his business to the court in The Hague—including that of the former queen of Bohemia, Charles's sister—and the court in Copenhagen. He was the leading master in the Utrecht consortium that decorated Kronborg Castle with scenes from the history of Denmark; his contract alone amounted to 37,500 guilders for thirty-five paintings. Honthorst can be credited with turning Utrecht painting into an industry, and the story of his enterprise can

hardly be written without some knowledge of accounting. His brother, Willem van Honthorst, became his chief assistant.

Honthorst joined the Guild of St. Luke in The Hague and opened a second studio in 1637, after which time he commuted between Utrecht and The Hague, painting large numbers of portraits and giving lessons to the children of the elite, such as the offspring of the king and queen of Bohemia. In his later years the avant-garde of the time began to view his late, "slick" style with less favor. Even Constantijn Huygens, who had once thought him a great master, spoke disparagingly of him in 1649 as a "grand seigneur."

Gerard van Honthorst died on 27 April 1656 and was buried in the Catharijnekerk, where a large memorial tablet was placed to the memory of this "Apelles of painters and favorite of kings" (Pictorum Apelles Regibusque dilectus). Sophia Coopmans died two years later. On both occasions five hundred guilders were given to the poor. The couple was survived by several children, one of whom became a priest.

Nicolaus Knupfer
[LEIPZIG CA. 1609–1655 UTRECHT]

Nicolaus Knupfer was one of the group of foreign painters attracted to Utrecht by its reputation as a training center for young artists.[1] He was born in Leipzig, where he was first apprenticed to Emanuel Nysse.[2] He then went to Magdeburg, where he worked as a brush maker and painter until he traveled to Utrecht at the age of twenty-six. The caption to Pieter de Jode's engraving of Knupfer's portrait, published by Johannes Meijssens in 1649, explicitly states that he had gone to Utrecht to work with Abraham Bloemaert.[3] Cornelis de Bie, who gives many personal details and who apparently drew from a reliable source, describes him as an assistant in Bloemaert's workshop.

It is unclear exactly when Knupfer arrived in Utrecht. Meijssens gives his year of birth as 1603,

stating that he arrived in Utrecht in 1630. Doubt has been cast on this chronology, however, by a document recently published by Paul Huys Janssen in which Knupfer gave his age as only "about thirty" in 1639.[4] Furthermore, when he registered with the Guild of St. Luke in 1637, he registered as a "visiting" painter, meaning that he had come from elsewhere to work in Utrecht for a period of just one year. He apparently changed his mind, and from that time on we find his name in the archives, although exactly when he arrived in Utrecht remains a question. He may indeed have been Bloemaert's assistant from about 1630 onward, but in that case he must have arrived in Utrecht when he was not much older than twenty.

Knupfer had become a successful painter even before 1640, having already taken part in the most ambitious project undertaken by the Utrecht school: the illustrated history of Denmark for the decoration of Kronborg Castle.[5] Only one extant drawing testifies to Knupfer's having taken part in this project, but Cornelis de Bie speaks of three paintings done for the Danish king, apparently part of the Kronborg series. In fact Knupfer was one of the Utrecht painters most active in collaborative projects. He is known to have painted the figures in landscapes done by outstanding masters such as Jan Both and Jan Baptist Weenix. His own paintings were sought after as well; Joachim von Sandrart states that his works were collected by kings and princes.[6] In Utrecht Knupfer sold to the collector Johan Schade two small paintings, framed together with a round, embossed silver portrait of King Charles I of Great Britain, for two hundred guilders or more in 1650.[7] And a year later the collector Willem Vincent, baron van Wyttenhorst paid him three hundred guilders for his *Pursuit of Pleasure (Il Contento)* (see Spicer, introduction to this catalogue, fig. 7), in which Both and Weenix had executed the landscape and the animals.[8]

Like Bloemaert and Honthorst, Knupfer's reputation as an artist was such that he also attracted pupils from outside Utrecht. In 1646 the guardians of the Rotterdam artist Pieter Crijnsen Volmarijn sent the boy to study with Knupfer, before being sent to Antwerp to finish his training with the even more highly respected artist Jacob Jordaens.[9] Knupfer could charge his pupils seventy-two guilders a year, which places him among the more expensive Utrecht teachers. Jan Steen is also said to have been his pupil.[10]

In November 1640 Nicolaus Knupfer was married in a civil ceremony to Cornelia Back, the daughter of a notary. Although their marriage lasted less than three years, two children were born to the couple before Cornelia died and was taken from their home on the Voorstraat to be buried in the Geertekerk. The youngest child was sent to a wet nurse in the village of Cothen but died six weeks later.[11] The father and the other child, a boy named Johannes, were still living at Voorstraat in 1646 but may later have moved in with his parents-in-law on the Neude.[12] There Knupfer died shortly before 15 October 1655, leaving not a penny. The next year his only son was apprenticed to a goldsmith.[13] He died in 1660 in his grandparents' house on the Neude and was buried in the Geertekerk with his parents.

Diderick van der Lisse
[THE HAGUE 1607–1669 THE HAGUE]

Diderick (Dirck) van der Lisse was born in The Hague on 6 August 1607, the son of Abraham Claesz. van der Lisse and Dirckie Dircx van Swieten.[1] He was probably apprenticed to a master in The Hague before he was sent to Utrecht to complete his training as an artist.[2] In 1626, at the age of eighteen, he is registered in Utrecht as a member of the Reformed Church.[3] Adam Willarts, at that time dean of the Painters' Guild and himself a devout Calvinist, acted as a witness. Van der Lisse lived in rented quarters on the corner of the Nieuwegracht and the Schalkwijksteeg.

Houbraken lists Van der Lisse among the pupils of Cornelis van Poelenburch. If indeed he

was sent to Utrecht to study with this master, this would mean that Poelenburch had already returned from Italy by the summer of 1626, almost a year before we first find him recorded in Utrecht.[4]

Not much is known about Van der Lisse's early years as a painter. So far as we know he did not travel abroad, and we do not find him registered as a master painter in the Utrecht guild. Most probably he worked in Poelenburch's studio until well into the 1630s. In 1635, however, he was his own man, contributing with Abraham Bloemaert, Herman Saftleven, and Cornelis van Poelenburch to the *Pastor fido* series commissioned for Prince Frederik Hendrik's palace at Honselaarsdijk (see Spicer, introduction to this catalogue, fig. 20).[5]

From then on Van der Lisse must have renewed his contacts with his native town, The Hague. When, in 1637, Jan Gerritsz. van Bronchorst sent a letter to the prince's secretary, Constantijn Huygens, he asked Van der Lisse to deliver it.[6] Two years later he married Anna Petronella van der Houve, daughter of the lawyer and historian Matthijs van der Houve, lord of Campen.[7] The bride had inherited Campen and several other seigniories and was a good match indeed. When they married, both bride and groom were living in The Hague. According to Van der Lisse's own notes, they then moved to Utrecht on 1 May 1640.[8] The family lived on the Snippevlucht, not far from the town hall.[9] Because Van der Lisse apparently was still a member of the Reformed Church, only his wife registered with the Utrecht congregation.[10] In late 1640 a son—Abraham—was born.

In May 1642 Van der Lisse and his family moved to Amsterdam, where a second son was born. Both children died that same year. A daughter was born in December 1643. On 1 October 1644 the family returned to The Hague, where the artist registered as a member of the local Painters' Guild. The next year he was elected a member of the board for the first time.

Before Anna Petronella van der Houven died

in May 1646, another daughter was born to the couple. Two years later Van der Lisse married Maria Both van der Eem, daughter of a deputy registrar at the high court of the provinces of Holland and Zeeland. Two more daughters resulted from this marriage.

As a deacon of the Reformed Church, Dirck van der Lisse witnessed in 1646 the marriage of Prince Frederik Hendrik's daughter Louise Henriëtte to Friedrich Wilhelm, Grand Elector of Brandenburg. In the 1650s he embarked on a very successful political career in The Hague, becoming an alderman in November 1654, a member of the town council in November 1656, and burgomaster in November 1659, posts he held alternately until his death in January 1669. In 1656 he was instrumental in the founding of the Confrérie Pictura.

Van der Lisse left a large collection of paintings including works by Lucas van Leyden and Jacob Jordaens. He owned four paintings by Cornelis van Poelenburch, as well as five copies of works after Poelenburch.[11]

Johannes Pauwelsz. Moreelse
[D. 1634 UTRECHT]

It is not known when Johannes Moreelse, son of the painter Paulus Moreelse, was born.[1] He was named after his paternal grandfather, so custom would lead us to assume that he was the eldest son. His parents married in the summer of 1602, and he was probably born not many years later. His father was his teacher, and he may also have taken drawing lessons at the Utrecht drawing academy.

On 27 February 1627 Johannes Moreelse was in Rome, where, together with the painter Hendrick Bloemaert and several other Utrecht witnesses, he signed a notarial document for the Utrecht Catholic cleric Johannes Honorius van Axel de Seny. In Rome he must have served the pope, for which he received a knighthood in the Order of St. Peter.

Back in Utrecht, the "knight" Johannes Moreelse may have worked in his father's studio. He died a bachelor in December 1634 during an epidemic of the plague.[2]

Paulus Moreelse
[UTRECHT 1571–1638 UTRECHT]

Paulus Moreelse was born in Utrecht in 1571.[1] His father, Jan Jansz. Moreelse, was a cooper from Louvain who settled in Utrecht in the early years of the Revolt. According to Karel van Mander in his *Schilder-boeck* of 1604, Paulus was apprenticed to the Delft portrait painter Michiel van Mierevelt. After completing his training, Moreelse traveled to Italy, where he is said to have stayed for a long time, receiving many portrait commissions. Indeed, portraits were to become his specialty, and this is most likely the reason why Van Mander paid relatively little attention to Moreelse—portraiture being considered less "artful" than history painting. Nevertheless, Van Mander classified Moreelse already in 1604 as a "very good master."

In 1596 Moreelse joined the Utrecht Saddlers' Guild which, until the artists founded their own Guild of St. Luke in 1611, also included the painters. Moreelse was one of the founders of the new guild and became its first dean, occupying this post again in 1612, 1615, and 1619. Together with Abraham Bloemaert, Moreelse was also a principal teacher at the Utrecht drawing academy, which was started in about 1612. The guild's records list no fewer than twenty-eight of Moreelse's pupils.

Among his many clients numbered the duke of Braunschweig, the count and countess of Culemborg, and the statesman Johan van Oldenbarnevelt, to name but a few. His fame brought him commissions from all over the country, and in 1616 he painted a large militia piece for the Amsterdam Archers' Civic Guard.

In 1605, three years after he married Antonia van Wyntershoven, Moreelse bought a large house on the Boterstraat, where he and his wife would live for the rest of their lives. His success as an artist made Moreelse a wealthy man, and he eventually bought several houses, as well as an orchard outside the city gates. Like Joachim Wtewael and several other Utrecht painters, Moreelse became involved in politics. He is listed as a reliable citizen in a roster of militiamen drawn up in 1610 by the short-lived revolutionary town council.[2] His chance, however, came in 1618, when he took part in the coup against the Libertine council and was rewarded with a lifelong seat in the city council by the stadholder, Prince Maurits. At the time his opponents labeled him a political as well as a religious opportunist. The fact that he was the only member of his family to join the Reformed Church suggests that Contra-Remonstrant religious fervor was not in fact his chief motive in participating in the coup.

His new status as a member of the city council opened up many new opportunities. After 1620 he became churchwarden of the Buurkerk, and later captain of a civic guard company, as well as alderman and chief treasurer of the city. We also find Moreelse active as an architect. In 1624 he submitted an ambitious plan to enlarge the city of Utrecht. He also designed a new city gate and was involved in the construction of a new Fleshers' (Butchers') Hall and a church at Vreeswijk.

Paulus Moreelse was a central figure in the Utrecht art world. He is mentioned in numerous documents in connection with fellow painters from that city. He was also a good friend of the humanist scholar Aernt van Buchel (Arnoldus Buchelius), who wrote poems mourning the deaths of two of Moreelse's children. Moreelse died on 6 March 1638 and was buried in the Buurkerk. Two of his sons, Johannes and Benjamin, also became painters. His son Hendrick became a lawyer, as well as a professor at Utrecht university and a burgomaster of Utrecht.

Cornelis van Poelenburch

[UTRECHT 1594–1667 UTRECHT]

Cornelis van Poelenburch was born in Utrecht either in late 1594 or sometime during the first three weeks of 1595.[1] His father, Simon van Poelenburch van Schiedam, a canon of the Utrecht cathedral chapter, died in January 1596, leaving his partner, Adriaentgen Willemsdr. van Leerdam, with two young children.[2] She lived on the Ambachtstraat close to the Nieuwegracht, and we may assume that this is where Cornelis van Poelenburch grew up until, not long before 1611, he was apprenticed to Abraham Bloemaert.[3]

After completing his training, Poelenburch traveled to Italy, where he is recorded in 1617.[4] He belonged to the founding members of the society of Netherlandish artists in Rome, and his fellow *Bentvueghels* gave him the nickname "Satir" (Satyr). In Rome Poelenburch soon made a name for himself with his Italianate landscapes. According to Von Sandrart, he was employed by Grand Duke Cosimo II de' Medici of Florence, a statement that is confirmed by a 1638 inventory that lists four of Poelenburch's paintings in the former duke's bedroom. In Florence he befriended the famous French engraver Jacques Callot.[5]

Poelenburch returned to Utrecht about the mid-1620s.[6] He was immediately accepted as one of the leading Utrecht masters, and in the spring of 1627 the States of Utrecht purchased his *Wedding Banquet of the Gods* (see Spicer, introduction to this catalogue, fig. 11) as a gift for the stadholder's consort, Amalia van Solms. When Rubens went to Utrecht a few months later, he visited Poelenburch's studio and, according to Von Sandrart, liked his work so much that he ordered several paintings.[7] In the following years Poelenburch worked for the courts of the stadholder and the former king of Bohemia in The Hague.

In the spring of 1629 Poelenburch began to frequent the office of the notary and registrar of the provincial court, Jacob van Steenre, on the Oudmunsterkerkhof. We find him acting as a witness to the signing of several deeds, but his real interest must have been the notary's daughter, Jacomina.[8] They were married in a civil ceremony on 30 May 1629.[9] The next year Poelenburch acquired Utrecht citizenship. The couple rented a house on the Winssensteeg, not far from the Oudmunsterkerkhof,[10] where they probably lived until Cornelis was appointed court painter to King Charles I of Great Britain in 1637. Between 1637 and 1641 he is recorded as having lived, though absent from time to time, in London.

On New Year's Day 1642 Poelenburch was back in Utrecht.[11] His father-in-law had died, and from his estate the artist and his wife acquired two large medieval houses on the prestigious Oudmunsterkerkhof.[12] He now had enough space to house a large studio, where he employed many pupils. His production of relatively small cabinet pieces was so prodigious that wealthy collectors were able to buy his paintings by the dozen. Willem Vincent, baron van Wyttenhorst, Utrecht's foremost collector, owned no fewer than fifty-five paintings by Cornelis van Poelenburch, and Margareta Ram, widow of Willem van Baerle, is recorded as owning thirteen in 1677.[13] Two years later a pupil of his, Johan van Haensbergen, owned five paintings by his master, as well as eleven copies after Poelenburch.[14] He listed his own painted studies after Poelenburch as essential to his workshop.

Cornelis van Poelenburch was one of the most successful and influential Utrecht painters of his time. He served as headman (hoofdman) and dean of the local Painters' Society and enjoyed close contact with many of his fellow artists. One of the painters with whom he collaborated was the well-known painter of "perspectives," Bartholomeus van Bassen. Poelenburch had already done business with him as early as 1628.[15] In 1652 his daughter Adriana married Van Bassen's son, Aernout van Bassen, a lawyer.

Van Poelenburch died in Utrecht in July 1667 and was buried in the chapel of the former Convent of Mary Magdalene. His widow left Utrecht during or after the French occupation and is recorded as living in the village of Pijnacker in 1675.

Cornelis Saftleven
[GORINCHEM 1607–1681 ROTTERDAM]

Cornelis Saftleven can hardly be called a Utrecht painter.[1] His brother, Herman Saftleven, lived in Utrecht for most of his life, but Cornelis spent only a short time in the city.

Cornelis Saftleven was born in Gorinchem in 1607. His father, Herman Saftleven, a native of Antwerp, was a painter.[2] His mother, Lijntge Cornelisdr. Moelants, came from Gorinchem. After their marriage they lived in Gorinchem for several years until moving to Rotterdam shortly after Cornelis's birth. There his brother Herman was born in 1609. Undoubtedly the Saftleven boys were initially trained by their father until his death in 1627. It is not known whether they had other masters.

Cornelis's brother Herman settled in Utrecht in the early 1630s and was married there in 1633. Cornelis joined him soon after that, although it is unclear whether he ever really settled in Utrecht. In the years between 1634 and 1637 the brothers collaborated on several paintings, usually barn interiors in which Cornelis painted the animals. Their best-known collaborative painting is the portrait of the family of Godard van Reede van Nederhorst from 1634 (see Olde Meierink and Bakker, fig. 8, in this catalogue).[3]

From 1637 onward Cornelis Saftleven lived in Rotterdam. He took on apprentices and served as headman (hoofdman) of the local Painters' Guild. He did not marry until 1648, his bride being Catharina van der Heyden, the widow of a baker. She died in 1654, and the next year he married Elisabeth van den Avondt. They had one daughter who died before she was two. Cornelis Saftleven

died on 1 June 1681 and was buried in the Walloon Church in Rotterdam.

Herman Saftleven the Younger
[ROTTERDAM 1609–1685 UTRECHT]

Herman Saftleven was born in Rotterdam in 1609.[1] Like his brother Cornelis (see his biography) he was trained by his father, who died in 1627. In 1632 or 1633 Herman Saftleven settled in Utrecht, where he lived in the Korte Jansstraat. In May 1633 he married Anna van Vliet, daughter of the painter Dirck van Vliet.[2] They had at least six children, two of whom were baptized in the Remonstrant Church.[3]

Being a Remonstrant, Herman Saftleven belonged to a small but influential religious minority. He was a deacon of the congregation in 1637 and is found to have been in close contact with leading Utrecht Remonstrants throughout his life.[4]

Saftleven was rapidly accepted by Utrecht's artistic community. Within a year of his marriage he was asked by the artist Adam Willarts and his wife to witness the appointment of Cornelis van Poelenburch as guardian of their underage children.[5] In 1635 he contributed, along with Abraham Bloemaert, Diderick van der Lisse, and Cornelis van Poelenburch, to the *Pastor fido* series commissioned for Prince Frederik Hendrik's palace at Honselaarsdijk (see Spicer, introduction to this catalogue, fig. 15).[6] The figures in his landscape in the painting *Silvio and Dorinda* were probably painted by Hendrick Bloemaert.

Saftleven was also successful in finding patrons. In 1634 Herman and his brother Cornelis were commissioned by the nobleman Godard van Reede van Nederhorst to paint a large family portrait in a landscape (see Olde Meierink and Bakker, fig. 8, in this catalogue).[7] Van Reede was no stranger to Saftleven: He had been the guardian of Saftleven's wife, Anna van Vliet, along with the glass painter Dirck Both, father of the artists Jan and Andries Both.[8] About the time of the artist's

marriage Van Reede must have decided to rent to Saftleven a house near the St. Pieterkerk, close to the Domkerkhof, where the artist is first recorded in 1636.[9] Three years later Van Reede sold him the house. The ties with the Van Reedes lasted many years. In 1652 Saftleven witnessed the signing of the will of Godard's son Gerard.[10] In that same year Godard's influential brother, Johan van Reede van Renswoude, who was president of the States of Utrecht and dean of the cathedral chapter, had Saftleven's underage son Dirck endowed with a (nominal) vicariate of the cathedral.[11] Another important patron was the collector Willem Vincent, baron van Wyttenhorst, who bought no fewer than eighteen of his paintings during the 1640s and 1650s.[12]

We may assume that Herman Saftleven was not registered as a master painter in the Utrecht Painters' Society until 1654, the year in which he acquired citizenship for himself and his sons.[13] In 1655 he served for the first time as dean of the society, a function he fulfilled regularly until at least 1681.[14] He was one of the leading Utrecht masters and, apart from some trips to Germany, where he made study drawings for his landscapes, he stayed in Utrecht until his death. A more extensive biography would also deal with his friendship with the famous poet Joost van den Vondel or with his participation in the sale in 1662 of the famous Arundel collection, as well as with his activities as an engraver and chronicler of Utrecht's decline after 1672. Suffice it to say here that this decline also had grave consequences for the artist personally. He died on 5 January 1685, leaving a heavily indebted estate.[15] Saftleven had survived his wife by less than a year and was buried with her in the Buurkerk.

Roelandt Saverij
[COURTRAI 1578–1639 UTRECHT]

Roelandt Saverij was born in Courtrai in the Southern Netherlands in 1578.[1] His parents, Maerten Saverij and Catelijne van der Beecke, were Anabaptists and must have fled the city when it was captured by the Spanish in 1580. After a stay in Bruges they moved north in about 1585 to Haarlem, where Roelandt's mother died in 1586.

According to Karel van Mander, Roelandt Saverij received his training as an artist from his elder brother Jacques Saverij.[2] Jacques moved from Haarlem to Amsterdam after his marriage and acquired Amsterdam citizenship in 1591. Roelandt must have gone with him: He is still recorded in 1602 in Amsterdam, where in December of that year, a few months after the death of his father, he drew up his will. In April 1603 his brother died of the plague. We do not know whether his brother's death induced Roelandt to travel abroad, or whether he had already made up his mind to do so by the time he made his will. At any rate, Roelandt Saverij left home for good. He is last recorded in Amsterdam on 19 August 1603, after which he traveled to Prague, where he is first recorded in 1604.[3] He served both Emperor Rudolf II (1552–1612) and Emperor Matthias (1557–1619) as court painter. He provided the court with paintings of flowers, animals, Bohemian and alpine landscapes, and scenes of peasant life. His preparatory drawings for these paintings, which he often inscribed *naer het leven* (from life), are among his most important works.

In 1613 the emperor allowed him to travel to Amsterdam to settle some family affairs. There he is recorded in late 1614 and early 1615. In the spring of that year Saverij is listed among the Prague court artists as a "landscape painter." It has generally been assumed that this meant that he was then back in Bohemia. Yet as Spicer has shown, this document does not explicitly state that he was actually residing at the court.[4] Whether or not he did in fact return briefly to Prague, in January 1616 he was in the Low Countries, where he was to stay.

After a short intermezzo in Amsterdam and Haarlem, in 1618 Saverij settled in Utrecht, where

he rented a house on the Snippevlucht, not far from the town hall. A year later he joined the Guild of St. Luke, and at about the same time his nephew Hans Saverij—who had already been his assistant in Prague—and his niece Catharina Saverij moved in with him. Hans remained his uncle's assistant for the next twenty years. Joachim von Sandrart later recalled that the Saverijs spent the day painting, but that their evenings were spent in "merry company."[5]

In 1621 Saverij bought a large medieval house on the Boterstraat, just a few houses away from Paulus Moreelse.[6] He hung out a sign saying *The Emperor's Arms*,[7] and set up a household with his sister Maria Saverij and some of the orphaned children of his brother Jacques. The house had a large garden, which he planted with flowers. After his death, the flowers and plants alone were sold for four hundred guilders, more than the average annual income of an unskilled laborer. We may assume that the garden was one of the things that attracted other Utrecht artists to Saverij's house. It is no surprise that we find Saverij in close connection with still-life painters like Balthasar van der Ast and with the sons of Ambrosius Bosschaert, to whom he became a family friend. The Emperor's Arms attracted more than still-life painters, however. In 1622 the artists Paulus Moreelse, Aernt van der Eem, Balthasar van der Ast, Herman van Vollenhoven, and Adam Willarts all declared that they visited Saverij almost daily.

In the 1620s Roelandt Saverij was one of the most highly paid artists in Utrecht. His paintings appeared on the Amsterdam art market and at the stadholder's court, as well as finding their way to Central Europe. Nonetheless, Saverij ran into financial difficulties, which led to bankruptcy in his last years. Several sources speak of Saverij's losing control of his faculties toward the end of his life, according to one source partly because of heavy drinking. He started spending more than he earned, and one of his relatives, taking advantage of his indisposition, absconded with part of his

art collection. In September 1638 he was declared bankrupt, and his house was sold to the painter Petrus Portengen.

Roelandt Saverij died a bachelor in February 1639. Three months later his former housekeeper, Willemtgen van Angeren, married Hans Saverij. Willemtgen was most probably the woman referred to in one source as Roelandt Saverij's "widow." Hans Saverij also continued the workshop.

Jan Baptist Weenix
[AMSTERDAM 1621–1659 DE HAAR]

Jan Baptist Weenix was born in Amsterdam in 1621.[1] His father, Jan Jansz. Weines, a painter from Enkhuizen, married Grietje Heremansdr. of Amsterdam in 1612.[2] Arnold Houbraken compiled an extensive account of Weenix's life, which he based on oral information obtained from the artist's son Jan.[3] According to Houbraken, Weenix's father was a well-known architect, nicknamed "Jan met de Konst" (Jan with the Arts), who had died when the boy was only a year old. He was subsequently raised by his mother, who first apprenticed him to a bookseller and then to a cloth merchant, both times with little success because the boy preferred to draw. He was finally apprenticed to the Amsterdam artist Jan Micker, who taught him to draw,[4] after which he continued his studies in Utrecht with Abraham Bloemaert. His last two years as an apprentice were spent in Amsterdam with Nicolaes Moeyaert.

Weenix was married in a civil ceremony in Amsterdam to Josijntje de Hondecoeter, daughter of the artist Gillis Claesz. de Hondecoeter.[5] The wedding took place in the summer of 1639. According to Houbraken, the groom was eighteen years old at the time, rather young for a painter to get married. Abraham Bloemaert, whom he must have left about 1636, had always encouraged his pupils to continue their studies in Italy before settling in Holland. It seems that his early marriage disturbed Weenix's own plans to do so, although

he did not give up on the idea. Houbraken's vivid account of the artist's attempts to sneak away from his family to go on his Grand Tour testifies to his intense frustration at not being able to travel. In October 1642 Weenix drew up a will in which he explicitly stated that he was planning to travel to Italy.[6] In March 1643 he passed through the French port of Rouen, continuing from there to Rome.[7] He joined the society of Netherlandish artists in Rome, and his fellow *Bentvueghels* gave him the nickname "Ratel" (Rattle) because of his speech impediment.[8] In Rome he worked for Cardinal Giovanni Battista Pamphili, who became Pope Innocent X in 1644. According to Houbraken, Weenix tried to persuade his wife to join him in Rome, but she refused; as a Protestant, she did not want to live in the Eternal City. He felt compelled to return home, albeit against the will of his employer and with pain in his heart. He would be called "Giovanni Baptista" ever after.

Weenix was still in Rome in the summer of 1646, but a year later he was back in Amsterdam, by which time his mother had died. Weenix and his family moved to Utrecht, where his brother-in-law, the painter Gijsbert de Hondecoeter, had lived since 1630. Weenix was soon accepted as a leading master and was appointed to the board of the Painters' Society in 1649. He also took part in collaborative projects. In 1651 he painted the animals in Nicolaus Knupfer's painting *The Pursuit of Pleasure (Il Contento)*, in which Jan Both executed the landscape (see Spicer, introduction to this catalogue, fig. 7).[9] The painting was sold to the collector Willem Vincent, baron van Wyttenhorst, who later bought a group portrait of his wife's dogs from Weenix, paying him 225 guilders.[10] Weenix also worked with Nicolaes Berchem.

In late 1653 Gijsbert de Hondecoeter died, and Weenix welcomed his son, Melchior de Hondecoeter, into his home, where he trained him to become a painter.[11] Two years later Weenix was still living in Utrecht, on the Zuilenstraat, although about this time he decided to move to the countryside. From the nobleman Hendrick Valckenaer he rented living quarters in Ter Mey Castle, in the village of De Haar.[12] According to Houbraken, Weenix spent his last three years there. He died in the spring of 1659, leaving a bankrupt estate. More than a hundred paintings left in his estate were sold at a public auction on 25 April 1659.[13]

After Weenix's death his widow moved back to Utrecht, where she died in October 1662.[14] Melchior de Hondecoeter moved to The Hague before settling in Amsterdam a few years later. Weenix's two sons both became painters: Johannes Weenix, active first in Utrecht and later in Amsterdam; and Gillis Weenix, in Lyons, France.[15]

Adam Willarts
[ANTWERP 1577–1664 UTRECHT]

Adam Adamsz. Willarts was born in Antwerp in 1577.[1] Nothing is known about either his family background or his training. His family, however, must have fled Antwerp for religious reasons, probably after the fall of the city to the Spanish in 1585. They settled in London, whence the young artist moved to Utrecht around the turn of the century. In 1602 the Utrecht cathedral chapter commissioned Willarts and Salomon Vredeman de Vries to paint the shutters of one of the cathedral organs.

In 1605 Willarts was married in the Utrecht Reformed Church to Maeyken Adriaensdr. van Herwijck. He acquired citizenship three years later and is listed as a reliable citizen in the 1610 roster of militiamen.[2] By that time he must have had a good reputation as a drawing teacher. He registered no fewer than fourteen drawing pupils during the first three years after the founding of the Guild of St. Luke (1611), in which he himself had played a leading role. Apart from these pupils he also trained his own sons Cornelis (d. 1666), Abraham (1613–1669), and Isaack (d. 1693), all of whom became painters who contributed to the output of Willarts's studio.

From the outset the style of Willarts's sea-scapes testifies to his Flemish origins. He had no competitors in Utrecht and catered to the Utrecht art market for mannerist seascapes long after this style had become outdated, just as Joost Cornelisz. Droochsloot retained a monopoly on village scenes in the style of Pieter Bruegel.

In 1612 Willarts bought a house on the Anna-straat, not far from the town hall. As long as the Libertines ruled the city, the Contra-Remonstrant Willarts had little business there. This all changed after 1618, however. Between 1620 and 1637 he served almost continuously as dean of the guild. Because of his central position in the Utrecht painters' community, he is encountered in numerous documents involving other artists. Since he was a poet as well as a painter, we also find him in close contact with the intellectual elite of the city.

Modern scholarship offers no well-defined judgment of Willarts's art, and as yet no one has attempted to compile a catalogue of his oeuvre. He was held in high esteem by his contemporaries, however, and was given important and honorable commissions. He worked for the city and the States of Utrecht, as well as for the chapter of St. John. His enormous *View of Dordrecht* dating from 1629—more than twenty-two feet wide—is still the focal point of the Dordrecht museum. He also contributed to the decoration of Kronborg Castle in Denmark.

Willarts never became a wealthy man and never held public office, apart from being a governor of St. Job's Hospice from 1639 onward. Public respect, however, resulted in his being granted an annual allowance by the city in 1654. He was also given free housing in the former Convent of St. Agnes, where he may have been caretaker of the display room of the Utrecht Painters' Society. Ten years later, on 4 April 1664, he was buried in the convent's chapel.

Joachim Wtewael
[UTRECHT 1566–1638 UTRECHT]

Joachim Wtewael was born in Utrecht in 1566.[1] His father was the glass painter Anthonis Jansz. Wtewael, who trained Joachim in the same craft. The boy, however, opted for a career as a painter. After completing his apprenticeship with the Utrecht artist Joost de Beer, he traveled to Italy in about 1586. At Padua he entered the service of Charles de Bourgneuf de Cucé, bishop of St. Malo, whom he followed to France two years later.

Wtewael probably returned to Utrecht shortly before 1592. He joined the guild around that time, set up a studio, and began to take on apprentices. During the 1590s he accepted commissions from the local bailiwick of the Teutonic Order, as well as from the States of Holland, for which body he designed cartoons for a stained-glass window for the Janskerk in Gouda. Already before the publication of Karel van Mander's *Schilder-boeck* in 1604, however, Wtewael had given up the idea of becoming a full-time artist. Van Mander states that Wtewael spent much of his time trading in flax, and it was probably these other activities that enabled him to prosper rapidly. In 1596, a year after his marriage to the shoemaker's daughter Christina Petersdr. van Halen, Wtewael bought a large house on the Oudegracht.[2] In 1602, when the Dutch East India Company was founded, Wtewael underwrote shares worth nine hundred guilders, which yielded high profits from 1610 onward. In the course of his life, Wtewael's known investments in mortgages came to almost twenty-five thousand guilders, and he also owned several houses and plots of land.

This explains his rather loose connection with the Utrecht art world: He had very few apprentices apart from his sons, and his name is rarely found in documents in connection with other artists. Even though Wtewael helped found the Guild of St. Luke in 1611, he never served on its board.

Wtewael, it seems, preferred to serve on other boards. His appetite for political influence became apparent in 1610, when he took part in a short-lived coup and served on the revolutionary council for three months before being removed. With Paulus Moreelse, his elder brother Johan Wtewael, and others, Joachim Wtewael again took part in a coup in 1618. Stadholder Prince Maurits rewarded Moreelse and Johan Wtewael with life-long seats in the city council. Because two brothers were not permitted to hold seats at the same time, however, Joachim had to wait until after the death of his brother in 1630. In the meantime Joachim, who was a member of the Reformed Church, served in various capacities in church and charitable functions. He was churchwarden and dispenser of the poor box of the Jacobikerk, deacon of the Reformed Church, and regent of St. Maarten's Hospice. In 1632 he was finally appointed to the town council, though by that time his health had deteriorated to such an extent that he never attended meetings. In 1636 Prince Frederik Hendrik decided that Peter Wtewael should take over his father's seat.

Joachim Wtewael died on 1 August 1638 and was buried in the Buurkerk. Throughout his life he had combined his two professions, although he must have sold more flax than paintings.[3] A large part of his oeuvre was still in his estate at the time of his death. His son Johan Wtewael, also a painter, carried on the work of his father's studio.

Peter Wtewael
[UTRECHT 1596–1660 UTRECHT]

Peter Wtewael was born in Utrecht on 5 June 1596.[1] He was the eldest son of the painter Joachim Wtewael, who was probably his first and only teacher. All of his dated paintings are from the 1620s; early in the next decade he gave up painting altogether. Joachim von Sandrart, however, who visited the Wtewael studio in the 1620s and prob-

ably again on a short visit in 1637, thought that Peter was wasting his talent when he gave up painting to give priority to the family flax business.[2]

Like his father, Joachim, Peter Wtewael had political ambitions. Also like Joachim Wtewael, who had to wait in the wings as long as his brother held a seat in the city council, Peter Wtewael had to wait for his father to relinquish his post. In September 1635, at the age of thirty-nine, Peter joined the Reformed Church, a prerequisite for membership on the council.[3] A year later his father resigned and Peter Wtewael was appointed a councilor by Stadholder Prince Frederik Hendrik.[4] He subsequently embarked on a long political career, in which he served as a magistrate at the local court almost continuously starting in 1642, the year in which he took over the seat of Johan Pater, his deceased brother-in-law. In addition, he served as deacon and elder of the Reformed Church.[5]

After his father's death in 1638, Peter Wtewael did not register as a master painter in the Utrecht Painters' Guild. His brother, Johan Wtewael, however, registered a year later, probably intending to continue the family workshop. The two brothers, both bachelors, lived in the family home on the Oudegracht.[6] In 1639 they had a completely new facade erected in a sober, classicist style.[7]

Peter Wtewael died in Utrecht on 16 January 1660. He left an impressive estate, containing a large proportion of his father's oeuvre, as well as paintings by himself and by several other Utrecht masters. Two sons-in-law of his sister Antonetta Wtewael continued the political tradition of the family. The family portraits of the Wtewaels, as well as several other paintings by Joachim Wtewael, remained with their descendants until well into the twentieth century.

Notes

Frequently Used Abbreviations

DTB: Doop-, Trouw- en Begraafregisters (Registers of Baptisms, Marriages, and Burials; these are explicitly referred to only in cases where confusion about the source might exist)

GAA: Gemeentearchief Amsterdam (Amsterdam Municipal Archives)

GAU: Gemeentearchief Utrecht (Utrecht Municipal Archives)

NH: Nederlands Hervormd (Dutch Reformed)

RAU: Rijksarchief in de provincie Utrecht (Public Record Office of the Province of Utrecht)

NOTES TO THE ESSAYS

An Introduction to Painting in Utrecht, 1600–1650

JOANEATH A. SPICER

This essay is for Egbert Haverkamp-Begemann, J. Richard Judson, and the Honorable Francis D. Murnaghan, in great appreciation.

1. See Von Sandrart/Peltzer 1925, 157; Swillens 1945–46; Van Gelder 1950–51.
2. The best overall recent source on the political situation is Israel 1995.
3. Van Strien 1993, 6.
4. Years later, after working in Italy, England, Germany, and Amsterdam, Von Sandrart wrote the only "lives of the artists" from a firsthand perspective of Dutch art in the Golden Age. The coverage by this sophisticated observer is lopsided in favor of Utrecht artists. Von Sandrart/Peltzer 1925. On Von Sandrart in the Netherlands, see Klemm 1986, 15–18.
5. The following is an amalgam of Van Mander's ideas pertinent to this discussion, especially from Van Mander 1973, chap. 1, fol. 1v; chap. 2, fol. 9v; chap. 4; chap. 5, in particular fol. 16v–17v. On Van Mander as a painter, see Melion 1991; Leesberg 1993–94.
6. Van Mander 1973, chap. 5, fol. 17v.
7. For Van de Passe's manual, see Bolten, in Van de Passe 1643; Bolten 1985.
8. These hypotheses have yet to be fully tested. The assertion that "there was hardly any difference between denominations in the iconographic use of biblical themes" made by Tümpel 1980, 54, was taken up by Manuth 1993–94, 238, but without adequate support. Halewood 1982 lacks nuance in his investigation of the manifestations of divine grace, but his approach is potentially fruitful and should not be ignored; see Spicer 1985.

9. For the vast subject of the Counter-Reformation, see, e.g., Cameron 1991; Rogier 1945–47; Pelikan 1984; Freedberg 1993; and further, the references in the following notes.
10. "No image shall be set up which is suggestive of false doctrine or which may furnish an occasion of dangerous error to the uneducated. . . . No one [shall] be allowed to place or cause to be placed any unusual image in any church . . . unless it be approved by the bishop. . . . All lasciviousness must be avoided so that figures shall not be painted or adorned with a beauty inciting to lust." Decree of the Council of Trent, Dec. 1563, in Schroeder 1978, 216–17. See also Freedberg 1988, 136.
11. The influential Italian Gabriele Paleotti argued that the aim of Christian images is the same as that of orations, "to persuade people to piety and to direct them to God . . . to lead men to penitence . . . to charity." On Paleotti, see Ostrow 1996, 117ff.; Prodi 1965. See more generally Freedberg 1988.
12. Enggass and Brown 1970, 163, quoting Francisco Pacheco, *Arte de la pintvra, sv antiqvedad, y drande zas* (The art of painting) (Seville, 1649).
13. General works consulted on the art of the Counter-Reformation and on Catholic art of the Northern Netherlands: Knipping 1974; Freedberg 1988; Dirkse 1989; Van Thiel 1990–91; Filipzak 1991; Kenseth 1991, 441–458; Schillemans 1992; Burke 1993; Freedberg 1993; Van Eck 1994; Ostrow 1996. The difficulty of assessing cause and effect in art going under the heading of the Counter-Reformation is signaled in Freedberg 1993, 61. Specifically on the Jesuits, see Dirkse 1991; O'Malley 1993; Freedberg 1993, 137–38; Burke 1993; Bok, in Roethlisberger 1993, 569–70; Seelig 1995, 125–34; Melion 1997.
14. See Melion 1997.
15. For an example of which, see cat. 7.
16. Binet 1632.
17. Binet 1632, fol. 85. Differences in Protestant and Catholic views of the Virgin as reflected in the comportment expected of her at the foot of the cross is discussed by Schwartz 1985, 118.
18. That Philip Rovenius, apostolic vicar in the Netherlands from 1614 to 1651, felt it necessary to work to shift devotional emphasis toward Christ himself, in keeping with the spirit of the Council of Trent, suggests that the small number of paintings of Christ relative to those of the saints or the Virgin, may indeed reflect contemporary devotional patterns. See Visser 1966, 91–94; Van Eck 1993–94, 217.
19. Coster 1616, 248–49.
20. For current conclusions on the purposes of this astonishing painting, see cat. 8 and the essay by Olde Meierink and Bakker.

21. Nicolaes Gyselaer's *Procession of the Eucharist in a Gothic Church* (Christie's [New York], 4 Oct. 1996, lot 18) would have reminded a Catholic of the dignity of the Eucharist, which could no longer be celebrated in public.

22. Huys Janssen 1994a, no. 30.

23. On the brotherhood, see Huys Janssen 1994a, under no. 30; Van Eck 1993–94, 220; Van Eck 1994, 115–16.

24. Dedicated to Gundaker, prince of Liechtenstein; Roethlisberger 1993, no. 459, with comments on sources.

25. Roethlisberger 1993, no. 489.

26. The divine presence in the consecrated communion wafer is the subject of Nicolaus Knüpfer's painted door of a tabernacle (see Kaplan, fig. 3, in this catalogue; Dirkse 1989, no. 158, illus. in color, inscribed above, "Here is the bread of angels."

27. For a general survey of the cult of the Virgin, see Knipping 1974, 245–84.

28. Binet 1632, fol. 25.

29. Roethlisberger 1993, no. 267; Seelig 1995, 115–20.

30. Roethlisberger 1993, no. 134. Similar images were painted by Hendrick Bloemaert (e.g., Roethlisberger 1993, no. H70); Jan van Bijlert (Huys Janssen 1994a, nos. 12, 14); and Paulus Moreelse (e.g., De Jonge 1938, no. 242). Moreelse's painting bears an inscription referring simply to Christ, "True man and true God," giving the image an interpretation that could speak more directly to Protestants.

31. Cited by Ostrow 1996, 167.

32. Roethlisberger 1993, no. 386; Seelig 1995, 134–35. See the discussion of Bloemaert's patrons in Seelig 1995, 76, 93–205.

33. Binet 1632, fol. 2.

34. Ostrow 1996, 184–251.

35. The *Catechism of the Council of Trent* emphasized that images of the saints are not only to be honored but also serve to "admonish us by their example to imitate their lives and virtues"; cited in Ostrow 1996, 117; Knipping 1974, 239–96, also 138–76.

36. The question of the relationship of style to content that these paintings raise has been posed most recently by Xander van Eck, specifically in regard to the effectiveness of Caravaggesque light and shadow for scenes of revelation—often an aspect of a saint's life; Van Eck 1993–94, 199.

37. Landwehr 1962, no. 83.

38. See, e.g., the paintings by Bernardo Strozzi in Spicer 1995, nos. 18, 27.

39. Van Eck 1993–94, 217, with references.

40. Roethlisberger 1993, no. 292. 's-Hertogenbosch had yet to be taken over by Protestant forces, and the Catholic community there, including a Jesuit station established in 1609, was a source of commissions for Bloemaert and others. The canonization in 1622 of Saint Ignatius prompted an outpouring of altarpieces dedicated to him. This one was accompanied by an equally large painting (also lost) of the Jesuit Saint Francis Xavier, also canonized in 1622.

41. Mary Magdalene appears primarily in individual prints (cat. 14, fig. 2), but the most important are the print series of hermits after Bloemaert's drawings, the first with fifty-two plates published in Antwerp in 1619, which Roethlisberger has connected to the Jesuit circle of Heribert Rosweyde from Utrecht, initiator of the great documentary project on the saints, the *Acta sanctorum*. Roethlisberger 1993, nos. 163–212 (engraved already in 1612), also 577–657.

42. The assessment of the interpretation of Old Testament subjects in Utrecht in Tümpel et al. 1991, 10–11, 13–14, leaves many questions unasked and unanswered.

43. E.g., seven paintings of the story of Job were among those given to the St. Job's Hospice in Utrecht; Huiskamp 1991, 151; Bok 1984. In the mid-1640s the general *rapprochement* of Utrecht painting with that of Holland is reflected in the theatrical Old Testament narratives by Nicolaus Knüpfer.

44. The popularity of the subject was noted in Blankert 1967, 45, but with no sustained effort to explain it. This fine piece of scholarship is so detailed that subsequent writers apparently considered the issue closed.

45. Noted in passing by Blankert 1967, 67, 68, 70, with reference to Weisbach 1928, the principal previous study, and citing editions of 1612 and 1615.

46. De Besse 1611, 3.

47. De Besse 1618, "Au lecteur," n.p.

48. Lowenthal 1986, no. A-92. Christian duty toward the education of children within the family as interpreted by the Reformed Church informs *The Van Bochoven Family at the Table* (Centraal Museum, Utrecht) of 1629 by Andries van Bochoven, a pupil of Wtewael's, in which the young painter has depicted his family gathered for a meal with the father preparing to read the Bible aloud before grace is said; Bok and De Meyere 1986; De Jongh 1986, no. 75; Franits 1986; Huys Janssen 1990, fig. 57. For the theme of the family saying grace as a reflection of Pietist and Reformed Church teachings on the raising of children, see De Jongh and Franits.

49. In Paulus Moreelse's 1628 *Portrait of the Jesuit Jacobus Gouda* (private collection) the priest is depicted in clerical costume of gold brocade with his hand on a book with a marker inscribed *Transubstantiatio*, in reference to the traditional Catholic position (disputed by Protestants) on the real presence of Christ in the consecrated Host; De Jonge 1938, no. 93, illus.

50. The absence of portraits of the leading citizens serving as officers of local militia companies may be due to the lack of continuity in the way that local defense was organized and the degree to which the position of the militia was undermined as it became the focus of religious clashes and divided loyalties.

51. De Jonge 1938, no. 44.

52. Van Luttervelt 1947b; Muller 1985, 93–103.

53. This varies from Bok 1994, 181–82, in that the third figure from the left is identified as Poelenburch by comparison with his portrait from Van Dyck's *Iconography* (illus. on cover of Sluijter-Seijffert 1984), and the fourth (obscured) is provisionally identified as Van Bijlert by comparison with the engraving by Jean Meyssens (illus. on cover of Huys Janssen 1994a). See also Van de Passe 1643, n. 20.

54. For the representation of genre or contemporary life in Utrecht, see further the essay by Wayne Franits in this catalogue. The outline by Huys Janssen 1990, 41–53, is organized around artistic developments and gives considerable weight to Jacob Duck and Andries Both. For the uncertainties surrounding Duck's years in Utrecht, see cats. 20 and 34 and

the biography. Andries Both's *Peasants in an Inn*, 1634 (Centraal Museum, Utrecht; Huys Janssen 1990, fig. 44), looks to Droochsloot, but such paintings would have been executed after Both reached Italy (Levine and Mai 1991, under no. 4). The brief pages focused on Utrecht in Sutton 1984, xxxi–xxxii, are insightful but focused on the Caravaggisti and the issue of style. A good overview of Dutch genre painting organized by theme is found in Brown 1984, though there is little on Utrecht.

55. Roethlisberger 1993, nos. 297–312, refers to them as "The Leisure Series"; they have also been called "Pastoral Scenes," which is misleading. See also Kettering 1983, 85–87; Raupp 1986, 202–3; Bruyn 1994, 144; Ackermann 1993, 63; De Jongh and Luijten 1997, no. 37.

56. For the theme of sleep in Dutch art, see Salomon 1984. The theme is expanded in a forthcoming work by Salomon, with particular reference to Jacob Duck.

57. See the essays by Orr and Franits in this catalogue.

58. Student life was in some way the same everywhere, though some of the scenes—the botanical garden, the library, the anatomy theater—are those of Leiden. Institutions of higher learning such as the Hieronymus school in Utrecht would be complemented by a university only in 1636.

59. In contrast, Christ's parable of the Prodigal Son, the story of the wealthy young man who squanders his inheritance in riotous living only to be reduced to caring for pigs before being forgiven and reinstated by his father, which is an important and often explicit moralizing backdrop to representations of "merry companies" by artists in Holland, does not play the same role in Utrecht. For the Prodigal Son, see Renger 1970; Sutton 1984, xxx; De Jongh and Luijten 1997, nos. 19, 29. A more gentle approach to moralizing is represented by Moreelse's *Allegory of Vanity* (cat. 21). The love of pleasure may be mocked and called unwise and even rejected, as in Van Bijlert's allegory (cat. 19), but it is treated as part of human nature. One is urged to improve one's behavior, but there are few threats of punishment.

60. The connections between the artists suggest that the inscription would not be contrary to Baburen's intent. See T. Matham's series the Consequences of Drunkenness, in De Jongh and Luijten 1997, no. 30.

61. For music in seventeenth-century Dutch paintings, see most recently Buijsen and Grijp 1994; on the lute see also De Jongh 1975–76, no. 21; Christiansen 1990.

62. See, e.g., Honthorst's *Young Woman Playing a Violin*, 1626 (Mauritshuis, The Hague), and a related engraving after a lost work also of 1626 in De Jongh and Luijten 1997, no. 38, fig. 1.

63. See Buijsen and Grijp 1994; Kettering 1983, 95–99.

64. Huys Janssen 1990, 44.

65. Kuznetsov 1974, no. 92, based on a painting by Elsheimer; Andrews 1977, no. 19.

66. For this novel, see further the esssay by Franits in this catalogue.

67. Lowenthal 1986, nos. A-38, A-40, A-73.

68. Roethlisberger 1993, no. H54.

69. Laws did not allow individuals to give alms personally, in part to counteract the influence of Catholic charity. For the organization of charity and its expression in art in the Dutch

Republic, see Muller 1985. The material assembled by Muller is very useful; however, her conclusions are compromised by having underestimated the continued influence of Catholic sentiment toward the nature of charity.

70. Lowenthal 1986, no. A-15; De Jongh 1986, no. 65; Luijten et al. 1993, no. 255.

71. For a good, concise commentary on Van Mander's comments in his preface, fol. 6, see Melion 1991, 63–66.

72. De Jongh 1986, under no. 65, reads the inscription in this wider sense.

73. The suggestion that in general Wtewael found portraiture beneath him is probably correct; Lowenthal 1986, 53.

74. This is one of the general theses of Schama 1987.

75. Franits 1993 is structured around Cats's text and offers the best way to approach it. See also Brown 1984, 132–51.

76. *Sinnepoppen* (1614); see Schama 1987, 379, also fig. 171. As Schama 1987, 383, gracefully puts it, Cats was aiming at a middle-class audience that would have found the arcane, metaphorical symbolism of the early-sixteenth-century emblem books devised for a social elite too obstruse. Though Cats's emblems are based on pictures of tangible, common-place objects or situations, the accompanying motto and texts may be from several languages, including Latin, so he is still making assumptions about the education of his reader. Cats's definition of emblems as cited by Schama 1987, 383, is to the point: "they are mute pictures which speak, little mundane matters that are yet of great weight; humorous things that are not without wisdom; things that men can point to with their fingers and grasp with their hands."

77. See Schama 1987, 384–85.

78. See most recently Buijsen and Grijp 1994, no. 25.

79. Given the associations of the lute with dalliance and the dissolute life and those of the keyboard instrument played by a well-bred, well-dressed young woman with discipline and self-control, it is arguable that Vermeer's placing Baburen's *Procuress* on the back wall of his *Concert* (cat. 38, fig. 1) was meant to underline these differences.

80. Durantini 1983; Schama 1987, 481–561; Franits 1993, 111–60. There are no family festivals such as Twelfth Night in which children usually abound, as in the paintings by Jan Steen. For Twelfth Night, originally a Catholic feast celebrated on 6 Jan. in honor of the arrival in Bethlehem of the Three Magi, its secularization as a family festival, and its representation in seventeenth-century Dutch art, see Van Wagenberg-Ter Hoeven 1993–94.

81. For the treatment of mythological subjects in Dutch art in the first half of the seventeenth century, see Sluijter 1986; Blankert et al. 1980.

82. The subject of the Wedding Banquet of the Gods in Dutch art has been discussed most acutely in Sluijter 1986 and Froitzheim-Hegger 1993; the latter is devoted to the subject. Sluijter's nuanced discussion gives considerable weight to the moralizing approach that Van Mander and some other early-seventeenth-century Dutch writers brought to the interpretation of the story and the related one of the Judgment of Paris (see under cats. 50, 72). Froitzheim-Hegger does not question that some contemporaries might bring a moral viewpoint to bear on the subject, but she questions whether this should determine our understanding of the popularity

of the subject when set in a wider context established first by Raphael's fresco.

83. *Metamorphoses* 1:100: "mollia securae peragebant otia gentes" (they lived secure, carefree, at their ease). This is the point of departure for Froitzheim-Hegger 1993.

84. See under cat. 53.

85. Riggs and Silver 1993, 76; Froitzheim-Hegger 1993, 62–91; Kloek, in Luijten et al. 1993, 19.

86. Adam van Vianen, *Wedding Banquet of Peleus and Thetis*, 1595–1600, bronze, 19 cm diam., The Walters Art Gallery, Baltimore; Ter Molen 1984, no. 531 [ABa], E); Van Zijl 1984, no. 55, illus.; version in lead, Rijksmuseum.

87. Ter Molen 1984, no. 7 (EBa), fig. 4.

88. There are other Banquets of the Gods by Van Bijlert (Huys Janssen 1994a, no. 31, 1635–40); Knüpfer (Kuznetsov 1974, nos. 80, 81, 81a), and Cornelis Willaerts (Christie's [Amsterdam], 7 May 1992, lot 37).

89. See Sluijter 1986, 210–11; see also Froitzheim-Hegger 1993, 101–9.

90. Knüpfer treated the theme of male sexual audacity getting its comeuppance at the hands of mirthful, vengeful females in his *Death of Orpheus* (Centraal Museum, Utrecht); Huys Janssen 1990, pl. II.

91. The following remarks on pastoral imagery in Utrecht are very much indebted to the outstanding contribution made by Kettering 1983 and also to the fine essays in Van den Brink and De Meyere 1993, especially those by Sluijter and by Smits-Veldt and Luijten, which concentrate on the literature.

92. Kettering 1983, 3.

93. The celebration of the life of the landsman found in Horace's second epode, which begins with the well-known phrase "Beatus ille . . ." (Happy is the man . . .), is certainly a contributing factor to the classical tradition behind these Dutch images, but it does not appear to have had a concrete influence on the artistic imagery at hand. See Smits-Veldt and Luijten 1993, 63–64.

94. See Sluijter 1993, 38 n. 24.

95. He also engraved captioned plates illustrating Virgil's *Aeneid* (Holl. 232ad) and even Homer (Holl. 857). His captioned plates to Ovid's *Metamorphoses* were published earlier (107 plates; Cologne, 1602; Holl. 852).

96. Included in *Nederduytsche poemata* (1616), for which see Kettering 1983, 22.

97. See also Moreelse's earliest pendant *Shepherd* and *Shepherdess* dated 1622 (Krayer-LaRoche coll., Basel); De Jonge 1938, nos. 263, 264; Kettering 1983, figs. 3–4.

98. Most of the specific references to Coridon in the following paragraphs come from Sluijter 1993, 33–36.

99. The book has been attributed to the young Daniel Heinsius, for whom see Smits-Veldt and Luijten 1993, 59, 67, fig. 42.

100. Sluijter 1993, 36; see below.

101. See also various renderings of the story by Bloemaert, e.g., his *Mercury and Argus* of 1645 (Van den Brink and De Meyere 1993, no. 13).

102. See Kettering 1983, 51–53.

103. The most blatant is Moreelse's *Shepherdess*, 1624 (Bayerische Staatsgemäldesammlungen, Munich); Van den Brink and De Meyere 1993, fig. 41.2. The bawdy references in contemporary songs to the shepherd slipping his pipe or flute

between a shepherdess's breasts would be going too far for paintings; Kettering 1983, 42.

104. E.g., Paulus Moreelse's *Vertumnus and Pomona*, 1623–24 (Boymans van Beuningen Museum, Rotterdam); Van den Brink and De Meyere 1993, no. 41.

105. Kettering 1983, 59, illus., shows Flora, personification of flowers, as a seductress who is compared to the lure of making money from speculation in tulip bulbs in the 1620s and early 1630s.

106. For an example by Bloemaert, see Van den Brink and De Meyere 1993, no. 11.

107. See Smits-Veldt and Luijten 1993, 62–63. In Vondel's *Het Pascha ofte de verlossinge Israels wt Egijpten* (1612) Moses is a herder, seen as prefiguring Christ as the "good shepherd." The harmony with the land is contrasted with the corruption of the court of the pharaoh.

108. See Willem van Honthorst's *Portrait of Louise Henriette van Oranje as Diana*, 1643 (Rijksmuseum Palace Het Loo); De Jongh 1986, no. 5.

109. For Frederik Hendrik, see Poelhekke 1978; his patronage will be the subject of an exhibition at the Mauritshuis in 1998.

110. For Huygens as an advisor to Frederik Hendrik, see most recently Rasch 1996.

111. See Broos 1993, under no. 5; Crispijn van de Passe, *Les Amours de Théagène et de Cariclée* (Paris, 1633), Holl. 185; Hans Horions, *Theagenes and Chariclea* (Centraal Museum, Utrecht); Van Gelder and Renckens 1967; De Meyere and Luna 1992, no. 40.

112. See cat. 58; Van de Brink and De Meyere 1993, nos. 28, 29; Judson 1959, no. 142; Braun 1966, no. 78.

113. The story: The shepherd Mirtillo loves Amaryllis who comes of noble stock and is promised to Silvio, also noble. Silvio, who cares only for the hunt, is loved by Dorinda. Corsica, a wanton woman from the city, loves Mirtillo, and through her scheming Amaryllis is unjustly convicted of sexual misbehavior, which is punishable by death. She is saved by the faithful Mirtillo, who offers to be sacrificed in her stead. Amaryllis's accuser is unmasked, and it is revealed that Mirtillo is actually of noble birth. Mirtillo and Amaryllis marry. Silvio is overwhelmed by Dorinda's faithful love for him and falls in love with her.

114. Van den Brink and De Meyere 1993, no. 48.

115. Ibid., no. 35.

116. Ibid., no. 51.

117. See De Meyere 1993, 28–29; Verkuyl 1971, 287–309.

118. This playacting parallels that of Frederick and Elizabeth, who had adopted between themselves the romantic allusions of the recent French pastoral novel *Astrée* by Honoré d'Urfée; Kettering 1983, 12.

119. In 1637 a commission for designs for a series on the early kings of Denmark was parceled out to several Utrecht artists including Honthorst, Van de Passe the Younger, Knüpfer, and Willarts, but the extant drawings and paintings show that by then most of the artists had lost their momentum; Schepelern and Houkjaer 1988.

120. Peter-Raupp 1980.

121. Kettering 1983, 10.

122. Van den Brink and De Meyere 1993, no. 9; Huys Janssens 1994a, no. 155. See also *Godard van Reede van Nederhorst and*

His Family (see Olde Meierink and Bakker, fig. 8, in this catalogue) of 1635 by Cornelis and Herman Saftleven, with its emphasis on family continuity; decorum is more important than naturalism; De Jongh 1986, no. 48, and Scholten 1996.

123. See Groeneweg 1995.

124. As proposed in cat. 64.

125. This is underlined by Elizabeth's gift of a replica of this painting, also dated 1628, to her brother Charles I, very likely as a response to the pastoral portraits of the king and queen by Honthorst that Charles had just sent to her. Class differences are clear in contrasting these images of family values with contemporary portraits of a family at table saying grace; see n. 48.

126. For a concise, informative introduction in English, see Schenkeveld 1991, 98–104.

127. Ibid., 27: "The opposition *otium-negotium* [negotium meaning business of life, absence of leisure] actually seems to be almost the central theme of his literary production."

128. Wilson 1980, no. 68.

129. For broader discussions of Dutch pastoral portraiture, including the contributions of other Utrecht painters such as Bernard Zwaerdecroon and Willem van Honthorst, see Kettering 1983, 63–82; Van den Brink and De Meyere 1993.

130. As suggested by Kettering 1983, 63.

131. Paulus Moreelse's only pastoral portrait of the 1620s is *Two Children in Pastoral Dress*, 1622 (Centraal Museum, Utrecht); Van den Brink and De Meyere 1993, no. 40. Although it is charming, the pastoral convention treats adults, and one would expect the initial experiments to be applied first to young adults.

132. See Kettering 1983, 177; De Meyere 1993, 25–27. He went with Elizabeth's recommendation and the commission to paint an *Apollo and Diana (Allegory of the King and Queen as Supporters of the Arts)* for Whitehall Palace: Judson 1959, 113–15, no. 73.

133. Kettering 1983, 67. As a reciprocal gift for Charles, Elizabeth then commissioned from Honthorst the immense *Portrait of the Family of Elizabeth and Frederick, King and Queen of Bohemia* (prince of Hannover, Schloß Marienburg), completed in 1629, in which the royal pair may be invoking roles from one of their favorite plays, Honoré d'Urfée's *Astrée;* Braun 1966, no. 83; De Meyere 1993, 26–27, illus.

134. This included one by Honthorst of the eldest daughter, *Princess Elizabeth II of Bohemia as a Shepherdess* (private coll.), which may have been made at the time of the portrait of the whole family and which was sent to Charles as well; Kettering 1983, 67, illus.

135. Kettering 1983, 75–77.

136. Kettering 1983, 75–76, with translation and original.

137. The only discussion of landscape painting in Utrecht per se is the short, perceptive overview in Huys Janssen 1990, 91–103, which covers the whole century and takes a different perspective. For the idealized Italianate landscape in the Netherlands, see Blankert 1965; Stechow 1966; Salerno 1977; Trnek 1986; Sutton 1987, 27ff.; Duparc and Graif 1990; Levine and Mai 1991.

138. See the essay by Jan de Vries in this catalogue.

139. See most recently Levesque 1994 for a discussion of the sense of place in the landscapes of Haarlem.

140. Van Mander 1604, fol. 298.

141. A drawing of the Mariakerk dated 1636 was used for a painting of 1662. For Saenredam and the Mariakerk, see Jansen 1987; Swillens et al. 1961, 205–31. For Saenredam in general, see Schwartz and Bok 1990; Giltaij and Jansen 1991.

142. E.g., *Church Interior with the Appearance of Gabriel to Zacharias* (Centraal Museum, Utrecht); De Jonge 1952, no. 114.

143. See also his *Skating Scene outside Utrecht* of 1632 (Centraal Museum, Utrecht); De Meyere and Luna 1992, no. 29, and a *Panorama of Utrecht* of 1624, best known in the engraving made after it (GAU).

144. For Hondecoeter, see Stechow 1966, 67, 69–70; Brown 1986, under nos. 23, 24; Sutton 1987, under no. 48; Spicer, in *Dictionary of Art* 1996, 14:706.

145. See the biography by Bok in this catalogue.

146. Spicer, in Fučíková 1997, not yet available; Müllenmeister 1988, no. 75, as datable to around 1606.

147. The still life of a fisherman's catch, as in *Fish Heaped on a Beach*, 1658 (New Orleans Museum of Art); Bullard 1995, 42, by Abraham Willaerts and Willem Ormea, or their *Beach Scene with the Miracle of the Fishes* (Public Center for Social Welfare, Bruges); Haak 1984, fig. 260, as Adam but surely Abraham, appears to have evolved out of such coastal scenes by Adam Willarts as this one. For Jan de Bont's 1653 *Fisherman's Catch on a Beach* (Centraal Museum, Utrecht), see De Meyere and Luna 1992, no. 17. On fish still lifes, see Bol 1982b, 83–88; Grimm 1979; Huys Janssen 1990, 86–87.

148. As Müllenmeister 1988, no. 230, has suggested, the figures of Adam and Eve in a *Garden of Eden* signed and dated 1625 by Roelandt Saverij (private coll., U.S.A.) certainly appear to be by Poelenburch, who contributed other figures to Saverij's paintings.

149. The painting has sparked a variety of different perspectives: e.g., Chong, in Sutton 1987, no. 679; Sluijter-Seijffert, in Van den Brink and De Meyere 1993, no. 47; and Helmus in cat. 68.

150. He is the only Utrecht artist for whom we have drawings after the antique. See cat. 53 and Spicer 1995, for the general issue of the response to the past.

151. For the environment in Rome, see Salerno 1977–80; Levine and Mai 1991.

152. See Van den Brink and De Meyere 1993, no. 31; Burke 1976, 45–50.

153. Apparent references to the Roman catacombs, for which there seems to be no tradition in Netherlandish art, support the assumption that De Hooch was in Rome before settling in Utrecht, even though there is no separate documentation for the trip; Burke 1976, 47.

154. Caldwell and McDermott 1980, 42; for Van Cuylenborch, see Trnek 1986, under no. 26.

155. For comparable works by Van der Lisse, see Van den Brink and De Meyere 1993, no. 36; and Duparc and Graif 1990, 30, fig. 12. On the artist, see cat. 55.

156. Kettering 1983, fig. 161, as Gillis de Hondecoeter.

157. The purpose of the *Coastal Scene* (Schloß Grunewald, Berlin) by Willarts is a mystery; Kettering 1983, fig. 163.

158. The importance of Both's combination of naturalism with golden light, new for Dutch painting, is emphasized by Burke 1976, 73.

159. Von Sandrart/Peltzer 1925, 185.

160. Huys Janssen and Sutton 1991, no. 3. For Stoop's paintings, see Levine and Mai 1991, 32; Trnek 1986, nos. 69–70.

161. Schulz 1978, no. 39.

162. For example his *Woodland Interior* of 1647 (Bredius Museum, The Hague); Schulz 1978, no. 48; Sutton 1987, under no. 96, illus.

163. For Saftleven's Rhineland views, see Sutton 1987, no. 97. One of Saftleven's most startlingly painterly landscapes in its exploration of the modeling power of light is an etching of one of the gates of Utrecht done in 1646, *The Wittevrouwenpoort*. The geometry of the gate dramatically lit by the slanting light of late afternoon is an inspired adaptation of Both's Italianate vision to a Dutch subject. For Saftleven's views of Utrecht, see De Meyere 1988b; Schulz 1978, no. 45, illus. Thereafter Saftleven's views of the city become increasingly descriptive, immersed in the detail that would inspire Joost van den Vondel's poem "On a Representation of Utrecht by Herman Zachtleven." As Freedberg 1980, 64, notes, the poem written about 1650 is more a celebration of Utrecht than of Saftleven's unidentified drawing.

164. Müllenmeister 1988, no. 233. The composition is derived from a painting dated 1601 by his brother and teacher Jacob Saverij (Girardet coll., Essen); Roelofsz 1980, fig. 9, though many details such as the dodo are added. Saverij's mental and creative energies were already on the wane by this point. The States purchased it from the art dealer Herman van Vollenhoven in Dec. 1626. For the transaction with Vollenhoven, see Kramm 1857–64, 5:1296, 1446–47. For Saverij, see under cat. 67. Huys Janssen 1990 does not really address animal painting as a separate genre. There is no real survey of Dutch animal painting; see Müllenmeister 1978; Bol 1982a.

165. See Prest 1981; Taylor 1995, 28–42, on "the Bible of Nature"; Fruchtbaum 1964, chap. 9; Wallace 1988; Ingegno 1988.

166. See, e.g., Thomas 1983, 17–50.

167. Roethlisberger 1993, nos. 135–48, illus. A second series based on drawings of a few years later was engraved by Frederick Bloemaert after 1635 (Roethlisberger 1993, nos. 149–62). There were no animals included in Frederick Bloemaert's *Artis Apellae liber (Tekenboek)*, the drawing book published after his father's drawings ca. 1650–55, though several plates engraved by Frederick are included in Bernard Picart's edition of 1740; for these editions, see Roethlisberger 1993, 389–94, nos. T1–166, esp. T156–66; Bolten 1985, 51–67.

168. Van den Vondel 1974.

169. On the dodo, see the recent exhibition publication Van Wissen 1995 with earlier literature. The authors are not so well versed on the seventeenth-century artistic renderings of the dodo. The extended discussion in Spicer 1979, 367–79, has been ignored. Although a living dodo was presented to the emperor in Prague before Saverij's arrival, the creature is absent from his paintings done in Prague, and it is unlikely that the artist saw it alive. Best known is a drawing attributable to Hans Saverij; Spicer 1979, no. 143, as Roelandt

Saverij. For a drawing by Adriaen van de Venne, see Van Wissen 1995, 89; Spicer 1979, 373.

170. Spicer 1979, 151, 158–77.

171. For Gysbrecht de Hondecoeter (1604–1653) see Müllenmeister 1978, 76; Bol 1982a, 126; Huys Janssen 1990, fig. 83; Spicer, in *Dictionary of Art* 1996, 14:706. His father, Gillis de Hondecoeter, has been referred to as a pupil of Saverij's in Utrecht; Haak 1984, 147. Gillis, who left Utrecht for Amsterdam in 1610, would have known Saverij in Amsterdam, and it is there, when already a mature artist, that he painted his Saverij-inspired animal pieces. One of the elegant barnyard scenes by Gysbrecht's son Melchior (1636–1695) was included in the exhibition on Utrecht painting by De Meyere and Luna 1992. Though Melchior was born in Utrecht, he never worked there and therefore was not considered for inclusion in the present exhibition.

172. Van Hoogstraten 1678, 75–78.

173. There is no specific literature on still-life painting in Utrecht. For Dutch flower painting in general, see Taylor 1995.

174. See also the puzzling *Boy in a Laboratory* (Centraal Museum, Utrecht) attributed to Jan Adriaensz. van Attevelt and dated to ca. 1630 in De Meyere and Luna 1992, no. 3.

175. Crispijn van de Passe the Younger, Holl. 171; Savage 1924; Ackley 1981, no. 55; Segal 1990, nos. 17A, B; Segal and Roding 1994, 77–78; Kenseth 1991, no. 148.

176. Bol 1960, 14–27; Segal 1984, 31–41; see, e.g., *Vase of Flowers* dated 1606 (Cleveland Museum of Art), Brenninkmeijer-de Rooij 1992, fig. 2; and *Basket of Flowers* dated 1614 (J. Paul Getty Museum, Los Angeles); Segal 1984, no. 4.

177. For the possible adaptation of a late-sixteenth-century decorative engraving by Hendrick Hondius, see cat. 75, fig. 2.

178. For Breughel's letters to Cardinal Borromeo, see Brenninkmeijer-de Rooij 1996, 47–71; Jones 1993, 82.

179. For Saverij's flower pieces, see Spicer 1979, 246–61; Segal 1982; Bol 1982b, 35–36; Müllenmeister 1988, 164–80 (should be used with care); Taylor 1995, 142–46. The uneven quality of Saverij's flower pieces in the 1620s is partially a consequence of his declining health. Some works may be partially by Hans Saverij.

180. Segal 1982, 315–19. There are 102 varieties in a painting by Jan Breughel for Cardinal Borromeo; Brenninkmeijer-de Rooij 1996, 57.

181. Müllenmeister 1988, no. 274.

182. For Van der Ast, see Taylor 1995, 146–49; cats. 76, 77.

183. Van der Ast also explored casual presentations: a few flowers lying on a table or baskets of flowers and fruits often combined with shells. A pair of such baskets cited in the 1632 inventory of the collections of the prince and princess of Orange may be those in the National Gallery of Art in Washington (cat. 76, fig. 1). Wheelock 1995a, 5–8; but see also the pair discussed by Brenninkmeijer-de Rooij et al. 1992, under no. 3.

184. See Segal and Roding 1994, 83.

185. For Ambrosius Bosschaert the Younger, see Bol 1982b, 61–64. The second oldest brother, Johannes, moved to Haarlem before painting his first known works.

186. Bol 1982a, 64–65.

187. Segal 1990, under no. 38; De Jongh 1982, no. 27; Bol 1982b, 76–77.

188. Meijer 1988; Bok 1990a; Segal 1991. This great painter of sumptuous still lifes returned to Utrecht years later, but his career was shaped by his years in Antwerp.

189. For Marrel, see Bott 1966; Bol 1982b, 65–67; Segal 1990, 32–33, no. 39; Wettengl 1993, nos. 138–41.

190. For these drawings, see Bol 1982b, 67; Segal 1993, 21–23; Segal and Roding 1994, 80–81.

191. Of the vast literature on the interpretation of flower painting, see esp. the balanced discussions in De Jongh 1982; Taylor 1995, 28–76; Brenninkmeijer-de Rooij 1996.

192. Bleiler 1976, xi; see also Wettengl 1993, no. 127.

193. Brenninkmeijer-de Rooij 1996, 50.

194. See the useful assemblage of prices and values in Taylor 1995, 1–27. For Brueghel's comments, see Brenninkmeijer-de Rooij 1996, 52; Jones 1993, 82. Van de Passe insisted that he went to great efforts to find the flowers he drew from life.

195. On tulips see, e.g., Segal 1993; Segal and Roding 1994.

196. On tulipmania, see most recently Taylor 1995, 10–14. For many, the costs involved made the preoccupation with rare flowers ridiculous. Around the time of the speculative frenzy in the mid-1630s, the tulip became a symbol of greed and foolishness.

197. Brenninkmeijer-de Rooij 1996, 51.

198. Segal 1990, no. 6.

199. For the Dutch game piece, see Sullivan 1984. Two artists who took up Jan Baptist Weenix's conception of the trophy piece were the Scotsman William Gowe Ferguson, in Utrecht 1649–51 (Sullivan 1984, 49, 68, 70–71), and Jan Baptist's son Jan Weenix (Sullivan 1984, 61–67), who carried his father's formulation of the trophy piece into the next century.

200. Simons had worked as a still-life painter in Antwerp and was in Utrecht by 1669, but his domicile about 1650 is not documented. The ties of this painting to Utrecht offer a reason to place him in the city about 1650. For Simons, see Sullivan 1984, 29–30.

201. De Meyere and Luna 1992, no. 58.

202. Ibid., no. 17.

Searching for a Role: The Economy of Utrecht in the Golden Age of the Dutch Republic
JAN DE VRIES

1. A good introduction to Utrecht's social structure and social tensions is provided in Kaplan 1995.

2. Huizinga 1941, 10.

3. The discussion that follows is drawn from my study of *trekschuit* transportation; De Vries 1981.

4. Faber 1986.

5. Roorda 1975, 91–133.

6. Rommes 1995, 169–88. Exceptions were sometimes made to these blanket prohibitions. "Useful and necessary" Catholics and, beginning in 1663, a few Jews were granted burgher rights.

7. The activity depicted in the foreground of Herman Saftleven's print *View of Utrecht* illustrates the varied richness of Utrecht's surroundings. It inspired Joost van den Vondel to these words in his poem "On the Representation of Utrecht by Herman Zachtleven": "[Utrecht] lies in a fertile lap of clay ground, blessed in its riches; here swell the ears of corn, there the udders full with milk; here the shepherd rests in the shadow of the tree; here flow the river *Vecht* and the *Vaart*, through orchard, arbor and country estate. Here are the woods, the turtledoves, the cattle; there the honey-bee sucks, and yonder the nightingale and happy lark sing a charming song, which never tires the ear. So what is Utrecht to be called? A paradise of profusion." Cited in Freedberg 1980, 64.

8. Den Tex 1975.

9. Ritter 1988. Ritter found nearly 300 members of the Smiths' Guild about 1650, about 4 percent of the adult male population.

10. Kaplan 1995, 120–21. Of the 21 traditional Utrecht guilds (those holding political power in the period 1304–1528), the largest in 1569 was the carpenters, with 249 masters. In order of size, the next four were the smiths, with 216; the tailors, with 208; linen weavers, with 124; and saddlers, with 85.

11. The only firm quantitative basis for comparison is a list of *lakendrapeniers* (woolen cloth manufacturers) as of 1642. Leiden dominated the industry, with 217 such entrepreneurs; Utrecht had 18, Amsterdam 30, Haarlem 25, Gouda 24, and Delft 14. Van Dillen 1970, 186.

12. Bok 1994, 146–47.

13. Israel 1989, 158; Israel 1982, 241.

14. Koen 1991.

15. For a full discussion of the city-planning dimension of the proposal to enlarge the city, see Taverne 1978. The economic objectives are discussed in Bok 1994, 146–53.

16. Moreelse 1664, 373–437.

17. "door de vermeerderinghe van Consumptie, ende daer uyt spruytende veerbeteringe van alle publyke ende privé incomsten."

18. Frijhoff 1981.

19. Berents 1994. The Maliebaan, a broad promenade lined by four rows of trees, was a site of recreation (especially croquet) and consumption in bordering taverns.

20. De Vries and Van der Woude 1997, 317. With 46 booksellers and printers in the 1660s, Utrecht was exceeded only by Amsterdam, Leiden, and Rotterdam in this sector.

21. On the economic contraction that set in at this time, see De Vries and Van der Woude 1997, chap. 13.

Confessionalism and Its Limits: Religion in Utrecht, 1600–1650
BENJAMIN J. KAPLAN

1. Brown 1980, 101; Huys Janssen 1990, 22. Compare Rosenberg, Slive, and Ter Kuile 1977, 21, 30; Faber 1986, 16. For a historiographic review of the "Protestantization thesis," see Elliot 1990, 1–47.

2. Kaplan 1995, 29, 68, and works cited there.

3. "De Noortsche Rommelpot"; Janssen and Van Toorenenbergen 1880, 7.

4. Recent contributions include Van Eck 1993–94; Van Eck 1994; Manuth 1993–94; Montias 1991; Van Thiel 1990–91.

5. Schilling 1980, 204–22.

6. See n. 2.

7. For the course of the Reformation in Utrecht, see Kaplan 1995.

8. On Libertinism, see Kaplan 1995, 68–110.

9. On the Remonstrant controversy in Utrecht, see Kaplan 1995, 229–60; on its national dimensions, see Van Deursen 1974, 227–345. The close association in Utrecht of Contra-Remonstrants with subversion resulted from a major popular uprising in 1610 in which future Contra-Remonstrants, including Joachim Wtewael, played leading roles. See Felix 1919.

10. Vijlbrief 1950, 78–81; Bezemer 1896; Van de Water 1729, 3:183–84. Moreelse was appointed to the new city council (*vroedschap*) in 1618, as was Wtewael's brother Jan; Wtewael himself joined it in 1632.

11. Israel 1995, 492–94. Consistory and magistracy overlapped in personnel quite substantially in these years. For a list of magistrates see Van de Water 1729, 3:183–95; for a list of elders and deacons see Van Lieburg 1989, 152–59. By contrast, the scholar Aernt van Buchel complained in 1640 that Arminians and Catholics still ran the provincial court (Van Buchell 1940, 106).

12. Struick 1986; Kernkamp et al. 1936, 1:1–72, 229–63; Duker 1897–1915, 2:1–70, 132–229, 3:1–102; Israel 1995, 584–87.

13. On Voetius's *preciesheid*, see Voetius 1978, esp. 11–15; Voetius 1965, 316–34; Duker 1897–1915, 2:230–70. Concerning paintings, Voetius declared in 1643 that hanging them for decoration was permissible so long as they were not obscene, did not show people of either sex naked or scantily covered, and did not include representations of God, the Trinity, the Holy Spirit, or other (Catholic) subjects that encouraged idolatry and superstition. Duker 1897–1915, 2:261 n. 2.

14. See Buchelius 1887, 56.

15. Evers 1933; GAU, Stadsarchief II, 2244, items dd. 1619–28; GAU, Stadsarchief II, 1, item 80; Duker 1897–1915, 2:14 n. 1 and appendix VI. After the building of their *schuilkerk*, the services of Utrecht's Remonstrants were never again disturbed, and with peace and safety ensured, the 1630s saw explosive growth in the size of the congregation, as it brought in once-frightened sympathizers as active members. Served by three ministers, the Remonstrants needed a larger *schuilkerk* by 1640; thwarted by the magistrates from building a grand new one, they settled for enlarging their existing house of prayer, actually a converted barn, on the Rietsteeg.

16. Berghuijs 1926; GAU, Archief der Doopsgezinde Gemeente te Utrecht, 192.

17. GAU, Archief van de Evangelisch-Lutherse Gemeente te Utrecht, 16; Visser 1963; Domela Nieuwenhuis 1839; Rommes 1996.

18. Roorda 1975, 102.

19. Siccama 1905. For Calvinist complaints about the situation, see Vijlbrief 1950, 70; Buchelius 1887, 53–54; Duker 1897–1915, 2:294–328. By the 1660s, if not earlier, some Calvinists in the elite had joined Utrecht's French-speaking, Walloon Reformed congregation, which was less precisionist and had no rule against canons, as an alternative to the regular, Dutch-speaking Reformed congregation. Roorda 1975, 102.

20. Spiertz 1989, 287–97; Rogier 1945–47, 2:5–164, 380–86.

21. Rogier 1945–47, 2:386–95; Israel 1995, 378–79.

22. *AAU* 5 (1878): 183–91; *AAU* 9 (1881): 201–15; Boukema 1982, 57–58; Rogier 1945–47, 2:395–96.

23. *AAU* 20 (1893): 358–59; *AAU* 12 (1884): 193.

24. Dirkse 1989, 6; Van Eck 1993–94, 217–18; Van Eck 1994. Compare Rogier 1945–47, 2:676–77, 686–87, and passim.

25. Quoted in Enno van Gelder 1972, 118.

26. Van de Ven 1955.

27. Boukema 1982, 72.

28. Van de Ven 1952, 60; Dirkse 1989, 12.

29. Van de Ven 1952, 60; Dirkse 1989, 11, 115, cat. 158, 105, cat. 132, 107, cat. 138.

30. Dirkse 1989, 12, 13, 31 n. 29; Dirkse and Schillemans 1993, color illus.; Van Eck 1993–94, 225.

31. Van Eck 1993–94; Van Eck 1994.

32. Rogier 1945–47, 2:762–67.

33. Van de Water 1729, 3:470–73; Bogaers 1985, 111–14.

34. Spiertz 1989, 297–98. So dependent on its core of lay followers was the Catholic Church in the Netherlands that Vosmeer considered creating a formal hierarchy of lay officials.

35. Van Deursen 1974, 130; contemporary quotation from Bergsma 1989, 269. For this phenomenon within Utrecht's congregation, see Buchelius 1887, 50.

36. GAU, Archief der Kerkeraad der Nederlandse Hervormde Gemeente, 205. To be precise, the census counted 1,678 members in seven of Utrecht's eight quarters; either the last quarter was not counted or, more likely, the count has not survived.

37. Van Lieburg 1989, 52, 77; from the number of new members must be subtracted the number of members who died or moved away. These figures exclude the Walloon Reformed congregation, which at any rate was small.

38. See n. 14.

39. Rommes 1996, 38.

40. GAU, Archief der Doopsgezinde Gemeente te Utrecht, 192.

41. De Kok 1964, 54–68, 248, 470. See also Knippenberg 1992, 15–32. Though wary of them, Knippenberg still uses the figures from the 1656 mission report.

42. Rogier 1945–47, 380; Van der Woude et al. 1965, 149–80; Spiertz 1977.

43. *AAU* 1 (1874): 209.

44. Bok 1994, 195–98, 233. Bok's even more dramatic claim that Utrecht's painters were no more Catholic at all than the general population rests on a miscalculation of marriage rates for the latter.

45. This list is based on the findings of Marten Jan Bok as they appear in the following publications: Luijten et al. 1993, 299–327; Blankert and Slatkes 1986, 66–67, 194–95, 209, 218–20, 236–37, 276–78, 328–29; Bok 1984; and Bok 1993b; Marten Jan Bok also provided information on Nicolaus Knüpfer. The list also draws on Blankert 1978, 61 n. 9; Van Lieburg 1989, 152–59; and GAU, Stadsarchief II, 2244. People are listed as "Calvinist" if they a) were members of the Reformed Church, b) were married *and* had their children baptized in it, or c) are said by a contemporary source to be Calvinist.

46. Van Buchell 1940, 69.

47. Van Lieburg 1989, 69.

48. De Booy 1980, 66; Buchelius 1887, 45, 47; GAU, Stadsarchief II, 2244, pack dd. 31 Jan. 1616; GAU, Stadsarchief II, 121, 4 Dec. 1615.

49. Buchelius 1887, 31–32; GAU, Stadsarchief II, 2244, 1 Nov. 1619; GAU, Stadsarchief II, 1, item 80; Van de Water 1729, 3:469; Evers 1933, 100–102.

50. Groenveld 1995.

51. See, e.g., Van Lieburg 1989, 42.

52. Van de Water 1729, 3:570–71, 511–12.

53. Luijten et al. 1993, 311; Bok 1994, 178–89; Bok 1990b, 58–68.

54. Huys Janssen 1994a; Van Eck 1993–94, 219. Other Protestant painters who received commissions from *schuilkerken* include Utrecht's Ter Brugghen, Gouda's Wouter Pietersz. Crabeth the Younger, and Antwerp's Jacob Jordaens. Van Thiel 1990–91, 55 n. 72; Van Eck 1994, 44–45 and 232 n. 19 (see also Blankert and Slatkes 1986, 249); Manuth 1993–94, 238. For German parallels, see François 1982, 788.

The Utrecht Elite as Patrons and Collectors

BEN OLDE MEIERINK AND
ANGELIQUE BAKKER

We thank Dr. Marten Jan Bok for graciously sharing with us his primary sources. J. van Meerwijk transcribed a number of household furniture inventories and conducted supplementary genealogical research. For the household furniture inventories the *Getty Provenance Index* 1996 was used extensively.

1. The estate was left to the attorney Jan de Wijs; see Faber 1988, 147–48; Van den Brink and De Meyere 1993, 87–91.

2. Huys Janssen 1985; Bok 1984.

3. Huys Janssen 1990 does not treat this subject. De Meyere 1978 suggests a direction to take for a consideration of the sixteenth century in this regard. For the relationship between artist and patron in general, see Hendrix and Stumpel 1996 and, esp., Boschloo 1996.

4. Bok 1994.

5. The population of the Northern Netherlands was estimated at about 60,000 in 1577. Eighty percent lived in the cities of Utrecht, Amersfoort, and the provincial towns of Rhenen, Montfoort, and Wijk bij Duurstede. See Van den Hoven van Genderen and Rommes 1995, 54–85.

6. Faber 1986, 142–49.

7. See the surveys in Van den Water 1729.

8. Van Drie 1986.

9. Van Drie 1995, 45. The *Ridderschap* was extended in 1640 to twelve and in 1642 to twenty-two members.

10. Olde Meierink 1995, 30–31.

11. Faber 1986, 13–16.

12. See Groenveld and Leeuwenberg 1985.

13. Muller 1911, 21.

14. Haak 1984, 40.

15. See Bok 1993c, 5–8, and Hoogsteder 1986.

16. Friedländer 1905.

17. Cuppen 1983; Bok 1994, 59.

18. Since the beginning of the sixteenth century, the family also owned Horst Castle in northern Limburg. After the death of Johan van Wyttenhorst the Elder in 1569, the castle was inherited by his eldest son, Johan van Wyttenhorst the Younger, and, through further inheritance, descended to the Huyn family of Amstenrade Castle in southern Limburg.

The other son, Herman, the grandfather of Willem Vincent, was the only one of the Van Wyttenhorsts to convert to Protestantism; he was court steward to Prince Maurits. Sonsfeld Castle later became the property of Willem Vincent's brother Herman, while Willem Vincent inherited the Brabant possessions Drongelen, Besoyen, and Gansoyen Castle. Cuppen 1983; *NNBW* 7: col. 133.

19. Janskerkhof nos. 17 and 18; see Dolfin, Kylstra, and Penders 1989, B:44.

20. Hermans, "Nijenrode," in Olde Meierink et al. 1995, 341–45.

21. For an illustration, see Postma 1983, 21; for the engraved portraits of Matham, see Beelaerts van Blokland et al. 1912–15, 226–27.

22. Collection Fürstenberg Schloß Herdingen, transcription in Knipping 1905.

23. Bok 1994, 58–59.

24. See Cuppen 1983, 193–94.

25. Described in Cuppen 1983, 63–83.

26. GAU, Stad II, Transporten en Plechten 1665.

27. M. Knuijt, "Amerongen," in Olde Meierink et al. 1995, 114–19; Zonneveld 1986.

28. For illustrations, see Wittert van Hoogland 1909–12, 1:1–25.

29. GAU, Stad II, 3146 (18-6-1650).

30. Van der Goes and De Meyere 1996, 2.

31. Ibid., 122, no. 49.

32. Wintermans 1996.

33. Zweder Schele, a nobleman from Overijssel, installed a similar gallery in the hall of Weleveld in 1622. See also Shürmeyer 1937, 222–27.

34. The oldest known example in the Northern Netherlands is an epitaph with four members of the De Roevere family, lords of Montfoort, kneeling in adoration before the Virgin Mary, dating to the fourteenth century.

35. Such pieces were also found at Loenersloot Castle. Rijksarchief Gelderland, House Doomenburg, inv. 234.

36. Compare, e.g., the epitaph of Adriaen van Meerssenbroek and Anna Elant by Jan Anthonisz. van Ravesteijn, 1618, Rijksmuseum Het Catharijneconvent, Utrecht.

37. Illustrated in Van der Goes and De Meyere 1996, 44–46.

38. Bok 1996.

39. A study of the Roman Catholic nobility in the seventeenth century is a desideratum. For the nobility in the province of Utrecht, see Marshall 1987; Price 1995.

40. In his mission report of 1656 Jacobus de la Torre mentions Nijenrode, Kronenburg, Snavelenburg, and Loenersloot Castle in the area of the river Vecht; Amelisweerd and Rhijnauwen near Bunnik; Blikkenburg in Zeist; Den Ham near Vleuten; Rijssenburg, Weerdestein, and Groenstein on the Langbroekerwetering and Rijnennburg; and Vronestein and Heemstede to the south of the city of Utrecht. The report was published in Van Lommel 1882.

41. Olde Meierink 1996, 150–51.

42. De Vries 1994, 219–30.

43. See Donkersloot-de Vrij, "Zuylenburg," in Olde Meierink et al. 1995, 517–21.

44. See Weytens 1965.

45. These could possibly be identified with three paintings by David Vinckboons, after which engravings were made by Hessel Gerrits. A fourth painting from Zuylen, probably

by the same Hessel Gerrits, still in Zuylen Castle, is illustrated in Olde Meierink et al. 1995, 80.

46. Wevers 1991.
47. For this house, see Dolfin, Kylstra, and Penders 1989, A:415.
48. Rijksarchief Algemeen, family Heereman, (ARA) 940. The inventory of the country estate Heemstede has been published in Wevers 1991, 202–5.
49. RAU, House Zuylen, 784, inventory Nederhorst Castle 1648.
50. Defoer 1977.
51. For these premises, see Kylstra 1986.
52. See Wevers 1991, 202–5.
53. Des Tombe 1905.
54. ARA, family Heereman van Zuydtwijck, 764.
55. Staal 1996.
56. RAU, House Zuylen, inv. 784.
57. See Blankert et al. 1980, 108–9.
58. Groenveld and Leeuwenberg 1985, 236.
59. Van der Goes and De Meyere 1996.
60. RAU, House Zuylen, 959. So far as is known, the inventory does not mention any paintings by Utrecht artists other than those by Van Hoet. There was in the town house a "painted kitchen piece by Sachtleven."
61. Van der Goes and De Meyere 1996, 58–60.
62. RAU, House Zuylen, 784–5.
63. Van der Goes and De Meyere 1996.
64. See Ekkart, Kuus, and Schaffers-Bodenhausen 1996.
65. De Jonge 1938, 84–85.
66. Ibid., p. 109.
67. Stenvert 1994.
68. RAU, House Linschoten 587; Huys Janssen 1994b, 317.
69. Huys Janssen 1994a, no. 154.
70. Huys Janssen 1994b, 303.
71. Huys Janssen 1994a, 213–19.
72. Van Kretschmar 1978.
73. Knoester and Graafhuis 1970, 154–223.
74. Briels 1987.
75. Because the painting was heavily damaged, only a fragment has been preserved. The fate of the work by Droochsloot is unknown.
76. Janskerkhof nos. 15a and 16. See De Vries et al. 1983; Dolfin, Kylstra, and Penders 1989, B:43.
77. Van Thiel and De Bruyn-Kops 1984, nos. 48, 204. The portraits remained in the family until the death of the last scion of the Martens dynasty in 1972. In 1974 they were given to the Centraal Museum, Utrecht.
78. GAU, family Martens, 95 (d.d. 1-1-1669); published in Lowenthal 1986, Appendix B. One of the works is now in the International Palace of Justice in The Hague.
79. RAU, Court of Utrecht.
80. Ibid.
81. GAU, notaries GU022a037.

Artists at Work: Their Lives and Livelihood

MARTEN JAN BOK

Much of the information in this essay was taken from Samuel Muller's publication of the papers of the Utrecht Painters' Guild (Muller 1880) and from my doctoral dissertation published in 1994, of which an English translation is forthcoming. Reference is made to these two books only in those cases in which the reader might be confused as to the source.

I should like to thank Dr. Paul Huys Janssen, curator of paintings at the Noord-Brabants Museum in 's-Hertogenbosch, for our fruitful discussions of this subject, as well as Diane Webb for her translation of my text.

1. 't Hart 1993, 43–44.
2. For Duke Christian, see NNBW, 3: cols. 217–18; and Luijten et al. 1993, 592, cat. 264.
3. Dodt van Flensburg 1846, 98–102; Van Buchell 1940, 1–4.
4. "Den Constverdervenden roeckloosen Mars" (Van Mander 1604a, fol. 299v). For this concept, see Bok 1994, 121–24.
5. Van Buchell 1940, 1–2. For a discussion of this event, see Bok 1988.
6. Bok 1994, 191–92.
7. Dodt van Flensburg 1846, 100; Van Buchell 1940, 2.
8. Aitzema 1657–71, 1:12–16.
9. Van Buchell 1940, 1. In a previous publication I incorrectly stated the location of this inn to be the Zegelpoort (Bok 1988, 135). It was actually situated fifty yards to the west, currently part of no. 14 Ganzenmarkt (Kipp 1994).
10. The sculptors' great-grandfather Colijn de Nole had been Utrecht's most important sculptor in Jan van Scorel's time. Buchelius wrote "Blom," which should be interpreted as an abbreviation for Blommaert or Bloemaert (Van Buchell 1940, 1). It is hard to imagine that, in this context, he could have meant anyone other than the painter Abraham Bloemaert. For Gÿsbrecht van Vianen's collection of porcelain, see Ter Molen 1984, 11.
11. "Illi artem et ingenium Rubenii elevabant, plus illi profuisse fortunam quam industriam sustinebant. Eius plura in aes incisa prodibant a quondam Vorstermanno in aedibus eius operata, sed nimis illa care vendebantur et longe supra communem modum, minima nempe in dimidio folio flor" (quoted from Van Campen 1940, 2).
12. Dodt van Flensburg 1846, 100–111.
13. Bok 1988, 135.
14. Bok 1994, 132.
15. For an overview of Utrecht paintings in the second half of the sixteenth century, see De Meyere 1978.
16. "dem Welt-berühmten Utrecht" (Von Sandrart 1675–80, 2:303).
17. See the essay by Jan de Vries in this catalogue.
18. Described in Bok 1994, 97–130.
19. Montias 1982, 181.
20. No paintings can be attributed with any certainty to Joost de Beer.
21. For the history of the guild, see Muller 1880 and Bok 1994, 165–68.
22. As argued by Muller 1904, 2–3.
23. Bok 1994, 165.
24. Roethlisberger 1993, 562.
25. Muller 1880, 63–64.
26. Bok 1994, 171–72.
27. See Roethlisberger 1993, 572–75, 645–51.
28. Bok 1994, 178–89.

29. For the academy, see ibid., 178–89.

30. Learning how to model clay apparently made up part of an artist's training as well, as witnessed by the otherwise unknown Jacob Willemsz., who became a pupil of Paulus Moreelse in 1615, attended the drawing academy, and in 1616 learned to model clay for four months under the tutelage of the sculptor Willem Colijn de Nole (Muller 1880, 102). His training was sponsored by the Teutonic Knights (Utrecht, archief Duitse Orde, Balije van Utrecht, 332, rekeningen, Mar. 1616–Mar. 1617, fol. 14, 29 Oct. 1616; idem, fol. 14v, 8 Dec. 1616; idem, fol. 36, Jan. 1617 [published by De Geer van Oudegein 1895, 20 n. 3]).

31. Van de Passe 1643. The engraving of a drawing school (fig. 3) was published in the same book.

32. Van de Passe 1643, introduction to vol. 2, n.p.

33. Roethlisberger 1993, 389–420.

34. Ter Molen 1984, 55.

35. Dr. Ilja Veldman is currently writing a book about the firm of Van de Passe. Neither is there a study of the engravings commissioned for use as book illustrations by Utrecht printers.

36. Bok, in Roethlisberger 1993, 625, doc. 21 June 1612.

37. Ibid., and earlier literature.

38. Bok, in Roethlisberger 1993, 539.

39. For this phenomenon, see Floerke 1905, 138–47. Dorien Tamis at the University of Amsterdam is writing a dissertation on this subject.

40. Extensive art-historical writings exist on this subject, owing to the differences in quality detected by connoisseurs within the oeuvre attributed to one and the same master.

41. Described by Sutton 1993, 35–37.

42. Vente 1975, 63.

43. Berlin, Jagdschloß Grunewald; for this series, see Börsch-Supan 1964, 12–20.

44. Huys Janssen 1994a, 293.

45. Braun 1966, 358–61. For Jan van Bijlert's contribution, see Huys Janssen 1994a, 117–23, cats. 48–50. The names of the other participants are unknown.

46. "elli più pretiosi Pittori di questa nostra Città" (quoted from Braun 1966, 359).

47. "men Heer hout voor seeker het altemael xterordenaerisse fraeye sticke weesse sulle want elick die om strijt maekt en ick ben selver beij een igelijck as seij die geordeneert hebbe en ick gaeij daer dickwils beij en seg mijn oopini" (my Lordship may be certain that they will all be exceptionally beautiful paintings, because they [the artists] all compete with each other, and I have been personally present as each of them made designs, and I still go to them often to give my opinion; quoted from Braun 1966, 360). Here we are allowed a rare glance at the actual bringing together of Montias's "critical mass."

48. For this project, see Schepelern and Houkjaer 1988.

49. In 1637 Van de Passe received an initial commission to order eighty-four design drawings in the Netherlands to be used for the publication of an illustrated history of the Danish royal family. These were later used as preparatory drawings for the paintings.

50. Beutin 1950, 18–20. The Amsterdam painter Nicolaes Moyaert received 800 guilders for two paintings in this series (Bredius 1915–22, 1:264–65; Schepelern and Houkjaer 1988, cats. I and VII).

51. Floerke 1905, 145.

52. Willnau 1952.

53. De Jonge 1932, 123.

54. Little research has been done until now on the history of the art market in Utrecht.

55. For the fact that the art markets of various Dutch towns remained relatively isolated, see Montias 1988.

56. Kernkamp 1902, 226–30.

57. Bok 1988.

58. This had occurred already in 1597, when the Amsterdam painters Mathijs Adamsz. and Francois Badens delivered paintings to the Utrecht wheelmaker Hendrick Jansz., who had organized a lottery on behalf of the orphanage and the insane asylum (GAU, Stadsarchief II, 3253, register van schuldbekentenissen en borgtochten, 13 May 1598). The lottery did not take place after all (Briels 1976, 213).

59. For this and other lotteries, see Kosse 1992.

60. Bok 1984.

61. Bok 1994, 191–92.

62. Van Hoogstraten 1678, 234.

63. Von Sandrart 1675–80, 2:307.

64. Quoted from Roethlisberger 1993, 603 n. 24.

Reverberations: The Impact of the Italian Sojourn on Utrecht Artists

LYNN FEDERLE ORR

I wish to thank Alfred Moir for his careful reading of an early draft of this essay; his encouraging and insightful comments continue to be of great value, as do those of Marion Stewart and Chiyo Ishikawa.

1. Domenicus Lampsonius, *Pictorum aliquot celebrium Germaniae inferioris effigies* (Antwerp, 1572), as translated in Miedema 1995–96, 2:290.

2. Wilhelm and Johannes Blaeu, *Tooneel des Aerdriicx, ofte nienwe atlas, Dat is beschryving van alle Landen . . .*, 2 (Amsterdam, 1635), under "Italy," n.p., as translated in Schloss 1982, 162 n. 1.

3. The contribution of Utrecht masters to the spread of Caravaggism in the North has been extensively studied; see, e.g., Blankert and Slatkes 1986 and Klessmann 1988. As a source of illustrations of Caravaggesque paintings, Nicolson and Vertova 1989 is indispensable. Similarly, the role of the Utrecht landscape painters in the development of the Dutch Italianate landscape genre has been examined in several publications and exhibitions, including most recently Duparc and Graif 1990 and Levine and Mai 1991.

4. Bok 1994, 19 and graph 6.4, proposes that 25 percent of Utrecht masters went to Italy.

5. Prohibition of the celebration of the Mass was initiated in 1580; on the religious climate in Utrecht, see Kaplan in this catalogue.

6. The Delft priest Sasbout Vosmeer served as apostolic vicar from 1592 to 1614; Philip Rovenius's appointment ran from 1614 until 1651.

7. Adrian had important political contacts, having in 1516 secured the Spanish succession for Charles V, who had previously been his student. See Kuyper 1994, 1:122. In 1959 an exhibition celebrated the life and times of Adrian VI: Utrecht 1959.

8. On Scorel, see De Meyere 1981.

9. Pastor 1940, 25:456 n. 1.

10. Aernt van Buchel, the Utrecht lawyer, humanist, historian, and poet, had traveled to Paris and then on to Florence and Rome in 1587–88. His reflections on Italian culture appear in his *Iter Italicum*, published in Lanciani 1900–1902.

11. In the now famous passage from his autobiography, written between 1629 and 1631, Constantijn Huygens, who had himself served as a diplomat in Venice, recounts his criticism of the young Rembrandt and Jan Lievens for not traveling to Italy: "satisfied with themselves [they] had not considered Italy worthwhile, although they would need only a couple of months to visit it" (p. 974 of Huygens's MSS in the Koninklijke Academie voor Wetenschappen, Amsterdam; as translated in Duparc and Graif 1990, 21). The two artists reportedly said that there was so much Italian art to be seen in the Netherlands that the lengthy journey was not necessary. On specific paintings by Italian masters in the Netherlands in the seventeenth century, see Lugt 1936.

12. On Van Mander's use and rejection of the tenets of his Italian models, see Melion 1991, chaps. 6–8.

13. Van Mander 1604, fol. 236v, l. 30; see n. 1 above.

14. Van Mander 1604, *Grondt der edel vry schilderconst* (Bk. I: Foundations of the noble free art of painting), fols. 6–7, as translated in Duparc and Graif 1990, 20–21.

15. The 1656 inventory of Rembrandt's possessions gives a good idea of the availability of such material, including albums of prints by Raphael; Annibale, Agostino, and Ludovico Carracci; Guido Reni; and Antonio Tempesta. See Strauss and Van der Meulen 1979, 369–73.

16. For the few prints after Caravaggio, see Moir 1976. The chiaroscuro effect typical of Caravaggesque painting does not lend itself particularly to the print medium. Moir, 23–25, also suggests that many of the foreign Caravaggesque painters did not have access to print shops while in Rome. It should be further noted that they did not become printmakers once home in the Dutch Republic either.

17. For a translation of Van Mander's passage, see Hibbard 1983, 343–45. The Dutch artist Floris van Dyck was Van Mander's informant in Rome.

18. For a discussion of duchal ties between Lorraine and Florence and dating of Jacques Bellange's print after the *Annunciation*, see Cinotti 1983, 467.

19. As recorded in letters from the Flemish artist Frans Pourbus to the duke of Mantua, two late works by Caravaggio had been purchased in Naples in September 1607: the *Madonna of the Rosary* (1606–7) and a *Judith and Holofernes* (Hibbard 1983, 316 n. 118). Finson left both of these to his partner and friend, the Amsterdam painter-dealer Abraham Vinck, with whom Finson had traveled in Italy. A third painting by Caravaggio, *The Crucifixion of Saint Andrew* (perhaps the picture now in Cleveland; see Moir 1976, no. 73, 151 n. 252), also from the Finson estate, was evaluated in 1619 by a group of Dutch painters, including Pieter Lastman, who pro-

claimed it to be an exceptional work by the master's own hand (Bodart 1970b, 234–35; see also Back-Vega 1958, 65–66). Yet another image by Caravaggio, *The Fainting Magdalene*, was known in Holland through copies, including several by Finson and a version, signed and dated 1620, by Wybrandt de Geest. See Moir 1976, no. 69d, and Blankert and Slatkes 1986, no. 55.

20. On the relationship between Goudt and Elsheimer, see Andrews 1977, 38–40.

21. Bok 1994, 192–93, lists fifteen artists who are known to have died either in Italy or on the return; the most famous is Jan Both's brother, Andries, who drowned in Venice in 1643.

22. On the specifics of these itineraries, see Hoogewerff 1952, 54–56; Schloss 1982, 31–33; Slatkes 1992, 13–14.

23. Livorno also served as the staging point for Dutch trade with the Levant farther east in the Mediterranean and in the mid–seventeenth century as the base of operations against Barbary pirates, who threatened to ruin the Dutch Mediterranean trade. See Van Veen and McCormick 1984, 12.

24. So many Dutch traveled through Europe that several multilingual phrase books were published in the Republic during the period; Schenkeveld 1991, 138. On seventeenth-century travel books, see Wilton and Bignamini 1996, 95; Schloss 1982, 31–33.

25. For an overview of the cultural life of seventeenth-century Rome, see Maguson 1982.

26. The letter is translated in Enggass and Brown 1970, 16–20. Contemporary inventories attest to the popularity of the Dutch Italianate artists with Italian collectors; see Chong, in Sutton 1987, 114–15.

27. See Hoogewerff 1952, 85, and Hoogewerff 1953, 13–14; Bodart 1970a, 1:13 n. 2. Previously only sparsely inhabited, this area was developed during the reign of Sixtus V.

28. A number of foreign institutions were established in the vicinity, including SS. Trinità dei Monti, which was the church of the French king, the residence of the Spanish ambassador, and later in the century the French Academy in Rome.

29. The literature on Caravaggio is extensive; Hibbard 1983 and Cinotti 1983 provide good surveys with detailed illustrated catalogues.

30. See Benedetti 1993.

31. On those aspects of contemporary Northern painting that paved the way for the favorable reception of Caravaggesque painting, see Kloek, in Blankert and Slatkes 1986, 51–58, who restates the concerns of Nicolson 1952, 247, that every masked candle in seventeenth-century Dutch painting was not necessarily derived from Caravaggio.

32. See Hibbard 1983, 167–68, fig. 104.

33. Von Sandrart 1675–79, 170.

34. On Seghers, see Nicolson 1971.

35. Nicolson 1958b, 32. Perhaps Ter Brugghen met Rubens through Hendrick Goudt, who was in Rome by 1604. From 1607 Goudt and the German painter Adam Elsheimer lived in the same house. Elsheimer is known to have been part of the circle of the humanist Johannes Faber, which also included Rubens and the Dutch philosopher Lysipus.

36. See Bok's biography of Ter Brugghen in this catalogue, and Blankert and Slatkes 1986, 175 n. 25.

37. MacLaren and Brown 1991, 1: no. 3679, 2: pl. 168.

38. *Classical* is not a term usually applied to Honthorst. See discussion in cat. 9.

39. See Slatkes, in *Dictionary of Art* 1996, 3:7.

40. Giustiniani owned Baburen's *Christ Washing the Feet of the Apostles* (formerly Gemäldegalerie, Berlin), and Cardinal Borghese owned his *Arrest of Christ* (Galleria Borghese, Rome).

41. Slatkes 1965, 6–7, 31–39, 102–8, no. A3, fig. 1; Slatkes 1966; Hibbard 1983, 171–79, fig. 107.

42. The essential sources on the *Schildersbent* are Hoogewerff 1952 and Bodart 1970a. For additional bibliography, see *Dictionary of Art* 1996, 28:92–93.

43. The paintings of Saverij (cat. 67) exhibit this artificial segmentation of the landscape.

44. Chong, in Sutton 1987, 120 n. 44.

45. See Levine and Mai 1991, 268.

46. This is demonstrated by comparing seventeenth-century auction prices. See Duparc and Graif 1990, 43 n. 4. Houbraken, e.g., claims in his *Groote Schouburgh* that the century of Poelenburch respected only those artists who had seen Rome. Houbraken 1718–21, 1:128, as translated in Duparc and Graif 1990, 14. On patronage of Dutch Italianate artists, see Chong, in Sutton 1987, 114–15.

47. Roethlisberger 1993, no. 284, fig. 417.

48. On the migration of Caravaggesque elements from Rome to Leiden via Utrecht, see Judson, in Blankert and Slatkes 1986, 53–62.

49. For the influence of the Utrecht school on Vermeer, see cat. 38.

50. Carel de Hooch is not documented in Italy, but his style is closely aligned to that of both Poelenburch and Breenbergh. On De Hooch, see Daniëls 1982–83; Sutton 1987, 61 n. 173.

51. On De Heusch, see De Groot 1979, 188–91; *Dictionary of Art* 1996, 14:499.

52. On the Utrecht town hall, begun in 1546 at the instigation of Charles V, see Kuyper 1994, 114–23.

53. See Reznicek 1972, 173–75; De Meyere 1976.

54. See Bissell 1981, no. 29, figs. 51–60.

55. For the rich Italian tradition on which Honthorst drew, and subsequent Dutch interpretations of the genre, see Judson 1959, 106–12.

56. On Bramer's frescoes, which could hardly have fared well in the damp Dutch climate, see Ten Brink Goldsmith et al. 1994, 22.

57. See, e.g., the dramatic invention for the ceiling of a staircase illustrated in ibid., no. 19.

58. See, e.g., Döring 1993, nos. A36 and A37. These are very similar in composition and mood to part of the decorative cycle at Honselaarsdijk, recorded in drawings by Cornelis Holsteyn (Rijksprentenkabinet, Amsterdam). See Haak 1984, 42, fig. 33.

59. Bok 1994, 178–83, and Miedema 1987; see also Bok, in this catalogue.

60. For Mancini's notice, including an English translation, see Judson 1959, 133–34.

61. Bok 1994, 180–81.

Emerging from the Shadows: Genre Painting by the Utrecht Carravaggisti and Its Contemporary Reception

WAYNE FRANITS

This essay is affectionately dedicated to Egbert Haverkamp-Begemann in honor of his seventy-fifth birthday. An earlier version of it was presented as a lecture at the conference "Het beeld van de vrouw in de Nederlandse kunst van de zeventiende eeuw," which took place in Rotterdam in December 1995. My thanks are extended to many colleagues who commented on it at that conference; I also wish to thank Lynn Orr, Gary Radke, and Joaneath Spicer for helping me to rewrite the lecture as an essay for this exhibition catalogue.

1. For this painting, see Judson 1959, cat. 179; Braun 1966, cat. 27; and the literature cited in n. 2 below. The male figure has sometimes been identified as a soldier.

2. For example, Brussels 1971, 175–77 and cat. 55; De Jongh et al. 1976, cat. 28; Müller, Renger, and Klessmann 1978, cat. 15; Blankert and Slatkes 1986, cat. 62. As a number of these entries note, the iconographic roots of the motif of the glowing coal date back to descriptions by ancient authors of long-lost paintings.

3. Cats 1632, pt. 1, 136–37.

4. Such interpretations are usually proposed on the basis of print inscriptions; for a recent example, see Slatkes 1995. Slatkes's moralizing reading of Hendrick ter Brugghen's *Gamblers* (The Minneapolis Institute of Arts) is based in part on an engraving after a now-lost painting by Dirck van Baburen (his fig. 4), which carries, among others, the inscription *Irarvm cavsas fvgito*, "Flee from the causes of anger." There are certainly other examples of contemporary prints with moralizing inscriptions after paintings by the Utrecht Caravaggisti. Yet these prints were not necessarily made with the direct participation of the painters. Nor were they necessarily addressed to the same audiences as the much more expensive paintings. In the end, these prints can only suggest one possible manner in which contemporaries understood the paintings. Given the complexity and multivalency of audience reception in the seventeenth century, prints cannot furnish exclusive interpretations of particular paintings or themes. For this problem, see McGrath 1984; Renger 1984; and esp. Ackermann 1993, 23, 32, 163, 171–76. For an important counterargument, see De Jongh and Luijten 1997, 37–38.

5. Teellinck 1627, 198. See also the examples cited by Van Lieburg 1989, 19–67, passim; Sluijter 1991–92, 356–57; Sluijter 1992, 37–38. As Sluijter 1991–92, 387 n. 109, observes, complaints about lewd paintings were not restricted to Calvinist ministers; moralists and theologians of all faiths condemned them.

6. See the essay by Benjamin Kaplan in this catalogue.

7. See the many examples discussed by Van Lieburg 1989, 19–67, passim.

8. The recent study by Mandel 1996 challenges the current tendency to glean moralizing messages from seventeenth-century Dutch paintings in general. Firmly wedded of course to current interpretive perspectives is the principal

method utilized to analyze Dutch paintings, namely, iconology; see Franits 1994, 129–36.

9. For the conventional nature of Dutch painting in general, see Goedde 1989b, 16, 20, 163–64; Sluijter 1990.

10. For other representations of prostitution in seventeenth-century Dutch art in general, see Van de Pol 1988a.

11. See the essay by Ben Olde Meierink and Angelique Bakker in this catalogue.

12. For the history of prostitution in Utrecht, see Van der Wurf-Bodt 1988. For a more comprehensive study of prostitution in the seventeenth-century Netherlands (focusing on Amsterdam), see Van de Pol 1996.

13. For changes in the organization of brothels through the seventeenth and eighteenth centuries, see Van de Pol 1985.

14. For the near universal, contemporary view of innately aggressive female sexuality, see, among others, Van de Pol 1988a, 139; Van de Pol 1988b, 170–72; Dixon 1995, 159–67, passim.

15. For example, Sutton 1984, cat. 49; Blankert and Slatkes 1986, cat. 63.

16. For sixteenth-century representations of the parable, see Renger 1970. See also De Jongh and Luijten 1997, cat. 19.

17. See, for example, a painting by Jan van Bijlert, formerly with Sotheby's in London (sale, 9 Apr. 1986, lot 99), where the Prodigal Son is depicted in the background fleeing from broom-wielding prostitutes (identifiable with Huys Janssen 1994a, cat. 20). Van Bijlert's depiction of the Prodigal Son in this painting is unusual and is far outnumbered by brothel scenes lacking any references whatsoever to this infamous character from the Bible.

18. Friedlaender 1955, 84, first raised the question of the influence of picaresque novels on the subject matter of Caravaggist painting. I also benefited from a paper on the subject given by Ethan Matt Kavaler at the Institute of Fine Arts, New York University, in a colloquium on seventeenth-century Dutch painting held during the fall 1981 semester.

19. This novel was first published in Spain in 1554—its author is unknown; see Rico 1984, 1–29. See also n. 21 below. For the picaresque novel in the Netherlands, see Van Gorp 1978, 57–61, 175–77, passim.

20. See, for example, Alemán 1622, 157–58.

21. Actual illustrations by Dutch artists of specific passages from picaresque novels are rare; see Leonaert Bramer's drawings of episodes from the popular novel *Lazarillo de Tormes* in Ten Brink Goldsmith et al. 1994, cats. 6–11.

22. In light of the previous discussion, it is noteworthy that the rogues featured in picaresque novels are usually skilled musicians.

23. See De Jongh 1971, 178. See also Becker 1984, 22, fig. 10.

24. For example, Sluijter 1991–92; Sluijter 1992.

25. See n. 4 above.

26. See my comments above concerning scholarly attempts to link depictions of prostitution with the parable of the Prodigal Son.

27. See n. 5 above.

28. As Sluijter repeatedly demonstrates (Sluijter 1991–92, 352–59; Sluijter 1992, 38–39), seventeenth-century texts abound with references to how depictions of female nudes and their lovers invite identification of the beholder with the latter. See also Weber 1991, 204–25.

Collecting Utrecht School Paintings in the United States

GEORGE KEYES

1. The four Utrecht school paintings acquired by Henry Walters were part of the Massarenti collection, purchased *en bloc* in 1902. I am much obliged to Quint Gregory for providing me with this information.

2. Liedtke 1990, 14–59 and esp. 34.

3. Haverkamp-Begemann 1978, 11.

4. Richard Codman of Boston and Lincoln had a shipment of 80 paintings sent from Paris, including a *Nymphs Bathing* ascribed to Poelenburch; Liedtke 1990, 22.

5. No inventory of Gilmor's collection survives, and all the pictures in his collection remain untraceable; see Liedtke 1990, 24; and Rutledge 1949, 19–39. Also see Smith 1996, 24–26.

6. For Bryan as a collector, see Liedtke 1990, 28; and Schaeffer 1995.

7. For further discussion of Bryan's collection of Italian gold-ground painting, see Smith 1996, 26–28.

8. Sale, New-York Historical Society, Sotheby's (New York), 12 Jan. 1995, lot 33, illus.

9. Durr's collection suffered the same fate as Bryan's. His European pictures have all been dispersed, the last having been sold at auction in New York by Sotheby's on 12 Jan. 1995. See Schaeffer 1995.

10. Sale, New-York Historical Society, Sotheby's (New York), 12 Jan. 1995, lot 126, illus. This painting is now in a private collection in New York City. I am much obliged to the owner for kindly permitting me to reproduce this picture.

11. For further discussion of Scripps, see Peck 1991, 23–24, 31–32, 39–40.

12. Liedtke 1990, 43–44.

13. Reproduced in Duparc and Graif 1990, 192–93, cat. 62.

14. Haverkamp-Begemann 1978, 12.

15. Cadogan 1991, 13, 17–18. Austin elucidated his views on this subject in an article in *Art News*, 1939, in which he states that a smaller museum flanked by giants should pursue an independent acquisitions policy so as not to mimic in a minor key his neighbors with far greater financial resources.

16. Reproduced in Haverkamp-Begemann 1978, 201–2, cat. 169, pl. 69, 1937.483.

17. Haverkamp-Begemann 1978, 13.

18. *King David Playing the Harp, Surrounded by Angels*, acquired in 1942; Haverkamp-Begemann 1978, 195–96, pl. 54, with discussion of the several versions of this composition.

19. Stechow, in Slatkes and Stechow 1966, 7. In organizing this exhibition Stechow collaborated with Leonard Slatkes, who at the time was just completing his monograph on Dirck van Baburen. Stechow also received the support of Charles Parkhurst, then director of the Baltimore Museum of Art, but who had formerly been chair of the art department at Oberlin College.

20. Prior to his tenure in Minneapolis, Clark, working with John Maxon at the Rhode Island School of Design Museum of Art, secured important Dutch pictures for that institution. During the twelve years that I was in Minneapolis, the Minneapolis Institute of Arts acquired four more works by

Utrecht masters, including a pair of portraits by Paulus Moreelse, Jacob Duck's *Guardroom Scene,* and a *Fruit Still Life* by Abraham Mignon.

21. For example, David Carter was instrumental in securing major paintings by Jan van Bijlert, Jan Both, Abraham Bloemaert, Roelandt Saverij, and other Dutch masters for the Indianapolis Museum of Art. I am much obliged to him for discussing American museum collecting activity during the 1950s through the 1970s with me.

22. Stechow 1964.

23. Stechow 1966.

24. For example, the Museum of Fine Arts, Boston, acquired its Wtewael, *Diana and Actaeon,* in 1957, the same year that the St. Louis Art Museum purchased Wtewael's *Death of Procris.* The Rhode Island School of Design Museum of Art, through David Carter's efforts, acquired its painting by the same artist in 1962. This interest in Northern international mannerism was not restricted to paintings done in Utrecht. American museums also acquired an equally impressive number of paintings by Cornelis Cornelisz. van Haarlem and Hendrick Goltzius, plus a wide range of Northern mannerist drawings, engravings, and chiaroscuro woodcuts.

25. For example, Lowenthal 1986; Kettering 1983; Nichols 1991.

26. Stechow 1970.

27. Brown, Kelch, and Van Thiel 1991; Sonnenburg, Liedtke, et al. 1995; Slive and Hoetink 1981; Chapman, Kloek, and Wheelock 1996; Langemeyer et al. 1974; Wheelock 1995b.

28. Sutton 1984; Sutton 1987; Keyes 1990.

29. De Jongh et al. 1976; Müller, Renger, and Klessmann 1978.

30. Broos et al. 1990.

31. Including works by Abraham Bloemaert, Ambrosius Bosschaert the Elder, Jacob Duck, Gerard van Honthorst, Nicolaus Knüpfer, Cornelis van Poelenburch, Hendrick ter Brugghen, and Joachim Wtewael.

NOTES TO THE ENTRIES

Cat. 1

1. Stechow, in Stechow 1970, 19, no. 3 (followed by Lowenthal 1975, 133), saw "salvation through living water in a typological reference to Baptism," which is theologically incorrect. The typological link was made to Christ's side wound producing blood and water. Together with the creation of Eve from the rib, i.e., the side of Adam, the scene, therefore, accompanied the Crucifixion in the *Biblia pauperum.*

2. For the central female figure a number of Italian paintings have been named as points of reference, namely Bronzino and Vasari (Roethlisberger 1993, 92), although the similarities are limited, and the knowledge in the Netherlands of the particular works remains doubtful.

3. Bloemaert's own son Hendrick would later bring home drawings after antique architecture and Venetian paintings; Seelig 1997b.

4. Van Buchell 1928, 93–94. In a drawing, Goltzius also revived the *Aurora* from the Medici Chapel in a characteristically free way (Pierpont Morgan Library, New York; Reznicek 1961, no. K.442).

5. There are a number of Bloemaert drawings and a painting (Roethlisberger 1993, no. 38) with a very similar figure that also turns up in Cornelis's and Wtewael's work; see Luijten et al. 1993, 375–76.

6. Paris, Louvre, Cabinet des Estampes, 20.483.

7. This group seems to have been prepared in reverse in a drawing now in the Berlin Kupferstichkabinett, KdZ 13005.

8. See Seelig 1997a, 59–60.

9. An important drawing at Weimar (fig. 2) perhaps documents some preparatory stage of another Bloemaert painting of the subject known only from an eighteenth-century description (Roethlisberger 1993, 93). A number of details described there can be found in the Weimar drawing, though not in the New York painting. Since many further details do not occur, it cannot be a full rendering of the lost work.

10. Dated examples in Breslau (1592, lost since 1945), Vienna (1593), and private coll. (1593; Roethlisberger 1993, nos. 21, 34, and fig. B16).

11. Regarding this habit of pushing the main figures to the background, regardless of the subject, the claim of Ben Broos (Broos et al. 1990, 168) that the painting is an allegorical representation of water seems farfetched and cannot really be substantiated since it could be made for most other pictures of Moses Striking the Rock.

12. In the same year Aernt van Buchel already recorded another treatment of Moses Striking the Rock in *maxima forma,* since lost (Van Buchell 1907, 257).

Cat. 2

1. Murray and Murray 1996, 480–83. On Georges de La Tour's paintings of Saint Sebastian and for more about the saint, see Conisbee 1996, esp. 85–88, 129–31, 210–11, 294–99, and cats. 16, 39, 40, 78. Jacobs 1993 is a rich source of information and imagery concerning Saint Sebastian from early times to the present.

2. Kloek (Luijten et al. 1993, 557) sees an olive branch and suggests an allusion to Irene's anointing of Sebastian and to the civic guard's task of maintaining law and order, which follows from his thoughts about the painting's function, to be discussed.

3. Compare the two decorously draped and posed putti in Wtewael's *Judgment of Paris,* cat. 50.

4. Lowenthal 1986, 91–92, A-13. I regard the Los Angeles painting as a replica of the *Lot and His Daughters* in the State Hermitage Museum, St. Petersburg. For the latter, see Luijten et al. 1993, 557–58, cat. 229, with a suggested date of about 1610. If this is the painting mentioned by Van Mander (d. 1606) in his biography of Wtewael, a date before 1604 is necessary. On the interpretation of Wtewael's depictions of Lot and his daughters, see Lowenthal 1988.

5. Signed *IOACHIM WTEN WAEL FECIT* at lower center. Sold at Christie's (New York), 12 Jan. 1994, lot 102. This unpublished picture is, I believe, the best of the four known versions of the composition. See Lowenthal 1986, 167, C-30 and C-31 for copies. There is a third copy in a private collection, Paris.

6. Wtewael painted at least three sets of the four Evangelists. See Lowenthal 1986, 127–29, A-54, A-55, and A-56; and 136–38, A-65 through A-71.

7. According to Van Eck 1993–94, 229, two altarpieces datable about 1615 are among the earliest examples of paintings from a Dutch clandestine church. Whether such commissions came as early as 1600 is to be considered.

8. Van Eck 1993–94, with further sources. On Utrecht, see 225–28. See also Manuth 1993–94, 238.

9. Correggio's *Martyrdom of Four Saints* (1524–26; Galleria Nazionale, Parma) and Titian's *Saint Sebastian* (1570s; The State Hermitage Museum, St. Petersburg, 191) exemplify those prototypes. For specific traces of Wtewael's Italian sojourn in his work, see Lowenthal 1986, 39–42 and individual catalogue entries.

10. Freedberg 1989, 322–23 and chap. 13, "The Senses and Censorship," esp. 346–48 and 368–71.

11. Canvas, 136 × 97.5 cm. Although the picture is signed and dated 1619, Roethlisberger challenges the validity of the date and suggests the mid-1590s instead. Roethlisberger 1993, 1:91–92, cat. 45, 2: fig. 80.

12. That suggestion was first made by Orr in Broos et al. 1990, 491, then by Kloek in Luijten et al. 1993, 557.

13. Jan van Ravesteyn's group portrait *The Burgomasters and Aldermen Receiving the Officers of the Civic Guard* (1618; Haags Historisch Museum, The Hague) depicts the civic guard hall in the Saint Sebastian's Guild Hall in The Hague; it includes the bottom of an overmantel painting of a Saint Sebastian. Luijten et al. 1993, 597–98, cat. 270, color illus. 250–51. Kloek, in ibid., 557 n. 4, suggests relevance to Wtewael's *Saint Sebastian*.

14. Carasso-Kok and Levy-van Helm 1988, 69, fig. 45.

15. Still another possibility is that the *Saint Sebastian* had a private, not a public, function, perhaps as a sophisticated comment on the veneration of saints. Anticlerical invectives by Aernt van Buchel provide context for that interpretation. See Lowenthal 1986, 93–94.

16. Bok 1993, 142, fig. 6.

17. Small-scale depictions include a figure study of 1593 by Abraham Bloemaert that may be an unconventional image of the saint; Roethlisberger 1993, 1:86–87, cat. 38; 2: fig. 73, color pl. 3. For a drawing by Jacques de Gheyn of a Saint Sebastian after Ludovico Carracci, datable about 1603, see Van Regteren Altena 1983, 2:34, no. 103, 3: pl. 266. See also a *Martyrdom of Saint Sebastian* by Jacopo Palma, engraved by Aegidius Sadalaer (Holl. 96); and a *Saint Sebastian* engraved by Jan Muller after Hans van Aachen's altarpiece in the church of St. Michael, Munich (Holl. 41). Van Aachen places even greater emphasis on the archers' attack than Wtewael does.

Cat. 3

1. An anonymous Utrecht artist varyingly identified as Jan van Bijlert, Hendrick Bloemaert, or one R. van Adelo (Nicolson and Vertova 1989, no. 1122; Huys Janssen 1994a, no. R-6), and, more closely modeled on Bloemaert's example, a painting that was sold under his name by H. Jüngeling (Amsterdam), 16–17 May 1944, lot 4 (not in Roethlisberger 1993).

2. Roethlisberger 1993, no. 222.

3. Munich, Staatliche Graphische Sammlung, 1074; other drawings for the *Evangelists* must obviously have existed; the *Tekenboek*, pl. 58, reproduces some more of the hands.

4. Roethlisberger 1993, nos. 267, 292.

5. Seelig 1997a, 278.

6. Seelig 1997a, 61–63 and 94–96.

7. *Adoration* of 1612, *Intercession Altarpiece*, *Vision of Saint Ignatius*, *Adoration of the Magi*, two of three pictures in the *Theagines* cycle.

8. See Seelig 1997a, 216–22.

9. The drawing in the Witt Collection, Courtauld Institute Galleries, London; the print by Giovanni Girolamo Frezza, 1692.

10. Roethlisberger 1993, no. 489. Comparing the two works is perhaps more than superficial. It should be noted that since the fifteenth century the four Church Fathers were sometimes combined with the symbols of the Evangelists. Saint Jerome would be accompanied by the angel of Matthew (not by the lion of Mark, as might have been expected), etc.; see, for instance, the painting by Pietro Francesco Sacchi of 1516 in the Louvre, Paris.

11. For Blocklandt, see Filedt Kok, Halsema-Kubes, and Kloek 1986, no. 317; of Wtewael two such series are known: Lowenthal 1986, nos. A-54 through 56 (1610–15) and A-65 through 68 (1616).

12. Nicolson 1958b, nos. A21–24; Huys Janssen 1994a, nos. 25–28.

13. Illustrated by Beatrijs Brenninkmeijer-de Rooij in Broos 1986, 57.

14. In 1766 (sale, N. van Bremen [Amsterdam], 15 Dec., lots 3–6) four single paintings were sold as Bloemaert, the description of which corresponds closely to the figures of the Princeton canvas. They included "Matthew seen from the back, the angel in front of him": Roethlisberger 1993, no. 759(2).

15. See Seelig 1997a, 261–74.

Cat. 4

1. Kassel, Staatliche Kunstsammlungen, Gemäldegalerie Alte Meister, G.K. 179, G.K. 180.

2. The episode is also related in Luke 5:27–28: "And after these things he went forth, and saw a publican, named Levi, sitting at the receipt of custom: and he said unto him, Follow me. And he left all, rose up, and followed him." Levi is the Jewish form of Matthew.

3. See Van Eck 1993–94, 217–34.

4. Further examination is needed to determine whether the canvas has been cut down on the left. X-rays reveal thread cupping on three sides, but not on the left. If the canvas has indeed been trimmed, it is possible that it was done by Ter Brugghen himself. This would mean that he originally placed Christ's pointing hand in the center of the composition, and that the figure was not as cropped as it is now.

5. Albrecht Dürer, *The Twelve-Year-Old Jesus in the Temple*, 1506. Thyssen-Bornemisza collection, Lugarno, 134. See also Kauffmann 1954, 57 n. 57.

6. Nicolson 1958b, 99–101, cat. A69.

Cat. 5

1. See Von der Osten 1965, 371–88.

2. Friedlaender 1955, 161–62, cat. 17. The picture is now in Potsdam, Sanssouci. The Northern aspects of Caravaggio's

iconography were already noted by Friedlaender, who suggested Dürer's woodcut of the same theme (B. 49) from the Small Passion as a possible source of inspiration.

3. See, for example, *A Notary*, Munich, Alte Pinakothek, 718, signed and dated 1542. The related figure on the right of this panel is close enough to have been Ter Brugghen's model for the bespectacled old man.

4. On Ter Brugghen's use and reuse of drawings, especially heads, see Slatkes 1987, 324–30.

5. Pentimenti reveal that the hands and perhaps the face of this figure have been painted over Christ's drapery. It is also worth noting that in a more general way, the physiognomic types of both Christ and Saint Thomas hark back to Ter Brugghen's 1616 *Supper at Emmaus*, in Toledo, Ohio; see Blankert and Slatkes 1986, cat. 1, color illus.

6. Nicolson 1958b, 45, under cat. A2, dated the picture 1623–25.

7. Van Thiel 1971, 110.

8. Nicolson 1956, 103–10, had suggested a date of ca. 1623 or earlier.

9. Bodart 1970a, 91 n. 4; the picture was sold L'Antonina (Rome), 21 Feb.–12 Mar. 1966, 40, lot 468, pl. 2. Nicolson 1979, 18, listed this work, correctly, as an uncertain attribution to Baburen.

10. Causa 1970, 87–88, cat. 3, color pl. XIV, as by Baburen. Although this interesting work is related to Baburen's style, I would assign it to the hand of the Flemish Caravaggesque painter Theodoor Rombouts. Significantly, David de Haen, who assisted Baburen in S. Pietro in Montorio and later lived in the Palazzo Giustiniani, also painted an *Incredulity of Saint Thomas*. This lost picture is listed in the 1630 inventory of the collection of Gaspar Roomer in Naples; see Moir 1967, 1:156 n. 10, 2:120; and Ceci 1920.

Cat. 6

1. Interestingly, it was Morell who misattributed Ter Brugghen's *Liberation of Saint Peter* (cat. 11) to Guido Reni.

2. Significantly, only Matthew gives the color of the robe as scarlet.

3. See Holl. 10, 99–101, illus., and for B. 69, 103, illus.

4. Nicolson 1958b, 58, suggested that these figures were related to Albrecht Dürer's disputants in the background of the engraving *Christ Crowned with Thorns* (B. 9), from the Small Passion; see n. 11, below. For the Dürer, see Holl. German, 7, 11, illus.

5. Already noted by Nicolson 1958b, 58.

6. See, for example, Friedländer 1975, 13: pl. 101, fig. 197, the painting by Martin van Heemskerck in the Frans Halsmuseum, Haarlem, 153.

7. De Voragine 1969, 210–16, in a chapter entitled "The Passion of Our Lord."

8. It may be that Ter Brugghen chose this Bonasone frieze because it was intended to be iconographically relevant. Indeed, the relief recalls late antique and early Christian Vintage scenes. Ludolph of Saxony, *Vita Christi* (pars 2, cap. 62) had already connected the well-known passage from Isaiah (63:3), "I have trodden the winepress alone," with the "torments of the passion, in which I was squeezed as if in a press." Marrow 1979, 83, has specifically related this image

of "Christ pressed" to the events of the Mocking of Christ and the Crowning with Thorns.

9. Van Kooij 1987, 7–9.

10. Italian sources such as the Pseudo-Bonaventura's meditations make it clear that Pilate was indeed present; see *Bonaventure* 1961, 329:76, "Meditation on the Passion of Christ at the First Hour."

11. Strauss 1980, cat. 119 (B. 34), the ca. 1509 woodcut, *Christ Crowned with Thorns*, from the Small Passion. Strauss identifies the two figures on the left as Caiaphas and Pilate.

12. For example, the Oberlin *Saint Sebastian Attended by Irene*, see cat. 10, and the Warsaw *King David Playing the Harp, Surrounded by Angels*; see Nicolson 1958b, cat. A77, pl. 96b.

13. For example, Abraham Bloemaert's 1624 *Adoration of the Magi*, in the Centraal Museum, Utrecht; see Blankert et al. 1980, cat. 6.

14. On loan to the Rijksmuseum Het Catharijneconvent, Utrecht, from the Oud-Katholieke Kerk; see Amsterdam 1951, cat. 149.

15. Rose 1961, 420.

16. See Prohaska 1980.

17. Bodart 1970a, 12–13, 132–36.

Cat. 7

1. Nicolson 1990, 1:43.

2. Once back in Utrecht, Baburen found a very different range of patronage available to him. With the suppression of Catholicism in the Dutch Republic, few large-scale religious pictures were ordered. Nonetheless, there was still some demand, and perhaps the present picture was painted for a "hidden" church.

3. Slatkes 1965, no. A17, A18.

4. Caravaggio fled Rome in 1606, so his painting must have been completed by that time; see Salerno 1960, 102:685, pt. 3, 135, no. 3. For Annibale Carracci's related engraving, signed and dated 1606, see Friedlaender 1955, 77, fig. 50.

5. Salerno 1960, 102:684, pt. 2, 95, no. 45.

6. Moir 1976, 146 n. 245; Hibbard 1983, 72, fig. 41, 291 n. 41. The attribution of this painting has been debated, but scholars generally agree that it records a lost composition by Caravaggio, most probably the Giustiniani picture; see Gregori, in Salerno et al. 1985, no. 90, illus., and Christiansen 1986, 445, figs. 42–45. Another version of the subject by Caravaggio exists in a vertical format; see Hibbard 1983, 291–92, n. 41, illus.; see also Salerno et al. 1985, no. 81, illus.

7. Brejon 1979, 306–9; Nicolson and Vertova 1989, 1:143.

8. Bartolomeo Manfredi (?), *Crowning of Thorns*, Bayerische Staatsgemäldesammlungen, Alte Pinakothek, Munich. As Manfredi, see Nicolson and Vertova 1989, 1:143; as De Haen, see Slatkes 1965, fig. 53. Slatkes no longer believes this painting to be by De Haen, but a connection with his works would not be unexpected. In Rome in 1619–20, the two Northerners lived in the same house in the parish of S. Andrea delle Fraté and collaborated on the decoration of the Pietà Chapel in S. Pietro in Montorio. De Haen painted a *Mocking of Christ*, still in situ; Baburen contributed the *Entombment* (see Orr, fig. 9, in this catalogue), the *Christ on the Mount of Olives*, and the *Way to Calvary*. See Slatkes 1966.

9. Nicolson and Vertova 1989, 1:143, as formerly in the F. Pearsons collection, New York.

10. This sequence for the two paintings follows Slatkes (1965, 64–67), who used the criteria Walter Friedlaender employed (1955, 32) to work out a similar problem of multiple versions in Caravaggio's oeuvre.

11. See Brejon 1979, fig. 47; Nicolson and Vertova 1989, 1:143.

12. This is the same effect as obtained in the Vienna composition and in yet another version by Manfredi proposed by Slatkes in Blankert and Slatkes 1986, 184, fig. 105.

13. On the Passion of Christ, see Réau 1959, 2, pt. 2, 427–528.

14. Matt. 26:63–64.

15. Matt. 27:27–31.

16. Baburen had worked for the Franciscan order in the Pietà Chapel of S. Pietro in Montorio, his paintings depicting scenes from the Passion of Christ (see n. 8 above). Interestingly, almost all of Baburen's religious paintings treat this subject matter.

17. On Bonaventure's *Meditations on the Life of Christ*, now given to the Pseudo-Bonaventure, see Bonaventure 1961.

18. To evoke in the reader or listener an emotional state conducive to personal devotions, Bonaventure uses vivid language and repetition in his *Meditations*:

> What should we think that our Lord . . . from the hour of His capture at night until the sixth hour of His Crucifixion, was in a continuous battle, in great pain, injury, scorn, and torment, that He was not given a little rest! One of them seizes Him . . . another binds Him, another attacks Him, another scolds Him, another pushes Him, another blasphemes Him, another spits on Him, another beats Him . . . another mocks Him, another blindfolds Him, another strikes His face, another goads Him, another leads Him to the column, another strips Him, another beats Him while He is being led, another screams, another begins furiously to torment Him, another binds Him to a column, another assaults Him, another scourges Him, another robes Him in purple to abuse Him, another places the crown of thorns, another gives Him the reed to hold, another madly takes it away to strike His thorn-covered head, another kneels mockingly, another salutes Him as king. (Bonaventure 1961, 318)

19. On the stylistic, chronological, and interpretative relationship between the Ter Brugghen and Baburen pictures, see Blankert and Slatkes 1986, 182.

Cat. 8

1. Since at least March 1983, it has no longer been possible to read the *2*, the third digit of the date, recorded by Nicolson and observed by this writer on many occasions.

2. Van Thiel 1971, 109, has also found the references to Grünewald a bit too specific.

3. See, e.g., some of the rather crude false epitaph paintings recently published by Bok 1996, 108, fig. 1, and 113, fig. 8.

4. Strauss 1980, vol. 3, pt. 1, and 1982, vol. 3, pt. 2, no. 18.

5. See the discussion in Reznicek 1961, 9, and Ackley 1981, cat. 7: Goltzius's *Pietà* of 1596, another example of the same tendency in the graphic arts.

6. I would like to thank Walter Liedtke of the Metropolitan Museum of Art for arranging the opportunity for me to study the Oberlin *Saint Sebastian* and the New York *Crucifixion* side by side when the *Saint Sebastian* was being cleaned in the conservation department of the museum.

7. See Haslinghuis and Peeters 1965, 347–48.

8. Châtelet 1981, 189–90, cat. 3; see, esp., the detail of Christ, 15.

9. Boon 1960, fig. 12, formerly in the Robert Lebel coll., Paris.

10. Ibid., 12, fig. 5.

11. Rijksmuseum, Amsterdam, A-1491.

12. See Schillemans 1993, 137–51, and Bok 1996, 108–11.

13. The most likely date is 1630 since in that year Van Buchel and two other witnesses endorsed a declaration that they had seen what they called "an old epitaph" in Ploos's home; see Bok 1996, 110. Given the date and their description, it is tempting to believe that what they actually saw was the picture now in the Centraal Museum. Possibly they were fooled into thinking it was really old, or more likely, they were willing to stretch the truth a bit for the powerful and well-connected Ploos.

14. I cannot follow the argument in Schillemans 1993, 148, that the Centraal Museum picture precedes the present painting and is an accurate copy of the Loosdrecht epitaph described by Van Buchell. Is it likely that Ter Brugghen's picture is a direct copy of the same Loosdrecht painting, especially given the relationship between two of the heads with Ter Brugghen's earlier *Doubting Thomas* (cat. 5)? More likely, the Centraal Museum work is part of the "documentation" that Ploos commissioned to support his 1634 petition and thus is similar to the other false epitaphs used to support claims of nobility published by Bok 1996.

15. Schillemans 1993, 146–47.

16. Bok 1996, 110.

17. Schillemans 1993, 145, fig. 7, and Bok 1996, 110, fig. 5.

Cat. 9

1. J. Richard Judson very kindly shared with me the manuscript for his forthcoming revised monograph on Honthorst; no. 85, pl. 42.

2. See De Voragine 1993, 1:97–101; Réau 1959, 3, pt. 3 1190–99; Jameson 1890, 2:412–24. For depictions of Saint Sebastian in art up to modern times, see Jacobs 1993.

3. For Sebastian as "plague saint," see Réau 1959, 3, pt. 3, 1192, and Jameson 1890, 2, 414–15.

4. Rome's seven major pilgrimage churches were dedicated to Saints Peter, John, Agnes, Sebastian, Lawrence, and Paul, and the Virgin Mary.

5. In 1613 Vasanzio succeeded Ponzio to the post of architect for the papal palaces, responsible for the vast projects undertaken by both the Borghese pope and his ambitious nephew, including the Palazzo Quirinale, Palazzo Borghese, Villa Borghese, and the Vatican Palace. During Vasanzio's tenure as court architect (1613–21), Honthorst received several commissions from Cardinal Scipione Borghese, but it is not known if Vasanzio was instrumental in bringing Honthorst to the attention of the pope and his nephew. See Judson 1959, 30.

6. On the early history of S. Andrea delle Valle, see Hibbard 1961, 289–318.

7. To mark the occasion of the building of this chapel, Cardinal Maffeo Barberini, later Pope Urban VIII, commissioned from

Ludovico Carracci a painting of Saint Sebastian Thrown into the Cloaca Maxima, a rarely depicted event. The painting (ca. 1612, J. Paul Getty Museum, Los Angeles) was not installed in the church, but entered Barberini's personal collection. See Briganti et al. 1986, no. 114, illus.

8. According to tradition, the church of S. Sebastiano on the Palatine Hill stands on the site of Sebastian's martyrdom. This project began in 1623 under the patronage of Taddeo Barberini, a brother of Pope Urban VIII, Maffeo Barberini.

9. See Blankert and Slatkes 1986, 284, n. 6, for a summary of opinions; see also cat. 10 n. 13, in this catalogue.

10. Regarding the increase in depictions of Saint Sebastian during these plague years, see cat. 10. For the plague in Utrecht, see Rommes 1991, 118–19.

11. See cats. 2 and 10 for seventeenth-century variations with Saint Sebastian accompanied by archers or tended by Irene. Slatkes (cat. 10 n. 13) also suggests that Honthorst drew upon symbolic and compositional associations with the theme of the Man of Sorrows, especially from depictions of the slumped body of Christ, usually supported by angels.

12. *Disegno* simply means drawing or design. The concept of *disegno* was also at the heart of a theoretical debate that weighed the relative value of *disegno* and *colore* and, by extension, the relative value of central Italian painting, with its insistence on contour lines and preparatory studies, and Venetian art, which relied on expressive brushwork and color applied directly to the canvas without the aid of drawings. For the evolution of the debate, which continued over four centuries, see *Dictionary of Art* 1996, 9:6–9.

13. Reznicek 1972, 169–71, fig. 2.

14. Pepper 1984, no. 48, pl. 75; Mahon et al. 1988, no. 18, illus.

15. Bissell 1981, no. 18, fig. 35; Salerno et al. 1985, no. 42.

16. Cavina 1968, no. 51, fig. 51. Saraceni's *Saint Sebastian* is thought to reflect the swooning figure in Caravaggio's lost *Magdalene*; see Moir 1976, 148 n. 247. Although Bellori 1675, 216, notes a painting of Saint Sebastian with two soldiers by Caravaggio, no picture recognizably reflecting this composition has emerged. Bellori reports that the painting had already made its way to Paris. On Caravaggio's lost *Saint Sebastian*, see Gilbert 1995, 269–70 n. 60.

17. For a discussion of Caravaggio's several representations of young men seated in the landscape, variously called Saint John the Baptist, *Pastor fido*, and Phrixus, see Hibbard 1983, 151–55, 191–92, 305–7, 319–20; and Gilbert 1995, 1–78. For the Corsini *Saint John the Baptist*, see Cinotti 1983, no. 56.

18. Judson 1988, 113, suggested that Honthorst looked closely at the *Belvedere Torso*, a famous antique sculpture of the first century B.C., then standing in the Vatican's Belvedere statue court. See Haskell and Penny 1981, no. 80, fig. 165.

19. Radcliffe, Baker, and Maek-Gerard 1992, no. 18, illus.

20. In Blankert and Slatkes 1986, no. 61, 284 n. 3.

21. Lavin 1968, 230; Radcliffe, Baker, and Maek-Gerard 1992, 136–37. Scholars now hypothesize that the unusual pose of Bernini's seated *Saint Sebastian* was dictated by his use of a partially worked block belonging to his father. Pietro Bernini was at that time working on his own sculpture of *Saint John the Baptist*, one of six seated figures designed for the new Barberini chapel in S. Andrea delle Valle.

22. In this group Lavin 1968, 230 n. 77, also included a *Saint Sebastian* (Museo di Capodimonte, Naples), given to Bartolo-

meo Schedoni. Slatkes 1973, 271, 273 n. 38, followed suit; see illus. in Moir 1976, 2: fig. 312. See also a *Saint Sebastian* (Museum of Fine Arts, Moscow, formerly in the Hermitage, St. Petersburg) by an unknown Italian artist reproduced in Stechow 1954, fig. 6.

23. It is, however, doubtful that Sebastian could stand with his arms bound the way they are.

Cat. 10

1. When I examined the picture, under laboratory conditions while it was being cleaned in the conservation department of the Metropolitan Museum of Art, New York, it was no longer possible to read the last two digits of the date.

2. Bredius 1915–22, 6:1985.

3. Gerson 1959, 315, correctly rejected the version of the story of the failure of the Centraal Museum, Utrecht, to acquire the painting, offered by the then director; Houtzager 1955, 143–50, as "unwahrscheinlich" (unlikely). Nevertheless, this "official" version of the story is repeated by Bok 1986b without reference to Gerson. This writer, having read the correspondence file on this matter in the Centraal Museum, Utrecht, and corresponded with the dealer who discovered the painting, is able to attest to the fact that Houtzager's version of what occurred is both self-serving and false.

4. Baronius 1586, 279.

5. See Carr 1964 and Slatkes 1973, 268–73.

6. Künstle 1926, 527.

7. Hoogewerff 1965, 5. Carr's 1964, 70, statement that the Ter Brugghen was commissioned by a Dutch shooting company in 1623 is unsupported by any documentation.

8. This would also be true for Honthorst's single-figure painting of Saint Sebastian (cat. 9) in London.

9. Slatkes 1973, 268–73. There is also a painting of this theme signed and dated 1624 by Jan van Bijlert; see Blankert and Slatkes 1986, cat. 39. The painting is in the Harrach collection, Rohrau.

10. R. Baistrocchi and A. Sanseverino, *Memorie artistiche . . .*, MS, ca. 1780, Galleria Nazionale, Parma, no. 129 B.

11. The picture, in the collection of Bob Jones University, Greenville, South Carolina, is assigned to Baburen's own hand by the museum; it is not, however, autograph. See Blankert and Slatkes 1986, cat. 20; Slatkes 1973, 272 n. 16; Slatkes 1965, 158, cat. E18; and Nicolson 1979, 19, pl. 126, as by an "imitator of Baburen."

12. Pariset 1948, 210. See also Sandoz 1955, 69.

13. Nicolson 1958b, 87, suggests that the slumped pose of Sebastian owes something to the figure of Job from the wing of Dürer's Jabach altar, yet the association is not completely convincing. For the Dürer, see Panofsky 1955, fig. 112. Panofsky, however, notes on 93 that the pose of Dürer's Job is reminiscent of Northern Man of Sorrows types. Given the association between Christ and Saint Sebastian, it is more likely that one of the general sources for Ter Brugghen's pose was some Netherlandish Man of Sorrows. Indeed, the slumped position of Honthorst's *Saint Sebastian* (cat. 9) may have been influenced by the same general type.

14. It is probable that Baburen, who was not yet thirty, fell victim to this outbreak of the plague early in 1624.

15. De Vries 1974, 110–11. For example, the Crude Death Rate, based on burials in Amsterdam, rose from 56 per 1,000 in 1623 to 112 in 1624. The burial rate was 5,929 in 1623 and 11,795 in 1624. In Rotterdam the Crude Death Rate of 120 to 135 occurred repeatedly during the decade 1625–35. The same epidemic seems to have also struck repeatedly in the north of France between 1624 and 1640, explaining the popularity of depictions of Saints Sebastian and Irene there; see Paris 1983, 170, 144–49.

16. It is also possible that Honthorst's *Saint Sebastian* (cat. 9) was commissioned in response to the same outbreak of the plague. Unfortunately, there is no consensus on the date of the picture. Although Judson 1959, cat. 68, puts it about 1623, and Nicolson 1958b, under cat. A54, as "almost contemporary with the Oberlin picture," others have dated it 1620 and earlier, and thus during the artist's Roman period.

17. Lowenthal 1986, 94, suggests that some of the Utrecht depictions of Saint Sebastian "might have been commissioned for the Heilig Kruisgasthuis, a hospital built in the Kruisstraat in 1408 . . . consisting of the St. Sebastiaans-, the St. Adriaans- and the St. Juliaanshospital." Unfortunately, at the present time there is no documentation either to confirm or to deny this attractive hypothesis.

Cat. 11

1. When Nicolson 1958b, 59, cat. A19, catalogued the picture, which he had never seen, no inscription had been recorded.

2. Blankert and Slatkes 1986, under cat. 32, the Diest *Annunciation*.

3. Nicolson 1958b, cat. A48, fig. 41c. Although in very poor condition, there is no reason to reject the Tokyo picture, although it is perhaps a second version of a lost prime composition.

4. Blankert and Slatkes 1986, cat. 31, color illus.

5. Nicolson 1958b, cat. A77, fig. 96b.

6. For example, the *Singing Lute Player* (cat. 42), National Gallery, London, signed and dated 1624, and the two *Bagpipe Players* in Oxford and Cologne, also both dated 1624; see Blankert and Slatkes 1986, cat. 15.

7. Hibbard 1983, 65–68. The painting is now in the Palazzo Barberini, Rome.

8. Slatkes 1965, cat. A23.

9. See Slatkes 1995, 6–11, color illus.

10. Nicolson 1958a, cat. A50, figs. 89, 100d.

11. Hibbard 1983, 164–66.

Cat. 12

1. J. Richard Judson very kindly shared with me the manuscript of his forthcoming revised monograph on Honthorst; no. 56, pl. 21, 21a–c.

2. MacLaren and Brown 1991, no. 3679, pl. 168.

3. On Honthorst's commissions for Carmelite institutions, see Lorizzo 1995.

4. Restricted from practicing their faith openly, Dutch Catholics were restrained in the amount of art they could commission for their "hidden" or house churches. One wonders how Honthorst's art would have developed had he remained in Italy, where there was a continual demand for large-scale religious works, instead of returning to the Northern

Netherlands, where he turned increasingly toward decorative secular subjects and flattering portraiture of Europe's nobility.

5. Matt. 26:69–75; Mark 14:66–72; Luke 22:54–62.

6. Mark 14:30.

7. At this point Matthew (26:73) says that the bystanders said to Peter, "Certainly you are also one of them, for your accent betrays you."

8. Luke 22:54–62.

9. Nicolson and Vertova 1989, 1:124, 3: fig. 1236.

10. Nicolson and Vertova 1989, 1:124, 3: figs. 1290–91.

11. Valentin de Boulogne arrived in Rome about 1614 and was patronized by the same group of elite Roman collectors that favored other Caravaggesque artists, including Honthorst. For Valentin's treatment of the theme, see Nicolson and Vertova 1989, 1:203.

12. Nicolas Tournier was in Rome from about 1619 until 1626. Several of Manfredi's lost compositions are known through copies by Tournier, as is one of Valentin's paintings of the *Denial of Saint Peter*; Tournier's copy is now in the Musée des Augustins, Toulouse; see Nicolson and Vertova 1989, 1:198.

13. Nicolson and Vertova 1989, 1:144, 2: fig. 309.

14. Salerno et al. 1985, no. 100, illus.

Cat. 13

1. Matt. 26:69–75; Mark 14:66–72; Luke 22:54–62; and John 18:16–18, 25–27.

2. Lowenthal 1986, 153–54, A-91, pl. 127.

3. Bieneck 1992, A11 through A13.

4. Lowenthal 1974, 461, 465.

5. Zeder 1995, 30.

6. Oil on panel, 36 × 56.5 cm, signed and dated 1623, 992.8. See Zeder 1995, color illus.

7. Lowenthal 1986, 179–81, D-15, D-17 through D-20. The *Entombment of Christ*, oil on panel, 58.4 × 83.8 cm, was sold at Christie's (Scotland), 23 May 1996.

8. On the situation in Utrecht, see Van Eck 1993–94, 225–26.

Cat. 14

1. "Magnus in obscuro latet hic HIERONYMVS antro, / lucubrat inquirens dogmata sacra Dei."

2. Roethlisberger 1993, print nos. 28, 29, 41, 42, 43; painting nos. 37, 45.

3. See *Venus and Cupid in the Forge of Vulcan* of 1619 in Hanau; Seelig 1996, fig. 1.

4. See Kloek 1988, 51 and n. 2. Compare *Fortune-teller* signed by Cornelis van Haarlem (illus. in Nicolson and Vertova 1989, 1:13), as well as the examples in Seelig 1997a, 73–75, figs. 19–21.

5. Already in 1604 Van Mander singled out Caravaggio as a praiseworthy modern painter.

6. For Finson, see Bodart 1970a; Briels 1978; and the essay in this catalogue by Lynn Orr.

7. Roethlisberger 1993, no. 285; compare nos. 287–89, 395–99, 401, 402.

8. Müller-Hofstede 1988, 30; Manuth, in Döring, Desel, and Marnetté-Kühl 1993, 146; Müller-Hofstede 1993, 40–41; J. Russel-Corbett in Manuth et al. 1996, 66.

9. Seelig 1997a, 96–97.

Cat. 15

1. Nicolson 1958b, 62. See also Bredius 1915–22, 4:1147.
2. Brown, in Blankert et al. 1980, 108.
3. Additional support for this provenance is provided by the fact that the Begijnhofkerk also owns a version of Baburen's *Entombment;* Slatkes 1965, cat. A3, version O.
4. However, see the discussion of the function of cat. 8, the Metropolitan *Crucifixion.*
5. Slatkes, in Blankert and Slatkes 1986, cat. 32.
6. Interestingly, the pose of the foremost angel, although not its form, was adapted from one in an *Annunciation* by Guido Reni, 1610 (Quirinal Palace, Rome); see Brown 1988, 93, fig. 120.
7. It was first published by Bloch 1968, pl. 1. Nicolson 1973, 239, dated the picture about 1622–23 and noted the strong influence of Baburen.
8. Bloch 1952, 19, and Nicolson 1958b, 63, noted the dependence of the Janssens on Baburen. Later, Nicolson 1979, 62, suggested—correctly, in my opinion—that the *Annunciation* might be a copy after a lost Baburen. Significantly, the Ghent canvas is signed *Joannes Jansenius Gandensis invenit et Fe,* the same way he fraudulently signed his copy after Baburen's *Roman Charity* (City Art Gallery, York); Slatkes 1965, cat. A22. The Janssens copy of the *Roman Charity* is in the Academia de S. Fernando, Madrid.
9. Earlier it had been thought that the Janssens reflected the Diest picture; see Hubala 1970, 175, and Brown, in Blankert et al. 1980, 108. See also the discussion under cat. 11, the Mauritshuis *Liberation of Saint Peter.*
10. Beguines were members of a Roman Catholic lay society of pious women and widows who lived together in a semicloistered religious community known as a Begijnhof.
11. Mâle 1932, 239–43.
12. Holl. 329; and Roethlisberger 1993, 84–85, cat. 35, fig. 70. The plate was also reissued in a third state with the date changed to 1599. Interestingly, the print is not reproductive but an original composition. Bloemaert's placement of his yarn winder, which does hold yarn, and the other objects near it indicates that he saw it mainly as a symbol of female virtue. Another possible influence, although more general, might be Hendrick Goltzius's 1609 *Annunciation* in Moscow; see Egorova 1989, 24–27, color illus.
13. I have found only one other example of Mary's being crowned by angels before the Nativity, the very odd *Expectant Madonna with Saint Joseph,* attributed to the school of Amiens, in the Kress Collection, National Gallery of Art, Washington, D.C., reproduced by Hall and Uhr 1985, 576, fig. 6.
14. Ibid., 575. See also Hall and Uhr 1978, 248–70.
15. The convention of depicting the flowers in three stages of unfolding appears in some early-fifteenth-century renditions of the *Annunciation;* see, for example, Jean de Limbourg's 1405–8 *Annunciation,* fol. 30 of *The Belles Heures,* The Cloisters, The Metropolitan Museum of Art, New York, illus. in Meiss 1974, fig. 410.
16. Hall and Uhr 1985, 567 n. 1 and passim. The third meaning, Doctor of the Church, obviously does not apply to any aspect of the picture.
17. Möller 1926, 62. For the earlier use of yarn winders and other related devices, frequently in connection with Annunciations, see Wyss 1973, 113–88. Wyss, unfortunately, was not interested in the symbolic aspects of the yarn winder. Nevertheless, it is clear from the numerous examples he reproduces that until Leonardo, the device was used only to support the apocryphal account of the Annunciation.
18. Washington 1973, cat. 181: an engraving of about 1513 by Jacopo Francia, *The Holy Family with Saint Elizabeth and the Infant Saint John the Baptist.* The author of this entry cites Möller to support the reading of this yarn winder, similar to the type found in Ter Brugghen, as a symbol of the cross.
19. Boorsch and Spike 1985, cat. B2, illus.
20. This type of prefiguration was usual in Early Netherlandish art. See, for example, the *Annunciation* panel from the Merode Altar, by the Master of Flémalle, ca. 1425, The Cloisters, The Metropolitan Museum of Art, New York, where a small image of the Christ Child carrying the cross is shown descending toward Mary.
21. See, for example, Rowland 1973, 58–66.
22. Van Mander 1604, fol. 128v.

Cat. 16

1. Bolten and Roethlisberger also believe that it is very probably a portrait of the patron. See Bolten 1993, 28 n. 11; Roethlisberger 1993, 255, 387; and in an earlier publication, Delbanco 1928, 76, cat. 28.
2. Van Buchel wrote: "Het stuck van Huter [?], dat ik anno 1621 bij hem hebbe gesien, van Bloemaert gemaect, is redelicken groot, wesende een carsnacht, waerin sijn tronie compt tusschen de twee harderen, na het leven" (The piece by Bloemaert that I saw at Huter's in 1621 is quite large and contains his portrait, done from life, between the two shepherds). The word *his* could refer to either Bloemaert or Huter; Hoogewerff and Van Regteren Altena 1928, 51. For the portrait in *The Adoration of the Shepherds,* see, for example, Bolten 1993, 2, and Roethlisberger 1993, 211.
3. Döring 1993, 202, cat. A6, 211, cat. A32.
4. On this point see Blankert et al. 1980, 90, cat. 6.
5. The New York gallery, Spencer A. Samuels & Company, advertised the painting in *Apollo* 128, no. 322 (1988): 22. There is not the slightest reason to believe that the Utrecht canvas has been cut down on all sides, as suggested in Blankert et al. 1980, 90, cat. 6, on the evidence of the engraving by Girolamo Frezza. The engraving largely corresponds with the painting, but has a vertical format. Roethlisberger rightly observes that it is almost inconceivable that both the original and the copy of *Adoration of the Magi* would have been cropped in exactly the same way. Moreover, there is not a shred of technical evidence that the top, bottom, and left side of the Utrecht painting have been trimmed. See Roethlisberger 1993, 255–57, no. 387.
6. De Vries and Bredius 1885, 27–28, cat. 16.
7. Houtzager et al. 1967, 34, fig. 20.

Cat. 17

1. This holds true although the usual blue of the cloak seems to have been exchanged for a dark green.

2. An example is the church for which Bloemaert's Hague *Adoration* was intended; see Stal, in Broos 1983, 87–91.

3. Schillemans 1992, 42 and n. 3.

4. For examples, see Seelig 1997a, 142–46.

5. Roethlisberger 1993, 257–58.

6. Drossaers and Lunsingh Scheurleer 1974, 319 (1673 inventory of Amalia's possesions): no. 775: "Een schilderijtje zijnde een Maraebeelt met een kindeken, gedaen door A.Bloemaert, in een vergulde lijst."

7. This suggestion by Roethlisberger 1993, no. 278, fits in well with what is being established about the young painter by Seelig 1997b and Seelig 1997a, 261–74. The inscription is echoed by a second list of Amalia's posessions of 1676, where "Een stuckje van de jonge Bloemart, f.60" is recorded. Since, as Drossaers and Lunsingh Scheurleer 1974, 372 n. 1485, have proposed, this is probably the *Virgin and Child* mentioned in 1673, the provenance from Amalia's collections is more likely to belong to the painting in Tokyo than to the present picture by Abraham.

8. Roethlisberger 1993, no. 386.

9. Sale, Christie's (Amsterdam), 25 Nov. 1991, lot 61; 1993 with Kate de Rothschild, catalogue Didier Aaron, *Master Drawings 1993*, no. 4.

10. Roethlisberger 1993, no. 462.

11. See Seelig 1997a, 156 and 234–37, as well as Cornelis's engraving *Virgin and Child* of 1625 (Roethlisberger 1993, no. 393) after a study sheet for the 1623 *Adoration*.

12. Roethlisberger 1993, no. 462, notes that the French privilege makes a publication of the print in or after 1630 likely.

13. See the remarks on Bloemaert's *Four Evangelists*, cat. 3.

Cat. 18

1. (1) painting, 1604 (The State Hermitage Museum, St. Petersburg), Roethlisberger 1993, no. 83, illus.; (2) engraving by Johan Barra based on the preceding, Holl. 30, ibid., under no. 83, illus.; (3) engraving by Jacob Matham after Bloemaert's lost drawing, Holl. 69, ibid., no. 84; (4) chalk drawing, dated to 1615–20 (Koninklijke Musea voor Schone Kunsten, print room, Brussels), Roethlisberger 1990, fig. 3; (5) painting, dated to the 1640s (private coll., London), Rothelisberger 1993, no. 554, illus.; (6) engraving by Frederick Bloemaert after an unidentified drawing by Abraham, included as August in a series of genre scenes entitled after the months and published in the middle of the century, possibly after Abraham's death, ibid., no. 416, illus. from the series nos. 409–20, probably based on drawings from 1625–35, though engraved much later and with a title page designed by another hand. As Roethlisberger notes, the series appears to be cobbled together. The devil's horns are suppressed, presumably to suppress the actual subject; however, without the biblical story, it is only an image of sowing, not of harvest, and makes no sense for August.

2. "While unknowing sleep seizes the soul of mortals, the devil cunningly plants, alas, bad seeds, blending them with the good ones and striving to exterminate the good ones in the soil. With difficulty the grain grows delicate shoots, just as soon as the disgraceful and sterile weeds thrust forth and repress the heavy spikes. At harvest time, fire will destroy the plague and the good crop will then be gathered into the granaries." (Roethlisberger 1993, no. 84)

3. For early interpretations of the parable, see Wailes 1987, 103–8.

4. As cited by Knipping 1974, 1:235 n. 172.

5. The English translation of 1621, 3.

6. See Kaplan in this catalogue.

7. Sutton 1987, no. 112.

8. Van Mander 1604, fol. 298.

9. Roethlisberger 1993, no. 261.

10. Sutton 1987, fig. 12-3.

11. See Giezen-Niewenhuys 1987.

12. Roethlisberger 1993, no. 393, sees no particular meaning in this dovecote. Given the salience of the dovecote here and the pattern of use, it seems likely, however, that Bloemaert expected the viewer to make a connection with those individuals who just slide by in life.

13. Bruyn 1987.

14. Roethlisberger 1993, no. 512; dated to 1630–35.

15. For example, the subjects Farmyard with the Expulsion of Hagar (ibid., nos. 511, 547, D26), Tobias Traveling with the Angel Raphael (ibid., nos. 478, 482), and Christ and Two Disciples on the Road to Emmaus (ibid., no. 258).

16. By Bolsert; ibid., nos. 135–48.

17. Ibid., no. 92, 98, 478.

18. Ibid., no. 100, 224, 261, 282.

19. This is confirmed in an X-ray taken by Karen French.

20. Bowron 1973; accepted by Sutton 1987, but rejected by Roethlisberger 1993, under no. 17.

21. Bowron 1973 pointed to the *Concordantia caritatis* or *Speculum salutis* (Mirror of salvation), a typical late-medieval text typologically linking the Old and New Testaments, in which the Parable of the Wheat and the Tares is exemplified by the Fall of Adam and Eve; see also Schmid 1954, 838.

22. Wailes 1987, 108–13.

23. Roethlisberger 1993, under no. 84, illus.

Cat. 19

1. Steel 1984, no. 4.

2. Huys Janssen 1994a, nos. 114 (and 115), 132, 145. For the various associations with pearls, see De Jongh 1975–76.

3. See, most recently, Wheelock 1995b, no. 20.

4. Ibid., under no. 20.

5. Huys Janssen 1994a, no. 30.

6. Steel 1984, 28, though the works he cites in comparison are not dated and not necessarily from the late 1620s; Huys Janssen 1994a, under no. 56, but with no discussion.

7. See Neumann 1992, fig. 1.

8. Huys Janssen 1994a, 49.

Cat. 20

1. For the present entry, I am much indebted to De Jongh's classic study (1973/1995) on the symbolism of the globe or a map in conjunction with a young woman as a metaphor for the temptations of the world.

2. Ibid., 65–66, with reference to Adriaen Poirters, *Het masker van de wereldt afgetrocken* (The mask of the world torn off) (Antwerp, 1649).

3. For the associations with pearls, see De Jongh 1975–76.

4. See n. 1 above.

5. De Jongh 1973/1995, 74–75; Sutton 1984, no. 78.

6. Salomon 1984, 142. In her forthcoming study, provisionally entitled *Jacob Duck and the Gentrification of Dutch Genre Painting*, Salomon will consider this painting in the wider context of Duck's interest in the theme of the worldly woman.

7. See Peter Nolpe's engraving after Pieter Potter, *Hercules at the Crossroads*, in De Jongh (1973) 1995, fig. 17.

8. De Jongh offers a slightly different reading of her body language.

9. See Sutton 1984, no. 37, where the painting is assigned the date "c. 1640" without further explanation. Presently available evidence does not permit certainty about how Duck split his time between Haarlem and Utrecht in these years.

10. Nanette Salomon has kindly confirmed that this comparison is consistent with her view of Duck's development as conveyed in her forthcoming study; see n. 6 above.

11. For examples, see the entries on Codde and Hals in Sutton 1984.

Cat. 21

1. In two of the three paintings the young woman points—as in the painting in Cambridge—to her reflection; only in the third is the reverse of the mirror visible, and the woman sticks a hairpin with a pearl in her hair. For the first two paintings, see De Jonge 1938, 40, 67, 122, nos. 279, 280, fig. 182, pl. VII. The third one was auctioned in New York in 1923 and 1932 and showed up later in the Gram Hansen collection in Copenhagen.

2. De Jongh et al. 1976, 190–93.

3. Both De Jongh and Sluijter interpret the small figure as a kneeling man; see De Jongh et al. 1976, 192; Sluijter 1988a, 156; and also Tapié 1990, 174. The small figure, however, wears a dress that reaches to the ankles, which clearly indicates that it is a woman.

4. The Latin text reads as follows: "Non sibi, sed Veneri, / carnis—Lascivia vinit [De Jongh reads *vinit* and guesses correctly that *vivit* is meant]: / Huic aurum & gemmas, / et bona cuncta sacrat."

5. Van Mander 1604, *Wtbeeldinghen der Figuren*, fol. 133v: "Den Spieghel . . . vertoonende slechts den schijn van 't waer wesen maar de waerheyt selfs niet." According to Van Mander the mirror can signify a second meaning— self-knowledge—but it does not apply in the painting under discussion.

6. This previously unpublished poem reads in Latin: "In picturam lascivae vanitatis / P. Moreelsij. / Hoc vani exemplar Mundi, carnisque triumphus, / Daemon ubi partes semper avarus habet. / Funguntur Veneri Plutus, mala crapula Amori, / Caecus uterque furit, nescit utraque modum. / Antidotum sint lascivo & medicina dolori; / Jeiunium lachrymae, ceu metanoea mali." See for this poem, which has survived in manuscript only, Aernt van Buchel, *Poemata errantia variorum de quibus dubitur an edita*, Utrecht, Universiteitsbibliotheek, MS 7 E 6, fol. 173r.

7. Overvoorde 1903, 79, no. 33.

8. Hoogsteder 1986, 1:162–64, 2:37.

9. This hypothesis is especially plausible since the earls of Craven themselves bought very few Dutch paintings. On the other hand, the painting is mentioned in an inventory of

Combe Abbey only in 1866. Interesting in this context is a painting by Moreelse that is mentioned in two eighteenth-century Parisian sales catalogues. It is described in the catalogue of the auction of 6–18 Feb. 1786 of the De Saint Morys collection as "no. 123. Paul Morels. Une figure de femme représenté[e] à mi-corps, tenant un miroir, dans lequel son visage se réfléchit; elle est devant un table, sur laquelle sont différen[t]s Bijoux & un livre ouvert." The same painting appears on 10 Mar. 1788 in the auction of the Lenglier collection: "no. 152. Paul Moreelze. Un tableau . . . , représentant une femme à sa toilette coëffée en cheveux mêlés de fleurs, elle est réflétée de profil dans un miroir qu'elle tient sur une table couverte d'un tapis rouge, sur laquelle se voit un livre & des byoux. Hauteur 38 pouces, largeur 29 pouces." Of the four paintings with young women with mirrors the descriptions in the two sales catalogues can only refer to the version in Cambridge. Also, the measurements correspond. Of course, it cannot be excluded that a fifth, unknown version was offered for sale in Paris. If the painting in Cambridge is the same as the one sold in Paris in 1786 and 1788, then it is very unlikely that it is identical with the overmantel in the inventory of 1633 in Rhenen.

Cat. 22

1. Nicolson 1958b, cat. A58, as "*Magdalen*," however, see his text, 89–90.

2. Finlay 1984.

3. Schuster 1982, 99.

4. Blankert and Slatkes 1986, 146, under cat. 25. Schuster 1982, 98–99, also suggested, in a slightly more tentative way, a joining of the elements of the two themes. Both Schuster and this writer were correctly taken to task for this scholarly fence-sitting by Müller-Hofstede 1988, 37–38 n. 56.

5. See Conisbee 1996.

6. Schuster 1982, 98–99.

7. For the Pencz *Melancholy*, see Gmelin 1966, 86, no. 23, illus. 92. Schuster 1982, 98–99, in keeping with his interpretation of the Ter Brugghen, believes the Pencz represents a meditating Magdalene.

8. There are two autograph versions of this composition: Accademia, Venice, and Louvre, Paris. Unfortunately, they differ only in one detail, the inclusion of the dividers. This device, which is the critical symbol in Ter Brugghen's painting, is lacking in the Louvre picture. See also Schuster 1982, 91.

9. Indeed, Dürer's winged personification of Melancholy holds a large pair of dividers in the famous 1514 engraving *Melancholia I*.

10. Van Thiel et al. 1976, A-3903, as attributed to Aertgen van Leyden, *Saint Jerome in His Study by Candlelight*.

11. Klibansky, Panofsky, and Saxl 1964, passim, discuss, at length, the various complex associations and symbols of the melancholic.

12. See cat. 23, fig. 1, and Nicolson 1958b, 110–11, cat. B79, pl. 101b.

13. See Lurie 1979, 279–87. Lurie's attempt to see the relationship between these two figures as iconographically identical is unfounded; see Nicolson 1973, 240, and Slatkes 1981–82, 182.

14. Nicolson 1958b, 89.

15. Bok and Kobiyashi 1982, 28, doc. 28.

16. Nicolson 1958b, 28; see also Von Sandrart/Peltzer 1925, 178. One should not exclude the possibility that Von Sandrart may have meant the term in a general sense, similar to the way we might describe someone as "intellectual," "thoughtful," or even "reserved" today.

Cats. 23, 24

1. The term used in antique sources is *vita humana*. In the Renaissance, however, it was replaced by the idea of *mundus*, "the world." See Blankert 1967, 78.

2. For the history and development of this theme and its early sources, see ibid.

3. Ibid., 36–40, 85, cat. 4.

4. Ibid., cat. 5, illus. 35, fig. 2.

5. For the theme in the sixteenth century, see ibid., 40–43.

6. Nicolson 1958b, cat. B79, 110–11, pl. 101b, knew the picture only from a poor photograph and thus tentatively placed it in his "B" category. After having seen the picture, Nicolson 1973, 240, correctly called it "an indisputable original." Blankert 1967, 102, cat. 41.

7. Oddly, Blankert, in Blankert and Slatkes 1986, under cat. 29, fig. 95, suggests Cornelis van Haarlem's *Democritus and Heraclitus* as the source for Ter Brugghen's Rijksmuseum pendants despite the fact that it is closer to the earlier picture. See also Blankert 1967, 94, under cat. 23.

8. According to ibid., cats. 6–16, it is limited mainly to book illustrations and prints.

9. Van Mander 1604, fol. 278r–v, and Blankert 1967, 91–92, cat. 19. See also Slatkes 1970, 430–31, fig. 7. According to Van Mander 1604, fol. 278r, in 1599 Ketel also painted another pendant pair of the same theme with his feet; see Moiso-Diekamp 1987, 357, E 2. Neither picture is known today. The pictures painted with feet only were said to have been a commission from Hendrick van Os of Amsterdam.

10. Van Mander 1604, fol. 278r, importantly indicates these 1599 Ketels were a pendant pair; see also Moiso-Diekamp 1987, 357, E 2. However, see Slatkes 1970, 430–31, fig. 7, and Moiso-Diekamp 1987, 356–57, cat. B1. For Ketel's pictures painted without brushes, see Stechow 1973, 310–11.

11. There is, however, a copy of the lost *Democritus* paired with its surviving mate in a single painting. See Kloek 1988, 53, 54, fig. 55, in a German private collection.

12. Slatkes 1965, cat. D4, fig. 44, and cat. D3, fig. 45.

13. Several studio versions of known works by Baburen and Ter Brugghen carry this form of a signature. Perhaps it was a studio "trademark" as the initials could stand for Ter Brugghen or Baburen (Baburen always signed his paintings with a *T* for "Teodore"). In this case, however, both works are clearly Baburen-like; nevertheless, they appear to be by different hands. Perhaps there was a prime set, entirely by Baburen, and several workshop pairs of which by chance two, by two different assistants, have survived.

14. Baglione 1642, 136–39; the original Italian and an English translation can be found in Hibbard 1983, 351–56.

15. For the negative meaning of this gesture, see Blankert 1967, 57.

16. For another reading of the globes, see Blankert, in Blankert and Slatkes 1986, 159, cat. 29.

17. Weisbach 1928, 151–52.

18. On this problem, see Blankert 1967, 100.

Cat. 25

1. Pigler 1974, 2:300–7, cites eight pages of examples of the theme from the fifteenth through the nineteenth centuries, with most of the works dating from the baroque period.

2. The most recent review of the Roman Charity as a subject is Tapié et al. 1986. Other studies include De Ceuleneer 1919; Pigler 1934, 3: col. 355–60; Braun 1954; Rosenblum 1972.

3. Seemingly, confusion about the title of this work has led to the erroneous citation of the passage on Cimon and Pero as appearing in book 9; the correct citation is book 5, chap. 4, 7, and chap. 4, ext. 1. Other important ancient texts include Pliny *Natural History* 8:36, 121–22; Hyginus *Fabularum liber* section 254, 59.

4. For example, in the thirteenth century, Boccaccio retold the story of Cimon and Pero in his *De claris mulierbus* 62, using it as an exemplar of feminine heroism. Important editions of the *Factorum et dictorum* appeared in 1470–71 in Strasbourg and Mainz; another important edition, which popularized the text among German humanists, appeared in Basel in 1502, published by Alde Manuce. At least seventeen editions were published in the Dutch Republic during the seventeenth century.

5. In the original text, the father's name is given as Mycon, which was eventually supplanted by Cimon.

6. This translation, appearing in Fremantle 1963, 109 n. 30, is based on Lipsius's edition of *Factorum et dictorum* published in Amsterdam in 1647. The departure point for Valerius is a painting, but the motif also appeared on other types of ancient objects, such as mirror backs; see Tapié et al. 1986, 35.

7. Cinotti 1983, no. 36, figs. 614.2, 615.

8. A sixteenth-century Venetian prototype is recorded in a suite of engravings by Bolzetta; see Tapié et al. 1986, 43. Caravaggio's Cimon and Pero grouping represents both "visiting the prisoner" and "feeding the hungry."

9. Perhaps these are the works recorded in the 1635 inventory of the collection of the duke of Savoy (Brejon 1979, 309 n. 38) and the 1635 inventory of the duke of Buckingham's collection at York House (ibid., 1979, 309 n. 39).

10. Nicolson and Vertova 1989, 1:142; Gregori et al. 1987, no. 10, illus.

11. With Finarte, Milan, in 1963, see Brejon 1979, fig. 50.

12. On Rubens's four paintings and the prints after them, see Tapié et al. 1986, no. 24.

13. It is interesting to note that Rubens's composition of 1625, that is, postdating Baburen's painting, is a vertical format very similar in figural arrangement to the Manfredi that was on the art market in 1963. For the Rubens painting, see Fremantle 1963, fig. 8; the print after it by Willem Panneels is illustrated in Tapié et al. 1986, no. 24.

14. There has been speculation that Rubens's painting reflects knowledge of an ancient wall painting of the subject, as seen in an example in the Museo Archeologico Nazionale, Naples, that includes many of the specific pictorial elements seen in

both the Rubens and the Baburen; see Pacelli 1984, 55, fig. 39; Blankert and Slatkes 1986, 192 n. 7.

15. See Pigler 1974, 2:303–5. A terracotta maquette records Quellien's design, about 1650, for a fountain fittingly to be placed outside the passageway to Amsterdam's prisons, adjacent to the new Town Hall; see Fremantle 1963, 108–12.

16. This is in contrast to many Protestant sects that believe in predestination, that grace comes directly from God and thus good works are not a mitigating factor in the search for salvation. On the emphasis on good works in religious communities in Utrecht, see cat. 31.

17. For an extensive bibliography on the concept of *ut pictura poesis*, see *Dictionary of Art* 1996, 31:767–69.

Cat. 26

1. The principal sources are Valerius Maximus, *Facta et dicta Memorabilia* 4.6.1 and Aulus Gellius *Noctes Atticae* 10.18.3. The Artemisia story is discussed in detail in Von Haumeder 1976.

2. See Landau 1981, no. 91 (B. 83).

3. For a detailed analysis, see Gaehtgens 1995a; on the difficulties of political representations in the seventeenth century, Gaehtgens 1995b.

4. The tapestries were most recently examined in depth by Adelson 1994, 269–77.

5. The tapestry from which he borrowed is entitled *A Gift to the Orator* and depicts the queen giving an elaborate chest to Teopompus, the winner of the contest for the best funeral oration. Honthorst incorporated such motifs as the columns and urns, as well as the disposition of the figures. The designs for the tapestries were supplied by Henri Lerambert. Examples of the tapestries can be seen in Paris (Musée des Gobelins) and Minneapolis (The Minneapolis Institute of Arts). For further information, see Gaehtgens 1995a, 19, figs. 8, 9.

6. Rembrandt, *Artemisia* (or *Sophonisba Receiving the Poisoned Cup*), signed and dated 1634, Museo del Prado, Madrid, illus. in Bruyn et al. 1986, 504, no. A.96, and Bruyn et al. 1989, 774, no. A.94; Jacob A. Backer, *Artemisia*, ca. 1635, present location unknown, illus. in Sumowski 1983–94, appendix no. 1991. See also Gaehtgens 1995a, nn. 49, 50.

7. Gaehtgens 1995a.

8. The painting is listed as the property of Amalia von Solms in the palace inventory of 1631–32; Drossaers 1930, 227. It is now in the gallery of Frederick the Great in Sanssouci, Potsdam; see, most recently, Bartoschek 1978, 11, no. 3.

9. This hypothesis was first proposed in Gaehtgens 1995a.

10. See Judson 1959 and Braun 1966.

11. Scheurleer 1969, 57–58.

Cat. 27

1. On the couple's display of splendor at their residence in Heidelberg, particularly on the creation of the *hortus palatinus*, see Walther 1990.

2. For the life and works of Frederick V and Elizabeth Stuart, see Yates 1972, esp. chap. 1.

3. On his return from Italy in 1628, Cornelis van Poelenburch painted a group portrait of the couple's children and a portrait on copper of the Winter King; see Sluijter-Seijffert 1984.

4. *Celadon and Astrée*, 1629, Ernst August of Hanover coll., Schloß Marienburg; Braun 1966, no. 83; Kettering 1983, 67.

5. For documentation and the history of the portrait's creation, see Braun 1966, 46, 227–30.

6. Piper 1963, 130.

7. Van Loon 1732, 2:201.7.

8. The medallion is examined in detail in Gaehtgens 1995a, 18–19.

9. *The History of the Family of the Winter King*, Ernst August of Hanover coll.; Judson 1959, no. 121; Braun 1966, 288–89, no. W 13.

10. In this work, Henri IV is depicted in the costume of a Roman commander. On the combination of the death of the ruler with the Roman tradition of the apotheosis, particularly in the Medici cycle, see Saward 1983, 98.

11. Honthorst, too, had painted portraits for such galleries of emperors, for example in Schloß Grunewald in Berlin; created in 1622–25, the collection contains the likenesses of twelve Roman emperors, painted mainly by Utrecht artists. Honthorst's contribution was a portrait of Emperor Marcus Salvius Otho. See Börsch-Supan 1964, no. 8.

Cat. 28

1. On the entire cycle and Baburen in particular, see Börsch-Supan 1964, 12–20; Börsch-Supan 1992, 28–31; and Slatkes 1965, 90–91, as well as cat. A 16.

2. See Slatkes 1965: *A Boy Musician*, cat. A 9, and *The Lute Player*, cat. A 13.

3. Oldenbourg 1917, 207, already remarked on the similarity of this work to surviving portraits of Titus, although he describes the face and mouth of our figure as "more fleshy." The hairstyle, for example, resembles that of the Titus statue in the Vatican. Oldenbourg described the painting as "progressive, if artistically still somewhat crude" (207).

4. On this cycle see Wethey 1975, 3:43–47. Titian painted eleven of the portraits in 1537–38 for Count Federigo Gonzaga; the twelfth was executed by Giulio Romano.

5. Van Dulen 1989. Unfortunately, it was not possible to consult this unpublished dissertation. This work could help answer a number of questions, particularly as the author dates the cycle to about 1615.

6. Rubens's portrait at least—the only one in the series painted on wood—must have been created independently. The pentimenti indicate that the armor was painted over a red cloak at a later point. On Rubens's *Caesar*, see Börsch-Supan 1992, 281gff.; and Gaehtgens 1977, 23–25.

7. Oldenbourg 1917, 204.

8. Börsch-Supan 1964, 12; Börsch-Supan 1992, 28.

9. Inventarium 1698, no. 227, fol. 23.

10. On this aspect, see Börsch-Supan 1967, 143–98.

11. Slatkes 1965, 90.

12. Oldenbourg 1917, 203.

13. On the Nassau Genealogy, a collection of tapestries of the Nassau-Orange family, see Fock 1948–49, 1–28.

Cat. 29

1. The earliest portrait that can be confidently attributed to Moreelse is the portrait of an unknown man from 1602; see De Jonge 1938, 13, 62, 80, no. 28, fig. 18. It is extremely likely that the portrait dated 1600 in Heino in the collection of the

Stichting Hannema-De Stuers is also by the hand of Moreelse; see Hannema 1971, 17–18, no. 678, fig. 1.

2. Van Mander 1604, fol. 299v.

3. Amsterdam, Rijksmuseum (on loan from the City of Amsterdam); see De Jonge 1938, 14, 16, 63, 83, no. 44, fig. 30. Moreelse was the first non-Amsterdam painter to receive a commission for an Amsterdam civic guard portrait. The only other non-Amsterdam painter to receive a similar commission was Frans Hals. Hals received the commission for *The Officers of a Company of the Amsterdam Crossbow Civic Guard under Captain Reynier Reael and Lieutenant Cornelis Michielsz. Blaeuw* (City of Amsterdam; on loan to the Rijksmuseum, Amsterdam, C374) in 1633, but when the militia piece was still not finished in 1636, Pieter Codde was asked to complete it.

4. Eisler 1977, 126–27. Colin Eisler refers here to a letter dated 22 Oct. 1968 from P. G. L. O. van Kretschmar to the National Gallery of Art in Washington, D.C. The letter, now in the archives of the Iconographisch Bureau in The Hague, shows that Van Kretschmar identified the copy. The only one who considers the fragment as a copy painted by Moreelse himself is Paul Huys Janssen; see Huys Janssen 1994b, 310, 315, 324. I am of the opinion that the copy was executed by an unknown artist.

5. Huys Janssen 1994b, 302–38.

6. Ippenburg, Von dem Bussche coll.; see Huys Janssen 1994a, 213–14, no. 146, fig. 19.

7. Ishikawa, in Ishikawa et al. 1994, 145–49.

8. For Johan Strick, see Huys Janssen 1994a, 210–11. In 1616 Johan Strick married Beatrix Gibels van der Goes (1595–1655).

9. Stichting G. Ribbius Peletier Jr. tot Behoud van het Landgoed Linschoten, Linschoten; see Kettering 1983, 174; Van den Brink and De Meyere 1993, 104–5. Until now the painting has been considered a pastoral family portrait, even if it does not include a single pastoral motif. It should be classified under the autonomous subgenre of portraits in which the subjects are portrayed in fantasy hunting costume. An important earlier example of a group portrait that belongs to this subgenre is *Portrait of the Children of the King and Queen of Bohemia in a Landscape* from 1628 by Cornelis van Poelenburch (Museum of Fine Arts, Budapest); see Sluijter-Seijffert 1984, 246, no. 194. This portrait was without doubt an important source of inspiration for Van Bijlert.

10. For Dirck Strick, see Eisler 1977, 126.

Cat. 30

1. According to Hubert van Sonnenburg (oral communication), the original canvas was laid down on panel at an early date, in part to repair the damage visible in the maid's midriff.

2. Lowenthal 1986, 114–15, A-39. See also Luijten et al. 1993, 603–4, cat. 275 (entry by Wouter Kloek).

3. Lowenthal 1986, 115, A-40, pl. 54.

4. See also Pieter Aertsen's *Still Life with Christ, Martha, and Mary* (1552; Kunsthistorisches Museum, Vienna); Filedt Kok, Halsema-Kubes, and Kloek 1986, 345–46, cat. 227, with references. For other kitchen scenes with Christ, Martha, and Mary, see Ghent 1986–87, 122–23, cat. 7; 129–30, cat. 11; and 135–36, cat. 15.

5. My interpretation of the pictorial structure follows Emmens 1973. Craig 1983 discusses the exegetical writings concerning Christ, Martha, and Mary, and offers a variation of Emmens's interpretation. See also Buijs 1989 for an alternative view, in which Martha represents not the *vita activa* but materialism and excess. In either case (Emmens and Craig or Buijs), the opposition between foreground kitchen scene and background biblical one holds.

6. De Jongh 1968–69, 22–28.

7. See Segal 1983, 51, 62–63.

8. See Manuth 1993–94, esp. 238, for the influence of the more or less multidenominational nature of Dutch society on history painters' choice of biblical subject matter. Manuth writes, "There is no convincing evidence that any one denomination privileged certain themes or iconography."

9. See Goedde 1989a, 38–43, for a discussion of *ekphrasis* and Dutch still life. See also Lowenthal 1996.

10. Lowenthal 1986, 147, A-82, pl. 115, and 153–54, A-91, pl. 127, respectively.

11. Ibid., 151, A-88, pl. 122, color pl. 22.

12. Roethlisberger 1993, 1:467, cat. H54, 2: fig. H57.

Cat. 31

1. The inventories are included in Lowenthal 1986, 190, 196.

2. Other representations of Saint Martin: (1) dated 1635, oil on canvas, 68 × 100 cm, with Nystad (The Hague), 1967, sale, Mme Ch. Kreglevger (Brussels), Apr. 1936 (DIAL, 11H Martinus); private coll. (Brussels), Muller 1985, fig. 92. A painting of a man on horseback (not Saint Martin) distributing charity, oil on panel, 54 × 74 cm, was with Hoogsteder (The Hague), 1968.

3. For the life of Saint Martin and for his representation elsewhere and by other artists, see, e.g., Vossen 1975; Tours 1961; Kimpel 1974; and Bonnard 1965.

4. De Jonge 1952, no. 272, illus.; Muller 1985, 127, fig. 93.

5. Muller 1985, 126–27, fig. 89; Monballieu 1979, 200–2.

6. Muller 1985, 59.

7. Van Luttervelt 1947b, 121, fig. 11; De Jonge 1952, no. 76.

8. Van Luttervelt 1947b, 113ff.; De Jonge 1952, no. 77; Muller 1985, 93.

9. Five other versions of the subject: (1) dated 1626, 109 × 168 cm, Sotheby's (London), 9 May 1973, lot 108; (2) similar to preceding, 96.5 × 127 cm, Sotheby's (London), 29 July 1976, lot 22; (3) Centraal Museum, Utrecht, on loan (photo in Rijksbureau voor Kunsthistorisch Documentatie, The Hague [hereafter RKD]); (4) auction (Berlin), 5 May 1925, lot 118; (5) dated 1644, oil on panel, 61 × 107 cm, Bredius Museum (The Hague), Blankert 1991, no. 48.

10. Van Luttervelt 1947b, 117, illus.; De Jonge 1952, nos. 81, 82.

11. *Housing the Poor*, 1647; Van Thiel et al. 1976, 200.

12. Muller 1985, 54.

13. Christie's (London), 18 May 1990, lot 119, color illus. Other treatments prompted by the larger theme of feeding the poor as an expression of charity: (1) 1623, private collection (Milan), oil on panel, 58 × 85.5 cm (photo in RKD); (2) 1623, with Richard Green (London) in 1975, oil on canvas, 85 × 188 cm; (3) 1623, Christie's (London), 18 May 1980, lot 119; (4) 1654, Christie's (London), 4 July 1986, lot 11; National Gallery (Prague), DO5832.

14. The story (John 5:2–9) is treated by Droochsloot in several paintings listed in Klessmann 1983, 57.

15. Dated 1625, oil on panel, 45 × 98 cm, J. Fontana (Santa Barbara, Calif.) in 1979 (photo in RKD).

16. One such (dated 1631) was sold at Christie's (London), 1 Dec. 1978, lot 24.

17. An example is in Frans Halsmuseum (Haarlem); Huys Janssen 1990, fig. 46.

18. Ibid., 50.

19. Muller's comments on the painting catalogued here, like the rest of her rich but flawed argument, rest on the incorrect assumption that seventeenth-century Dutch paintings did not still reflect Catholic premises: "The image seems intended to show Saint Martin not as an exemplar of charity but as the personification of winter from the point of view of the poor. Given the greater opportunities for poor relief that existed during winter, the arrival of the saint's feast day meant the beginning of a season of alms" (1985, 126–27).

20. *Scene on the Ice*, Segoura (Paris); *Winter Day*, 1624, Christie's (New York), 14 Jan. 1993, lot 36 (from the Museum of Fine Arts, Boston).

21. For that dated 1629 in the Centraal Museum, Utrecht, see Huys Janssen 1990, fig. 31, and De Jonge 1952, no. 80.

22. Dorotheum (Vienna), 14 Sept. 1976, lot 37, color illus. In addition there is in the files for Droochsloot at the RKD a photo of an *Acts of Charity* (private coll., Bad Schönborn in 1988) bearing a convincing attribution: Droochsloot after Vinckboons.

23. For the interpretation of Beham's woodcut, see Moxey 1989.

24. *Feeding the Poor*, 1623 (private coll., Milan, photo in RKD) and *Procession of the Lepers*, 1625 (location unknown; with J. Goudstikker, 1932, photo in RKD).

25. Van Luttervelt 1947b, 124.

26. Inv. A-1920; Van Thiel et al. 1976, 199.

Cat. 32

1. Bok 1984, 4.
2. Ibid., 38.
3. Ibid., 38–39; Bok identified the beadle and the housemaster.
4. Huys Janssen 1994a, 32–33.
5. Bok 1984.
6. Ibid. "Moeyelyke vertroosting van Hiobs Huisvrouw." The paintings from St. Job's Hospice are also listed in Muller 1880, 133–34.
7. Bok 1984, 35: "Dit schilderij is door Bijlert voor 't Gasthuis geschilderd dog doen dit gebouw in den franschen tyd in eenen caserne is veranderd is dit stuk met eenige anderen daar uitgenomen, en door mij op eene publieke verkooping gekocht."
8. Huys Janssen 1994a, 60–63, 210–19, cats. 146–55.

Cat. 33

1. The term was not at all fixed in the seventeenth century; see De Paauw-de Veen 1969, 190–93. In spite of its common use in art-historical literature, it still lacks a clear definition; see Bruyn 1983, 209–10, dismissing the hypothesis of Blankert 1982, 26–28 and 57–59, that it was a type of painting half-way between history and portrait. Bruyn 1988 himself addresses as *tronies* heads in all kinds of paintings, from history to genre.

2. Held 1980, 597: "Many of the extant heads [by Rubens] seem to have been painted with a particular composition in mind, but it is easy to see that they continued to serve as models wherever the context fitted them." Compare Tümpel 1986, 60, for parallels in Rembrandt's workshop practice.

3. Roethlisberger 1993, no. 523.

4. Ibid., nos. 528, T48.

5. See ibid., 389–90.

6. Ibid., figs. T7, T14, T18, T29, T40, T44, T46, T47, T57.

7. Ibid., nos. 486, 517, 518 (1632), 519, 520, 521 (1634), 522, 524, 525 (1635), 526, 527 (1634), 528, 529, 530, 534 (1635, fig. 2), 535 (1637), 536, 537 (1636), 538, 539, 540 (1639), furthermore 532, 533, 541 (1641) (for attribution of these, see Seelig 1996, 104), and Delbanco 1928, no. 27 (not in Roethlisberger 1993).

8. Roethlisberger 1993, nos. 17, 21.

9. To be sure, Huys Janssen 1994a, nos. L60, L65, L121, cites a few lost works by Jan van Bijlert, called *tronie*, or *hoofd*, head, in the documents.

10. See the Utrecht examples cited by Bruyn 1988.

11. Most are panels of the size of the Feigen picture, five panels are about 52 × 46 cm (Roethlisberger 1993, nos. 486, 517, 528, 529, 539), and two are even bigger canvases (Roethlisberger 1993, no. 535; Delbanco 1928, no. 27).

12. Klessmann, in Ekkart et al. 1979, 70 (my translation). For a broader discussion of Bloemaert's inspiration taken from Lievens's and Rembrandt's example, see Seelig 1997a, 120–26.

13. Nicolson 1958b, nos. A14, A15. For a discussion of pendants in Dutch painting, see Moiso-Diekamp 1987, including a few of Bloemaert's *tronie* pairs as nos. A3, A4, B2.

Cat. 34

1. The little-known brothers Dirck (ca. 1618–after 1672) and Maerten (ca. 1620–1647) Stoop painted military subjects but with only an occasional treatment of the theme of soldiers in a guardroom. See Huys Janssen 1990, 49, and Swillens 1934, 116–35, 175–81. Hendrick ter Brugghen painted the most important Utrecht image of the soldier; his *Mars Sleeping*, about 1625 (Centraal Museum, Utrecht), was celebrated as an emblem of peace in verses written on the occasion of the Treaty of Münster in 1648, an interpretation that likely paralleled its original meaning. See Slatkes, in Blankert and Slatkes 1986, 137–40, with further literature. Though the Dutch Republic resumed its war with Spain following the expiration of the Twelve Year Truce in 1621, Utrecht, unlike other major cities such as Amsterdam and Haarlem, did not have a vital civic militia and certainly not a tradition of civic guard portraiture. See Carasso-Kok and Levy-van Helm 1988, esp. 126. For literature on soldiers in art, see Playter 1972; Fishman 1982; Sutton 1984, xxxvi–xxxviii; Salomon 1984, 63–115; and Borger 1996.

2. See Sutton 1984, 189–90, for a cogent discussion of this work's date.

3. A painting by Duck was sold at a lottery sponsored by the St. Luke's Guild in Haarlem in 1636, indicating that by this time the artist was apparently a resident. For the work of Duyster and Codde, see Playter 1972.

4. For example, Duyster's *Soldiers beside a Fireplace*, oil on panel, 42.6 × 46.4 cm, John G. Johnson Collection, Philadelphia Museum of Art; in Sutton 1984, cat. 42.

5. For example, Codde's *Soldiers Mustering Out*, oil on panel, 41 × 54 cm, Slot Wawel, Staats-Kunstcollecties, Cracow; in Borger 1996, cat. 1. One of Duck's few dated paintings, a merry company scene from 1635 (oil on panel, 52.7 × 63.2 cm, location unknown, illus. in *Connoisseur* [July 1980]: 50) is also set in a boxlike room (the painting on the back wall of this work is a later addition and has since been removed), which gives additional evidence for the dating of the present work.

6. Sutton 1984, 189–90. A copy of the Minneapolis painting is in the National Gallery, Prague. See Sutton, in Sutton 1984, 190 n. 7. For Codde's work and development of the theme, see Playter 1972, with additional illustrations of the mustering-out theme, including sleeping soldiers, in Borger 1996, figs. 14, 26.

7. Though figure studies by Duck are known, he apparently also made studies of costume elements, for the sleeve of the officer's right arm is, with only minor variations, that of the left arm of a standing youth in a painting from the mid-1630s, *Merry Company*, illustrated in Steneberg 1953, no. 19, pl. 13.

8. Borger 1996, 24–29, 31, posits that these scenes represent not the Dutch army but local militia companies, or civic guards, primarily those of Amsterdam. Since neither the militia companies nor the Dutch army (of which they were nominally a part) wore uniforms, and officers in both branches wore the orange sash, it is difficult to identify these groups of soldiers as belonging to one or another body.

9. The harsh and boring conditions of the life of a seventeenth-century soldier are discussed in Parker 1972, which, although focusing on the Flemish-Spanish army, is broadly applicable to military experience in the seventeenth century.

10. Salomon 1984, 78.

11. Ibid., 74–78. She adduces the "idle hand motif" argued by Koslow 1975, in discussing soldiers whose hands lie uselessly in their laps or elsewhere.

12. For a discussion of Duck's, and other artists' treatments of sleep in their art, see Salomon 1984.

13. Duck painted a slightly smaller (45.7 × 68.8 cm), and probably primary, version of the work, now in a private collection and illustrated in Christie's (New York), 15 Jan. 1988, lot 105. The officer with drawn sword corresponds to a Renaissance conception of anger, the figure of Ira, for which see Hale 1990, 203, fig. 251. I thank Otto Naumann for pointing out this connection when discussing the work with me. See Salomon 1984, 71.

14. Ibid., 80–81.

Cat. 35

1. J. Richard Judson very kindly shared with me the manuscript for the forthcoming revision of his monograph on Honthorst; no. 288, pl. 173.

2. Among them, Caravaggio's *Cardsharps* (see Orr, fig. 3, in this catalogue).

3. Von Sandrart/Peltzer 1925, 1675, 170.

4. For numerous early examples, see Feigenbaum 1966, 150–81, and Cuzin, 184–99, in Conisbee 1996.

5. See, e.g., Jan Saenredam's engravings after designs by Goltzius for a series of the Senses acted out by courting couples (Welu and Biesboer 1993, 328, fig. 36a). For the Five Senses, see Kauffman 1943; Putscher 1971; and Pigler 1974, 2:483–85.

6. See, e.g., Welu and Biesboer 1993, 223–24, figs. 10c, 17a; Judson MS, 217 n. 1.

7. For a discussion of contemporary interpretations of secular themes in Utrecht painting, see Franits in this catalogue.

8. For a full discussion of the theme of the Prodigal Son, see Renger 1970. Judson 1959, 70 n. 5, argues against reading the Copenhagen picture as a Prodigal Son.

9. Müller-Hofstede, in Klessmann 1988, 33–34.

10. On the differences of mood and interpretation between Honthorst and Ter Brugghen, see cat. 40 and Judson 1959, 69–70.

11. Reversing the figural group in the Copenhagen picture, De Grebber's composition updates the indigenous merry company type popularized in Haarlem in the 1610s by artists such as Willem Buytewech and Dirck Hals. What is new is the scale. These are no longer cabinet-sized panels with small full-length figures, but large-scale canvases peopled by half-length figures that take over almost the entire pictorial surface. On De Grebber's *Musical Trio* and its possible pendant, see Slatkes 1981–82, 174–75, and Welu and Biesboer 1993, no. 17.

12. See, for example, Lievens's *The Feast of Esther* (North Carolina Museum of Art, Raleigh), as discussed by Judson, in Blankert and Slatkes 1986, 57–58, fig. 51.

13. Snoep 1968–69, 79, notes that the ability to read both the words and the music in a songbook is indicative of a high level of education.

Cat. 36

1. Witness to the picture's years in France, it is still in an early nineteenth-century French gilded frame with neoclassical gadrooning, or fluting.

2. J. Richard Judson very kindly shared with me the manuscript for his forthcoming revised monograph on Honthorst; no. 262, pl. 151.

3. See Judson 1959, no. 161, fig. 16; for relationship with other Northern interpretations of the motif, see Slatkes 1996, 211–12, 216 n. 74.

4. See Judson 1959, 63. The painting is known in several versions; see Wethey 1962, 1:81, nos. 121–22, 2: fig. 21–22.

5. On the evolution of the motif in Italian art circles, see Davies 1989, 11–15.

6. Pliny *Natural History* 34.79, 35.138.

7. Scholars believe that since the Renaissance artists have attempted to re-create subjects treated by ancient artists but known only through ancient literary texts, the original artworks themselves not having survived. Visual references to the ancient literature on art also suggested the learnedness of the artist and/or his collaboration with learned patrons. Such allusions would certainly have appealed to Honthorst, who throughout his career was frequently employed by powerful men in the clergy, distinguished collectors, and monarchs. For a bibliography on *ekphrasis*, see *Dictionary of Art* 1996, 10:128–31.

8. Pliny *Natural History* 35.138.

9. For the migration of the motif from Italy north, see Davies 1989.

10. El Greco had previously elaborated on the motif, now with three figures—a youth, a man, and a monkey—in an

enigmatic composition often called *Fabula* (Fable); see Wethey 1962, 1:81–83; Davies 1989; Bury 1997, 24–25. A picture by El Greco, now lost, was recorded as depicting a woman, accompanied by a man (or men), and blowing on an ember; this may have been even closer to Honthorst's Braunschweig painting in composition and meaning; see Davies 1989, 19.

11. See De Jongh et al. 1976, no. 28; Müller, Renger, and Klessmann 1978, no. 15; Blankert and Slatkes 1986, no. 62.

12. *'t Sal smetten of branded/Vrient wacht uw handen . . . /Dus ben ick in gevaer waer ick de vingers set;/Uw kool doet als haer vrou, sy brant, of sy besmet.* From Cats 1726, 1:537, as cited by (Braun 1966) 151, and as translated by Judson (MS, no. 262). The image accompanying this verse is reproduced in this catalogue; see Franits, fig. 1.

Cat. 37

1. Judson 1959, 65; Slatkes 1965, 11, 95–96; Bok 1986a, 173–75.
2. Frans Hals, *Buffoon Playing a Lute*, ca. 1623. Musée du Louvre, Paris, R.F. 1984–32.
3. Nicolson 1958b, 13 n.7; Slatkes 1965, 10.
4. See Ypey 1976.
5. See Slatkes 1965, 112–13, cat. A9.
6. See ibid., 10–11, 88, 95–96, 112–13, cat. A9, 138–39, cat. B5; Moiso-Diekamp 1987, 169, cat. B1, 295, 297–98 cat. C3.

Cat. 38

1. See Renger 1970; Sutton 1984, no. 1, pl. 10.
2. We look forward to Slatkes's forthcoming publication reiterating this interpretation.
3. See Van de Pol 1988a; Van der Wurf-Bodt 1988.
4. Interestingly, from 1558 until 1649 St. Job's Hospice in Utrecht (see cat. 32) provided treatment for patients with syphilis, called the Spanish pox. See Van der Wurf-Bodt 1988, 25.
5. Van de Pol 1988a, 131.
6. Ibid., 124–26, explores among other questions: Who bought such pictures depicting prostitutes and their clients? Where were they hung? Why would a good, upstanding wife or mother allow such images in her household? and How was the reaction of men and women to such images different?
7. Hendy 1974, 282–84, fig. 33; Blankert, Montias, and Aillaud 1988, 87–90, 183–84, no. 17, pl. 17; this picture was among those stolen from the Gardner Museum 18 Mar. 1990.
8. MacLaren and Brown 1991, 1: no. 2568, 2: pl. 394; Wheelock 1995b, no. 22, illus.
9. The document from the city archives of Gouda was published in Blankert, Ruurs, and Van de Watering 1978, 145–46, doc. 7. The painting in question passed to Maria's brother, Jan Willemsz., and was eventually inherited by Maria after his death in 1651 and the death of her sister, Cornelia, in 1661 (Montias 1989, 123).
10. Ibid., 122–23, lists the paintings recorded in this collection. They represent subjects characteristically depicted in Utrecht, including a "Roman Charity"—a painting of this subject was depicted hanging on the back wall of an interior in Vermeer's *Music Lesson* (coll. of Her Majesty Queen Elizabeth II)—a "flute player," and "One Who Decries the World" (the weeping Heraclitus?).

11. Bloemaert had witnessed Jan Geensz. Thins's wedding in 1647. See Montias 1989, 106–7, 110.
12. Ibid., 123.
13. Ibid., 106–7.
14. Wheelock 1995b, no. 1.
15. Ibid., no. 2.
16. Ibid., no. 3.
17. Three copies of the Boston composition exist: a seventeenth-century copy in the Rijksmuseum, Amsterdam (C 612); a copy put up for sale at Christie's, London, 29 Nov. 1968, lot 10 (unsold); and a modern forgery by Hans van Meegeren, now in the Courtauld Institute of Art, London.
18. Blankert, Ruurs, and Van de Watering 1978, no. 3, pl. 3, 3a, 3b; Slatkes 1981, 20–22, illus.
19. Wheelock 1995b, 200–2.

Cat. 39

1. In his remarks on the seventeenth-century Dutch perception of cats as wanton and incompatible with good domestic order, Schama 1987, 377, 461, cites *The Experienced and Knowledgeable Householder* (De Ervarene en verstandige Huyshouder), 2d ed., 1743, 30ff., and such paintings as *The Listening Maid* by Nicolaes Maes (Wallace Collection, London).
2. For depictions of children playing with cats by Haarlem artists, see Welu and Beisboer 1993, under nos. 3 and 13 (by C. Kortenhorst-von Bogendorf Rupprath) with further bibliography, and Durantini 1983, 268–87. See further, Huys Janssen 1994a, under no. 105.
3. For Leyster, see Welu and Beisboer 1993.
4. For Molenaer, see Weller 1992.
5. Huys Janssen 1994a, no. 105, as with Jean-Max Tassel, Paris, in 1990, as datable to 1625–35.
6. Roethlisberger 1993, no. H13, illus.
7. Ibid., no. H10. See also Cornelis Bloemaert's engraving after Hendrick's *Cat* (ibid., no. H11, illus.).
8. On the associations of the training of dogs with the training of children see Durantini 1983, 268–87; Bedaux 1983; Spicer 1988.
9. Durantini 1983, 268–87.
10. See Salerno et al. 1985, no. 69.
11. The only change visible in the X-ray recently taken by Karen French, the conservator at the Walters Gallery, is a slight retraction of the girl's right knee.
12. For the larger issue of the response to the past by Dutch artists, see Spicer 1995.
13. Huys Janssen 1994a, no. 122; Blankert and Slatkes 1986, no. 41.
14. See note 5 above.
15. Huys Janssen 1994a, no. 104, dated to 1630/40; Blankert and Slatkes 1986, no. 43.

Cat. 40

1. Egan 1961, 184–85.
2. Salerno et al. 1985, cat. 69.
3. Nicolson 1953, 52.
4. Nicolson 1956, 109, 110 n. 34. The date of ca. 1628–29 suggested by Nicolson is a bit too late. Indeed, Nicolson himself modified his opinion in his later catalogue entry for the painting; see Nicolson 1958b, 72, cat. A37.

5. The other picture, unfortunately lacking the last digit of the date, is the so-called *Woman with a Candle*, now on the London art market; see Blankert 1991a, and the forthcoming article by Slatkes, in *Bulletin du Musée National de Varsovie*, in which this unusual painting is identified as *The Death of the Virgin*, and compared in its double light source to the London picture.

6. Czobor 1956, 230, places the work close to the Erlau *Boy Lighting a Pipe*; see Blankert and Slatkes 1986, cat. 13, color illus., that is to say ca. 1623–24. Kitson 1959, 111, would also date the painting early, 1622–24, "by reason of its relatively shallow and frontal space composition." Only Gerson 1959, 317, and Van Thiel 1971, 103, suggested a more acceptable later date, ca. 1625 by the former and 1626 by the latter.

7. Blankert and Slatkes 1986, cat. 26, color illus. The picture is in the Thyssen-Bornemisza collection, Madrid.

8. Nicolson 1958b, cat. A38. The picture is signed with a monogram and dated 1626, on the sheet of music.

9. Ibid., cat. A38, pl. 76.

10. Traces of these overpainted parts can still be seen with the naked eye, most clearly in the jaw of the repoussoir male and his cloak, where it is apparent that both the violin and the violinist's hand were completed before they were covered over when the trio was executed. Unfortunately, these observations do not always show up clearly in photographs. There have also been important changes in the features of the young violinist that seem to indicate an even more boisterous music making than now seen; see the X-rays made at the time of the 1988 exhibition in New York published by Liedtke 1989, 155. I would like to thank Dr. I. Linnik, keeper of Dutch and Flemish painting at the Hermitage, for allowing me to study the picture, which was in storage when I visited the museum.

11. These are most noticeable around the neck of the lute held by the woman and behind her head.

12. Judson 1959, 68–69, compared this picture with Honthorst's *Musical Group by Candlelight* in Copenhagen.

13. Blankert and Slatkes 1986, cat. 66; and Judson 1959, cat. 199, Centraal Museum, Utrecht.

14. A similar group, although not playing the same instruments, can be found in a lost Baburen painting known through a stipple engraving by F. Frick; see Slatkes 1965, cat. B2, fig. 35.

15. Egan 1959, 310 n. 41.

16. Significantly, Baburen's related composition cited in n. 14 has no wind instruments but two lutes. For the lowly character of wind instruments, see Blankert and Slatkes 1986, under Ter Brugghen's Oxford *Bagpipe Player*, cat. 15. In some theoretical constructions percussion instruments are placed in a category even lower than the winds; see Egan 1959, 310 n. 41.

17. These wings of Eros, painted out in an early restoration, have reappeared in a recent cleaning.

18. Close examination of the painting and the infrared photographs indicate that Ter Brugghen enlarged the still-life elements; originally, however, the glass was larger, although of a less elegant shape. These changes support the important symbolic role played by these objects.

Cat. 41

1. Frederiks 1894, 62–63. It is likely that this was a lot of two pictures rather than one picture with two musicians. For example, in the same catalogue, another single lot with two pictures is listed as "Twee braave groote stukken van Rembrandt," most likely the 1625 *Stoning of Saint Stephen*, in Lyons, and the 1626 history painting in Leiden.

2. I would like to thank Dr. Bernhard Schnackenburg of Schloß Wilhelmshöhe, Kassel, for calling the old Saxon standard to my attention. The Saxon *Fuss* had only 28.3 cm and the *Zoll* 2.36 cm.

3. Significantly, in this instance, frames were not mentioned in every lot description. For example, lot 7, just before our fife player, identified as Honthorst, "a young man with a feathered hat singing from a music book," 30 × 25 Zell (approx. 81 × 67.5 cm), makes no mention of a frame.

4. Van Thiel 1971, 110. The evidence cited by Kettering 1983, 137 n. 13, overlooks the fact that this picture is closely related to Ter Brugghen's *Beheading of Saint John the Baptist*, ca. 1621–22, in Kansas City, in which the same effects of a broken wall are found as well as a closely related, shadowed lost profile with a crenellated beret, in the figure of the executioner. For the Kansas City picture, see Nicolson 1958b, cat. A12.

5. Both the present work and the Kansas City *Beheading* reveal the influence of Dirck van Baburen's early Utrecht period *Sacrifice to Ceres*, in a French private collection, in the handling of the shadowed lost profile. For a discussion of this stylistic relationship, see Slatkes forthcoming.

6. In his *Orchesographie* of 1588, Thinot Arbeau states, "we apply the name fife to a small transverse flute with six holes, which is used by the Swiss and the Germans, and which, as it has a very narrow bore no bigger than a pistol bullet, gives a piercing sound. Those who perform on this instrument play according to their own pleasure, and it is enough for them to keep time with the sound of the drum." See Rockstro 1967, 213, and Buijsen and Grijp 1994, 369. Thus Kettering 1983, 36, who identifies the instrument as a "more sophisticated transverse flute" and believes the picture depicts a tavern musician, is apparently incorrect on both points.

7. Van de Waal 1952, 1:61, discusses the revival of *Landsknechtendracht*, and 2:31 n. 7, cites sources that suggest a self-conscious parallel was drawn between the Netherlands and Switzerland, e.g., Jan François le Petit, *Nederlantsche Republycke . . . geconfereert ende vergeleken met die van de Swytsersche Cantoenen* (Arnhem, 1615).

8. This is apparently confirmed by the 1588 description of the instrument in n. 6, above. In the visual arts a pairing of a fifer with a drummer is found in Lucas van Leyden's engraving *The Dance of the Magdalene* (B. 122). Lucas's fife player is dressed in a manner close to Ter Brugghen's, thus at least partially confirming the interpretation presented here.

9. The instrument would appear to be, technically, a treble recorder; see Baines 1957, 74. The standard length of the treble recorder is about 48 cm (18 15/16 in.).

10. Egan 1959, 303–13.

11. On Ter Brugghen's use of antithetical pendants, see Slatkes forthcoming.

12. Interestingly, Ter Brugghen either did not know how to play these instruments or did not care about depicting accurate finger positions in these two pictures. Significantly, there are pentimenti around the fingers and hands in both canvases.

13. It is worth noting in this context that the Baburen had a pendant, now lost, depicting a fife player; see Slatkes 1965, cat. B5, fig. 40. Although the instruments in these two Baburen pictures are somewhat different from those used by Ter Brugghen, the costumes suggest a similar contrast of types.

Cat. 42

1. The central part of the monogram—the *HTB* section—has been filled in and retouched. I would like to thank Christopher Brown, of the National Gallery, London, for allowing me access to the curatorial files on the Ter Brugghen paintings at that museum.

2. Bredius 1915–22, 5:1669.

3. Bok, in Blankert and Slatkes 1986, 71. Significantly, several other Ter Brugghen pictures are listed in this same inventory.

4. Nicolson 1958b, cat. A1, pl. 45.

5. The translation is from Welu and Biesboer 1993, 126. The Dutch text reads: "Ick speel Trefelyck op de Luijdt soet met veel snaeren / Daer bij singh ick oock braef en weet het moeij te claeren." Some caution with such texts is of course required. Indeed, we remain uncertain whether subscripts represent the full understanding of such themes or merely one of the more popular levels of comprehension. Furthermore, from one reproductive print to another, these added subscripts to the same representation sometimes change substantially in tone and meaning. Nevertheless, they do provide the only contemporary guidelines we have.

6. A major pentimento runs around the right edge of the hat, and another is found in the right sleeve, which was probably originally white. Unfortunately, some of the blues have become transparent and discolored owing to the use of smalt.

7. Slatkes 1965, cat. A13, fig. 31.

8. Nicolson 1958b, 63.

Cat. 43

1. See, for example, the *Singing Boy*, in the Gothenburg, Konstmuseum, reproduced in Nicolson 1958b, cat. A32, pl. 90, which must date from the same period as the present picture.

2. Nicolson 1958b, cat. A38, pl. 76.

3. Slatkes 1965, cat. A11, fig. 13; Blankert and Slatkes 1986, cat. 34, illus.

4. Nicolson 1958b, cat. A27, pl. 30a. When Nicolson first saw the painting, the last digit of the date was not visible, thus he placed it about 1623–24, to make it close to Baburen's 1622 rendering of the same subject. For the Baburen *Singer*, in Halberstadt, see Slatkes 1965, cat. A14, fig. 33. For the correct reading of the Boston date as 1627, see Nicolson 1960, 470.

5. Related to both the Bloemaert and our picture is a *Shepherdess with a Letter* by Paulus Moreelse (location unknown). Significantly, the "letter" in the Moreelse contains an abbreviated version of the same poem in the Toledo Bloemaert. See

Kettering 1983, 47, fig. 30, for the Moreelse, and fig. 107 for the Bloemaert.

6. The closest parallel I have been able to find is Domenichino's 1616–17 *Cumaean Sybil*, in the Borghese collection, Rome; see Spear 1982, cat. 51, fig. 171. There is no evidence at this time, however, to indicate that our picture is meant to represent a Sybil, although I would not remove that possibility.

7. Blankert and Slatkes 1986, cat. 27, color illus.

8. Slatkes 1987, 324–30.

9. The suggestion made in Ten Doesshate-Chu and Boerlin 1987, 108 n. 4, that our picture is possibly a pendant to a male musician, such as one of Ter Brugghen's *Lute Players*, is based on the traditional but incorrect supposition that our work represents a singer.

Cat. 44

1. Held 1985–86, 50.

2. Döring 1993, no. A25; Döring knew the painting only from a photograph.

3. Blankert and Slatkes 1986, no. 50; Döring 1993, no. A38.

4. Döring 1993, 117–22.

5. Ibid., 38–40, no. A4.

6. Van de Passe's text and prints are discussed by Spicer and Bok in this catalogue; see also Döring 1993, 12.

7. Von Sandrart/Peltzer 1925, 191.

8. For Bronchorst's identified drawings, see Döring 1993, 113–17.

9. Ibid., no. A17.

10. Ibid., no. A18, illus.

Cat. 45

1. A recent cleaning removed the signature of Jan Baptist Weenix, which had been added at a later date. Weenix is a more well known painter than Knüpfer, and the fake signature was certainly meant to increase the value of the picture.

 Despite the claims made by Paul Huys Janssen 1989, the author maintains the spelling of the artist's name with an umlaut. It can be assumed that Knüpfer used the squiggle over the *u* because there is no umlaut in Dutch. In Germany, where the artist was born, the spelling "Knupfer" would have been highly unusual.

2. Knüpfer often painted what appears to be the edge of a stage at the bottom of his paintings: see *David before Saul* (n.d., oil on panel, 24 × 36.1 cm; Centraal Museum, Utrecht, 11148), which even includes a stage curtain; *Zerbabel before Darius* (n.d., oil on panel, 69 × 53 cm; Musée des Beaux-Arts, Narbonne, 616); and *The Death of Sophonisba* (n.d., oil on panel, 30.7 × 25.2 cm; National Museum, Kazan [Russian Federation], 449). It is possible that Knüpfer, whose wife and child died early, had close contacts with the theater or the *Reederijkers* movement.

3. Nippold 1923; Woltjer 1991, 32–48.

4. The Haarlem painter Johannes Torrenius (1589–1644), for example, was condemned to death for his indecent pictures; he escaped the sentence thanks to a call from England to go to the court of Charles I. See Van Steur 1967; Muizelaar 1993.

5. Luke 15:11–32.

6. See Renger 1970. The first depiction as an independent theme is Lucas van Leyden's *Prodigal Son* of about 1520

(Holl. 33; unique impression, Bibliothèque Nationale, Paris), where the banderole with the words "wacht, hoet varen sal" (wait and see what happens) points to the ominous end of the story.

7. Schweckendieck 1930; Kat 1952.

8. Renger 1970, 42–64.

9. Busch 1983.

10. Ripa 1644, 470: "de veerbos op't Hooft, bedient dat de Sinnen sich so licht bewegt als de pluymen, door een kleyen windeken" (Like the feathers of a hat, the senses are moved by a light breeze); quoted in De Jongh et al. 1976, 60, cat. 8.

11. Boekenoogen 1908, 10 (with an illustration of the brothel scene), where the Prodigal is described as being treated "like a prince" (*ghelijk een Prince ghetracteert*); 11, where he is called a *Joncker* (wealthy landowner); 20–21; and 47–48 (illustration of a *Joncker* on horseback).

12. Galama 1941.

13. The dating can be confirmed by comparison with the *Contento* picture in Schwerin, dated 1651 (see Spicer, introduction to this catalogue, fig. 7), which exhibits a similarly delicate brushstroke.

14. *Merry Company*, ca. 1640, oil on panel, 49 × 67 cm, Musée Municipal des Ursulines, Macon.

15. See Huys Janssen 1994a, 202, cat. 137; 203, cat. 138; 205, cat. 141; 208, cat. 145.

16. Maerten Stoop, *Merry Company*, n.d., oil on panel, 45 × 72 cm, Statens Museum for Kunst, Copenhagen.

17. Jan Steen, *Merry Company*, n.d., oil on panel, ca. 50 × 65 cm, Kunsthand Goudstikker, Amsterdam (before 1940; photo in RKD). See also Beuckelaer's *Bordello Scene* (Franits, fig. 9, in this catalogue).

18. As seen in some great examples of this, for instance, Hendrick ter Brugghen's *Musical Group* (cat. 40) and Gerard van Honthorst's *Musical Group by Candlelight* (cat. 35) and *A Soldier and a Girl* (cat. 36).

19. For example, Rembrandt, *Andromeda*, oil on panel, 34.1 × 24.5 cm, Mauritshuis, The Hague (Gerson 55); Govaert Flinck, *Landscape with an Obelisk*, oil on oak, 54.5 × 71 cm, Isabella Stewart Gardner Museum, Boston.

20. De Jongh 1968–69.

Cat. 46

1. Sources are Catullus 64 and Apollodorus, epit. 3.2, with the motif of the apple of Eris (missing in this composition by Bloemaert but included in figs. 1, 2) that will lead to the Trojan War.

2. See esp. the drawings in Braunschweig and Munich, the latter dated 1593; Bevers 1989, no. 57 and fig. 56.

3. Van Mander 1604, fol. 94r; see Sluijter 1986, 198–210.

4. See Froitzheim-Hegger 1993, 122.

5. For Arcadian painting, see Kettering 1983 and Van den Brink and De Meyere 1993.

6. Amsterdam, Rijksprentenkabinet, 1890 A-2339; see Luijten et al. 1993, no. 1.

7. Ibid., no. 2.

8. For the terminology, see Seelig 1997a, 23.

9. Lowenthal 1986, nos. A-4, A-20, A-49, A-50, A-53, A-81.

10. For the person of Simon zur Lippe, see Roethlisberger 1993, 63.

11. Roethlisberger 1993, nos. 11 (*Wedding of Cupid and Psyche*), 12, 13, 24, 548. The last work (fig. 2) is too late, and our small painting is unlikely to be mentioned. For the other three numbers, of which only two refer to extant pictures, compare Seelig 1996, 103.

12. Van Buchell 1907, 257.

13. Rotterdam 1976, no. 19; the inscription on the verso reads, *d Heer Barth. Spranger van den Schilde.*

14. Ibid., 64.

15. Ibid., nos. 21, 34.

16. Ibid., no. 548. In this picture, also in the Mauritshuis, the wedding couple is surely to be seen at the head of the table to the right. The youthful Peleus is wearing a helmet, Thetis is shown with her hand on a vase with marine motifs as would be fitting for a Nereid. Roethlisberger 1993, 342, identifies these same figures erroneously as Athena and Psyche and comments on the presumed absence of the main couple.

17. Ibid., nos. 25, 26, 27, 550; compare nos. 495, 562, 563, 564, 565.

18. Van Mander 1604, fol. 285r; Luijten et al. 1993, no. 26.

19. Van Mander 1604, fol. 278.

Cat. 47

1. The most important classical sources are Homer *Odyssey* 8.266–366, and Ovid *Metamorphoses* 4.171–89. See Reid 1993, 1:195–203, on the myth, other classical sources, and postclassical depictions.

2. Van Mander 1604, *Het leven*, fols. 296v–297r. Jan van Wely was a leading merchant in Amsterdam, and Melchior Wijntgis was mint-master of Zeeland from 1601 to 1612; see Bok 1993a, 147–49, 161–62.

3. See Lowenthal 1995, 35–36. Broos 1986, 374, and Broos 1987, 418, identifies the Hague painting as Wijntgis's and the Getty painting as Van Wely's, which necessitates dating both before 1604, unlikely on the basis of style. Lindeman 1929, 251, under no. 21, mentions a painting by Wtewael of the subject in the British Institution Exhibition, 1834 (cat. 59); later sale, Sir Charles Bagot (London), 17 June 1836. He mentions a fourth, ibid., 252, no. 32, oval, 13 × 10 cm, Professor K. Glaser coll., Berlin, formerly Böhler coll., Munich. One of them might have been the second painting mentioned by Van Mander.

4. See Lowenthal 1996, 52–56; and Weddigen 1994.

5. See Bowron 1995 on the use of copper as a support.

6. *Het leven*, fol. 296v.

7. See Lowenthal 1996, figs. 4, 7, 12.

8. A common feature of erotic subjects at the time; see De Jongh 1968–69, 45–47 nn. 51–53.

9. For more on the significance of shoes and slippers, see Lowenthal 1986, 120. Broos 1986, 375, and Broos 1987, 420, sees in the slippers a sign of adultery.

10. Luijten et al. 1993, 342–43, cat. 11.

11. "It is a sure thing that one can conceal one's evildoing from men but not from God, who clearly sees into the depths of our hearts and knows our hidden thoughts and desires." Van Mander 1604, *Wtlegghingh*, fol. 15v, in my translation. See further Lowenthal 1995, 20.

12. Pen and brown ink and wash, 21.8 × 16.7 cm, inv. 9587 Santorelli.

13. Pen and brown ink, gray and brown wash, heightened with white (partly oxidized), 20.3 × 15.4 cm. See Lowenthal 1995, fig. 19.

14. Broos 1986, 374; and Broos 1987, 420. For the vicissitudes of the Getty picture, see Lowenthal 1996, 67.

Cat. 48

1. A similar helmet appears in The Hague *Mars and Venus Discovered by Vulcan*, cat. 47.

2. Monogrammed and dated 1602, oil on copper, 47.6 × 34.3 cm, 61.006.

3. For a useful history of the use of copper as a support, see Bowron 1995.

4. Van Mander 1604, *Het leven*, fols. 296v–297r. See also Wtewael's *Mars and Venus Discovered by Vulcan*, cat. 47.

5. Coornhert 1586, 31, my translation.

6. For more on the moralizing implications of mythological scenes, see Sluijter 1986, 580–85. See also Schama 1987, esp. chap. 3, "Feasting, Fasting, and Timely Atonement." Schama sees in seventeenth-century Dutch culture two simultaneous but divergent value systems, centered on appetite and restraint, that exist in complementary symbiosis.

7. Lowenthal 1986, 99, A-19; and Lowenthal 1995, 6, fig. 6 in color. There is in addition a copy of the Amsterdam *Mars, Venus, and Cupid;* see Lowenthal 1986, 161, B-3.

8. On this significance of bowls and baskets of fruit, see Lowenthal 1988, 14, 17 n. 18.

9. For a discussion of seventeenth-century conceptions of love (*minne* and *liefde*), see De Jongh 1968–69, 60–62.

10. Bredius 1915–22, 2:396. On Niquet, see Bok 1993a, 158.

11. Mielke 1979, 27–28, no. 7. See cat. 47, on the pertinence of such inscriptions to paintings.

Cat. 49

1. Van Mander 1604, *Wtlegghingh*, fols. 90v–91r.

2. The most important ancient source is Catullus *Carmina* 64. For more on the myth in Wtewael's time, see Sluijter 1980, 57–58; Sluijter 1986, 198–210, 582; and McGee 1991, 193–203. On Peleus and Thetis, see Reid 1993, 2:1027–32.

3. For other Netherlandish depictions of the time, see Sluijter 1986, 590; McGee 1991, 175–82; and Roethlisberger 1993, 1:62–65. See also cat. 53, *Feast of the Gods* by Cornelis van Poelenburch.

4. Lindeman 1929, 134, 262, no. 54, pl. 57, accepted as by Wtewael a drawing related to the Clark painting; Herzog Anton Ulrich-Museum, Braunschweig, Z 264. I believe it to be a copy. For Wtewael's weddings of Peleus and Thetis, see Lowenthal 1986, A-4 (Alte Pinakothek, Munich), with a related drawing in Berlin (Kupferstichkabinett, 12297); A-20 (Herzog Anton Ulrich-Museum, Braunschweig); A-49 (Saul Steinberg, New York); A-50 (Musée des Beaux-Arts, Nancy); A-53 (1610; Museum of Art, Rhode Island School of Design, Providence), with three related drawings, in Amsterdam (Rijksprentenkabinet, A-568), Berlin (Kupferstichkabinett, 12860), and Munich (Staatliche Graphische Sammlung, 41062). For the Amsterdam drawing, see Luijten et al. 1993, 559–60, cat. 231, illus. Wtewael's latest known depiction is recorded by a drawing in Haarlem (1622; Teyler's Stichting,

023); Lowenthal 1986, 146, pl. 114. Fragments of the related painting are in Vienna (Schwarzenberg coll., by 1654), ibid., 146, A-81; and with Bernard Houthakker, Amsterdam. See also Lowenthal 1986, A-30, a Feast of the Gods that omits Eris.

5. Froitzheim-Hegger 1993, 133–41, offers a Neoplatonic interpretation of the Braunschweig painting. On Wtewael's other Feasts of the Gods, see 122–33. Froitzheim-Hegger's suggestion that the wedding theme is conflated with the Golden Age fails to acknowledge the specific character of the latter subject, which Wtewael depicted in a painting of 1605; The Metropolitan Museum of Art, New York, 1993.333. See Lowenthal 1997.

6. I examined the picture under magnification with Sandy Webber, paintings conservator at the Williamstown Art Conservation Center. There are minor abrasions at the perimeter, and retouchings repair damage caused by the frame. The paint on all four sides is smooth and rounded off.

7. For more on copper as a support, see Bowron 1995.

8. Now Frans Halsmuseum, Haarlem, 246 × 419 cm. Sluijter 1986, 590, no. 5, illus.; McGee 1991, 194–203.

Cat. 50

1. Van Mander 1604, *Wtlegghingh*, fol. 90v. On classical sources and postclassical depictions, see Reid 1993, 2:821–31. Damisch 1996 considers diverse representations as a focus for Freudian and Kantian explorations of the linking of beauty and desire.

2. Van Mander 1604, *Den grondt der edel vry Schilder-const*, the section of the *Schilder-boeck* on the fundamentals of painting, fol. 42r, chap. 9, v. 47.

3. Van Mander 1604, *Wtbeeldinghen der Figuren*, fol. 131r.

4. Sluijter 1986, 24.

5. Lowenthal 1986, A-21, A-22, A-25, pls. 32–33, 37. An unpublished replica of the Waddesdon Manor painting (A-25) is in a private collection; copper, 16.5 × 21.5 cm. The London painting closely resembles an even larger panel (81 × 104.5 cm) in composition and style; ibid., A-64, pl. 93. I now regard the copper in the Szépművészeti Múzeum, Budapest (Lowenthal 1986, A-26, pl. 38) as a copy of the Waddesdon Manor picture. For other copies, see ibid. 168–69, C-39 through C-47.

6. Ibid., 82–83, A-4 (Alte Pinakothek, Munich), 100–101, A-20 (Herzog Anton Ulrich-Museum, Braunschweig; cat. 49, fig. 2); and 124, A-50 (Musée des Beaux-Arts, Nancy). The London painting is, however, the only known *Judgment of Paris* by Wtewael that includes the wedding scene.

7. Ancient sources convey the compelling appeal of this beauty contest: "'Will it be enough to judge them as they are?' Paris asked Hermes [Mercury], 'or should they be naked?' 'The rules of the contest are for you to decide,' Hermes answered with a discreet smile. 'In that case, will they kindly disrobe?'" Graves 1960, 2:271, drawing on Ovid *Heroides* 16.71–73 and 5.35–36; Lucian *Dialogues of the Gods* 20; and Hyginus *Fabula* 92.

8. Damisch 1996, 280–81, notes Wtewael's dependence on the Raphael/Marcantonio composition and comments on the unusual inclusion of the wedding scene. See Sluijter 1986, 24–29, on Netherlandish depictions of the Judgment of Paris and their dependence on that engraving.

9. Roethlisberger 1993, 69, cat. 17, fig. 40.

10. For the related painting of the *Judgment of Paris*, see Lowenthal 1986, A-64, pl. 93.

Cat. 51

1. The main classical source is Ovid *Metamorphoses* 4.663–752, according to which Perseus flew with the aid of magical winged sandals. Wtewael, following postclassical precedents that include Bernard Salomon's illustration from the *Métamorphoses d'Ovide figurée* (Lyons, 1557), shows Perseus astride Pegasus. On classical sources for the myth and later treatments, see Reid 1993, 2:875–83.

2. Van Mander mentions a small *Perseus and Andromeda* by Abraham Bloemaert in his biography of that artist; see Van Mander 1604, *Het leven*, fols. 297r–298v. A panel painting datable in the mid-1590s (Richard L. Feigen, New York) is attributed to Gerrit Pietersz., panel, 40.5 × 31 cm, sale, Sotheby's (London), 29 June 1966, lot 18, as attributed to Cornelis van Haarlem. Sluijter 1986, 48–49, suggests an attribution to Gerrit Pietersz. Sweelinck.

3. See also Hendrick Goltzius (1583; Holl. 157), Jacob Matham after Goltzius (1597; Holl. 227), and Jacques de Gheyn after Karel van Mander (Holl. 422). See Sluijter 1986, 386 n. 48-1, for a more complete listing.

4. Rearick 1988, 170–71, no. 86, color illus. Oil on canvas, 257.8 × 208.9 cm.

5. Luijten et al. 1993, 85. Sluijter 1986, 584–85, discusses seventeenth-century Dutch ideas linking the erotic and moralistic, esp. in depictions of nudes. The Eros/Thanatos opposition is also important in the theme of Lot and His Daughters, which Wtewael treated several times. See Lowenthal 1988.

6. Segal 1988, 77–92, "Shell Still Life," esp. 80.

7. Hendrick Goltzius's portrait of the conchologist Jan Govertsz. van der Aar (1603; Museum Boymans-van Beuningen, Rotterdam, on loan from the Stichting Collectie P. and N. de Boer, Amsterdam), which includes prized specimens from the sitter's collection, bespeaks that collector's patronage of the arts. See Luijten et al. 1993, 584–85, cat. 256, illus. Govertsz. died in 1612 and thus theoretically could have commissioned Wtewael's *Andromeda*, but there is no evidence for that.

8. Shells are attributes of Venus, recalling the circumstances of her birth and signifying her sensuality. See Van Mander 1604, *Wtbeeldinghen der Figuren*, fol. 131r. Jacques de Gheyn the Younger's *Neptune and Amphitrite* (Wallraf Richartz-Museum, Cologne), in which Cupid explores the contents of a nautilus shell, demonstrates Wtewael's contemporaries' attunement to the natural suggestiveness of shells. See Segal 1988, 79, fig. 5-3.

9. Van Mander 1604, *Wtlegghingh*, fols. 41r–42v.

10. See Sluijter 1986, 386 n. 48-1, for sources on the political implications of the subject.

11. See Lowenthal 1986, 32–33; Luijten et al. 1993, 327; and the biography in the present catalogue.

12. Lowenthal 1986, 131.

13. Described as a "tableau d'une composition délicate, et executé avec soin." Probably sold by Schmidt, for 5¼ guilders. See Lowenthal 1986, 208. A *Perseus and Andromeda* that I catalogued as problematical on the basis of a photograph has not reappeared. Lowenthal 1986, 161–62, B-4, pl. 139.

14. Broos et al. 1990, 491.

Cat. 52

1. The classical literature on Prometheus and its interpretation by later artists is surveyed in Raggio 1958. See also Graves 1960; Dempsey 1967. Thus far, examination of contemporary Dutch literary sources, for example the section on Vulcan and Prometheus in Van Mander's *Wtlegghingh op den Metamorphosis Pub. Ovid. Nasonis* (in *Het Schilder-boeck*, 1604) and Joost van den Vondel's *Den Gulden Winckel* (1613, emblem 5), has not been fruitful.

2. Of the series of the Four Damned, taken from Ovid's *Metamorphoses* and painted in 1548–49 for Maria of Hungary, governor of the Netherlands, *Tityus* and *Sisyphus* were commissioned from Titian, and *Tantalus* and *Ixion* from Michiel Coxcie. See Van den Brink and De Meyere 1993, no. 233; Valcanover et al. 1990, no. 44.

3. 1566, Holl. 192; illus. most recently in Luijten et al. 1993, under no. 4, as "Tityus" without comment on the addition of the torch.

4. See Sutton 1990, no. 91, for a wide-ranging discussion.

5. The closest conception is a later drawing by Nicolaus Knüpfer showing Vulcan, with the help of an assistant and under the eye of Mercury, chaining Prometheus to a boulder (Kupferstichkabinett, Dresden, C 1937-739; DIAL, 91 C24).

6. For Heemskerck's 1536 painting (National Gallery, Prague) and its sources, see Veldman 1977, 21–32, and Grosshans 1980, no. 21.

7. My thanks to Wouter Kloek for looking at this detail with me.

8. Van Regteren Altena 1983, 2:6, cat. 3. Not recognizing the relevance of the subject for the Smiths' Guild, Van Regteren Altena did not posit a commission but rather assumed that the donors had acquired the painting from De Gheyn's heirs. Even though there are no extant paintings signed or documented by Jacques de Gheyn III, Van Regteren Altena's acceptance of the traditional attribution of *Prometheus* to him on the basis of connections to his signed drawings (esp. those involving close study of the male anatomy), other stylistically related but unsigned paintings, and the paintings of Jacques de Gheyn the Younger is plausible. Nevertheless, the interpretation of the subject in connection with the Smiths' Guild is not affected by the attribution.

9. Huys Janssen 1985, 85–109, esp. 98–101 notes that, because it was not in De Gheyn's will, which was written just before his death in 1641, the painting would have had to have left his hands before then. Huys Janssen posits that it might have been acquired by the deacons through an intermediary owner. However, the highly specific qualities of the interpretation of the story—the unprecedented emphasis on the manacles (which escaped Huys Janssen's attention)—that point to the painting's having been commissioned to celebrate the craft of ironworking militate against this view. For the history of the Sint Eloyengasthuis, see Koch 1947–48, 49–61; Van Hulzen 1981, 29–47.

10. Huys Janssen 1985, 88–91, fig. 1.

11. Vervaet 1976, 219–20; kindly brought to my attention by Walter Melion.

12. For the Smiths' Guild in Utrecht, see Ritter 1988.

13. Ibid., 25.

14. The painting is known through an engraving by Cornelis Cort; Sellink 1994, no. 63.

15. Van Mander 1604, *Wtlegghingh* bk. 2, 14–15. Strangely enough, Van Mander draws no narrative connection between Vulcan and Prometheus (ibid., bk. 1, 2–4), nor does he comment on their both being called the discoverer of metallurgy.

16. Not in Roethlisberger 1993; published in Seelig 1995, A14, illus.

17. Though the painting suggests the representations of Fire from the series of the Four Elements by Jan Breughel and Hendrik van Balen (Ertz 1979, no. 251ff., 382), there is no evidence for such a series by Bloemaert.

18. Slatkes 1965, under no. C6.

19. Slatkes (ibid., 79–81), followed by Christopher Brown (in Blankert et al. 1980, under no. 14), has posited a connection because Prometheus was described by Ovid as the creator of humankind. This explanation would be more persuasive if it accommodated the preeminence of Vulcan.

20. Nicolson and Vertova 1989, 3: fig. 1064.

21. Slatkes 1965, no. C7, with speculations of the visual appearance of the lost painting; publication of the lost painting (Schleier 1972) proved Slatkes's speculations on its appearance to be correct.

22. Slatkes 1965, no. A1, illus.; Nicolson and Vertova 1989, 3: fig. 1035.

23. Von Schneider 1933, 42, was the first.

24. See Nicolson and Vertova 1989, under Caravaggio?, Reni, Valentin, and Stom[er], especially the latter's *Death of Cato*, fig. 1505.

25. Slatkes 1965, under no. A21, has proposed that the immediate source for the figure of the prone Prometheus was an illustration by S. Frisius in *Chronique ofte Historische geschiedenisse van Vrieslant* (Franeker, 1622), for which see Bauch 1926, fig. 3. The comparison is interesting, but, given the pattern of variations of the fallen male figure beginning already in Italy, it seems unlikely that the relationship of Frisius's print is causal.

26. The original text is as follows:

In einem andern Gemähl sind ganze Bilder, wie Hercules in der Hölle dem auf der Erden an Ketten geschmidten und in Verkürzung ligenden Titio seine eiserne Bänder zerreisset und ihn erlediget zu Trutz des dabey gebildeten Cerberus, welches alles mit grosser Verwunderung zu sehen und billich hoch gelobt und gepriesen wird. (Von Sandrart 1675, part 2, bk. 2, 83, in Von Sandrart/Peltzer 1925, 277)

27. Garas 1980, 275.

28. Illustrated by Raggio 1958, 10-a, without real comment; Martin 1965, 140–41, fig. 99, considered it attributable to Lanfranco after Annibale's design.

Cat. 53

1. For Poelenburch's paintings of Banquets of the Gods in the context of those by other Netherlandish painters, see Sluijter 1986, 70–71, 209–10; Froitzheim-Hegger 1993, 146–49; also Sluijter-Seiffert 1984, 92–24.

2. Broos 1993, under no. 29.

3. Sluijter-Seiffert 1984, 267–68.

4. Cuppen 1983, 161–62; Sluijter-Seiffert 1984, no. 22.

5. See Welu 1979, no. 23.

6. Some of Poelenburch's versions are noted by Sluijter 1986, 71 n. 5, and Trnek 1986, under no. 58. Also, from his shop, Sotheby's (New York), 14 Jan. 1994, lot 50A.

7. Sluijter-Seiffert 1984, no. 19; Froitzheim-Hegger 1993, 148.

8. Whatever the perspective of other artists toward the subject of the Banquet of the Gods as an opportunity for moralizing, there is a consensus that the motifs that would suggest a moralizing posture are not characteristic of Poelenburch's renderings (Sluijter-Seiffert 1984, 132; Sluijter 1986, 209–10; Froitzheim-Hegger 1993, 147).

9. In conversation, Alan Chong indicated that he was aware of the drawing when he published his article on Poelenburch's drawings in 1987, but as the red chalk drawings were not then his focus, he hesitated to assess *The Three Graces*.

10. See most recently Clifford et al. 1994, nos. 45, 46; Dussler 1971, 97–99.

11. Chong 1987, no. 32, fig. 14.

12. Von Sandrart/Peltzer 1925, 175.

13. Poelenburch's most "cheeky" picture is his *Scene from the Deluge* (Hallwylska Museet, Stockholm; Cavalli-Björkman 1992, no. 10, illus.).

14. Broos 1993, 241–42, fig. 4.

15. For example, in *Psyche Escorted to Olympus by Mercury* (Öffentliche Kunstsammlung, Basel; Sluijter-Seiffert 1984, no. 27; Welu 1979, fig. 23b), the figure of Venus echoes Ceres' back from the Mauritshuis painting and her elegant right leg from the Los Angeles composition.

16. Froitzheim-Hegger sees here "the silvery tonality that Van Poelenburch developed in Italy" (1993, 148).

17. Broos 1993, 241.

18. Sluijter-Seiffert 1984, no. 32, illus.; 1993b, 241, fig. 3 (erroneously dated as 1624).

Cat. 54

1. See Sluijter-Seijffert 1984, 94–96, 138–39, nos. 105–22. She did not know the present work.

2. Blankert 1978, no. 19 (as dated 1624); Sluijter-Seijffert 1984, no. 117 (1624, not questioned); however, White 1982, no. 142, raised the possibility of a reading as 1627, which has since been confirmed with the assistance of Nicole Hartje. That the conception of the landscape accords more nearly with those done after the artist's return was noted by Duparc and Graif 1990, under no. 52.

3. See the discussion of Van Haensbergen's monogrammed *Landscape with Bathing Nymphs* (Centraal Museum, Utrecht), based directly on a painting by Poelenburch and workshop in the National Gallery, London, in Van den Brink and De Meyere 1993, no. 24.

4. For example, the same standing woman appears in *Landscape with Roman Ruins* (Norwich Castle Museum; Wright 1983, no. 11, illus.). The suggestion (Duparc and Graif 1990, 170) that the standing woman is the same figure as the daughter in *Grotto with Lot and His Daughters* (cat. 69) is not convincing. The issue of repeated figures and the role of drawing is outlined by Chong 1987, 13.

5. See the facsimile by Van Gelder and Jost 1985, pl. 82; Chong 1987, 60.

6. See, for example, the studies of grottos illustrated by Duparc and Graif 1990, figs. 59, 60; Chong 1987.

7. Duparc and Graif 1990 have proposed that they allude to the Baths of Diocletian.

8. Duparc and Graif (ibid., 172) refer to the probability that "the richly decorated frame was designed by Charles Percier (1764–1838) and Pierre-François Fontaine (1762–1853), the two architect-decorators responsible for planning and beautifying the residences of the Imperial Family."

9. The verso of the panel is beveled on all six sides (idem, based on information from Galerie Sankt Lucas, Vienna). The verso is now covered with a protective backing.

10. A curved top was more common for paintings intended for such doors, but one shaped exactly like the one on this Poelenburch, found on a chest datable to ca. 1650–70, is illustrated in Riccardi-Cubitt 1992, fig. 29; see also fig. 31. See, further, the discussion of an *Ebony Cabinet Inset with Italianate Landscape Panels* by Jan Siebrechts, 1653, Wieseman, in Sutton 1993, no. 92; Fabri 1991.

Cat. 55

1. Some of Van der Lisse's paintings do have real subjects, the pastoral *Crowning of Mirtillo* (location unknown, Van den Brink and De Meyere 1993, fig. 35.2) being one, but most of his landscapes are animated by small figures that appear to be interchangeable—bathing nymphs, Diana and her nymphs, nymphs and satyrs dancing; even depictions of Diana and Actaeon are treated generically. See Van den Brink and De Meyere 1993, no. 36; Foucart 1970, figs. 5, 6; Klessmann 1983, nos. 195–97.

2. Sale, F. Muller (Amsterdam), 29 Nov. 1939, lot 973; Colnaghi's (London), 1979. The identification as the family of Adolf van Nassau was shown to be impossible by Kettering 1983, 174–75, who also questions the previous attributions to Poelenburch or Van der Lisse: Both artists were dead by the time (ca. 1673) the children (if they are Adolf's) had attained the age at which they were painted. If they are not Adolf's children, there is nothing to obstruct a dating to the 1640s or 1650s nor an attribution to Van der Lisse (as suggested by Sluijter-Seijffert 1984, 191), to whose style the execution is closer, so far as can be judged from the photograph.

3. See Broos 1993, under no. 23, fig. 6.

4. Fifth Day, First Story; see Spaans, in Van den Brink and De Meyere 1993, under nos. 38, 49.

5. Ibid., under no. 38.

6. Iphigenia showed no interest in him. Cimon then abducts her completely against her will. She is liberated and he abducts her again, again against her will. Boccaccio says that Cimon lived happily ever after, the implication being that this is a romantic story.

7. See Van den Brink and De Meyere 1993, under no. 49.

8. Städelsches Kunstinstitut, Frankfurt; illus. in Broos 1993, under no. 23.

9. Van den Brink and De Meyere 1993, under no. 38.

10. The young woman in *Sleeping Nymph Spied on by Two Shepherds* (Gemäldesammlungen, Munich) is nude except for a garland of flowers, and has no crescent moon. Also by Van der Lisse in the same collection is a *Diana Sleeping near a Cascade*, with no voyeurs.

11. Judson 1959, no. 89.

12. See Saftlevens's *Sleeping Hunter in a Landscape* (cat. 73).

13. Broos 1993, under no. 23.

Cat. 56

1. Slavíček 1994, 56, cat. 15, mistakenly claims that Diana is the figure emerging from the bath. The way in which the cloak is being removed, however, demonstrates that this cannot be the case.

2. Hunger 1981, 64–67, 106–8.

3. Pigler 1974, 74–76.

4. In fact, the story itself combined two mythological traditions. The oldest sanctuary of the Diana cult was a cave near Arricia on the shore of Lake Nemi, once known as Diana's Mirror. She also had a temple on the Aventine Hill in Rome which, according to legend, was founded by King Servius Tullius (Radice 1988, 103). The nymphs, by contrast, derived from Greek mythology; the Romans adopted and transformed them for their own purposes. They were frequently the victims of male gods and, as Naiads, were always associated with sources of water (ibid., 173). Nymphs were the Hellenistic contribution to fountain design, where they were often represented in a manner similar to the one seen here. The fountains themselves generally had no direct connection to a particular shrine and in the course of time developed into a permanent component of palatial architecture. Examples can be found in Pompeii and Herculaneum as well as in the Villa Giulia in Rome (dating from the sixteenth century).

5. *Diana and Her Companions at the Hunt*, oil on panel, 50 × 66 cm, formerly the Dutchess Caracciolo di Brienza coll. (1928; photograph Witt Library); the landscape is by another hand, possibly Willem de Heusch (see n. 10 below).

6. "*Wijn is Venusmelk,*" oil on panel, 49 × 60 cm, formerly with Galerie Müllenmeister, Solingen. The study for it is pen and brush on laid paper, 295 × 399 mm, Museum der bildenden Künste, Leipzig, J 2698.

7. See Kuznetsov 1974.

8. Willnau 1935.

9. See the background figure in *David before Saul* in Utrecht (illus. in Kuznetsov 1974, 183, no. 7, fig. 2); *Absalom and Tamar* in St. Petersburg (ibid., 184, no. 12, fig. 3); Cleopatra in *Anthony and Cleopatra* in Ljubljana (ibid., 199, no. 107, fig. 16); and Chariclea in *Theagenes and Chariclea* in Stockholm (ibid., 203, no. 128, fig. 20).

10. The coauthorship of Nicolaus Knüpfer and Willem de Heusch is established and published here for the first time. See my unpublished dissertation on Knüpfer, Rohe n.d.

11. See, for example, the picture by Jan Both and Cornelis van Poelenburch, *Arcadian Landscape with the Judgment of Paris*, cat. 72. Both and Poelenburch were probably more active in this sort of cooperation than any other artists.

12. Willem de Heusch, *Diana and Her Nymphs*, probably oil on canvas, signed, with R. H. Ward (London, as of 1932; photograph in the Rijksbureau voor Kunsthistorische Documentatie, no measurements given).

Cat. 57

1. The original poem reads as follows:

 Mijn Son die boven d'ander claer, is,
 Ick houd' u in mijn arm, en twijfel oft het waer, is.
 Mijn siel is soo beroert (ayme!) dat ijck daer van De
 grondelose vreuchd niet vol genieten can.
 Ick en gelove nauw mijn staet dus hooch geresen,
 En denck vast of jck wel Daifilo niet sou wesen.
 (Hooft 1615, 4, 5, 1569–74)

2. As far as is known, the only other painting to depict this scene is by Gerard van der Kuyl, a pupil of Honthorst's. See Sluijter 1977, 176–77, cat. A5; Van den Brink and De Meyere 1993, 173–76, cat. 27, fig. 27.1.

3. Van den Brink and De Meyere 1993, 87–91, cat. 4.

4. See Hibbard 1983, 138–48, esp. 144.

5. The evidence for this is provided by Willem's monogram, which was uncovered on the back of the original canvas during conservation treatment. See De Meyere 1989, 93–96.

6. "Schoorsteenstuck van Honthorst synde de Fabel uyt Ariosto van Angelica en Medor . . . [in] Syne Majestyts antichambre aan de parterre" (Börsch-Supan 1967, 198, cat. 127).

7. Angelica and Medoro are two characters in Ludovico Ariosto's *Orlando furioso*, which was published in 1516. The painting was later referred to simply as a "shepherds' idyll." See Berlin 1890, cat. 114.

8. Stechow 1928–29, 185.

9. The hypothesis that the painting might have been a wedding present was put forward by Jos de Meyere (1988a, 96), who suggested that it may have been given by Elector Frederick V of the Palatinate and his wife Elizabeth. Before her marriage, Amalia van Solms was lady-in-waiting to Elizabeth.

Cat. 58

1. J. Richard Judson very kindly shared with me the manuscript for the forthcoming revision of his monograph on Honthorst; no. 207, pl. 107.

2. See Spicer, introduction to this catalogue.

3. The version with Wildenstein, New York, is signed and dated 1623; see Blankert and Slatkes 1986, no. 37.

4. Honthorst's 1628 pastoral portraits of Charles I and Queen Henrietta Maria, now lost, popularized the genre among the English elite. Charles's sister, Elizabeth Stuart, who resided in The Hague with her husband, Frederick V, the exiled king of Bohemia, also commissioned pastoral works from Honthorst, including portraits of herself and her family. See, for example, *The Family of Elizabeth and Frederick, King and Queen of Bohemia*, Prince von Hannover collection, Schloß Marienburg (Kettering 1983, fig. 82), and a painting of Elizabeth Stuart's daughter, *Portrait of Elizabeth II of Pfalz as a Shepherdess*, earl of Pembroke's collection, Wilton House (Kettering 1983, fig. 59).

5. It has been suggested that either Honthorst's *Pastoral Concert* (fig. 1) or the Seattle *Shepherdess Adorned with Flowers* may be the picture referred to in this inventory; see Ishikawa et al. 1994, 158. Kettering (1983, 171–98) provides a list of pastoral works cited in Dutch inventories; for the Honthorsts recorded in the stadholder's collection, see 182–84. On the

stadholder as patron and collector of pastoral subject matter, see cats. 57, 59.

6. Cafritz, Gowing, and Rosand 1988, p. 38.

7. Ishikawa et al. 1994, no. 22.

8. Van den Brink and De Meyere 1993, no. 29.

9. See ibid., no. 28. To substantiate this reading, the Munich girl is compared with a drawing by Honthorst possibly representing *The Four Seasons* (Centraal Museum, Utrecht), in which a figure playing a lute approximates the pose of the figure in the painting. But one wonders if the Utrecht figure is actually a female and if the theme is indeed the Four Seasons as suggested.

10. The gesture of offering flowers is seen in, among other examples, Moreelse's 1627 *Shepherd* (see Spicer, introduction to this catalogue, fig. 13), now in Schwerin.

11. Judson 1995, 128–29.

12. See Welu and Biesboer 1993, 126–27, fig. 1c.

13. Judson 1995, 128.

Cat. 59

1. Roethlisberger 1993, 488–89.

2. For editions and other aspects of literary interest, see Verkuyl 1971.

3. The paintings are illustrated this way by Börsch-Supan 1967, 170–73. For the most extensive account of the series, see Van den Brink and De Meyere 1993, where the four larger paintings, which are separated in Berlin, were exhibited together (nos. 12, 35, 48, 51).

4. Börsch-Supan 1967, 167, has speculated that these landscapes seem to have illustrated four ways of providing food: cattle breeding, fishing, hunting, and agriculture (now missing). Stated as a fact by Roethlisberger 1993, 327.

5. This tends to be forgotten by later authors, although it was already established by Börsch-Supan 1967, 169, who first reconstructed the provenance and the parts of the series.

6. See Snoep 1969, 284–88; and Drossaers and Lunsingh Scheurleer 1974, 525, nos. 82–85 with notes.

7. For these paintings, see Seelig 1997a, nn. 426, 434.

8. Van Gelder 1948–49.

9. Roethlisberger 1993, no. 425.

10. I have tried to trace some of the iconographic aspects of Honthorst's contribution in a paper delivered at the symposium "Dutch Art and Life" at Hofstra University, 19 Oct. 1995, entitled "Caravaggesque Genre Paintings as Court Art."

11. As an outstandingly positive author, see Hudig 1928; for the subject in regard to the relation of Honthorst and Bloemaert, see Seelig 1997a, chap. 7.

12. See Seelig 1997a, 274–77, for other examples of another hand's being responsible for the background figures.

13. Ibid., 32.

14. Roethlisberger 1993, no. 511.

15. Ibid., no. 544.

Cat. 60

1. Elias 1903–5, 645. For assistance in checking this and other details in this entry, I wish to thank Marten Jan Bok and Karen Schaffer-Bodenhausen.

2. For pastoral portraiture, see Spicer, introduction to this catalogue; also Smith 1982, chap. 7; Kettering 1983; De Jongh 1986, under no. 79; Van den Brink and De Meyere 1993, 13–14. The only reference to the Baltimore portraits in these publications is a footnote reference to the sitters in Van den Brink and De Meyere 1993, under no. 10.
3. Sluijter-Seijffert 1984, no. 194; Pigler 1967, 552.
4. See Kettering 1983, 177; De Meyere, in Van den Brink and De Meyere 1993, 25–27.
5. See under cat. 27.
6. Smith 1982, chap. 7.
7. Cats 1625, 80, as cited by De Jongh 1986, 37.
8. De Jongh 1986, 37–39. The many seventeenth-century representations of courting couples "walking out" together include that on the title page of Jacob Cats's immensely influential *Houwelick* (1625).
9. The *Portrait of Jan Pellicorne with His Son Casper* and the *Portrait of Susanna van Collen with Her Daughter Anna* (Wallace Collection, London) are described in Bruyn et al. 1986, 2:714, C65, C66, as showing the "same sitters at about the same age" as in the Baltimore paintings. This does not address the weight gain and settling of features, especially Susanna's, noticeable in the London portraits.

Similarities between Poelenburch's portrait of Jan Pellicorne and Jan van Bijlert's *Portrait of a Man in a Plumed Hat* (1630s; with Noortman [Maastricht] in 1993), which prompted Van den Brink and De Meyere 1983, no. 10A, to wonder if Bijlert's sitter could be Pellicorne, are restricted to elements of fashion.
10. In the inventory that Willem Vincent, baron van Wyttenhorst, made of his family's paintings in the 1650s (Cuppen 1983), the small portraits of family and friends by Poelenburch are listed as being in his wife's *cabinet*.

Cat. 61
1. Sluijter-Seijffert's discussion of Poelenburch's portraits (1984, 108–10) does not include a chronological analysis. She follows Wilson 1980 in supposing that the Baltimore portraits should be dated in connection with the couple's marriage.
2. The initial attempt to X-ray the painting was not successful. The copper support itself will absorb the X radiation. However, the electron-emission radiograph shown in fig. 1 makes use of the electrons emitted by the paint itself when bombarded with X rays.
3. In referring to the article by Bridgman et al. (1965), Sluijter-Seijffert 1984, 191 n. 65, queries whether Poelenburch was painting over a preexisting portrait by another hand or had altered a portrait painted by himself. Because the changes to the facial features are so slight, it is clear that the artist has altered a portrait he himself painted.
4. My thanks to Terry Drayman-Weisser for having carried out a series of electron-emission radiographs of the painting and for her help in analyzing them for this entry.
5. See Cuppen 1983; Sluijter-Seijffert 1984, 109–10.

Cats. 62, 63
1. Kettering 1983, 45.
2. Ibid., 42–43.

3. The perceptive, individualized conceptions led me to suggest (Lowenthal 1986, 150) that these might be *portraits historiés* of Wtewael's daughter Antonietta and her husband-to-be, Johan Pater, whose formal portraits Joachim painted in 1626 (Centraal Museum, Utrecht). It now seems likely that if Wtewael's family served as models it was only in a general sense.
4. Smits-Veldt and Luijten 1993, 59, fig. 42. See also Sluijter 1993, 33–35.
5. See Buijsen and Grijp 1994, 202–5, no. 19, esp. n. 6, for other pastoral paintings with shepherd pipers. See 246, on bagpipes as peasants' instruments, actually and in art. See also Winternitz 1979, 66–85.
6. Kettering 1983, 36.
7. Buijsen and Grijp 1994, 246.
8. Kettering 1983, 40–41. For the Utrecht painting, see Lowenthal 1986, 84–85, A-6, pl. 8; and Helmus 1997, 121–24.
9. *Shepherd:* canvas, 107.5 × 142 cm. Lowenthal 1974, 466, and Lowenthal 1986, 178–79, D-12, D-13, pls. 174–75, color pls. 26–27. See also the *Shepherd Piper* attributed to Peter Wtewael, oil on canvas, 84 × 76 cm, sale, Sotheby's (London), 11 Dec. 1996, lot 112.
10. Four paintings are dated 1628. See Lowenthal 1986, 156–59, A-95 through A-98, pls. 131–34.

Cat. 64
1. For the development of Dutch pastoral painting, see Kettering 1983.
2. See also Van Haeften 1992, no. 24, illus.
3. It is generally accepted that the four paintings were presented as a gift on the occasion of the marriage of Frederik Hendrik with Amalia van Solms on 4 April 1625. This hypothesis has been doubted by J. de Meyere and E. Domela Nieuwenhuis, for which see Van den Brink and De Meyere 1993, 23, 225–27. According to De Meyere the gift marked a birthday, while Domela Nieuwenhuis thought it was made in connection with the birth on 27 May 1626 or with the baptism on 1 June in that year of Prince Willem II. It is unlikely that it was a wedding gift, since the States of Utrecht only began to arrange for the preparations of the gifts in December 1626, in other words eighteen months after the wedding, which is more than just a little late. Nor is it likely to be a birthday present, since Amalia was born in October, and she received the present in May. Nor is the third hypothesis acceptable because in the seventeenth century it was the custom to offer a gift to the child and not to the mother. Even if Frederik Hendrik had taken office as stadholder of Utrecht already in the summer of 1625, his installation took place only in November 1626. This installation was an event of great significance for Utrecht. For this see Poelhekke 1978, 96–97.
4. Staatliches Museum, Kunstsammlungen, Schlösser und Gärten, Schwerin, 330; De Jonge 1938, no. 271, fig. 173; Van den Brink and De Meyere 1993, 23, 225–27, no. 42, fig. 5.
5. Graf von Schönborn Kunstsammlungen, Schloß Wießenstein, Pommersfelden; see Maue and Brink 1989, 417–18, no. 322, illus.
6. For pastoral poetry, see Smits-Veldt and Luijten 1993, 58–75; and for examples of pastoral songs, Van Baak Griffioen 1991,

77–78, 103–8, 113–15, 121–24, 253–61, 317–18, 359. Jacob van Eyck (ca. 1590–1657) was from 1625 the most important carillon player in Utrecht. At the same time he composed innumerable (pastoral) songs for flute, which he himself on occasion played for the public in the Janskerkhof, at that time the second-largest park in the city.

7. De Jonge 1938, 123, no. 285, fig. 189. De Jonge is mistaken in considering nos. 338 and 339 variants of no. 285.

8. The replica of 1633 is in the Art Museum, Princeton University; the shepherdess of 1630 in the Rijksmuseum, Amsterdam; for these two paintings, see respectively, De Jonge 1938, nos. 284, 275, figs. 180, 179.

9. Voorhelm-Schneevoogt 1873, 165, 174, nos. 97, 98; a second state of no. 98, from 1775, exists. The print was, according to De Jonge, included as an illustration in a sales catalogue of the same year; see De Jonge 1938, 123. I have not been able to trace this catalogue.

10. See n. 9 and Rooses 1890, 4:182, no. 953.

11. A shepherdess from about 1624, auctioned Christie's (London), 8 Dec. 1989, lot 50, illus., was engraved by William Elliot as "Helena Forman, second wife of Rubens," and in 1775 it was thought that the shepherdess of 1624 in Munich represented the first wife of Rubens and had been painted by one of his best pupils; see De Jonge 1938, 119–20, no. 268, fig. 170.

Cat. 65

1. The painting appeared as a Paulus Moreelse in the *Burlington Magazine* 131, no. 1031 (February 1989): XXVII, illus. In 1989 the painting had already been recognized by Paul Huys Janssen at the antique fair in Maastricht as a Johannes Moreelse. This attribution was published for the first time only in 1991 in Buijs and Van Berge-Gerbaud 1991, 104 n. 1.

2. See Blankert and Slatkes 1986, 318–22, nos. 71, 72, illus.

3. De Jonge 1938, nos. 263, 265, 289, 290, figs. 165, 166, 186, 197.

4. Slatkes 1965, 95.

5. Judson 1959, 65.

6. Bok 1988.

7. Private coll., Spain; see also Van Haeften 1992, no. 24, illus.

8. Sale, F. Muller (Amsterdam), 15 Dec. 1908, lot 9, illus. A year later auctioned off once again; sale, F. Muller (Amsterdam), 10 Nov. 1909, lot 4. The presumable pendant of the shepherd by Moreelse, according to Peter van den Brink, in Van den Brink and De Meyere 1993, 217–18, is the version of the shepherdess (panel, 76 × 61 cm) that in 1957 was in the collection of Mrs. Julia Muldowney, New York. The photo in the Rijksbureau voor Kunsthistorische Documentatie in The Hague, to which Van den Brink refers, is however of such poor quality that, on the basis of the photo alone, little can be said about the authenticity of the painting. For a summary of yet four other copies of the shepherdess, see Van den Brink and De Meyere 1993, 218.

9. Van den Brink, in Van den Brink and De Meyere 1993, 217, is correct in noting that the shepherdess is somewhat more traditional in composition than the shepherd by Johannes Moreelse. Nevertheless, Van den Brink suspects that the shepherdess is from the hand of Johannes Moreelse. The manner in which the folds of the dress of the shepherdess are painted reminds me, however, of the style of painting

of Paulus Moreelse from the years 1630–35. All in all, it is probably wisest to wait with an attribution until the original shepherdess shows up.

10. A nineteenth-century panpipe, made up of individual recorders and without finger holes, can be found in the collection of the Haags Gemeentemuseum in The Hague. My thanks to Rob van Acht, who brought this instrument to my attention.

11. Covering the finger hole of one of the recorders produces a tonal variation of at least a third to a quarter. In addition, the recorders cannot be described as flageolets, as these have a minimum of four frontal holes.

12. De Jonge 1938, 57–58, 129–30, illus. 197–200.

13. Fremantle 1974, 618–20. Supplements to Fremantle were published in the same year: Nicolson 1974, 620–23.

14. In addition to *Shepherd with Pipes* and the five monogrammed and signed works noted by Fremantle and Nicolson, only one other painting by Johannes Moreelse has reappeared since 1974: *The Penitent Magdalen* (signed, oil on panel, 58 × 71.5 cm, Musée des Beaux-Arts de Caen).

Of the five unsigned pictures attributed to Johannes, only one fits smoothly into his oeuvre as a whole: *Saint Peter Repenting* (oil on canvas, 74 × 97 cm, Musée des Beaux-Arts, Besançon); see Pinette 1992. A certain kinship can, however, be seen in the other four as well. Two of these are *Narcissus* (oil on canvas, 76 × 63 cm, Gallery R. Millet [Paris], as of 1995) and *Marcus* (oil on canvas, 71.6 × 96.5 cm, sale, Christie's [London], 31 Nov. 1980, lot 126, illus.). *Singing Shepherdess and Shepherd with Pipes* has recently been attributed to Johannes Moreelse by Peter van der Brink, albeit with some reservations (oil on canvas, 110 × 92 cm, Öffentliche Kunstsammlung, Kunstmuseum, Basel); see also Van der Brink and De Meyere 1993, 78–80, no. 1, illus. (here attributed to an anonymous painter). *John the Baptist at the Well* (oil on canvas, 149 × 171 cm, Musée des Beaux-Arts, Lyons) has also been repeatedly ascribed to Johannes; see, among others, Buijs and Van Berge-Gerbaud 1991, 103–5, no. 33, illus.

Finally, there remain two other works, *Portrait of a Man* (National Museum, Stockholm) and *Portrait of a Woman* (Museum of Fine Art, Budapest), both certainly executed by one artist and bearing the same monogram as the *Shepherd with Pipes*. Stylistically speaking, they, too, are difficult to place within Johannes Moreelse's oeuvre. If indeed they are by his hand, they must have been painted in or shortly before 1634, as their costumes indicate. The *Democritus* and the *Heraclitus* in the Art Institute of Chicago usually ascribed to Johannes seem to me not to be his work but rather that of a Mediterranean artist; on these pendants see, among others, Nicolson 1974, 623, illus. (attributed to Moreelse) and Blankert in Blankert and Slatkes 1986, 319, illus. Blankert, too, doubts the attribution.

15. Van der Brink and De Meyere 1993, 117; on Catharina de Garby's inventory, see Bredius 1915–22, 3:786–87. This inventory, dated 21 April 1656, lists more paintings by Johannes and Paulus Moreelse.

Cat. 66

1. The material surveyed in this entry is discussed at length by the author in Spicer 1997b and was initially developed for a paper given at University College, London, in 1989. The most recent treatment of Adam Willarts is Giltaij and Kelch 1996, where discussion of the artist is limited to the entries.
2. White 1982, no. 235.
3. Van Thiel et al. 1976, no. A1387; Bol 1973, 65, illus.
4. Issues pertinent to the interpretation of the Willarts coastal scenes noted here, such as the significance of the flags, are discussed at length in Spicer 1997b.
5. In Willarts's paintings, details that do not record a specific historical moment are interchangeable. This galley does not appear in an autograph version of the present painting (103.5 × 179 cm, signed *A. Willarts f. 1621*) that was formerly in the Rabbani collection (Van de Watering et al. 1981, no. 14; Sotheby's [London], 11 Apr. 1990, lot 107).
6. There is a nice set of illustrations of basic ship types in Giltaij and Kelch 1996, 21–33.
7. That Willarts must have been in some degree inspired by Saverij was recognized by Van Luttervelt 1947a; see, further, Bol 1973 and esp. Zwollo 1983. The closest Saverij drawing is in the Fitzwilliam Art Museum, Cambridge (Spicer 1979, no. 92; Zwollo 1983, 408; Spicer, in Fučíková 1988, no. 255). The range of borrowings and their implications for interpretation are laid out in Spicer 1997b.
8. The suggestion that the profile of Prague Castle is meant as an allusion to Prague as the former capital of Frederick, the exiled king of Bohemia (Van Luttervelt 1947a; *Dictionary of Art* 1996, 33:193–95), does not address the fact that Willarts began using the motif long before Frederick and Elizabeth settled in the Dutch Republic, that there is no evidence that the couple really wanted to be reminded of their sojourn in Prague, and that this usage is an aspect of a larger pattern of borrowings.
9. Jacob van Ruisdael's varied uses of Bentheim Castle and the ruins of the house, Kostverloren, provide instructive counterpoints, for which, see Slive 1988; Walford 1991, 77–86, 121–23; Spicer 1997b.
10. Formerly in the Rudolf coll.; sale, Sotheby's (Amsterdam), 6 June 1977, lot 57; see Spicer 1997b.
11. The didactic poem, *Den Grondt der Edel vrij Schilder-const*, Van Mander 1604, bk. 2, "Van het teyckenen," st. 15, and bk. 5, "Van der Ordinancy," st. 10; see Van Mander 1973.
12. See Keyes 1990, no. 54, for a description of a version in a private coll. and the Greenwich version illustrated; Giltaij and Kelch 1996, no. 4, for a rendering of the subject by Hendrick Vroom.
13. Amsterdams Historisch Museum, Amsterdam; *Dictionary of Art* 1996, 33:193–95.

Cat. 67

1. Fechner 1966–67, 94; Spicer 1979, 107, 133 ff., 362; not in Müllenmeister 1988.
2. Müllenmeister 1988, no. 150; Kaufmann 1988, 19–32; also Spicer 1979, 332, 364.
3. Bird fantasies from 1618: Müllenmeister 1988, nos. 143 (Jagdschloß Grunewald, Berlin), 144 (Gemäldegalerie, Dresden), 145 (Museum voor Schone Kunsten, Antwerp).

4. Ibid. 1988, no. 151.
5. Białostocki 1958.
6. For connections of the court with Persia, see Kurz 1966, 461–83. The idea that Saverij owed his avian fantasies to Persian miniatures seen in Rudolf's collections was first proposed by Białostocki 1958 and repeated by Šíp 1969 and, most recently, by Slavíček 1994, under no. 36, who was unaware of the discussion of the issue in Spicer 1979, 140–41.
7. Van Nierop 1993, 104.
8. Spicer 1979, 152–89.
9. For the garden designed by Jacques de Gheyn the Younger, see Van Regteren Altena 1983, 141, fig. 106; see also Van Regteren Altena 1970.
10. See Spicer 1979, 126–96, nos. 120–40; entries in Fučíková 1997, forthcoming.
11. The well-known drawing *Dodos* (Crocker Art Museum, Sacramento, Calif.), catalogued as Roelandt Saverij in Spicer 1979, no. 143, must be reassigned to Hans Saverij.
12. See Spicer, introduction to this catalogue.
13. The suggestion that these ruins were inspired by ones seen on a trip to the Tirol and Istria (Müllenmeister 1988, under no. 148; followed by Slavíček 1994, under no. 36) is puzzling. There is no reason to think Saverij went to Istria and no reason to think that ruins like these were to be seen in the Tirol.
14. Müllenmeister 1988, no. 226; also Spicer 1979, 126, 143, 332.
15. For the history of the Nostitz family collections, see Slavíček 1994.
16. Müllenmeister 1988, no. 132.

Cat. 68

1. Bok "List of Pupils," in Roethlisberger 1993, 646.
2. Ibid., 144–45, cat. 101.
3. Some authors believe that the picture is dated 1626. The last digit, is, however, quite clearly a five.
4. See the catalogue of works in Sluijter-Seijffert 1984, 223–47.
5. Ibid., 85.

Cat. 69

1. For a different reading of this subject in Dutch painting, see Tümpel et al. 1991, 32–34, no. 6.
2. Joseph and Potiphar's Wife, David and Bathsheba, Susanna and the Elders, Samson and Delilah, Judith and Holofernes are the other five.
3. Poelenburch kept a repertoire of figure studies (for which, see his *Feast of the Gods* [cat. 53]), but no figure study has been associated with this painting. Duparc and Graif's suggestion (1990, under no. 55) that the same study was used for the main figure here and in *Arcadian Landscape with Nymphs Bathing* (cat. 54) is not convincing.
4. Other versions by Poelenburch with more emphasis on the figures include: Hampton Court, 141, acquired by James II (White 1982, no. 143); Christie's (London), 18 Mar. 1938, lot 41 (Sluijter-Seijffert 1984, no. 47); Schloß Bamberg, Bamberg, 191 (Duparc and Graif 1990, under no. 54 n. 3).
5. Chong 1987, no. 28. For grottoes and natural arches, see Duparc and Graif 1990, 170 n. 2 and figs. 59, 60; Chong 1987, no. 31.

6. Unaware of the date on this painting, published by Duparc and Graif 1990, or that the date *1624* on the London *Nymphs and Satyrs in a Hilly Landscape* (cat. 54, fig. 1) had been questioned in favor of 162[7] (White 1982, no. 142; since confirmed), Sluijter-Seijffert 1984, 84, dated the present painting to Poelenburch's last years in Italy. Nevertheless, she comments on the more subtle integration of planes than is apparent in other paintings of those years.

7. See Trnek 1986, no. 26, for a good summary of the artist's contribution.

Cat. 70

1. Perhaps Both did the initial etching on the basis of his drawings, and the publisher, Matham, finding them too unfinished without more anecdotal, pictorial interest, added the figures or animals using motifs from Both's paintings. The "horizontal" series, of which *Landscape with the Ponte Molle* is a part, was then etched by Both from his paintings so that they met the pictorial requirement for anecdotal detail from the beginning.

2. For the "discovery" of the waterfall by European artists, see Spicer 1997a.

Cat. 71

1. Both's free adaptation of the monuments and indeed of the site, which is actually less mountainous, is extensively analyzed in Walsh and Schneider 1981, no. 5.

2. For the origins and early development of the waterfall as a motif in European painting, see Spicer 1997a.

3. Spicer 1979, no. 30; Spicer 1997a.

4. Müllenmeister 1988, no. 242, illus.

5. For cascades in Both's work, see Steland 1985; Trnek 1986, under no. 23.

6. Burke 1976, no. 65; Scott 1987, under no. 8, fig. 2; Steland 1985, fig. 11 with the attribution queried.

7. Burke 1976, no. 70, chap. 5; Trnek 1986, under no. 23.

8. See Burke 1976, no. 1; Sutton 1987, no. 15.

9. Laskin and Pantazzi 1987, 38; Duparc and Graif 1990, no. 18.

10. Boston 1981, n. 4; Duparc and Graif 1990, fig. 36.

11. Though the painting was not known to Burke in 1972 when he completed his monograph on Both (Burke 1976), it was subsequently accepted by him and dated to the second half of the 1640s, as noted by Scott 1987, n. 15.

12. See Duparc and Graif 1990, under no. 17.

13. Scott 1987, 30.

14. Burke 1976, no. 3.

Cat. 72

1. See MacLaren and Brown 1991, 53, for sources.

2. That the figures are by Poelenburch was already recognized in the eighteenth century; ibid.

3. For the story and interpretation of the Judgment of Paris, see most recently Damish 1996, esp. "The Story without the Picture." For the subject and its interpretation in Dutch art, see Sluijter 1986, 210–24, who assigns rather too much weight to moralizing accounts such as that in Van Mander 1604, and, more generally, Froitzheim-Hegger 1993; see also the introduction to this catalogue.

4. Paintings of the Judgment of Paris by Poelenburch alone include: Sotheby's (London), 5 July 1995, lot 160, illus.; Schönborn coll., Pommersfelden (Sluijter 1986, fig. 121, Sluijter-Seijffert 1984, no. 31); Staatliche Kunstsammlungen, Gemäldegalerie Alte Meister, Kassel (Sluijter 1986, fig. 122, Sluijter-Seijffert 1984, no. 30); earl of Bradford, Weston Park, (Sluijter 1986, fig. 123 [school]). There is a red chalk drawing in Copenhagen (Statens Museum for Kunst) that, Chong 1987, no. 109, suggests may be preparatory to the painting in Pommersfelden.

5. Sheard 1978, no. 90; Bober and Rubenstein 1986, nos. 119, 120.

6. See the version dated to ca. 1645 in the National Gallery of Art, Washington, D.C.; Russell 1982, no. 34.

7. The moralizing approach is the focus of Sluijter's interesting discussion of the literary treatments of the story (1986; see n. 3 above). Nevertheless, he is careful to stress that in the present painting there is no hint of moralizing.

8. Burke 1976, no. 90; Laskin and Pantazzi 1987, 38.

9. Burke 1976, no. 79; Kuznetsov 1974, no. 166. In correspondence, Michael Rohe has proposed an alternative, attributing the two figures to Nicolaes Berchem, with whom Both also collaborated. Two other versions attributed to Knüpfer, Both, and Weenix: (1) *Mercury with Juno and the Dead Argus*, Bayerische Staatsgemäldesammlungen, Munich (Burke 1976, no. 81; Kuznetsov 1974, no. 165); (2) *Mercury and Argus*, Kunsthistorisches Museum, Vienna (Burke 1976, 115; Kuznetsov 1974, no. 167; see also Trnek 1986, under no. 24).

10. Burke 1976, no. 106; Kuznetsov 1974, no. 92; Cuppen 1983, 89–91, Wyttenhorst inv. no. 42.

11. Burke 1976, no. 43; Kuznetsov 1974, no. 66.

Cat. 73

1. Among other collaborative works are the *Two Musicians*, ca. 1633 (Akademie Bildenden Künste, Vienna), thought to be a double self-portrait of the brothers themselves (Schulz 1978, no. 639, fig. 10), and the *Van Reede Family Portrait* of 1634–35 (Stichting Slot Zuilen, Maarsen), illustrated in Schulz 1982, no. 21, fig. 8).

2. Schulz 1978, records almost 475 drawings, two-fifths of which are figure studies.

3. Schulz 1978, no. 56, fig. 64; Robinson 1991, no. 70, illus.

4. However, by the 1640s, Cornelis no longer lived in Utrecht, having moved back to Rotterdam by 1637. Although the Abrams drawing is not folded, An Zwollo has suggested that the brothers corresponded about such collaborative projects by sending drawings through the mail. As evidence, she published a drawing (preserved in a Dutch private collection) that had previously been folded to the size of a typical seventeenth-century letter. On the back of the drawing, written in Cornelis's hand, is Herman Saftleven's name and his address in Utrecht. See Zwollo 1987, 404–5, figs. 1, 2.

5. Roethlisberger 1993, no. T106, illus.

6. The drawings are preserved at the Fitzwilliam Art Museum, Cambridge, England. Roethlisberger 1993, 389, dates Abraham's drawings on which the *Tekenboek* prints are based from between about 1620 and 1650, with most dating from about 1625–35.

7. Ibid., fig. T106a.

8. Ibid., 407.

9. A series of sixteen prints, including a title page, engraved and published during the 1620s, by Cornelis Bloemaert after designs by Abraham. Ibid., 231–36, nos. 297–312, figs. 434–49. I wish to thank Joaneath Spicer for pointing out this relationship.

10. Ibid., no. 297. For a discussion of the *Otia* series see Spicer, introduction to this catalogue.

11. The text reads: *Quisquis opus coeptum deduxit ad ultima felix,/ Otia securo ducere blanda licet.* Roethlisberger 1993, no. 302.

12. The theme of sleep in Dutch painting is examined in Salomon 1984.

13. Cornelis was, apparently, as intrigued by the formal challenges of representing the human figure supine as Bloemaert must have been. In a number of figure studies, Cornelis posed his male models out of doors in a variety of reclining positions, some approximating the poses in Bloemaert's *Otia* engravings. See, for example, a *Man Sleeping on the Ground* (Schulz 1982, no. 58, fig. 59), also in the Abrams collection, which is not too dissimilar from Bloemaert's sleeping shepherd on the title page of *Otia*.

Cat. 74

1. Susan Donahue Kuretsky very kindly shared with me her manuscript entry for this painting to be published in the catalogue of the paintings in the collection of the Detroit Institute of Arts.

2. Potterton 1986, 174–75.

3. The introduction of relatively large-scale figures into landscape genre compositions was Weenix's particular contribution.

4. This motif appears repeatedly, in, among others, his last dated picture, *Landscape with Inn and Ruins*, signed and dated 20 October 1658 (Mauritshuis, The Hague); see Broos 1980, 122–23, 243 illus.

5. On Wyttenhorst, see Olde Meierink and Bakker in this catalogue.

6. Ginnings 1970, no. 29; Brown and Mai 1991, no. 37.1, illus. Weenix's *capricci* of widely scattered monuments, include, among others, quotations of the Temple of Vespasian (Szépművészeti Múzeum, Budapest), the Temple of Jupiter Tonans (S. A. Millikin collection, Cleveland), and sculptural pieces, such as the Dioscuri in the Utrecht *Italian Seaport*.

7. It is interesting to note that Weenix's father, Jan Jansz. Weines, who died when Jan was only a baby, was an architect of some repute.

8. Bredius 1928, 177–78.

9. It has often been speculated that Weenix adopted the Italian spelling of his first names—Gio[vanni] Batt[ist]a—in deference to Pope Innocent X (Giovanni Battista Pamphili), who became pontiff in 1644. Weenix worked for the pope's nephew, Prince Camillo Pamphili, from whom, as recorded in Pamphili family documents, he received payments in 1645 and 1646. See Schloss 1983, 237–38.

10. Pieter van Laer was in Rome from 1625 to about 1639; on Bamboccio and his followers, the *Bamboccianti*, see Briganti, Trezzani, and Laureati 1983; and Levine and Mai 1991.

Cat. 75

1. For a good, concise analysis of Ambrosius Bosschaert's oeuvre and that of his sons, see Taylor 1995, 134–42; for more detail, see Bol 1960 and Segal 1984.

2. Segal 1984, 32.

3. Bol 1960, 20.

4. Ibid., no. 33.

5. Segal 1990, 49.

6. Other examples of duplicated blossoms: The rose at the lower right appears in *Chinese Vase with Flowers* (1619; Rijksmuseum, Amsterdam; Bol 1960, no. 47, illus.); the yellow iris at the top is equally prominent in *Bouquet in a Roemer* (private coll., Italy; ibid., no. 41, illus.); the variegated carnation on the sill is similar to though not identical with one in the Amsterdam *Chinese Vase* and another in the *Beaker with Flowers* in the Mauritshuis that is illustrated here as fig. 1. See, further, Bergström 1956, 69; Bol 1960, 30; Segal 1984, 31–32.

7. As initially identified by Bergström 1956, 65.

8. Dewdrops begin to appear in 1617 but occur from then on in all Bosschaert's dated paintings; only Saverij was painting them earlier; Segal 1984, 32.

9. For the possibilities for moralizing, see Walsh and Schneider 1981, 17–18; however, see as well Taylor 1995, 28–76, for the potential and limitations of the moralistic approach.

10. Segal 1990, 49.

11. The six are: (1) 1618–19, *Beaker with Flowers in an Arched Window*, fig. 1, Mauritshuis, The Hague (Bol 1960, no. 37); (2) 1619, the present painting, *Bouquet of Flowers on a Ledge* (ibid., no. 46); (3) 1619–20, *Roemer with Flowers in an Arched Window*, oil on copper, 22 × 17.5 cm, Musée du Louvre, Paris (ibid., no. 38); (4) 1619–20, *Roemer with Roses in an Arched Window*, oil on panel, 31 × 23 cm, private coll. (ibid., no. 45); (5) 1619–20, *Roemer with Roses in an Arched Window*, oil on copper, 27.5 × 23 cm, private coll., United States (ibid., no. 44); (6) 1619–20, *Roemer with Roses in an Arched Window*, oil on copper, 28 × 23 cm, private coll., London (Luijten et al. 1993, no. 279, illus. in color).

12. Oil on copper, 31.6 × 21.6 cm. The *Large Bouquet in a Vase*, dated 1620, in the Nationalmuseum in Stockholm (oil on panel, 129 × 85 cm; Bol 1960, no. 48, illus.), returns so explicitly to compositions of about 1610 conceived under the influence of Jan Breughel that it may well have been specifically commissioned in that manner and therefore is of questionable use as a point of reference for stylistic development.

13. Luijten et al. 1993, no. 279.

Cat. 76

1. For literature on Van der Ast, see Bergström 1956, 68–74; Bol 1960, 36–40, 69–87; Bol 1982a, 52–56; Segal, in Bakker et al. 1984, 45–62; Taylor 1995, 146–51.

2. For Saverij's still-life paintings, see Bol 1982a, 68–73; Müllenmeister 1988, 165–80, and Spicer, introduction to this catalogue.

3. See Segal 1988, 77–92, for an excellent discussion of the collecting of shells and their use in still-life painting.

4. See Kenseth 1991, esp. 33–38; Ashworth 1991; Kaufmann 1993, 10–18, 79–99; Maselis, Balis, and Marijnissen 1989.

5. See Spicer 1979, 250–51. For this sheet of drawings, the collected sheets, and their history, see Bol 1982a, 84, fig. 3; Van Regteren Altena 1983, 1:70, 2:141–42, 3:103.

6. The use of models by still-life painters is frequently discussed in the literature on still life (for example, Taylor 1995,

118; Bakker et al. 1984, 63; Spicer 1979, 246–61), but few drawings that survive are illustrated, including a finished drawing by Balthasar van der Ast of one of his still-life paintings (see Koetser 1967, 55; the summary on 54 attributes the drawing to Jan van Os, an eighteenth-century artist). Tulip books produced in the 1630s and 1640s for flower collectors, bulb speculators, and even artists by Jacob Marrel, Van der Ast, and others were another means of disseminating flower models; see Segal and Roding 1994, 81, 118, figs. 8, 13.

7. See Bol 1960, 38, for a list of some of the other works in which the Summer Beauty tulip appears.

8. See Wheelock 1995a, 5–8.

9. See North Carolina Museum of Art 1992, 86.

10. Bol 1982a, 57–60.

11. Van Thiel et al. 1976, 90, A-2152.

12. Duparc 1985, 18–19, where it is dated 1630–35, and Bol 1982a, 54, who places it in Van der Ast's Delft period on the basis of the loose, light-filled composition. See also nn. 8, 11, above.

13. A dating to the Middelburg years (ca. 1610–15) has been proposed (*National Gallery Report* 1995, 16).

14. Taylor 1995, 142, 144, 146, 149.

15. See Bol 1982a, 54.

16. This common belief was given expression in an emblem in Cats 1627. The emblem, no. 52, which shows a butterfly emerging from its cocoon, is given four explanations (Cats normally provided only three), the last two of which, with supporting quotes from the Bible, center on the power of God to cleanse the soul both in life and after death.

17. For the symbolism of flowers, see, more recently, Taylor 1995, 28–76. The iris is often considered a Marian symbol, hence the connection to heaven.

Cat. 77

1. For Van der Ast, see Segal 1984, 45–64; Segal 1988; Taylor 1995, 146–49; also Bol 1960, Bol 1982a.

2. This appears to be an atalanta butterfly, found as well in the later Mauritshuis still life, cat. 76, fig. 2.

3. For example, the iris, this flame tulip, and two roses very like those at the lower left are found in Van der Ast's *Flowers in an Urn with Shells*, Christie's (London), 8 July 1988, lot 116.

4. For Van der Ast's watercolors of flowers and shells, see Segal and Roding 1994, 96, fig. 13. The forty-six sheets collected by Frits Lugt are in the Fondation Custodia in Paris. As very few of these drawings have been illustrated in the literature, it has not been possible to connect drawings to the present bouquet.

5. From the left: a Hebrew cone (*Conus ebraeus*), an ordinary scallop, unidentified, a *Conus geographus* (?), and a common trochus (from the Indian Ocean, as is the Hebrew cone).

6. On the general interpretation of flowers (and its limitations) see esp. Taylor 1995, 28–76; also Segal, in Segal and Roding 1994, 8–23, both with literature.

7. For drawings of tulips, their introduction from Persia, the types valued in the seventeenth century, and the speculation in them, see, most recently, Segal and Roding 1994; also Roding and Theunissen 1993.

Cat. 78

1. Sullivan 1984, 34.

2. Van Nierop 1993, 38.

3. Van Nierop 1993; Marshall 1987.

4. Broos 1987, 397, fig. 1, reproduces a drawing of Weenix's manor house.

5. Sullivan 1984, 32, fig. 68.

6. Sullivan 1979, 68, fig. 6. The Detroit picture is trimmed somewhat at the bottom, which detracts from its original appearance, but it is still an imposing picture.

NOTES TO THE BIOGRAPHIES

Balthasar van der Ast

1. Based on Bol 1960, 36–40. For the latest literature see Meissner 1992, 5:478–79.

2. GAU, notary C. Verduyn, U009a006, fols. 79v–80, 29 June 1618. He rejected the estate of his brother, Johan van der Ast, who had recently died in Utrecht.

3. Hulshof and Breuning 1940, 92.

4. Luijten et al. 1993, 315.

5. Briels 1976, 293–94.

6. GAU, notary C. Verduyn, U009a014, fols. 156–156v, 19 May 1629.

7. GAU, NH Kerkeraad, 406, lidmaten, 3 July 1628; Bol 1960, 41–42.

8. GAU, Stadsarchief II, 3243, register van transporten en plechten, 234, 4 May 1629; see also idem, 389–92, 13 May 1631. He had a completely new facade built (GAU, notary C. Verduyn, U009e001, 22 May 1629).

9. For his Delft period, see also Montias 1982.

10. GAU, Stadsarchief II, 349, tappersregister, kwartier van Cornelis van Deuverden, 7 Sept. 1635. For this sale, see GAU, Stadsarchief II, 3243, register van transporten en plechten, 40–42, 30 Jan. 1639.

Dirck van Baburen

1. Based on Blankert and Slatkes 1986, 173–75. For the latest literature, see Meissner 1992, 6:109–11.

2. For this series, see Börsch-Supan 1964, 12–20.

3. Rommes 1990, 254.

Jan van Bijlert

1. For an extensive biography and all relevant documentation, see Huys Janssen 1994a. An English translation will soon be published.

2. Currently no. 195. The name of the house was mentioned when Van Bijlert's sister Lucretia joined the Reformed Church (GAU, NH Kerkeraad, 405, register van lidmaten, fol. 46v, 10 July 1623. The Dutch word *ruit* means both "lozenge" and "pane," the latter probably referring to the family's trade.

3. Johan van Bijler, painter, aged about twenty-seven, gave testimony on 28 Sept. 1625 (GAU, Stadsarchief II, 2244, criminele stukken, no. 30). Duyck and Van Bijlert were playing for the small sum of one *stuiver* when another guardsman became angry because they were too noisy.

Abraham Bloemaert

1. Based on Bok, in Roethlisberger 1993. No new relevant documents have since surfaced.
2. RAU, Staten van Utrecht, 364-3-42, quarter of Captain Johan Fransz. van Leuwerden.

Ambrosius Bosschaert

1. Based on Bol 1960, 14–33, and Luijten et al. 1993, 302–3. For the latest literature see Meissner 1996, 13:200–201.
2. It appears that his father was still alive in 1602, as a dated drawing from that year is signed *Ambrosius Bosschaert the younger* (Ambrosius Bosschaert de Jonghe; Luijten et al. 1993, 630–31, cat. 302).
3. Van de Passe 1614. Also published in a Dutch edition and, a year later, in an English edition as *Garden of Flowers*, . . .

Jan Both

1. For the most recent biography and the latest literature see Blankert, in Meissner 1996, 13:240–42. Dirck Joriaensz. Both acquired Utrecht citizenship in the fiscal year 1603–4 (GAU, Stadsarchief II, 1243, thesauriersrekeningen, fol. 68v).
2. The year of his birth has long been a subject of debate; see De Bruyn 1952 and Blankert 1965, 113–14 n. 2.
3. RAU, coll. Buchel-Booth, 179, p. 1440. For the family relationship between the Boths and the famous Amsterdam sculptor Albert Jansz. Vinckenbrinck, see Bok 1996.
4. The Venetian death register states his age as thirty-six at the time of his death in Mar. 1642 (Limentani Virdis 1990, 24). The *status animarum* of the Roman parish of San Nicola in Arcione gives his age as twenty-four at Easter 1636 (Hoogewerff 1942–43, 280).
5. GAU, Stadsarchief II, 3243, register van transporten en plechten, 172–73, 28 Oct. 1616.
6. Von Sandrart 1675–80, 2:312. If we accept Cornelis Booth's statement that Andries was the elder brother, then he must have been the son for whom Dirck Both paid apprenticeship fees to the guild in 1624–25 (Muller 1880, 118). Jan Both may have been the son for whom the father paid fees in 1634–37 (Muller 1880, 122). However, this seems to conflict with Sandrart's reliable statement that both brothers were pupils of Abraham Bloemaert in the mid-1620s.
7. Their mother died in 1634 (GAU, DTB, 122, registered 15 Dec. 1634). One would assume that the brothers shared lodgings. The fact that Jan Both was not living with Andries in 1635 suggests that Von Sandrart's recollections were blurred and that Jan arrived a while later.
8. GAU, notary J. van Vechoven, U017a004, fols. 306–307v, 3 Apr. 1644 (an exact copy on fols. 308–309v). This document was originally written in Latin by the notary Jacobus Lenich van 's-Hertogenbosch, residing in Rome, on 6 Sept. 1641. It was registered at the Capitol in Rome on 27 May 1643. The Utrecht document is a Dutch translation of the Latin original.
9. Published by Limentani Virdis 1990, 24. The date of his death has led to confusion. The new year in Venice began on 1 Mar. ("more Veneto"; Grotefend 1922, 13). On the mistaken assumption that the new year did not begin until 25 Mar., Bert Meijer later incorrectly stated the year of Andries's death as 1643 (Meijer 1991a, 71, 127 n. 245; Meijer 1991b,

141). I quoted the wrong year in Roethlisberger 1993, 649, and in Bok 1994, 193.
10. According to Houbraken 1718–21, 2:193, Verschuring (baptized in Gorinchem on 2 Nov. 1627) came to Both at the age of thirteen and stayed for six years before going on to Rome. He is still mentioned in a Gorinchem document of 12 Nov. 1647 and may not have left for Italy until after that time (GA Gorinchem, Rechterlijk Archief, 699, fol. 138; Tissink and De Wit 1987, 59–60, 95 n. 6 [with the wrong date and inv. no.]).
11. For his cooperation with Knupfer and Weenix, see the biography of Knupfer in this book.
12. De Jonge 1932, 123.
13. Ibid.
14. RAU, klapper op de overluidingen van de Dom, 30 July 1652.
15. GAU, DTB, 123, registered 9 Aug. 1652.

Jan Gerritsz. van Bronchorst

1. An extensive biography and all relevant documentation concerning the Bronchorst family were published in Döring 1993.
2. De Bie 1661, 278.
3. For the Rozengracht, see Dudok van Heel 1991, 61.

Hendrick ter Brugghen

1. All relevant documentation known at the time was published by Bok and Kobayashi 1985. A few new additions were published by Bok, in Blankert and Slatkes 1986, 64–75. For the latest literature, see Blankert, in Meissner 1996, 14:504–5.
2. Dusseldorpius 1893, 324. This confirms information that has come down from Hendrick ter Brugghen's son, Richard ter Brugghen (Blankert and Slatkes 1986, 72 n. 17).
3. GAU, notary J. van Herwaerden, U003a017, 23 Apr. 1607; published by Houck 1899, 354.
4. Bok and Kobayashi 1985, 26, doc. 21, and 27, doc. 23. Unaware of the limited use of this epithet, Yoriko Kobayashi and I were hesitant to include the 1607 document in our 1985 article. The possibility of Ter Brugghen's having been a soldier might also explain his extraordinary interest in the depiction of soldiers in his works.
5. After the beginning of the Twelve Year Truce in April 1609, half the Dutch standing army was demobilized ('t Hart 1993, 43–44). We should also consider this as the possible time of Ter Brugghen's departure for Italy.
6. Bok and Kobayashi 1985, 25, doc. 17.
7. De Bie 1708, 277.
8. In two as yet unpublished documents Ter Brugghen acted as a witness for people living in the same neighborhood. In 1619 he witnessed the signing of the will of Christiaen le Petit and his wife, Johanna van Drielenburch, who lived near the Plompetoren (GAU, notary C. Verduijn, U009a006, fols. 223v–225v, 12 June 1619; kindly communicated by Paul Huys Janssen). In 1625 he witnessed the signing of a deed for Johan van Noort in a house in the Ballemakersstraat (GAU, notary W. van Galen, U012a007, fols. 13–15v, 9 Mar. 1625 [three deeds]).
9. "tiefsinnige jedoch schwermütige Gedanken" (Von Sandrart 1675–80, 2:308).

Joost Cornelisz. Droochsloot

1. The only relevant literature on his life is Hofman 1893. His year of birth is first given in Von Wurzbach 1906–11, 1:426.
2. A document from 1581 records Droochsloot's father's settling the estate of his first wife (GAU, Stadsarchief II, 3243, register van transporten en plechten, 19–21, 10 Jan. 1586). It was customary to do this on the eve of a second marriage. There were no children from the first marriage.
3. GAU, klapper op de nieuwe burgers, 5 Jan. 1581.
4. GAU, Stadsarchief II, 3243, register van transporten en plechten, 129–130, 24 Oct. 1581.
5. GAU, DTB 92, p. 79.
6. Cornelis was baptized on 29 Nov. 1640 (GAU, DTB, 4, p. 26). He was previously believed to have been the son Cornelis born in 1630 (Hofman 1893, 349–50), although this child must have died at an early age.
7. Muller 1882–83.
8. For this house see Eldering-Niemeijer 1956, 247–48.
9. Bok 1994, 185.
10. Van Lieburg 1989, 154.
11. GAU, Stadsarchief II, 1259, rekening van de tweede kameraar, 1650–51, uitgaven voor de schutterij.
12. Bok 1994, 199–200.

Jacob Duck

1. They were married in a civil ceremony on 10 Jan. 1596 (GAU, DTB, 85, fol. 47v). Johan is called the eldest son in his parents' will dated 20 Sept. 1638 (GAU, notary W. van Galen, U012a017, fols. 155–156v).
2. Jacob Duck was married in a civil ceremony on 29 Apr. 1620 (GAU, DTB, 85).
3. GAU, notary L. van Leeuwen, U005a002, 22 Sept. 1617.
4. GAU, Bewaarde archieven I, 131, leerjongensboek Goudsmedengilde, 1611 (as Jacob Jansz.); idem, 130, meesterboek, 1619.
5. Muller 1880, 115. He was registered as "a bachelor named Duyck" (een jonghman genaemt Duyck). The scribe was unaware of his having been married.
6. Muller 1880, 134.
7. Muller 1880, 120 (accounts covering 1630–32).
8. GAU, notary W. Zwaerdecroon, U013a004, 11 May 1631. He acted as a witness. See also, GAU, notary B. van Eck, U015a001, fol. 60, 3 Sept. 1631.
9. GAU, Bewaarde archieven I, 128, resolutieboek Goudsmedengilde, fol. 7, 25 Jan. 1642.
10. For Jacob Bool, see Dussledorpius 1893, 526, and Kaplan 1995, 276.
11. For Jan Duck's arrest, see RAU, Hof van Utrecht, 46, 23 Dec. 1642. For Cornelis see GAU, Stadsarchief II, 2244, dated 1662.
12. For Jacob Croock, see RAU, Hof van Utrecht, 230, octrooien om te testeren, 7 May 1624. For his death see RAU, Domkapittel, 702, overluidingen, 6 Mar. 1643. For her business see GAU, notary J. van Steenre, U025a001, 1 June 1643. See also GAU, Stadsarchief II, 175, procuratieboek, 4 June 1647.
13. We find him there in 1637 (GAU, notary H. Ruijsch, U020a001, fols. 405–406, 1 June 1637).
14. Bok, in Roethlisberger 1993, 630.
15. Bok, in Roethlisberger 1993, 631.

16. RAU, Domkapittel, 702, overluidingen, 23 June 1648; GAU, DTB, 123, fol. 196, 3 July 1648.
17. GAU, notary J. van Steenre, U025a001, 6 Nov. 1649; GAU, notary F. Zwaerdecroon, U028b001, 31 Aug. 1650. For Van Weede, see Roethlisberger 1993.
18. GAU, notary J. van Snelderweert, U046a002, 23 July 1663. The father was the postmaster Dirck Wilberingh, who died in 1664.
19. He is named at the sale of the house on the Donkere Gaard (GAU, Stadsarchief II, 3243, transportregister, 173–177, 18 Aug. 1702).
20. GAU, notary B. van Eck, U015a013, fols. 101–101v, 22 Jan. 1667.
21. GAU, notary B. van Eck, U015a013, fols. 101–101v, 22 Jan. 1667; GAU, DTB, 125, 28 Jan. 1666.

Gerard van Honthorst

1. The Honthorst documents, as well as the most extensive biography so far, have been published by Braun 1966. Some additions were published by Bok, in Blankert and Slatkes 1986, 276–79. A new monograph by J. R. Judson will soon be published.
2. Muller 1880, 106, 127–28. We may assume that Herman van Honthorst gave his son Gerard drawing lessons, as he did later to his son Herman Hermansz. van Honthorst, who was apprenticed to a sculptor in 1616–17. Herman Hermansz.'s registration as an apprentice explicitly states that he had already had drawing lessons, apparently from his father (Muller 1880, 106).
3. RAU, Oudmunster, 501–1, acquitten van de fabriek, 7 Oct. 1622, with a receipt signed by Honthorst on 9 Oct. 1622 (kindly communicated by Bini van der Wal).
4. The date is given in GAU, Stadsarchief II, 175, register van procuraties en certificaties, 6 Dec. 1630.

Nicolaus Knupfer

1. Unless otherwise stated all biographical data are taken from De Bie 1661, 115–16; Brinkhuis 1935; Kuznetsov 1974.
2. Nothing is known with certainty about his background, but future research should address the hypothesis of his being related to the Antwerp painter Hans Knipper, who went to work for the Danish court in 1578 (Von Wurzbach 1906–11, 1:299). In Utrecht documents Nicolaus Knupfer—he never used the umlaut in signatures—is usually referred to as Knipper(t). The umlaut is an invention of modern historiography.
3. De Bie 1661, 115.
4. Huys Janssen 1989.
5. Schepelern and Houkjaer 1988, 58–59, cat. 11.
6. Von Sandrart 1675–80, vol. 1, pt. 2, p. 301.
7. GAU, notary B. Terbeeck van Coesfelt, U035a002, 27 Sept. 1650; Brinkhuis 1935, 116; Kuznetsov 1974, 207, cats. 163–64.
8. Kuznetsov 1974, 172, 195, cat. 92.
9. Bok, in Roethlisberger 1993, 573. The boy boarded for 236 guilders a year with Knupfer's in-laws on the Neude (GA Rotterdam, Weeskamer, 615, rekeningen van de weesmeesters, 1 Apr. 1651, fols. 65v–66, paid 28 Aug. 1647).
10. Weyerman 1729–69, 2:348.
11. Brinkhuis 1935, 111, has suggested that the child of "Hans

Knippi," baptized in the Lutheran Church on 9 Feb. 1643, was Knupfer's daughter. On 2 Apr. 1649, however, a "Hans Knipping" had another girl baptized in that same church (GAU, DTB, 25, fol. 167). Brinkhuis may thus have been mistaken and Knupfer may not have been a Lutheran after all.

12. For this house, see GAU, Stadsarchief II, 3243, register van transporten en plechten, 164–66, 2 May 1639; 18–19, 13 Jan. 1654.

13. GAU, Bewaarde Archieven I, 131, leerjongensboek van het Goudsmedengilde, 1656.

Diderick van der Lisse

1. Van der Lisse's handwritten notes on the biographical details of his family and himself were published in Van Epen 1927. For the most recently discovered information on his life, see Van den Brink and De Meyere 1993, 200–207, 300, and Broos 1993a. See also Fölting 1985, 128–29.

2. The painter Abraham van der Lisse alias Speclatijff (born ca. 1638), who is recorded in Rome in 1659 and 1660 (Hoogewerff 1924, xlvi; Hoogewerff 1938, 92), has been wrongly identified as either the brother (see Thieme-Becker, 23:287) or the father (Broos 1993a) of the artist. I suggest that he was actually Dirck van der Lisse's nephew, Abraham Marinusz. van der Lisse, who married Catharina Beckers on 8 Jan. 1665 (Van Epen 1927, col. 50).

3. GAU, NH Kerkeraad, 406, lidmaten, fol. 9, 4 July 1626.

4. Kramm 1857–64, 4:1296.

5. Van den Brink and De Meyere 1993, 200–203, cat. 35.

6. See Döring 1993, 275–76.

7. For Matthijs van der Houve, see *NNBW* 1930, 7: col. 860; Fölting 1985, 17, 128–29; Haitsma Mulier and Van der Lem 1990, 203–4; Huijbrecht 1996, 176.

8. A day later he gave his brother the power of attorney to take care of his affairs in The Hague (GAU, notary G. van Nijendael, U030a0001, fol. 42).

9. GAU, DTB 4, baptisms NH Jacobikerk, fol. 26, 18 Nov. 1640.

10. GAU, NH Kerkeraad, 408, lidmaten, fol. 14v, shortly before 30 June 1640.

11. Bredius 1881.

Johannes Pauwelsz. Moreelse

1. Based on Fremantle 1974 and on Blankert and Slatkes 1986, 317–18. No new documents have since been published.

2. For the plague in Utrecht, see Rommes 1990, 260.

Paulus Moreelse

1. This biography is based on Luijten et al. 1993, 311–12, as well as on earlier literature. An extensive new biography will be published by Eric Domela Nieuwenhuis in his forthcoming monograph.

2. RAU, Staten van Utrecht, 364-3-42, quarter of Captain Jacob Henricksz. van Bemmel.

Cornelis van Poelenburch

1. Based on Sluijter-Seijffert 1984, 25–35, 249–58, as well as on earlier literature. For his year of birth see Bok 1985. See also Chong, in Sutton 1987, 402–3.

2. Cornelis van Poelenburch explicitly names them as his parents in GAU, notary Johan van Steenre, U025a0001, 4 May

1658. Dr. Cornelis Booth, in his contemporary genealogical notes, states that Simon was the son of Sebastiaen Anthonisz. van Schiedam and of a sister of the cathedral canon Jacobus Cornelii called Van Poelenburch van Schiedam ("postea dictus Poelenburch Schiedamensis") (RAU, coll. Buchell-Booth, 173, 892).

3. GAU, Stadsarchief II, 3243, register van transporten en plechten, 148–50, 19 Apr. 1602. For his apprenticeship, see Bok, in Roethlisberger 1993, 646.

4. Sluijter-Seijffert 1984, 26, 249, has suggested that he is the same artist named Poelenburch who was listed by Theodorus Rodenburgh in 1618 as being among the most famous Amsterdam painters. It seems more likely, however, that this artist was the Amsterdam painter Govert Jansz. Poelenburch, whose works were among a cargo of paintings offered to the Danish king by that same Rodenburgh about 1621 (Kernkamp 1902, 229). I assume that this artist was actually the painter Govert Jansz. Mijnheer (Thieme-Becker, 17:415).

5. Von Sandrart 1675–80, 2:305, 370.

6. For his probable residence in Utrecht in 1626, see the biography of Dirck van der Lisse in this catalogue.

7. Von Sandrart 1675–80, 2:291, 305.

8. GAU, notary Jacob van Steenre, U014a0001, fols. 340–341v, 15 Mar. 1629; fols. 348–348v, 3 May 1629. In later years he frequently acted as a witness.

9. For their children see GAU, notary C. van Vechten, U031a005, 20 Dec. 1653.

10. They are first recorded in the Winssensteeg when they appointed guardians for their children on 2 Aug. 1631 (GAU, notary Jacob van Steenre, U014a0001, fols. 416–416v).

11. GAU, notary Johan van Steenre, U025a0001, 1 Jan. 1642.

12. GAU, Stadsarchief II, 3243, register van transporten en plechten, 15–16, 21 Jan. 1642; Sluijter-Seijffert 1984, 251–52. Currently Wed No. 1/3/3A (oral communication from Dr. Martin de Bruijn).

13. For Margareta Ram's will, see GAU, notary W. van Velpen, U072a007, akte 46, 17 May 1677.

14. Bredius 1915–22, 6:2074–77. Van Haensbergen witnessed the signing of a notarial document in Poelenburch's home in 1661 (GAU, notary Johan van Steenre, U025a0001, 12 Jan. 1661).

15. GAU, notary C. Verduyn, U009a014, fol. 7, 24 Dec. 1628.

Cornelis Saftleven

1. Based on Schulz 1978, 1–5. For the most recent literature, see Schadee 1994, 295–96.

2. In 1600, while in Strasbourg, he made an inscription in the *album amicorum* of Friedrich Brentel in which he referred to himself as being "van hant doerf" (from Antwerp) (see Schulz 1978, 1).

3. De Jongh 1986, 218–20, cat. 48.

Herman Saftleven

1. Based on Schulz 1982, 1–11. New documentation was published by De Meyere 1990. For the most recent literature see Sutton, in Sutton 1987, 475–80.

2. For Anna van Vliet's family see the genealogical manuscript by C. Booth (RAU, coll. Buchel-Booth, 171, fol. 623).

3. GAU, DTB, 23. The Remonstrant baptism registers begin only in 1639.

4. GAU, archief Remonstrantse Gemeente, 8, acta, fol. 4v, 1637 (kindly communicated by D. E. A. Faber). He refused to be appointed an elder in 1652 (fol. 36v) and took part in the election of a new minister in 1663 (fol. 177).

5. GAU, notary Jacob van Steenre, U014a001, fol. 496, 27 Jan. 1634.

6. Van den Brink and De Meyere 1993, 254–58, cat. 51.

7. De Jongh 1986, 218–20, cat. 48.

8. GAU, notary W. Brecht, U016a003, fols. 201–201v, 7 Apr. 1632.

9. GAU, notary W. Brecht, U016a004, fols. 39–39v, 8 Apr. 1636, in which Saftleven and his wife appoint guardians.

10. GAU, notary H. Ruysch, U020a004, fols. 35–36, 27 Oct. 1652. Saftleven also witnessed the signing of the will of Gerard's Remonstrant parents-in-law, Adam van Lochorst and Swana van Ledenberch (GAU, notary G. Houtman, U022a025, fols. 9, 11, 18 Jan. 1655).

11. RAU, Domkapittel, 1–32, resoluties, 9 Apr. 1652 (kindly communicated by A. de Groot). See also 14 Jan. 1653 and 30 July 1655. Dirck Saftleven had just turned eighteen previous to that last date.

12. De Jonge 1932, 126–29. Some of these paintings were done in collaboration with Jacques Saverij.

13. GAU, Stadsarchief II, 1243, thesauriersrekeningen, 1654 (achterin, correcties op de rekening). Citizenship was required for membership in a guild.

14. For the last year see Bok and Jansen 1995, 341.

15. Bok 1994, 200 n. 158.

Roelandt Saverij

1. This biography is based on Luijten et al. 1993, 315–16, as well as on earlier literature. For an extensive genealogy, see Dudok van Heel and Bok 1990. See also Briels 1976, 281–301, and Spicer 1979, 11–42.

2. Van Mander 1604, fol. 260v.

3. For the date and circumstances of his departure, see Spicer 1979, 19.

4. Spicer 1979, 35.

5. Von Sandrart 1675–80, 2:305.

6. Presently Boterstraat no. 20.

7. In Dutch, "het Keijserswapen."

Jan Baptist Weenix

1. There is no extensive scholarly biography of Jan Baptist Weenix. This biography was based on Bredius 1915–22, 1:294–98, and Ginnings 1970, 3–9. For a recent overview of the literature see Sutton, in Sutton 1987, 520–21.

2. The date of the reading of their banns can be found in GAA, DTB 667, 21, 19 May 1612. Jan Jansz. Weines was twenty-five, his bride, Grietje Heremans, seventeen. They both lived on a street near the St. Anthonisbreestraat.

3. Houbraken 1718–21, 2:77–83, 111, 113, 131, 3:70, 72.

4. Weenix's sister Lysbeth married the painter Barent Micker.

5. The reading of their banns in the Reformed Church in Amsterdam can be found in GAA, DTB 451, 227, 23 July 1639.

6. Bredius 1928, 177.

7. GAU, notary W. van Galen, U012a023, fol. 92, 18 June 1647; published by Kramm 1857–64, 6:1836. In 1647 Weenix declared that he had deposited paintings in Rouen about five years previously, in March. Considering that in Oct. 1642 he was making plans to go to Rome, it seems unlikely that he had already been in Rouen in March of that same year. I would opt for March 1643.

8. His nickname, as given by Houbraken 1718–21, 2:77, is confirmed by the inventory of Willem Vincent, baron van Wyttenhorst, in which he is called "Jan Baptista Wyninx deur de wandeling genaempt Ratelaer" (quoted from a transcript in The Hague, Iconographisch Bureau, fol. 88).

9. Kuznetsov 1974, 172, 195, cat. 92.

10. De Jonge 1932, 129.

11. Houbraken 1718–21, 3:72–73. For Weenix's involvement with Gijsbert de Hondecoeter's orphans, see GAU, Stadsarchief II, 1385, Besoigne-register van de Momboirkamer, 11 May 1655, 23 May 1655, 28 May 1655.

12. For Ter Mey Castle, see Olde Meierink et al. 1995, 310–12.

13. *Getty Provenance Index* 1996, N-1699 (transcript by E. A. J. van der Wal). For other documents concerning Weenix's bankruptcy, see Bok, in Roethlisberger 1993, 650.

14. GAU, DTB, 124, p. 472, 6 Oct. 1662.

15. For the estate of Johannes Weenix's widow, see Bredius 1928, 178, and the *Getty Provenance Index* 1996, N-1265. Gillis Weenix was living in Utrecht in 1668 and 1669, probably apprenticed to Jan Davidsz. de Heem (GAU, notary B. van Eck, U015a013, 30 July 1668, 1 Mar. 1669, 4 May 1669, 6 Sept. 1669). In 1680 he married in Lyons (Chomer 1992, 33), where he was still living about 1684 (Houbraken 1718–21, 3:341).

Adam Willarts

1. This biography is based on Luijten et al. 1993, 325–26, as well as on earlier literature.

2. RAU, Staten van Utrecht, 364–3–42, quarter of Captain Jacob Warnertsz. (van Velthuysen).

Joachim Wtewael

1. This biography is based on Lowenthal 1986, as well as on earlier literature and Luijten et al. 1993, 311–12.

2. Now no. 58.

3. His heirs were still collecting money from his debtors in the flax trade in 1646. A document from 5 Sept. 1646 refers to "fol. 113 verso" of Joachim Wtewael's ledger of outstanding debts (GAU, notary G. van Waey, U019a015, fols. 67–67v).

Peter Wtewael

1. For the life of Peter Wtewael, see Lowenthal 1986 and Luijten et al. 1993, 326–27.

2. Von Sandrart 1675–80, 2:289. For his second visit, see Bok, in Roethlisberger 1993, 584.

3. GAU, NH Kerkeraad, 407, lidmaten, fol. 22, 24 Sept. 1635. For another case of a similar, politically motivated "conversion," see the example of Paulus Moreelse's son Hendrick (Luijten et al. 1993, 311).

4. Van de Water 1729, 3:185, 195–96.

5. Van Lieburg 1989, 158.

6. Now no. 58.

7. GAU, notary G. van Waey, U019a010, fols. 53–53v, 24 Apr. 1639. It was to contain a sculpture of a "round ball, with a copper cross . . . meaning 'The World'" (zeeckere ronde boll, ende copere cruijs . . . bediedende "De Werelt").

Short References

Ackermann 1993
Ackermann, Philipp. *Textfunktion und Bild in Genreszenen der niederländischen Graphik des 17. Jahrhunderts.* Alfter: Verlag und Datenbank für Geisteswissenschaften, 1993. Originally Ph.D. diss., Universität Bonn.

Ackley 1981
Ackley, Clifford S. *Printmaking in the Age of Rembrandt.* Exh. cat. Boston: Museum of Fine Arts. Also The Saint Louis Art Museum.

Adams 1985
Adams, Ann Jensen. "The Paintings of Thomas de Keyser (1596–1667): A Study of Portraiture in Seventeenth-Century Amsterdam." 4 vols. Ph.D. diss., Harvard University.

Adams 1988
Adams, Ann Jensen. *Dutch and Flemish Paintings from New York Private Collections.* Exh. cat. New York: National Academy of Design.

Adelson 1994
Adelson, Candace A. *European Tapestry in the Minneapolis Institute of Arts.* Minneapolis: The Minneapolis Institute of Arts; New York: Harry N. Abrams.

Aitzema 1657–71
Aitzema, L. van. *Historie of Verhael van saken van staet en oorlogh, in, ende ontrent de Vereenigde Nederlanden,* 14 vols. The Hague: I. Veely.

Alemán 1622
Alemán, Mateo. *The Rogue; or, the Life of Guzmán de Alfarache.* London: Printed for Edward Blount.

Allentown 1960
The Samuel H. Kress Memorial Collection of the Allentown Art Museum. Allentown: Allentown Art Museum.

Amsterdam 1920. *See* Rijksmuseum 1920

Amsterdam 1951
Bourgondische pracht van Philips de Stoute tot Philips de Schone. Exh. cat. Haarlem: J. Enschede. Rijksmuseum, Amsterdam.

Andrews 1977
Andrews, Keith. *Adam Elsheimer: Paintings, Drawings, Prints.* New York: Rizzoli.

Ashworth 1991
Ashworth, William B., Jr. "Remarkable Humans and Singular Beasts," 113–44. In Kenseth 1991.

B.
Bartsch, Adam. *Le Peintre-graveur.* 21 vols. Vienna: J. V. Degen, 1803–21.

Van Baak Griffioen 1991
van Baak Griffioen, Ruth. *Jacob van Eyck's "Der fluyten lust-hof" (1644–c. 1655).* Muziekhistorische monografieen, no. 13. Utrecht: Vereniging voor Nederlandse Muziekgeschiedenis. Abridgment of Ph.D. diss., Stanford University, 1988.

Back-Vega 1958
Back-Vega, Emmerich, and Christa Back-Vega. "A Lost Masterpiece by Caravaggio." *Art Bulletin* 40 (March): 65–66.

Baglione 1642
Baglione, Giovanni. *Le vite de' pittori, scultori, et architetti* Rome: Biblioteca Apostolica Vaticana.

Baines 1957
Baines, Anthony. *Woodwind Instruments and Their History.* New York: W. W. Norton.

Baker and Henry 1995
Baker, Christopher, and Tom Henry. *The National Gallery, Complete Illustrated Catalogue.* London: National Gallery Publications. Distributed by Yale University Press.

Bakker et al. 1984
Bakker, Noortje, et al. *Masters of Middelburg: Exhibition in Honour of Laurens J. Bol.* Exh. cat. Amsterdam: Waterman Gallery.

Baronius 1586
Baronius, Caesar. *Annales Ecclesiastici.* 1. Rome.

Bartoschek 1978
Bartoschek, Gerd. *Flämische Barockmalerei in der Bildergalerie von Sanssouci.* Potsdam: Staatliche Schlösser und Gärten Potsdam-Sanssouci.

Bauch 1926
Bauch, Kurt. "Beiträge zum Werk der friesischer Künstler, II. Simon Frisius." *Oud Holland* 43:107–11.

Bauch 1960
Bauch, Kurt. *Der frühe Rembrandt und seine Zeit: Studien zur geschichtlichen Bedeutung seines Frühstils.* Berlin: Gebr. Mann.

Bauer 1993
Bauer, Linda Freeman. "Further Reflections on an Emblematic Interpretation of Caravaggio's Early Works," 1–21. In *Emblematica.* 3d International Emblem Conference. Pittsburgh.

Baumgart 1929
Baumgart, Fritz. "Beiträge zu Hendrick Terbrugghen." *Oud Holland* 46:222–33.

Becker 1984
Becker, Jochen. "'De duystere sin van de geschilderde figueren': zum Doppelsinn in Rätsel, Emblem, und Genrestück," 17–29. In *Wort und Bild in der niederländischen Kunst und Literatur des 16. und 17. Jahrhunderts,* edited by Herman Vekeman and Justus Müller Hofstede. Erftstadt: Lukassen Verlag.

Bedaux 1983
Bedaux, Jan Baptist. "Beelden van 'leersucht' en tucht. Opvoedingsmetaforen in de Nederlandse schilderkunst van de zeventiende eeuw." *Nederlands Kunsthistorisch Jaarboek* 33:49–74.

Beelaerts van Blokland et al. 1912–15
Beelaerts van Blokland, W. A., et al. *Nederlandsche kasteelen en hun histories.* 3 vols. Amsterdam: Uitgeverij-Maatschappij, Elsevier.

Bellori 1675
Bellori, Giovanni Pietro. *Le vite de' pittori, scvltori et architetti moderni.* Rome: Per il succeso, al Mascardi.

Benedetti 1993
Benedetti, Sergio. *Caravaggio, the Master Revealed.* Exh. cat. Dublin: National Gallery of Ireland.

Berents 1994
Berents, Dirk Arend. *Kerken en karossen: Fransen in Utrecht, 800–1900.* Utrecht: Het Spectrum.

Berghuijs 1925
Berghuijs, H. B. *Geschiedenis der Doopsgezinde Gemeente te Utrecht.* Utrecht: Doopsgezinde Gemeente.

Bergner 1905
Bergner, Paul. *Verzeichnis der Gräflich Nostitzschen Gemälde-Galerie zu Prag.* Prague: Carl Bellmann.

Bergsma 1989
Bergsma, Wiebe. "Calvinismus in Friesland um 1600 am Beispiel der Stadt Sneek." *Archiv für Reformationsgeschichte* 80:252–85.

Bergström 1956
Bergström, Ingvar. *Dutch Still-Life Painting in the Seventeenth Century,* translated by Christina Hedström and Gerald Taylor. London: Faber and Faber Ltd.

Berlin 1890
Katalog der Ausstellung von Werken der niederländischen Kunst des siebzehnten Jahrhunderts . . . im Berliner Privatbesitz. Exh. cat. Berlin: Ernst Siegfried Mitter und Sohn. Königlichen Akademie.

Bernard 1983
Bernard, B. *The Bible and Its Painters.* London: Orbis.

De Besse 1611
de Besse, Pierre. *L'Heraclite chrestien, c'est a dire Les Regrets et les larmes du Pecheur Penitent.* Limousin.

De Besse 1618
de Besse, Pierre. *Democrite chrestien, c'est a dire Le Mesprits, et mocquerie des vanites du Monde.* Limousin.

Beutin 1950
Beutin, Ludwig. *Simon Peter Tilman, 1601–1668: ein bremish-niederländischer Maler.* Schriften der Wittheit zu Bremen, Reihe H, Bremische Weihnachtsblätter, vol. 11. Bremen: C. Schunemann.

Bevers 1989
Bevers, Holm. *Niederländische Zeichnungen des 16. Jahrhunderts in der Staatlichen Graphischen Sammlung München.* Exh. cat. Munich: Staatliche Graphische Sammlung.

Bezemer 1896
Bezemer, W., ed. "De magistraatsverandering te Utrecht in 1618." *Bijdragen en Mededelingen van het Historisch Genootschap* 17:71–106.

Białostocki 1958
Białostocki, Jan. "Les bêtes et les humains de Roelant Savery." *Bulletin des Musées Royaux des Beaux-Arts de Belgique* 7:69–92.

Białostocki 1966
Białostoski, Jan. "Puer sufflans ignes," 591–95. In *Arte in Europa: scritti di storia dell'arte in onore di Eduardo Arslan.* Vol. 1. Milan: Tip. Artipo.

De Bie 1661
de Bie, Cornelis. *Het gulden cabinet van de edel vry schilderconst* Antwerp: Ian Meyssens. Reprint, Soest: Davaco, 1971.

De Bie 1708
de Bie, Cornelis. *Den spiegel van de verdrayde werelt.* Antwerp.

Bieneck 1992
Bieneck, Dorothea. *Gerard Seghers, 1591–1651: Leben und Werk des Antwerpener Historienmalers.* Lingen: Luca Verlag.

le Bihan 1990
le Bihan, Olivier. *L'or et l'ombre: La peinture hollandaise du XVIIe et du XVIIIe siècles au Musée des Beaux-Arts de Bordeaux.* Bordeaux: Musée des Beaux-Arts de Bordeaux, in association with William Blake and Co.

Binet 1632
Binet, Estienne. *Meditations affecteuses sur la vie de la Tressainte Vierge Mère de Dieu.* Antwerp: Martin Nutius.

Birmingham 1938
An Exhibition of Treasures from Midland Homes. Exh. cat. Birmingham: City Museum and Art Gallery.

Bissell 1971
Bissell, R. Ward. "Orazio Gentileschi: Baroque without Rhetoric." *Art Quarterly* 34:275–300.

Bissell 1981
Bissell, R. Ward. *Orazio Gentileschi and the Poetic Tradition in Caravaggesque Painting.* University Park and London: Pennsylvania State University Press.

Blankert 1965
Blankert, Albert. *Nederlandse 17e eeuwse italiserende landschapschilders.* Exh. cat. Utrecht: Centraal Museum.

Blankert 1967
Blankert, Albert. "Heraclitus en Democritus; in het bijzonder in de Nederlands kunst van de zeventiende eeuw." *Nederlands Kunsthistorisch Jaarboek* 18:31–124.

Blankert 1978
Blankert, Albert. *Nederlandse 17e eeuwse Italiserende landschapschilders.* Soest: Davaco. Revised and enlarged edition of Blankert 1965.

Blankert 1982
Blankert, Albert. *Ferdinand Bol (1616–1680): Rembrandt's Pupil.* Aetas aurea: Monographs on Dutch and Flemish Painting, no. 2. Doornspijk: Davaco.

Blankert 1991a
Blankert, Albert. *A Newly Discovered Painting by Hendrick ter Brugghen.* Zwolle: Waanders.

Blankert 1991b
Blankert, Albert. "Vrouw 'Winter' door Caesar van Everdingen." *Bulletin van het Rijksmuseum* 39, no. 4:505–23.

Blankert et al. 1980
Blankert, Albert, et al. *Gods, Saints, and Heroes: Dutch Painting in the Age of Rembrandt*. Exh. cat. The Hague: Staatsuitgeverij. Washington: National Gallery of Art; The Detroit Institute of Arts; Rijksmuseum, Amsterdam.

Blankert, Montias, and Aillaud 1988
Blankert, Albert, John Michael Montias, and Gilles Aillaud. *Vermeer*. Paris: Hazan.

Blankert, Ruurs, and Van de Watering 1978
Blankert, Albert, Robert Ruurs, and Willem L. Van de Watering. *Vermeer of Delft: Complete Edition of Paintings*. Oxford: Phaidon.

Blankert and Slatkes 1986
Blankert, Albert, and Leonard Slatkes. *Nieuw licht op de Gouden Eeuw. Hendrick ter Brugghen en tijdgenoten*. Exh. cat. Utrecht: Centraal Museum. Also Herzog Anton Ulrich-Museum, Braunschweig.

Bleiler 1976
Bleiler, E. F., ed. *The 1612 "Florilegium" of Emanuel Sweerts*. New York: Dover Publications.

Bloch 1940
Bloch, Vitale. "De Schilders van de Realiteit." *Elsevier's geillustreerd maandschrift* 50:91–109.

Bloch 1952
Bloch, Vitale. "I Caravaggeschi a Utrecht e Anversa." *Paragone* 33, no. 3 (Sept.): 14–20.

Bloch 1968
Bloch, Vitale. *Michael Sweerts: Suivi de Sweerts et les missions étrangères*. The Hague: L. J. C. Boucher.

Bob Jones University 1968
The Bob Jones University Collection of Religious Paintings. Supplement to the Catalogue of the Art Collection: Paintings Acquired 1963–1968. Greenville, N.C.: Bob Jones University.

Bober and Rubenstein 1986
Bober, Phyllis Pray, and Ruth Rubenstein. *Renaissance Artists and Antique Sculpture: A Handbook of Sources*. London: H. Miller; Oxford: Oxford University Press.

Bodart 1970a
Bodart, Didier. *Louis Finson*. Académie royale des sciences, des lettres, et des beaux-arts de Belgique. Classe des beaux-arts. Mémoires. Coll. in 4, series 2, vol. 12, fasc. 4. Brussels.

Bodart 1970b
Bodart, Didier. *Les Peintres des Pays-Bas méridionaux et de la principauté de Liège à Rome au XVIIème siècle*. 2 vols. Rome: Academia Belgia.

Von Bode 1883
von Bode, Wilhelm. *Studien zur Geschichte der holländischen Malerei*. Braunschweig: F. Vieweg und Sohn.

Bodkin 1929
Bodkin, Thomas. "Two Unrecorded Landscapes by Abraham Bloemaert." *Oud Holland* 46:101–3.

Boekenoogen 1908
Boekenoogen, G. J. *De Historie van de verloren sone naar de Antwerpschen druk van Godtgaf Verhulst uit het Jaar 1655*. Nederlandsche Volksboeken, no. 11. Leiden: E. J. Brill.

De Boer 1934
de Boer, Pieter. *De Helsche en de fluweelen Brueghel en hun invloed op de kunst in de Nederlanden*. Exh. cat. Amsterdam: Kunsthandel P. de Boer.

Boerlin 1987
Boerlin, Paul H. "A la lumière de la Hollande." *L'Oeil*, no. 386 (Sept.): 32–39.

Bogaers 1985
Bogaers, Llewellyn. "Een kwestie van macht? De relatie tussen de wetgeving op het openbaar gedrag en de ontwikkeling van de Utrechtse stadssamenleving in de zestiende en zeventiende eeuw." *Volkskundig Bulletin* 11:102–26.

Bok 1984
Bok, Marten Jan. "Vijfendertig Utrechtse kunstenaars en hun werk voor het Sint Jobs Gasthuis, 1622–1642." M. Phil. thesis, Rijksuniversiteit Utrecht.

Bok 1985
Bok, Marten Jan. "The Date of Cornelis van Poelenburch's Birth." *Hoogsteder-Naumann Mercury*, no. 2:9–11.

Bok 1986a
Bok, Marten Jan. "Dirck Jaspersz. van Baburen," 173–75. In Blankert and Slatkes 1986.

Bok 1986b
Bok, Marten Jan. "Sint Sebastiaan, de gemiste kans van het museum." *Utrechts Nieuwsblad*, Oct. 18.

Bok 1988
Bok, Marten Jan. "On the Origins of the Flute Players in Utrecht Caravaggesque Painting," 135–41. In Klessmann 1988.

Bok 1990
Bok, Marten Jan. "'Nulla dies sine linie.' De opleiding van schilders in Utrecht in de eerste helft van de zeventiende eeuw." *De zeventiende eeuw* 6, no. 1: 58–68.

Bok 1993a
Bok, Marten Jan. "Art-Lovers and Their Paintings: Van Mander's *Schilder-boeck* as a Source for the History of the Art Market in the Northern Netherlands," 136–66. In Luijten et al. 1993.

Bok 1993b
Bok, Marten Jan. "Schilderkunst in Utrechts Overkwartier in de zeventiende eeuw." *Tussen Rijn en Lek* 27:1–24.

Bok 1994
Bok, Marten Jan. *Vraag en aanbod op de Nederlandse kunstmarkt, 1580–1700*. Ph.D. diss., Rijksuniversiteit Utrecht.

Bok 1996
Bok, Marten Jan. "Laying Claims to Nobility in the Dutch Republic: Epitaphs, True and False." *Simiolus* 24:209–26.

Bok and Jansen 1995
Bok, Marten Jan, and Guido Jansen. "De Utrechtse schilder Johannes van Wijckersloot en zijn 'Allegorie' op de Franse invasie, 1672." *Bulletin van het Rijksmuseum* 43:336–49.

Bok and Kobayashi 1985
Bok, Marten Jan, and Yoriko Kobayashi. "New Data on Hendrick ter Brugghen." *Hoogsteder-Naumann Mercury*, no. 1:7–34.

Bok and De Meyere 1986
Bok, Marten Jan, and Jos A. L. de Meyere. "Een familie portret door de Utrechtse schilder Andries von Bochoven (1609–1634)." *Antiek* 20 (Jan.): 323–39.

Bol 1960
Bol, Laurens J. *The Bosschaert Dynasty: Painters of Flowers and Fruit.* Leigh-on-Sea: F. Lewis.

Bol 1973
Bol, Laurens J. *Die holländische Marinemalerei des 17. Jahrhunderts.* Braunschweig: Klinkhardt and Biermann.

Bol 1982a
Bol, Laurens J. *'Goede Onbekenden': Hedendaagse herkenning en waardering van verscholen, voorbijgezien en onderschat talent.* Utrecht: Tableau.

Bol 1982b
Bol, Laurens J. *Höllandische Maler des 17. Jahrhunderts nahe den großen Meistern.* Munich: Klinkhardt and Biermann.

Bol, Keyes, and Butôt 1981
Bol, Laurens, George Keyes, and F. C. Butôt. *Netherlandish Paintings and Drawings from the Collection of F. C. Butôt by Little-Known and Rare Masters of the Seventeenth Century.* London: Sotheby's Parke Bernet Publications, in association with Totowa, N.J.: P. Wilson.

Bolten 1985
Bolten, Jaap. *Method and Practice: Dutch and Flemish Drawing Books, 1600–1750.* Landau: PVA.

Bolten 1993
Bolten, Jaap. "The Portraits of Abraham Bloemaert." *Delineavit et Sculpsit. Tijdschrift voor Nederlandse prent- en tekenkunst tot omstreeks 1850* 10 (June): 1–34.

Bonaventure 1961
Bonaventure, Saint. *Meditations on the Life of Christ,* edited and translated by Isa Ragusa and Rosalie B. Green. Princeton, N.J.: Princeton University Press.

Bonnard 1965
Bonnard, L. "Culte et iconographie de saint Martin dans les anciennes paroisses du département de la Haute-Vienne." *Bulletin de la Société Archéologique et historique du Limousin* 92:207–92.

Boon 1942
Boon, Karel G. *De schilders voor Rembrandt: de inleiding tot het bloeitijdperk.* Maerlantbibliotheek, no. 9. Antwerp: De Sikkel.

Boon 1960
Boon, Karel G. "De Meester van de Virgo inter virgines." *Oud-Delft* 2.

Boorsch and Spike 1985
Boorsch, Suzanne, and John T. Spike. *Italian Masters of the Sixteenth Century. The Illustrated Bartsch,* 28. New York: Abaris Books.

De Booy 1980
de Booy, E. P. *Kweekhoven der wijsheid. Basis- en vervolgonderwijs in de steden van de provincie Utrecht van 1580 tot het begin der 19de eeuw.* Zutphen: De Walburg Pers.

Borger 1996
Borger, Ellen. *Geschilderde wachtlokalen: de Hollandse kortegaard uit de Gouden Eeuw.* Exh. cat. Zwolle: Waanders. Nederlands Vesting-museum, Naarden.

Börsch-Supan 1964
Börsch-Supan, Helmut. *Die Gemälde im Jagdschloß Grünewald.* Exh. cat. Berlin: Verlag Gebr. Mann. Verwaltung der Staatlichen Schlösser und Gärten.

Börsch-Supan 1967
Börsch-Supan, Helmut. "Die Gemälde aus dem Vermächtnis der Amalie van Solms und aus der Oranischen Erbschaft in den brandenburgisch-preußischen Schlössern: Ein Beitrag zur Geschichte der hohenzollernschen Kunstsammlungen." *Zeitschrift für Kunstgeschichte* 30:143–98.

Börsch-Supan 1992
Börsch-Supan, Helmut. *450 Jahre Jagdschloß Grunewald, 1542–1992.* 3 vols. Vol. 2, *Aus der Gemäldesammlung.* Exh. cat. Berlin: Staatliche Schlösser und Gärten.

Boschloo 1996
Boschloo, A. "De kunstenaar, de opdrachtgever en de onderzoeker. Een inleiding." 1–6. In Hendrix and Stumpel 1996.

Bott 1966
Bott, Gerhard. "Stilleben des 17. Jahrhunderts: Jacob Marrell." *Kunst in Hessen und am Mittelrhein* 6:85–117.

Boukema 1982
Boukema, Niek. "Geloven in het geloof. Een onderzook naar de positie van de katholieke seculiere zielzorg binnen de stad Utrecht gedurende de periode, 1580–1672, met accent op de eerste helft van de 17de eeuw." Ph.D. diss., Rijksuniversiteit Utrecht.

Bowron 1973
Bowron, Edgar Peters. "A Landscape by Bloemaert." *Bulletin of the Walters Art Gallery* 26, no. 3:1–3.

Bowron 1995
Bowron, Edgar Peters. "'Full of Details and Very Subtly and Carefully Executed': Oil Paintings on Copper around 1600," 9–19. *The International Fine Art Fair.* New York.

Boyer 1989
Boyer, Jean-Claude. *Le peintre, le roi, le héros: l'Andromède de Pierre Mignard.* Exh. cat. Paris: Ministère de la culture, Editions de la Réunion des musées nationaux. Musée du Louvre.

Braun 1954
Braun, Edmund. "Caritas Romana." *Reallexikon der deutschen Kunstgeschichte,* 3: cols. 355–62, edited by Otto Schmitt. Stuttgart: Alfred Druckenmüller Verlag.

Braun 1966
Braun, Hermann. *Gerard und Willem van Honthorst.* Ph.D. diss., Georg-August-Universität, Göttingen.

Braune 1914
Braune, Heinz. "Honthorst oder Terbrugghen?" *Oud Holland* 32:262–63.

Bredius 1881
Bredius, Abraham. "Aanvullingen op Kramm. V. Diederick van der Lisse." *Nederlandsche Kunstbode* 3:196–98.

Bredius 1915–22
Bredius, Abraham. *Künstler-Inventare: Urkunden zur Geschichte der holländischen Kunst des XVIten, XVIIten und XVIIIten Jahrhunderts.* 8 vols. The Hague: Nijhoff.

Bredius 1928
Bredius, Abraham. "Een testament van Jan Baptist Weenix."
Oud Holland 45:177–78.

Brejon 1979
Brejon, Arnauld. "New Paintings by Bartolommeo Manfredi."
Burlington Magazine 131, no. 914 (May): 305–10.

Brenninkmeijer-de Rooij 1996
Brenninkmeijer-de Rooij, Beatrijs. *Roots of Seventeenth-Century
Flower Painting.* Leiden: Primavera Pers.

Brenninkmeijer-de Rooij et al. 1992
Brenninkmeijer-de Rooij, Beatrijs, et al. *Boeketten uit de Gouden
Eeuw: Mauritshuis in bloei.* Exh. cat. Zwolle: Waanders.
Mauritshuis, The Hague.

Bridgman et al. 1965
Bridgman, Charles F., et al. "Radiography of a Painting on Copper
by Electron Emission." *Studies in Conservation* 10 (Feb.): 1–7.

Briels 1976
Briels, J. G. C. A. "De Zuidnederlandse immigratie in Amsterdam
en Haarlem omstreeks, 1572–1630: met een keuze van archivalische
gegevens betreffende de kunstschilders." Ph.D. diss., Rijksuniver-
siteit Utrecht.

Briels 1978
Briels, J. G. C. A. *Zuid Nederlandse immigratie, 1572–1630.* Haarlem:
Fibula-Van Dishoeck.

Briels 1987
Briels, J. G. C. A. "Het liber amicorum van mr. Carel Martens,
(1602–1649)." *Nederlands Kunsthistorisch Jaarboek* 38:53–61.

Briganti, Trezzani, and Laureati 1983
Briganti, Guiliano, Ludovico Trezzani, and Laura Laureati. *The
Bamboccianti: The Painters of Everyday Life in Seventeenth-Century Rome.*
Rome: Ugo Bozzi.

Briganti et al. 1986
Briganti, Giuliano, et al. *The Age of Correggio and the Carracci:
Emilian Painting of the Sixteenth and Seventeenth Centuries.* Exh. cat.
Washington: National Gallery of Art. Also Pinacoteca Nazionale,
Bologna; The Metropolitan Museum of Art, New York.

Ten Brink Goldsmith et al. 1994
ten Brink Goldsmith, Jane, et al. *Leonaert Bramer, 1596–1674:
Ingenious Painter and Draftsman in Rome and Delft.* Exh. cat. Zwolle:
Waanders. Stedelijk Museum Het Prinsenhof, Delft.

Van den Brink and De Meyere 1993
van den Brink, Pieter, and Jos de Meyere, eds. *Het Gedroomde Land:
Pastorale schilderkunst in de Gouden Eeuw.* Exh. cat. Zwolle: Waanders.
Centraal Museum, Utrecht; Ländisches Museum, Frankfurt;
Musée National d'Histoire et d'Art, Luxembourg.

Brinkhuis 1935
Brinkhuis, G. "Nieuwe gegevens over den kunstschilder Nicolaus
Knupfer." *Jaarboekje van Oud-Utrecht,* 110–16.

Broos 1980
Broos, Ben. *Maritshuise: hollandse Schilderkunst, Lanscappen 17de eeuw.*
The Hague: Staasuitgeverij.

Broos 1983
Broos, Ben. *Liefde, List en Lijden: Historiestukken in het Mauritshuis.*
Exh. cat. Mauritshuis: The Hague.

Broos 1986
Broos, Ben. *De Rembrandt à Vermeer: les peintres hollandais au
Mauritshuis de La Haye.* Exh. cat. The Hague: Fondation Johan
Maurits van Nassau. Also Galeries nationales du Grand Palais,
Paris.

Broos 1987
Broos, Ben. *Meesterwerken in het Mauritshuis.* The Hague:
Staatsuitgeverij.

Broos 1993
Broos, Ben. *Intimacies and Intrigues: History Painting in the Maurits-
huis.* The Hague: Mauritshuis, in association with Ghent: Snoeck-
Ducaju & Zoon.

Broos 1994
Broos, Ben. *The Mauritshuis: Royal Cabinet of Paintings Mauritshuis
and Gallery Prince William V,* edited by Quentin Buvelot and Jane
Havell; translated by Phil Goddard. London: Scala Publications,
in association with the Royal Cabinet of Paintings Mauritshuis,
The Hague.

Broos et al. 1990
Broos, Ben, et al. *Great Dutch Paintings from America.* Exh. cat.
Zwolle: Waanders. Mauritshuis, The Hague; The Fine Arts
Museums of San Francisco.

Brown 1976a
Brown, Christopher. *Art in Seventeenth-Century Holland.* Exh. cat.
London: The National Gallery.

Brown 1976b
Brown, Christopher. *Dutch Genre Painting.* London: The National
Gallery.

Brown 1977
Brown, Christopher. *Dutch and Flemish Paintings.* London: Phaidon.

Brown 1980
Brown, Christopher. "The Utrecht Caravaggisti," 101–21. In
Blankert et al. 1980.

Brown 1984
Brown, Christopher. *Images of a Golden Past: Dutch Genre Painting of
the Seventeenth Century.* New York: Abbeville Press.

Brown 1986
Brown, Christopher. *Dutch Landscapes: The Early Years, Haarlem and
Amsterdam, 1590–1650.* Exh. cat. London: The National Gallery.

Brown 1988
Brown, Christopher. "The London *Jacob and Laban* and ter
Brugghen's Italian Sources," 89–97. In Klessmann 1988.

Brown and Mai 1991
Brown, Christopher, and Ekkehard Mai. *Hendrick ter Brugghen
(1588[?]–1629): Jakob, Laban und Lea. Ein Bild im Vergleich.* Exh. cat.
Cologne: Nordstern Versicherungen. Wallraf-Richartz-Museum,
Cologne.

Brown, Kelch, and Van Thiel 1991
Brown, Christopher, Jan Kelch, and Pieter van Thiel. *Rembrandt:
The Master and His Workshop. Paintings.* Exh. cat. New Haven and
London: Yale University Press. The National Gallery, London;
Gemäldegalerie, Altes Museum, Staatliche Museen zu Berlin;
Rijksmuseum, Amsterdam.

Brussels 1971
Rembrandt en zijn tijd. Exh. cat. Brussels: Paleis voor Schone Kunsten.

Bruyn 1952
Bruyn, L. de. "Het geboortejaar van Jan Both." *Oud-Holland* 67:110–12.

Bruyn 1983
Bruyn, Josua. Review of Blankert 1982. *Oud Holland* 97: 208–15.

Bruyn 1987
Bruyn, Josua. "Toward a Scriptural Reading of Seventeenth-Century Dutch Landscape Paintings," 84–103. In Sutton 1987.

Bruyn 1988
Bruyn, Josua. "Jung und alt: Ikonographische Bemerkungen zur 'tronie,'" 67–76. In Klessmann 1988.

Bruyn 1994
Bruyn, Josua. Review of Van den Brink et al. 1993. *Oud Holland* 108:141–48.

Bruyn et al. 1986
Bruyn, Josua, et al. *A Corpus of Rembrant Paintings.* Vol. 2, *1631–1634.* Stichting Foundation Rembrandt Research Project. The Hague: Martinus Nijhoff; Boston and Hinghma, Mass.: Kluwer Boston.

Bruyn et al. 1989
Bruyn, Josua, et al. *A Corpus of Rembrant Paintings.* Vol. 3, *1635–1642.* Stichting Foundation Rembrandt Research Project. The Hague: Martinus Nijhoff; Boston and Hinghma, Mass.: Kluwer Boston.

De Bruyn 1952
de Bruyn, Lia. "Het geboortejaar van Jan Both." *Oud Holland* 67:110–12.

Buchelius 1887
Buchelius, A. *Observationes ecclesiasticae sub presbyteratu meo. 1622–1626,* edited by S. Muller. In *Bijdragen en Mededelingen van het Historisch Genootschap* 10:29–63.

Van Buchell 1907
van Buchell, Arend. *Diarium van Arend van Buchell,* edited by Gisbert Brom and L. A. van Langeraad. Werken uitgegeven door het Historisch Genootschap, ser. 3, vol. 21. Amsterdam: J. Muller.

Van Buchell 1928
van Buchell, Arend. *"Res Pictoriae": aantekeningen over kunstenaars en kunstwerken voorkomende in zijn Diarium, Res pictoriae, Notae quotidianae, en Descriptio urbis Ultrajectinae (1538–1639),* edited by G. J. Hoogewerff and I. Q. van Regteren Altena. The Hague: Martinus Nijhoff.

Van Buchell 1940
van Buchell, Aernout. *Notae Quotidianae,* edited by J. W. C. van Campen. Werken uitgegeven door het Historisch Genootschap, ser. 3, vol. 70. Utrecht: Kemink en Zoon.

Buijs 1989
Buijs, Hans. "Voorstellingen van Christus in het huis van Martha en Maria in het zestiende-eeuwse keukenstuk." *Nederlands Kunsthistorisch Jaarboek* 40:93–128.

Buijs and Van Berge-Gerbaud 1991
Buijs, Hans, and Maria van Berge-Gerbaud. *Tableaux flamands et hollandais du Musée des beaux-arts de Lyon.* Exh. cat. Paris: Institut Neerlandais. Also Musée des Beaux-Arts, Lyons.

Buijsen and Grijp 1994
Buijsen, Edwin, and Louis Peter Grijp, eds. *The Hoogsteder Exhibition of Music and Painting in the Golden Age.* Exh. cat. Zwolle: Waanders. Kunsthandel Hoogsteder and Hoogsteder, The Hague; Hessenhuis Museum, Antwerp.

Bullard 1995
Bullard, John E., ed. *Handbook of the Collection: New Orleans Museum of Art.* New Orleans: New Orleans Museum of Art.

Burke 1976
Burke, James D. *Jan Both: Paintings, Drawings, and Prints.* New York: Garland. Originally Ph.D. diss., Harvard University.

Burke 1993
Burke, M. B. *Jesuit Art and Iconography, 1550–1800.* Exh. cat. Jersey City, N.J.: Saint Peter's College Art Gallery.

Bury 1997
Bury, John. "El Greco's *Allegory:* An Interpretation." *Apollo* 145, no. 420 (Feb.): 24–25.

Busch 1983
Busch, Werner. "Rembrandts *Ledikant:* der Verlorene Sohn im Bett." *Oud Holland* 97:257–65.

Butôt 1972
Butôt, F. C. *Niederländische Kunst aus dem goldenen Jahrhundert: Gemälde und Zeichnungen im Umkreis Großer Meister aus der Sammlung F. C. Butôt.* Exh. cat. St. Gilgen: Butôt. Museumpavillon im Mirabellgarten, Salzburg.

Cadogan 1991
Cadogan, Jean K. *Wadsworth Atheneum Paintings, II: Italy and Spain, Fourteenth through Nineteenth Centuries.* Hartford, Conn.: Wadsworth Atheneum.

Cafritz, Gowing, and Rosand 1988
Cafritz, Robert, Lawrence Gowing, and David Rosand. *Places of Delight: The Pastoral Landscape.* Exh. cat. New York: Clarkson N. Potter. Phillips Collection, Washington, D.C., in association with the National Gallery of Art.

Caldwell and McDermott 1980
Caldwell, Joan G., and Betty N. McDermott. *New Orleans Museum of Art: Handbook of the Collection.* New Orleans: New Orleans Museum of Art.

Cameron 1991
Cameron, Evan. *The European Reformation.* New York: Clarendon Press; Oxford: Oxford University Press.

Carasso-Kok and Levy-van Helm 1988
Carasso-Kok, Marijke, and J. Levy-van Helm, eds. *Schutters in Holland: kracht en zenuwen van de stad.* Exh. cat. Zwolle: Waanders. Frans Halsmuseum, Haarlem.

Carr 1964
Carr, Carolyn Kinder. *"Saint Sebastian Attended by Irene:* An Iconographic Study." Master's thesis, Oberlin College.

Causa 1970
Causa, Raffaello. *Opere d'arte nel Pio Monte della Misericordia a Napoli.* Cava dei Tirreni: Mauro.

Cats 1625
Cats, Jacob. *Houwelyck, dat is de gantsche gelegentheyt des Echten-Staets.* Middelburg: I. P. van de Venne.

Cats 1627
Cats, Jacob. *Proteus, ofte, Minne-beelden verandert in sinne-beelden.* Rotterdam: Pieter van Waesberge.

Cats 1632
Cats, Jacob. *Spiegel van den ouden ende nieuwen tijdt.* 3 parts. The Hague: Isaac Burchoorn.

Cats 1726
Cats, Jacob. *Ouderdom, buyten leven, en hof gedachten.* Amsterdam: I. van der Putte.

Cavalli-Björkman 1992
Cavalli-Björkman, Gorel, ed. *Rembrandt och hans tid.* Exh. cat. Stockholm: Nationalmuseum.

Cavina 1968
Cavina, Anna Ottani. *Carlo Saraceni.* Milan: Mario Spagnol Editore.

De Ceuleneer 1919
de Ceuleneer, Adolf. "La charité romaine dans la littérature et dans l'art." *Annuales de l'Académie Royale d'Archéologie de Belgique* 67:175–206.

Chapman, Kloek, and Wheelock 1996
Chapman, H. Perry, Wouter Kloek, and Arthur K. Wheelock, Jr. *Jan Steen: Painter and Storyteller.* Exh. cat. Washington: National Gallery of Art, distributed by New Haven and London: Yale University Press. Also Rijksmuseum, Amsterdam.

Châtelet 1981
Châtelet, Albert. *Early Dutch Painting: Painting in the Northern Netherlands in the Fifteenth Century.* New York: Rizzoli.

Chomer 1992
Chomer, Gilles. "Les passages des artistes hollandais et flamands en Rhône-Alpes," 32–38. In *Flandre et Hollande au siècle d'or: chefs-d'oeuvre des Musées de Rhône-Alpes.* Exh. cat. Lyons: Musée des Beaux-Arts. Also Musée de Brou, Bourg-en-Bresse; Musée Joseph Déchelette, Roanne.

Chong 1987
Chong, Alan. "The Drawings of Cornelis van Poelenburch." *Master Drawings* 25 (Spring): 3–62.

Chong 1993
Chong, Alan. *European and American Painting in the Cleveland Museum of Art: A Summary Catalogue.* Cleveland: The Cleveland Museum of Art.

Christiansen 1986
Christiansen, Keith. "Caravaggio and *L'esempio davanti del naturale.*" *Art Bulletin* 68 (Sept.): 421–45.

Christiansen 1990
Christiansen, Keith. *A Caravaggio Rediscovered: "The Luteplayer."* Exh. cat. New York: The Metropolitan Museum of Art.

Chronique des Arts 1983
La Chronique des Arts (supplément à la *Gazette des Beaux-Arts*) no. 1368 (Jan.): 29, fig. 40.

Churchman and Erbes 1993
Churchman, Michael, and Scott Erbes. *High Ideals and Aspirations: The Nelson-Atkins Museum of Art, 1933–1993.* Kansas City: The Nelson-Atkins Museum of Art.

Cinotti 1983
Cinotti, Mia. *Michelangelo Merisi detto il Caravaggio: tutte le opere.* Bergamo: Poligrafiche Bolis.

Clifford et al. 1994
Clifford, Timothy, et al. *Raphael, the Pursuit of Perfection.* Exh. cat. Edinburgh: National Galleries of Scotland.

Collins Baker 1927
Collins Baker, C. H. "Hendrick Terbrugghen and Plein Air." *Burlington Magazine* 50 (April): 196–202.

Cologne 1982
Die Heiligen Drei Könige: Darstellung und Verehrung. Exh. cat. Cologne: Wallraf-Richartz-Museum.

Conisbee 1996
Conisbee, Philip. *Georges de La Tour and His World.* Exh. cat. Washington: National Gallery of Art, in association with New Haven and London: Yale University Press. Also Kimbell Art Museum, Fort Worth.

Coornhert 1586
Coornhert, Dirck Volkertsz. *Zedekunst, dat is, wellevenskunste,* edited and annotated by Bruno Becker. Leiden: E. J. Brill, 1942, based on 1586 edition.

Copenhagen 1988
Art Centres and Artists in Northern Europe. Exh. cat. Copenhagen: Royal Museum of Fine Arts.

Corrin and Spicer 1995
Corrin, Lisa G., and Joaneath Spicer, eds. *Going for Baroque: Eighteen Contemporary Artists Fascinated with the Baroque and Rococo.* Exh. cat. Baltimore: The Contemporary, in association with the Walters Art Gallery.

Coster 1616
Coster, F. *Meditations of the Whole Historie of the Passion of Christ.* Douai.

Craig 1983
Craig, Kenneth M. "*Pars Ergo Marthae Transit:* Pieter Aertsen's 'Inverted' Paintings of *Christ in the House of Mary and Martha.*" *Oud Holland* 97:25–39.

Cuppen 1983
Cuppen, Y. "Schilderijen uit de verzameling Wittenhorst." Ph.D. diss., Katholieke Universiteit Nijmegen. Kunstgeschiedenis der Nieuwe Tijden.

Czobor 1956
Czobor, Agnes. "Über ein unbekanntes Bild des Hendrick Terbrugghen." *Oud Holland* 71:229–32.

Damisch 1996
Damisch, Hubert. *The Judgement of Paris,* translated by John Goodman. Chicago: University of Chicago Press.

Daniëls 1982–83
Daniëls, G. L. M. "'Een grafmonument voor Octavianus' door Carel C. de Hooch (overl. 1638)." *Antiek* 17:9–17.

Davies 1989
Davies, David. *El Greco: Mystery and Illumination*. Exh. cat.
Edinburgh: National Gallery of Scotland.

Defoer 1977
Defoer, H. L. M. "Rembrandt van Rijn, *De Doop van de Kamerling*."
Oud Holland 91:3–26.

Delbanco 1928
Delbanco, G. *Der Maler Abraham Bloemaert (1564–1651)*.
Studien zur deutschen Kunstgeschichte, vol. 253. Strasbourg:
J. H. Ed. Heitz.

Dempsey 1967
Dempsey, Charles. "Euanthes Redivivius: Rubens's *Prometheus
Bound*." *Journal of the Warburg and Courtauld Institutes* 30:420–25.

Van Deursen 1974
van Deursen, Arie Theodorus. *Bavianen en slijkgeuzen: kerk en
kerkvolk ten tijde van Maurits en Oldebarnevelt*. Assen: Van Gorcum.

Van Deursen 1991
van Deursen, Arie Theodorus. *Plain Lives in a Golden Age:
Popular Culture, Religion, and Society in Seventeenth-Century Holland*.
Cambridge and New York: Cambridge University Press.

Dictionary of Art 1996
The Dictionary of Art, edited by Jane Turner. 34 vols. New York:
Grove Dictionaries; London: Macmillan Publishers.

Van Dillen 1970
van Dillen, Johannes Gerard. *Van rijkdom en regenten: handboek tot de
economische en sociale geschiedenis van Nederland tijdens de Republiek*.
The Hague: Nijhoff.

Dirkse 1989
Dirkse, Paul, ed. *Kunst uit Oud-Katholieke Kerken*. Exh. cat. Utrecht:
Rijksmuseum het Catharijneconvent.

Dirkse 1991
Dirkse, Paul. *Jezuieten in Nederland*. Exh. cat. Utrecht: Rijks-
museum Het Catharijneconvent.

Dirkse and Schillemans 1993
Dirkse, Paul, and Robert Schillemans. "Dirck van Voorst, ca. 1610/
1615–1658: een onbekend Utrechts schilder uit het atelier van
Abraham en Hendrick Bloemaert." *Jaarboek Oud-Utrecht*, 5–18.

Dixon 1995
Dixon, Laurinda S. *Perilous Chastity: Women and Illness in
Pre-Enlightenment Art and Medicine*. Ithaca, N.Y.: Cornell University
Press.

Dodt van Flensburg 1846
Dodt van Flensburg, J. J., ed. "Utrechtsch kronijkjen." *Archief voor
kerkelijke en wereldsche geschiedenissen, inzonderheid van Utrecht* 6:9–222.

Ten Doesschate-Chu and Boerlin 1987
Ten Doesschate-Chu, Petra, and Paul H. Boerlin. *Im Lichte
Hollands: holländische Malerei des 17. Jahrhunderts aus den Sammlungen
des Fürsten von Liechtenstein und aus Schweizer Besitz*. Exh. cat.
Zurich: Verlagshaus Zurich. Öffentlichen Kunstsammlung,
Kunstmuseum Basel.

Dolfin, Kylstra, and Penders 1989
Dolfin, Marceline J., E. M. Kylstra, and Jean Penders. *Utrecht, de
huizen binnen de Singels, 's-Beschrijving. De Nederlandse monumenten van
geschiedenis en kunst, de provincie Utrecht, de Gemeente Utrecht*. 2 vols.
The Hague: SDU; Zeist: Rijksdienst voor de Monumentenzorg.

Domela-Nieuwenhuis 1839
Domela-Nieuwenhuis, F. J. "Geschiedenis der Evangelisch-
Luthersche gemeente te Utrecht," 77–150. In *Bijdragen tot de
geschiedenis der Evang-Luthersche kerk in de Nederlanden*, edited by
J. C. Schultz Jacobi and F. J. Domela Nieuwenhuis. Utrecht:
Van Paddenburg.

Donkersloot-de Vrij 1995
Donkersloot-de Vrij. "Zuylenberg," 517–21. In Olde Meierink
et al. 1995.

Döring 1993
Döring, Thomas. "Studien zur Künstlerfamilie Van Bronchorst."
Ph.D. diss., Univerisität Bonn. Published as *Studien zur Künstler-
familie Van Bronchorst: Jan Gerritsz. (ca. 1603–1661), Johannes
(1627–1656) und Gerrit van Bronchorst (ca. 1636–1673) in
Utrecht und Amsterdam*. Alfter: Verlag und Datenbank für
Geisteswissenschaften.

Döring, Desel, and Marnetté-Kühl 1993
Döring, Thomas, J. Desel, and B. Marnetté-Kühl. *Bilder von alten
Menschen in der niederländischen und deutschen Kunst, 1550–1750. Das
Alter in Kunst und Kultur*. Exh. cat. Braunschweig: Herzog Anton
Ulrich-Museum.

Van Drie 1986
van Drie, R. J. F. "Gebruik en inhoud van de begrippen
ridderschap en ridderhofstad in het Nederstict gedurende de
16de eeuw." *Jaarboek van het Centraal Bureau voor Genealogie*
40:67–99.

Van Drie 1995
van Drie, R. J. F. "Het begrip ridderhofstad in de 16de en 17de
eeuw," 51–54. In Olde Meierink et al. 1995.

Drossaers 1930
Drossaers, Sophie Wilhelmina Albertine, with notes by Cornelis
Hofstede de Groot and C. H. de Jonge. "Inventaris van de
meubelen van het Stadhouderlijk kwartier met het Speelhuis en
van het Huis in het Noordeinde te 's-Gravenhage." *Oud Holland*
47:193–236, 241–76.

Drossaers and Lunsingh Scheurleer 1974
Drossaers, Sophie Wilhelmina Albertine, and Theodoor Herman
Lunsingh Scheurleer. *Inventarissen van de inboedels in de verblijven van de
Oranjes en daarmede gelijk te stellen stukken, 1567–1795*. Vol. 1. Rijks
Geschiedkundige Publicatiën, Grote Serie, vol. 147. The Hague:
Martinus Nijhoff.

Drost 1926
Drost, Willi. *Barockmalerei in den germanischen Ländern*. Potsdam:
Akademische Verlansgesellschaft Athenaion.

Dudok van Heel 1991
Dudok van Heel, S. A. C. "Rembrandt van Rijn (1606–1669):
A Changing Portrait of the Artist," 50–67. In Brown, Kelch,
and Van Thiel 1991.

Dudok van Heel and Bok 1990
Dudok van Heel, S. A. C., and Marten Jan Bok. "De familie van
Roelant Roghman," 2:6–14. In *De kasteeltekeningen van Roelant
Roghman*, edited by H. W. M. van der Wyck. 2 vols. Alphen aan den
Rijn: Canaletto in samenwerking met de Stichting "Nederlandse
Buitenplaatsen en Historische Landschappen."

Duker 1897–1915
Duker, Arnoldus Cornelius. *Gisbertus Voetius*. 4 vols. Leiden:
E. J. Brill.

Van Dulen 1989
van Dulen, P. "Keizers in de Republiek: een serie Romeinse
Keizers-portretten door twaalf Nederlandse Schilders (ca. 1615–
ca. 1625)." Ph.D. diss., Vrije Universiteit, Amsterdam.

Duparc 1985
Duparc, Frederic J. *Masterpieces of the Dutch Golden Age*. Exh. cat.
Utrecht: Noro Group. Also High Museum of Art, Atlanta.

Duparc and Graif 1990
Duparc, Frederic J., and Linda L. Graif. *Italian Recollections: Dutch
Painters of the Golden Age*. Exh. cat. Montreal: Montreal Museum of
Fine Arts.

Durantini 1983
Durantini, Mary Frances. *The Child in Seventeenth-Century Dutch
Painting*. Studies in the Fine Arts, Iconography: no. 7. Ann Arbor,
Mich.: UMI Research Press.

Dusseldorpius 1893
Dusseldorpius, Franciscus. *Uittreksel uit Francisci Dusseldorpii
annales, 1566–1616*, edited by Robert Fruin. *Werken uitgegeven door
het Historisch Genootschap*, 3d ser., vol. 1. The Hague: M. Nijhoff.

Dussler 1971
Dussler, Luitpold. *Raphael, a Critical Catalogue of His Pictures,
Wall-Paintings and Tapestries*. London and New York: Phaidon.

Van Eck 1993–94
van Eck, Xander. "From Doubt to Conviction: Clandestine
Catholic Churches as Patrons of Dutch Caravaggesque Painting."
Simiolus 22, no. 4:217–34.

Van Eck 1994
van Eck, Xander. *Kunst, twist en devotie: Goudse katholieke schuilkerken,
1572–1795*. Delft: Eburon.

Egan 1959
Egan, Patricia. "*Poesia* and the *Fête Champêtre*." *Art Bulletin* 41
(Dec.): 303–13.

Egan 1961
Egan, Patricia. "'Concert' Scenes in Musical Paintings of the
Italian Renaissance." *Journal of the American Musicological Society*
14:184–95.

Egorova 1989
Egorova, Xenia S. "A Painting by Hendrick Goltzius at the
Pushkin Museum of Fine Arts, Moscow." *Burlington Magazine* 131
(Jan.): 24–27.

Eisler 1977
Eisler, Colin T. *Painting from the Samuel H. Kress Collection: European
Schools Excluding Italian*. Oxford: Phaidon Press, for the Samuel H.
Kress Foundation.

Ekkart and Domela Nieuwenhuis 1995
Ekkart, Rudolf E. O., and Eric N. Domela Nieuwenhuis. "Two
Portraits by Paulus Moreelse." *The Minneapolis Institute of Arts
Bulletin* 67:12–21.

Ekkart, Kuus, and Schaffers-Bodenhausen 1996
Ekkart, Rudolf, S. Kuus, and Karen Schaffers-Bodenhausen. "De
portretgalerij van Slot Zuylen: Het karakter van een particuliere
Portretgalerij," 13. In Van der Goes and De Meyere 1996.

Ekkart et al. 1979
Ekkart, Rudolf, et al. *Jan Lievens, ein Maler im Schatten Rembrandts*.
Exh. cat. Braunschweig: Herzog Anton Ulrich-Museum.

Eldering-Niemeijer 1956
Eldering-Niemeijer, W. "De Plompetorengracht en haar bewoners
van 1582 tot plm 1800." *De Stichtsche Heraut* 3:246–50.

Elias 1903–5
Elias, John Engelsbert. *De vroedschap van Amsterdam, 1578–1795*.
2 vols. Haarlem: Losjes. Reprint, Amsterdam: N. Israel, 1963.

Elliot 1990
Elliot, John Paul. "Protestantization in the Northern Netherlands,
a Case Study: The Classis of Dordrecht, 1572–1640." Ph.D. diss.,
Columbia University.

Elsenwanger 1781
Elsenwanger, A. "Anzeige der vorzüglichsten Gemälde- und
Kupferstich-Sammlungen zu Prag." In *Neueingerichteter Prager
Almach auf das Jahr Jesu Christi 1782*. Prague.

Emmens 1973
Emmens, J. A. "'Eins aber ist nötig': zu Inhalt und Bedeutung von
Markt- und Küchenstücken des 16. Jahrhunderts," 93–101. In
Album Amicorum J. G. van Gelder, edited by Josua Bruyn et al. The
Hague: Martinus Nijhoff.

Enggass and Brown 1970
Enggass, Robert, and Jonathan Brown. *Italy and Spain, 1600–1750:
Sources and Documents*. Englewoods Cliffs, N.J.: Prentice-Hall.

Enno van Gelder 1972
Enno van Gelder, Herman Arend. *Getemperde vrijheid. Een
verhandeling over de verhouding van kerk en staat in de Republiek der
Verenigde Nederlanden en de vrijheid van meningsuiting in zake godsdienst,
drukpers en onderwijs, gedurende de 17e eeuw*. Groningen: Wolters-
Nordhoff.

Van Epen 1927
van Epen, D. G. "Familie-aanteekeningen Van der Lisse."
De Nederlandsche Leeuw 24: cols. 47–51.

Erasmus 1908
Erasmus, Kurt. *Roelant Savery, sein Leben und seine Werke*. Halle.

Ertz 1979
Ertz, Klaus. *Jan Brueghel, der Ältere, 1568–1625: die Gemälde, mit
kritischem Oeuvrekatalog*. Cologne: Dumont Buchverlag.

Evers 1933
Evers, G. A. "De schuilkerk der Remonstrantsche gemeente in de
Rietsteeg en hare bezitting op 't Heilig-Leven." *Jaarboekje van
Oud-Utrecht*, 97–114.

Faber 1986
Faber, Dirck E. A. "Der Zustand in der Republik," 13–16. In
Blankert and Slatkes 1986.

Faber 1988
Faber, Dirck E. A. "Dirck van Baburen, His Commissioner, and
His Motifs," 143–49. In Klessmann 1988.

Fabri 1991
Fabri, Ria. *De 17de-eeuwse Antwerpse kunstkast: typologische en
historische aspecten*. Brussels: AWLSK

Fechner 1966–67
Fechner, J. "Die Bilder van Roelandt Savery in der Eremitage."
Jahrbuch des Kunsthistorischen Instituts der Universität Graz 2:93–100.

Felix 1919
Felix, Dina Albertina. *Het oproer te Utrecht in 1610.* Utrecht:
A. Oosthoek.

Filedt Kok, Halsema-Kubes, and Kloek 1986
Filedt Kok, J. P., Willy Halsema-Kubes, and Wouter Th. Kloek,
eds. *Kunst voor de beeldenstorm: Noordnederlandse kunst, 1525–1580.*
Exh. cat. The Hague: Staatsuitgeverij. Rijksmuseum, Amsterdam.

Filipczak 1991
Filipczak, Zirka Z. "'A Time Fertile in Miracles': Miraculous
Events in and through Art," 193–212. In Kenseth 1991.

Finlay 1984
Finlay, Karen A. "Terbrugghen *Melancholy.*" *Art Gallery of Ontario
Masterpiece Exhibition Series,* no. 2.

Fishman 1982
Fishman, Jane Susannah. *"Boerenverdriet": Violence between Peasants
and Soldiers in Early Modern Netherlands Art.* Studies in the Fine
Arts: Iconography, no. 5. Ann Arbor, Mich.: UMI Research Press.

Floerke 1905
Floerke, Hans. *Studien zur Niederländischen Kunst- und
Kulturgeschichte: die Formen des Kunsthandels, das Atelier und die
Sammler in den Niederlanden von 15.–18. Jahrhundert.* Munich:
G. Muller. Reprint, Soest, 1972.

Fock 1948–49
Fock, C. W. "Nieuws over de tapijten, bekend als de Nassause
Genealogie." *Nederlands Kunsthistorisch Jaarboek* 2:1–28.

Fölting 1985
Fölting, H. P. *De Vroedschap van 's-Gravenhage, 1572–1795.* Pijnacker:
Dutch Efficiency Bureau.

Foucart 1970
Foucart, Jacques. "Trois nouveaux tableaux néerlandais au Musée
du Louvre." *La Revue du Louvre* 20, nos. 4–5:221–30.

François 1982
François, Etienne. "De l'uniformité à la tolérance: confession et
société urbaine en Allemagne, 1650–1800." *Annales E. S. C.*
37:783–800.

Franits 1986
Franits, Wayne E. "The Family Saying Grace: A Theme in Dutch
Art of the Seventeenth Century." *Simiolus* 16:36–49.

Franits 1993
Franits, Wayne E. *Paragons of Virtue: Women and Domesticity in
Seventeenth-Century Dutch Art.* Cambridge and New York:
Cambridge University Press.

Franits 1994
Franits, Wayne. "Between Positivism and Nihilism: Some
Thoughts on the Interpretation of Seventeenth-Century Dutch
Paintings." *Theoretische Geschiedenis* 21:129–52.

Frankfurter 1939
Frankfurter, Alfred. "Dayton: European Loans from the Kress
Collection." *Art News* 38, no. 12 (Dec. 23): 13.

Fredericksen 1990
Fredericksen, Burton B., ed. *Index of Paintings Sold in the British Isles
during the Nineteenth Century.* Vol. 2, pt. 1. Oxford: Clio Press.

Frederiks 1894
Frederiks, J. G. "Het kabinet schilderijen van Petrus Scriverius."
Oud Holland 12:62–63.

Freedberg 1980
Freedberg, David. *Dutch Landscape Prints of the Seventeenth Century.*
London: British Museum Publications.

Freedberg 1988
Freedberg, David. *Iconoclasm and Painting in the Revolt of the
Netherlands, 1566–1609.* New York: Garland.

Freedberg 1989
Freedberg, David. *The Power of Images: Studies in the History and
Theory of Response.* Chicago: University of Chicago Press.

Freedberg 1993
Freedberg, David. "Painting and the Counter-Reformation in the
Age of Rubens," 131–45. In Sutton 1993.

Fremantle 1963
Fremantle, Katharine. "The Fountains Designed for Van Campen's
Amsterdam Town Hall and Quellien's Models for Them," 101–18.
In *Album Discipulorum,* edited by J. G. van Gelder. Utrecht:
Haetjens Dekker & Gumbert.

Fremantle 1974
Fremantle, Katharine. "The Identity of Johan Moreelse, Painter."
Burlington Magazine 116 (Oct.): 618–23.

Friedländer 1905
Friedländer, Max J. "Das Inventar der Sammlung Wyttenhorst."
Oud Holland 23:63–68.

Friedländer 1975
Friedländer, Max J. *Antonis Mor and His Contemporaries. Early
Netherlandish Painting,* vol. 13. New York: Praeger.

Friedlaender 1955
Friedlaender, Walter. *Caravaggio Studies.* Princeton, N.J.: Princeton
University Press.

Frijhoff 1981
Frijhoff, Willem. *La société néerlandaise et ses gradués, 1575–1814: une
recherche serielle sur le statut des intellectuels.* Amsterdam: Academic
Publishers Associates.

Von Frimmel 1889
von Frimmel, Theodoor. "Ein Gang durch die Galerie Nostitz in
Prag." *Kunstchronik* 24: col. 721.

Von Frimmel 1892a
von Frimmel, Theodoor. "Die Galerie Nostitz zu Prag," 115–35,
318–20. In vol. 1 of *Kleine Galeriestudien.* Bamberg.

Von Frimmel 1892b
von Frimmel, Theodoor. "Zur Geschichte der Wrschowetz'schen
Gemälde Sammlung in Prag," 22–26. In *Mitteilungen der k. k.
Zentral Commission zur Erforschung und Erhaltung der Kunst- und
Historischen Denkmale,* N.F., 17.

Von Frimmel 1894
von Frimmel, Theodoor. *Verzeichnis der Gemälde in gräflich Schönborn-
Weisentheid'schem Besitze.* Pommersfelden.

Von Frimmel 1910
von Frimmel, Theodoor. "Von der Galerie Nostitz in Prag." *Blätter
für Gemäldekunde* 5:1–9.

Froitzheim-Hegger 1993
Froitzheim-Hegger, Eva-Marina. *Sie lebten dahin sorglos in behaglicher Ruhe: Studien zum niederländischen und flämischen Göttermahl.* Hildesheim, Zurich, New York: Georg Olms Verlag.

Fruchtbaum 1964
Fruchtbaum, F. "Natural Theology and the Rise of Science." Ph.D. diss., Harvard University.

Fučíková 1988
Fučíková, Eliška. "Die Malerei am Hofe Rudolfs II," 188–92. In *Prag um 1600: Kunst und Kultur am Hofe Rudolfs II.* Exh. cat. Freren: Luca Verlag. Kulturstiftung Ruhr, Villa Hügel, Essen.

Fučíková 1997
Fučíková, Eliška. *Rudolf II and Prague.* Exh. cat. London.

Gaehtgens 1977
Gaehtgens, Barbara. "Julius Caesar." In *Rubens in der Graphik: Rubens, Van Dyck, Jordaens und die Rubens-Stecher.* Exh. cat. Wurzburg: Martin von Wagner. Museum der Universität Wurzburg.

Gaehtgens 1995a
Gaehtgens, Barbara. "*L'Artémise* de Gérard van Honthorst ou les deux corps de la reine." *Revue de l'Art* 109:13–25.

Gaehtgens 1995b
Gaehtgens, Barbara. "Macht Wechsel oder die Übergabe der Regentschaft," 64–78. In *Die Galerie der starken Frauen: die Heldin in der italienischen Kunst des 17. Jahrhunderts. Regentinnen, Amazonen, Salondamen.* Exh. cat. edited by B. Baumgärtel and S. Neysters. Munich: Klinkhardt & Biermann. Kunstmuseum Düsseldorf; Kessisches Landesmuseum, Darmstadt.

Galama 1941
Galama, Egidius Gerardus Antonius. "Twee zestiende-eeuwse Spelen van de verloren Zoon door Robert Lawet." Ph.D. diss., Universiteit Utrecht.

Garas 1980
Garas, Klara. "Unbekannte italienische Gemälde in Gotha: Probleme um Bigot und Manfredi." *Acta Historiae Artium* 26:265–83.

De Geer van Oudegein 1895
de Geer van Oudegein, J. J. *Excerpten uit de oude rekeningen der Ridderlijke Duitsche Orde, Balye van Utrecht, vóór de kerkhervorming.* Utrecht.

Van Gelder 1948–49
van Gelder, Jan Gerritsz. "De schilders van de Oranjezaal." *Nederlands Kunsthistorisch Jaarboek* 2:118–64.

Van Gelder 1950–51
van Gelder, Jan Gerritsz. "Rubens in Holland in de zeventiende eeuw." *Nederlands Kunsthistorisch Jaarboek* 3:103–50.

Van Gelder 1978
van Gelder, Jan Gerritsz. "Pastor fido-voorstellingen in de Nederlandse kunst van de zeventiende eeuw." *Oud Holland* 92:227–63.

Van Gelder and Jost 1985
van Gelder, Jan Gerritsz., and Ingrid Jost. *Jan de Bisschop and His Icones and Paradigmata: Classical Antiquities and Italian Drawings for Artistic Instruction in Seventeeth-Century Holland.* Doornspijk: Davaco.

Van Gelder and Renckens 1967
van Gelder, Jan Gerritsz., and B. J. A. Renckens. "Werken van Hans Horions." *Oud Holland* 82:137–38.

Gerson 1957
Gerson, Horst. "Herwaardering van H. ter Brugghen." *Het Vaderland*, Feb. 16 and 23.

Gerson 1959
Gerson, Horst. Review of Nicolson 1958b. *Kunstchronik* 12 (Nov.): 314–19.

Gerson 1964
Gerson, Horst. "Hendrick ter Brugghen," 1:562–64. *Kindlers Malerei Lexikon,* edited by Germain Bazin et al. 6 vols. Zurich: Kindler Verlag.

Gerson and Goodison 1960
Gerson, Horst, and J. W. Goodison. *Catalogue of Paintings. Dutch and Flemish, Volume I* [Fitzwilliam Museum]. Cambridge: Cambridge University Press.

Gerson and Ter Kuile 1960
Gerson, Horst, and Engelbert Hendrik ter Kuile. *Art and Architecture in Belgium, 1600–1800.* Harmondsworth and Baltimore: Penguin Books.

Getty Provenance Index 1996
The Getty Provenance Index: Cumulative Edition on CD-ROM. Los Angeles: The Getty Information Institute.

Ghent 1986–87
Joachim Beuckelaer: Het markt- en keukenstuk in de Nederlanden, 1550–1650. Exh. cat. Ghent: Gemeentekrediet. Museum voor Schone Kunsten, Ghent.

Giezen-Niewenhuys 1987
Giezen-Niewenhuys, H. W. M. *Nederlandse duiventillen: Historische duifhuizen geschilderd en beschreven.* Zutphen: Terra.

Gilbert 1995
Gilbert, Creighton E. *Caravaggio and His Two Cardinals.* University Park: Pennsylvania State University Press.

Giltaij and Jansen 1991
Giltaij, Jeroen, and Guido Jansen. *Perspectives: Saenredam and the Architectural Painters of the Seventeenth Century.* Exh. cat. Seattle: University of Washington Press. Rotterdam: Museum Boymans-van Beuningen.

Giltaij and Kelch 1996
Giltaij, Jeroen, and Jan Kelch. *Praise of Ships and the Sea: The Dutch Marine Painters of the Seventeenth Century.* Exh. cat. Ghent: Snoeck Ducaju. Museum Boymans-Van Beuningen, Rotterdam; Staatliche Museen zu Berlin, Gemäldegalerie im Bodemuseum.

Ginnings 1970
Ginnings, Rebecca J. "The Art of Jan Baptist Weenix and Jan Weenix." Ph.D. diss., University of Delaware.

Gmelin 1966
Gmelin, Hans Georg. "Georg Pencz als Maler." *Münchner Jahrbuch der bildenden Kunst* 17:49–126.

Goedde 1989a
Goedde, Lawrence O. "A Little World Made Cunningly: Dutch Still Life and *Ekphrasis*," 35–44. In *Still Lifes of the Golden Age, Northern European Paintings from the Heinz Family Collection.* Exh. cat.

Washington: National Gallery·of Art. Also Museum of Fine Arts, Boston.

Goedde 1989b
Goedde, Lawrence O. *Tempest and Shipwreck in Dutch and Flemish Art: Convention, Rhetoric, and Interpretation.* University Park and London: Pennsylvania State University Press.

Van der Goes 1995
van der Goes, A. "Kasteelinterieurs," 58–68. In Olde Meierink et al. 1995.

Van der Goes and De Meyere 1996
van der Goes, A., and Joos de Meyere, eds. *Op stand aan de wand: vijf eeuwen familieportretten in Slot Zuylen.* Zuylen.

Goheen 1988
Goheen, Ellen R. *The Collections of The Nelson-Atkins Museum of Art.* New York: Harry N. Abrams.

Van Gorp 1978
van Gorp, Hendrik. *Inleiding tot de picareske verhaalkunst of de weder waardigheden van een anti-genre.* Groningen: Wolters-Noordhoff.

Göthe 1910
Göthe, Georg. *Notice descriptive des tableaux du Musée national de Stockholm.* 3d ed. Stockholm: Imp. I. Haeggstrom.

Graves 1960
Graves, Robert. *The Greek Myths.* London: Penguin Books.

Gregori et al. 1987
Gregori, Mina, et al. *Dopo Caravaggio: Bartolomeo Manfredi e la manfrediana methodus.* Exh. cat. Milan: Arnoldo Mondadori. Museo Civico, Cremona.

Grimm 1979
Grimm, Claus. "Küchenstücke, Marktbilder, Fischstilleben," 351–79. In *Stilleben in Europa.* Exh. cat. edited by Gerhard Langemeyer and H.-A. Peters. Münster: Westfälisches Landesmuseum für Kunst- und Kulturgeschichte. Also Staatliche Kunsthalle, Baden-Baden.

Groeneweg 1995
Groeneweg, Irene. "Regenten in het zwart: vroom en deftig?" *Nederlands Kunsthistorisch Jaarboek* 46:198–251.

Groenveld 1995
Groenveld, Simon. *Huisgenoten des geloofs: was de samenleving in de Republiek der Verenigde Nederlanden verzuild?* Hilversum: Verloren.

Groenveld and Leeuwenberg 1985
Groenveld, Simon, and H. L. Ph. Leeuwenberg. *De bruid in de schuit: de consolidatie van de Republiek, 1609–1650.* Zutphen: De Walburg Pers.

Grosshans 1980
Grosshans, Rainald. *Maerten van Heemskerck: die Gemälde.* Berlin: Horst Boettcher Verlag.

De Groot 1979
de Groot, Irene. *Landscape Etchings by the Dutch Masters of the Seventeenth Century.* London: Gordon Fraser, in association with Rijksmuseum, Amsterdam.

Haak 1984
Haak, Bob. *The Golden Age: Dutch Painters of the Seventeenth Century,* translated and edited by Elizabeth Willems-Treeman. New York: Abrams, in association with Amsterdam: Meulenhoff/Landshoff.

Van Haeften 1987
van Haeften, Johnny. *Dutch and Flemish Old Masters: Paintings.* Exh. cat. London: Johnny van Haeften Gallery.

Van Haeften 1992
van Haeften, Johnny. *Dutch and Flemish Old Master Paintings.* Exh. cat. London: Johnny van Haeften Gallery.

Haitsma Mulier and Van der Lem 1990
Haitsma Mulier, E. O. G., and G. A. C. van der Lem. *Repertorium van geschiedschrijvers in Nederland, 1500–1800. Bibliografische reeks van het Nederlands Historisch Genootschap.* Vol. 7. The Hague: Nederlands Historisch Genootschap.

Hale 1990
Hale, John R. *Artists and Warfare in the Renaissance.* New Haven and London: Yale University Press.

Halewood 1982
Halewood, William H. *Six Subjects of Reformation Art: A Preface to Rembrandt.* Toronto: University of Toronto Press.

Hall and Uhr 1978
Hall, Edwin, and Horst Uhr. "*Aureola* and *Fructus*: Distinctions of Beatitude in Scholastic Thought and the Meaning of Some Crowns in Early Flemish Painting." *Art Bulletin* 60 (June): 249–70.

Hall and Uhr 1985
Hall, Edwin, and Horst Uhr. "*Aureola super Auream:* Crowns and Related Symbols of Special Distinction for Saints in Late Gothic and Renaissance Iconography." *Art Bulletin* 67 (Dec.): 567–603.

Hannema 1967
Hannema, Dirk. *Beschrijvended catalogus van de schilderijen, beeldhouwwerken, acquarellen en tekeningen: behorend tot de verzameling van de Stichting Hannema-De Stuers Fundatie in het Kasteel Het 't Nijenhuis bij Heino, Overijssel.* Rotterdam: Ad Donker.

Hannema 1971
Hannema, Dirk. *Supplement 1971 van de Catalogus. schilderijen, beeldhouwwerken, . . . aquarellen en tekeningen: behorend tot de verzameling van de Stichting Hannema-De Stuers Fundatie in het Kasteel Het Nijenhuis en in het bouwhuis uit 1687 bij Heino, Overijssel.* Rotterdam: Ad. Donker.

't Hart 1993
't Hart, Marjolein C. *The Making of a Bourgeois State: War, Politics, and Finance during the Dutch Revolt.* Manchester and New York: Manchester University Press.

Haskell and Penny 1981
Haskell, Francis, and Nicholas Penny. *Taste and the Antique: The Lure of Classical Sculpture, 1500–1900.* New Haven and London: Yale University Press.

Haslinghuis and Peeters 1965
Haslinghuis, E. J., and C. J. A. C. Peeters. *De Dom von Utrecht.* De Nederlandse monumenten van geschiedenis en kunst, no. 2. De provincie Utrecht, part 1. The Hague: Staatsuitgeverij.

Von Haumeder 1976
von Haumeder, Ulrika. "Antoine Caron. Studien zu seiner *Histoire d'Artémise.*" Ph.D. diss., Ruprecht-Karl-Universität, Heidelberg.

Haverkamp-Begemann 1978
Haverkamp-Begemann, Egbert. *Wadsworth Atheneum Paintings. Catalogue I: The Netherlands and the German-Speaking Countries, Fifteenth–Nineteenth Centuries.* Hartford: The Atheneum.

Heiberg 1988
Heiberg, Steffen, ed. *Christian IV and Europe.* Exh. cat. Copen-
hagen: Foundation for Christian IV Year. Nationalmuseum,
Stockholm.

Held 1980
Held, Julius S. *The Oil Sketches of Peter Paul Rubens: A Critical
Catalogue.* 2 vols. Princeton, N.J.: Princeton University Press.

Held 1985–86
Held, Julius. "Some Studies of Heads by Flemish and Dutch
Seventeenth-Century Artists." *Master Drawings* 23–24:46–53.

Helmus 1997
Helmus, Liesbeth M. *Madonna met wilde rozen en een selectie van
zestiende- en zeventiende-eeuwse meesterwerken uit Utrecht.* Exh. cat.
Stockholm: Nationalmuseum.

Helsinki 1987
*Barokin taidetta Prahan kansallisgalleriasta. Barockens Konst fran
Nationalgalleriet i Prag.* Exh. cat. Helsinki: Museo.

Hendrix and Stumpel 1996
Hendrix, J., and J. Stumpel, eds. *Kunstenaars en opdrachtgevers.
Utrecht Renaissance Studies.* Vol. 2. Amsterdam.

Hendy 1974
Hendy, Philip. *European and American Paintings in the Isabella Stewart
Gardner Museum.* Boston: Trustees of the Isabella Stewart Gardner
Museum.

Hentzen 1970
Hentzen, Alfred. "Erwerbungen für die Gemälde-Galerie und die
Sammlung Neuerer Plastik in den Jahren 1968 und 1969." *Jahrbuch
der Hamburger Kunstsammlungen* 14–15:244–74.

Hermans 1995
Hermans, T. "Nijenrode," 341–45. In Olde Meierink et al. 1995.

Hibbard 1961
Hibbard, Howard. "The Early History of Sant'Andrea della
Valle." *Art Bulletin* 43 (Dec.): 289–318.

Hibbard 1983
Hibbard, Howard. *Caravaggio.* London: Thames and Hudson;
New York: Harper & Row.

Hirschmann 1919
Hirschmann, Otto. "Erwerbungen der holländischen Museen
während der Kriegsjahre." *Monatshefte für Kunstwissenschaft*
12:88–94.

Hoet 1752
Hoet, Gerard. *Catalogus of naamlyst van schilderyen, met derzelver
pryzen . . . in Holland als op andere plaatzen in het openbaar verkogt.*
Vols. 1–2. The Hague: Pieter Gerard van Baalen; Vol. 3. The
Hague: P. Terwesten, 1770.

Hofman 1893
Hofman, J. H. "Joost Cornelisz. Droochsloot en zijn zoon
Cornelis." *Dietsche Warande,* 343–53.

Hofstede de Groot 1908–27
Hofstede de Groot, Cornelis Pieterz. *A Catalogue Raisonné of the
Works of the Most Eminent Dutch Painters of the Seventeenth Century,*
translated by Edward G. Hawke. 8 vols. London: Macmillan.

Holl.
Hollstein, F. W. H. *Dutch and Flemish Etchings, Engravings, and
Woodcuts, ca. 1450–1700.* Amsterdam: M. Hertzberger, 1949–.

Hollstein German
Hollstein, F. W. H. *German Engravings, Etchings, and Woodcuts,
ca. 1400–1700.* Amsterdam: M. Hertzberger, 1954–.

Hope 1965
Hope, Henry R. "The Bob Jones University Collection of
Religious Art," *Art Journal* 25 (Winter): 154–62.

Hooft 1615
Hooft, Pieter Cornelisz. *Granida.* Amsterdam: Willem Iansz op 't
water in de vergulde Sonnewyser.

Hoogewerff 1924
Hoogewerff, Godefridus Joannes. "Verslag van verrichtte studiën
en belangrijke voorvallen op kunstwetenschappelijk gebied."
Mededeelingen van het Nederlandsch Instituut te Rome 4:xxxviii–xlviii.

Hoogewerff 1938
Hoogewerff, Godefridus Joannes. "Nederlandsche kunstenaars
te Rome, 1600–1725. Uittreksels uit de parochiale archieven:
I. Parochie van Santa Maria del Popolo." *Mededeelingen van het
Nederlandsch Historisch Instituut te Rome,* 2d reeks. 8:49–125.

Hoogewerff 1942–43
Hoogewerff, Godefridus Joannes. *Nederlandsche kunstenaars te Rome
(1600–1725): uittreksels uit de parochiale archieven. Studiën van het
Nederlandsch historisch instituut te Rome,* vol. 3. The Hague: Gedrukt
ter Algemeene Landsdrukkerij; Martinus Nijhoff.

Hoogewerff 1952
Hoogewerff, Godefridus Joannes. *De Bentvueghels.* The Hague:
Martinus Nijhoff.

Hoogewerff 1953
Hoogewerff, Godefridus Joannes. "Via Margutta, centro di vita
artistica." *Quaderni di Storia dell' Arte dell' Instituto di Studi romani,*
1:13–14.

Hoogewerff 1965
Hoogewerff, Godefridus Joannes. "Jan van Bijlert, Schilder van
Utrecht (1598–1671)." *Oud Holland* 80:2–33.

Hoogewerff and van Regteren Altena 1928
Hoogewerff, Godefridus Joannes, and I. Quirijn van Regteren
Altena. *Arnoldus Buchelius "Res Pictoriae." Aantekeningen over
kunstenaars en kunstwerken voorkomende in zijn Diarium, Res pictoriae,
Notae quotidianae, en Descriptio urbis Ultrajectinae, 1583–1639.*
Quellenstudien zur holländischen Kunstgeschichte, no. 15. The
Hague: Martinus Nijhoff.

Hoogsteder 1986
Hoogsteder, W.-J. "De schilderijen van Frederik en Elisabeth,
koning en koningin van Bohemen." Ph.D. diss., Kunstgeschiedenis
Utrecht.

Van Hoogstraten 1678
van Hoogstraeten, Samuel. *Inleyding tot de hooge schoole der
schilderkonst: anders de zichtbaere werelt.* Rotterdam: Francois van
Hoogstraeten. Reprint, Utrecht: Davaco, 1969.

Houbraken 1718–21
Houbraken, Arnold. *De groote schouburgh der Nederlantsche
konstschilders en schilderessen.* 3 vols. Amsterdam: Arnold Houbraken.

Houck 1899
Houck, M. E. "Mededeelingen betreffende Gerhard Terborch . . .
en Hendrick ter Brugghen." *Verslagen en mededeelingen der Vereeniging
tot beoefening van Overijsselsch regt en geschiedenis* 20:348–434.

Houck 1900
Houck, M. E. "Hendrick Ter Brugghen en zijn *vier Evangelisten*
te Deventer." *Eigen Haard*, 519–23.

Houtzager 1955
Houtzager, Maria Elisabeth, et al. "Opmerkingen over het werk
van Hendrick Terbrugghen." *Nederlands Kunsthistorisch Jaarboek*
6:143–50.

Houtzager et al. 1967
Houtzager, Maria Elisabeth. *Röntgenonderzoek van de oude schilderijen
in het Centraal Museum te Utrecht.* Utrecht: Centraal Museum.

Van den Hoven van Genderen and Rommes 1995
van den Hoven van Genderen, B., and R. Rommes. *"Rijk en Talrijk:*
*Beschouwingen over de omvang van de Utrechtse bevolking
tussen circa 1300 en het begin van de 17de eeuw." Jaarboek Oud-
Utrecht*, 54–85.

Hubala 1970
Hubala, Erich. *Die Kunst des 17. Jahrhunderts.* Propylaen Kunst-
geschichte, vol. 9. Berlin: Propylaen Verlag.

Hudig 1928
Hudig, Ferrand Whaley. *Frederik Hendrik en de kunst van zijn tijd: rede
uitgesproken . . . aan de Universiteit van Amsterdam op 1 October 1928.*
Amsterdam: Menno Hertzberger.

Huijbrecht 1996
Huijbrecht, R. *Album advocatorum: de advocaten van het Hof van
Holland, 1560–1811.* Algemeen Rijksarchief Publicatiereeks, vol. 3.
The Hague.

Huiskamp 1991
Huiskamp, M. "Openbare lessen in geschiedenis en moraal. Het
Oude Testament in stadhuizen en andere openbare begouwen,"
134–55. In Tümpel et al. 1991.

Huizinga 1941
Huizinga, Johan. *Nederland's beschaving in de zeventiende eeuw, een
schets.* Haarlem: H. D. Tjeenk Willink.

Hulshof and Breuning 1940
Hulshof, A., and P. S. Breuning, eds. "Zes brieven van Joh. de Wit
aan Arend van Buchell." *Bijdragen en Mededeelingen van het Historisch
Genootschap* 61:60–99.

Van Hulzen 1981
van Hulzen, Albertus. *250 jaar Kolfbaan.* Utrecht.

Hunger 1981
Hunger, Herbert. *Lexikon der griechischen und römischen Mythologie*
. . . . 8th ed. Hamburg: Reinbek bei Hamburg.

Huys Janssen 1985
Huys Janssen, Paul. "Zeven zeventiende-eeuwse schilderijen in het
Sint Eloyengasthuis te Utrecht." *Jaarboek Oud Utrecht*, 85–109.

Huys Janssen 1989
Huys Janssen, Paul. "Philip Sandrart en Nicolaus Knupfer: een
briefbestelling uit 1639 te Utrecht." *Oud Holland* 103:152–54.

Huys Janssen 1990
Huys Janssen, Paul. *Schilders in Utrecht, 1600–1700.* Historische
Reeks Utrecht, vol. 15. Utrecht: Matrijs.

Huys Janssen 1994a
Huys Janssen, Paul. *Jan van Bijlert (1597/98–1671), schilder in
Utrecht.* Ph.D. diss., Rijksuniveriteit Utrecht.

Huys Janssen 1994b
Huys Janssen, Paul. "Portretten voor het Huis Linschoten,"
302–38. In Reinink 1994.

Huys Janssen and Sutton 1991
Huys Janssen, Paul, and Peter C. Sutton. *The Hoogsteder Exhibition
of Dutch Landscapes.* Exh. cat. Zwolle: Waanders. Hoogsteder and
Hoogsteder, The Hague.

Ingegno 1988
Ingegno, A. "The New Philosophy of Nature." In *The Cambridge
History of Renaissance Philosophy*, edited by Charles B. Schmitt,
Quentin Skinner, and Eckhard Kessler. Cambridge and New York:
Cambridge University Press.

Isarlo 1941
Isarlo, George. *Caravage et le caravagisme européen.* Vol. 2.
Aix-en-Provence.

Ishikawa et al. 1994
Ishikawa, Chiyo, et al. *A Gift to America: Masterpieces of European
Painting from the Samuel H. Kress Collection.* Exh. cat. New York:
Abrams. North Carolina Museum of Art, Raleigh; The Museum
of Fine Arts, Houston; Seattle Art Museum; and the Fine Arts
Museums of San Francisco.

Israel 1982
Israel, Jonathan Irvine. *The Dutch Republic and the Hispanic World,
1606–1661.* Oxford: Oxford University Press.

Israel 1989
Israel, Jonathan Irvine. *Dutch Primacy in World Trade, 1585–1740.*
Oxford: Oxford University Press.

Israel 1995
Israel, Jonathan Irvine. *The Dutch Republic: Its Rise, Greatness, and
Fall, 1477–1806.* Oxford: Oxford University Press.

Jackson 1922
Jackson, A. Y. "Notes and Queries: *The Incredulity of St. Thomas*
(no. 397)." *Connoisseur* 62 (Feb.): 97.

Jacobs 1993
Jacobs, Johanna, ed. *Sebastiaan, martelaar of mythe.* Exh. cat. Zwolle:
Waanders. Het Markiezenhof, Bergen op Zoom; Limburgs
Museum, Venlo; Haags Historisch Museum, The Hague.

Jameson 1890
Jameson, Anna. *Sacred and Legendary Art.* 2 vols. London and New
York: Longmans, Green, and Co.

Jansen 1987
Jansen, Guido. *Gezicht op der Mariaplaats en de Mariakerk te Utrecht.*
Rotterdam: Museum Boymans-van Beuningen.

Janssen and Van Toorenenbergen 1880
Janssen, Hendrik Quirinus, and J. J. van Toorenbergen, eds. *Brieven
uit onderscheidene kerkelijke archieven.* Vol. 2. Werken der Marnix-
Vereeniging, ser. 3, vol. 4. Utrecht: Kemink en Zoon.

Jantzen 1910
Jantzen, H. "De ruimte in de Hollandsche zeeschildering." *Onze Kunst* 18:108ff.

Jones 1993
Jones, P. M. *Federico Borromeo and the Ambrosiana: Art Patronage and Reform in Seventeenth-Century Milan.* Cambridge: Cambridge University Press.

De Jong 1987
de Jong, Joop. *Een deftig bestaan: het dagelijks leven van regenten in de 17de en 18de eeuw.* Utrecht: Kosmos.

De Jonge 1932
de Jonge, C. H. "Utrechtse schilders der XVIIde eeuw in de verzameling van Willem Vincent, baron van Wyttenhorst." *Oudheidkundig Jaarboek,* 4th ser., 1:120–34.

De Jonge 1938
de Jonge, C. H. *Paulus Moreelse: portret- en genreschilder te Utrecht (1571–1638).* Assen: Van Gorcum.

De Jonge 1952
de Jonge, C. H. *Catalogus der schilderijen.* Utrecht: Centraal Museum.

De Jongh 1968–69
de Jongh, Eddy. "Erotica in vogelperspectief: de dubbelzinnigheid van een reeks 17de eeuwse genrevorstellingen." *Simiolus* 3:22–74.

De Jongh 1971
de Jongh, Eddy. "Realisme en schijnrealisme in de Hollandse schilderkunst van de zeventiende eeuw," 143–94. In Brussels 1971.

De Jongh 1973/1995
de Jongh, Eddy. "Vermommingen van Vrouw Wereld in de 17de eeuw," 198–206. In *Album Amicorum J. G. van Gelder,* edited by Josua Bruyn et al. The Hague: Martinus Nijhoff. Slightly revised as a chapter in *Kwesties van betekenis, Thema en motief in de Nederlandse schilderkunst van de zeventiende eeuw,* 59–82. Leiden: Primavera Pers.

De Jongh 1975–76
de Jongh, Eddy. "Pearls of Virtue and Pearls of Vice." *Simiolus* 8, no. 2:69–97.

De Jongh 1986
de Jongh, Eddy. *Portretten van echt en trouw: huwelijk en gezin in de Nederlandse kunst van de zeventiende eeuw.* Exh. cat. Zwolle: Waanders. Frans Halsmuseum, Haarlem.

De Jongh and Luijten 1997
de Jongh, Eddy, and Ger Luijten. *Mirror of Everyday Life: Genre Prints in the Netherlands, 1550–1700.* Exh. cat. Ghent: Snoeck-Ducaju & Zoon. Rijksmuseum, Amsterdam.

De Jongh et al. 1976
de Jongh, Eddy, et al. *Tot lering en vermaak: betekenissen van Hollandse genrevoorstellingen uit de zeventiende eeuw.* Exh. cat. Amsterdam: Rijksmuseum.

De Jongh et al. 1982
De Jongh, Eddy, et al. *Still Life in the Age of Rembrandt.* Exh. cat. Auckland: Auckland City Art Gallery.

Judson 1959
Judson, J. Richard. *Gerrit van Honthorst: A Discussion of His Position in Dutch Art.* Utrechtse bijdragen tot de kunstgeschiedenis, no. 6. The Hague: Martinus Nijhoff.

Judson 1961
Judson, J. Richard. Review of Nicolson 1958b. *Art Bulletin* 43 (Dec.): 341–48.

Judson 1988
Judson, J. Richard. "New Light on Honthorst," 111–20. In Klessmann 1988.

Judson 1995
Judson, J. Richard. "A New Honthorst Allegory: Can This Be Love?" 128–29. In *Shop Talk: Studies in Honor of Seymour Slive,* edited by Cynthia P. Schneider, William W. Robinson, and Alice I. Davies. Cambridge, Mass.: Harvard University Art Museums.

Kaplan 1995
Kaplan, Benjamin J. *Calvinists and Libertines: Confession and Community in Utrecht, 1578–1620.* Oxford: Oxford University Press.

Kat 1952
Kat, Johan M. F. "De Verloren Zoon als letterkundig Motief." Ph.D. diss., Universiteit Nijmegen.

Kauffman 1943
Kauffman, Hans. "Die Fünfsinne in der niederländischen Malerei des 17. Jahrhunderts," 133–57. In *Kunstgeschichtliche Studien für Dagobert Frey.* Breslau.

Kauffmann 1954
Kauffmann, Hans. "Albrecht Dürer in der Kunst und im Kunsturteil um 1600." In *Vom Nachleben Dürers. Beiträge zur Kunst der Epoche von 1530 bis 1650.* Berlin: Gebr. Mann. Germanisches Nationalmuseum Nürnberg.

Kaufmann 1988
Kaufmann, Thomas DaCosta. *The School of Prague: Painting at the Court of Rudolf II.* Chicago: University of Chicago Press.

Kaufmann 1993
Kaufmann, Thomas DaCosta. *The Mastery of Nature: Aspects of Art, Science, and Humanism in the Renaissance.* Princeton, N.J.: Princeton University Press.

Kenseth 1991
Kenseth, Joy, ed. *The Age of the Marvelous.* Exh. cat. Hanover, N.H.: Hood Museum of Art, Dartmouth College, distributed by University of Chicago Press. Also North Carolina Museum of Art, Raleigh; The Museum of Fine Arts, Houston; High Museum of Art, Atlanta.

Kern 1992
Kern, Steven, ed. *List of Paintings in the Sterling and Francine Clark Art Institute.* Williamstown, Mass.: Sterling and Francine Clark Art Institute.

Kern et al. 1996
Kern, Steven, et al. *The Clark: Selections from the Sterling and Francine Clark Art Institute.* New York: Hudson Hills Press.

Kernkamp 1902
Kernkamp, Gerhard Wilhelm. "Memoriën van ridder Theodorus Rodenburg betreffende het verplaatsen van verschillende industrieën uit Nederland naar Denemarken, met daarop genomen resolutiën van koning Christiaan IV (1621)." *Bijdragen en Mededeelingen van het Historisch Genootschap* 23:189–258.

Kernkamp et al. 1936
Kernkamp, Gerhard Wilhelm, et al. *De Utrechtsche universiteit, 1636–1936.* 2 vols. Utrecht: N. v. A. Ooosthoek.

Kettering 1983
Kettering, Alison McNeil. *The Dutch Arcadia: Pastoral Art and Its Audience in the Golden Age.* Montclair, N.J.: Allanheld & Schram, the Boydell Press.

Keyes 1990
Keyes, George S. *Mirror of Empire: Dutch Marine Art of the Seventeenth Century.* Exh. cat. Minneapolis: Minneapolis Institute of Arts, in association with Cambridge and New York: Cambridge University Press. Also The Toledo Museum of Art; Los Angeles County Museum of Art.

Kimpel 1974
Kimpel, S. "Martin von Tours," 7:572–79. *Lexikon der christliche Ikonographie.* Rome.

Kind 1967
Kind, J. B. "*The Drunken Lot and His Daughters:* An Iconographical Study of the Uses of the Theme in the Visual Arts from 1500–1650, and Its Bases in Exigetical and Literary History." Ph.D. diss., University of Michigan.

Kipp 1994
Kipp, A. F. E. "Neude 35-Ganzenmarkt 14–16," 131–42. In *Archeologische en Bouwhistorische Kroniek van de Gemeente Utrecht, 1991–1992.* Utrecht.

Kitson 1959
Kitson, Michael. "The Art of Terbrugghen." *Burlington Magazine* 101 (Feb.): 109–11.

Kitson 1987
Kitson, Michael. "Brunswick, Herzog Anton Ulrich-Museum. Hendrick ter Brugghen and His Contemporaries." Review of Blankert and Slatkes 1986. *Burlington Magazine* 129 (Feb.): 135–37.

Klemm 1986
Klemm, Christian. *Joachim von Sandrart: Kunst, Werke, und Lebens Lauf.* Berlin: Deutscher Verlag für Kunstwissenschaft.

Klessmann 1983
Klessmann, Rüdiger. *Die holländischen Gemälde.* Braunschweig: Herzog Anton Ulrich-Museum.

Klessmann 1987
Klessmann, Rüdiger. Review of Ten Doesschate-Chu and Boerlin 1987. *Kunstchronik* 40 (Dec.): 603–08.

Klessmann 1988
Klessmann, Rüdiger, ed. *Hendrick ter Brugghen und die Nachfolger Caravaggios in Holland: Beiträge eines Symposions aus Anlaß der Ausstellung "Hollandische Malerei in neuem Licht, Hendrick ter Brugghen und seine Zeitgenossen" im Herzog Anton Ulrich-Museum Braunschweig von 23. bis 25. März 1987.* Braunschweig: Herzog Anton Ulrich-Museum.

Klibansky, Panofsky, and Saxl 1964
Klibansky, Raymond, Erwin Panofsky, and Fritz Saxl. *Saturn and Melancholy: Studies in the History of Natural Philosophy, Religion, and Art.* London: Nelson.

Kloek 1988
Kloek, Wouter Th. "The Caravaggisti and the Netherlandish Tradition," 51–57. In Klessmann 1988.

Knippenberg 1992
Knippenberg, Hans. *De Religieuze Kaart van Nederland: omvang en geografische spreiding van de godsdienstige gezindten vanaf de Reformatie tot heden.* Assen: Van Gorcum.

Knipping 1905
Transcription of "Willem Vincent van Wittenhorst, Register van de schilderyen en van de printen staende in de boecken." Düsseldorf.

Knipping 1939–42
Knipping, John B. *Iconografie van de Contra-Reformatie in de Nederlanden.* 2 vols. Hilversum: P. Brand.

Knipping 1974
Knipping, John B. *Iconography of the Counter Reformation in the Netherlands: Heaven on Earth.* 2 vols. 2d ed. Nieuwkoop: De Graaf.

Knoester and Graafhuis 1970
Knoester, H., and J. Graafhuis. "Het kasboek van Mr. Carel Martens." *Jaarboek Oud-Utrecht,* 154–223.

Knuijt 1995
Knuijt, M. "Amerongen," 114–19. In Olde Meierink et al. 1995.

Koch 1947–48
Koch, A. C. F. "Schets van een geschiedenis van het Sint Eloyengasthuis te Utrecht." *Jaarboekje van Oud-Utrecht,* 49–61.

Koen 1991
Koen, D. T. "Utrecht havenstad? Zeventiende- en achttiende-eeuwse plannen tot aanleg van een scheepvaartverbinding met de Zuiderzee." *Jaarboek Oud Utrecht,* 121–42.

Koetser 1967
Koetser, Leonard. *1967 Spring Exhibition of Flemish, Dutch, and Italian Old Masters, April 7th to May 31st.* Exh. cat. London: Leonard Koetser Ltd.

De Kok 1964
de Kok, Johannes. *Nederland op de breuklijn Rome-Reformatie: numerieke aspecten van protestantisering en katholieke herleving in de noordelijke Nederlanden, 1580–1880.* Assen: Van Gorcum.

Van Kooij 1987
van Kooij, Paul. "Ter Brugghen, Dürer and Lucas van Leyden." *Hoogsteder-Naumann Mercury,* no. 5:11–19.

Koslow 1975
Koslow, Susan, "Frans Hals's *Fisherboys:* Exemplars of Idleness." *Art Bulletin* 57 (Sept.): 418–32.

Kosse 1992
Kosse, R. "'Een raere loterye': Het verloten van schilderijen in de zeventiende eeuw." Ph.D. diss., Rijksuniversiteit Utrecht.

Kramm 1857–64
Kramm, Christiaan. *De levens en werken der Hollandsche en Vlaamsche kunstschilders, graveurs en bouwmeesters van den vroegsten tot op onzen tijd.* 6 vols. Amsterdam: Gebroeders Diederichs. Reprint, 2 vols. Amsterdam: B. M. Israel.

Van Kretschmar 1978
van Kretschmar, F. G. L. O. "De portrettenverzameling Martens van Savenhoven, een beeldkroniek van een Utrechtse familie." *Jaarboek Centraal Genealogie* 32:147–237.

Künstle 1926
Künstle, Karl. *Ikonographie der Heiligen.* Freiburg im Breisgau: Herder.

Kurz 1966
Kurz, Otto. "Umelecké Vztahy mezi Prahou a Persií za Rudolfa II. a poznámky k historii jeho sbírek." *Umění* 14:461–89.

Kuyper 1994
Kuyper. W. *The Triumphant Entry of Renaissance Architecture into the Netherlands: the Joyeuse Entrée of Philip of Spain into Antwerp in 1549. Renaissance and Mannerist Architecture in the Low Countries from 1530 to 1630.* 2 vols. Alphen aan den Rijn: Canaletto.

Kuznetsov 1974
Kuznetsov, Juri I. "Nikolaus Knupfer (1603?–1655)." *Oud Holland* 88:169–219.

Kylstra 1986
Kylstra, E. M. "Plompetorengracht 5–7." *Maandblad Oud-Utrecht* 59:3–6.

Lanciani
Lanciani, R. *Archivio della Società Romana* 23:5–66; 24:49–93; 25:103–35.

Landau 1981
Landau, D. "Catalogo completo dell'opera grafica di Georg Pencz." In *I Classici dell'incisione* 6–7. Milan.

Landwehr 1962
Landwehr, J. *Dutch Emblem Books.* Utrecht: Haentjens Dekker and Gumbert.

Langemeyer et al. 1974
Langemeyer, Gerhard, et al. *Gerard ter Borch: Zwolle 1617–Deventer 1681.* Exh. cat. The Hague: Mauritshuis. Also Landesmuseum, Münster.

Laskin and Pantazzi 1987
Laskin, Myron, and Michael Pantazzi. *European and American Painting, Sculpture, and Decorative Arts, 1300–1800.* Ottawa: National Gallery of Canada.

Lavin 1968
Lavin, Irving. "Five New Youthful Sculptures by Gianlorenzo Bernini and a Revised Chronology of His Early Works." *Art Bulletin* 50 (Sept.): 223–48.

Leesberg 1993–94
Leesberg, Marjolein. "Karel van Mander as a Painter." *Simiolus* 22:5–57.

Leeuwenberg and Van Tongerloo 1975
Leeuwenberg, H. L. Ph., and L. van Tongerloo, eds. *Van standen tot staten: 600 jaar Staten van Utrecht, 1375–1975.* Utrecht: Stichting Stichtse Historische Reeks.

Levesque 1994
Levesque, Catherine. *Journey through Landscape in Seventeenth-Century Holland: The Haarlem Print Series and Dutch Identity.* University Park: Pennsylvania State University Press.

Levine and Mai 1991
Levine, David A., and Ekkehard Mai, eds. *I Bamboccianti: niederländische Malerrebellen im Rom des Barock.* Exh. cat. Milan: Electa. Wallraf-Richartz-Museum, Cologne; Centraal Museum, Utrecht.

Van Lieburg 1989
van Lieburg, F. A. *De nadere Reformatie in Utrecht ten tijde van Voetius: sporen in de gereformeerde kerkeraadsacta.* Rotterdam: Lindenberg.

Liedtke 1989
Liedtke, Walter. "Dutch and Flemish Paintings from the Hermitage." *Oud Holland* 103:154–68.

Liedtke 1990
Liedtke, Walter. "Dutch Paintings in America: The Collectors and Their Ideals," 14–59. In Broos et al. 1990.

Limentani Virdis 1990
Limentani Virdis, Caterina. "I Fiamminghi e la Serenissima Pittori e Generi," 13–24. In *Fiamminghi: arte fiamminga e olandese del seicento nella Repubblica Veneta.* Exh. cat. edited by Caterina Limentani Virdis and David Banzato. Milan: Electa. Palazzo della Ragione, Padua.

Lindeman 1929
Lindeman, C. M. A. A. *Joachim Anthonisz. Wtewael.* Utrecht: A. Oosthoek.

Linnik 1980
Linnik, Irina Vladimirovna. *Gollandskaia zhivopis XVII veka i problemy atributsii kartin.* Leningrad: Iskusstvo.

Van Lommel 1882–83
van Lommel, A., ed. "Jacobus de la Torre, *Relatio seu descriptio status religionis catholicae in Hollandia.*" *AAU* 10:95–241; 11:57–212, 374–94.

London 1938
Seventeenth-Century Art in Europe. Exh. cat. London: Clowes. Royal Academy of Arts, London.

London 1952–53
Dutch Art. Exh. cat. London: Royal Academy of Arts.

London 1976. *See* Brown 1976a

Longhi 1927
Longhi, Roberto. "TerBrugghen e la parte nostra." *Vita artistica* 2:105–16. Reprinted in Roberto Longhi. *Opere complete,* 2:163–78. Florence: Sansoni, 1967.

Longhi 1952
Longhi, Roberto. "Caravaggeschi Nordici." *Paragone* 3, no. 33:52–58.

Van Loon 1732
van Loon, Gerard. *Histoire métallique des XVII provinces des Pays-Bas depuis l'abdication de Charles-Quint, jusqu'à la paix de Bade en MDCCXVI.* 5 vols. The Hague: P. Gosse.

Lorizzo 1995
Lorizzo, Loredana. "Spiritualità carmelitana nelle opere romane del pittore olandese Gerrit van Honthorst." In Silvia Danesi Squarzina, *"fiamenghi che vanno e vengono non li si puol dar regola": Paesi Bassi e Italia fra Cinquecento e Seicento: pittura, storia e cultura degli emblemi,* edited by Irene Baldriga. Sant'Oreste: Apeiron.

Lowenthal 1974
Lowenthal, Anne Walter. "Some Paintings by Peter Wtewael (1596–1660)." *Burlington Magazine* 116 (Aug.): 458–66.

Lowenthal 1975
Lowenthal, Anne Walter. "Wtewael's *Moses* and Dutch Mannerism." *Studies in the History of Art* 6:124–41.

Lowenthal 1986
Lowenthal, Anne Walter. *Joachim Wtewael and Dutch Mannerism.* Doornspijk: Davaco.

Lowenthal 1988
Lowenthal, Anne Walter. "Lot and His Daughters as Moral Dilemma," 12–27. In *The Age of Rembrandt: Studies in Seventeenth-Century Dutch Painting*, edited by Roland E. Fleisher. Papers in Art History from the Pennsylvania State University, 3. University Park: Pennsylvania State University.

Lowenthal 1995
Lowenthal, Anne Walter. *Joachim Wtewael: "Mars and Venus Surprised by Vulcan."* Getty Museum Studies on Art. Malibu: The J. Paul Getty Museum.

Lowenthal 1996
Lowenthal, Anne Walter. "Contemplating Kalf," 29–39. In *The Object as Subject: Studies in the Interpretation of Still Life.* Princeton, N.J.: Princeton University Press.

Lowenthal 1997
Lowenthal, Anne Walter. "*The Golden Age* by Joachim Wtewael at the Metropolitan Museum of Art." *Apollo* 145, no. 420 (Feb.): 49–52 and cover.

Lugt 1936
Lugt, Frits. "Italiaansche kunstwerken in Nederlandsche verzamelingen van vroeger tijden." *Oud Holland* 53:97–135.

Luijten et al. 1993
Luijten, Ger, Ariane van Suchtelen, Reinier Baarsen, Wouter Kloek, and Marijn Schapelhouman, eds. *Dawn of the Golden Age. Northern Netherlandish Art, 1580–1620.* Exh. cat. Zwolle: Waanders Uitgevers. Rijksmuseum, Amsterdam.

Lurie 1979
Lurie, Ann Tzeutschler. "*The Weeping Heraclitus* by Hendrick Terbrugghen in the Cleveland Museum of Art." *Burlington Magazine* 121 (May): 279–87.

Van Luttervelt 1947a
van Luttervelt, R. "Een zeegezicht met een historische voorstelling van Adam Willaerts." *Historia* 12:225–28.

Van Luttervelt 1947b
van Luttervelt, R. "Joost Cornelisz. Droochslot en zijn werken voor het Sint Barbara- en Laurentius Gasthuis te Utrecht." *Nederlands Kunsthistorisches Jaarboek* 1:113–36.

Maastricht 1989
Maastricht Exhibition and Congress Centre. *European Fine Art Fair. Handbook 1989.* 's-Hertogenbosch: European Fine Art Foundation.

McGee 1991
McGee, Julie L. *Cornelis Corneliszoon van Haarlem (1562–1638): Patrons, Friends, and Dutch Humanists.* Nieuwkoop: De Graaf.

McGrath 1984
McGrath, Elizabeth. "Rubens's *Susanna and the Elders* and Moralizing Inscriptions on Prints," 73–90. In *Wort und Bild in der niederländischen Kunst und Literatur des 16. und 17. Jahrhunderts*, edited by H. W. J. Vekeman and Justus Müller Hofstede. Erftstadt: Lukassen Verlag.

MacLaren and Brown 1991
MacLaren, Neil, revised and edited by Christopher Brown. *The National Gallery Catalogues: The Dutch School, 1600–1900.* 2 vols. London: National Gallery Publications.

Madrid 1985
El Siglo de Rembrandt. Exh. cat. Madrid: Ministerio de Cultura. Prado Museum, Madrid.

Maguson 1982
Maguson, Torgil. *Rome in the Age of Bernini.* 2 vols. Uppsala: Almqvist & Wiksell.

Mahon et al. 1988
Mahon, Sir Denis, et al. *Guido Reni: 1575–1642.* Exh. cat. Los Angeles: Los Angeles County Museum of Art; Bologna: Nuova Alfa. Also Pinacoteca Nazionale, Bologna; Kimbell Art Museum, Fort Worth.

Mai et al. 1985
Mai, Ekkehard, et al. *Roelant Savery in seiner Zeit (1576–1639).* Exh. cat. Cologne: City of Cologne. Wallraf-Richartz-Museum, Cologne; Centraal Museum, Utrecht.

Mâle 1932
Mâle, Emile. *L'art religieux après le Concile de Trente: étude sur l'iconographie de la fin du XVIe siècle, du XVIIe siècle et du XVIIIe siècle: Italie, France, Espagne, Flandres.* Paris: A. Colin.

Mandel 1996
Mandel, Oscar. *The Cheerfulness of Dutch Art: A Rescue Operation.* Doornspijk: Davaco.

Van Mander 1604
van Mander, Karel. *Het Schilder-Boeck* Haarlem: Paschier van Wesbvach. Facsimile, Utrecht: Davaco, 1969.

Van Mander 1973
van Mander, Karl. *Den grondt der edel vry schilder-const*, edited by Hessel Miedema. 2 vols. Utrecht: Haentjens Dekker and Gumbert.

Manuth 1990
Manuth, Volker. "Die Augen des Sünders: Überlegungen zu Rembrandts *Blendung Simsons* von 1636 in Frankfurt." *artibus et historiae* 21:169–98.

Manuth 1993–94
Manuth, Volker. "Denomination and Iconography: The Choice of Subject Matter in the Biblical Painting of the Rembrandt Circle." *Simiolus* 22:235–52.

Manuth et al. 1996
Manuth, Volker, et al. *Wisdom, Knowledge, and Magic: The Image of the Scholar in Seventeenth-Century Dutch Art.* Exh. cat. Kingston, Canada: Agnes Etherington Art Centre, Queens University.

Marrel 1661
Marrel, Jacob. *Artliches und Kunstreichs Reissbüchlein, für die ankommende Jugendt zu lehren, insonderheit für Mahler, Goldtschmidt und bildhauer zusammengetragen und verlegt durch Jacob Marrel, Bürger und Mahler, in Frankfurt, Anno 1661.* Frankfurt am Main.

Marrow 1979
Marrow, James H. *Passion Iconography in Northern European Art of the Late Middle Ages and Early Renaissance: A Study of the Transformation of Sacred Metaphor into Descriptive Narrative.* Kortrijk: Van Ghemmert.

Marshall 1987
Marshall, Sherrin. *The Dutch Gentry, 1500–1650: Family, Faith, and Fortune.* Westport, Conn.: Greenwood Press.

Martin 1965
Martin, John Rupert. *The Farnese Gallery*. Princeton, N.J.: Princeton University Press.

Maselis, Balis, and Marijnissen 1989
Maselis, Marie-Christiane, Arnout Balis, and Roger H. Marijnissen. *De Albums van Anselmus de Boodt (1550–1632): geschilderde natuurobservatie aan het Hof van Rudolf II te Praag.* Tielt: Uitgeverij Lanoo.

Maue and Brink 1989
Maue, Hermann, and Sonja Brink. *Die Grafen von Schönborn: Kirchenfürsten, Sammler, Mazene.* Exh. cat. Nürnberg: Germanisches Nationalmuseum.

Meijer 1988
Meijer, F. G. "Jan Davidsz. de Heem's Earliest Paintings, 1626–28." *Hoogsteder-Naumann Mercury*, no. 7:29–36.

Meiss 1974
Meiss, Millard. *French Painting in the Time of Jean de Berry: The Limbourgs and Their Contemporaries.* New York: G. Braziller.

Meissner 1992–
Meissner, Gunter, ed. *Allgemeines Künstler-Lexikon: die Bildenden Künstler aller Zeiten und Völker.* Munich and Leipzig: K. G. Saur Verlag.

Melion 1991
Melion, Walter S. *Shaping the Netherlandish Canon: Karel van Mander's "Schilder-Boeck."* Chicago: University of Chicago Press.

De Meyere 1976
de Meyere, Jos A. L. "Nieuwe gegevens over Gerard van Honthorst's beschilderd plafond uit 1622." *Jaarboek Oud-Utrecht*, 7–29.

De Meyere 1978
de Meyere, Jos A. L. "Utrechtse schilderkunst in de tweede helft van de 16de eeuw." *Jaarboek Oud Utrecht*, 106–92.

De Meyere 1981
de Meyere, Jos A. L. *Jan van Scorel, 1495–1562: schilder voor prinsen en prelaten.* Utrecht: Centraal Museum.

De Meyere 1987a
de Meyere, Jos A. L. "Hendrick ter Brugghen en tijdgenoten (I): Nieuw Licht op de Gouden Eeuw." *Antiek* 21:341–53.

De Meyere 1987b
de Meyere, Jos A. L. "Nederlandse Schilderkunst van de 17de eeuw: de smaak van de burger," 35–44. In *Nederlandse 17de eeuwse schilderijen uit Boedapest.* Exh. cat. Cologne: Wallraf-Richartz-Museum. Also Museum voor Schone Kunsten, Budapest; Centraal Museum; Utrecht.

De Meyere 1988a
de Meyere, Jos A. L. *"Granida en Daifilo" (1625) van Gerard van Honthorst: onderzoek en restauratie.* Utrecht: Centraal Museum.

De Meyere 1988b
de Meyere, Jos A. L. *Utrecht op schilderijen: zes eeuwen topografische voorstellingen van de stad Utrecht.* Utrecht: Kwadraat.

De Meyere 1989
de Meyere, Jos A. L. "Een monogram op het schilderij *Granida en Daifilo* van Gerard van Honthorst geïdentificeerd." *Maandblad Oud-Utrecht* 62, no. 10 (Oct.): 93–96.

De Meyere 1990
de Meyere, Jos A. L. "De Utrechtse schilder Herman Saftleven en 'An extensive Rhineland view . . .' uit 1669." *Maandblad Oud-Utrecht* 63:33–40.

De Meyere 1993
de Meyere, Jos A. L. "Utrecht als centrum van pastorale schilderkunst," 23–32. In Van den Brink and De Meyere 1993.

De Meyere and Luna 1992
de Meyere, Jos, and Juan J. Luna. *La Pintura Holandesa del Siglo de Oro: La Escuela de Utrecht.* Exh. cat. Madrid; Bilbao; Barcelona.

Miedema 1987
Miedema, Hessel. "Kunstschilders, gilde en academie: over het probleem van de emancipatie van de kunstschilders in de Noordelijke Nederlanden van de 16de en 17de eeuw." *Oud Holland* 101, no. 1:1–34.

Miedema 1995–96
Miedema, Hessel, ed. *Karel Van Mander: The Lives of the Illustrious Netherlandish and German Painters.* 2 vols. Translated by Derry Cook-Radmore. Doornspijk: Davaco.

Mielke 1979
Mielke, Hans. *Manierismus in Holland um 1600: Kupferstiche, Holzschnitte und Zeichnungen aus dem Berliner Kupferstichkabinett.* Exh. cat. Berlin: Kupferstichkabinett, Staatliche Museen Preußischer Kulturbesitz.

Milan 1951
Mostra del Caravaggio e dei caravaggeschi. Exh. cat. Milan: Sansoni. Palazzo Reale, Milan.

De Mirimonde 1960
de Mirimonde, A.-P. *"L'accord retrouvé* de Gerrit van Honthorst." *La Revue des Arts* 10, no. 3:109–16.

Mitchell 1973
Mitchell, Peter. *European Flower Painters.* London: Adam and Charles Black.

Moir 1967
Moir, Alfred. *The Italian Followers of Caravaggio.* 2 vols. Cambridge, Mass.: Harvard University Press.

Moir 1976
Moir, Alfred. *Caravaggio and His Copyists.* New York: New York University Press.

Moiso-Diekamp 1987
Moiso-Diekamp, Cornelia. *Das Pendant in der holländischen Malerei des 17. Jahrhunderts.* Europäische Hochschulschriften, ser. 28, vol. 40. Frankfurt am Main and New York: P. Lang. Originally Ph.D. diss., Universität Köln.

Ter Molen 1984
ter Molen, Joh. R. *Van Vianen, een Utrechtse familie van zilversmeden met een internationale faam.* 2 vols. Leiderdorp: J. R. ter Molen. Originally Ph.D. diss., Rijksuniversiteit te Leiden.

Möller 1926
Möller, Emil. "Leonardo's *Madonna with the Yarn Winder."* *Burlington Magazine* 39 (Aug.): 61–68.

Möller 1954
Möller, Liefelotte. "Demokrit und Heraklit," 3: cols. 1244–51. *Reallexikon zur deutschen Kunstgeschichte*, edited by Otto Schmitt. Stuttgart: Alfred Druckenmüller Verlag.

Monballieu 1979
Monballieu, A. "De 'Hand als teken op het kleed' bij Brueghel en Baltens." *Jaarboek van het Koninklijk Museum voor Schone Kunsten*, 197–209.

Montias 1982
Montias, John Michael. *Artists and Artisans in Delft: A Socio-Economic Study of the Seventeenth Century*. Princeton, N.J.: Princeton University Press.

Montias 1988
Montias, John Michael. "Art Dealers in the Seventeenth-Century Netherlands." *Simiolus* 18:244–56.

Montias 1989
Montias, John Michael. *Vermeer and His Milieu: A Web of Social History*. Princeton, N.J.: Princeton University Press.

Montias 1991
Montias, John Michael. "Works of Art in Seventeenth-Century Amsterdam: An Analysis of Subjects and Attributions," 331–72. In *Art in History / History in Art: Studies in Seventeenth-Century Dutch Culture*, edited by David Freedberg and Jan de Vries. Malibu, Calif.: Getty Center for the History of Art and the Humanities.

Moreelse 1664
Moreelse, Hendrick. "Deductie geëxhibeert bij de heere borgermeester Moreelse, in het college van de vroedtschap der stadt Utrecht: den xxiii–en januarij 1664. Raeckende de verbeteringe end het nodigh uyt-leggen der selver stad." In *Tijdschrift voor geschiedenis, oudheden en statistiek van Utrecht*, edited by N. van der Monde, 6 (1840): 373–437.

Moxey 1989
Moxey, Keith P. F. *Peasants, Warriors, and Wives: Popular Imagery in the Reformation*. Chicago: University of Chicago Press.

Muizelaar 1993
Muizelaar, Klaske. "Hoere-waardinnen en andere bordeelscenes." *Kunstschrift* 37, no. 2:7–8.

Müllenmeister 1973
Müllenmeister, Kurt J. *Meer und Land im Licht des 17. Jahrhunderts*. Bremen: C. Schunemann.

Müllenmeister 1978
Müllenmeister, Kurt J. *Tierdarstellungen in Werken niederländischer Künstler*. Bremen: C. Schunemann.

Müllenmeister 1988
Müllenmeister, Kurt J. *Roelandt Savery. Die Gemälde mit kritischem Oeuvrekatalog*. Freren: Luca Verlag.

Muller 1880
Muller, Samuel. *Schilders-vereenigingen te Utrecht. De Utrechtsche archieven*. Vol. 1. Utrecht: J. L. Beijers, P. A. Geerts.

Muller 1882–83
Muller, S. "Contract van den schilder Joost Droochsloot met eenen Utrechtschen kunstkooper, 1620." In *Archief voor Nederlandsche kunstgeschiedenis*, edited by D. O. Obreen, 5:328–30.

Muller 1904
Muller, S. "Utrechtsche schildersvereenigingen." *Oud-Holland* 22:1–11.

Muller 1911
Muller, Fz., S. *Oude Huizen te Utrecht*. Utrecht.

Muller 1985
Muller, Sheila D. *Charity in the Dutch Republic: Pictures of Rich and Poor for Charitable Institutions*. Ann Arbor, Mich.: UMI Research Press.

Müller Hofstede 1988
Müller Hofstede, Justus. "Artificial Light in Honthorst and Terbrugghen: Form and Iconography," 13–43. In Klessmann 1988.

Müller Hofstede 1993
Müller Hofstede, Justus. "Vita mortalium vigilia: Die Nachtwache der Eremiten und Gelehrten," 34–53. In *Leselust: niederländische Malerei von Rembrandt bis Vermeer*, edited by Ann Jensen Adams and Sabine Schulz. Exh. cat. Stuttgart: G. Hatje. Schirn Kunsthalle Frankfurt.

Müller, Renger, and Klessmann 1978
Müller, Wolfgang J., Konrad Renger, and Rüdiger Klessmann, eds. *Die Sprache der Bilder: Realität und Bedeutung in der niederländischen Malerei des 17. Jahrhunderts*. Exh. cat. Braunschweig: Herzog Anton Ulrich-Museum.

Murray and Murray 1996
Murray, Peter, and Lindo Murray. *The Oxford Companion to Christian Art and Architecture*. Oxford and New York: Oxford University Press.

NNBW
Nieuw Nederlandsch Biographisch Woordenboek
Molhuysen, Philip Christiaan, et al., eds. *Nieuw Nederlandsch biografisch woordenboek*. 10 vols. Leiden: A. W. Sijthoff's uitgevers-maatschappij, 1911–37.

Nash 1972
Nash, John M. *The Age of Rembrandt and Vermeer: Dutch Painting in the Seventeenth Century*. London: Phaidon.

National Gallery Report 1995
The National Gallery Report, April 1994–March 1995. London: National Gallery Publications.

Neumann 1992
Neumann, Jaromír. "Tableaux de Simon Vouet conservés dans les musées de Tchécoslovaquie," 44–64. In *Simon Vouet*. Actes du colloque international Galeries nationales du Grand Palais 5–6–7 février 1991. Paris: La Documentation française.

New York 1954
Dutch Painting: The Golden Age. Exh. cat. The Metropolitan Museum of Art, New York; The Toledo Museum of Art; The Art Gallery of Toronto.

Nichols 1991
Nichols, Lawrence W. "The 'Pen Works' of Hendrick Goltzius." *Philadelphia Museum of Art Bulletin* 88, nos. 373–74 (Winter).

Nicholson 1952
Nicolson, Benedict. "Caravaggio and the Netherlands." *Burlington Magazine* 94 (Sept.): 247–52.

Nicolson 1953
Nicolson, Benedict. "An Unknown Terbrugghen." *Burlington Magazine* 95 (Feb.): 52.

Nicolson 1956
Nicolson, Benedict. "The Rijksmuseum *Incredulity* and Terbrugghen's Chronology." *Burlington Magazine* 98 (April): 103–10.

Nicolson 1957
Nicolson, Benedict. "Terbrugghen Repeating Himself," 193–203. In *Miscellanea Prof. Dr. D. Roggen*, edited by Domien Engelbert Roggen. Antwerp: De Sikkel.

Nicolson 1958a
Nicolson, Benedict. "*De heilige Hieronymous van Hendrick Terbrugghen.*" *Bulletin Museum Boymans-Van Beuningen* 11 (1960): 86–91.

Nicolson 1958b
Nicolson, Benedict. *Hendrick Terbrugghen*. London: Lund Humphries; The Hague: Mauritshuis.

Nicolson 1958c
Nicolson, Benedict. "Terbrugghen's *Old Man Writing.*" *Bulletin of the Smith College Museum of Art* 38:52–57.

Nicolson 1960
Nicolson, Benedict. "Second Thoughts about Terbrugghen." *Burlington Magazine* 102 (Nov.): 465–73.

Nicolson 1971
Nicholson, Benedict. "Gerard Seghers and the *Denial of St Peter.*" *Burlington Magazine* 113 (June): 304–9.

Nicolson 1971–73
Nicolson, Benedict. "A Honthorst for Minneapolis." *The Minneapolis Institute of Arts Bulletin* 60:39–41.

Nicolson 1973
Nicolson, Benedict. "Terbrugghen since 1960," 237–41. In *Album Amicorum J. G. van Gelder*, edited by Josua Bruyn et al. The Hague: Martinus Nijhoff.

Nicolson 1974
Nicolson, Benedict. "Additions to Johan Moreelse," *Burlington Magazine* 116 (Oct.): 620–23.

Nicolson 1979
Nicolson, Benedict. *The International Caravaggesque Movement: Lists of Pictures of Caravaggio and His Followers throughout Europe from 1590 to 1650*. Oxford: Phaidon.

Nicolson and Vertova 1989
Nicolson, Benedict. *Caravaggism in Europe*. 3 vols. 2d ed., revised and enlarged by Luisa Vertova. Turin: Umberto Allemandi.

Van Nierop 1993
van Nierop, Henk F. K. *The Nobility of Holland: From Knights to Regents, 1500–1650*. Translated by Maarten Ultee. Cambridge and New York: Cambridge University Press.

Nippold 1923
Nippold, F. "Die altkatholische Kirche im Erzbistum Utrecht." *Internationale Kirchlichen Zeitschrift*, 1–25, 26–32.

North Carolina Museum of Art 1992
The North Carolina Museum of Art. *Introduction to the Collections*. Revised ed. Raleigh: North Carolina Museum of Art.

Olde Meierink 1995
Olde Meierink, Ben. "Architectuur van kastelen en ridder-hofsteden na de middeleeuwen," 30–40. In Olde Meierink et al. 1995.

Olde Meierink 1996
Olde Meierink, Ben. "Conflict tussen oud en nieuw: De zeventiende eeuw," 142–70. In *1000 Jaar kastelen in Nederland:*

Functie en vorm door de eeuwen heen, edited by H. L. Janssen, J. M. M. Kylstra-Wielinga, and B. Olde Meierink. Utrecht.

Olde Meierink et al. 1995
Olde Meierink, Ben, et al., eds. *Kastelen en ridderhofsteden in Utrecht*. 2d ed. Utrecht: Stichting Utrechtse Kastelen.

Oldenbourg 1917
Oldenbourg, Rudolph. "Die niederländischen Imperatorenbilder im Königlichen Schlosse zu Berlin." *Jahrbuch der Königlich-preußischen Kunstsammlungen* 38:203–12.

O'Malley 1993
O'Malley, J. W. *The First Jesuits*. Cambridge, Mass.: Harvard University Press.

Von der Osten 1965
von der Osten, Gert. "Zur Ikonographie des ungläubigen Thomas angesichts eines Gemäldes von Delacroix." *Wallraf-Richartz Jahrbuch* 27:371–88.

Ostrow 1996
Ostrow, Steven F. *Art and Spirituality in Counter-Reformation Rome: The Sistine and Pauline Chapels in S. Maria Maggiore*. Cambridge and New York: Cambridge University Press.

Overvoorde 1903
Overvoorde, J. C. "Het slot van den Winterkoning te Rhenen." *Bulletin van den Oudheidkundigen Bond* 4, no. 2:74–79.

De Paauw-de Veen 1969
de Paauw-de Veen, Lydia. *De begrippen "schilder," "schilderij" en "schilderen" in de zeventiende eeuw*. Brussels: Paleis der Academien.

Pacelli 1984
Pacelli, Vincenzo. *Caravaggio: le sette opere di Misericordia*. Salerno.

Panofsky 1955
Panofsky, Erwin. *The Life and Art of Albrecht Dürer*. 4th ed. Princeton, N.J.: Princeton University Press.

Parker 1972
Parker, Geoffrey. *The Army of Flanders and the Spanish Road, 1567–1659: The Logistics of Spanish Victory and Defeat in the Low Countries' Wars*. London: Cambridge University Press.

Paris 1983
Saint Sébastian: rituels et figures. Exh. cat. Paris: Musée national des arts et traditions populaires.

Pariset 1948
Pariset, François-Georges. *Georges de La Tour*. Paris: H. Laurens.

Parthey 1863
Parthey, Gustav. *Deutscher Bildersaal, Verzeichnis der in Deutschland vorhandenen Oelbilder verstorbener Maler aller Schulen*. Vol. 1. Berlin.

Van de Passe 1614
van de Passe, Crispijn, the Elder. *Hortus floridus in quo rariorum et minus vulgarium florum icones ad vivam veramque formam accuratissim delineatae* Arnhem: J. Jansson.

Van de Passe 1643
van de Passe, Crispijn, the Younger. *Van 't Licht der teken en schilderkonst*. Amsterdam: I. Iantz. Reprint, Jaap Bolten, ed. Soest: Davaco, 1973.

Pastoor 1991
Pastoor, G. M. C. "Bijbelse historiestukken in particulier bezit," 122–34. In Tümpel et al. 1991.

Pastor 1940
Pastor, Ludwig, Freiherr von. *The History of the Popes from the Close of the Middle Ages.* 40 vols. Translated by E. Graf. London: K. Paul Trench, Trübner & Co.

Pauwels 1951
Pauwels. "Nieuwe toeschrijvingen bij het oeuvre van Hendrick ter Brugghen." *Gentse Bijdragen tot de Kunstgeschiedenis* 13:153–67.

Peck 1991
Peck, William H. *The Detroit Institute of Arts: A Brief History.* Detroit: The Detroit Institute of Arts, distribued by Wayne State University Press.

Pelikan 1984
Pelikan, Jaroslav Jan. *Reformation of Church and Dogma, 1300–1700.* The Christian Tradition: A History of the Development of Doctrine, 4. Chicago: University of Chicago Press.

Pepper 1984
Pepper, D. Stephen. *Guido Reni: A Complete Catalogue of His Works.* Oxford: Phaidon.

Peter-Raupp 1980
Peter-Raupp, Hans. *Die Ikonographie des Oranjezaal.* Hildesheim and New York: Georg Olms Verlag. Originally Ph.D. diss., Universität Bonn.

Pevsner 1935
Pevsner, Nikolaus. "The Birmingham Exhibition of Midland Art Treasures." *Burlington Magazine* 66 (Jan.): 30–35.

Pigler 1934
Pigler, Andor. "Valerius Maximus és az újkori képzömúvészetek," 130–41, 213–26. In *Petrovics Elek Emlékkönycv (Hommage à Alexis Petrovics).* Budapest.

Pigler 1967
Pigler, Andor, ed. *Katalog der Galerie Alter Meister, Museum der Bildenden Künste.* 2 vols. Budapest: Akadémiai Kiadó.

Pigler 1974
Pigler, Andor. *Barockthemen: Eine Auswahl von Verzeichnissen zur Ikonographie des 17. und 18. Jahrhunderts.* 2d revised ed. 3 vols. Budapest: Akadémiai Kiadó.

Pinette 1992
Pinette, Matthieu. "Acquisitions: XVIIe siècle. No. 11, *Saint Pierre.*" *La Revue du Louvre* 42 (Oct.): 69.

Piper 1963
Piper, David. *Catalogue of Seventeenth-Century Portraits in the National Portrait Gallery, 1625–1714.* Cambridge: Cambridge University Press, in association with the Trustees of the National Portrait Gallery.

Playter 1972
Playter, Caroline Bigler. "Willem Duyster and Pieter Codde: The 'Duystere Werelt' of Dutch Genre Painting, c. 1625–1635." 2 vols. Ph.D. diss., Harvard University.

Plietzsch 1960
Plietzsch, Eduard. *Holländische und flämische Maler des XVII. Jahrhunderts.* Leipzig: E. A. Seemann.

Poelhekke 1978
Poelhekke, Jan Joseph. *Frederik Hendrik, Prins van Oranje: een biographisch dreiluik.* Zutphen: De Walburg Pers.

Van de Pol 1985
van de Pol, Lotte C. "Van speelhuis naar bordeel? Veranderingen in de organisatie van de prostitutie in Amsterdam in de tweede helft van de 18de eeuw." *Documentatie. Workgroep Achttiende Eeuw* 17:157–72.

Van de Pol 1988a
van de Pol, Lotte C. "Beeld en werkelijkheid van de prostitutie in de zeventiende eeuw," 109–144. In *Soete minne en helsche boosheit: seksuele voorstellingen in Nederland, 1300–1850,* edited by Gert Hekma and Herman Roodenburg. Nijmegen: SUN.

Van de Pol 1988b
van de Pol, Lotte C. "Seksualiteit tussen middeleeuwen en moderne tijd," 163–93. In *Vijf eeuwen gezinsleven: liefde, huwelijk en opvoeding in Nederland,* edited by H. F. M. Peeters et al. Nijmegen: SUN.

Van de Pol 1996
van de Pol, Lotte C. "Het Amsterdam hoerdom. Prostitutie in de zeventiende en achtiende eeuw." Ph.D. diss., Erasmus Universiteit, Rotterdam.

Posner and Posner 1966
Posner, Donald, and Kathleen Weil-Garris Posner. "More on the Bob Jones University Collection of Religious Art." *Art Journal* 26 (Winter): 144–53.

Postma 1983
Postma, E. B. J. *Nijenrode in prent.* Alphen aan de Rijn.

Potterton 1986
Potterton, Homan. *Dutch Seventeenth- and Eighteenth-Century Paintings in the National Gallery of Ireland: A Complete Catalogue.* Dublin: National Gallery of Ireland.

Prest 1981
Prest, J. *The Garden of Eden: The Botanic Garden and the Re-Creation of Paradise.* New Haven: Yale University Press.

Preston 1974
Preston, Rupert. *The Seventeenth-Century Marine Painters of the Netherlands.* Leigh-on-Sea: F. Lewis.

Price 1995
Price, J. L. "The Dutch Nobility in the Seventeenth and Eighteenth Centuries," 82–113. In *The European Nobilities in the Seventeenth and Eighteenth Centuries,* edited by Hamish M. Scott. 2 vols. London and New York: Longman.

Prodi 1965
Prodi, Paolo. "Ricerche sulla teorica delle arti figurative nella Riforma Cattolica." *Archivio italiano per la storia della pietà* 4:123–212.

Prohaska 1980
Prohaska, Wolfgang. "Untersuchungen zur *Rosenkranz Madonna* Caravaggios." *Jahrbuch der Kunsthistorischen Sammlungen in Wien* 76:111–32.

Putscher 1971
Putscher, Marielene. "Die fünf Sinne." *Aachner Kunstblätter.* 41:152–73.

Radcliffe, Baker, and Maek-Gerard 1992
Radcliffe, Anthony, Malcolm Baker, and Michael Maek-Gerard. *The Thyssen-Bornemisza Collection: Renaissance and Later Sculpture, with Works of Art in Bronze.* London: Sotheby's Publications.

Radice 1988
Radice, Betty. *Who's Who in the Ancient World*. London.

Raggio 1958
Raggio, Olga. "The Myth of Prometheus: Its Survival and Metamorphoses up to the Eighteenth Century." *Journal of the Warburg and Courtauld Institutes* 21:44–62.

Rasch 1996
Rasch, R. "Een raadsman voor de kunsten, Constantijn Huygens als adviseur van Frederik Hendrik." In Hendrix and Stumpel 1996.

Raupp 1984
Raupp, Hans-Joachim. *Untersuchungen zur Künstlerbildnis und Künstlerdarstellung in den Niederlanden im 17. Jahrhundert*. Hildesheim and New York: Georg Olms Verlag.

Rearick 1988
Rearick, William. R. *The Art of Paolo Veronese, 1528–1588*. Exh. cat. Cambridge and New York: Cambridge University Press. Washington: National Gallery of Art.

Réau 1959
Réau, Louis. *Iconographie de l'art chrétien*. 3 vols. Paris: Presses universitaires de France.

Van Regteren Altena 1970
van Regteren Altena, I. Quirijn. "Grotten in de tuinen der Oranjes." *Oud Holland* 85:33–44.

Van Regteren Altena 1983
van Regteren Altena, I. Quirijn. *Jacques de Gheyn: Three Generations*. 3 vols. The Hague: Martinus Nijhoff; Boston and Hingham, Mass.: Kluwer Boston.

Reid 1993
Reid, Jane Davidson, with Chris Rohmann. *The Oxford Guide to Classical Mythology in the Arts, 1300–1990s*. 2 vols. New York: Oxford University Press.

Reinink 1994
Reinink, A. W., ed. *Landgoed Linschoten*. Bussum: Stichting Landgoed Linschoten.

Renckens 1950
Renckens, B. J. A. "*De Zeven Werken der Barmhertigkeit* te Kassel." *Oud Holland* 65:75–78.

Renger 1970
Renger, Konrad. *Lockere Gesellschaft. Zur Ikonographie des verlorenen Sohnes und von Wirtshausszenen in der niederländischen Malerei*. Berlin: Gebr. Mann Verlag.

Renger 1984
Renger, Konrad. "Verhältnis von Text und Bild in der Graphik. (Beobachtungen zu Mißverhältnissen)," 151–61. In *Wort und Bild in der niederländischen Kunst und Literatur des 16. und 17. Jahrhunderts*, edited by Herman Vekeman and Justus Müller Hofstede. Erftstadt: Lukassen Verlag.

Reznicek 1961
Reznicek, Emil Karel Josef. *Die Zeichnungen von Hendrick Goltzius*. 2 vols. Utrecht: Haentjens Dekker & Gumbert.

Reznicek 1972
Reznicek, Emil Karel Josef. "Hont Horstiana." *Nederlands Kunsthistorisch Jaarboek* 23:167–89.

Riccardi-Cubitt 1992
Riccardi-Cubitt, Monique. *The Art of the Cabinet: Including a Chronological Guide to Styles*. New York: Thames and Hudson.

Rico 1984
Rico, Francisco. *The Spanish Picaresque Novel and the Point of View*, translated by C. Davis. Cambridge Iberian and Latin American Studies. Cambridge: Cambridge University Press.

Riggs and Silver 1993
Riggs, Timothy, and Larry Silver. *Graven Images: The Rise of Professional Printmakers in Antwerp and Haarlem, 1540–1640*. Exh. cat. Evanston, Ill.: Mary and Leigh Block Gallery, Northwestern University. Also Ackland Art Museum, University of North Carolina, Chapel Hill.

Rijksmuseum 1920
Katalog der Gemälde, Miniaturen, Pastelle, eingerahmten Zeichnungen, usw. im Reichsmuseum zu Amsterdam, edited by B. W. F. van Riemsdijk. Amsterdam: Das Ministerium, Kunste.

Rijksmuseum 1982
"Keuze uit de aanwinsten." *Bulletin van het Rijksmuseum* 30:27, fig. 1, and cover illus.

Ripa 1644
Ripa, Cesare. *Iconologia of uytbeeldingen des verstands*, translated by D. P. Pers. Amsterdam: Pers.

Ritter 1988
Ritter, G. J. "Het Utrechtse smedengilde: metaalbewerkers in Utrecht in de 17de en 18de eeuw." Ph.D. diss., Rijksuniversiteit Utrecht.

Robinson 1974
Robinson, Franklin Westcott. *Gabriël Metsu (1629–1667): A Study of His Place in Dutch Genre Painting of the Golden Age*. New York: A. Schram.

Robinson 1991
Robinson, William W. *Seventeenth-Century Dutch Drawings: A Selection from the Maida and George Abrams Collection*. Exh. cat. Lynn, Mass.: H. O. Zimman. Rijksprentenkabinet, Rijksmuseum, Amsterdam; Graphische Sammlung Albertina, Vienna; The Pierpont Morgan Library, New York; Fogg Art Museum, Harvard University, Cambridge, Mass.

Rockstro 1967
Rockstro, Richard Shepherd. *A Treatise on the Construction, History and the Practice of the Flute*. 2d ed. London: Musica Rara.

Roding and Theunissen 1993
Roding, Michiel, and Hans Theunissen, eds. *The Tulip: A Symbol of Two Nations*. Utrecht: M. Th. Houtsma Stichting; Istanbul: Turco-Dutch Friendship Association.

Roelofsz 1980
Roelofsz, C. "*Orpheus en de dieren van Jacob Savery*." *Tableau* 2, no. 6:312–16.

Roethlisberger 1990
Roethlisberger, Marcel G. "Abraham Bloemaert's *Farmers in the Field*." *Hoogsteder Mercury*, no. 11:14–21.

Roethlisberger 1992
Roethlisberger, Marcel G. "Bloemaert's Altar-pieces and Related Paintings." *Burlington Magazine* 134 (March): 156–64.

Roethlisberger 1993
Roethlisberger, Marcel G. *Abraham Bloemaert and His Sons: Paintings and Prints*. Aetas aurea, no. 11. 2 vols. Doornspijk: Davaco.

Roggen 1949–50
Roggen, D. "Het Caravaggisme te Gent." *Gentse Bijdragen tot de Kunstgeschiedenis* 12:255–85.

Rogier 1945–47
Rogier, L. J. *Geschiedenis van het Katholicisme in Noord-Nederland in de 16e en de 17e eeuw.* 3 vols. Amsterdam: Urbi et Orbi.

Roh 1921
Roh, Franz. *Holländische Malerei.* Jena: E. Diederichs.

Rohe n.d.
Rohe, Michael. "Nicolaus Knüpfer (ca. 1609–1655), Monographische Studien und Werksverzeichnis." Ph.D. diss., Kiel s.a. (unpublished).

Rome 1954. *See* Salerno 1954

Rommes 1990
Rommes, Ronald. "Pest in perspectief. Aspecten van een gevreesde ziekte in de vroeg-moderne tijd." *Tijdschrift voor sociale geschiedenis* 16:244–66.

Rommes 1991
Rommes, Ronald. "Op het spoor van de dood. De pest in ed rond Utrecht." *Jaarboek Oud Utrecht,* 93–120.

Rommes 1995
Rommes, Ronald. "Duitse immigratie in Utrecht vanaf de zestiende tot de achttiende eeuw," 169–88. In *De Republiek tussen zee en vasteland: buitenlandse invleoden op cultuur, economie en politiek in Nederland, 1580–1800,* edited by Karel Davids et al. Louvain: Garant.

Rommes 1996
Rommes, Ronald. "Lutherse immigranten in Utrecht tijdens de Republiek," 35–53. In *Nieuwe Nederlanders. Vestiging van migranten door de eeuwen heen,* edited by Marjolein 't Hart, Jan Lucassen, and Hen Schmal. Amsterdam: SISWO/Instituut voor Maatschappij-wetenschappen.

Roorda 1975
Roorda, D. J. "Prins Willem III en het Utrechtse regerings-reglement. Een schets van gebeurtenissen, achtergronden en problemen," 91–133. In Leeuwenberg and Van Tongerloo 1975.

Rooses 1890
Rooses, Max. *L'oeuvre de P. P. Rubens: histoire et description de ses tableaux et dessins.* Antwerp: J. Maes.

Rose 1961
Rose, Martial, ed. *The Wakefield Mystery Plays.* Garden City, N.Y.: Doubleday.

Rosenberg, Slive, and Ter Kuile 1977
Rosenberg, Jakob, Seymour Slive, and Engelbert Hendrik ter Kuile. *Dutch Art and Architecture, 1600–1800.* 3d ed. New York and Harmondsworth: Penguin.

Rosenblum 1972
Rosenblum, Robert. "Caritas Romana after 1760: Some Romantic Lactations." In *Woman as Sex Object, Studies in Erotic Art, 1730–1970,* edited by Thomas B. Hess and Linda Nochlin. *Art News Annual* 38. New York: Alvin Garfin.

Rotterdam 1976
Le cabinet d'un amateur: dessins flamands et hollandais des XVIe et XVIIe siècles d'une collection privée d'Amsterdam. Exh. cat. Museum Boymans-van Beuningen, Rotterdam; Institut Néerlandais, Paris; Bibliothèque Albert Ier, Brussels.

Rowland 1973
Rowland, Beryl. *Animals with Human Faces: A Guide to Animal Symbolism.* Knoxville: University of Tennessee Press.

Royal Museum of Fine Arts, Copenhagen 1856
Fortegnelse over den Moltkeske Malerisamling. Copenhagen.

Royal Museum of Fine Arts, Copenhagen 1931
Den Moltkeske Malerisamling. Copenhagen.

Royal Museum of Fine Arts, Copenhagen 1951
Catalogue of Old Foreign Paintings. Copenhagen: Royal Museum of Fine Arts.

Russell 1982
Russell, Helen Diane. *Claude Lorrain, 1600–1682.* Exh. cat. Washington: National Gallery of Art.

Russell 1996
Russell, Margarita. "Willaerts," 33:193–95. In *Dictionary of Art* 1996.

Rutledge 1949
Rutledge, Anna Wells. "Robert Gilmor, Jr., Baltimore Collector." *Journal of the Walters Art Gallery* 12:19–39.

Salerno 1954
Salerno, Luigi. *Mostra di pittura olandese del Seicento.* Exh. cat. Introduction by Ary Bob de Vries. Rome: De Luca. Palazzo delle esposizioni, Rome; Palazzo Reale, Milan.

Salerno 1960
Salerno, Luigi. "The Picture Gallery of Vincenzio Giustiniani." *Burlington Magazine* 102 (Jan.): 21–27; (March): 93–104; (April): 135–48.

Salerno 1977–80
Salerno, Luigi. *Pittori di paesaggio del seicento a Roma/Landscape Painters of the Seventeenth Century in Rome.* 3 vols. Rome: Ugo Bozzi Editore.

Salerno et al. 1985
Salerno, Luigi, et al. *The Age of Caravaggio.* Exh. cat. New York: The Metropolitan Museum of Art, in association with Electra International/Rizzoli. Also Museo Nazionale di Capodimonte, Naples.

Salomon 1984
Salomon, Nanette. "Dreamers, Idlers and Other Dozers: Aspects of Sleep in Dutch Art." Ph.D. diss., New York University.

Sandoz 1955
Sandoz, Marc. "Ribera et le thème de 'Saint Sébastien soigné par Irène.'" *Cahiers de Bordeaux, Journées Internationales d'études d'art* 2:69–71.

Von Sandrart 1675–79
von Sandrart, Joachim. *Academie der Bau-, Bild- und Mahlerey-Künste.* Nuremberg: Joachim von Sandrart; Frankfurt: M. Merian and J. P. Miltenberger. 1975 ed.

Von Sandrart 1675–80
von Sandrart, Joachim. *Teutsche Academie der Bau-, Bild- und Malerei-Künste.* 3 vols. Nuremberg. Reprint, 3 vols. Nördlingen: Verlag Dr. Alfous Uhl, 1994–95.

Von Sandrart/Peltzer 1925
von Sandrart, Joachim. *Joachim von Sandrart's Academie der Bau-, Bild- und Mahlerey-Künste von 1675,* edited and annotated by Dr. Arthur Rudolf Peltzer. Munich: G. Hirth's Verlag.

San Francisco 1939
Masterworks of Five Centuries. Exh. cat. San Francisco: Golden Gate International Exposition.

San Francisco 1966
The Age of Rembrandt: An Exhibition of Dutch Paintings of the Seventeenth Century. Exh. cat. New York: Published by the October House for the Museum of Fine Arts, Boston. Also California Palace of the Legion of Honor, San Francisco; The Toledo Museum of Art; Museum of Fine Arts, Boston.

Savage 1924
Savage, Spencer. *The "Hortus Floridus" of Crispin van de Pas the Younger.* London: The Library.

Saward 1983
Saward, Susan. *The Golden Age of Marie de' Medici.* Studies in Baroque Art History, no. 2. Ann Arbor, Mich.: UMI Research Press.

Scarisbrick 1993
Scarisbrick, Diana. *Rings: Symbols of Wealth, Power, and Affection.* London: Thames and Hudson.

Schadee 1994
Schadee, Nora, ed. *Rotterdamse Meesters uit de Gouden Eeuw.* Exh. cat. Zwolle: Waanders. Historisch Museum Rotterdam.

Schaeffer 1995
Schaeffer, Scott. "Private Collecting and the Public Good." In Sotheby's (New York), 12 Jan. 1995, for The New-York Historical Society, unpaginated.

Schaffhausen 1949
Rembrandt und seine Zeit. Zweihundert Gemälde der Blützeit der holländischen Barockmalerei des 17. Jahrhunderts aus deutschem, holländischem und schweizerischem Museums und Privatbesitz. Exh. cat. Schaffhausen: Lempen. Museum zu Allerheiligen, Schaffhausen.

Schama 1987
Schama, Simon. *Embarrassment of Riches: An Interpretation of Dutch Culture in the Golden Age.* New York: Knopf.

Schenkeveld 1991
Schenkeveld, Maria A. *Dutch Literature in the Age of Rembrandt: Themes and Ideas.* Amsterdam and Philadelphia: J. Benjamins.

Schepelern and Houkjaer 1988
Schepelern, H. D., and Ulla Houkjaer. *The Kronborg Series: King Christian IV and His Pictures of Early Danish History.* Exh. cat. Copenhagen: The Royal Museum of Fine Arts.

Scheurleer 1969
Scheurleer, Th. H. Lunsingh. "De woonvertrekken in Amalia's Huis in het Bosch." *Oud Holland* 84:29–66.

Schillemans 1992
Schillemans, Robert. "Schilderijen in Noordnederlandse katholieke kerken uit de eerste helft van de zeventiende eeuw." *De zeventiende eeuw* 8, no. 1:41–52.

Schillemans 1993
Schillemans, Robert. "Over Hendrick ter Brugghens *Kruisigingen* en de aanspraak van Adriaen Ploos op een adellijke afkomst." *De zeventiende eeuw* 9, no. 2:137–51.

Schilling 1980
Schilling, Heinz. "Religion und Gesellschaft in der Calvinistischen Republik der Vereinigten Niederlande. 'Öffentlichkeitskirche' und Säkularisation; Ehe und Hebammenwesen; Presbyterien und politische Partizipation," 197–250. In *Kirche und Gesellschaftlicher Wandel in deutschen und niederländischen Städten der werdenden Neuzeit,* edited by Franz Petri. Cologne and Vienna: Bohlau.

Schleier 1972
Schleier, Erich. "A Lost Baburen Rediscovered." *Burlington Magazine* 114 (Nov.): 787.

Schloss 1982
Schloss, Christine Skeeles. *Travel, Trade, and Temptation: the Dutch Italiante Harbor Scene, 1640–1680.* Ann Arbor, Mich.: UMI Research Press.

Schloss 1983
Schloss, Christine Skeeles. "A Note on Jan Baptist Weenix' Patronage in Rome," 237–38. In *Essays in Northern Art Presented to Egbert Haverkamp Begemann on His Sixtieth Birthday.* Doornspijk: Davaco.

Schmid 1954
Schmid, Alfred. "Concordantia caritatis," 3: cols. 833–53. *Reallexikon zur deutschen Kunstgeschichte,* edited by Otto Schmitt. Stuttgart: Alfred Druckenmüller Verlag.

Schnackenburg 1987
Schnackenburg, Bernhard. Review of Blankert and Slatkes 1986. *Kunstchronik* 40 (April): 169–77.

Schnackenburg 1996
Schnackenburg, Bernhard. *Gemäldegalerie Alte Meister: Gesamtkatalog* [Staatlich Museen Kassel]. 2 vols. Mainz: Verlag Philipp von Zabern.

Schneede 1968
Schneede, Uwe M. "Gabriel Metsu und der holländische Realismus." *Oud Holland* 83:44–61.

Von Schneider 1933
von Schneider, Arthur. *Caravaggio und die Niederländer.* Marburg-Lahn: Verlag des Kunstgeschichtlichen Seminars.

Von Schneider 1966
von Schneider, Arthur. *Il seguaci del Caravaggio nei Paesi Bassi.* Milan: Fratello Frabbi.

Schoenenberger 1957
Schoenenberger, Walter. *Giovanni Serodine: pittore di Ascona.* Basler Studien zur Kunstgeschichte, no. 6. Basel: Birkhauser.

Scholten 1996
Scholten, Frits. "Good Widows and the Sleeping Dead: Rombout Verhulst and Tombs for the Dutch Aristocracy." *Simiolus* 24:328–49.

Schroeder 1978
Schroeder, Henry Joseph, ed. *The Canons and Decrees of the Council of Trent.* Rockford, Ill.: TAN Books.

Schulz 1978
Schulz, Wolfgang. *Cornelis Saftleven, 1607–1681: Leben und Werke.* Berlin and New York: de Gruyter.

Schulz 1982
Schulz, Wolfgang. *Herman Saftleven, 1609–1685: Leben und Werke. Mit einem kritischen Katalog der Gemälde und Zeichnungen.* Berlin and New York: de Gruyter.

Schürmeyer 1937
Schürmeyer, Walter. "Ahnengalerie," 1: cols. 221–27. *Reallexikon zur deutschen Kunstgeschichte,* edited by Otto Schmitt. Stuttgart: Alfred Druckenmüller Verlag.

Schuster 1982
Schuster, Peter-Klaus. "Das Bild der Bilder." *Idea. Jahrbuch der Hamburger Kunsthalle* 1:72–134.

Schwartz 1985
Schwartz, Gary. *Rembrandt: His Life, His Paintings.* New York: Viking.

Schwartz 1986
Schwartz, Gary. *The Dutch World of Painting.* Exh. cat. Vancouver: Vancouver Art Gallery.

Schwartz and Bok 1990
Schwartz, Gary, and Marten Jan Bok. *Pieter Saenredam: The Painter and His Time.* Maarssen: Gary Schwartz; The Hague: SDU.

Schweckendiek 1930
Schweckendiek, Adolf. *Bühnengeschichte des Verlorenen Sohnes in Deutschland. 1. Teil (1527–1627).* Theatergeschichtliche Forschungen, vol. 40. Leipzig: Voss.

Scott 1987
Scott, Mary Ann. *Dutch, Flemish, and German Paintings in the Cincinnati Art Museum: Fifteenth through Eighteenth Centuries.* Eden Park, Cincinatti: Cincinatti Art Museum.

Seelig 1995
Seelig, Gero. "Abraham Bloemaert, Studien zur Utrechter Malerei um 1620." Ph.D. diss., Berlin.

Seelig 1996
Seelig, Gero. Review of Roethlisberger 1993. *Kunstchronik* 49 (March): 97–105.

Seelig 1997a
Seelig, Gero. *Abraham Bloemaert (1566–1651). Studien zur Utrechter Malerei um 1620.* Berlin.

Seelig 1997b
Seelig, Gero. "Hendrick Bloemaert in Italy." *Master Drawings* (forthcoming).

Segal 1982
Segal, Sam. "The Flower Pieces of Roelandt Savery." *Leids Kunsthistorisch Jaarboek* 1:309–37.

Segal 1983
Segal, Sam. *A Fruitful Past: A Survey of the Fruit Still Lifes of the Northern and Southern Netherlands from Breughel till Van Gogh.* Exh. cat. S. I.: Drukkerij Verweij. Gallery P. de Boer, Amsterdam; Herzog Anton Ulrich-Museum, Braunschweig.

Segal 1984
Segal, Sam. "Still-lifes by Middelburg Painters," 25–95, 118–223. In Bakker et al. 1984.

Segal 1988
Segal, Sam. *A Prosperous Past: The Sumptuous Still Life in the Netherlands, 1600–1700.* Exh. cat. edited by William B. Jordan. The Hague: SDU Publishers. Stedelijk Museum Het Prinsenhof, Delft; Fogg Art Museum, Harvard University, Cambridge, Mass.; Kimbell Art Museum, Fort Worth.

Segal 1990
Segal, Sam. *Flowers and Nature: Netherlandish Flower Painting of Four Centuries.* Exh. cat. The Hague: SDU Publishers. Nabio Museum of Art, Osaka; Tokyo Station Gallery, Tokyo; The Art Gallery of New South Wales, Sydney.

Segal 1991
Segal, Sam. *Jan Davidsz de Heem und sein Kreis.* Exh. cat. Braunschweig: Herzog Anton Ulrich-Museum (German ed.); The Hague: SDU Uitgeverij (Dutch ed.). Centraal Museum, Utrecht; Herzog Anton Ulrich-Museum, Braunschweig.

Segal 1993
Segal, Sam. "Tulips Portrayed: The Tulip Trade in Holland in the Seventeenth Century," 9–24. In Roding and Theunissen 1993.

Segal and Roding 1994
Segal, Sam, and Michiel Roding. *De Tulp en de Kunst.* Exh. cat. Zwolle: Waanders. De Nieuwe Kerk, Amsterdam.

Seifertová 1989
Seifertová, Hana. *Nemecké malírství 17. století z ceskoslovenskych sbírek.* Prague: Narodnigalerie. Sternbersky palac, Hradcanske Namesti, Prague.

Seifertová 1993
Seifertová, Hana. In *Artis pictoriae amatores: Evropa v zrcadle prazskéko barokního sberatelství,* 228, cat. V/2-44. Exh. cat. edited by Lubomír Slavíček. Prague: Národní Galerie v Praze.

Sellink 1994
Sellink, Manfred. *Cornelis Cort: "constich plaedt-snijder van Horne in Hollandt."* Exh. cat. Rotterdam: Museum Boymans-van Beuningen.

Sheard 1978
Sheard, Wendy Stedman. *Antiquity in the Renaissance.* 2 vols. Exh. cat. Northampton, Mass.: Smith College Museum of Art.

Siccama 1905
Siccama, Duco Gerrold Rengers Hora. *De geestelijke en kerkelijke goederen onder het cannonieke, het gereformeerde en het neutrale recht. Historisch-juridische verhandeling, voornamelijk uit Utrechtsche gegevens samengesteld.* Utrecht: Kemink & Zoon.

Šíp 1964
Šíp, Jaromír. "Some Remarks on a Little-Known Masterpiece by Roelant Savery," 165–69. In *Sborník Prací Filosofické Fakulty Brnénské University.*

Šíp 1965
Šíp, Jaromír. *Holandské krajinárství 17. století* Prague: Narodni Galerie.

Šíp 1969
Šíp, Jaromír. "Die Paradieses-Vision in den Gemälden Roelandt Saverys." *Jahrbuch der Kunsthistorischen Sammlungen in Wien* 65:29–38.

Šíp 1970
Šíp, Jaromír. "Roelant Savery in Prag." *Umění* 18:276–83.

Šíp 1976
Šíp, Jaromír. *Holandské malírství 17. století v prazské Národní galerii v Praze*. Prague: Odeon.

Šíp 1978
Šíp, Jaromír. *Holandija 17. stoletja v oceh svoijh umetnikov: iz zbirk Narodne galerije v Pragi*. Exh. cat. Ljubljana: Narodna galerija.

Slatkes 1965
Slatkes, Leonard J. *Dirck van Baburen (c. 1595–1624), a Dutch Painter in Utrecht and Rome*. orbis artium Utrechtse Kunsthistorische Studiën, no. 5. Utrecht: Heantjens Dekker & Gumbert. 2d ed. 1969.

Slatkes 1966
Slatkes, Leonard J. "David de Haen and Dirck van Baburen in Rome." *Oud Holland* 81:173–86.

Slatkes 1969
Slatkes, Leonard J. "Hendrick Terbrugghen," 5:300. *McGraw-Hill Dictionary of Art*. New York: McGraw-Hill.

Slatkes 1970
Slatkes, Leonard J. "Dutch Mannerism." *Art Quarterly* 33 (Winter): 420–40.

Slatkes 1973
Slatkes, Leonard J. "Additions to Dirck van Baburen," 267–73. In *Album Amicorum J. G. van Gelder*, edited by Josua Bruyn et al. The Hague: Martinus Nijhoff.

Slatkes 1981
Slatkes, Leonard J. *Vermeer and His Contemporaries*. New York: Abbeville Press.

Slatkes 1981–82
Slatkes, Leonard J. Review of Nicolson 1979. *Simiolus* 12, nos. 2–3:167–83.

Slatkes 1983
Slatkes, Leonard J. *Rembrandt and Persia*. New York: Abaris Books.

Slatkes 1987
Slatkes, Leonard J. "A New Drawing by Hendrick Ter Brugghen." *Was getekend . . . tekenkunst door de eeuwen heen; liber amicorum prof. dr. E. K. J. Reznicek. Nederlands Kunsthistorisch Jaarboek* 38:324–30.

Slatkes 1992
Slatles, Leonard J. "Bramer, Italy, and Caravaggism," 13–18. In *Leonard Bramer, 1596–1674: A Painter of the Night*. Exh. cat. edited by Frima Fox Hifrichter. Milwaukee: Marquette University, Patrick and Beatrice Haggerty Museum of Art.

Slatkes 1995
Slatkes, Leonard J. "Hendrick ter Brugghen's *The Gamblers*." *The Minneapolis Institute of Arts Bulletin* 67:6–11.

Slatkes 1996
Slatkes, Leonard J. "Georges de La Tour and the Netherlandish followers of Caravaggio," 202–217. In Conisbee 1996.

Slatkes forthcoming
Slatkes, Leonard J. "Bringing Ter Brugghen and Baburen up-to-date." *Bulletin du Musée National de Varsovie*.

Slatkes and Stechow 1965
Slatkes, Leonard J., and Wolfgang Stechow. *Hendrick Terbrugghen in America*. Exh. cat. Dayton: Dayton Art Institute. Also Baltimore Museum of Art.

Slavíček 1994
Slavíček, Lubomír. *Barocke Bilderlust: holländische und flämische Gemälde der ehemaligen Sammlung Nostitz aus der Prager Nationalgalerie*. Exh. cat. Braunschweig: Herzog Anton Ulrich-Museum.

Slive 1970–74
Slive, Seymour. *Frans Hals*. 3 vols. London: Phaidon.

Slive 1988
Slive, Seymour. "The Manor Kostverloren: Vicissitudes of a Seventeenth-Century Dutch Landscape Motif," 133–68. In *The Age of Rembrandt: Studies in Seventeenth-Century Dutch Painting*, edited by Roland E. Fleisher. Papers in Art History from the Pennsylvania State University, 3. University Park: Pennsylvania State University Press.

Slive 1995
Slive, Seymour. *Dutch Painting, 1600–1800*. New Haven and London: Yale University Press.

Slive and Hoetink 1981
Slive, Seymour, and Hans R. Hoetink. *Jacob van Ruisdael*. Exh. cat. New York: Abbeville Press. Mauritshuis, The Hague; Fogg Art Museum, Harvard University, Cambridge, Mass.

Sluijter 1977
Sluijter, Eric Jan. "Niet Gysbert van der Kuyl uit Gouda, maar Gerard van Kuijl uit Gorinchem (1604–1673)." *Oud Holland* 91:166–94.

Sluijter 1980
Sluiter, Eric Jan. "Depiction of Mythological Themes," 55–64. In Blankert et al. 1980.

Sluijter 1986
Sluijter, Eric Jan. *De "Heydensche Fabulen" in de Noordnederlandse schilderkunst, circa 1590–1670*. The Hague: E. J. Sluijter. Ph.D. diss., Rijksuniversiteit Leiden.

Sluijter 1988a
Sluijter, Eric Jan. "Een stuck waerin een jufr. voor de spiegel van Gerrit Douw." *Antiek* 23 (Oct.): 150–61.

Sluijter 1988b
Sluijter, Eric Jan. "'Een volmaeckt schilderij is als een spiegel van de natuer': spiegel en spiegelbeeld in de Nederlandse schilderkunst van de zeventiende eeuw," 160, 162–63. In *Oog in oog met de spiegel*, edited by Nico J. Brederoo. Amsterdam: Aramith.

Sluijter 1990
Sluijter, Eric Jan. "Hoe realistisch is de Noordnederlandse schilderkunst van de zeventiende eeuw? De problemen van een vraagstelling." *Leidschrift* 6, no. 3:5–39.

Sluijter 1991–92
Sluijter, Eric Jan. "Venus, Visus en Pictura." *Goltzius-Studies: Hendrick Goltzius (1558–1617). Nederlands Kunsthistorisch Jaarboek* 42–43:337–96.

Sluijter 1992
Sluijter, Eric Jan. "Rembrandt's Early Paintings of the Female Nude: *Andromeda* and *Susanna*," 31–54. In Cavalli-Björkman 1992.

Sluijter 1993
Sluijter, Eric Jan. "De entree van de amoureuze herdersidylle in de Noord-Nederlandse prent- en schilderkunst," 33–57. In Van den Brink and De Meyere 1993.

Sluijter-Seijffert 1984
Sluijter-Seijffert, Nicolette. "Cornelis van Poelenburgh (ca. 1593–1667)." Ph.D. diss., Rijksuniversiteit Leiden.

Smith 1982
Smith, David R. *Masks of Wedlock: Seventeenth-Century Dutch Marriage Portraiture.* Ann Arbor, Mich.: UMI Research Press.

Smith 1996
Smith, Elizabeth Bradford. *Medieval Art in America: Patterns of Collecting, 1800–1940.* Exh. cat. University Park: Palmer Museum of Art, Pennsylvania State University.

Smith 1829–42
Smith, John. *A Catalogue Raisonné of the Works of the Most Eminent Dutch, Flemish, and French Painters.* 9 vols. London: Smith.

Smits-Veldt and Luijten 1993
Smits-Veldt, Mieke B., and Hans Luijten. "Nederlandse pastorale poëzie in de 17de eeuw: verliefde en wijze herders," 58–75. In Van den Brink and De Meyere 1993.

Snoep 1968–69
Snoep, D. P. "Een 17de eeuws liedboek met tekeningen van Gerard ter Borch de Oude en Pieter Roeland van Laer." *Simiolus* 3:77–134.

Snoep 1969
Snoep, D. P. "Honselaersdijk: restauraties op papier." *Oud Holland* 84:270–94.

Sonnenburg, Liedtke, et al. 1995
Rembrandt/Not Rembrandt in the Metropolitan Museum of Art: Aspects of Connoisseurship. Exh. cat. 2 vols. 1: Hubert von Sonnenburg, *Paintings: Problems and Issues;* 2: Walter Liedtke, Carolyn Logan, Nadine M. Orenstein, and Stephanie S. Dickey. *Paintings, Drawings, and Prints: Art-Historical Perspectives.* New York: The Metropolitan Museum of Art, distributed by H. N. Abrams.

Spear 1971
Spear, Richard E. *Caravaggio and His Followers.* Exh. cat. Cleveland: The Cleveland Museum of Art.

Spear 1982
Spear, Richard E. *Domenichino.* 2 vols. New Haven and London: Yale University Press.

Spicer 1979
Spicer-Durham, Joaneath A. "The Drawings of Roelandt Savery." 2 vols. Ph.D. diss., Yale University.

Spicer 1985
Spicer, Joaneath. Review of Halewood 1982. *RACAR: Revue d'art canadienne/Canadian Art Review* 12, no. 1: 75–78.

Spicer 1988
Spicer, Joaneath. "An Experiment with Perspective by Gabriel Metsu." *Zeitschrift für Kunstgeschichte* 51:574–83.

Spicer 1995
Spicer, Joaneath. "The Response to the Art of the Past by Seventeenth-Century Northern Artists," 13–16. In Corrin and Spicer 1995.

Spicer 1997a
Spicer, Joaneath. "The Discovery of the Alpine Waterfall by Roelandt Savery." In Fučíková 1997.

Spicer 1997b
Spicer, Joaneath. "The Genesis of a Pictorial Vocabulary: Roelandt Savery, the Willarts Family and the Representation of Foreign Climes." *Nederlands Kunsthistorisch Jaarboek* 48: forthcoming.

Spicer 1997c
Spicer, Joaneath. "Romance and Reality: Seventeenth-Century Marriage Portraits from Utrecht." *Bulletin of the Walters Art Gallery* 50 (Jan.): 4–5.

Spiertz 1977
Spiertz, Mathieu G. "Het aandeel van de katholieken in de Friese bevolking tussen 1663 en 1796." *Archief voor de Geschiedenis van de katholieke kerk in Nederland* 19:147–69.

Spiertz 1989
Spiertz, Mathieu G. "Priest and Layman in a Minority Church: The Roman Catholic Church in the Northern Netherlands, 1592–1686." *Studies in Church History* 26:287–301.

Staal 1996
Staal, C. J. "Johan Ludolph van Rhenen, vicaris te Vleuten, paap on Den Ham en redder van de Cunera-relieken." *Jaarboek Oud-Utrecht,* 70–86.

Stechow 1928
Stechow, Wolfgang. "Zu zwei Bildern des Henrick Terbrugghen." *Oud Holland* 45:277–81.

Stechow 1928–29
Stechow, Wolfgang. "Illa Budde, *Die Idylle im holländischen Barock,* Köln 1929." *Kritische Berichte zur Kunstgeschichtliche Literatur* 2, no. 9:181–87.

Stechow 1944
Stechow, Wolfgang. "Rembrandt-Democritus." *Art Quarterly* 7 (Fall): 233–38.

Stechow 1948
Stechow, Wolfgang. "Jan Baptist Weenix." *Art Quarterly* 11 (Spring): 181–99.

Stechow 1954
Stechow, Wolfgang. "Terbrugghen's *Saint Sebastian.*" *Burlington Magazine* 96 (March): 70–72.

Stechow 1964
Stechow, Wolfgang. *Italy through Dutch Eyes: Dutch Seventeenth-Century Landscape Artists in Italy.* Exh. cat. Ann Arbor: University of Michigan Museum of Art.

Stechow 1966
Stechow, Wolfgang. *Dutch Landscape Painting of the Seventeenth Century.* Kress Foundation Studies in the History of European Art. London: Phaidon.

Stechow 1970
Stechow, Wolfgang. *Dutch Mannerism: Apogee and Epilogue.* Exh. cat. Poughkeepsie: Vassar College Art Gallery.

Stechow 1973
Stechow, Wolfgang. "'Sonder borstel oft pinseel,'" 310–11. In *Album Amicorum J. G. van Gelder*, edited by Josua Bruyn et al. The Hague: Martinus Nijhoff.

Steel 1984
Steel, David H., Jr. *Baroque Paintings from the Bob Jones University Collection.* Exh. cat. Raleigh: North Carolina Museum of Art.

Steenhoff 1916
Steenhoff, W. "Aanwinsten Rijksmuseum." *Onze Kunst* 15:25–7.

Steland 1985
Steland, A. "Wasserfälle, die Emanzipation eines Bildmotivs in der holländischen Malerei um 1640." *Niederdeutsche Beiträge zur Kunstgeschichte* 24:85–104.

Steneberg 1953
Steneberg, Karl Erik. *Gamla Holländare i Skånska Hem.* Exh. cat. Lund: Universitetet Lund. Skånska Konstmuseum, Lund.

Stenvert 1994
Stenvert, R. "Bouwgeschiedenis, het Huis en andere opstallen," 228–301. In Reinink 1994.

Van Steur 1967
van Steur, A. G. "Johan Torrenius." *Spiegel Historiael* 4:217–24.

Strauss 1980
Strauss, Walter L. *Albrecht Dürer, Woodcuts and Woodblocks.* New York: Abaris.

Strauss and Van der Meulen 1979
Strauss, Walter L., and Marjon van der Meulen, eds. *The Rembrandt Documents.* New York: Abaris Books.

Van Strien 1993
van Strien, C. D. *British Travellers in Holland during the Stuart Period: Edward Browne and John Locke as Tourists in the United Provinces.* Leiden and New York: E. J. Brill.

Struick 1968
Struick, J. E. A. L. *Utrecht door de eeuwen heen.* Utrecht and Antwerp: Het Spectrum.

Struick 1986
Struick, J. E. A. L. "De stichting van een tehuis voor de Muzen en de eerste bewoners," 7–24. In *Goede buur of verre vriend: de relatie tussen de Universiteit en de stad Utrecht, 1636–1686*, edited by J. E. A. L. Struick et al. Utrecht: Impress Broese Kemink.

Sullivan 1979
Sullivan, Scott A. "Jan Baptist Weenix: *Still Life with a Dead Swan*." *Bulletin of The Detroit Institute of Arts* 57, no. 2:65–71.

Sullivan 1984
Sullivan, Scott A. *The Dutch Gamepiece.* Montclair, N.J.: Allanheld & Schram; Woodbridge, Suffolk: Boydell Press.

Sumowski 1983–94
Sumowski, Werner. *Gemälde der Rembrandt-Schüler.* 5 vols. Landau, Pfalz: Pfalz. Verlagsanstalt.

Sutton 1984
Sutton, Peter C., ed. *Masters of Seventeenth-Century Dutch Genre Painting.* Exh. cat. Philadelphia: Philadelphia Museum of Art. Also Gemäldegalerie, Staatliche Museen zu Berlin; Royal Academy of Arts, London.

Sutton 1986
Sutton, Peter C. *A Guide to Dutch Art in America.* Washington: The Netherlands-American Amity Trust, in association with Kampen: J. H. Kok, and Grand Rapids: Wm. B. Eerdmans.

Sutton 1987
Sutton, Peter C., ed. *Masters of Seventeenth-Century Dutch Landscape Painting.* Exh. cat. Boston: Museum of Fine Arts. Also Rijksmuseum, Amsterdam; Philadelphia Museum of Art.

Sutton 1990
Sutton, Peter C. *Northern European Paintings in the Philadelphia Museum of Art, from the Sixteenth through the Nineteenth Century.* Philadelphia: Philadelphia Museum of Art.

Sutton 1993
Sutton, Peter C., ed. *The Age of Rubens.* Exh. cat. Boston: Museum of Fine Arts, in association with Ghent, New York: distributed by Harry N. Abrams.

Swillens 1931
Swillens, P. T. A. "De schilder Theodorus (of Dirck?) van Baburen." *Oud Holland* 48:88–96.

Swillens 1934
Swillens, P. T. A. "De Utrechtsche Schilders Dirck en Maerten Stoop." *Oud Holland* 51:116–35, 175–81.

Swillens 1945–46
Swillens, P. T. A. "Rubens' bezoek aan Utrecht." *Jaarboekje Oud Utrecht*, 105–25.

Swillens et al. 1961
Swillens, P. T. A., et al. *Pieter Jansz. Saenredam.* Utrecht: Centraal Museum.

Tapié 1990
Tapié, Alain. *Les vanités dans la peinture au XVIIe siècle: méditations sur la richesse, le dénuement et la rédemption.* Exh. cat. Paris: Albin Michel. Musée des Beaux-Arts de Caen.

Tapié et al. 1986
Tapié, Alain, et al. *L'allégorie dans la peinture: la représentation de la charité au XVIIe siècle.* Exh. cat. Musée des Beaux-Arts de Caen.

Taverne 1978
Taverne, Ed. *In 't land van belofte: in de nieuwe stadt: ideaal en werkelijkheid van de stadsuitleg in de Republiek, 1580–1680.* Maarssen: Gary Schwartz.

Taylor 1995
Taylor, Paul. *Dutch Flower Painting, 1600–1720.* New Haven and London: Yale University Press.

Teellinck 1627
Teellinck, Willem. *Noodwendigh vertoogh, aengaende den tegenwoordigen bedroef den staet van Gods volck* Middelburg.

Den Tex 1975
den Tex, Jan. "De Staten in Oldebarnevelt' tijd," 51–89. In Leeuwenberg and Van Tongerloo 1975.

Van Thiel 1971
van Thiel, Pieter J. J. "De aanbidding der koningen en ander vroeg werk van Hendrick ter Brugghen." *Bulletin van het Rijksmuseum* 19:91–116.

Van Thiel 1974
van Thiel, Pieter J. J. "*L'adoration des Mages* de Hendrick ter Brugghen (1588–1629)," 115–24. In *Colloquio sul tema Caravaggio e i caravaggeschi*. Problemi attuali di scienza e di cultura, no. 205. Rome: Accademia Nazionale dei Lincei.

Van Thiel 1990–91
van Thiel, Pieter J. J. "Catholic Elements in Seventeenth-Century Dutch Painting, apropos of a Children's Portrait by Thomas de Keyser." *Simiolus* 20:39–62.

Van Thiel and De Bruyn-Kops 1984
van Thiel, Pieter J. J., and C. J. de Bruyn-Kops. *Prijst de lijst: De Hollandse schilderijlijst in de zeventiende eeuw*. Exh. cat. The Hague: Staatsuitgeverij. Rijksmuseum, Amsterdam.

Van Thiel et al. 1976
van Thiel, Pieter J. J., et al. *All the Paintings of the Rijksmuseum in Amsterdam*. Amsterdam: Rijksmuseum.

Van Thiel et al. 1992
van Thiel, Pieter J. J., et al. *All the Paintings of the Rijksmuseum. First Supplement: 1976–1991*. Amsterdam: Rijksmuseum; The Hague: SDU.

Thieme-Becker
Thieme, Ulrich, and Felix Becker, eds. *Allgemeines Lexikon der bildenden Künstler von der Antike bis zur Gegenwart*. 37 vols. Leipzig: E. A. Seemann, 1907–50.

Thiéry 1953
Thiéry, Evan. *Le paysage flamand au XVIIe siècle*. Paris: Elsevier.

Thomas 1983
Thomas, K. *Man and the Natural World: A History of the Modern Sensibility*. New York: Pantheon Books.

Tissink and De Wit 1987
Tissink, Fieke, and H. F. de Wit. *Gorcumse schilders in de gouden eeuw*. Gorinchem: Stichting Merewade.

Tokyo 1984
Dutch Painting of the Golden Age from the Royal Picture Gallery Mauritshuis. Exh. cat. Tokyo: The Tokyo Shimbum. The National Museum of Western Art, Tokyo.

Des Tombe 1905
des Tombe, J. W. "De lotgevallem van een oud huis te Utrecht." *De Navorscher* 55:4.

Tours 1961
Saint Martin dans l'art et l'imagerie. Exh. cat. Tours: Musée des Beaux-Arts.

Trnek 1986
Trnek, Renate. *Die Niederländer in Italien: italianisante Niederländer des 17. Jahrhunderts aus österreichischem Besitz*. Exh. cat. Salzburg: Residenzgalerie Salzburg, Gemäldegalerie der Akademie der Bildenden Künste in Wien.

Tümpel 1980
Tümpel, Christian. "Religious History Paintings," 45–54. In Blankert et al. 1980.

Tümpel 1986
Tümpel, Christian. *Rembrandt: Mythos und Methode*. Königstein imTaunus: Langewiesche.

Tümpel et al. 1991
Tümpel, Christian, et al. *Het Oude Testament in de Schilderkunst van de Gouden Eeuw*. Exh. cat. Zwolle: Waanders. Joods Historisch Museum, Amsterdam.

Utrecht 1952
Caravaggio en de Nederlanden. Exh. cat. Netherlands: Gemeentebesturen van Utrecht en Antwerpen. Centraal Museum, Utrecht; Koninklijk Museum voor Schone Kunsten, Antwerp.

Utrecht 1959
Paus Adrianus VI. Exh. cat. Centraal Museum, Utrecht; Stadhuis, Louvain.

Utrecht 1992
Het Landschap: Vijf eeuwen meesters van de landschapsschilderkunst uit de collectie van het Centraal Museum. Exh. cat. Utrecht: Centraal Museum.

Valcanover 1990
Valcanover, Francesco, et al. *Titian: Prince of Painters*. Exh. cat. Venice: Marsilio Editori; Munich: Prestel. Palazzo Ducale, Venice; National Gallery of Art, Washington.

Van Veen and McCormick 1984
van Veen, Henk Th., and Andrew P. McCormick. *Tuscany and the Low Countries: An Introduction to the Sources and an Inventory of Four Florentine Libraries*. Florence: Centro Di.

Veldman 1977
Veldman, Ilja M. *Maarten van Heemskerck and Dutch Humanism in the Sixteenth Century*. Maarssen: Gary Schwartz.

Van de Ven 1952
van de Ven, A. J. "Het Huis Clarenburch te Utrecht." *Jaarboekje van Oud-Utrecht*, 32–61.

Van de Ven 1955
van de Ven, A. J. "De driehoek van Sint Marie te Utrecht." *Jaarboekje van Oud-Utrecht*, 33–80.

Vente 1975
Vente, Marten Albert. *Orgels en organisten van de Dom te Utrecht van de 14de eeuw tot heden*. Utrecht: M. A. Vente.

Verkuyl 1971
Verkuyl, P. E. L. *Battista Guarini's "Il Pastor Fido" in de Nederlandsr dramatische literatuur*. Assen: Van Gorcum. Ph.D. diss., Rijksuniversiteit Utrecht.

Vervaet 1976
Vervaet, J. "Catalogus van de altaarstukken van gilden en ambachten uit de Onze-Lieve-Vrouwekerk van Antwerpen en bewaard in het Koninklijk Museum." *Jaarboek van het Koninklijk Museum voor Schone Kunsten* 10:197–244.

Vijlbrief 1950
Vijlbrief, Izaäk. *Van anti-aristocratie tot democratie: een bijdrage tot de politieke en sociale geschiedenis der stad Utrecht*. Amsterdam: Em. Querido.

Virch 1958
Virch, Claus. "The Crucifixion by Hendrick Terbrugghen." *The Metropolitan Museum of Art Bulletin* 16 (April): 217–26.

Visscher 1614
Visscher, Roemer. *Sinnepoppen*. Amsterdam: W. Iansz.

Visser 1963
Visser, C. Ch. G. *De Luthersen in Utrecht*. Utrecht.

Visser 1966
Visser, Jan. *Rovenius und seine Werke*. Assen: Van Gorcum and Co.

Voetius 1965
Voetius, Gisbertus. *Selectae Disputationes Theologicae*, 263–334. In *Reformed Dogmatics: J. Wollebius, G. Voetius and F. Turretin*, edited by John W. Beardslee III. New York: Oxford University Press.

Voetius 1978
Voetius, Gisbertus. *Inaugurele rede over godzaligheid te verbinden met de wetenschap: gehouden aan de Illustre School te Utrechte op de 21ste augustus 1634*, edited by Aart de Groot. Kampen: J. H. Kok.

Van den Vondel 1974
van den Vondel, Joost. *Vorstelijke Warande der Dieren*. Introduction by J. Becker. Soest: Davaco.

Voorhelm-Schneevoogt 1873
Voorhelm-Schneevoogt, C. G. *Catalogue des éstampes gravées d'après P. P. Rubens*. Haarlem: Loosjes.

De Voragine 1969
de Voragine, Jacobus. *The Golden Legend of Jacobus de Voragine*, edited and translated by Granger Ryan and Helmut Ripperger. New York: Longman.

De Voragine 1993
de Voragine, Jacobus. *The Golden Legend of Jacobus de Voragine*, edited and translated by Granger Ryan and Helmut Ripperger. 2 vols. Princeton, N.J.: Princeton University Press.

Voss 1924
Voss, Hermann. *Die Malerei des Barock in Rom*. Berlin: Propylaen-Verlag.

Vossen 1975
Vossen, Carl. *Sankt Martin: sein Leben und Fortwirken in Gesinnung, Brauchtum und Kunst*. Düsseldorf: Rheinisch-Bergische Druckerei- und Verlagsgesellschaft.

De Vries 1963
de Vries, Ary Bob. "De bevrijding van Petrus, Hendrick Ter-brugghen Getekend en Gedateerd 1624." *Jaarverslag Vereeniging Rembrandt, verslag over 1963*, 33.

De Vries 1994
de Vries, Dirk J. *Bouwen in de late Middeleeuwen: stedelijke architectuur in het voormalige Over- en Nedersticht*. Utrecht: Matrijs.

De Vries et al. 1983
de Vries, Dirk J., et al. "Originele Bestekken Janskerkhof 16 Utrecht," 16–33. In *Vijfenzestige Jaarverslag Vereniging Hendrick de Keyser*.

De Vries 1974
de Vries, Jan. *The Dutch Rural Economy in the Golden Age, 1500–1700*. New Haven and London: Yale University Press.

De Vries 1981
de Vries, Jan. *Barges and Capitalism: Passenger Transportation in the Dutch Economy (1632–1839)*. Utrecht: HES Publishers.

De Vries 1984
de Vries, Jan. *European Urbanization, 1500–1800*. Cambridge, Mass.: Harvard University Press.

De Vries and Bredius 1885
de Vries, A. D., and Abraham Bredius. *Catalogus der schilderijen in het Museum Kunstliefde te Utrecht*. Utrecht: J. L. Beijers.

De Vries and Van der Woude 1997
de Vries, Jan, and Ad van der Woude. *The First Modern Economy: The Success, Failure, and Perseverance of the Dutch Economy, 1500–1815*. Cambridge and New York: Cambridge University Press.

Waagen 1837
Waagen, Gustav Friedrich. *Kunstwerke und Künstler in England und Paris*. 3 vols. Berlin: In der Nicolaischen Buchhandlung.

Waagen 1857
Waagen, Gustav Friedrich. *Galleries and Cabinets of Art in Great Britain: Being an Account of More than Forty Collections of Paintings, Drawings, Sculptures, MSS., etc., visited in 1854 and 1856, and Now for the First Time Described*. London: John Murray.

Van de Waal 1952
van de Waal, Henri. *Drie eeuwen vaderlandsche geschied-uitbeelding, 1500–1800: een iconologische studie*. 2 vols. The Hague: Martinus Nijhoff.

Van Wagenberg-ter Hoeven 1993–94
van Wagenberg-ter Hoeven, Anke A. "The Celebration of Twelfth Night in Netherlandish Art." *Simiolus* 22:65–96.

Wailes 1987
Wailes, Stephen L. *Medieval Allegories of Jesus' Parables*. Berkeley and Los Angeles: University of California Press.

Walford 1991
Walford, E. John. *Jacob van Ruisdael and the Perception of Landscape*. New Haven and London: Yale University Press.

Walgrave 1967
Walgrave, Jan. "Hendrick ter Brugghen." *Openbaar Kunstbezit in Vlaanderen*, pl. 28.

Wallace 1988
Wallace, W. "Traditional Natural Philosophy." In *The Cambridge History of Renaissance Philosophy*, edited by Charles B. Schmitt, Quentin Skinner, and Eckhard Kessler. Cambridge and New York: Cambridge University Press.

Walsh and Schneider 1981
Walsh, John, Jr., and Cynthia P. Schneider. *A Mirror of Nature: Dutch Paintings from the Collection of Mr. and Mrs. Edward William Carter*. Exh. cat. Los Angeles: Los Angeles County Museum of Art. Also Museum of Fine Arts, Boston; The Metropolitan Museum of Art, New York.

Ward and Fidler 1993
Ward, Roger, and Patricia J. Fidler. *The Nelson-Atkins Museum of Art: A Handbook of the Collection*. New York: Hudson Hills Press, in association with the Nelson-Atkins Museum of Art.

Washington 1973
Early Italian Engravings from the National Gallery of Art. Exh. cat. Washington: National Gallery of Art.

Van de Water 1729
van de Water, Johan, ed. *Groot placaatboek, vervattende alle de placaten, ordonnantien en edicten der edele mogende heeren Staten 's lands van Utrecht: mitsgaders van de borgemeesteren en vroedschap der stad Utrecht; tot het jaar 1728 ingesloten*. 3 vols. Utrecht: Jacob van Poolsum.

Van de Watering 1982
van de Watering, Willem. *Terugzien in bewondering / A Collector's Choice*. Exh. cat. The Hague: G. Cramer Oude Kunst, Hoogsteder Gallery, and S. Nystad Oude Kunst, in association with the Mauritshuis.

Van de Watering et al. 1981
van de Watering, Willem L., et al. *Oude Meesters in de Verzameling M. S. Rabbani*. Wassenaar.

Walther 1990
Walther, Gerhard. *Der Heidelberger Schlossgarten*. Heidelberg: Heidelberg Verlangsanstalt.

Weber 1991
Weber, Gregor J. M. *Der Lobtopos des "lebenden" Bildes: Jan Vos und sein "Zeege der Schilderkunst" von 1654*. Hildesheim and New York: Georg Olms Verlag.

Weddigen 1994
Weddigen, Erasmus. *Das Vulkan paralleles Wesen: Dialog über einen Ehebruch mit einem Glossar zu Tintorettos Vulkan überrascht Venus und Mars*. Munich: Scaneg.

Weisbach 1928
Weisbach, Werner. "Der sogenannte Geograph von Velazquez und die Darstellungen Demokrit und Heraklit." *Jahrbuch der Preussischen Kunstsammlungen* 49:141–58.

Welu 1979
Welu, James A. *Seventeenth-Century Dutch Painting: Raising the Curtain on New England Private Collections*. Exh. cat. Worcester: Worcester Art Museum.

Welu and Biesboer 1993
Welu, James A., and Pieter Biesboer. *Judith Leyster: A Dutch Master and Her World*. Exh. cat. Zwolle: Waanders. Worcester Art Museum; Frans Halsmuseum, Haarlem.

Wethey 1962
Wethey, Harold E. *El Greco and His School*. 2 vols. Princeton, N.J.: Princeton University Press.

Wethey 1975
Wethey, Harold E. *The Paintings of Titian*. 3 vols. London and New York: Phaidon.

Wettengl 1993
Wettengl, K., ed. *Georg Flegel, 1566–1638: Stilleben*. Exh. cat. Frankfurt: Historisches Museum Frankfurt am Main.

Wevers 1991
Wevers, L. *Heemstede: Architectuurhistorisch onderzoek van een 17de eeuwse buitenplaats in de provincie Utrecht*. Leiden.

Weyerman 1729–69
Weyerman, Jacob Campo. *De levens-beschryvingen der Nederlantsche konst-schilders en konst-Schilderessen*. 4 vols. Vols. 1–3, 's-Gravenhage: By de weduwe E. Boucquet, 1729; Vol. 4, Dordrecht: A. Blusset en zoon, 1769.

Weytens 1965
Weytens, H. C. "De zwerftocht van een koperen grafplaat." *Jaarboekje Oud-Utrecht*, 57–62.

Wheelock 1995a
Wheelock, Arthur K., Jr. *Dutch Paintings of the Seventeenth Century*. National Gallery of Art Systematic Catalogue, vol. 8. Washington: National Gallery of Art, in association with New York and Oxford: Oxford University Press.

Wheelock 1995b
Wheelock, Arthur K., Jr., ed. *Johannes Vermeer*. Exh. cat. Zwolle: Waanders, in association with the National Gallery of Art, Washington, and the Mauritshuis, The Hague.

White 1982
White, Christopher. *The Dutch Pictures in the Collection of Her Majesty the Queen*. Cambridge and New York: Cambridge University Press.

Willnau 1935
Willnau, Carl. "Die Herkunft des Nikolaus Knüpfer." *Familiengeschichtliche Blätter* 33, no. 1:6–12.

Willnau 1952
Willnau, Carl. "Die Zusammenarbeit des Nikolaus Knüpfer mit anderen Künstlern." *Oud-Holland* 67:210–17.

Wilson 1980
Wilson, William H. *Dutch Seventeenth-Century Portraiture: The Golden Age*. Exh. cat. Sarasota, Fla.: The John and Mable Ringling Museum of Art.

Wilton and Bignamini 1996
Wilton, Andrew, and Ilaria Bignamini. *Grand Tour: The Lure of Italy in the Eighteenth Century*. Exh. cat. London: Tate Gallery Publishing. Tate Gallery, London; Palazzo delle Esposizioni.

Wind 1937
Wind, Edgar. "The Christian Democritus." *Journal of the Warburg and Courtauld Institutes* 1:180–82.

Wintermans 1996
Wintermans, S. "'Gister sy, heden ick': De reeks voorouderportretten op slot Zuylen," 19–27. In Van der Goes and De Meyere 1996.

Winternitz 1979
Winternitz, Emanuel. *Musical Instruments and Their Symbolism in Western Art: Studies in Musical Iconology*. New Haven: Yale University Press.

Van Wissen 1995
Van Wissen, B., ed. *Dodo, Raphus cucullatus (Didus ineptus)*. Amsterdam: Zoölogisch Museum, Universiteit van Amsterdam.

Wittert van Hoogland 1909–12
Wittert van Hoogland, Everard B. F. F. *Bijdragen tot de geschiedenis der Utrechtse ridderhofsteden en heerlijkheden*. 2 vols. The Hague and Utrecht.

Woltjer 1991
Woltjer, Jan Juliaan. *Die Gründung der Republik der Vereinigten Niederlande*. Handbuch der europäischen Geschichte. 5th ed. Munich: DTV/Klett-Cotta.

Van der Woude 1980
van der Woude, Ad. "Demographische ontwikkeling van de Noordelijke Nederlanden, 1500–1800." *Algemene Geschiedenis der Nederlanden*, vol. 5. Bussum: Fibula-Van Dishoek.

Van der Woude et al. 1965
van der Woude, A. M., et al. "Numerieke aspecten van de protestanttisering in Noord-Nederland tussen 1656 en 1726." *A. A. G. Bijdragen* 13:149–80.

Wright 1983
Wright, Christoper. *Dutch Landscape Painting.* Exh. cat. Newcastle upon Tyne: Laing Art Gallery.

Wright 1995
Wright, Christopher. *The Masters of Candlelight: An Anthology of Great Masters including Georges de la Tour, Godfried Schalcken, Joseph Wright of Derby.* Landschut: Arcos Verlag.

Würbs 1864
Würbs, K. *Verzeichnis der Gräflich Nostitz'schen Gemälde-Sammlung in Prag.* Prague.

Van der Wurf-Bodt 1988
van der Wurf-Bodt, Coby. *Van lichte wiven tot gevallen vrouwen: prostitutie in Utrecht vanaf de late middeleeuwen tot het eind van de negentiende eeuw.* Utrecht: Kwadraat.

Von Wurzbach 1906–11
von Wurzbach, Alfred. *Niederländisches Künstler-Lexicon.* 3 vols. Vienna and Leipzig: Halm and Goldmann. Reprint, 2 vols., Amsterdam: B. M. Israel, 1974.

Wurzburg 1746
Beschreibung des fürtrefflichen Gemähld und Bilder Schatzes, wellcher in dene hochgräflichen Sschlossern und Gebäuen Deren Reichs Grafen Von Schönborn, Buchheim, Wolfsthal etc. sowohl in dem Heil. Rom. Reich, als in dem Ertz-Hertzogthum Oesterreich zu ersehen und zu finden. Wurzburg.

Wyss 1973
Wyss, Robert L. "Die Handarbeiten der Maria. Eine ikonographische studie unter berücksichtigung der textilen techniken," 113–88. In *Artes minores. Dank an Werner Abegg,* edited by Michael Stettler and Mechthild Flury-Lemberg. Bern: Stampfli.

Yates 1972
Yates, Frances Amelia. *The Rosicrucian Enlightenment.* London and Boston: Routledge and Kegan Paul.

Ypey 1976
Ypey, J. "Mondharpen." *Antiek* 11 (Oct.): 209–31.

Zafran 1988
Zafran, Eric. *Fifty Old Master Paintings from The Walters Art Gallery.* Baltimore: Trustees of the Walters Art Gallery.

Zeder 1995
Zeder, Olivier. "A propos du *Lavement des pieds* de Peter Wtewael (1596–1660) du Musée d'Arras." *La Revue du Louvre* 45 (Feb.): 26–30.

Van Zijl 1984
van Zijl, I. *Zeldzaan Zilver uit de Gouden Eeue: De Utrechtse edelsmeden Van Vianen.* Exh. cat. Utrecht: Centraal Museum.

Zonneveld 1986
Zonneveld, L. "Kasteel Amerongen, de herbouw in de 17de eeuw." Ph.D. diss., Rijksuniversiteit Leiden.

Zwollo 1983
Zwollo, An. "Ein Beitrag zur niederländischen Landschaftsmalerei um 1600: Stadansichten und antike Ruinen unter besonderer Berücksichtigung des Rudolfinischen Kreises." *Umêní* 31, no. 5:399–412.

Zwollo 1987
Zwollo, An. "Een 'Cornelis Saftleven' per brief." *Nederlands Kunsthistorisch Jaarboek* 38:402–6.

Index

Index to Artists in the Exhibition and
Works Illustrated in the catalogue. Page
numbers in italics indicate illustrations.

Photo Credits

All photography is credited to its lender unless otherwise noted.

Works in the exhibition:

Cat. 3 Bruce M. White
Cat. 6 Hans Petersen
Cat. 7 Ruben de Heer
Cat. 14 Cheryl O'Brian
Cat. 17 Carlo Catenazzi
Cat. 26 Bruce M. White
Cat. 32 Ernst Moritz, The Hague
Cat. 35 Hans Petersen
Cat. 36 B. P. Keiser
Cat. 41 Brunzel
Cat. 43 Öffentliche Kunstsammlung Basel, Martin Bühler
Cat. 44 Don Queralto
Cat. 51 © Photo RMN—Jean Schormans
Cat. 56 Cestmir Sila
Cat. 57 Ernst Moritz, The Hague
Cat. 64 Prudence Cuming Associates Limited, London
Cat. 67 Milan Posseit
Cat. 68 Ernst Moritz, The Hague
Cat. 69 Christine Guest
Cat. 78 Hans Westerink, Zwolle

Works accompanying the essays:

Spicer introduction
 fig. 1 Tim Koster
 figs. 9 and 16 Prudence Cuming Associates Limited, London
 fig. 10 SC
 fig. 22 Margareta Svensson, Amsterdam
 fig. 23 Jörg P. Anders, Berlin
Kaplan
 fig. 1 Photograph Iconografisch Bureau
 figs. 2–4 Ruben de Heer
Olde Meierink and Bakker
 fig. 7 RDMZ, Zeist 1946
 fig. 9 RDMZ, Zeist
Bok
 fig. 1 B. P. Keiser
Orr
 fig. 1 Alinari/Art Resource
 fig. 6 J. Lathion, Nasjonalgalleriet
 fig. 7 Alinari/Art Resource
 figs. 10–11 Jörg P. Anders
Franits
 fig. 5 IRPA-KIK
 fig. 7 Sotheby's, London

Works accompanying discussion of paintings in the "Catalogue of the Exhibition":

Cat. 1, fig. 1 B. P. Keiser
Cat. 1, fig. 2 Fotoatelier Louis Held
Cat. 3, fig. 1 John Stoel
Cat. 4, fig. 1 Jean Foultier Photorama
Cat. 10, fig. 1 Paul Bijtebier, Brussels
Cat. 11, fig. 1 Prudence Cuming Associates Limited, London
Cat. 12, fig. 2 B. P. Keiser
Cat. 14, fig. 1 Cheryl O'Brian
Cat. 17, fig. 1 Rijksbureau voor Kunsthistoriche Documentatie, The Hague
Cat. 17, fig. 2 A. C. Cooper Ltd.
Cat. 28, figs. 1–3 Jörg P. Anders
Cat. 29, figs. 2–3 Iconographisch Bureau, The Hague
Cat. 31, fig. 2 Courtesy Christie's, London
Cat. 33, fig. 2 Deutsche Fotothek, Dresden
Cat. 36, fig. 1 A. C. Cooper Ltd.
Cat. 39, fig. 1 Bernard Prud'homme
Cat. 39, fig. 3 B. P. Keiser
Cat. 44, fig. 1 B. P. Keiser
Cat. 50, fig. 2 Sir Brinsley Ford CBE: Courtauld Institute of Art
Cat. 51, fig. 1 © Rijksmuseum-Stichting Amsterdam;
Cat. 51, fig. 2 © Photo RMN—Jean Schomans
Cat. 52, fig. 2 © Henk Platenburg, Utrecht
Cat. 54, fig. 1 Sarah Wells 1997, © Her Majesty Queen Elizabeth II
Cat. 55, fig. 1 Photograph Iconografisch Bureau
Cats. 62, 63, fig. 2 Prudence Cuming Associates Limited, London
Cat. 64, fig. 1 Prudence Cuming Associates Limited, London
Cat. 64, fig. 2 Prentenkabinet der Rijksuniversiteit te Leiden, Leiden
Cat. 66, fig. 1 © 1997, Her Majesty Queen Elizabeth II
Cat. 67, fig. 1 Courtesy J. Spicer
Cat. 71, fig. 2 © 1997 Museum Associates, Los Angeles County Museum of Art. All rights reserved.
Cat. 76, fig. 1 © 1997, Board of Trustees, National Gallery of Art, Washington

Map:

pp. 372–73 Joseph McDonald